An Outline of 19th Century European Painting

Volume II: Plates (in preparation)

An
Outline of 19th Century European Painting

From David Through Cézanne

Lorenz Eitner

Volume I: Text

ICON EDITIONS

1817

HARPER & ROW, PUBLISHERS, New York
Cambridge, Philadelphia, San Francisco, Washington
London, Mexico City, São Paulo, Singapore, Sydney

Designer: C. Linda Dingler
Copyeditor: Ann Adelman
Indexer: Maro Riofrancos

Library of Congress Cataloging-in-Publication Data

Eitner, Lorenz.
 An outline of nineteenth-century European painting.

 (Icon editions)
 Includes bibliographies and index.
 1. Painting, European—Outlines, syllabi, etc.
2. Painting, Modern—19th century—Europe—Outlines,
syllabi, etc. I. Title. II. Title: Outline of
19th-century European painting.
 ND457.E38 1986 759.05 82-48690
 ISBN 0-06-432976-3
 87 88 89 90 91 MPC 10 9 8 7 6 5 4 3 2 1
 ISBN 0-06-430126-5 (pbk.)
 87 88 89 90 91 MPC 10 9 8 7 6 5 4 3 2

Contents

Foreword viii

1 Introduction 1
 The Late-Eighteenth-Century Background 3
 The Enlightenment and the Arts 4
 The Classical Revival 7
 The Arts in France at the End of the Eighteenth Century 8

2 David and His School 15
 Jacques-Louis David, 1748–1825 17
 Pupils and Followers 32
 Antoine-Jean Gros, 1771–1835 33
 Anne-Louis Girodet (de Roucy-Trioson), 1767–1824 38
 François-Pascal Gérard, 1770–1837 41
 Pierre-Narcisse Guérin, 1774–1833 44
 Pierre-Paul Prud'hon, 1758–1823 49

3 Francisco José de Goya y Lucientes, 1746–1828 55

4 British Neoclassicism and William Blake 75
 British Neoclassicism 77
 Gavin Hamilton, 1723–1798 77
 Benjamin West, 1738–1820 78
 James Barry, 1741–1806 79
 Henry Fuseli, 1741–1825 81
 John Flaxman, 1755–1826 83
 William Blake, 1757–1827 86

5 German Romantics 101
 Philipp Otto Runge, 1777–1810 103
 Caspar David Friedrich, 1774–1840 110

6 English Landscape 121
 John Constable, 1776–1837 123
 J. M. W. Turner, 1775–1851 138

7 French Romantics 155
 Jean-Dominique Ingres, 1780–1867 157
 Théodore Géricault, 1791–1824 171
 Eugène Delacroix, 1798–1863 184

8 French Landscape 197
 J.-B.-Camille Corot, 1796–1875 199
 French Naturalist Landscape and
 the School of Barbizon, 1830–1870 212
 The Painters of Barbizon 214
 Théodore Rousseau, 1812–1867 217

9 Realism 225
 Realism 227
 Social Realism 228
 Honoré Daumier, 1808–1879 232
 Jean-François Millet, 1814–1875 237
 Gustave Courbet, 1819–1877 249

10 Academic and Salon Painters 269
 Academic and Salon Painters 271
 The Academy and the Ecole des Beaux-Arts 272
 The Paris Salons and Their Juries 275
 The Salon Painters 281

11 Edouard Manet, 1832–1883 289

12 Edgar Degas, 1834–1917 313

13 Impressionism 333
 Impressionism 335
 The Term "Impressionism" 335
 Antecedents 336
 Development 337
 Method 340
 Fluctuations in the Reputation of Impressionism 342
 Claude Monet, 1840–1926 345
 Pierre-Auguste Renoir, 1841–1919 368

Alfred Sisley, 1839–1899 389

Camille Pissarro, 1830–1903 399

14 Paul Cézanne, 1839–1906 419

Index 443

Foreword

This book owes its existence to a teaching problem which I encountered in attempting to introduce students to European art of the early and mid-nineteenth century: the lack of a general text covering that period. The broad surveys were insufficiently detailed for my purpose; the essential monographic literature, on the other hand, went far beyond what my students could manage in the time given them. To bridge this gap, I began to prepare syllabi that amounted to miniature monographs and that presented what I considered the essential information concisely, but in considerably greater depth than the available surveys, including Walter Friedlaender's excellent *David to Delacroix,* my initial model. My book does not pretend to be a comprehensive history of the art of the period. It is, as I well know, limited by certain conventions of coverage and emphasis to which my teaching, in its time and place, was subject. It also reflects the attitudes, and perhaps prejudices, of its author. Its focus is on the individual artist, as the embodiment of the ideas and artistic movements current in a particular society and period. The brief bibliographies appended to its various sections are designed for practical use, by students within reach of a good library. They emphasize recent, well-illustrated, and reasonably accessible works, and are not meant to be comprehensive.

I owe thanks to many colleagues and students, but most of all to Trudi Eitner for her help and affectionate understanding.

L.E.
Stanford University

1
Introduction

The Late-Eighteenth-Century Background
The Enlightenment and the Arts
The Classical Revival
The Arts in France at the End of the Eighteenth Century

THE LATE-EIGHTEENTH-CENTURY BACKGROUND

The current of thought, known as the Enlightenment, that was to transform the political and intellectual life of Europe in the second half of the eighteenth century began in an effort to reform society by subjecting its customs and institutions to a rational examination: the objective truth, once established, would infallibly lead to improvement. This optimistic expectation helped to set in motion a vast enterprise in the collection and popularization of knowledge. One of its most influential results was the publication of the great French *Encyclopédie,* an alphabetically arranged compendium of facts and ideas, produced by some 160 contributors under the editorship of Denis Diderot and Jean le Rond d'Alambert. Its seventeen volumes of text and eleven volumes of plates, published from 1751 to 1772, contained articles ranging from agriculture to zoology, from questions of ethics, history, and economics to the techniques of the mechanical and fine arts.

Beneath the erudition and informative detail of these articles ran a current of criticism aimed at revealed religion, "monkish" Christianity, outworn dogma, and ancient superstition. The governments of the time, though not directly attacked, reacted nervously to what they felt to be a threat to social stability by a cabal of free-thinkers and self-appointed reformers bent—in the words of the royal edict of 1752 which temporarily suspended the *Encyclopédie*'s publication —on "destroying royal authority, fomenting a spirit of independence and revolt, and . . . laying the foundations of an edifice of error, for the corruption of morals and religion, and the promotion of unbelief."

Their suspicions were not groundless. Religious creeds and old traditions were the basis of divine-right rule. In subjecting them to a rational analysis, the thinkers of the Enlightenment were in fact questioning the legitimacy of kingship. But their purpose was not as yet to abolish monarchy. They meant, rather, to strengthen its executive power and direct it to the work of reform, by modernizing its political and economic machinery, and by freeing it from domination by clergy and aristocracy. The Enlightenment was not, to begin with, motivated by democratic impulses. Its leaders—lawyers, economists, scientists, journalists, and liberal churchmen—represented the aspiring middle class, conscious of its real power, impatient with the resistance that the obscurantist rearguard of a decaying system opposed to the progress of the new sciences and technologies. Their cause

had powerful supporters among the leading statesmen and the most powerful autocratic rulers of the time: Charles III of Spain, Frederick the Great of Prussia, Catherine the Great of Russia, and Joseph II, emperor of the Germanic Empire and the most radical of the enlightened despots.

The ideology of the Enlightenment was colored by a materialist bias, a view of nature as a calculable chain of cause and effect. The more radical of its thinkers regarded the world as an enormous machine, "matter in motion," that could be understood and mastered through a knowledge of physics and chemistry. Some went to the extreme of interpreting man himself as a complex but purely physical mechanism. Julien de La Mettrie, in his *Natural History of the Soul* (1745), treated the soul as a material phenomenon, and in a sequel to this book, provocatively entitled *L'Homme machine* (1748), went on to describe the workings of man's body and mind as being like those of a complicated clockwork. The spiritual was pure illusion—a figment invented by priests. A similarly materialist attitude marked the Enlightenment's approach to statecraft and economics. The state, even more obviously than man himself, was a machine made up of mechanical parts. Government was a form of engineering. Kings derived whatever authentic dignity they possessed from their more or less beneficent management of the great engine of the state, not from any divine sanction.

While the Enlightenment rejected faith in the supernatural, it was itself based on certain unscientific, optimistic assumptions: that Nature was good, that man as Nature's child shared in this fundamental goodness and only needed to be freed from the darkness of ignorance and the infection of corrupt civilization to achieve an entirely secular salvation—harmony with Nature. In the Utopian perspective of the Enlightenment, the good, i.e., the rational, society—a smoothly running machine within the larger mechanism of Nature—promised to perfect humanity by developing in it the qualities of happiness, virtue, and common sense with which all its members were equally endowed. From this attitude stemmed the period's passionate interest in constitutions, institutions, and social mechanisms for the regulation and improvement of mankind, and a dangerous tendency to coercive world improvement.

THE ENLIGHTENMENT AND THE ARTS

The Enlightenment philosophers regarded the dominant forms of art of their time as the expression of a corrupt state of society. They subjected the courtly Rococo to a devastating critique for its licentiousness, irrationality, and sheer inutility, the work of artists prostituted to a vicious system. Its constant gaiety and erotic effervescence grated on their nerves: "I am no Capucin," wrote Denis Diderot in 1763 with reference to François Boucher, "but I'll admit that I should gladly sacrifice the pleasure of seeing attractive nudities if I could hasten the moment when sculpture and painting, having returned to decency and morality, will compete in promoting virtue and purity of morals. I think I have seen enough teats and bottoms."

Reform-minded art administrators in the reigns of Louis XV and Louis

XVI gave official encouragement to efforts to raise the moral tone of the arts by commissioning paintings of exemplary acts of heroism and virtue for the king's buildings. Lenormant de Tournehem, "uncle" of Mme de Pompadour, named to the directorship of the Royal Buildings in 1745, attempted to reform the Academy by establishing a special school to prepare winners of the Rome Prize for the study of ancient history and literature and by giving preferential commissions to painters of serious historical subjects. His successor, the marquis de Marigny, brother of Mme de Pompadour, though privately fond of Boucher's frivolous work, officially promoted paintings of civic or humanitarian subjects. The comte d'Angevilliers, who replaced him and held the position until it was abolished in the Revolution (1791), prescribed morally uplifting subjects from ancient and French history for work to be executed for the royal residences and manufactures.

Princes of the Ancien Régime had sometimes bankrupted themselves by their reckless expenditures for buildings, sculptures, and pictures. Their enlightened successors strove to be frugal, and tended to measure the worth of art by inartistic standards of morality or social utility, by its contribution to the public's moral or material welfare. Official patronage throughout Europe declined. Artists were exhorted to consider themselves as citizens and to work for humanity according to their conscience, instead of prostituting themselves for pay.

The Enlightenment raised the moral tone but rather depressed the quality of art. Its sober rationalism discounted the essentially artistic side of art, it did not admit talent to be a rare and mysterious gift. Rather, to understand or to make art required only a good eye, a virtuous disposition and sound mind, a knowledge of principles, and sufficient diligence. Many artists found meager inspiration in the high-minded fables that the art bureaucracies assigned to them. Historic examples of virtue and self-sacrifice stimulated them less, on the whole, than had the erotic or dramatic fictions of the Rococo. As Rococo vivacity went out of fashion, no distinctive new style immediately took its place. The Enlightenment merely sedated the Rococo, straightening and stiffening its forms, introducing plainer, more rectilinear shapes into architecture and ornament, and calming the excitement of gestures, the flutter of draperies. Old conventions of clasically inspired decoration made their reappearance, in what amounted to a revival of the formality of the style of Louis XIV.

This final, "reformed" phase of the Rococo is sometimes referred to, derisively, as "Pompadour style" (ca. 1745–65). Its characteristic and highly influential representative among French painters was Joseph-Marie Vien (1716–1809), a native of Montpellier who had come to Paris in 1740 to study with Charles Natoire, a painter of grand mythological compositions and the occasional associate of Boucher in decorative projects. After winning the Rome Prize in 1743, Vien spent the years of 1744–50 at the French Academy in Rome, just at the time of the highest excitement over the rediscovery of Herculaneum and Pompeii. This had no immediate effect on his own painting, which, at that time, was rather indebted to an Italian Baroque realism that appealed to him as an antidote to the weaknesses he had found in current French—i.e., Rococo—art. Thirty years later, Vien's pupil Louis David was to undergo a similar, gradual conversion in

Rome from French Rococo to Italian Baroque and ultimately to Neoclassical style.

Back in France, Vien was taken in hand by the antiquarian comte de Caylus, who encouraged him to experiment with the ancient technique of encaustic (hot wax) painting. His style and choice of subjects underwent a marked change at this time, the result of his exposure to the climate of the Enlightenment and to incipient neoclassicism. The stiff and virtuously tame compositions in the "Greek" manner that he now exhibited, a *Greek Girl Garlanding a Bronze Vase* (1761), a *Priestess Burning Incense on a Tripod* (1763), were greeted with enthusiasm for their supposed purity of style. His best-remembered work, *The Cupid Seller* (1763, Château of Fontainebleau), shown at the Salon of 1763 to great acclaim, is the sweetened retelling of an antique motif, borrowed from the engraving of a fresco recently unearthed in Herculaneum: a woman offers small, winged cupids which she takes from a basket to two demure Roman matrons. The background, with its fluted pilasters and bronze vase, is the very image of a French drawing room furnished in the new "Greek" fashion. Contemporaries admired what to modern eyes seems the picture's special tedium—its isolated, static figures, aligned primly as in a frieze, its stiff gentility of pose, and the modest, clinging draperies of its figures—all in intentional contrast to Rococo vivacity. Yet the picture's trivial agreeableness is still quite Rococo. Its classicism is merely a veneer that, in keeping with the Enlightenment's demand for moderation, disguises the potential eroticism of the scene without denying the viewer some secret enjoyment.

Subsequently, Vien was among the artists commissioned to paint morally edifying subjects for royal residences. *Marcus Aurelius Distributing Food and Medicine in a Time of Famine* (1765, Amiens, Musée de Picardie) was destined for the Château de Choisy, as part of a series celebrating the good deeds of Roman emperors. Louis XV, bored with the subject, had the paintings removed.

During the 1760s and 1770s, Vien alternated between large religious compositions and easel pictures of chastely erotic, pseudo-classical themes. His altarpiece for the church of St. Rochus in Paris, *The Sermon of St. Denis* (1767), an ungainly attempt at monumentality, was followed by a commission for Mme du Barry's Château de Louveciennes, a series of canvases tracing the *Progress of Love in the Heart of a Young Girl,* translating into the "Greek" manner Honoré Fragonard's audaciously modern series on the same theme which the royal mistress had had the bad taste to reject.

The favorite of successive directors of Royal Buildings, received at court, ennobled, and treated with distinction by Mmes de Pompadour and du Barry, Vien received the highest honors. Named director of the French Academy, he composed in Rome a series of compositions for the Gobelin tapestry works on heroic subjects from Homer (1779–81). But he did not forsake his Greco-erotic formula for all that, painting while in Rome a *Young Greek Girl Comparing Her Breast to a Rose Bud* (1779) and a *Young Bride in Greek Costume at Her Toilet.*

Named First Painter to the king in 1789, the year of the Bastille, Vien remained unmolested during the Revolution. Napoleon appointed him to the

Senate in 1799 (when Vien was eighty-three) and made him a Count of the Empire. He was buried in the Panthéon among France's greatest sons, and eulogized as the "Regenerator" of French painting. He was, in fact, an artist of modest gifts and little imagination, more important as a teacher than as a painter. Through his studio passed a whole generation of neoclassical artists, including, most notably, Louis David, the true "Regenerator" of the French School. Vien did not create a style or open a new direction, but he helped to kill the Rococo, and for this earned the applause of a public and of critics steeped in the spirit of the Enlightenment. It is a proof of the irresistibility of historical change that work so lifeless as Vien's should nevertheless have driven from favor the exuberantly vital painting of Fragonard, the Rococo's last painter of genius.

THE CLASSICAL REVIVAL

The surge of interest in Greek and Roman antiquity that swept through Europe in the latter part of the eighteenth century produced a revolution of taste that affected not only the arts but the detail of everyday life, down to the shapes of dinnerware and the design of women's coiffures. The elegant chastity of classical form replaced Rococo opulence. Greek harmony, Spartan plainness, and Roman magnanimity were the qualities for which architects strove in their buildings, statesmen in their style of government, politicians in their rhetoric, and common citizens in their personal lives. This new cult of antiquity had several sources. The belief in the perfectibility of mankind and in the possibility of progress, two notions deeply imbedded in the Enlightenment, needed the support of history. In reaching for Utopia, it was important to be able to look back to the reality of a past Golden Age. Greece and Rome had shown to what heights humanity could rise; an ideal future was imaginable in terms of that past. To study and to imitate the ancients was thus a progressive effort—the surest way by which mankind could regain its highest potential. The belief in the superiority of the ancients became for many a secular religion, based on the evidence of history, literature, and art, rather than on an uncertain, supernatural revelation. Antiquity, besides, with its traditions of liberty, civic valor, and patriotic sentiment, furnished political models highly appropriate to a time in which outdated monarchical institutions seemed to be disintegrating. But the classical revival also owed something to a romantic fascination with tomb, treasure, and crumbling ruin, and with the melancholy pleasure of meditations on fallen greatness.

The lesson of antiquity could be most closely read, and most directly applied, in works of art. Archeology and the history of ancient art therefore caught the interest of a large lay audience. The excavation of the Roman cities of Herculaneum (begun in 1738) and Pompeii (1748) had an influence that rapidly spread beyond the study and the studio, and was soon felt in many fields of practical application, from the planning of towns to the designing of furniture.

The most effective apostle of the new classicism was Johann Joachim Winckelmann (1717–1768), born as the son of a shoemaker in provincial Prussia, who rose from the obscurity of a small-town schoolmaster's existence to a central

position in the intellectual life of Europe, as its foremost scholar of ancient art. His early studies of the sculptures in the princely collections of Dresden struck him with the force of revelation and inspired his pamphlet *Thoughts on the Imitation of Greek Works in Painting and Sculpture* (1755), the very first sentence of which soon electrified readers throughout Europe: "There is but one way for the moderns to become great, and perhaps unequalled; I mean, by imitating the Ancients." Winckelmann's polemic was an attack on the civilization of the Rococo, as revolutionary in its implications as Rousseau's call for a return to nature: there was no comfortable road from the Europe of the Rococo courts to the intellectual freedom, the beauty, the pagan nudity of ancient Greece. In his later career, as prefect of the antiquities of Rome, Winckelmann made a systematic study of the classical remains in Italian collections and excavations that resulted in a monumental *History of Ancient Art* (1764) which, soon translated into French, English, and Italian, became the basis for subsequent art historical scholarship, and exerted a profound influence on several generations of artists and critics.

THE ARTS IN FRANCE AT THE END
OF THE EIGHTEENTH CENTURY

The decades between 1775 and 1800 were a time of vehement political and social change, affecting all of Europe, and upsetting an old order of which the arts had been an integral part. The American Revolution (1775–83) came as a first signal, greeted by Europeans with a mixture of alarm and enthusiasm. In 1780, the Gordon Riots in London brought England to the brink of popular revolt. But it was the French Revolution (1789–95), finally, that radically broke with the past and began the work of transforming not only France but the world.

The French Revolution can be regarded as the final, convulsive effort of the Enlightenment. The faith in a secular salvation, through the application of reason and science, which inspired its beginnings derived from the doctrines of the philosophers and Utopian planners of the eighteenth century, and so did the tendency of its leaders to search for mathematical or materialist solutions and for geometric patterns of order. But the powerful emotional energies which fueled the Revolutionary struggle also flowed from other, darker sources, from the irrational fascinations and obsessions of the time: the sentimental cult of nature and of natural man, the admiration for untrammeled genius, the romantic enthusiasm for antiquity.

To men living in the 1790s, it seemed as if mankind were undergoing the torments of a new birth. They looked forward, with trepidation if they were attached to the old order, with fervent hope if they had dedicated themselves to the new, to the rise of a freer, more virtuous, and more beautiful humanity. The nations seemed to be casting off the shackles of autocratic government and dogmatic religion. Republics were rising on the ruins of monarchies. Distinctions of rank, class, and wealth appeared to be giving way to universal equality. The French Revolution, in its early stages, powerfully stirred the imagination of men

everywhere. It was greeted with lively sympathy by Kant and Schiller in Germany, by Blake and Wordsworth in England:

> *Bliss was it in that dawn to be alive*
> *But to be young was very heaven!—Oh, times,*
> *In which the meagre, stale, forbidding ways*
> *Of custom, law, and statute, took at once*
> *The attraction of a country in romance!*
> (Wordsworth, *Prelude,* II, 108ff)

The spirit of idealism and optimism, the readiness to conceive projects of colossal scale, to think in bold abstractions and reach radical conclusions, enlivened the intellectual life of the time and found expression in the arts. An appetite for speculation and experiment, a taste for simplicity and austere grandeur marked the highest political and cultural enterprises of the time, causing the final decades of the eighteenth century to appear, in retrospect, as a heroic age.

But disillusionment soon followed. The increasing bloodshed and oppression in Revolutionary France cooled the ardor of many former friends of the Revolution; the post-Thermidorian reaction, and the gradual decline of the Revolution into financial corruption and aggressive warfare, produced a general reaction of disgust and cynicism. The final years of the eighteenth century witnessed an ebbing of the Revolutionary momentum, a return to traditional ways and to smaller-scale, material interests. Those who had derived social or economic benefit from the Revolution now sought to consolidate and defend their gains. Those who felt threatened by it stiffened their resistance. The years around 1800 were a time of recoil. Disenchanted with the promise of Utopia, the people of France wished for renewed stability and a return of material comforts.

Throughout the eighteenth century, France had set the international standard in the arts, and surpassed all other countries in the sheer quantity and, on the whole, in the quality of work produced. How much of this production depended on royal and aristocratic patronage became evident when that patronage ceased around 1791. The years of the Revolution, particularly the period of 1792–97, were a time of unemployment and want for most French artists. Some followed their patrons into exile; others, compromised by former association with the court or the aristocracy, suffered persecution or hid themselves; the rest made every effort to accommodate the new order by displays of citizenship and revolutionary zeal. But there was little work for them. The Salons, which continued to be held throughout the years of the Revolution, gave melancholy proof of the poverty of what had only recently been the most brilliant European school.

This poverty cannot be blamed on deliberate neglect. The Revolutionary governments were not indifferent to art. Despite the heavy pressure of urgent business on them, they gave remarkable attention to such questions as the dissolution of the Academy and its replacement by a National Jury and a Republican Society of the Arts, to the award of art prizes, to the establishment of a Central Museum to house confiscated works from princely collections, the organization

of large-scale art looting in occupied Italy and the Netherlands, and the planning of patriotic monuments. There is much evidence that the Revolutionary leadership fully realized the usefulness of art for political propaganda. Their plans, elaborated mainly by the painter Louis David, lacked neither in ambition nor in imagination, but their finances were in a state of perpetual bankruptcy. Their actual commissions were few and went mostly to a small number of favored artists, most prominent among them David, who was also in charge of the solemn pageants and heroic funerals that were the Revolution's most original artistic enterprises. Like the costumes, chariots, and triumphal arches of plaster-and-cardboard used in these celebrations, most of the work produced during the Revolution was ephemeral and hardly survived the occasions for which it was created. More permanent, unfortunately, was the effect of Revolutionary vandalism: the deliberate destruction of churches, the dispersal of art collections and libraries, and the devastation of the royal tombs.

The Revolution's official style was a grandiloquent form of neoclassicism. But practical reasons—for instance, the commemoration of modern events, as in David's *Oath in the Tennis Court* or his *Death of Marat*—often forced artists to compromise with a more sober realism. The Revolution did not produce a distinctive pictorial or sculptural style. It used available stylistic and thematic material, developed in the period of 1780–90, without noticeably altering its forms. Except for the work of such artists as David, Girodet, Gérard, Boilly, and Hennequin, much of the work exhibited in the "free" (i.e., unjuried) Salons of the Revolution (1793 and 1795) was fairly perfunctory and crude. The artists of the other European countries, accustomed to take their cues from the latest French fashions, were for once thrown on their own devices. The temporary eclipse of Paris during the Revolutionary decade encouraged the growth of independent provincial or national developments in art. The relaxation of Revolutionary austerity during the Directory (1795–99) brought a revival of private patronage, particularly in portraiture, and a return to nearly normal conditions. French artists, in reacting against the severity of Republican neoclassicism, were at this time unusually prone to imitate foreign—and especially British—models in their efforts to create a modern style of beauty and fashion.

The period of the Consulate (1799–1804) and Empire (1804–15), astonishingly brief for having contained so much of history, was a time of stabilization and, in some respects, of restoration. It witnessed the revival of authoritarian institutions and, ultimately, the restoration of hereditary monarchy, the creation of a new aristocracy, and an accommodation with the Church. But the Revolution had a kind of afterlife in the wars that Napoleon waged in every part of Europe and in the system of military government that he gradually extended over the nations of the Continent, for these wars destroyed the old monarchies, redrew the map, and disturbed the old social and cultural order of Europe.

The decades between 1792 (when France became a republic and was invaded by Austrian and Prussian armies bent on restoring the monarchy) and 1815 (when Napoleon went to his final exile) were a period of almost uninterrupted war. France and Britain in particular remained locked in continuous struggle throughout this time, except for the two brief intervals of the Peace of Amiens

(1802–03) and the first Bourbon Restoration (1814–15). For about a quarter of a century the political and economic life of the world was dominated by the exigencies of warfare, first unleashed by the Revolution, maintained by Napoleon's drive for continental empire, and terminated at last by the national resurgence of the European peoples.

Contrary to what one might suppose, this was not a period of decline and unmitigated suffering, despite the terrible bloodletting and the vast material destruction. The conflict generated enormous energies. Out of the chaos of the French Revolution arose the most powerful and intelligently organized empire since the Caesars. From defeat, the nations of Europe drew resources of national strength which in the end enabled them to overcome their conqueror. War acted as a tonic to economic life. It stimulated industry and drove up profits. The sciences, the manufactures, and the politics of war helped to modernize the institutions and to transform the society of Europe. When peace finally came in 1815, the nations were on the whole more populous, more industrial, and actually more prosperous than they had been before the long wars. The victorious and the defeated nations recovered with equal speed—comparable to the later economic recovery of Europe and parts of Asia following World War II. For forty years thereafter, until the outbreak of the Crimean War in 1853, the European powers managed to stay at peace.

Throughout the crucial decades of 1795–1815, two principles stood opposed to one another: the aggressive elan of revolutionary overthrow and innovation, and the conservative response of resistance and restoration. The former was embodied in the dynamics of Napoleonic warfare and foreign policy, the latter in the reaction which these wars and policies provoked among the defeated nations. The injury done by Napoleon to the traditions, the national pride and religious feeling of Germans, Italians, Spaniards, and Slavs (not to mention tradition-minded and religious Frenchmen), produced a powerful backlash. This took a variety of forms: a growth of national self-awareness, even in countries where the sense of nationhood had never been strong; a sentiment of patriotism or monarchical loyalty; and a resurgence of piety and churchly devotion. Anti-Revolutionary and anti-French feelings generally assumed a markedly nostalgic and retrospective flavor. The national past and particularly the medieval period appeared as a Golden Age of national integrity and Christian faith in which good kings had governed God-fearing artisans and peasants. The philosophers of the Enlightenment and the leaders of the Revolution, disciples of neoclassicism, had also looked back to historical models—to Sparta and Republican Rome. But the vision of the past that had guided them was abstract, doctrinaire, and aesthetic. It did not appeal to national or religious feelings, it was not rooted in the practical interests of modern institutions, and lacked the power of rousing a truly popular response.

Bonaparte put into effect, on the grandest scale, the program of artistic propaganda that the Revolution had merely sketched out. Even while still only a general, during the Italian campaign of 1796, he surrounded himself with artists who had the task of recording his campaigns and glorifying his person. He also took an intelligent interest in the systematic looting of Italian art treasures for

the benefit of the Louvre, which was to become the Musée Napoléon. On assuming the government of France as consul (1799–1804) and emperor (1804–1815), he thoroughly reorganized the art establishments which the Revolution had dismantled. The former Royal Academy and the official art school were restored under different names (Institut de France and Ecole des Beaux-Arts). French artists were mobilized, in almost military fashion, for work in the national, i.e., Napoleon's, interest. An art budget was set aside and an art bureaucracy created, under the able direction of Baron Vivant Denon, for the direction of artists—their education, employment, political guidance, and reward.

Napoleon strictly regarded the arts as an instrument of state policy. He was generous in his support of them, but only so long as they fulfilled their assigned function: to give brilliance to his government and court, to glorify his victories and commemorate his diplomatic triumphs, and to carry the message of the unity and power of his Empire to all of France and to the dominated or occupied countries. It was a conception of art that Napoleon, who regarded himself as the heir of the Caesars, had borrowed from the traditions of the Roman Empire. In imitation of the Romans, he ruthlessly confiscated the art treasures of his defeated enemies and concentrated in Paris the enormous art spoils of his Italian, German, and Spanish campaigns, supplemented by the gleanings of the art commissions sent to the Netherlands, the Vatican, Venice, Berlin, and Madrid to carry away what was most valuable in the princely collections, churches, and monasteries. The Louvre, now the Musée Napoléon, became the most splendid trophy of victory and the richest museum the world has ever seen.

Napoleon's policies put the regimented artists into a serious dilemma. They found it difficult to resist the rewards offered them, the titles of nobility, the lucrative sinecures, the guaranteed commissions, the travel grants and gold medals. They were, for the most part, sincere admirers of the emperor and gladly took part in his glorification. The national significance of their work for him no doubt stimulated their imagination. But the artistic doctrine in which they had been trained committed them to classical subject matter and Neoclassical style. Military costume, battlefield landscape, the detail of state ceremonials, and the texts of army bulletins on which their assigned paintings had to be based frustrated their aesthetic aspirations. A fissure ran through the most ambitious work of the time: it marked the conflict between an ideal commitment to the timeless significance and beauty of the antique (to which most of the serious artists aspired, but for which Napoleon had little practical use), and the fascination of modern, national subjects, necessitating a realistic style (which contradicted their principles, but in some artists released unsuspected resources of vitality and talent).

READINGS

General Historical Background

C. Brinton, *A Decade of Revolution (1789–1799)*, Harper Torchbook, New York, 1934.

G. Brunn, *Europe and the French Imperium (1799–1814),* Harper Torchbook, New York, 1938. Two concise, lively surveys of European history at the turn of the nineteenth century.

A. Hauser, *The Social History of Art,* vol. III, *Rococo, Classicism, Romanticism,* New York, 1958. A study of art and literature from the point of view of a Marxist social historian.

H. T. Parker, *The Cult of Antiquity and the French Revolutionaries,* Chicago, 1937.

French Eighteenth-Century Art

W. Kalnein and M. Levey, *Art and Architecture of the Eighteenth Century in France,* London, 1973. Well illustrated.

P. Conisbee, *Painting in Eighteenth Century France,* Oxford, 1981. Well illustrated.

J. Locquin, *La peinture d'histoire en France de 1747 à 1785,* Paris, 1912. Still the best book on the beginnings of neoclassical history painting in France. Not available in English translation.

T. E. Crow, *Painters and Public Life in Eighteenth Century Paris,* New Haven and London, 1985. Attempts an analysis of the effect of public opinion on the development of late-eighteenth-century French painting.

French Painting 1774–1830: The Age of Revolution, exhibition catalogue, edited by P. Rosenberg, et al. Detroit, Institute of Arts, 1975. Essays on the general character and development of the art of the period, with useful biographies of the main artists. Well illustrated.

Neoclassicism, Revolution, and Empire

F. Benoit, *L'art français sous la Révolution et l'Empire,* Paris, 1897. The classic treatment of the subject. Not available in English translation.

H. Honour, *Neo-Classicism,* Harmondsworth, Middlx., 1968. An excellent, brief, illustrated account.

R. Rosenblum, *Transformations in Late Eighteenth Century Art,* Princeton, 1967. A discussion of symptomatic stylistic and iconographic features.

L. Eitner, *Neoclassicism and Romanticism, 1750–1850* (2 vols.), Englewood Cliffs, N.J., 1970. Contemporary documents relating to the general condition of the arts, to art doctrines, and to the lives and works of artists.

2
David and His School

Jacques-Louis David, 1748–1825

Pupils and Followers
 Antoine-Jean Gros, 1771–1835
 Anne-Louis Girodet (de Roucy-Trioson), 1767–1824
 François-Pascal Gérard, 1770–1837
 Pierre-Narcisse Guérin, 1774–1833

Pierre-Paul Prud'hon, 1758–1823

Jacques-Louis David, 1748–1825

In a period in which art had largely lost its social function and was on its way to becoming—as progressive art of the nineteenth century would mainly be —a matter of "free" personal self-expression and of artistic problem solving, David asserted art's traditional moral, social, and political role. He was not merely a politically engaged artist, but one whose art was fundamentally public and who saw himself as a servant of the commonweal. This enabled him to sustain two otherwise incompatible roles, that of Revolutionary activist in the time of Robespierre, and that of courtier in the empire of Napoleon. Of the great artists of the turn of the century, David is the most "conservative," or traditional, in this special sense—a painter-patriot whose art was in the service of a coherent political and moral ideology. The seriousness of his conviction enabled him to become the head of a school, the last of such size and influence in the history of modern art.

David was born in Paris in 1748. His father, a merchant in the iron trade, was killed in a duel when the boy was nine years old, an unusual circumstance in that social class, suggestive of a fiery temperament. His mother, Geneviève Buron, came from a family of substantial masons and architects who were professionally involved with the arts, and distantly related to the painter François Boucher. The fatherless boy, handicapped by a slight speech defect, was placed under the guardianship of his uncles on his mother's side. They saw to it that he received a good, classical education, first at the Collège de Beauvais, later at the Collège des Quatre Nations.

It was their wish to train him as an architect, but an unconquerable appetite for drawing made David insist on being allowed to study painting. The uncles consulted Boucher, who advised them to place the boy in Joseph-Marie Vien's studio. David had reached the age of seventeen, the normal age for a career start. Vien accepted him among his pupils, who included at the time Joseph-Benoit Suvée and François-André Vincent, future rivals of David; he also entered him in the courses of the Royal Academy.

David's student work, still strikingly Rococo in style and spirit, shows him to have been slow in following Vien's classicizing example. The portrait of his aunt, *Mme Buron* (1769, Chicago, Art Institute), is an animated robustly colorful performance in the taste of the time that gives no inkling of any innovative

17

ambitions. In 1771, David competed for the first time for the academic Rome
Prize, the assigned subject being the *Battle Between Mars and Minerva*. David's
entry (Louvre), an awkwardly composed pastiche of Boucher, was awarded the
second prize. In his next attempt, on the subject of *Diana and Apollo Killing the
Children of Niobe* (the picture is unlocated), he failed to win any prize. Indignant,
David threatened suicide by starvation, but was rather easily deterred.

He competed for a third time in 1773, with a *Death of Seneca* (Paris, Petit
Palais), staging the subject in an inappropriately profuse, operatic style, but also
managing its composition and dramatic illumination with a dashing confidence
that seems to owe much to the example of Fragonard, with whom he had dealings
at this period. His fourth attempt finally won him the Rome Prize, a four-year
study sojourn at the Academy's Villa Medici in Rome. The winning entry,
Antiochus and Stratonice (1774, Paris, Ecole des Beaux-Arts), with its relatively
calm and simple frieze arrangement, shows the first signs of his turning toward
classicism.

David left for Rome in the fall of 1775, accompanying Vien, who had just
been appointed director of the Villa Medici. The young artist had boasted that
he would not be "seduced" by classical art, "which lacks life and emotion," but
as he progressed southward, he was startled to admiration by what he saw of the
more modern Italians—Correggio in Parma, the great Bolognese, and the even
greater Florentines. By the time he reached Rome, he felt crushed by the superior-
ity of the Italian masters and ashamed of his ignorance. On Vien's advice, he
began to fill his sketchbooks with studies after Roman sculptures, the reliefs of
the Column of Trajan, and the engravings of Lord Hamilton's Greek vases. But
the main spur to David's effort at self-reform was his admiration of the clear
colors, energetic contrasts of tone, and firmly modeled bodies that he found in
the works of Caravaggio, the Bolognese, and Poussin. He made an effort to rid
himself of his "French"—i.e., Rococo—mannerisms, guided by the example of
classicizing Baroque masters rather than of authentically classical works.

The *Funeral of Patroclus* (1778, Dublin, National Gallery), a large oil
sketch full of Rococo flutter and fuss, demonstrates that he did not accomplish
this transformation without inner resistance. Two life-size oil studies of posing
nudes, *"Patroclus"* (1777, Cherbourg Museum) and *"Hector"* (1778, Montpel-
lier), show, by contrast, his attempt to acquire a larger, plainer, more sculptural
style. Several large contour drawings, composed as long frieze bands, among them
the fragment of a *Death of Patroclus* (dated 1778, Sacramento, Crocker Art
Gallery), illustrate his experiments with spaceless relief arrangements, reflect his
studies of Roman sculpture, and amount to his closest approach to current
neoclassicism. A visit to Naples, in 1779, finally opened his eyes and completed
his conversion.

David returned to Rome in a state of fevered exaltation, suffered a spell of
illness, was granted an extension of his stipend, and started on the three large
paintings that embody the final results of his Italian stay. The *Equestrian Portrait
of Count Potocki* (1779, Warsaw, National Museum) is based, according to
legend, on an incident—the taming of an unruly horse by the Polish nobleman

—witnessed at the court of Naples. It is the only wholly modern work of David's Italian period, a grand performance in an essentially realistic style strongly influenced by Rubens and Van Dyck, and offers a premonition of the manner in which he was later to treat modern, national subjects. *St. Rochus Interceding for the Plague-Stricken* (1780, Marseilles Museum), an altarpiece destined for a hospital chapel, imitates a composition by Poussin, but introduces a touch of brutal realism in the form of the huge figure of a plague sufferer in the immediate foreground.

Belisarius Begging Alms (1780, Lille Museum), begun in Rome but completed only in Paris, presents a morality in the guise of ancient history. The aged general, blind and reduced to beggary by the ingratitude of his emperor, is shown bearing misfortune with stoic dignity. There is as yet no sign of an ulterior, political intention in David's use of the emotion-charged subject—its sentiment is without message. Borrowings from Poussin mark the figures and their setting. The picture's calm grandeur and subdued, harmonious colors indicate a further advance in the direction of classicism.

Rumors of David's extraordinary talent had preceded him to Paris. He was given a studio in the Town Hall and here finished the works he had brought from Italy. The Academy hastened to admit him to the rank of Associate *(agrée)* on the strength of these paintings. Exhibited as a group at the Salon of 1781, they produced an overwhelming impression on critics and public alike. David now began to take students. Jean-Germain Drouais (1763–88), the first and favorite among his pupils, was shortly followed by Wicar, Fabre, Girodet, and Gros. The supervisor of Royal Buildings, Pecoul, offered him the hand of his daughter, Charlotte. David married her in 1782 and received a handsome dowry.

A year later, sponsored by Vien, he was admitted to full membership by the Academy. David's reception piece, *Andromache Mourning Hector* (1783, Paris, Ecole des Beaux-Arts), was exhibited at the Salon of the same year. The idea for its composition came from Poussin's *Testament of Eudamidas* and, more immediately, from Gavin Hamilton's *Death of Hector* of circa 1764. The picture starkly contrasts the side-lit figures with the dark architecture behind them, the horizontal repose of the dead hero with the agitated grief of his widow. With its classical weapons, furniture, and architectural ornament, it is the most consciously "Greek" of his works to this time.

As early as 1781, David had begun to consider the subject of the *Horatii,* taken from a stage play by Corneille that deals with an episode from early Roman history: To decide a conflict between Rome and the town of Alba, three young men from each town, the Roman Horatii and the Alban Curatii, were chosen to meet in mortal combat. The two families were related by marriage—victory for either side would bring tragedy to both. The battle was won by the Horatii. Returning from combat, the victorious Horatius was met by his sister Camilla, who cursed him for having slain her lover. The young hero, in a rage, killed her, but was acquitted of her murder on an appeal by his father to the people of Rome. David originally toyed with the episode of the *Slaying of Camilla* (pen drawing of 1781 in Vienna, Albertina), then chose the subject of *The Old Horatius Defend-*

ing His Son Before the Roman People (pen drawing, 1783, Louvre). For this, he was awarded a royal commission by d'Angivillers; the picture was to be ready for the Salon of 1783. But the project was laid aside while David completed his Academy reception piece, *Andromache Mourning Hector,* which was exhibited instead.

In reflecting further on the subject of the Horatii, David realized that the episode he had chosen and for which he had received a commission was unsuitable. He now decided to represent a scene of his own invention, for which there was no authority in Corneille's play or in history. He imagined the father arming his sons for the battle and pledging them to self-sacrifice, while the women of the family mourn the foreseeable deaths of brothers and husbands. The idea that guided David came from a pictorial source, Gavin Hamilton's *Oath of Brutus,* of which he knew the engraving. The association of the Horatii with the Brutus subject conjured up a new significance, unwarranted by the original story, that of resistance to tyranny and injustice. This was not the meaning intended by David, who at the time was still motivated by patriotic and moral enthusiasms rather than political ideas. But it may have opened his picture of the *Horatii* to interpretations that went beyond its literal subject and caused this royal commission to be misread in later years, after the Revolution, as a premature republican statement.

The final version of the composition of *The Oath of the Horatii* (Louvre) took shape in 1784. The execution of the large (10 × 13 ft., or 3.1 × 4.1 m.) canvas was begun in Paris, but David decided that he could complete it only in Rome. With financial help from his father-in-law, Pecoul, and accompanied by Drouais, David arrived in Rome in October and finished the picture there (with Drouais's assistance) in eleven months. It was exhibited with great success in David's studio near the Piazza del Popolo in August 1785, then transported to Paris, where it arrived late and was badly hung at the Salon, but excited great admiration. David henceforth was recognized as France's foremost painter.

The composition is of Spartan simplicity. The figures, sharply lit from the left, are set friezelike and with sculptural distinctness against a severely plain arcade, the openings of which divide the scene into three equal parts. The three Horatii—bounded by a single, taut contour—stand on the left, tensely erect, facing their father, who occupies the center of the stage, blessing his sons with his right and raising the three steel blades with his naked left hand. Behind him, to the right, the women swoon in helpless grief, their limp bodies and flowing garments in perfect contrast to the hard metal and muscle of the men. The meaning of the scene is expressed with diagrammatic clarity and concision. Masculine will is pitted against feminine sentiment; civic dedication hardens the men, natural feeling overwhelms the women.

The colors are clear, cool, and curiously lacteal, as if filmed over; the brushwork is smooth and flowing. The perfection of the surface contributes to the picture's sense of tension, of powerful emotion tightly controlled. The style still owes much to Poussin, and there are borrowings from Poussin in the mourning

women and in the figures of the young Horatii, whose stance was inspired by a figure in Poussin's *Rape of the Sabines* (Louvre).

After this resounding success, David attempted to obtain the position of director of the French Academy in Rome, but failed. He was in poor health, but undertook a private commission from the financier and collector Charles-Michel Trudaine, for a *Death of Socrates* (1787, New York, Metropolitan Museum). Socrates is shown in prison, surrounded by his disciples. He is about to reach for the cup of hemlock and consoles his grieving friends by speaking to them of the soul's immortality. Plato sits at the foot of the bed, Criton at Socrates' side. The picture's lesson is one of stoical courage, born of moral conviction, in the face of death. Its composition lacks the clarity and dramatic contrast of the *Horatii* and, despite its smaller size, is far more crowded, particularly on the right side, where six figures form an indistinct, gesticulating mass. It nevertheless won unanimous praise at the Salon of 1787.

A great sorrow befell David in 1788, when his favorite pupil, Drouais, died of smallpox in Rome. His next major work, commissioned by the king's brother, the comte d'Artois (future Charles X), was of an untypical and perhaps uncongenial subject. In *Paris and Helen* (1788, Louvre), he attempted to cast an erotic subject in the "Grecian" style, though he rather anachronistically included in its elaborate background the Louvre caryatids by the French Renaissance sculptor Jean Goujon. The seated Paris, shown entirely nude, holds the arm of Helen, who leans against him yieldingly in a revealing garment that appears to be gliding from her body. The sculptural physicality of the figures is disconcertingly out of keeping with the mannered gracefulness of their poses and the intense sweetness of their expression.

In marked contrast to the stylistic artifice of this painting stands the realism of the *Portrait of Lavoisier and His Wife* (1788, New York, Metropolitan Museum), in which neoclassical formality (the arrangement of the figures distantly recalls that of *Paris and Helen*) is wedded to the tough material realism that characterized David's approach to modern subjects—those he took from direct observation. The combination of disciplined style and solidly realized matter gives an extraordinary intensity to this and other portraits of the period, offering a foretaste of the manner in which he would later carry out monumental paintings of events from modern history.

Considerations of security prevented the exhibition of the *Portrait of Lavoisier* at the Salon of 1789. Lavoisier had become an object of political controversy in the turbulent early months of the Revolution. But considerations of this kind, significantly, did not interfere with the exhibition at that Salon of *Brutus in the Atrium of His House, after the Execution of His Sons* (Louvre), a royal commission, like the *Horatii,* and, like that earlier painting, based on a subject chosen by David himself in preference to the one originally agreed upon with the authorities. Brutus, founder of the Roman Republic after the expulsion of the Tarquinian kings, condemned his two sons to death for having conspired with the Tarquinians, and stoically witnessed their execution. David's painting

shows him at home, after the beheading, seated in the shadow of an arcade, while the lictors carry in the bodies and the women of his family abandon themselves to wild despair.

The subject, suggested by a tragedy by Voltaire, restates in more painful terms the message of the *Horatii:* that the bonds of natural feeling (again personified by women) must yield to the demands of great causes, in this instance that of Liberty. The composition, compartmentalized and disjointed, drives home the meaning of the scene in a harshly unclassical manner, though many of its details are taken from antique sources—the head of Brutus from a bust in Rome, the group of the women from ancient sculptures of the *Daughters of Niobe.*

David's pre-Revolutionary paintings do not as yet express a definite political ideology. Rather, they exemplify patriotic virtue, but do so with such radical vehemence and, in the case of *Brutus,* almost lustful brutality, that it is not difficult to understand why they became the favorite tools of political rhetoric at the height of the Revolution. The moral tone of the great early history paintings is aggressive and punitive, but these works are not as yet focused on a distinct cause. The Revolution was to provide David with such a cause, with legitimate hatreds, and with the occasion for an open expression of his angers and excitements.

Nothing is known of David's political opinions before 1789, but it is certain that he greeted the advent of the Revolution with enthusiasm and supported its most radical manifestations to the end. The Jacobins, in turn, cherished the painter of the *Horatii* and *Brutus* as man of virtue, lover of Liberty, and ardent patriot. His emotional extremism and gift of self-dramatization propelled him into strenuous activism and a fanatical, near-fatal allegiance to the organizers of the regime of Terror (1793–94).

David's political activity was initially confined to the Academy, in which he made himself the leader of a dissident faction of junior members. Motivated perhaps by wounded feelings and frustrated ambitions, he skillfully organized a vehement agitation against the Academy's officers. By enlisting the aid, first of the Commune of Paris, then of the National Assembly, and finally of the Jacobin Club, he managed to dismantle the traditional privileges of the Academy one by one. In 1792, he was elected to the National Convention, where, as member of the Committee of Public Instruction, he obtained the decree abolishing the Academy altogether (August 1793). As admirer and friend of Robespierre, he voted for the execution of the king (January 1793) and of the queen (October 1793), and briefly presided over the Convention. When Robespierre's government was toppled by the Thermidorian conspiracy in July 1794, David—who, remembering Socrates, had sworn to "drink the hemlock" with his leader—lost his nerve, lamely exculpated himself, and was spared the guillotine.

During the years of his close involvement with Revolutionary politics, he did not produce any didactic history paintings such as one might have expected from an artist-legislator working for a liberated people. He altogether abandoned "examples of virtue" from antiquity, and attempted only one many-figured com-

position; virtually all his work of the period was in the nature of portraiture. The overwrought emotionalism of the pre-Revolutionary paintings gave way to a calmer realism, unaffected by the hysteria that David sometimes displayed in political assemblies. His passions found an outlet in activity, so relieving his art of excessive tensions.

David's first work in the service of the Revolution was commissioned by a Jacobin group, the Society of the Friends of the Constitution, in October 1790. *The Oath in the Tennis Court* was to commemorate the impromptu meeting of the Third Estate in an indoor tennis court at Versailles, in June 1789, during which its members swore a solemn oath not to disperse in the face of coercion, but to stay together until they had given France a constitution. David, "painter of the *Horatii,*" was asked to paint the scene on a canvas measuring 20 by 30 feet. The payment for the work was to be realized by the subscription sale of a print of the composition. David's large pen-and-wash drawing for the print was shown at the Salon of 1791. It documents his attempt to transform a turbulent event (which he had not witnessed, but about which he had gathered detailed information) into a symmetrical frieze composition: a daring effort to raise realistic reportage to the dignity of classical art, without sacrifice of historical truth or emotional drama. The subscription failed, the large canvas was begun, but abandoned unfinished (it is now in the Versailles Museum). It defines the main figures in outline, nude (shaded lightly, with faint indications of costume), with only four heads executed in oil, as wholly realistic portraits.

Though increasingly distracted by his political involvements, David found time in the early years of the Revolution for private portrait commissions. Among these were two highly finished half-lengths, *Mme d'Orvilliers* (1790, Louvre) and her sister, *Mme de Sorcy-Thélusson* (1790, Munich, Neue Pinakothek), and several others that seem only partly completed, *M. Joubert* (ca. 1791, Montpellier, Museé Fabre), *Mme de Pastoret* (ca. 1791, Chicago, Art Institute), and *Mme Trudaine* (ca. 1792, Louvre). He also painted a vehement, staring *Self-Portrait* (ca. 1791, Florence, Uffizi).

As the leading member of the Convention's Committee of Public Instruction, David became in fact, though not in title, Robespierre's minister of the arts. During the years 1791 to 1794, the Revolutionary government assigned to him the project for embellishing Paris with colossal symbolical monuments; it also entrusted him with the organization of the Central Museum in the Louvre and the design of the uniforms of Revolutionary officials. His most important charge, however, was to plan the enormous national pageants that were the Revolution's most original device for the political indoctrination of the urban masses.

The first of the celebrations in which David had a share was the solemn translation of Voltaire's ashes to the Panthéon, in July 1791; but the first of which he was fully in charge was the Festival for the Mutinous Swiss Guards of Châteauvieux in April 1792. David designed the artificial mountains, the symbolical sculptures and monumental sanctuaries. Later, he supplied the scenarios for the processionals, the ritual chants and dances—involving thousands of partici-

pants—for the Festival of Brotherhood (1793) and the Feast of the Supreme Being (1794). The fall of Robespierre frustrated his plans for an elaborate funeral of the patriotic martyrs Barra and Viala.

In the artistic composition of these immense popular spectacles, David carried neoclassical rhetoric to an extreme of magniloquence that, on the whole, he avoided in his paintings of the time. His stage-management of the Revolutionary festivals was an attempt to apply the arts to an important purpose and democratic function, and to use them as instruments of moral regeneration. Further, the Convention three times called on David to commemorate "martyrs" of the Revolution in paintings that more or less deliberately recalled the Christian tradition of martyrdom imagery.

Having voted for the execution of Louis XVI, the deputy Lepelletier was killed by a former royal guard on January 20, 1793. David arranged his public funeral in an "antique" style, and offered a commemorative painting to the Convention in March 1793. *Lepelletier de Saint-Fargeau on His Funeral Bier* showed the martyred deputy in heroic semi-nudity (reminiscent of David's *Hector* of 1783) beneath the sword of Damocles, a reminder of the vengeance that threatens regicides. (The painting is now lost, but its composition is recorded by a drawing and a print.)

When Marat was stabbed in his bath by Charlotte Corday on June 13 in that same year, David (then presiding over the Convention) offered to paint the commemorative picture, *Marat* (Brussels, Musées Royaux). Assisted by a drawing (Louvre) made on the spot, he represented the dead man in his tub, holding Corday's letter. The light falls at a slant across Marat's face, beatified in death, and on his nude torso emerging from the reddened water. The right arm hangs lifeless, still holding a pen. David has combined powerfully direct, physical realism with a hint of classical ethos. His Marat evokes Christian martyrs and dead Christs (as in Caravaggio), and also something of antique heroes—the latter suggestion reinforced by the Spartan poverty of the setting and the laconic dedicatory inscription on the pine box in the foreground: *"A Marat, David."*

In 1794, a boy soldier was killed in the fighting against counter-Revolutionary guerillas in the Vendée. Unlike *Lepelletier* and *Marat,* the *Barra* (Avignon, Musée Calvet) is not a portrait but an idealized, oddly effeminate nude. (It was undoubtedly meant to be clothed in the final execution, like the figures of *The Oath in the Tennis Court.*) The body is lightly sketched, the background merely scumbled in delicate, transparent flesh colors. David has chosen to represent the young hero dying in a kind of ecstasy, pressing the tricolor cockade to his breast.

The fall of Robespierre on July 27 brought this painting to an abrupt stop and ended David's political activity. Denounced as "tyrant of the arts," he pleaded before the Convention that Robespierre's "hypocrisy" had deceived him and promised that "henceforth I shall follow not men but only principles." He was imprisoned from July to December of 1794 and again from May to August of 1795, when he was amnestied on the establishment of the Directory. While confined in the Luxembourg Palace, David painted yet another *Self-Portrait* (Louvre), somewhat more formal and composed than the one of 1791, though still

of extraordinary intensity, showing a face still young (he was now forty-six years old) set in an expression of indignant inquiry. In a more peaceful mood, he sketched from the window of his prison a *View of the Luxembourg Gardens* (Louvre), his only landscape in oil, which is surprising in the freshness and immediacy of its naturalism.

Recuperating in Saint-Ouen, at the home of his brother-in-law Sériziat, he painted the portraits of his hosts. The *Portrait of M. Sériziat* (1795, Louvre), is posed out of doors in elegantly "English" sporting attire. *Mme Sériziat* (1795 Louvre) is a graceful, joyously fashionable work, of exquisite color and finish, symptomatic of the astonishing promptness with which the youth of France returned to the pleasures of life after the Terror. Both portraits were shown at the Salon of 1795.

After the Jacobin's bloody overthrow, in which many of his political friends had perished, David—feeling betrayed and blameless—withdrew from the errors of politics into the innocence of art. The excitements of the Revolution had distracted him from his true vocation, classical history painting. In the quiet of his prison, his mind turned again to themes from antiquity that held a lesson for the present. He toyed with the subject of *Homer Reciting His Verses to the Greeks* (drawings in the Louvre), reminiscent of *Belisarius* and perhaps signifying to him the artist's plight in society, in short, his own situation. Then he settled on a theme of broader meaning, that of *The Sabine Women Stopping the Battle Between Romans and Sabines* (Louvre), depicting the intercession of the Sabine women, led by Hersilia, wife of Romulus, to prevent slaughter between their fathers and their husbands. The lesson, highly relevant to the situation of France after Robespierre, is one of reconciliation and forgiveness. Women and men are again set against one another in dramatic confrontation, as in the *Horatii* and the *Brutus,* but now with an entirely different result: natural feeling, embodied by the women and their children, puts an end to homicidal strife.

The picture occupied David from 1795 to 1799 and marks a change in his attitude toward classicism. No longer bound to a political cause, he was free to concentrate on matters of form and style. His earlier classical paintings, he now came to realize, had been too harshly "Roman" and made too ostentatious a display of muscular anatomies. In the *Sabines,* he aimed instead for "Greek" refinement and purity. His first compositional studies still presented a crowded scene in which the contestants were encumbered with elaborate armor, but as he moved on to the final execution he spread the main figures in a wide frieze, stripped them bare, and defined their smooth and slender bodies with contours of studied grace. He knew Flaxman's outline illustrations for the *Iliad* (e.g., the plate of the *Battle for the Body of Patroclus*) and appropriated something of their coolly elegant abstraction for his own purposes.

Impoverished after years without proper income, David exhibited his picture for a fee in a room in the Louvre that had been put at his disposal. The exhibition was a financial and critical success. David was determined to make his peace with the new order. When the Academy, which he had helped to abolish, was refounded under the name of Institute of Science and Art, he immediately

became a member. He exploited his new, refined classical manner for society portraits of fashionable women, such as the *Portrait of Mme Verninac* (1799, Louvre). The sitter was the older sister of Delacroix (who was an infant when this picture was painted). David, a Pygmalion in reverse, chose to give the flourishing young beauty the glacial perfection of a neoclassical statue.

The portrait *Mme Récamier* (1800, Louvre), commissioned by the sitter, was left unfinished because of irritations that arose between the capricious subject and the slow-working artist. Mme Récamier, wearing a "Greek" dress of light muslin of a type fashionable in the time of the Directory, half-reclines on a classical couch beside an antique candelabrum (similar to one in the *Death of Socrates*). Her feet are bare—a daring touch. Important as indicators of David's purified classicism around 1800 are the extreme plainness of the setting and the slender linearity of the decorative as well as anatomical forms: the candelabrum; the graceful arm; the line of Récamier's back and neck, rising in a slow curve from the long horizontals of her legs and thighs; and even the very execution, which in its light, half-transparent touches (recalling Hersilia of the *Sabine Women*) exemplifies the conciliatory classicism of the Directory and Consulate.

Immediately after completing the *Sabines,* David began to compose another classical subject, *Leonidas at the Pass of Thermopylae,* in which he planned to show Spartan heroes preparing for battle and for death. He wished to arrange this scene somewhat in the manner of Greek vase painting, with figures separately defined and clearly contoured, linked by feeling rather than stance or gesture. A large drawing in Montpellier gives his early idea of the subject. The canvas was begun, but put aside under the pressure of new political involvements.

The period between Robespierre's fall (1794) and Bonaparte's rise (1799) was for David an interlude of artistic independence between two intense political engagements. He used it to return to that form of art which he believed to be his mission—classical history painting on themes of moral heroism. To this higher, quasi-religious calling he could devote himself only when he was not pressed by political involvements. But a passionate ambition drew him toward power. He needed the support of strong personalities and compelling causes; he craved employment, and when employed in the service of power displayed energies of a formidably executive kind. He then also changed the direction of his art. The confrontation with political reality brought out his innate realism and made him forget, at least for the time being, ancient history and the classical ideal.

David first encountered Bonaparte in the winter of 1797–98, on the general's return to Paris after his victories in Italy and the ratification of the Treaty of Campo Formio. Some time earlier, when David was threatened with persecution, Bonaparte had sent him a message offering asylum in his Italian headquarters. David was eager to meet the hero of the hour, and Bonaparte, already preparing his ascent to power, sensed that the famous artist might prove useful to him in the future. A portrait session was arranged in David's studio. The general impatiently posed for three hours, giving David just enough time to sketch the face, framed by long hair, eyes turned to the side as if in deep meditation, and to indicate the contours of a life-size portrait that would have shown

the victor of the Italian campaign standing under the open sky, with horse and escort, holding the Treaty of Campo Formio in his hand. The *Portrait of General Bonaparte* (1798, Louvre) remained in this unfinished state, but David was struck by Bonaparte's "classical" physiognomy, "grand, pure, beautiful like the Antique." In common with many other ex-Jacobins, he was eager to rally to the victorious republican general who seemed capable of saving France from the instability and corruption of the Directory.

Shortly after returning from his campaign in Egypt and Syria, Napoleon overthrew the Directory in the coup of 18 Brumaire (November 9, 1799) and made himself the dictator of France, with the title of First Consul. A closer personal relationship now developed between Bonaparte and David. A brief, brilliant campaign against the Austrians in northern Italy, culminating in the victory at Marengo, strengthened the Consulate and confirmed Bonaparte in his secret monarchical ambitions, and he began to give thought to the propagandistic uses that could be made of art. David on his part dreamed of becoming the Consulate's minister of the arts. Bonaparte advised him to stop work on the picture *Leonidas at Thermopylae* ("Why paint a defeat?") and instead to paint a glorification of the victor of Marengo.

There are several versions of *Bonaparte Crossing the Great St. Bernard* (1801). David had proposed to show the Consul sword in hand. Bonaparte, pointing out to him that modern battles were no longer won by personal heroism, asked to be shown "calm on a fiery horse"—a motif that David had used earlier in his *Equestrian Portrait of Count Potocki* (1781). Bonaparte's classical steed, though rearing, has the metallic fixity of sculpture. It may have been suggested to David by reminiscences of Falconet's monument of Peter the Great. The suggestion of forward momentum is supplied only by the wind that blows the horse's mane and tail, and by the rider's yellow cloak. The Consul had refused to sit for his portrait ("Alexander did not pose for Apelles"), since he evidently desired not so much a likeness as a memorable image of genius overcoming natural obstacles. David, however, painted his uniform and other accessories "from life," with the odd result that the realism of the picture resides in the inessentials, while as a historical portrait it remains remote and generalized. Destined for propaganda use (the names *Hannibal* and *Charlemagne* on Bonaparte's path tell of his imperial ambitions), the first version was purchased by the king of Spain; the second, made for Napoleon, was taken to Berlin in 1815; the third is now in Vienna, in the Oesterreichische Galerie.

When Napoleon made himself emperor of France, he appointed David as his First Painter and informally commissioned him to commemorate the Empire's beginning in four pictures: the *Coronation,* the *Enthronement,* the *Presentation of the Eagle Standards,* and the *Arrival at the Town Hall.* For each of these very large canvases, David expected to be paid 100,000 francs, a sum considered exorbitant by Vivant Denon, Napoleon's chief art administrator. David's continuous, urgent demands for payment soon irritated Napoleon and led to a gradual dwindling of commissions. From 1810 onward, he was First Painter only in title and was given no further official work. Only two of the commemorative paintings

were executed, but the work on them occupied the artist from 1805 until 1810. David had witnessed the coronation in the choir of Notre Dame on December 2, 1804. He planned his painting of the ceremony as an immense group portrait—a brilliant crowd in a vast interior, immobile in the contemplation of a historical event. He had tried something of the kind in *The Oath in the Tennis Court,* but instead of the artificial frontal arrangement of that earlier composition, with its symbolical symmetry, he now chose to show his scene in sweeping side view, as it would have appeared to a spectator placed on the side of the choir, and to present it in its vivid reality of sumptuous stuffs struck by light from above (though he was obliged to depart from strict accuracy for the sake of clarity and dramatic emphasis). In striving to give artistic form to a scene from modern life, he followed the example of Rubens—who had faced a similar problem in his *Coronation of Maria de Medici*—in the placement of figures, the conduct of the light, and the interplay of colors.

David's innate realism was stimulated by the occasion: he found that crimson velvet and gold braid, repugnant to the doctrinaire classicist, "offered opportunities to the painter." To begin with, he had shown Napoleon putting the crown on his own head (drawings in the Louvre), but was persuaded to represent the crowning of Josephine instead. More than a hundred portraits, taken from life, had to be integrated into the composition. David painted them separately, one after the other, as was his custom, yet was able to give his vast canvas *The Coronation* (1805–08, Louvre) a compelling unity of effect. Among the profuse details, there are subtle observations, especially in the right half: the reflections from the green carpet in Josephine's shaded face are a noteworthy instance.

David's *Coronation,* a stupendous achievement of historical realism, skillful arrangement, and painterly delicacy, shows him as the competitor and superior of Gros in the interpretation of a modern subject. Official painting never again reached this height. Napoleon was satisfied. David had intended to represent the *Arrival at the Town Hall* next, and made a careful drawing of this subject (1805, Louvre), but deferred the work at the request of Napoleon, who was impatient for completion of the *Presentation of the Eagle Standards* (1808–10, Versailles Museum), which records the swearing in of the army at the Ecole Militaire several days after the coronation. Napoleon, flanked by his marshals, is shown pronouncing the formula of the oath "to guard the Eagles and maintain them on the road to victory," as the colonels of the regiments rush up the stairs of the tribune, dipping their standards and repeating the oath.

An early drawing for the picture (1808, Louvre) includes the figure of Fame in the sky and that of Josephine behind Napoleon; both were removed at the emperor's request—Fame for the sake of realism, Josephine because the emperor was about to divorce her. The surging movement of the composition was perhaps calculated as a contrast to the stillness of the *Coronation.* It did not suit David's talent. He created a tumultuous confusion of waving cloth and straining limbs, brightening the colors and multiplying sharply lit, fragmentary details to heighten the effect of frenzied agitation; but the picture's main figures seem frozen into statuesque attitudes: arrest mimicking motion. A hussar in the foreground imi-

tates the tiptoe stance of Giovanni da Bologna's *Mercury,* and the gold-covered marshals brandishing their batons around Napoleon seem like parodies of the *Horatii.*

After the Salon exhibition of the *Presentation of the Standards* in 1810, David received no further commands from the emperor. The series of commemorative pictures remained incomplete, and David's offer to paint murals in some newly renovated rooms of the Louvre was rejected by the imperial government.

At sixty-two, David began to show signs of weariness and artistic decline. The robust realism and delight in fresh color that the Napoleonic commissions had stimulated henceforth found their main outlet in portraits, to which he gave an increasing amount of his time. The series began with the half-length *Portrait of Pope Pius VII* (1805, Louvre), a byproduct of the work on the *Coronation* picture, and continued with portraits of state dignitaries, friends, and family members: *Mme Daru* (1810, New York, Frick Collection); *Count François of Nantes* (1811, Paris, Musée Jacquemart André); *Antoine Mongez and His Wife* (1812, Louvre); and *Mme David* (Washington, National Gallery).

For a francophile British collector, Alexander Douglas, he painted *Napoleon in His Study* (1812, Washington, National Gallery). It shows the emperor as a slightly corpulent bureaucrat in his study, rising from his desk after nightlong work on the *Code Napoléon* (the clock has struck 4 A.M.) to review his guards. The picture's prosaic hardness of execution and pedantic insistence on accessories are mitigated by an imaginative illumination: the reddish candlelight of the night still fills the background while a cooler morning light falls on the pensive figure of the emperor.

Lacking official employment, David reverted once again to classical subjects of his own choice. In *Sappho, Phaon, and Cupid* (1809, Leningrad, Hermitage), painted for the Russian collector Prince Yussupov, he returned to an erotic theme of the kind that he had last tried in 1788 *(Paris and Helen).* Surprised by her lover Phaon, Sappho drops her lyre, which is seized by Cupid, who starts to strum a hymn to Venus. The graceful triviality of a subject that might have been tolerable in a more abstractly formal style is made painful by the waxwork realism in which David chose to execute it. He also took up again the unfinished *Leonidas at the Pass of Thermopylae* (work resumed 1812, finished 1814, Louvre.) Abandoned in 1800, its subject had in the meantime become highly topical. It was now possible to see in the defiant, self-sacrificing Spartans an allusion to the defenders of France against an Allied invasion that threatened after the disasters of Napoleon's Russian and German campaigns. Leonidas is shown meditating on duty and death, while his Spartans arm for battle, sacrifice to Hercules, and don wreaths for the banquet they will share with Pluto in Hades before the day's end. Little remains of the painting's original, presumably more purely "Greek" version. Its present state seems entirely the result of the revision of 1812–14, in a manner that suffers from an uncertainty of direction, vacillating between classicist stereotypes and solidly realized life studies. The nudes are in part of admirable execution (e.g., the young men at the right who reach for their shields), but there are also passages in which David's hand seems heavy and crude.

In April 1814, Napoleon abdicated. The government of Louis XVIII, established under the protection of the victorious Allies, left David in peace, but he was once again in political disgrace. In the autumn of 1814, he exhibited his *Leonidas* privately (as he had once shown the *Sabine Women*), rather than risking a rebuff by the managers of the Salon, now under royal auspices. In March 1815, Napoleon returned from Elba, swept away the government of Louis XVIII, and reinstalled David as First Painter. David now signed a declaration of loyalty to Napoleon, a courageous act, since he sensed that Napoleon's fate was sealed and that this gesture would expose him to persecution. On the reinstatement of the Bourbon monarchy after Waterloo, David—along with other regicides who had opted for Napoleon in 1815—was banished from France.

He settled in Brussels in January of 1816, and—at age sixty-eight—prepared himself for a new life. Discreet offers of employment reached him from several royal courts, including that of Prussia, but he proudly refused them all, as he also refused offers of a free return to France. He gathered new pupils around him and maintained a lively correspondence with his followers in France, especially with Gros, who had taken over his Parisian studio. He was in great demand as a portraitist, particularly by fellow exiles, the former grandees of the Empire, and the remnants of the Revolutionary leadership.

In the late portraits—such as *General Gérard* (1816, New York, Metropolitan Museum), *Comte de Turenne* (1816, Copenhagen, Ny Carlsberg Glyptotek), *Sieyès* (1817, Cambridge, Mass., Fogg Museum), and *Alexandre Lenoir* (1817, Louvre)—David's sense of composition and vigor of execution were still in evidence, though somewhat coarsened. There was a shift in his work's balance between realism and stylization: the realist element remained strong, while the restraint of classical discipline grew feebler. Perhaps influenced by his Belgian followers (Navez, Paelinck, and Odevaere), he developed a penchant for bright local color and hard definition of detail. His collaboration with local artists resulted in some portraits in which his actual share is uncertain. Among these problematical works, attributed to him with insufficient cause, there is one masterpiece, the *Three Ladies of Ghent* (Louvre).

David's last attempts at classical subjects, now without ideological conviction or topical relevance, took the form of disagreeably precious, erotic mythologies, among them *Cupid and Psyche* (1817, Cleveland Museum). The picture was painted for the Italian war profiteer J.-B. Sommariva. After a night of love, Cupid rises from the couch of Psyche and, removing the sleeping girl's hand from his thigh, fixes the viewer with a meaningful leer. The body of Psyche is sweetly idealized; that of Cupid, by contrast, is the robust life study of a tanned, muscular adolescent. The couch, with its opulent, post-Empire ornament and David's prominent signature on the curving arm rest, is a curious specimen of the taste of the time.

Mars Disarmed by Venus and the Graces (1824, Brussels, Musées Royaux) was begun in 1822, when David was seventy-four. This painting was to be his last testament, a final public demonstration of his leadership, to raise the spirit of his loyal disciples and to devastate his enemies, the rebellious Romantics. In front

of a cloud-borne temple, Mars—a flaccid Leonidas—is shown resting from battle; Venus, entirely nude, reclines at his side. Mischievous Amor loosens the god's sandals, while the Graces approach on tiptoe to bear away his weapons and to offer him drink. Preceded by much publicity, the large painting was exhibited in Brussels and in Paris. More than twenty thousand visitors paid to see it. The triviality of its content, the feebleness of its execution (due in part to a Belgian assistant), and the hard brightness of color disconcerted friends and foes alike. The reviews were respectfully muted, but it was apparent to thoughtful critics that the dying master had dealt his own school a mortal blow.

The old terrorist and regicide ended his days in bourgeois comfort in Brussels, surrounded by affectionate disciples and friends. A heart ailment, endured for several months, brought on his death in December of 1825. The man who had arranged the Revolutionary funerals of Lepelletier and Marat was borne in solemn cortège to the ancient church of Sainte-Gudule and given a Christian burial.

READINGS

Among the recent general books on the life and work of David,

A. Schnapper, *David,* New York, 1982, is the most comprehensive, best illustrated, and generally most useful;

A. Brookner, *Jacques Louis David,* London, 1980, offers a forcefully argued personal interpretation;

L. Hautecoeur, *Louis David,* Paris, 1954, though outdated in some respects, is still useful.

For David's life,

J. David, *Le peintre Louis David, souvenirs et documents inédits,* Paris, 1880, written by the artist's grandson, is the fullest and most authentic source. It includes a catalogue of the work.

D. Wildenstein, *Documents complémentaires au catalogue de l'oeuvre de Louis David,* Paris, 1973, supplies additional hitherto unpublished documents.

E. J. Delécluze, *Louis David, son école et son temps,* Paris, 1855, an intimate memoir by a pupil of David, contains a matchless account of the master's practice, teaching, and human relationships, as well as a shrewd historical assessment of his position in French art of the period.

David's role in the French Revolution and the political significance of his early work are discussed in

D. L. Dowd, *Pageant Master of the Republic,* Lincoln, Nebr., 1948,

R. L. Herbert, *J. L. David: Brutus,* London, 1972.

Pupils and Followers

The so-called School of David, consisting of painters born around 1770–80 who had either been trained in his studio (he is believed to have had about four hundred pupils in his long career) or who closely imitated his manner, formed the most prestigious group of artists in Europe during the first quarter of the nineteenth century. Napoleon's patronage gave their production a common direction and an institutional backing. The official biennial exhibitions, the Paris Salons, gave them international visibility. They had few rivals in France, except for Prud'hon, who maintained an independent position, and Carle Vernet, who had a popular following but was generally considered to be of lesser rank. As French artists, they considered themselves—and were grudgingly so considered by others—to be naturally superior to the artists of Britain, the Germanies, Italy, and Spain. By comparison with them, Goya was an obscure provincial, hardly noticed outside Spain. Constable and Turner were slow in being recognized on the Continent, and as landscape painters represented a form of art that was believed to be essentially inferior to grand history painting—the special, undisputed glory of the French School led by David.

In actual fact, the authentic glory of that school was at its height for a decade, from about 1798 to about 1808. After 1810, its decline was extremely rapid, though this was not clearly noticed for a while. The fall of the Empire and the restoration of the Bourbons did not usher in a period of neglect; on the contrary, Bourbon state patronage was more generous financially and less restrictive politically than had been that of Napoleon. Nor were the artists who had served the Revolution and the Empire persecuted by the governments of the Restoration. They were in fact wooed with commissions, rewards, and titles of nobility; only David, for very special reasons, suffered exile. What was lacking after 1814 was the vivifying impulse of great ideas, such as the Revolution had once provided, or the enthusiasm that only a great leader such as Napoleon could arouse.

It was not lack of support but lack of inspiration that killed the School of David. Had the Restoration brought neglect and repression, the artists might have rallied to the heroic ideals that had animated the beginnings of neoclassicism. But coddled by a permissive government, lulled with honors, the School of David grew torpid. The Salons were the showcase of its decline: that of 1808 marked the peak of its prosperity; those of 1810 and 1812 gave the first, unmistak-

32

able signs of enfeeblement; those of 1814, 1817, 1819, and 1822 marked the successive steps of its deterioration. In 1824 and 1827, romanticism triumphed. David himself produced few notable works after 1814. His chief pupils—Girodet, Gros, Gérard—though much younger, actually preceded him into decay. At the funeral of Girodet, who was the first to die, in 1824, the despondent survivors seem to have been aware that the end had come for them as well. The remainder of their careers was overshadowed by the consciousness of their ebbing powers. The official honors still showered on them seemed almost a mockery. Gradually, the tone of criticism became irreverent, aggressive, and in the end cruel. The suicide of Gros, in 1835, ennobled this long descent with a touch of genuine tragedy.

Despite the shortness of its lifespan, the influence of David's school was very far-reaching. His pupils and followers continued his precepts well into the century and spread them beyond the boundaries of France. David's teaching thus gave rise to an international movement based on a well-defined body of doctrine, although David himself refrained from theorizing and was more broad-minded than his academic followers. The tendency to conformity among David's lesser disciples was strong; in time the sterile uniformity of their work brought neoclassicism into disrepute. But the more gifted went their own way and, within the not very rigid limits of the school, asserted their individual personalities.

ANTOINE-JEAN GROS (1771–1835)

Of David's immediate followers, Gros was the most gifted. Impulsive, passionate, and vulnerable, he fell deeply under the spell of his master and throughout his life felt bound to him by a sense of duty and of guilt. He ardently believed in David's classicist doctrine, but his personal inclinations went into a different direction. A strong feeling for color and motion, a gift for dramatic narrative, a taste for extreme sensations, all inclined him to modern subjects, and ideally suited him for the painting of battles, the very task for which Bonaparte chose him. Left to his own devices, Gros would have followed David's admonitions, devoted himself to mythical heroes, and let his talent languish. The fortunate compulsion of Napoleon's irresistible will turned him in the right direction.

The picturesqueness of military uniforms, the gore of battlefields and army hospitals, the beauty of high-bred horses excited Gros's artistic sensibility and released his powers of rapid, felicitous execution. Classical subjects and the heroic style, much as he labored to rise to them in deference to David, left him uninspired and misled him into pomposity. After Napoleon's fall, there was little further occasion for modern work. Gros was now free to devote himself to what David represented to him as his higher calling. His decline from this moment was very rapid. From his Belgian exile, David, whom Gros still regarded as his conscience, mercilessly pressed him to forsake his individuality and talent. Unable to extricate himself from dependency on the master, the obedient Gros became self-destructive and—having killed the artist in himself—sought release in suicide.

* * *

Gros was born in 1771 in Paris. Both his parents were painters of miniature portraits, so the boy grew up in an artistic environment and received his first instruction from his parents. Taken to the Salon of 1783, he admired David's *Andromache* and expressed the wish to be allowed to study with David. David agreed to take him into his studio after his return from Italy, which he was about to visit to paint *The Oath of the Horatii.*

In 1785, upon David's return, Gros became his pupil. His relationship with the master was particularly cordial from the start, though Gros's talent did not fit the classicist mold. He filled many sketchbooks with rapid, untidy drawings, showing an instinctive gift for expressive, harmonious color and a repugnance for compositional exercises. The study of a *Nude Bather* (1791, Besançon Museum), one of his earliest preserved works, painted in David's studio, surprisingly betrays the influence of Rubens in type and execution. In 1792, he competed for the Rome Prize, and failed. The Revolution had meanwhile broken out, bankrupting his father. Gros was reduced to earning a precarious living by painting portraits at six francs a head. The scenes of violence that he witnessed in the streets of Paris distressed him. Fearing for his safety, David used his influence to secure a study leave and passport for Gros.

Gros left for Rome in 1793, traveling via Genoa, where he was impressed by the work of Rubens, Van Dyck, and Puget. Anti-French rioting in Rome made it impossible for him to pursue his studies there, so for several years he led a migratory life in northern Italy, painting portraits to support himself and his mother, who remained in France.

In 1797, he encountered Josephine Bonaparte in Genoa. Delighted with the handsome young artist, she took him to Milan to introduce him to Napoleon. Well received by the general, Gros became a member of the small court at the Casa Serbelloni, and with Josephine's help persuaded the impatient Napoleon to pose for him. *Napoleon at the Battle of Arcola* (1797, versions in the Versailles Museum and the Louvre) represents the general in heroic action, advancing with sword and flag across the bridge at Arcola, swept by the Austrian guns. The youthfulness of the hero, the extreme closeness of the view, the somewhat unstable dynamism of the pose, the intensity of the expression, the dark glow of the colors and the dashing freedom of the brushwork, all render this a work of exceptional immediacy and emotional power—"romantic" in contrast to David's slightly later *Bonaparte Crossing the Great St. Bernard.*

The general was highly pleased. Gros received military rank, as inspector of the parades and as a member of the commission charged with the looting of works of art from Italian churches and palaces. He gathered personal military experience during the French retreat from Milan and the subsequent siege of Genoa.

Back in France, he continued his close relationship with the family of Bonaparte, who was now First Consul and the dictator of France. Gros was invited to paint the posthumous *Portrait of Christine Boyer* (1800, Louvre). The subject, the wife of Napoleon's brother Lucien, had died at age twenty-four in her

country house at Plessis-Chamant. Gros represents her in a shady solitude, dropping a rose into the stream at her feet, an allegory of transience and early death. At this time, he also completed several large military portraits of the First Consul and entered a competition for the painting of *The Battle of Nazareth* that was to commemorate an event of the Egyptian campaign: General Junot, at the head of five hundred French cavalry, routing a force of six thousand Turks in the shadow of Mount Tabor. Gros's composition was chosen.

His sketch (1801, Nantes Museum) gives an idea of how he meant to carry out his idea on a huge canvas (about 15 yards, or 13.7 m., wide). In the center of a wild melee, Junot mounting a white horse has shot a Turk and is about to saber another. To the right, the Turkish cavalry yields to a furious French attack; in the foreground, individual soldiers are shown in enthusiastic mutual slaughter. In organizing this animated panorama, Gros followed the example of Rubens, arranging his composition not in symmetrical groupings (as David had done in the *Battle Between Romans and Sabines*), but in surging streams of brightly colored masses.

Bonaparte stopped the execution of this painting, which did not concern him directly. But Gros, who was both disappointed and frustrated, received a compensatory commission, *Napoleon Visiting the Plague Hospital at Jaffa* (1804, Louvre). One half of the unused canvas of *The Battle of Nazareth* served for this work, which Gros finished in less than six months. The exotic setting is the arcaded court of a mosque that has been converted into a military hospital. In the midst of the dead and dying, Bonaparte, in the dress uniform of a general, fearlessly touches with his gloveless hand the bubonic sore in the side of a plague-stricken soldier. The gigantic nudes agonizing in the foreground are reminiscent both of the damned in Michelangelo's *Last Judgment* and of Dante's Ugolino. The light-struck group in the center brings a touch of Rubens-like color into the somber scene. Radiant and invulnerable, Napoleon manifests himself as a bringer of divine grace.

Gros deliberately invoked the traditions of Baroque church art in this work of official propaganda, just as David was about to fall back on the Baroque example of Rubens's *Coronation of Maria de Medici* in composing his *Coronation of Josephine*. The picture of Jaffa won a great success at the Salon of 1804. In retrospect, it appears as one of the great masterpieces of the period and, in its romantic beauty and terror, is vastly superior to the sycophantic and mendacious glorifications of Napoleon that were being produced in quantity by the lesser painters of the French School.

During the years of the Empire, 1804–14, Gros was constantly employed in painting battles and military portraits, as the most inventive and productive of the cohort of official artists whose tasks were generally assigned to them by Vivant Denon, Napoleon's director of artistic patronage. Commemorating a victory of the Egyptian campaign, the *Battle of Aboukir* (1806, Versailles Museum) was commissioned by Murat, who had commanded the charge (in July 1799) that drove the troops of Mustapha into the sea. The view is taken at closer range, the figures loom larger, and the scene is less panoramic than in *The Battle*

of Nazareth (the remaining half of whose canvas was used for this picture). Gros developed his composition in three horizontal zones, an arrangement that he was to favor from this time on. The immediate foreground is filled with the enormous bodies of the dead or dying and with figures locked in struggle. Above this, the main action takes place—Murat, saber in hand, attacks the wounded Pasha, whose son offers his sword as sign of submission. The upper part of the canvas contains a spacious, light-filled landscape, with the citadel of Aboukir overlooking the bay whose waters are dotted with the turbans of drowning Turks. *Aboukir* is one of the most beautiful and brutal of Gros's battle scenes in its profusion of dramatic incident, its richness of exotic suggestions, and its mixture of splendor and carnage.

The crowning achievement of Gros's career as a painter of battles was the result of a competition in which his composition was chosen over those of twenty-five rivals: *Napoleon at the Battle of Eylau* (1808, Louvre). The assigned subject was Napoleon's visit to the battlefield, in Prussia, on the morning after the slaughter (February 9, 1807), when he expressed horror at the sight of some 25,000 dead and wounded littering the snowy plain: "If all the kings of this earth could see this spectacle, they would be less eager for war and conquest." Above a foreground filled with huge cadavers, lightly snow-covered, and wounded Russians attended by French sanitary officers, the emperor and his brilliant retinue pass like a vision. Faithful to his program, Gros has assigned Napoleon the role of Prince of Peace: riding an Isabella-colored horse, clad in a gray silk coat lined with fur, he extends his arm and raises his eyes in an expression of compassion. Confronting him on a rearing black horse, the dark figure of Murat seems the very embodiment of War. A vast winter landscape under a gray sky provides the appropriate topographical setting for the scene and lends it a heroic cheerlessness, strikingly in contrast to the dazzle of Gros's Oriental battles.

To mark his satisfaction, Napoleon gave Gros his own cross of the Legion of Honor at the conclusion of the Salon. When the Decennial Prizes were awarded to the best history paintings, in 1810, *Napoleon Visiting the Plague Hospital at Jaffa* was awarded the second prize in the category of modern national history (the first having been given to David's *Coronation*).

After 1809, Gros's work underwent a gradual decline. He continued to compose huge celebrations of Napoleonic triumphs, but his paintings of the Empire's last years—the *Capitulation of Madrid* (1810), *Napoleon at the Battle of the Pyramids* (1810), the *Meeting of Napoleon and Francis II of Austria* (1812) —lack the conviction, the poetic intensity and vigorous execution of his earlier works. A last project, the *Burning of Moscow* (1812), was abandoned at the stage of the compositional study. Gros's best qualities remain in evidence in some of his martial portraits of these years: the *Portrait of General Lasalle* (1808), *Prince Yussupov* (1809), *Lieutenant Legrand* (1810, Los Angeles County Museum; the young officer had died in the Madrid riots of May 2, 1808, the subject of Goya's famous painting), and the splendid *Portrait of Fournier-Sarloveze* (1812).

At this time, Gros's energies were being taxed by an enormous, uncongenial project, the decoration of the dome of the Panthéon. Formerly the church of

Sainte-Geneviève, the Panthéon had been secularized during the Revolution. Napoleon, in a highly political move, returned it to Catholic worship. In 1811 he commissioned Gros to paint in its dome an apotheosis of St. Geneviève, and round the dome's base the colossal portraits of the representatives of the great dynasties of France—Clovis, Charlemagne, Louis the Saint, and Napoleon himself, who thus placed himself among the Christian monarchs of the realm. Before the work was quite finished, Napoleon fell; his portrait was replaced by that of Louis XVIII. When Napoleon returned in 1815, his portrait was restored. After Waterloo, the despondent Gros once again covered the figure of his hero with that of Louis XVIII.

The Restoration government wooed Gros with titles and commissions, but deprived him of what had been his chief inspiration. He became the official portrait painter to Louis XVIII, was made a professor of the Ecole des Beaux-Arts, and created a baron. He tried to make the most of the unheroic subjects that were assigned to him by the pacific Bourbons. *Louis XVIII Leaving the Tuileries on Napoleon's Return from Elba* (1817, Versailles) shows the elderly king bidding his followers farewell at the start of his flight to Ghent. *The Embarkation of the Duchess of Angoulême* (1819, Bordeaux Museum) is another scene of defeat to which this specialist in victorious battles managed to give a touch of poetry.

When David left for his exile in Brussels, he entrusted Gros with his studio and his pupils. Deeply loyal to his master, Gros now dedicated himself to the continuation of David's work as leader of the Neoclassical movement. The role did not suit him; it not only required the sacrifice of his own artistic activity but amounted to the sacrifice of his reputation. Classicism was already in decline. The most talented of the younger artists, many of them influenced by the exciting modernity of Gros's work, were beginning to look to new models. Gros was guiltily aware of his unwitting part in the school's decline: "I must accuse myself of having been one of the first to set a bad example by not choosing and executing my subjects with the severity that our master demanded."

In his teaching and his own practice, Gros began to follow classicist principles with rigor just when these principles were about to fall into disrepute. Thus he lost the sympathy of the young generation, of the critics, and of the public. From Brussels, David prodded him to abandon trivial modernity and to search Plutarch for noble themes. His spiritless attempts—*Amor, Stung by a Bee, Complains to Venus* (1833), *Acis and Galathea* (1835), *Hercules and Diomedes* (1835) —brought him scathing press notices. Gros began to suspect that he had lost his ability, that he was already hopelessly enfeebled, a "dead man," as he bitterly put it. His students drifted away. The young Romantics, triumphant at the Salons of 1824 and 1827, repaid the debt they owed him with ridicule and contempt.

In poor health, unhappily married, hurt in his pride, and disappointed with life, Gros despaired. On June 25, 1835, he drowned himself in the shallow water of a branch of the Seine, near the village of Meudon on the outskirts of Paris.

ANNE-LOUIS GIRODET (DE ROUCY-TRIOSON) (1767–1824)

Born in Montargis, in central France, to a family of comfortably well-off business-men, Girodet was orphaned at an early age. However, he received a good educa-tion in Paris, watched over by a guardian, Dr. Trioson, a military surgeon (and his natural father), who ultimately adopted him and left him a handsome fortune. David admitted the talented boy to his studio, in 1785, as one of his first pupils.

Girodet's character was complex. He set himself the highest intellectual goals, and pursued them with nervous, self-doubting perfectionism. His imagina-tion had a strongly literary bent. Tormented by poetic ambitions, he spent much of his energy on futile projects, among others a long didactic poem entitled *Le peintre.* The amateur poet in him (a mediocre, pedantic poet, alas!) was in compe-tition with the professional painter, and often betrayed him into obscurities and affectations.

A friend of the Revolution in his youth, a conservative in later life, Girodet suspiciously guarded his independence and was the least submissive of David's followers. Inherited wealth freed him from the necessity of working for money and gave him the leisure for private experiment. Well read, better educated than most artists of the time, Girodet exhausted his mind and body in the compulsive refining and polishing of his ideas. He labored like a galley slave, as he put it, and yet completed few works. Lacking both David's energetic conviction and Gros's swift intuition, he made a place for himself in the front rank of David's followers by the intensity of his unquiet intellect and by his particular openness to the subtler currents of thought and sentiment in his time.

In 1789, Girodet won the Rome Prize with a composition on the subject of *Joseph Recognized by His Brothers.* In this same year, he also painted *The Dead Christ Mourned by the Virgin,* for a Capucin convent in Paris (now in the church of Montesquieu-Volvestre). One of the very few religious works to come from the School of David, the large canvas represents Mary as a Roman matron, bending in deep sorrow over the nude body of her son. The solitary figures are illuminated by a light that filters down into the cavernous darkness which contains them. The grand simplicity and pathos of this precocious masterpiece (Girodet was twenty-two years old at the time) was to have few parallels in his later work.

He arrived in Rome in May of 1790, and later that year began *The Sleep of Endymion* (1791, Louvre). The antique motif of the sleeping youth visited by the moon goddess, which Girodet had taken from a sarcophagus in the Barberini Collection (the myth of Endymion was used by the Romans to symbolize death), is poetically transformed into a nocturnal vision. Zephir parts the branches of a tree to let a flood of silvery moonlight bathe the marmoreal, nude body of the sleeping Endymion. The dreamy sweetness of this figure and the romantic sugges-tiveness of the night setting won Girodet a great success at the Paris Salon of 1793, to which he had sent his picture from Rome.

By way of tribute to his guardian, Dr. Trioson, he then painted *Hippocrates Refusing the Presents of Artaxerxes* (1792, Paris, Faculté de Médcine), in which he showed the Greek physician rejecting the bribes of the Persian ambassadors,

sent by their king to lure him with gifts. The rather stiffly composed picture was intended as a lesson in stoic morality, after the manner of David. It is also a characteristic display of erudition. Girodet attempted to represent the Persian costumes with historical truth, and in detailing the facial types and expressions of the gesticulating figures, he demonstrated his knowledge of the fashionable, Lavaterian "science" of physiognomy.

After the execution of Louis XVI, French residents in Rome were exposed to police and mob violence. The papal government closed the Academy. Girodet fled to Naples, where he fell dangerously ill. In the years that followed he led a migratory life, penniless and in poor health, staying in Venice, Florence, and Genoa. But upon his return to Paris in 1796, he was granted a free studio in the Louvre in recognition of meritorious work done and persecution suffered for France.

During the years of the Directory and Consulate, the austerities of the Revolution gave way to a free and extravagant style of life. An elite of financiers, ambitious politicians, rising artists, and fashionable women formed a new aristocracy. The revival of cultural and social life both stimulated and distracted Girodet. He undertook no ambitious projects, but contributed illustrations for Pierre Didot's luxurious edition of Virgil. He also painted portraits, among them the *Portrait of J.-B. Belley* (1797, Louvre), a black deputy from the former colony of San Domingo. Another portrait, that of Mlle Lange, an actress and famous beauty, embroiled him in scandal. Mlle Lange had spoken ill of a portrait that he had painted of her *con amore,* and had haughtily asked him to send it to her, together with a bill. Stung in his vanity, Girodet cut the picture to pieces, sent them to the actress, and in a fury of revenge painted a *Satirical Portrait of Mlle Lange as Danae* (1799, Minneapolis, Art Institute). Lange-Danae, entirely nude, crowned with peacock feathers, a mirror in her hand, receives a shower of gold in her lap: Girodet has made her the embodiment of venal sex. The smooth elongation of her nude body is a caricature of the classical ideal, reminiscent of the erotic mannerisms of the School of Fontainebleau. The intricate, obscurely malicious symbolisms which crowd the small oval canvas express Girodet's special cleverness. Its refined execution and exquisite finish further envenom this corrupt allegory, the sardonic sequel of the chaste *Endymion.* The picture was briefly shown at the Salon of 1799, to the mortification of the subject and, after his anger had cooled, of the artist as well.

For Bonaparte's country residence at Malmaison, Girodet about this time undertook to paint, in direct competition with Gérard (who had been commissioned to paint *Ossian Playing the Harp*), *Ossian Receiving the Shades of French Heroes* (1802, Malmaison). The saga of Fingal and Ossian, claimed to be a Gaelic epic of the third century A.D. but in fact largely the invention of its Scottish "translator," James Macpherson, had enchanted the European public with its cloudy grandeur and melancholy tenderness. It was widely accepted as the Nordic equivalent of the Homeric epics. Napoleon was fond of reading the work in Italian translation. Girodet turned the spurious Gaelic myth into a celebration of recent French victories. His picture shows the blind Ossian, at the head of a

host of ghostly heroes, welcoming the fallen generals of recent French campaigns to his "aerial palace of glory." Shooting stars provide an eerie illumination. While something of terrestrial substance still marks the French officers (recognizable portraits of Generals Desaix, Kléber, Marceau, etc.) and the wingless Victory who guides them, the Gaelic heroes who greet them, and the maidens who offer them drink and song, have the consistency and color of luminescent vapor.

The picture shows Girodet in his most effervescent and eccentric mood. Its style is related to neoclassicism only in the clichés of faces and gestures. Girodet was proud to have invented every intricate detail of symbolism and incident. David, when shown the work on its completion, was speechless with astonishment and disapproval. Napoleon commented somewhat dryly that there was a great idea in it, that the figures seemed real "shades," and that he recognized some of the generals.

There followed a lengthy pause in Girodet's work, during which he prepared the painting that was to be his greatest critical success. *A Scene of the Deluge* (1806, Louvre) presents a lugubrious landscape, filled with gigantic, suspended figures: the herculean figure of a father, grasping the branch of a tree, supports his entire family like an immensely heavy human chain above the rising flood. David admired this painting at the Salon of 1806, and thought that it combined the power of Michelangelo with the grace of Raphael. The idea of the composition and the types of its figures are in fact derived from the Sistine *Last Judgment.* Four years after its first exhibition, the *Deluge* won one of the highest awards in the Decennial Competition of French artists, held under Napoleon's auspices in 1810. The jury preferred it to David's *Battle Between Romans and Sabines,* an indication of a general retreat from the more severe, "Grecian" form of neoclassicism.

At the Salon of 1808, Girodet gave yet another proof of his versatility and proneness to literary influence in *The Entombment of Atala* (1808, Louvre). The subject is taken from a romantic tale by Chateaubriand (whose portrait Girodet had painted in 1807) of virtuous love in the American wilderness. The chaste Atala is being laid to rest in a cave near the Mississippi by her lover, the Indian Chactas, and by the hermit who befriended them. The light of evening enters the cave through heavy foliage. The hermit's cross is outlined against the distant sky. The scene is conceived as a secular *pietà,* recalling Girodet's *Dead Christ* of 1789; its dramatic illumination and friezelike arrangement echo his *Endymion.* The precision of contour and hardness of surface are still neoclassical, but the spirit of the picture and its emotional impact belong to the realm of romance, and specifically of that sentimentalizing religiosity of which Chateaubriand was the apostle in France.

Like all prominent French painters of the time, Girodet was drafted into the service of imperial propaganda. His first commission, on the uninspiring subject of *Napoleon Receiving the Keys to Vienna* (1808, Versailles Museum), resulted in a dull picture. His second try produced a masterpiece: *The Revolt of Cairo* (1810, Versailles Museum). Girodet admired Gros's battle paintings. Always competitive, he attempted to surpass his friend in a scene of violent action, and this tumultuous composition at least equaled Gros in imaginative carnage

and extravagant Orientalism. An incident of Bonaparte's Egyptian campaign, a bloody rising of Muslims bloodily suppressed by French troops, is summed up by the action of the three principal figures, around whom the battle rages in a dense press of bodies. A French hussar raises his saber against a gigantic, naked Moor who holds in his arms his expiring Turkish master. The contrasts between gleaming silk and tawny, naked skin, between luxurious refinements of costume and barbaric horrors—a severed head held by its hair occupies the very center of the crowded canvas—are managed with the exquisite, studied meticulousness that is characteristic of Girodet's manner. The charging hussar is modeled on Giovanni da Bologna's *Mercury,* like one of the figures in David's *Presentation of the Eagle Standards,* which, along with Girodet's picture, was first exhibited at the Salon of 1810.

All of David's chief pupils lost their artistic vitality at a relatively early age. Girodet was no exception. After 1810, his productivity and the quality of his work rapidly declined. He had the misfortune of being charged, in 1812, with the execution of thirty-six life-sized portraits of Napoleon, and managed to finish twenty-six of them by the time of Napoleon's abdication in 1814. In addition to this quasi-industrial production, he labored for several years over his *Pygmalion and Galatea* (1819, Château de Dampierre), a feeble and affected work, in which scarcely a trace remains of Girodet's ingenious eccentricity and calculated perfection of finish.

His last years were spent in retirement in his properties close to Montargis and in a large, nearly unfurnished house that he had built in Paris. Death came on December 9, 1824, after a long and painful illness. He was made an officer of the Legion of Honor on the day of his death and Chateaubriand fixed the cross to his coffin.

Girodet's funeral was attended by most of the surviving pupils of David. It seemed to some of them to mark the death of neoclassicism, though David himself was still alive in exile in Belgium.

FRANÇOIS-PASCAL GÉRARD (1770–1837)

The painters who made up the School of David were not, in fact, a homogeneous group. Though held together by a general agreement on principles and by varying degrees of deference to the master, they differed in their actual practice, each taking from David only what particularly suited his own bent. Gérard, who was at one time considered the best of David's immediate pupils, "painter of kings and king of painters," seems in retrospect the least distinctive among them. In his history paintings, he softened and sentimentalized David's classicism; in his modern, military composition, the enormous *Battle of Austerlitz,* he produced a complicated and lifeless pantomime. Only in his best portraits, particularly the earlier ones, did he achieve a more clearly personal note.

Gérard was born in 1770 in Rome, of a French father, who was then in the service of the French ambassador to the Vatican, and an Italian mother, a woman of remarkable beauty. The boy was brought to Paris at age twelve and, having

shown some aptitude for drawing, was entered into the *Pension du roi,* a royally sponsored preparatory school, from which he went on to an apprenticeship with the sculptor Augustin Pajou.

In 1786, Gérard became the pupil of David. Three years later he competed, unsuccessfully, for the Rome Prize (won by Girodet, his fellow and friend in David's studio). In 1790, his father having died, he went to Rome on family business, but returned to Paris after a brief stay. The death of his mother, and lack of work due to the outbreak of the Revolution, brought him to the edge of despair as the sole breadwinner of his small family. He consolidated his position by the odd expedient of marrying his mother's younger sister and adopting his own brother.

David helped his distressed disciple by engaging him as his assistant in the completion of *Lepelletier de Saint-Fargeau on His Deathbed.* He also found work for him as an illustrator for the luxury editions of Virgil, Racine, and La Fontaine being prepared by the publisher Pierre Didot. In 1794, Gérard won first prize in a competition on the Revolutionary subject of *Louis XVI and His Family Seeking Refuge at the Convention on 10 August 1792.* His finished compositional drawing (modeled on the example of David's *Oath of the Tennis Court*) attempts to treat a dramatic modern subject in a heroic style. The project was not carried further.

To save him from military conscription, David had Gérard appointed to one of the Revolutionary tribunals. Gérard drew the salary attached to the position, but adroitly abstained from attending on days when death sentences were to be passed. Still under David's influence, he painted *The Blind Belisarius Carrying in His Arms His Youthful Guide Who Has Been Bitten by a Snake,* a sentimental sequel to David's *Belisarius* (1781). Completed in eighteen days, the picture attracted great attention at the Salon of 1795. Knowing of Gérard's desperate poverty, the miniature painter Isabey bought the work. In gratitude, Gérard then painted the portrait *Jean-Baptiste Isabey and His Daughter* (1795, Louvre), in which the painter, in casual riding habit, is shown full figure in the staircase of his studio in the Louvre. He holds his small daughter by the hand and is urged on by his impatient dog. The scene is illuminated by a patch of bright sunlight in the doorway at the bottom of the stairs.

At the Salon of 1798 Gérard exhibited *Psyche Receiving Cupid's First Kiss* (1797–98, Louvre), based on La Fontaine's poem and a byproduct of Gérard's work as an illustrator for the firm of Didot. The critical response to the work was mixed: its extreme artificiality, its icy "purity" of style and fusion of smooth abstraction with erotic suggestiveness were both admired and condemned. However, the picture marks the beginning of a new phase in the development of neoclassicism (foreshadowed by David's *Paris and Helen* of 1788)—its divorce from didactic, moralizing contents and conversion to decorative formality and elegant sentiment. In this diluted form, it was to become both academic and popular.

Introduced to the circle round Bonaparte, who had recently made himself First Consul, Gérard was employed in painting family and state portraits and commissioned to paint, for the First Consul's country house at Malmaison, an

Ossian Playing the Harp (1801, the original lost; an early replica now in Hamburg), which in his hands turned into a tame pendant to Girodet's wild *Ossian Receiving the Shades of French Heroes.*

From this time on, Gérard increasingly specialized in portraiture. The leading political and social personalities of France, and—as his fame grew—of the rest of Europe, sat to him in turn. The former Jacobin had changed into the aristocratic "painter of kings." Of his very numerous portraits, those executed between 1795 and 1805 are generally the best—*Mme Barbier-Valbonne* (1796, Louvre); *Larévellière-Lépeaux, Member of the Directory* (1798, Angers); *Comtesse Regnault de Saint-Jean d'Angély* (1798, Louvre); *Mme Tallien* (1804, Château de Chimay); *Count Fries and His Family* (ca. 1805, Vienna); and others. The most famous of his portraits, *Mme Récamier* (1802, Louvre), offers a telling contrast to David's unfinished portrait of 1800. Its ingratiating sweetness, richness of detail, and studied perfection of finish help to explain his enormous success and give an idea of his sensitivity to the precise nuance of beauty which was in fashion at that moment in the swiftly changing tide of styles.

Sooner than his peers, Gérard received every kind of recognition and all the honors the state could give. In 1802, Napoleon made him a Chevalier of the Legion of Honor, at a time when this distinction still had meaning. In 1806, he was appointed First Painter to the empress Josephine; in 1811, professor of the Ecole des Beaux-Arts; and a member of the Institute in 1812. A considerable coldness developed between him and his former fellow students in David's studio, Gros and Girodet. In 1810, he exhibited his *Battle of Austerlitz* (Versailles Museum), an enormous canvas, originally destined to decorate the ceiling of the chamber of the Council of State. This was Gérard's bid for recognition as a painter of modern, military history, in direct competition with Gros. Gérard's congested composition contains some clever narrative inventions, but is completely devoid of the imaginative power of Gros's best works.

When the Bourbon monarchy was restored, Gérard managed an effortless adaptation to the new order of things, and was immediately enlisted for lucrative official enterprises. He continued to be in high demand as a portraitist, and on occasion, when combining neoclassical discipline and firmness of design with grace of characterization, still achieved impressive works. But in trying to suit himself to new, foreign fashions, particularly the vogue of Thomas Lawrence's portrait manner, he often spoiled his paintings by straining after effects of dashing brushwork and vivid color. In the repetitious official state portraits, executed with the help of assistants, he gradually lapsed into stiffness and pomposity.

A work of dynastic propaganda, the *Entry of Henry IV into Paris* (1817, Versailles Museum) is an essay in the pseudo-medieval, picturesque style of history painting, the royalist reply to the republican classicism of David's school. Gérard's innate sense of harmonious color and flair for narrative invention enabled him to acquit himself with some distinction on this occasion. But his attempts at classical subjects, in a sweetened neoclassical style (*Daphnis and Chloe*, 1824), his venture into romantic literary illustration (*Corinne at Cape Miseno*, 1819, based on Mme de Staël's novel), and his curious effort at ecstatic piety

(*St. Theresa*, 1828), though briefly successful, were in fact disastrous failures, documenting the decay of the school once led by David.

Among Gérard's late works are the monumental pendentives beneath the dome of the Panthéon (decorated by Gros), on which he painted *Death, Glory, Justice,* and *Fatherland* (1832–36), and the *Coronation of Charles X* (1829, Versailles), a Bourbon sequel to David's *Coronation.* Both were expeditious official performances by an artist of great gifts.

In mid- and late life, Gérard was the host of a distinguished salon, one of the main centers of the social and intellectual life of Paris. Though without formal education, he was famous for the polish of his manners, his wit, and tact. His political past was not held against him by the predominantly aristocratic and conservative society in which his later years were spent. He himself had become a conservative, but curiously showed an interest in the rise of the young Romantic movement and generously promoted the beginnings of artists such as Delacroix, whose outlook was very unlike his own. A member of a Revolutionary Tribunal in 1793, a favorite artist at the court of Napoleon, Gérard was appointed First Painter to Louis XVIII in 1817 and made a baron in 1819. When, after the Revolution of 1830, the government of Louis Philippe, who held him in the highest esteem, proposed as a matter of course to maintain him in the position of First Painter, he had the taste and dignity to refuse an honor for which he felt obliged to the previous regime.

He died on January 11, 1837, whispering, in Italian, a prayer that his mother had taught him in his childhood.

PIERRE-NARCISSE GUÉRIN (1774–1833)

Guérin was not a direct pupil of David but a follower, who had appropriated the elements of David's classicism through careful imitation. "Guérin is a pupil of Regnault," David said of him, "but I think that he has been eavesdropping at the door of my studio." A thoughtful and methodical artist, he allowed himself fewer deviations from the strict principles of classicism than David's more impulsive and self-assertive pupils, such as Gros and Girodet. Yet beneath this controlled exterior there hid a flair for melodrama. Before deciding to become a painter, Guérin had considered the profession of actor, and a delight in extremes of emotional expression (quite unlike the stoical self-possession of David's heroes), an aptitude for scenic effect and eloquent pantomime, would always mark him among his contemporaries of the French School.

Guérin was born in Paris in 1774. He entered the artistic career hesitantly, at the prompting of his parents, having been strongly tempted by the world of the theater. He studied with Jean-Baptiste Regnault, a rival of David and a very popular teacher, who practiced an eclectic and somewhat academic form of classicism. In 1797, Guérin won the Rome Prize with *The Death of Cato* (Paris, Ecole des Beaux-Arts), a scene of heroism in the face of death which gave him an early opportunity to exercise his gift of narrating action through the play of

emotional gestures. In contrast to the compact order and restrained pantomime of David's *Death of Socrates,* the motions of Guérin's figures seem vehement to the point of frenzy.

The wars in Italy and the closing of the Rome Academy frustrated Guérin's travel plans. He stayed in Paris and started on a painting on the subject of the *Return of Belisarius,* evidently inspired by the example of David and Gérard, who had already used the story of the blind general reduced to beggary by his ungrateful monarch. But, responding to post-Revolutionary popular sentiment, Guérin at length decided to transform the republican morality into a counterrevolutionary one, by replacing the historical Belisarius with a mythical Roman, "Marcus Sextus," the martyr of unjust persecution.

The Return of Marcus Sextus (1799, Louvre) shows an aristocratic Roman, a victim of Sulla's (i.e., Robespierre's) proscriptions, sorrowing at the bier of his wife, whom he has found dead on his return from exile. Tragic immobility, instead of gesticulation, is the dramatic device of this composition. The huge silhouette of Marcus Sextus standing before the illuminated, prone body of his wife distantly echoes David's *Andromache Mourning Hector* (1783). The picture carried an obvious message at a time when French émigrés were beginning to return to devastated estates and decimated families. In part for this reason, it enjoyed a great success at the Salon. Tired of Spartan moralities, the public was ready for softer moods, for scenes of pity and tearful reconciliation.

In 1802, Guérin won a second critical success with a painting that, devoid of political overtones, brought him into purely artistic rivalry with David. *Phaedra and Hippolytus* (1802, Louvre) is based on one of Racine's most frequently performed plays. Guérin chose the crucial moment when Hippolytus, falsely accused of having made incenstuous advances to his stepmother, defends himself before Theseus, his father, and the guilt-tormented Phaedra. Although not taken directly from an actual stage performance, as has sometimes been supposed, the picture is highly theatrical. Its stagelike setting, the disposition of the "actors" (cast in the likenesses of such famous personalities of the contemporary stage as Talma and Mme Duchesnois), the conventional pantomime of arms raised in protestation, fists clenched in anger, frowning brows, and staring eyes, all recalled familiar stage business, and were therefore intelligible and delightful to Salon audiences. The picture was warmly praised. It is in some ways comparable to David's *Brutus* (1789), but by contrast to David's robustness and vitality seems thin and—for all its show of emotion—without a spark of believable humanity.

In 1803–05, Guérin was a pensioner at the French Academy in Rome. At the Salon, he exhibited *Bonaparte Pardoning the Rebels of Cairo* (1808, Versailles Museum), a commissioned work, and a very tame performance—considering Guérin's flair for the dramatic—in a genre in which Gros remained paramount. Guérin was a royalist at heart, and this command performance, his only contribution to the Napoleonic propaganda effort, evidently left him cold. The picture's "graceful composition," though rather out of place in a subject of this kind, was praised by the critics.

Two years later, Guérin returned to classical subject matter, again taking

his cue from a play by Racine. *Andromache and Pyrrhus* (1810, Louvre) combines two scenes of Racine's *Phèdre* in one composition. Pyrrhus gathers Andromache and the little Astianax under the protection of his scepter, while Orestes, who has come to claim Astianax, reminds Pyrrhus of the revenge of the Greeks that will follow his refusal to surrender the son of Hector. The figures are symmetrically grouped in front of a plain wall. Frozen into separate, statuesque attitudes, they are ingeniously combined into a purely formal unity by the repeated parallels or convergences of their extended legs and raised arms. The composition has the artificial regularity and effect of suddenly arrested motion of a "living picture." In the figure of Orestes, at the right, contemporaries recognized the actor Talma.

That same year, Guérin demonstrated his versatility by undertaking a daringly erotic subject. *Aurora and Cephalus* (1810, Louvre) shows the goddess of the dawn rising, bare-breasted and bathed in purplish light, above the languorous, nude body of the sleeping Cephalus (modeled on Girodet's *Endymion* of 1792). The suggestion of the incipient embrace of two nude bodies which constitutes the picture's excitement is mitigated by the graceful affectation of Aurora, her balletic posture, the mannered finger play, and the stagy silliness of the scene, all of which reassure the viewer that this is merely "art." Well received at the Salon, the picture was acquired by the Italian collector Sommariva, who had a taste for erotic themes. Guérin capitalized on his success by rapidly producing a pendant, *Iris and Morpheus* (1811, Leningrad, Hermitage Museum), a considerably weaker variation on the same motif, that of the sleeping nude youth visited by a radiant goddess. This painting too was acquired by a private collector, the Russian Prince Yussupov, who shared Sommariva's taste for the erotic.

Second to ancient history, the erotic myths of classical antiquity offered the most suitable themes for neoclassical artists, yet David and his followers generally failed at such subjects. This cannot quite be said of Guérin, whose two erotic compositions, whatever their shortcomings, rank relatively high among his works. Though they lack Prud'hon's emotional warmth and Girodet's eccentric originality, they are neither so icily vapid as Gérard's attempts nor so awkward as David's. In this specialty, at least, the shrewd follower surpassed his model and master.

Only slightly involved with the Napoleonic propaganda enterprise, and always a royalist at heart, Guérin had no difficulty in rallying to the restored Bourbons. He was among the distinguished artists whom Louis XVIII particularly wooed. Elected to the Institute in 1815, he was appointed director of the French Academy in Rome in 1816, but had to refuse the position because of ill health. He won a resounding triumph at the Salon of 1817, the first to be held after Napoleon's final downfall, with two paintings of very different character.

Clytemnestra Contemplating the Murder of Agamemnon (1817, Louvre), based on the tragedy by Aeschylus, starker in its terror than the psychologically complex themes from Racine that Guérin had used before, is the most melodramatic of his works. The heroine, powerfully built and heavily robed, stands silhouetted before a curtain through which a lurid red light glows. Urged on by her lover Aegisthus, she pauses, dagger in hand, on the threshold of the room in

which her husband lies sleeping—the lethal counterpart of Guérin's amorous Auroras and Irises.

Aeneas Recounting the Misfortunes of Troy Before Dido (1816, Louvre) figured at the same Salon, as the serene companion piece to the sinister *Clytemnestra.* On a spacious terrace, beneath a luminous sky and a distant view of Carthage, Dido reclines softly on an ornate couch, listening with fond attention to the tale of the strangely helmeted Aeneas. Entirely devoid of physical action, the composition is cast in the form of a polite conversation piece in thin classical diguise. Guérin's daring idea of placing the figures in an open-air setting results in a complex play of lights that apparently contributed to the picture's Salon success.

Guérin was among the artists whom the Bourbon government commissioned in 1816 to paint portraits commemorating the royalist martyrs of the Revolutionary wars. The *Portrait of Henri de La Rochejaquelein* (1816, Cholet, Municipal Museum) shows the young general at the moment when, having granted grace to a republican soldier, he is treacherously shot by the pardoned prisoner. This impressive picture is Guérin's counterrevolutionary reply to David's *Marat* and *Bara.*

In failing health for many years, Guérin produced little during the last period of his life. He received one major monumental commission, a series of *Scenes from the Life of St. Louis*—a very typical Restoration commission—for the church of La Madeleine in Paris, but was unable to carry out the work. The ambitious project of a vast canvas representing *The Last Night of Troy* (1822, a study in the Angers Museum) also remained unfinished.

In 1822, Guérin accepted the directorship of the French Academy in Rome. He returned to France briefly in 1828 and was created a baron by Charles X. Broken in health, he went back to Italy, where he died in 1833.

Success had come early to Guérin. From the start, he was well treated by the critics, some of whom seem to have set him up in opposition to David in the secret hope of diminishing David's glory. The Salon public admired the pictures that he so carefully fashioned to its taste. His works, though deeply calculated, were praised for their sensibility, their "soul." But his vogue was brief, like that of a popular actor; it hardly outlasted his death.

Guérin was never a serious rival to David, but he may have contributed to the decline of David's school. Though in appearance a more rigorous classicist than many of David's pupils, he played an important role in the transformation of neoclassical history into academic Salon painting. Very little involved in the political or aesthetic causes of his time, he was neither one of Napoleon's salaried boosters nor one of the purists who dedicated themselves, as a matter of conscience, to elevated style and noble themes. Instead, he made himself the servant of popular taste, and became a purveyor of visual entertainment for Salon audiences. His disengagement from ideology and didacticism occurred near the beginning of his career: his *Marcus Sextus* (1799), despite its anti-Revolutionary message, was still in the lineage of Davidian didactic history painting, his *Phaedra* (1802) already was painted theater. Guérin's dependence on theater went deeper

than the choice of subjects or the imitation of histrionic pantomime: his paintings functioned as theater. In his later works, few traces remain of the austerities of earlier neoclassical style. The amply proportioned figures, the stress on emotional expression, and the striking effects of light have nothing to do with any imitation of ancient art. Pure contour and eurhythmic composition yield to sensational effect, suspenseful dramatics, and emotion-arousing color. Except for the smooth impersonality of his brushwork, there is little that separates this lapsed classicist from the stars of the Salons of the midcentury.

Next to David, Guérin was the most sought-after teacher during the years of the Empire. His studio, organized as a private academy, chiefly attracted young artists of good family who "made it a point of honor to avoid the slovenliness, coarseness, and vulgarity of the students of the Ecole des Beaux-Arts." He impressed on them the importance of discipline and technical mastery, particularly in figure construction and arrangement, but made no effort to impose his own manner. It was perhaps not by pure chance that through the studio of this tolerant master passed many of the leading artists of the generation that was to renounce classicism altogether, chief among them Géricault and Delacroix.

READINGS

The literature on the School of David is sparse. The best general account is still E. J. Delécluze, *David, son école et son temps,* Paris, 1855 (republished in 1863), a source rich in information that deserves republication and translation.

French Painting 1774–1830: The Age of Revolution, an exhibition catalogue, edited by P. Rosenberg, et al., Detroit, Institute of Arts, 1975, contains pertinent essays, biographies, and illustrations.

W. Friedlaender, *David to Delacroix,* Cambridge, Mass., 1952, and subsequent editions, contains concise characterizations of Gros, Girodet, Gérard, and Guérin, with some illustrations.

For Gros, the essential biographies are J. B. Delestre, *Gros et ses ouvrages,* Paris, 1867, the work of one of Gros's pupils, and J. Tripier-le-Franc, *Histoire de la vie et de la mort du baron Gros,* Paris, 1880.

The most recent serviceable account of Girodet's life and work is the exhibition catalogue by J. Pruvost-Auzas, *Girodet,* Montargis, Musée Girodet, 1975.

Pierre-Paul Prud'hon, 1758–1823

Prud'hon is remarkable as the only French painter of first rank during the period of Revolution and Empire who did not fall under David's influence and who dared to challenge David in his own domain, that of the neoclassical grand style. Their talents were antithetical: the strength of the one was the other's weakness. Prud'hon excelled David in gracious and amorous subjects, but he avoided history. His approach to subject matter was allegorical and poetic rather than narrative or descriptive. He lacked David's grasp of physical reality. His goddesses and allegorical nudes are highly stylized, conforming to a single ideal type, yet saved from insipidity by an appearance of inward life and a troubling, sensuous appeal. There is little of the heroic or tragic about them, but their emotional impact is as great as that of David's self-absorbed, meditative heroes.

The tension between realism and stylization gave David's work a peculiar strength, an energy generated by conflict. Prud'hon's work, by contrast, is in harmony with itself and sometimes monotonously serene. It developed from a strain of erotically tinged, late-eighteenth-century classicism, and is often dismissed as pseudo-classical, or even as Rococo (David condescendingly compared Prud'hon to Boucher), yet comes closer than David's to the authentic form and spirit of classical art.

Pierre-Paul Prud'hon was born in 1758 in the Burgundian town of Cluny, the son of a poor stonecutter. Both his parents died when he was very young. The intelligent and attractive boy was befriended by a Benedictine of the abbey of Cluny, Father Besson, who made sure that he received a good education at the monastery. The sculptures and paintings of the great church first awakened his love of art. One of his early painting attempts was a shop sign for a local hatter. Father Besson saw that the boy had talent and recommended him to the bishop of Macon, by whom he was awarded a stipend for the provincial Academy of Dijon, directed by François Desvoges, a competent painter.

In 1778, Prud'hon returned to Cluny in order to marry Jeanne Peugnet, a notary's daughter, who was pregnant by him. The match was an extremely unhappy one from the start. Miserable in Cluny, Prud'hon found an enlightened patron in a local amateur, Baron Joursanvault, who gave him the funds for further study in Paris. For three years, Prud'hon received instruction from the painter Pierre, Boucher's successor as First Painter to the king. It may have been

in part through Jean-Baptiste Pierre that he was introduced to a strain of classi-
cizing Rococo, much influenced by Correggio.

Having successfully competed for the Rome Prize of the Burgundian Acad-
emy of Dijon, Prud'hon arrived in Rome at the end of 1784 and spent the
following three years there, as pensioner of the Estates of Burgundy. He saw
David's recently completed *Horatii* and became acquainted with Drouais, but
kept apart from the mainstream of the Neoclassical movement.

Prud'hon had been assigned by his Academy to paint a copy of the ceiling
by Pietro Cortona in the Palazzo Barberini, a task that he pursued slowly and
without enthusiasm, since he did not like Cortona, but the experience may have
left traces in his own work. Prud'hon looked to ancient art not for the austerities
of Roman style but for Hellenic grace. He grew particularly fond of the work of
Raphael, Correggio, and—most of all—Leonardo, a taste that separated him
from his more rigorously classicist contemporaries. Canova, then at the beginning
of his fame, met and liked Prud'hon, and offered to share his studio with him.
But pressed by personal responsibilities, Prud'hon resolved to return to France,
despite an extension of his stipend.

In the autumn of 1788 he left Rome, and after brief stays in Beaune and
Dijon arrived in Paris in early 1789. Here he lived during the years of the
Revolution, in poverty, earning a meager living by drawing allegorical vignettes
and letterheads for the government and painting occasional portraits (including
that of the arch-radical Saint Just). He was himself an ardent Jacobin and, like
David, a member of the Revolutionary Commune des Arts, to which he once
delivered an address "on the utility of the arts," arguing that artists should serve
the working class rather than the idle rich. Unlike David, however, he sought no
political function.

The works that Prud'hon submitted to the Revolutionary Salon of 1793,
at the beginning of the Terror, dealt with idyllic, erotic subjects, oddly devoid of
political significance, among them *Love Reduced to Reason,* one of a set of three
finished compositional drawings commissioned by the comte de Harlay (Paris,
private collection). These suavely Hellenic allegories, meant to be engraved, show
Prud'hon's drawing style arrived at its maturity. The full-bodied nudes are firmly
modeled by black chalk hatchings on blue-tinted paper and given relief by broad
highlights of white chalk.

In his paintings, Prud'hon treated similar subjects in a similar style, but
adjusted to the larger scale and to the medium of oil—graceful allegories on the
pleasures or torments of love, posed by voluptuous nudes set in harmonious
groupings very unlike David's stridently heroic, moralized histories, and modeled
by tonal gradations rather than the definite contours and color contrasts pre-
scribed by David. *The Union of Love and Friendship* (Minneapolis, Art Institute),
an odd presence at the Salon of 1793, casts Friendship in the form of a Leonar-
desque half-nude and Love in that of a winged Eros in graceful, hip-shot pose,
sinuously naked, emerging from the dusky background like moonlit sculptures.

Though Prud'hon was not alone in practicing a romantic, erotically tinged
classicism at that time (see, e.g., Girodet's *Endymion,* exhibited at the same

Salon), his work achieved a special, almost perverse detachment from the grim realities of the Revolution. In the days of Robespierre and the guillotine, he was able, in his artistic innocence, to compose the subject of the *Tormentor Laughing at the Tears He Has Caused* as a scene of delightful putto-play.

After Robespierre's fall, Prud'hon retired to the rustic security of the village of Rigny, in Franche-Comté, where he spent the next two years designing book illustrations for the firm of Didot. At about this time, he also painted the *Portrait of M. Anthony* (1796, Museum of Dijon), and the *Portrait of Mme Anthony and Her Two Children* (1796, Museum of Lyon) as half-figures, in a plain, intimately human, modern style.

The establishment of the Directory enabled Prud'hon to return to Paris, where he was coolly received by David and Girodet, but greeted as a kindred spirit by the old and neglected Greuze. His competition design for a large, circular ceiling destined for the Louvre, *Wisdom and Truth, Descending to Earth, Dispel the Darkness That Covers It* (1799), won him the commission, and the privilege of lodgings at the Louvre. The subject of this composition, hinting at pacification and renewal after strife, has affinities with that of David's *Sabine Women* of the same date. Though held in low esteem by the dominant Davidian faction, Prud'-hon from this time onward had to be reckoned with as a history painter. His evident aptitude for monumental, decorative composition brought him another important commission, this time from one of the newly enriched financiers who set the tone of the Directory's society, wall paintings for the Hôtel de Lanois (1796–99, now dispersed; studies in Montpellier and in the Louvre). A series of vertical panels of personifications, *Wealth, Pleasure, Art, Philosophy,* and the *Times of Day,* framed by intricately figured borders, was an elegant ensemble that was much admired. It inaugurated a new, lavishly opulent form of classicism, in deliberate contrast to the Revolution's severe and declamatory style.

Through his friendship with the powerful prefect of the Seine, Frochot, Prud'hon began to receive further official commissions and was brought into the orbit of Bonaparte. The years of the Consulate and the Empire became the most productive, and the happiest, of his life. Although badly treated by the critics, who blamed him for his deviations from "nature" and the canons of classicism (i.e., from the stereotypes of the School of David), he had influential admirers, chief among them Bonaparte and his two empresses, Josephine (whose preferred painter he was) and Marie Louise (who made him her drawing master). In the inner circle of the Napoleonic court, Prud'hon's sentiment, style, and pliant personality were better liked than David's strenuous and demanding ways.

The Triumph of Bonaparte, or "Peace" (1801, drawings in Chantilly and in the Louvre) is the design for a monumental composition, never executed, to celebrate the peace with Britain. It is conceived as a Roman triumph. The First Consul stands in a chariot, flanked by Victory and Peace. He is preceded by the Muses, who chant his glory, and followed by the Arts, who will record his deeds. The image aptly sums up the role assigned to the arts by Bonaparte. The idea for it is said to have been suggested by one of Prud'hon's patrons, T. C. Bruun-Neergard.

In 1803, Prud'hon separated from his mentally ill wife, after twenty-five years of domestic hell. Shortly thereafter, Constance Mayer, a former pupil of Greuze, came into his life, first as a student, then as his collaborator and intimate companion. Her presence cheered and animated him. He recorded her features in the justly famous *Portrait of Constance Mayer* (ca. 1806, Louvre), a drawing in his favorite black-and-white chalk technique that is a triumph of expressive characterization. Prud'hon now began to receive a generous share of state commissions, partly through the patronage of the prefect Frochot, in particular the design for a commemorative column in honor of the soldiers of the Revolution (1801; not carried out, but recorded in many studies), and the ceilings in two galleries of the Louvre, *Genius Guided by Study* (1801) and *Diana Imploring Jupiter* (1803).

After the establishment of the Empire, Prud'hon became one of the chief designers of imperial pomp, as David had been pageant master of the Revolution. He furnished decorations for the anniversary of the coronation (1805), for the celebration of the Peace Treaty of Tilsit (1807), and for the ceremonies surrounding Napoleon's second marriage, in 1810, to Marie Louise of Austria, which he allegorized as the *Nuptials of Hercules and Hebe.* He was also in demand as a portraitist for the family of Bonaparte. The *Portrait of the Empress Josephine* (1805, Louvre) shows her half-reclining in a shady grove at Malmaison. Her human situation is revealed with surprising poignancy: the slightly mannered pose and elegant dress only emphasize the solitude and melancholy resignation of the childless consort of a self-created monarch bent on founding a dynasty. Iphigenia-like, she seems to anticipate her abandonment. None of the Empire's other official artists would have touched on so delicate a subject with such warmth of feeling.

About 1804, the prefect Frochot approached Prud'hon with the request to paint a picture symbolizing Justice for the courtroom of the Palace of Justice. Prud'hon's first thought, inspired by a line from Horace, was to represent *Nemesis Bringing Crime and Vice Before the Throne of Justice,* showing Justice enthroned beside Force, Prudence, and Moderation, while vulture-winged Nemesis drags two assassins to her throne, before which lie a murdered woman and her child (drawings in the Louvre and at Chantilly). After some trials, he changed this static allegory into the dramatic image *Justice and Divine Vengeance Pursuing Crime* (1808, Louvre). The assassin (a figure resembling Cain, with the face of Caracalla) escapes into the moonlit night, casting a glance at his victim on the ground, while above, invisible to him, Justice and Vengeance glide through the air ready to strike.

At the Salon of 1808, the picture created a sensation by its brutal realism in the figure of the assassin and pathos in that of the victim. Its power of expression came as a surprise from a painter thought to be of very limited range, a specialist in vaporous love idylls. For once, the deep intensity of Prud'hon's colors, the suggestiveness of his tonal contrasts—between the dark figure of the assassin and the silvery nudity of the (very Endymion-like) victim—and the caressing subtlety of his brushwork were received with high praise. Napoleon

personally awarded the Legion of Honor to Prud'hon at the Salon's close.

Another picture, in Prud'hon's more accustomed manner, won almost equal praise: *Psyche Carried Off by Zephyr* (1808, Louvre). It is based on Apuleius' romance of Cupid and Psyche, one of Prud'hon's favorite sources of subject matter. Psyche is shown being carried by the winds. Her nude body, modeled by the moonlight, is of the most voluptuous, fluent grace. Her eyes are closed, as if in a dream, and her lips wear a faint smile. The treatment of the figure recalls Correggio: a sequence of foreshortened rotundities, from the head, lolling back, across the swelling breasts, the curving abdomen, down to the long thighs and slender feet. There is nothing neoclassical about this figure, nor much sense of the physical anatomy. Nothing like it is to be found in the School of David; its closest parallel, Girodet's *Atala* (also shown in 1808), presents a weighty, firmly contoured figure, very unlike the luminous, apparitional form of *Psyche*. Her sensuous languor has a spiritual intensity quite foreign to David, and equally remote from the drowsy inertia of Boucher's nudes.

Prud'hon continued to be heavily employed by the imperial court and the city of Paris during the Empire's last years. He designed the sumptuous furnishings offered by the city of Paris to the new empress, Marie Louise, in 1810, as well as the ornate cradle of the king of Rome, the son born to the imperial couple in 1811. When a drawing master was required for Marie Louise, Prud'hon was chosen rather than an artist of David's school.

On his own, Prud'hon continued to draw and paint erotic mythologies, some of them in collaboration with Constance Mayer. In the collector J.-B. Sommariva, he acquired an important private patron for whom he executed two paintings. The first of these, *Venus and Adonis* (1812, London, Wallace Collection), with its attenuated figures, represents the ultimate ripeness of Prud'hon's classicism. The second, *Zephyr* (Salon of 1814; large grisaille version in the Louvre), one of the last of his pagan subjects, shows the god of the breezes as a smiling boy swinging from branches overhanging a stream—he extends his foot to the water, causing it to ripple. In Prud'hon's hands, this trifling motif assumes a mysterious charm.

The fall of the Empire, though mourned by Prud'hon, did not impair his career. In 1816, the year of David's exile, he was admitted to the Institute. But his work now began to show signs of fatigue, such as are apparent in the large, rather empty *Assumption of the Virgin* (1816, Louvre), commissioned by the Bourbon government for the chapel of the Tuileries and first exhibited at the Salon of 1819.

In 1821, Constance Mayer, who had been suffering from spells of depression, committed suicide in Prud'hon's apartment at the Sorbonne. Prud'hon, his very existence shattered, survived her by only twenty months. He spent his last months finishing some of her paintings, including the *Unhappy Family,* a scene of domestic pathos reminiscent of the work of Mlle Mayer's teacher, Greuze.

Prud'hon's final great painting, a monument to his grief, is the *Christ Expiring on the Cross* (left unfinished in 1823; destined for the cathedral of Metz, now in the Louvre), a powerfully emotional and original conception of a subject

rarely attempted by modern French artists of the first rank, and perhaps never again treated with such deep conviction. He died on February 16, 1823.

Prud'hon left no school. His work was greatly admired throughout the nineteenth century, but for the past fifty years has been unjustly neglected by scholars. Many of his paintings have suffered gradual destruction because of his excessive use of bitumen, an unstable pigment that can cause irreparable darkening and cracking. He is at present best known as a draughtsman of striking individuality, whose studies of the nude, executed in black-and-white chalk on gray or blue paper, rank with Ingres's totally different drawings among the highest achievements in a graphic medium of neoclassicism—a movement less productive of first-rate draughtsmen than one might expect in view of its cult of contour.

READINGS

In the absence of a modern book on Prud'hon, Charles Clément, *Prud'hon, sa vie, ses oeuvres et sa correspondance,* Paris, 1872, remains the best, most fully documented monograph. The chapter in E. and J. de Goncourt's *L'art du dix-huitième siècle* offers an excellent biography and insightful appreciation of the work. It was unfortunately omitted from the English translation. The most recent catalogue of Prud'hon's work is J. Guiffrey's *L'oeuvre de P.-P. Prudhon,* Paris, 1924.

3
Francisco José de Goya y Lucientes, 1746–1828

Francisco José de Goya y Lucientes, 1746–1828

Eighteenth-century Spain would have seemed, to contemporary European observers, an unlikely setting for the rise of an artist of world importance. The country appeared to them as a remote backwater, sunk into torpid provincialism after long years of misrule by the last Habsburg kings under whose feeble governments it had slipped from its former greatness among the world's powers. The seventeenth century had in fact been a period of deepening political and economic decline, during which Spain maintained her rank among the European nations only in literature and the arts. The final decadence of the Habsburg reign had, paradoxically, witnessed a surge of native cultural vitality, in the writings of Cervantes, Lope de Vega, and Calderon and in the paintings of Ribera, Velasquez, Zurbaran, and Murillo, works equal in quality to the highest achievements of Europe's most brilliant artistic centers of the time. But the sunset glow of this Golden Age rapidly faded away during the century's last decades. When in 1700 a branch of the French Bourbons succeeded to the Spanish throne, little native energy or ability was left to assist in the enormous task of national reconstruction.

The work of modernization and reform that slowly brought the country from its backwardness to a level at least distantly comparable to that of the main European powers was carried on by the enlightened despots of the Bourbon dynasty, most effectively by Charles III (reigned 1759–88) and very largely with the help of French or Italian statesmen. The dearth of local talents in all fields was a main obstacle to reform. It was natural that these relatively modern-minded rulers should have brought foreign artists to Spain, very much for the same reasons that prompted them to import foreign administrators and economists. A wave of French painters (the Houasses, Jean Ranc, Michel van Loo, and others) followed the first of the Bourbons, Philip V (reigned 1700–46), to Spain. They were soon followed by an invasion of Italians (S. Amigoni, G. Corrado, and others), favored by Ferdinand VI (reigned 1746–59). Finally Charles III brought Giovanni Battista Tiepolo to Madrid (1763–1770), where this greatest and last of the Venetian Baroque painters decorated the ceilings of the royal palace, recently constructed by Italian architects. Even earlier, Charles III had called Anton Raphael Mengs to Spain, a German painter long resident in Italy, who represented the most advanced artistic movement of the time, neoclassicism. During Mengs's stays in Spain (1761–69 and 1773–77), he engaged Tiepolo (who was imcomparably the greater artist) in a fierce competition, in which Mengs—

as the more modern painter—was at length successful, and then went on to administer the art enterprises of the Spanish court with the systematic efficiency of a typical Enlightenment figure.

The importation of foreign artists undoubtedly brought fresh life and new ideas to Spanish art, but it hardly profited the native artists, who found themselves displaced by them. The visitors not only monopolized the most prestigious commissions, the marked preference shown these artists who had no roots in Spanish traditions expressed a disparagement of those traditions, to the obvious disadvantage and discouragement of Spanish artists. Nor were the comings and goings of competing foreigners, each representing a different school, apt to reinvigorate what survived of Spanish practices or to lay the foundations for a fresh start. Yet from this entirely inauspicious situation rose the genius of Goya, solitary and unaided, like a rocket in the night, one of the most mysterious occurrences in the history of modern art.

Francisco José de Goya y Lucientes was born in 1746 in the village of Fuendetodos, near Saragossa in Aragon. His father, a master gilder, was descended from peasant stock; his mother, Gracia Lucientes, belonged to the impoverished local gentry. In 1749 the Goya family moved to Saragossa, where Francisco briefly attended an elementary school run by Piarist friars. Little is known of his childhood. However, a friendship with Martin Zapater begun at that time continued, in later years, in a long correspondence that is an important source of information about Goya's early life.

The count of Fuendetodos showed a benevolent interest in the young Goya, and in 1760 the boy was sent to serve an apprenticeship with the Saragossa painter José Luzan, who had been the teacher of Francisco Bayeu. Luzan made Goya copy prints, but taught him little painting.

In 1763, Goya went to Madrid to continue his studies at the Academy of San Fernando, where Bayeu became his teacher. At the time the German Anton Raphael Mengs and the Venetian Giovanni Battista Tiepolo were carrying out large ceiling decorations in the Royal Palace, which Goya is likely to have seen. In 1764, he unsuccessfully competed for an Academy stipend. It is possible that he then returned to Saragossa. In 1766, he again competed without success for a stipend.

About two years later Goya journeyed, at his own expense, to Rome, possibly accompanying Mengs. Legendary accounts speak of scrapes with the police, abductions, and brawls. While there, he may have painted three small pictures—*Sacrifice to Vesta* (1771, Barcelona, Gudiol Collection), *Sacrifice to Pan* (1771, Barcelona, Gudiol Collection), and *Venus Mourning Adonis* (1771, Zurich, private collection)—that reflect his impressions of contemporary neoclassical painting in Rome.

Goya left Rome early in 1771. At Parma, then a Spanish dependency, he entered the painting *Hannibal Surveying the Italian Plains from the Alps* in a competition of the local Academy, winning an honorable mention. (The picture is lost.) The year spent in Italy left no very lasting marks on Goya's work. He did not use the opportunity that Rome offered of acquiring the cosmopolitan neoclassical style then in high vogue.

Back in Saragossa by June, he received his first commission, through Bayeu, for a large fresco in the choir of the Pilar basilica of that city, *Angels Adoring the Name of God* (1772). The work was accomplished in four short months, in a broad fresco technique that Goya apparently had learned in Italy. Other large-scale religious compositions in a grandly formal, out-of-fashion Baroque style rapidly followed: a series of *Doctors of the Church* in the pendentives of churches at Muel and Remolinos near Saragossa, circa 1772, and eleven large *Scenes from the Life of the Virgin* (1773–74) in the charterhouse of Aula Dei, near Saragossa, painted in oil on the plastered wall. These gave him valuable experience in monumental painting.

In 1773, Goya married Josepha Bayeu, the sister of his teacher Francisco Bayeu. She was to bear him a son, and to suffer many miscarriages, but her role in his life remains shadowy and was apparently slight. Through this marriage, Goya became the protégé and dependent of Bayeu. After Mengs's return to Rome in 1769 and Tiepolo's death, Bayeu had made himself a dominant presence on Madrid's art scene and was in a position to pass along important commissions to his brother-in-law.

Settled in Bayeu's house in Madrid, Goya petitioned Mengs (now back in Spain) for employment as a designer for the royal tapestry works of Santa Barbara. He had no experience in composing large-scale scenes from modern life such as were expected of him, and began this work under the guidance of Bayeu. The first series of tapestry cartoons (1775) consists of nine scenes of hunting and fishing, and was destined for the dining room of the prince of Asturias (the future King Charles IV) in the Escorial. These full-sized oil paintings on canvas were to serve as models for the weavers of Santa Barbara. Their compositions are rather incoherent, the figures stiff, the contours hard—possibly to accommodate the weavers.

The tradition of popular imagery for wall decorations, similar to the scenes of hunting, rustic amusements, and shepherd-play long fashionable in France, went back half a century in Spain, having been introduced by the French-born court painter Michel-Ange Houasse. Mengs approved Goya's trial designs, and a contract was drawn up for a second series of tapestry cartoons, to consist of two distinct sets:

1776–78, ten cartoons for the dining room of the prince of Asturias in the palace of El Pardo, depicting scenes of the manners and amusements of the Spanish people (*Picnic, Dance on the Banks of the Manzanares, Fight at the New Inn, Promenade in Andalusia, Men Flying Kites, The Parasol,* and so on, now in the Prado Museum, Madrid, together with all the other cartoons); and
1778–80, twenty cartoons for the bedroom and antechamber of the prince at El Pardo, with further scenes of Spanish popular life (*Madrid Fair, The Coach in the Crockery Market, Pelota Players, Washerwomen,* etc.).

The cartoons of 1776–80 show Goya, freed from Bayeu's influence, exercising his gift of sharp social observation for the first time, spicing his scenes sometimes with humor, sometimes with sardonic hints. The compositions are spacious and unconstrained, the painterly execution often deliciously fresh. Goya

clearly relished the opportunity of dealing with familiar reality in a personal manner. Throughout the series, the Spanish note is strong and specific—in the arid landscapes, the gamut of popular types, their characteristic costumes, gestures, and actions. This vivid realism raises his cartoons above the blander conventions of Rococo genre. They give an early intimation of the two master faculties that combined in his genius, penetrating vision and expressive force.

Goya suffered one of his periodic serious illnesses in 1777. During his convalescence, he produced thirteen etchings after Velásquez (1778–79), based on the paintings from the royal collections that Charles III had recently ordered put on public display at the palace. Goya's intensive occupation with Velásquez was to have a profound effect on his subsequent portrait painting. His etchings are executed in a graphic technique, modeled after that of G. B. Tiepolo's *Scherzi* and *Capricci*, which with its light, silvery hatchings lent itself particularly well to the translation of color and tone. By linking him with Velásquez and Tiepolo, the etchings of 1778–79 mark a momentous stage in Goya's self-education.

Having unsuccessfully applied for the position of court painter after the death of Mengs in 1779, Goya was elected a member of the Academy in 1780. He submitted a *Crucifixion* (Prado) in the style of Mengs as his reception piece. Bayeu secured for him the commission for a monumental painting in fresco, *Mary, Queen of Martyrs,* in one of the domes of the Pilar basilica in Saragossa. But Goya's broad, sketchlike execution displeased the chapter of the church, who particularly criticized the picture *Charity* on one of the pendentives supporting the dome. Goya was asked to make corrections under Bayeu's guidance. Deeply offended in his dignity as an academician, he vehemently refused at first, though a compromise was ultimately arranged. Goya modified his work, but the quarrel led to a temporary estrangement from Bayeu.

Goya was now thirty-five years old, and had not yet achieved artistic or professional independence. The time around 1780 was one of crisis and discouragement for him. He even thought briefly of abandoning the arts. Thrown on his own devices in his struggle to gain recognition, however, he had the good fortune —through a friend's intervention with the minister Floridablanca—to receive a royal commission for one of seven altarpieces for the new church of San Francisco el Grande. His *St. Bernard of Siena Preaching Before King Alfons of Aragon* (1782–83), a work of curiously antiquated style over which he labored for two years, was judged superior to the panels of his competitors (including Bayeu's), and won Goya the attention of influential patrons. Chief among these was the powerful prime minister of Charles III. The *Portrait of Count Floridablanca* (1783, Madrid, Banco Urquijo) shows the minister posing with stiff formality amid the trappings of high authority. Goya himself appears at the lower left in an uncharacteristically sycophantic posture, offering a canvas to the statesman.

His hopes of further patronage from Floridablanca were, in fact, disappointed, but he shortly formed an even more promising connection with the king's younger brother, Don Luis, who lived in semi-exile on a country estate at Areñas de San Pedro for having married a woman of non-regal rank, the handsome Maria Teresa de Vallabriga. Something like a friendship sprang up between the prince

and the painter. Goya was admitted to the domestic intimacy and to the hunts of Don Luis, and commissioned to paint the members of his small court. The *Portrait of the Infante Don Luis* (1783, Madrid, Prado) is a close imitation of Mengs's hard and brilliant portrait stereotype. *The Family of the Infante Don Luis* (1783, Florence, Ruspoli Collection), by contrast, is a strikingly informal, quasi-bourgeois domestic scene illuminated by candlelight. The elderly prince watches his young wife's hair being dressed, while Goya paints, and attendants in the dark background grimace into the flickering light.

Don Luis died in 1785, but members of the high aristocracy now adopted Goya as their favorite portraitist. In the following six years, he painted two dozen large portraits, some of them of disconcerting woodenness, others instinct with intense life. Among the most memorable are the *Marquesa de Pontejos* (ca. 1786, Washington, National Gallery), whose archaic stiffness of pose is redeemed by sophisticated color harmonies of silver, green, rose, and pale yellow, and the *Countess Altamira and Her Daughter* (1787, New York, Metropolitan Museum). In *Don Manuel Osorio* (1788, New York, Metropolitan Museum), the flat, white face of the little boy—a son of the countess Altamira—is dramatically offset by the flaming scarlet of his suit. At his feet, Goya has staged an anxious little drama: a magpie, taken from its cage, is being menaced by two cats, symbolical perhaps of the precariousness of the state of childhood.

In 1785, Goya acquired important new patrons in the persons of the ninth duke of Osuna and his wife, the duchess of Benavente, whose portraits he painted: *The Duke and Duchess of Osuna and Their Chidlren* (1788, Prado). Cultivated, cosmopolitan, and modern-minded members of Spain's highest aristocracy, the Osunas had a country seat at La Alameda for which they commissioned a set of wall decorations, genre scenes in the style of Goya's tapestry cartoons: *The Swing, The Attack on the Stage Coach, The Road Accident,* and *The Greased Pole* (1786–87, Madrid, de Montellano Collection).

A reshuffle in the management of the royal tapestry works became the occasion for Goya's promotion to the rank of painter to the king, with a salary of 15,000 reales. He resumed his work for the court, painting a *Portrait of Charles III as a Hunter* (1786, Prado) that pays homage to Velásquez (e.g., his *Philip IV as a Hunter*) as well as to the kindly old monarch. He also received the commission for a third series of tapestry cartoons, consisting of a set for the Infante's dining room at El Pardo, divided into thematic groups—the Seasons, children's games, and social subjects *(The Poor Family, The Wounded Mason)*—and another set for the prince's bedroom at El Pardo. The execution of this second set was stopped by the death of Charles III in 1788. Only one full-scale cartoon was executed *(Blind Man's Buff);* the other compositions, notably the splendid, panoramic *Meadow of San Isidro,* remained in the state of small sketches.

In several of the cartoons of 1786–88, particularly those for *Spring* and *Autumn,* Goya displays a dazzling richness of color and elegance of finish. Courtly grace replaces Majo swagger. The harshness and angularity of his earlier cartoons has vanished, though he still possesses—as he proves in *Winter,* with its muffled figures striding rhythmically against the icy wind—all his expressive

force. In the brilliant sketch *Meadow of San Isidro,* a landscape painted from the life with a keen relish for its luminous space, its light-filtering atmosphere, and its teeming crowds, Goya appears as the forerunner of nineteeth-century *plein-air* naturalism.

After the death of Charles III, Goya continued in the service of the new king, Charles IV, and was raised to the rank of court painter. He was in high favor with the queen, the odious Maria Luisa, and with her lover, Manuel Godoy, formerly a guards officer and now transformed into an all-powerful prime minister. Goya was chosen to paint a series of state portraits of the new monarchs (1789) and was also required to furnish further tapestry cartoons, much against his will, since he had begun to consider such work as beneath his newly gained dignity. The final series of tapestry cartoons, dated 1791–92, consists of seven designs for the secretariat of Charles IV at the Escorial, including the *Straw Dummy* (which, with its sardonic suggestion of female domination and male impotence, prefigures the *Caprichos*) and the *Wedding,* possibly an allegory of the Ages of Man disguised as rustic genre.

In 1791, Goya seemed to have reached the pinnacle of success. Famous and honored, sought after by aristocrats and intellectuals, living in a handsome house and earning large sums of money, he could consider himself the most prominent painter in the kingdom. In early November 1792, he left Madrid, without authorization, to go to Cadiz in the south of Spain. Here he painted the *Portrait of Don Sebastian Martinez* (New York, Metropolitan Museum), his host, in whose house he suffered the onset of a devastating illness, of unknown nature, from which he recovered ony slowly, having also lost his hearing. For months he remained incapable of doing any work.

During his convalescence, he painted a series of fourteen "cabinet" pictures on metal, small genre subjects, most of them of bulls and bullfights, three of popular scenes—*Strolling Actors,* a *Seller of Marionettes,* an *Attack on a Stage Coach.* In addition, there are three astonishingly realistic visions of human suffering: a *Conflagration;* a *Shipwreck* (or *Flood*); and, most surprising of all, the *Yard of a Lunatic Asylum* (1794, Dallas, Meadows Museum), based, according to Goya, on something he had seen in Saragossa. He painted these scenes as a form of therapy after his illness, "to occupy my imagination." Hitherto, Goya's work had been entirely given over to official or private commissions. These small paintings are the first purely personal statements, intended to "make observations for which there is normally no opportunity in commissioned work."

Though shut off from some professional and social intercourse by his total deafness, Goya's withdrawal from public life was by no means complete. The progress of the French Revolution had repercussions in Spain. The government vacillated between liberal, pro-French, and national or conservative (i.e., churchly and royalist) policies. Goya's sympathies and his personal friends were on the liberal side. He took an interest in the struggle for power that centered on the court, and profited from the temporary ascendancy of a liberal government under the ministry of Jovellanos in 1797–1800.

On the death of Bayeu in 1795, Goya became the director of the Academy.

Illness had not diminished his ability, as the particularly fine portraits he executed during this period, such as the *Marquesa de la Solana* (1794–95, Louvre), *Francisco Bayeu* (1795, Madrid, Prado), and *The Bullfighter José Romero* (ca. 1795–98, Philadelphia Museum), prove.

In May of 1796, Goya once again traveled to Andalusia, perhaps to complete paintings for the church of Santa Cueva in Cadiz that he may have planned, or begun, on his earlier visit in 1792. The duke of Alba died at Seville in June 1796. The year before, Goya had painted his portrait and *The Duchess of Alba in a White Dress* (1795, Madrid, Alba Collection). The duchess was an intelligent, eccentric, and famously beautiful woman. From July to September of 1796, Goya stayed with her at her summer residence, San Lucar, near Cadiz. They were again together at San Lucar in the following winter and the early spring of 1797. It is probable that during this time they became lovers.

The Duchess of Alba Dressed as Maja (New York, Hispanic Society) was painted in 1797. The widowed duchess, in black mantilla, points with her right hand (on which she wears rings with the names of Alba and Goya) to the ground before her, on which she has traced the words *"Goya solo."* Goya kept this painting and at some later date seems to have overpainted the word *"solo."* Whatever relationship existed between Goya and the duchess ended in a bitter rupture early in 1797. But he remembered her, and when she died in 1802, he made some sketches for her tomb.

While at San Lucar, Goya filled the pages of a sketchbook (the so-called *Sanlucar Sketchbook,* or *Sketchbook A*) with brush-and-wash drawings of the duchess and of other young women, some nude or in intimate, erotically suggestive situations. These fairly casual drawings give the impression of having been done from life, or recent memory. A sketchbook of larger format, the so-called *Madrid Sketchbook,* or *Sketchbook B,* consisting of forty-seven numbered pages, begins with similar subjects, drawn in a similar style—scenes of flirtation, love-making, bathing, and so on—but continues with increasingly grim or fantastical ones: a dying duelist; ominous, masked figures threatening a woman; witches and demons engaged in obscene rituals. The execution of these latter drawings, in India ink-and-sepia washes, is of great subtlety and richness.

The scenes themselves are carefully composed; page numbers and captions indicate a planned sequence, and suggest that Goya intended to publish these designs. To this end, he made some twenty-eight careful pen-and-sepia drawings, titling them *Sueños* (Dreams), and arranging them in a numbered sequence that begins with a prefatory image, *The Author Dreaming.* . . . The first ten subjects in this series deal with witchcraft, the following ten with love's illusions, the remainder with a variety of satirical themes. Changing his original plan, Goya then drew some sixty further scenes in a distinctive red chalk or red wash technique on a variety of subjects, both realistic and fantastical.

From these preparatory studies, more numerous and elaborate than those for any of his other projects, Goya developed the *Caprichos,* a series of eighty etchings (all but one with aquatint), executed in about 1797–98, and first published in 1799 (five additional plates were withheld from publication). The series

is very roughly divisible into two parts, each with a self-portrait frontispiece. The first part, plates 1–42, is mainly composed of fairly realistic images that represent the "normal" disorders of society—faulty education, the prostitution of love, greed, violence, cruelty, and ignorance. The satirical tone of these images reflects the rational morality of the Enlightenment. The second part, plates 43–80, introduced by the frontispiece the *Dream of Reason* (originally the frontispiece of the *Sueños* project), is more fantastic and mysterious. The monsters and witches that haunt many of the plates have been variously interpreted as referring to contemporary social and political conditions, and as veiled denunciations of the aristocracy, the clergy, the queen, Godoy, and the general corruption and decrepitude of the Spanish monarchy. Several of the images clearly contain a more personal meaning, notably the plates that refer to the inconstancy and perfidy of the duchess of Alba. Goya himself commented cautiously: "Fantasy abandoned by reason produces monsters, united with reason she is the mother of the arts and the source of their marvels."

The *Caprichos* were advertised for sale in February 1799. Despite their dangerous allusiveness, Goya did not suffer persecution. In 1803, he made a gift of the unsold copies and the copper plates to the king. Though he remained a court painter, the *Caprichos* mark his emancipation from that quasi-servile role. In them, he speaks his own mind, not merely to entertain but to pass judgment. The language he uses is private and obscure, but it is meant to be understood by a select and sympathetic audience. The difference between Goya and the moralizing artists of the English and French Englightenment is largely one of political circumstance. He did not have the advantage of representing a powerful, aspiring, liberal middle class and had to guard himself against a particularly repressive censorship. Hence the veiling mystery; hence also the special poignancy in his prints. Their fantasy, and even their titles, are however not purely personal inventions: they derive from the tradition of the *capriccio* that goes back to Tiepolo, Castiglione, and other Italian artists of the Baroque. Blake and Fuseli offer some contemporary parallels, though they were not known to Goya. The execution of these *Caprichos* is of the highest refinement, particularly in its mastery of tonal nuances. The compositions show an astonishing variety and power. For its wealth of invention and grandeur of vision, the series stands as one of the supreme achievements in the art of the period.

Favored by the short-lived liberal ministry of Jovellanos and Saavedra, Goya received several important royal commissions in 1797–1800. In 1798, he was commissioned to execute a vast program of fresco decorations for the church of San Antonio de la Florida, a "hermitage" recently completed in a royal estate on the Manzanares River, just outside the gates of Madrid. The commission called for the painting of the central dome, the pendentives, vaults, and apse of the small structure, which is built on the plan of a Greek cross. Goya violated tradition by painting a terrestrial scene in the dome, normally the place for celestial visions. Behind a railing, a motley crowd of beggars, cripples, and majas presses around the saint, who is about to perform the miracle of resurrecting a dead man. There is something of the popular flavor of the tapestry cartoons in

this circle of gesticulating figures, but also something of the style of the *Caprichos,* translated to monumental scale. In the vaults and apse, Goya painted adorant angels, figures of unearthly beauty in iridescent garments, bathed in light that wells up from below.

The work was completed in three months, an astonishing feat. Goya used sponges to lay in the broad patches of color that model the figures in vivid contrasts of light and dark. He was assisted by the painter Asensio Julia, of whom he painted a portrait (in a private collection in Paris), showing him standing beneath the scaffolding in San Antonio. The frescoes in San Antonio are the last great works in the tradition of Baroque illusionist mural decoration; in them, Goya asserts himself as the worthy heir of Tiepolo. An echo of the figures behind the railing in the dome of San Antonio is to be found in *Majas on a Balcony* (New York, Metropolitan Museum), which, however, appears to be of somewhat later date (ca. 1808–10).

In 1799, Goya was promoted to the rank of First Court Painter, the highest to which a Spanish artist could rise. For the next two years he was to be heavily occupied with a series of official portraits of the king and queen, the princes and princesses, the favorite, Manuel Godoy, and his wife, the countess Chinchon. All these portraits are marked by a striking objectivity of conception and a great simplicity of pose, unusual in state portraiture. It is often claimed that Goya used these occasions for scathing exposures of his royal patrons, but this is not borne out by the portraits, nor by what is known of Goya's relations with his monarchs. The king and queen were not handsome, and Goya did not flatter them, but he also did not exaggerate their ugliness. The queen, a vain and sensitive woman, was satisfied with his portraits of her.

The Family of Charles IV (1800, Madrid, Prado), the most important of the court portraits, is based on separate studies of the individual members of the king's family that Goya painted from life at the summer residence of Aranjuez. Later, in Madrid, he combined these studies into a loosely composed group, lining up the gorgeously costumed and bejeweled personages in a patch of bright sunlight before a shaded wall. Maria Luisa occupies the center, a figure of diabolical vitality beside her genial royal capon, Charles IV, on whose chest Goya has lit a firework of flashing diamonds. Goya himself appears in the dark background, on the left, working at his easel—a touch deliberately reminiscent of Velásquez and *Las Meninas,* the picture that was in his mind's eye when he composed his group. The framed paintings on the wall behind the royal family have defied identification (it has been suggested that the one at the left is *Lot and His Daughters*); their significance, if any, is unclear. Various special interpretations of *The Family of Charles IV* have been advanced, none of them entirely persuasive. Perhaps the most memorable historical fact connected with it is that it shows Goya to have been the last great painter to draw from a dull commission—the official family portrait of a king—inspiration for a profound and beautiful work of art.

Probably about this time, or slightly later, Goya painted *The Naked Maja* and *The Clothed Maja* (Madrid, Prado), widely, but probably erroneously be-

lieved to represent the duchess of Alba. There is no reason to believe that these paintings were ever owned by the duchess, who died in 1802, but they were owned by Godoy in 1808, and referred to in his inventory as *The Gypsy.* Godoy had acquired Velásquez's *Toilet of Venus* (now in the London National Gallery) at the sale of the duchess of Alba's estate. It is possible that he commissioned *The Naked Maja* as a kind of pendant to Velásquez's nude, and that *The Clothed Maja* served as a cover for the other.

The nude body of the Maja is an exquisite and unusually smoothly finished bit of painting. The pensive head, somewhat awkwardly joined to the shoulders, may have been modified in a later overpainting. *The Clothed Maja,* more loosely brushed, may be of later date. Its bold brushwork has affinities with that of *The Family of Charles IV.* The tousled hair and more direct gaze distinguish the *Clothed* from the *Naked Maja,* and confirm the impression that they were not painted at the same time. In 1814, the Inquisition summoned Goya to account for the "obscenity" of these two paintings, but nothing is known of his response.

Godoy's government in 1807 allowed a French army to pass through Spain on its way to battle with a British force in Portugal. In March 1808, Spanish patriots attempted to oust Godoy, compel Charles IV to resign, and to raise his son, Ferdinand, to the throne. Napoleon used this opportunity for a massive intervention. He lured the royal family, including Ferdinand, to Bayonne and forced them to abdicate in favor of his brother, Joseph Bonaparte. French troops under Marshal Murat entered Madrid. On May 2, the citizens of Madrid rioted and were put down by Murat's troops after a brief battle. The following day, more than a hundred hostages were shot on the Principe Pio heights outside the city. The risings continued throughout Spain. During the summer of 1808, Spanish troops and irregular forces defeated several French corps. In the late autumn, Napoleon himself entered Spain at the head of a large army. By February of 1811, all Spain was under French occupation, except for the peninsular stronghold of Cadiz, in the extreme south, where a national assembly was formed to function as a government-in-exile and to draft a constitution.

On the mainland, meanwhile, the resistance against the French (known as the "little war," hence the term *guerilla*) was maintained by bands of irregulars, supported by British expeditionary forces led by Wellington and Moore. In August 1812, Wellington drove Joseph Bonaparte from Madrid, but he was later compelled by the French to retreat to the Portuguese frontier. A series of British and Spanish victories in 1813, culminating in the Battle of Vittoria, finally led to the expulsion of the French and the restoration of King Ferdinand VII in 1814.

Goya's position during Spain's national struggle was ambiguous. Like other Spanish liberals, he did not oppose and may at first even have welcomed the accession of Joseph Bonaparte, under whom he continued to serve as court painter. But he also showed his sympathy with the national Spanish forces under General Palafox, whom he visited in the ruins of Saragossa after the town's first siege by the French. When Wellington occupied Madrid briefly in 1812, Goya painted several portraits of him. His vacillations are documented by the curious transformations of the *Allegory of Madrid* (1810, Madrid, Ayuntamiento), which

was commissioned by the municipality of Madrid in homage to King Joseph. The shield to which the figure representing Madrid points at first held a portrait of Joseph. This was replaced in 1812 by the inscription *"Constitucíon,"* which in turn was covered over with a second portrait of Joseph when the French returned. In 1813, the word *"Constitucíon"* reappeared in the shield, to be covered in 1814 by a portrait of Ferdinand VII. The present inscription, *"Dos de Mayo,"* was placed after Goya's death.

The labored conventionality of this *Allegory* expresses the half-heartedness of Goya's allegiance to the successive governments and to the political causes they represented. He appears to have been neither an ardent nationalist nor a doctrinaire liberal. A humanitarian rather than a partisan, he took the part of those who suffered, regardless of what side they served, and was horrified by brutality, even when committed by Spaniards defending themselves.

The Disasters of War (to which Goya gave the title "Fatal Consequences of the Bloody War in Spain Against Bonaparte, and Some Striking Caprichos") form a series of eighty-two etchings, many toned with aquatint, that record his observations and emotions during the war and its aftermath. Most of the plates were drawn in 1809–13, a few are dated 1810, and the later ones date from 1814–15. The series was not published in Goya's lifetime; its first public issue was arranged only in 1863.

The sequence of the prints has dramatic meaning: images of hand-to-hand combat (plates 2–8) are followed by scenes of rape (9–11, 13) and of atrocious executions (14–15, 31–38) and mutilations (37, 39). Battlefields or execution grounds littered with cadavers (16, 18, 20–24) alternate with episodes of mob violence (28–29) and of headlong flight (42–45). The latter part of the series emphasizes the passive forms of suffering, destitution, starvation, and despair (48–56, 58–64). It is likely that the earlier plates reflect Goya's impressions of the active warfare of 1808–09, while the later ones record the hunger and oppression of 1811–12. The last in the series (plates 65–82), which Goya called the *caprichos enfaticos* ("striking Caprichos"), constitute an addendum, concerned mainly with churchly abuses and stated in obscurely fantastical imagery, reminiscent of the visionary scenes of the *Caprichos* of 1797–99. Goya drew these final plates in 1815. Preparatory drawings in red chalk exist for most of the plates of the *Disasters.* The compositions are more spacious, more densely populated, and more turbulent than those of the earlier *Caprichos.* The scenes are often silhouetted against the white paper; their tonal contrasts are very abrupt.

The treatment of war as misery rather than glory, and its presentation from the victim's point of view is rare in art before Goya. A celebrated instance, certainly known to Goya, is Jacques Callot's series of etchings, the *Misères de la guerre* (1633). The very opposite attitude is expressed by the French painters in Napoleon's service—chief among them Antoine Gros—who, in celebrating the victories of France, distilled a kind of romance from carnage.

Closely related in theme and conception to the *Disasters* are two paintings that are said (without evidence) to have decorated a triumphal arch improvised on the occasion of King Ferdinand's solemn entry into Madrid in 1814. Earlier

that year, the regency government had allowed Goya a sum of money to enable him to paint "the most notable and heroic actions of our glorious insurrection against the tyrant of Europe," in other words, Napoleon. *Massacre of the Mamelukes (The Second of May, 1808)* (1814, Madrid, Prado) represents the first outbreak of popular resistance at the Puerta del Sol, where a troop of French Mamelukes was attacked by citizens of Madrid. Goya treated the scene with a brilliance of color and a turbulence of movement that is reminiscent of Rubens's great hunt pictures. The fury of the battle is represented in all its cruelty, without nationalist partiality, and there are touches of great painterly beauty, despite the violence of the subject. The picture is dominated by the red trousers of a Mameluke who, thrown back on his white horse, is about to receive a knife thrust in his unprotected belly. The *Massacre* invites comparison with Girodet's *Revolt of Cairo* (1810), which is similar in subject but very different in its intricately neoclassical composition.

The *Execution of the Hostages (The Third of May, 1808)* (1814, Madrid, Prado) continues the tradition of Baroque martyrdom pictures. The scene of the nocturnal shooting is a modern Golgotha. The chief victim, Christlike in his pose, appears to be exhibiting the nail wounds of the Crucifixion in his upraised hands. In contrast to the compact, machine-like group of soldiers, faceless behind their guns, the men about to be shot express a great variety of very human expressions, sharply footlit by a large lantern.

In his record of the national war of liberation, Goya worked as a private observer, radically objective not only in his freedom from official guidance and artistic stereotypes but also from subjectivism and sentimentality. Under the pressure of emotion, his view of reality was not distorted but became sharpened, enabling him to record visual facts that had not been observed, or considered paintable, before him. This is apparent in the astonishingly "modern" scenes of the *Disasters* that document aspects of war with a harsh truthfulness unrivaled before the advent of documentary photography. It is evident that Goya was able to separate realistic vision from fantasy. Although he often clothed fantasy in realistic forms, he generally did not allow fantasy to cloud his perceptions when observation was his goal. In the *Caprichos* and the *Disasters,* significantly, realistic and visionary images are kept separate.

During the war years and the years immediately following them, Goya executed genre scenes in oil, typically forming series of four to six pictures, on themes related to the *Disasters,* on religious observances, or on popular festivities. The most remarkable of these series is composed of five panels of fair size:

> *Bullfight in a Village Square* (ca. 1812–15, Madrid, Academy of San Fernando),
> *Procession of Flagellants* (ca. 1812–15, ibid.),
> *Tribunal of the Inquisition* (ca. 1812–15, ibid.),
> *"Burial of the Sardine"* (Carnival) (ca. 1812–15, ibid.),
> *The Madhouse* (ca. 1812–15, ibid.).

In their dramatic realism and subject matter these paintings have some affinities with Goya's fourteen "cabinet" pictures of 1793, with which they are often confused. They are, like those earlier paintings, private comments on contempo-

rary life, "observations for which there is normally no opportunity in commissioned work."

Among his paintings of the time, there are also some large figure paintings in a powerful and sober style, such as *The Water Carrier* (ca. 1808–12, Budapest Museum), *The Knife Grinder* (ca. 1808–12, Budapest Museum), and *The Forge* (ca. 1812–15, New York, Frick Collection)—remarkable, heroic representations of workers at work. Occasionally, Goya returned to the satirical vein of the *Caprichos* in paintings of large scale, for example in the *Old Women and Time* (ca. 1810–12, Lille Museum) and the *Young Women Under a Sun Umbrella* (ca. 1810–12, Lille Museum), two paintings probably conceived as a pair, the first derived from one of the *Caprichos* (no. 55, *Hasta la muerte*), the second, recalling the tapestry cartoons, possibly a portrait of Goya's companion Leocadia Weiss.

Finally, there are among the paintings of the war years some visionary subjects that obscurely speak of fear and oppression. The *Colossus* (or *Panic*) (1808–12, Madrid, Prado) has a close relative in the grandiose mezzotint *Colossus,* of about the same date. The enormous nude rising from behind the mountains or seated on the horizon, cloud shadows moving across his back, has been variously interpreted. The giant may represent the oppressive invader, or Napoleon himself, who was at the time referred to as the Colossus of Europe. But he may also be the Spanish people, awakening to the realization of its force.

City on a Rock (ca. 1812–15, New York, Metropolitan Museum), which is related in conception and style to the *Colossus,* offers the fantastic vision of a siege. Fires burn round the base of the fortress rock, while in the sky winged figures soar, giving a foretaste of the plate *Modo de volar* (plate 13) in Goya's last great series of etchings, the *Proverbios* (ca. 1815–20). In the lower portions of the canvas (whose attribution to Goya is contested), the paint is laid on with the palette knife.

After his restoration to the throne in May 1814, Ferdinand VII lost no time in reviving the institutions of the old monarchy, including the Inquisition. The years that followed brought total disillusionment to those who had fought against the French. The Constitution of 1812 was abolished, the Jesuits were recalled, the clergy readmitted to power. The civil administration sank into chaos; despotic ministers ruled without check. Goya himself was summoned before the Inquisition to account for his *Naked Maja.* His *Self-Portrait* (1815; versions in the Prado and the Academy of San Fernando) offers the artist's self-appraisal at age seventy: a massive head in a striking play of light and deep shadow. The portrait gives an appearance of unbroken strength, but bears the marks of suffering and of melancholy.

When his wife died in 1812, Goya took for his companion Leocadia Weiss, a young woman recently separated from her husband, who seems to have borne him a child in 1814. His rank of court painter was not taken from him, but he chose to withdraw from public life. Ferdinand VII had no affection for him. Goya on his part sympathized with the currents of liberal thought and political opposition that eventually resulted in mutinies in 1819 and in a full-scale revolutionary rising in 1820, but he took no active part.

Knowing the impossibility of publishing his *Disasters of War* in the repres-

sive climate of 1815, he abandoned that series for a less controversial project, *La Tauromaquia (The Art of Bullfighting)*, a set of thirty-three large etchings with aquatint, with an additional twelve plates that remained unpublished. The work occupied him from 1815 to 1816, when its first edition appeared. It illustrates characteristic moments in the ritual of the bullfight, enacted by famous matadors of Goya's time, and also offers a history of the sport going back to its Moorish origins. The execution of these essentially realistic images shows Goya's mastery of tone and line at its highest point, and demonstrates his ability to derive dramatic effect from factual observation.

The various portraits he painted of the unprepossessing Ferdinand VII in 1814–19 are based on earlier studies; the king did not pose for him after 1808. Other portraits from this period—of court dignitaries and personal friends—are marked by a particular, somber intensity. The compact figures are modeled in broad touches of color on very dark grounds.

The promotion of churchly piety was a matter of state policy under the restored monarchy. Goya was anti-clerical, but not unreligious. Some of his large religious paintings of this period, such as *Sts. Justa and Rufina* (1817, Seville Cathedral), are evidently conventional command performances. But two of the late religious compositions leave no doubt about the sincerity and intensity of his feelings. *The Last Communion of St. Joseph of Calasanz* (1819, Madrid, San Anton Abad), a very large canvas for which Goya refused payment, was painted for the chapel of a teaching order, in one of whose schools Goya had been a pupil in his Saragossa childhood. It shows the dying saint kneeling in a dark church while a priest administers the sacrament to him. Rays of grace descend from above. In the distance, children and their teachers kneel in prayer.

Christ on the Mount of Olives (1819, Madrid, Escuelas Pias), a small picture painted on wood, was also a gift to the teaching order of St. Joseph of Calasanz. Christ's gesture, part prayer, part despair, significantly resembles that of the kneeling figure of the *Disasters of War* (plate 1), captioned *"Sad Presentiments of Things to Come."*

In 1819, Goya bought a two-storied country house on the banks of the Manzanares River outside the gates of Madrid. Later that year, he suffered another of his periodic attacks of illness and came close to dying. For the physician who had saved his life, he painted *Goya and Dr. Arrieta* (1820, Minneapolis Art Institute), a secular *ex-voto* in which he represented himself as half-conscious, about to receive the life-saving glass of medicine. The most poignant of Goya's self-portraits, this is also a scene of salvation, and in this respect curiously reminiscent of *The Last Communion of St. Joseph of Calasanz.*

As he had done after his great illness of 1792–93, Goya spent the period of his recovery in part working on a cycle of wall paintings, in part on a series of visionary etchings. The *Disparates (Follies)* or *Proverbs* consist of twenty-two etchings with aquatint, of the same size (and in several instances printed from the same plates) as the *Tauromaquia* series. Some of them may date from as early as 1815; the majority seem to have been executed about 1820–23. They were not published in Goya's lifetime. In content and spirit, the series is related to the more fantastical of the *Caprichos,* but it also contains echoes of his visionary paintings

of the war years (e.g., *City on a Rock*). Images of daemonic animals and of gigantic figures, some of them bogeys, some actual giants, are conspicuous in this series. Their symbolical references are particularly obscure and have resisted interpretation. Many of the plates deal with superstitions, fears, and obsolete beliefs, hence the pervasive mention of "Follies" in the captions. Several of the plates have a political implication, but most seem to be of private and occasionally sexual meaning.

The Constitutionalist Revolution of 1820 found Goya on the side of the Liberals. He attended a meeting of the Academy, his last, to swear allegiance to the Constitution of 1812. During the period of confusion and near-anarchy which now followed under several incompetent Liberal governments, he made a final retreat into total privacy, staying in his house outside Madrid, which became popularly known as the *Quinta del Sordo* (House of the Deaf Man).

During the years of his residence in this house, Goya covered the walls of two rooms with large paintings (now transferred to canvas and exhibited at the Prado in Madrid), using oil paints applied directly to the plaster. The room on the upper floor, possibly a dining room, may have been painted first.

```
 ┌──────────────────┐   ┌──────────────────┐
 │4      5       6  │   │     12     13    │
 │                  │  11│                 14
 │   Lower floor  Entrance│   Upper floor  Entrance
 │                  │ 10 │                  │
 │3      2       1  │   │     9       8    │
 └──────────────────┘   └──────────────────┘
```

In the room on the lower floor, the long lateral walls held, on the one side, the painting *Witches' Sabbath* (2) and on the opposite side the *Pilgrimage of San Isidro* (5). On the narrow end walls, Goya placed beside the door *Leocadia Standing at a Tomb* (1) and *Two Old Men* (6), and above the door, *Two Old People Eating Soup* (7); on the end wall opposite he painted *Saturn Eating One of His Children* (3) and *Judith Slaying Holofernes* (4).

The room on the upper floor contained along the side walls (interrupted by windows) on the one side *The Fates* (8) and *Men Fighting with Clubs* (9), and on the other side the *Flight of the Witch Asmodea* (13) and the *Procession of the Inquisition* (12). On the narrow flanking walls, on the entrance side, was *Dog Buried in Sand* (14), perhaps damaged or unfinished, and on the opposite wall *Men Reading a Letter* (10) and *Women Mocking a Man* (11).

The paintings were described and their subjects identified in 1828 and again in 1867, when they were still in place. They were removed to the Prado in 1873. Like an intimate sketchbook, but on a monumental scale, the murals of the Quinta del Sordo resume aspects of Goya's earlier work. There is something of the tapestry cartoons in them, much of the fantasy of the *Caprichos* and *Disparates,* and a touch, as well, of the colossal visions of the war years. The brushwork has the power and masterly breadth that generally marks Goya's late paintings. The colors vary, but on the whole tend to very somber combinations of dark brown, gray, muted blue, red, and yellowish white.

A deliberate plan underlies the sequence and juxtaposition of the images.

The reference throughout is to fate and time, old age and death. The diabolical ritual of witches is confronted by a nightmarish throng of pilgrims. The man-slaying Judith looks across the room to Leocadia leaning on a tomb (which may be Goya's). The old men (one of whom seems to be deaf) face Saturn, god of relentless time, who devours his child. While particular symbols may be obscure, the sense of the whole is stated clearly and with rational symmetry. Nothing in these "black paintings" indicates that Goya derived comfort or hope from the recent victory of the liberal cause. They express, rather, a deeply pessimistic view of man's delusion, futility, and mortality, a view that has a bleak grandeur but no social application. Goya seems to be speaking of himself and to himself alone. Nothing in European art of the time is comparable to the intensely personal content and the radically original style of these paintings. They are entirely unrelated to any of the modernisms then current.

At the Congress of Verona, the European powers decided to authorize the French Bourbon government of Louis XVIII to come to the rescue of the Spanish Bourbon, Ferdinand VII. A French army entered Spain in April 1823 and, meeting only feeble resistance, traversed the peninsula, destroyed the Liberal junta, and restored Ferdinand to the full enjoyment of his absolutist powers. A period of savage repression now began. Goya, feeling unsafe even in his retirement, made a gift of his house to his grandson, and went into hiding. In 1824 he obtained permission from the king to visit the French spa of Plombières for his health. He had chosen to go into voluntary exile.

Goya left for Bordeaux in June, and continued almost immediately to Paris, where he may have seen the Salon of 1824, which included works by Delacroix, Ingres, Constable, and Bonington. The aged provincial briefly found himself in the center of the world of art, face to face with innovations that were less bold than what he had achieved in his solitude. The remaining four years of his life passed uneventfully in Bordeaux, except for two brief trips to Madrid in 1826 and 1827. Vigorous for his age, he lived in fairly cheerful domesticity with Leocadia and her (and probably his) daughter Rosario.

Goya's appetite for work was undiminished. He continued to fill his sketch-books with mordantly aphoristic drawings, painted portraits, scenes of bullfighting, and some genres, such as the monumental, bust-length *Milkmaid of Bordeaux* (1825-27, Madrid, Prado), his last large painting, surprising after the recent dark fantasies for the delicacy of its colors and the serenity of its feeling.

Open as ever to new ideas, Goya experimented with a technique of miniature painting on ivory: blackening small pieces of ivory, he formed random spots of lighter tone on the dark surfaces by dropping water on them. These vague shapes he then developed, with touches of watercolor, into figures and faces. The images that resulted from this interplay of accident and fantasy resemble the "black paintings" of the Quinta del Sordo reduced to diminutive size. Goya wrote of having painted some forty of these miniatures; about twenty are known today.

While still in Madrid, in 1819, he had begun to make lithographs, encouraged by the publisher Cardano, who had recently introduced this new technique to Spain. He used a process for transferring his drawings to the stone that

produced poor results. During his stay in Paris, in 1824, he may have seen works by the French pioneers of lithography, the Vernets, Charlet, and Géricault. In Bordeaux in the months that followed, he drew a number of lithographs, working directly on the stone with fresh confidence and mastery. The series of four large lithographs, known as the *Bulls of Bordeaux* (1825), ranks among the early classics of lithography. At age eighty, Goya, having outlived David and David's followers, was still an innovative artist at the forefront of modernity.

He died, after a brief illness, on April 16, 1828. Only the *Caprichos,* of all his works, were beginning to be known outside Spain. Goya had a few Spanish imitators, but left no school. The generation which was to discover him—that of Gautier, Baudelaire, and Manet—was still in its cradle when he died.

READINGS

General

P. Gassier, *The Life and Complete Work of Francisco Goya,* New York, 1971. A convenient, well-illustrated survey of the biographical material and the entire work, with documents and detailed annotations.

J. Gudiol, *Goya,* 4 vols., Barcelona, 1971.

Enriquetta Harris, *Goya,* New York, 1969.

Xavier de Salas, *Goya,* London, 1979.

Individual Works

Jutta Held, *Die Genrebilder der Madrider Teppichmanufaktur und die Anfänge Goyas,* Berlin, 1971.

E. Lafuente Ferrari, *The Frescoes in San Antonio de la Florida,* New York, 1955.

H. Thomas, *Goya, the Third of May,* New York, 1973.

F. J. Sanchez Canton, *Goya, la Quinta del Sordo,* Florence, 1965.

Prints and Drawings

P. Gassier, *The Drawings of Goya: Sketches, Studies, and Individual Drawings,* New York, 1973.

P. Gassier, *The Drawings of Goya: Complete Albums,* New York, 1973.

J. Lopez-Rey, *Goya's Caprichos,* Princeton, 1953.

Tomas Harris, *Goya, Engravings and Lithographs,* Oxford, 1964.

E. Sayre, *The Changing Image: Prints by Francisco Goya,* Boston, 1974.

Interpretations

F. D. Klingender, *Goya in the Democratic Tradition,* New York, 1968.

F. Nordström, *Goya, Saturn and Melancholy,* Stockholm, 1962.

4

British Neoclassicism and William Blake

British Neoclassicism
> *Gavin Hamilton, 1723–1798*
> *Benjamin West, 1738–1820*
> *James Barry, 1741–1806*
> *Henry Fuseli, 1741–1825*
> *John Flaxman, 1755–1826*

William Blake, 1757–1827

British Neoclassicism

Britain played an early, leading part in the classical revival that swept Europe in the second half of the eighteenth century. The literary and artistic heritage of antiquity was nowhere cultivated with greater zeal: British antiquarians studied and published the remains of ancient architecture in Greece and the Near East; British architects applied their knowledge of classical style to the construction and decoration of town and country houses; British collectors scoured the ancient sites of Italy for sculptures and vases with which to fill these houses. The clarity and order of classical ornament and the white purity of antique marbles had a special appeal to British taste, never wholly won over to Rococo opulence. British painters, more scholarly on the whole than their French contemporaries, were in the forefront of the classical revival in the 1760s and 1770s, conspicuous for their efforts at stylistic authenticity, at accuracy in costumes and accessories and the correct interpretation of classical subjects.

GAVIN HAMILTON (1723–1798)

A typical and influential British pioneer of neoclassicism was Gavin Hamilton, a Scotsman of good family and private means, who went to Rome in 1748 to study painting, but became absorbed in the adventure of archeological excavation and the business of art dealing. Early in his Italian stay, he befriended the architects Stuart and Revett and with them visited Pompeii and Herculaneum. He also knew and advised Robert Adam, encouraged the young sculptor Canova, and generally occupied a central position in Rome's international colony of artists and collectors. A serious archeologist in his own right, he conducted extensive excavations at Tivoli and Ostia. The numerous marbles which he unearthed and restored were for the most part sold to British collectors.

As a painter, Hamilton is noteworthy for having been one of the earliest artists to treat heroic subjects taken from Homer. In 1761–65, he painted a series of large canvases on Homeric themes for different British patrons—*Andromache Mourning the Death of Hector* (1761, lost), *Hector's Farewell to Andromache* (1762, Duke of Hamilton Collection), and *Achilles Dragging Hector's Body Around the Walls of Troy* (lost)—that attracted great attention when shown in London. These became even more influential through D. Cunego's engraved copies of them, which had a wide circulation in all parts of Europe, and their

influence could still be felt in later decades. One of Hamilton's Roman subjects, *Brutus Swearing to Avenge the Death of Lucretia* (ca. 1763, London, Haymarket Theatre), was among the sources of David's *Oath of the Horatii* (1784).

Hamilton was a painter of moderate talent. Dead in color and dull in execution, his ponderous compositions do not seem "classical" to modern eyes. He borrowed the heavy, somewhat bloated forms and dusky colors in his pictures from Baroque paintings of the Bolognese School, which he extensively pillaged. His familiarity with classical sculptures has left surprisingly few traces in his work. The qualities that contemporaries admired in them, as reflections of a classical spirit, were their lofty seriousness, their emotional restraint, and the statuesque immobility of their figures.

Despite the earliness of the British contribution to the development of neoclassicism and the high regard in which history painting was held in England, as elsewhere, England failed to produce a national school of history painting comparable to that of David in France. The early surge had no sustained sequel. One reason for this was the lack of official support, such as was given in France by the ministries of the Ancien Régime before the Revolution and by the governments of Napoleon and of the restored Bourbons after 1800. Portrait painting, genre, and landscape continued to be the specialties in which British artists excelled and in which they displayed their special aptitude for naturalism and color. Sir Joshua Reynolds extolled the grand style in his presidential *Academy Discourses,* but in his own practice kept to portrait painting. The efforts by some artists, such as James Barry, to counteract the national preference for practical and lucrative work of an "inferior" kind and to raise the national level of taste by providing exemplary historical art, often at great personal sacrifice, failed to rouse the British public or, indeed, the artists to a genuine enthusiasm for classical history painting. From its precocious beginning, British history painting went on to a rather languid state, marked by eccentricity, by high ambition without sustaining energy or talent, and without the passionate convictions that animated the works of mature French classicism in the period 1780–1800.

BENJAMIN WEST (1738–1820)

The case of Benjamin West is the great exception among English history painters, the one instance of lavish patronage, constant employment, and high honors in that otherwise ungrateful field. Born in the colony of Pennsylvania, of Quaker stock, he began as a portrait painter in New York, went to Italy in 1760 to complete his artistic education, and here was exposed to the first flowering of neoclassicism. Mengs and Hamilton determined his early development. Highly receptive to influence, he rapidly assimilated the new style. Settled in England from 1763, he won almost immediate success with classical compositions of heroic and stoical subjects, such as *Pylades and Orestes Brought Before Iphigenia* (1766, London, Tate Gallery), *The Departure of Regulus* (ca. 1767, Royal Collections), *Agrippina Landing at Brundisium with the Ashes of Germanicus* (1768,

Yale University Gallery), and *Hannibal Swearing Never to Make Peace with Rome* (1770, Royal Collections). Skillfully composed, solidly, if rather stiffly painted, marked by that virtuous lifelessness which passed for classical nobility in the era of Mengs and Hamilton, these paintings foreshadow David, but without any of the emotional intensity that gives David's scenes of self-sacrifice a revolutionary impact.

A founding member of the Royal Academy in 1768, much patronized by the high clergy of the Church of England, West attracted the attention and warm personal support of George III, who in 1772 appointed him "historical painter" and in the following four decades showered him with commissions. West's rapidity in assimilating classicism was equaled by the speed with which he renounced it in order to try other, more exciting novelties. In his *Death of General Wolfe* (1770, Ottawa, National Gallery), he daringly staged a modern scene of heroism in modern military costume, though with a skill of compositional management born of his experience with classical subjects. After 1770, he increasingly deviated from classical restraint into a melodramatic turbulence, and in such compositions as *Death on a Pale Horse* (first sketched in 1783, enlarged to grandiose size in 1817; Pennsylvania Academy) and *Christ Rejected by the Jews* (1814, Pennsylvania Academy), enormous, crowded canvases, aimed for effects of sublimity and terror. The hollowness of these colossal, laboriously mannered performances became apparent shortly after West's death, and led to an abrupt decline of his formerly great reputation.

JAMES BARRY (1741–1806)

The frustrations that were the normal lot of English artists aspiring to practice the grand style that Sir Joshua Reynolds of the Royal Academy had merely preached are tragically evident in the career of James Barry, an artist whose imagination, ambition, and power of will far exceeded his technical gifts. Born in Cork, Ireland, the son of a shipmaster, he was essentially self-educated as an artist. At the age of twenty-two, he exhibited a painting on a subject from early Irish history in Dublin. His *Baptism of the King of Cashel by St. Patrick* caught the attention of Edmund Burke, author of the *Philosophical Enquiry into the Origin of Our Ideas of the Sublime.* Burke found signs of natural genius in Barry's precocious and untaught achievement, encouraged the young painter to go to London in 1764, and later financed his five-year period of study in Italy (1766–71).

What Barry saw in Rome and Florence painfully reminded him of his country's backwardness in grand history painting and sharpened his distaste for such lesser work as portraits, sporting pictures, and landscapes by which British artists were compelled to earn their living. He resolved to become the reformer or, rather, the initiator of a national British school of historical art, worthy to rank with those of antiquity and the Renaissance. Believing that he had the strength to compete with Raphael's great frescoes in the Vatican, he prepared himself by treating classical subjects in large canvases of ponderously monumen-

tal style: *Philoctetes on the Island of Lemnos* (1770, Bologna, Pinacoteca), *Venus Rising from the Sea* (1772, Dublin, National Gallery), and a biblical scene, the *Temptation of Adam and Eve* (1771, Dublin, National Gallery), to which he gave the heroic physicality of the classical types of Hercules and Venus. Powerful in conception, simply composed, vigorously if still rather awkwardly executed, these large canvases compelled attention when exhibited in London, and won Barry admission to the Royal Academy in 1773. He was one of the academicians who lobbied for the decoration of the interior of St. Paul's Cathedral with large murals, a scheme that was intended to stimulate history painting but was refused by the bishops, prompting Barry to publish a stinging pamphlet, *Real and Imaginary Obstructions to the Acquisition of the Arts in England.*

A fresh opportunity for work on a heroic scale arose when the Society for the Advancement of Arts, Manufactures and Commerce, a private body, proposed that members of the Academy decorate the Great Hall of its new building in the Adelphi. When his fellow academicians refused, Barry offered to paint six large canvases—the two largest measuring 11 by 42 feet—without pay or help. The program over which he labored for seven years (1777–84) amounted to nothing less than the story of the creation of culture and its progress from primitive to modern times, ending—like Michelangelo's creation epic in the Sistine Chapel—with a Last Judgment.

In the first panel, Orpheus brings civilization to primeval savages; in the second, the rustics of an Arcadian Golden Age celebrate the harvest; next, a long frieze shows the victors of the Olympic Games in solemn procession, bringing to a close the "antique" portion of the cycle. This is followed by an allegory of Commerce in which a giant, personifying the Thames, is ludicrously conveyed in a barge by swimmers (including Captain Cook in modern costume) assisted by mermaids. The next scene shows members of the Society distributing awards to encourage agriculture, art, and commerce. In the last large canvas, entitled *Elysium, or the State of Final Retribution,* Barry assembled the elect, the great men of all history and all nations, at the feet of Homer, while offering a glimpse, at the lower right, of the unworthy consigned to Hell.

The Adelphi murals are the most ambitious and original large-scale didactic program of their period. In carrying out this unpopular and unrewarded work, which strained his powers of execution, Barry demonstrated a heroic idealism. His scheme boldly invites comparison with the great mural cycles of the Renaissance, and at the same time looks forward to such later attempts as Ingres's *Apotheosis of Homer* (1827) and Delacroix's murals in the Palais Bourbon and the Luxembourg Palace (1838–47).

In the last decades of his life Barry's character became progressively more violent, his chronic suspiciousness developed into paranoia. By his insults and quarrels, he made himself obnoxious to his peers, who responded by stripping him of his professorship and expelling him from the Academy. He continued to paint with undiminished zeal, though rarely supported by commissions. For Boydell's Shakespeare Gallery, a scheme for the promotion of British national history painting to which Reynolds, West, and Henry Fuseli also contributed, he painted

a luridly dramatic *King Lear Weeping Over the Body of Cordelia* (1787, London, Tate Gallery) and an equally unclassical *Iachimo and Imogen* (1792, Dublin, Royal Society). Entirely without external help, he carried out his last, grandly conceived classical subject, the huge *Birth of Pandora* (1804, Manchester Art Galleries). Barry died, alone and miserably poor, in 1806.

British history painters differed in characteristic ways from their French counter-parts. The French, better trained and supported by an older painting culture, were expert in stating their subjects with economy and eloquent restraint, while the British inclined toward a more profuse and elaborately illustrative manner, and often resorted to sensational effects or to colossal dimensions to make their work impressive. French classicism, even in its more highly stylized forms, always relied on a careful study of the posing model, which lent to its works a sense of underlying material reality. In English neoclassical painting, imagination out-weighs nature, figures tend to be stereotypical and phantom-like: born of artistic conventions uncorrected by fresh observation, they sometimes lapse into extreme mannerisms and eccentricities, such as would not have been tolerated in France. British naturalism triumphed in portraiture and landscape painting exclusively, leaving historical composition to the artists' inventive or imitative fantasy. The result was artificiality or awkwardness in the management of basic painting problems; even the conscientious Barry rarely achieved plausible anatomies—his figures have been described, not unfairly, as "big and boneless, mere sacks of flesh." Whether such distortions of reality were intentional or signs of helpless-ness, it is not always possible to tell. Compared to the French, British history painters showed a carelessness, or conscious indifference, in matters of execution and technique that gives to some of their work an appearance of spirited amateur-ishness.

HENRY FUSELI (1741–1825)

This imbalance between lofty intellectual conception and limited technical grasp, so common in British history painting, is one of the striking qualities in the work of Henry Fuseli, who was a native of Zurich, but in forty-five years of residence in England made himself a dominant figure among English artists. He had received a very thorough literary and historical education from the Swiss philolo-gist J. J. Bodmer, who introduced him to Nordic and medieval literature, to Dante, Shakespeare, and Milton. Ordained as a Zwinglian minister, Fuseli made himself unpopular in Zurich by pamphleteering against a corrupt magistrate, and was advised to leave the town. During 1763, he traveled in Germany, seeking the acquaintance of the leading figures among the rebellious young generation of German poets, the men of "Storm and Stress." His phenomenal mastery of languages enabled him to earn a living by translating works of English literature into German.

In 1764, Fuseli went on to England, where he continued as an international publicist, producing an English translation of Winckelmann's *Thoughts on the*

Imitation of Greek Art. His career to this point had been entirely that of a man of letters; suddenly, at age twenty-seven, fortified by words of encouragement from Sir Joshua Reynolds, he decided in 1768 to become an artist. He had, in his childhood, received some lessons from his father, and had later practiced drawing as a gifted amateur. With extraordinary self-confidence, Fuseli now prepared to educate himself in art, starting with oil painting, which he had never tried before, and continuing with a lengthy course of self-training in Italy (1770–78), where he steeped himself in ancient art and in the work of Michelangelo.

From this exclusive occupation with art, Fuseli rapidly distilled the distinctive manner of pen-and-wash contour drawing that was to become his chief means of expression. His retentive memory of antique sculptures and of works by Michelangelo and his mannerist followers gave him the stock figures that from then on made up his repertory: small-headed, elongated bodies, the women high-bosomed and long-limbed, the men hugely muscular, generally nude or clad in tightly clinging garments, their gestures furiously emphatic and as stereotypical as the figures themselves. Instead of inventing new subjects, he generally chose his themes from literature—from Dante, Shakespeare, and Milton, as well as the ancients—stressing violent conflict, terror, cruelty, and lust. He served no moral or political cause, unlike David, nor did he present a philosophic message, as Barry had done in the Adelphi murals. Instead, he offered a sophisticated dramatic entertainment, addressed to the emotions, the intellectual curiosities and erotic tastes of a cultivated audience.

On his return to London in 1780, he attracted attention at Royal Academy exhibitions with paintings in oil of indifferent execution but very striking subject matter. The most lastingly famous of these, the *Nightmare* (1781, Detroit Art Institute; a smaller version in Frankfurt, Staedelsches Institut), is one of Fuseli's original inventions, describing the voluptuous torments of a subconscious mental state. A young woman lies in uneasy sleep on a couch, her head thrown back, her arm hanging listlessly. On her raised bosom crouches a naked gnome, the embodiment of an evil dream, while through the parted curtains appears the ghostly head of a horse with glowing eyes. In a time surfeited with Enlightenment common sense, such spookery was calculated to appeal to a fashionable taste for things irrational and uncanny. Recent interpretations of the picture have made Fuseli appear as a profound student of dream imagery and psychologist of the unconscious, but perhaps overlooked his wit and facility in mystifying his public. Fuseli's daemonic pose, which greatly contributed to his celebrity in England, was mainly for show: he never surrendered his very lucid mind to the forces of instinct, obsession, or madness. But his work does contain, beside much bombast and spoofing, glimpses of the mental depths into which his great contemporaries, Goya and Blake, were also to look, and rather more deeply than he.

For Boydell's Shakespeare Gallery, Fuseli painted nine subjects taken from Shakespeare's plays (1768–89), dramatic scenes teeming with grandiose and fantastical inventions. Ever since his Roman stay, he had toyed with the idea of treating Shakespearean themes in the style of Michelangelo, combining the literary with the pictorial Sublime. In 1790, the year of his admission to full member-

ship in the Academy, he formed the plan of a Milton Gallery, proposing to do for Milton, single-handed, what Boydell's team of artists had done for Shakespeare. In the following ten years, he put his energies into the composition of more than forty scenes from Milton's poems, many of them on canvases of very large size. When opened to the public in 1799, the Milton Gallery had a moderate critical success. Fuseli was appointed to the professorship from which Barry had recently been dismissed. But the public, true to British indifference to history painting, paid little attention to his big canvases. Roughly painted, with too much use of bitumen, they soon blackened and decayed; many have since been lost or cut up, a disappointing end to the most ambitious British challenge to French superiority in history painting.

Fuseli's large picture series were, like nearly all his work, essentially illustrative. Their pretensions to monumentality were in conflict with their literary character: the successive canvases read like the enlarged plates of a book. What he had to say was best said with pen and wash. His paintings are less impressive than his drawings; large size and color add nothing to the force of his ideas, but rather dilute their expression. The material aspects of art were a hindrance to his mind. He was wholly preoccupied with the expression of imaginary reality, had little interest in representation, never used models, and found nature disagreeably confusing: "Damn Nature, she always puts me out!"

Elected to the position of Keeper of the Royal Academy in 1804, Fuseli occupied himself in his later years with teaching, historical study, and writing. He edited Pilkington's *Dictionary of Artists* (1805), published his own Academy *Lectures* (1801, 1810), composed striking *Aphorisms on Art* (1788–1818, published in 1831), and wrote a *History of Art in the Schools of Italy* (published posthumously) based in part on his studies, in 1802, of Napoleon's art loot at the Louvre. His writing style, with its startling metaphors and paradoxes, has much in common with his pictorial mannerisms. Despite his academic domestication, he retained from his youthful days of Storm and Stress an aura of untamed genius, and spread mild terror among his students. A fine diplomat, unlike poor Barry, Fuseli managed to remain friends with both his fellow professors and the Academy's arch enemy, William Blake. He died in 1825, an exotic but universally respected figure in the world of art.

JOHN FLAXMAN (1755–1826)

The art of expressing ideas from literature in the abstraction of purely linear design and within the small format of the book page was brought to its highest point by John Flaxman, who, though by profession a sculptor, achieved international fame and influence through his illustrations of Homer, Aeschylus, and Dante.

The son of a maker of plaster casts, Flaxman was a sickly child and precocious reader of the classics, who at the age of twelve began to exhibit drawings after the antique and at fifteen entered the Royal Academy School to study sculpture. He competed several times in the annual Academy exhibitions

for the gold medal that would have enabled him to finish his education in Italy. Failing in this, and seeing no other way of earning a living by his work, he became a designer for the "Etruria" pottery works of Wedgwood and Bentley, one of England's large industrial enterprises, specializing in the mass production of fine stoneware, so-called Jasperware—vessels of classical shape, tinted blue, green, or buff, and decorated with low reliefs in white, in imitation of antique polychrome vases. Flaxman's task was to copy Greek vase paintings or Roman reliefs and to adapt their compositions to the shapes of Wedgwood ceramics, first making precise drawings in pen and wash, and then modeling them in wax for reproduction by the factory. Such commercial work was a far cry from the Academy's lofty usage, but it gave him a useful familiarity with authentic classical methods of composing narrative subjects, quite unlike the ways of modern imitators. It also taught him to draw figures in pure outline, without shadow, color, or depth, and to arrange them on plain surfaces, clearly and simply, and yet with decorative effect.

Compared with the large canvases and high ambitions of Barry, West, and Fuseli, young Flaxman's work for industry was modest. But it shared one condition with history painting: it depended on reproduction to reach its public, just as the work of the history painters ultimately depended on print and book sellers, in other words, on the trade in reproductions, to reach a wider audience. Flaxman's experience in designing for mass reproduction had an influence on the formation of his style. It led him to minimize detail, to avoid complexity and subtle nuance, and to stress those qualities of simplicity and legibility in his drawings that would make them fit for mechanical reproduction. The mercantile slant of English art patronage and the technology of the Industrial Revolution thus combined, in his employment by Wedgwood and Bentley, in starting him on his progress toward a radical form of classicism.

In 1787, with Wedgwood's help, Flaxman was at last able to go to Italy. His purpose was to study, and to carry out several projects of monumental sculpture. By way of side occupation, and almost accidentally, he became involved through private commissions in the composition of illustrations for the works of Homer, Aeschylus, and Dante. He drew them in his spare time, in late 1792: a series of 34 plates for the *Iliad* (later augmented to 39) and 28 plates for the *Odyssey* (later increased to 34), 27 plates for the *Tragedies* of Aeschylus, and 110 for Dante's *Divine Comedy*. These more than two hundred pen drawings, completed in a surprisingly short time and sold for a pittance, were reproduced in the form of rather stiff line etchings by the Roman engraver Tommaso Piroli, and issued in separate volumes, the illustrations of Homer and Dante in 1793, those of Aeschylus in 1795. Their success was virtually instant. Within the decade, artists in all parts of Europe had become familiar with Flaxman's designs. Traces of their influence occur in the work of David, Gros, Girodet, Ingres, Géricault, Runge, and even of Goya.

By reducing his illustrations to the simplicity of pure outline and to a vocabulary of stereotype figures and gestures mainly borrowed from classical art (with some medieval suggestions in the Dante illustrations), Flaxman sought to

give his texts the most clear and essential visual expression. Discarding any pretense of realism, he told his stories in an entirely artificial graphic shorthand that combined high legibility with decorative grace, a form of picture-writing geared to the conveyance of meaning rather than the description of physical appearance. Like Fuseli, he dealt with ideas rather than representation. But the difference between the two artists was great. Fuseli's Baroque melodramas were designed to excite and entertain with their terrific sublimities. There was an element of self-exhibition in his work; the excessive energy of his execution was a complacent tribute to his own stormy genius. Flaxman's self-effacing correctness and delicacy, the tidy impersonality of his line (coarsened in Piroli's reproductions), by contrast, show his determination to let nothing, not even his own emotion, becloud the meaning of his statements. The intensity of his designs comes from clarity of mind rather than strength of feeling. In their gentility, their avoidance of the horrific and erotic, his illustrations, despite their dependence on classical subject matter and style, have little to do with the robust materialism of antiquity. Their classicism is a form of spirituality, congenial to Christian sentiment—a fact that may explain their immense success from about 1800 until well into the Victorian age.

In Flaxman's career, these illustrative projects were only a brief episode from which he immediately returned to sculpture, henceforth his main vocation. In England, he was best known for his many funeral monuments, including those of the Admirals Howe and Nelson, of Lord Cornwallis and Sir Joshua Reynolds. But it was by his outline designs that he achieved a lasting, international celebrity such as was denied to West, Barry, and Fuseli. His compositional inventions were plundered by generations of artists; as examples of neoclassicism's farthest advance in the direction of ideographic abstraction, they constitute his claim to historical importance. In his later life, he only once returned to classical outline illustration, in a series of designs to the *Theogony* and *Works and Days* of Hesiod (1817) for which William Blake executed the engravings.

Honored by the creation of a special chair for Sculpture at the Royal Academy in 1810, Flaxman lived a busy and uneventful life, loved by his small circle of friends, which included Blake, even-tempered in all things except when challenged in his Christian piety and mysticism. He died in 1826, having caught cold in church.

William Blake, 1757–1827

Blake was born in London in 1757, the son of a "moderately prosperous" stocking weaver who kept a shop in Soho. Even in early childhood, the boy showed signs of extraordinary talent for poetic and graphic composition. At age ten, he was sent to the drawing school of Henry Pars in the Strand, to train his hand by copying plaster casts of antique sculptures. His family background, very similar to John Flaxman's, was that of the respectable, intellectually awake class of striving tradesmen, a setting favorable to self-education. Young Blake read much, as his early poetic efforts prove, and his artistic ambitions appear to have been stirred by his readings rather than by any actual impressions of art.

From the very start, he felt a vocation for the most heroic and least lucrative branch of the arts, the historical and poetic, instead of for such better patronized specialties as portrait painting. His parents did not oppose his choice of profession, but wished to launch him into a reasonably life-sustaining trade. When he was fifteen, they apprenticed him to James Basire, an engraver and large-scale supplier of illustrative plates to book publishers. Blake served Basire for seven years, becoming expert in the standard techniques of reproductive etching and engraving on copper, the craft by which he was to earn his living for the rest of his life.

His introduction to the profession of art was thus entirely unacademic. The Royal Academy School, nonexistent when he started to draw in Pars's school, had meanwhile opened in 1768, but Blake's intimate intellectual development remained dependent on his own eager curiosity and initiative. He haunted the auction rooms and spent his small allowance on engravings by the masters, showing his independence of judgment by preferring the hard linearists of the Renaissance (Dürer and the engravers of Raphael and Michelangelo) to the opulent Baroque tonalists (Rembrandt and Rubens). His *Joseph of Arimathea,* a line engraving (ca. 1773), is an exercise based on a drawing or engraving of a figure from Michelangelo's *Crucifixion of St. Peter,* which Blake imaginatively transformed into that of Joseph, the legendary bringer of Christianity to Britain. This specimen of his student work is significant in revealing one of the main sources—engravings after Michelangelo—from which Blake stocked his imagination.

Basire, much involved in the illustration of antiquarian publications which were then in high fashion, sent Blake to Westminster Abbey to draw the tomb

effigies of the kings and queens of medieval Britain. This exposure to the formality and emotional intensity of Gothic style was important to Blake's subsequent development. Antique and medieval forms, the flow of Gothic line and the definiteness of classical contour hereafter became fused in his drawing. (A rather similar synthesis was attempted, a decade later, by Flaxman.) Several of these drawings of the royal effigies, among them *Queen Eleanor, from Her Effigy in Westminster Abbey* (pencil, ca. 1775, Oxford, Bodleian Library), were later engraved and published, under Basire's name, in Richard Gough's *Sepulchral Monuments of Great Britain* (1786).

When his apprenticeship to Basire ended in 1779, Blake made an effort to raise himself from the status of reproductive engraver to that of original history painter. To this end, he enrolled in the Royal Academy School, where, briefly, he entered into the regular routines of academic training. But he was repelled by the Academy's methods and doctrines, and conceived a dislike for its president, Sir Joshua Reynolds. He particularly hated the study of the living model, "life study," declaring that in its physical presence, nature to him looked like death and "smelled of mortality." Apparently he refused to take advantage of the instruction in oil painting. At any rate, he left the Academy after a few months as he had entered it—a journeyman engraver rather than a full-fledged painter —and thus eliminated himself forever from the scene on which he might have competed with the recognized history painters of his time, with West, Barry, Fuseli, and their kind.

But Blake did not give up history painting as such. Instead, he searched for a more spiritual, less matter-encumbered medium in which to express his ideas. His wash drawings and watercolors of subjects from medieval English history and the Bible, though small and of rather timid execution, give the poetic essence, which to Blake was all that mattered. They show him obedient to current conventions of composition, dressing up his neoclassical figures in pseudo-medieval costumes. One of his watercolors, *The Death of Earl Goodwin,* was exhibited at the Royal Academy in 1780. To some of his early compositions of 1779–84 he returned repeatedly in the following years, enlarging them and elaborating their compositions. His imaginative scenes of war, *War Unchained by an Angel, Fire, Pestilence, and Famine Following* (ca. 1780–84), *A Breach in the City, the Morning after a Battle* (ca. 1780–84), and *Pestilence, or the Great Plague of London* (ca. 1779–84), went through several such revisions.

This phase of Blake's work came to a climax about 1785, when he exhibited three watercolor compositions of the story of Joseph at the Royal Academy, and drew two large biblical compositions, *The Complaint of Job* (pen and India ink, ca. 1785, San Francisco, Achenbach Collection), and *The Death of Ezekiel's Wife* (pen and India ink, ca. 1785, Philadelphia Museum of Art), of much bolder and more personal conception. These give a foretaste of his visionary imagery in their facial and body types, and their ponderous bulk, while still reflecting the general character of Barry's bloated and wildly bearded patriarchs. Of both he later engraved masterful prints.

Blake's efforts at historical composition ended, around 1793, in the modest

project of a "small book of engravings" on the History of England. For this, he redrew some of his earlier medieval subjects, such as *The Penance of Jane Shore* and *The Ordeal of Queen Emma,* and made a finished engraving, *Edward and Elenor.* In the choice of these subjects, he expressed personal views: all of them celebrate instances of female valor and virtue; *Jane Shore* and *Queen Emma* in addition deal with the hypocrisy of conventional morality and established religion in sexual matters.

While engaged in this work, Blake took whatever jobs of reproductive engraving came his way, copying, pell-mell, designs by Watteau, Fuseli, and Stothard, fully aware that his original works would not earn him a living. His marriage to Catherine Boucher, in 1782, gave him a new reason for continuing with commercial work. This was a relatively worldly period in his life. He resided in Green Street, off Leicester Square, exhibited at the Royal Academy in 1784 and 1785, befriended Flaxman, the illustrator Stothard, the publisher Joseph Johnson, and the blue-stocking circle of Mrs. Matthew, whose husband, the Reverend Matthew, together with Flaxman financed the publication of his youthful poems, *Poetical Sketches* (1783).

After the death of his father in 1784, Blake attempted to set up a print business in partnership with James Parker, but this soon failed. Then occurred an event that cut deeply into his life: his younger brother Robert, whom he loved and who had been his pupil and assistant, died after a lengthy illness in February 1787.

Blake's career now took a decisive turn. Rather than illustrate the texts of other authors or engrave the designs of other artists, he decided to concentrate on the expression of his own ideas in word and image. Having little hope of finding a publisher for his poems, and wishing to go beyond the conventional format of illustrated books, with their mechanical letterpress text and inserted reproductive pictures, he literally *dreamed* of a new method of text-and-image printing, one that would enable him to make of each book an individual, hand-wrought work of art. His dead brother Robert appeared to him in his sleep (so he claimed) and taught him an etching technique, relief etching, that called for the lettering of the text and the drawing of the design on the copper plate with an acid-resisting varnish. By placing the plate into an acid bath that would etch away the unprotected surfaces, lettering and lines could be made to stand out in relief, ready to be inked and impressed on paper. Text and image could thus be printed in a single process, and in any desired color. The finished print could then be washed with watercolors and given the brilliance and detail of a miniature painting, making it resemble the page of an illuminated medieval manuscript, the model that was probably in Blake's mind as he planned his books. A sequence of individual prints, with their texts, in the end need only be assembled and bound to form a book.

Assisted by his wife, Blake henceforth became the exclusive publisher, as well as illustrator, decorator, printer, and binder, of his own poems. In this way he realized—more completely than his English contemporaries Fuseli and Flaxman, who had tended in the same direction—the ideal of ideographic art, a

language of pictorial and verbal poetry, bound to the book, and entirely dedicated to the visualization of imaginary reality. The process of producing the books was laborious, and the demand for them pitifully small. Blake printed only a very few copies of each, often at long intervals, assembling and coloring individual copies for individual purchasers. None attained a larger edition than twenty-seven copies; of several, only four or five copies saw the light of day.

In 1789, Blake produced his first important illuminated book. *Songs of Innocence* consists of twenty-seven etched pages containing a series of short pastoral poems, each set in a lively, elaborate marginal framework of figural and decorative imagery. The pages are of miniature size, the outlines and the letters of the text are printed in colors (varying from copy to copy), the designs are delicately washed with watercolors and in some copies touched with gold. The poems, ostensibly for children or in the voices of children, express Blake's thoughts about childhood as a state of joyous purity and wholeness, as yet unaffected by corrupt society. Such notions were widely current in the late eighteenth century; Blake gave them an air of homely truth by the simplicity of his language and the unaffected naivety of his imagery.

In the following years he composed and issued a sequel, the *Songs of Experience* (1794), which was similar in format and graphic style but darker in mood, dealing with the disappointments of the material world and the gradual enslavement of the mind by mechanical reason, or "ratio." The two books, ultimately brought to a total of fifty-four plates, were from this time on combined in one volume under a common title, subtitled "Showing the Two Contrary States of the Human Soul." Made to order, a copy at a time, the *Songs of Innocence and of Experience* became the most popular of Blake's illuminated books. Twenty-seven copies produced by him are known.

At about the same time that Blake's need to communicate his ideas had created an outlet for itself in the form of his illuminated books, he composed and decorated with relief etchings *The Marriage of Heaven and Hell* (1790–93), which expresses, in disconnected prose passages, his philosophy of the resolution of conflict by the reconciliation of opposites ("The road of excess leads to the palace of wisdom"). The book consists of twenty-seven etched and illuminated plates, in a format somewhat larger than that of the *Songs of Innocence.* Only nine copies survive. In 1793, he issued yet another illuminated book, *Visions of the Daughters of Albion* (subtitled "The Eye sees more than the Heart knows"). The book has eleven plates and corresponds in size to *The Marriage of Heaven and Hell.* It deals with the evil of political oppression and of sexual repression, and—in keeping with what was to be Blake's regular practice—personifies abstract principles in the form of mythical beings of his own invention. The Daughters of Albion stand for England's oppressed womanhood; the poem's heroine, Oothoon, for the search for freedom; Theothormon for the forces of emotion; and Bromion for the countervailing ones of reason. Seventeen copies are known.

The intellectual ferment in Blake's work of this time reflects his initially enthusiastic response to the French Revolution. Like many liberal-minded Englishmen, he saw in the early phase of that Revolution the hope-inspiring dawn

of a new era for the entire world. At the time he was closely associated with a group of radical thinkers and polemicists that centered on Joseph Johnson, a publisher who had occasionally employed him, and included Thomas Paine, William Godwin, Mary Wollstonecraft, and Joseph Priestley. Blake's Revolutionary fervor was dampened by the September massacres in Paris (1792) and the atrocities of the Terror, and his disillusionment probably contributed to the depression which he suffered during the later years of his residence in Lambeth, from 1790 to 1800.

Two of his illuminated books are concerned with contemporary history and express, though often in obscure allegorical terms, his political thought. *America, a Prophecy* (1793) interprets the American and French revolutions as conflicts between timeless, elemental forces which Blake personifies as colossal, mythical creatures, with attributes part-biblical, part-Ossianic. Orc, the embodiment of energy, confronts the powers of the established order, which Blake identifies as "Albion's Angel," or Urizen, in whose aged, bearded form the features of Jehovah merge with those of George III. The book consists of eighteen plates, of larger format than the earlier volumes, executed in relief etching. Of the sixteen recorded copies, only four are illuminated with watercolor.

Europe, a Prophecy (1794) surveys the first eighteen centuries of the Christian era in terms of the same grandly symbolical imagery. The theme is man's fall from his original, spiritual state of grace, and his gradual subjugation to religious dogma, repressive laws, and the rules of morality—all personified by the terrifying father figure of Urizen, who stands for Authority and for Reason separated from the Imagination. In Blake's inverted theology, the successive steps of this fall are marked by the creation of Adam, the fall of Adam, the birth of Man, the laws of Moses, and the evil of the Ten Commandments. The consequences of man's fall from spirit into matter and mechanical order are the miseries of Europe's history: plague, famine, terror, and war, culminating in the political order of the Ancien Régime. The frontispiece of the book represents the initial "fall," the creation of the material universe. God-Urizen, emerging from a sphere of light, extends a pair of dividers into the darkness of the Abyss, "binding the infinite with an eternal band," in other words, confining the created world in the bounds of rational order and law, unenlightened by the Imagination. *Europe* consists of seventeen plates corresponding in size to those of *America,* with which they are often bound. Twelve copies of the book are known.

Wholly centered on the human figure, Blake's imagery is closer in style and expression to that of Fuseli's vehement muscle men and women than to Flaxman's decorous classical stereotypes. The colossal bodies, small-headed and firmly sculpted, often set into frenetic motion or knotted into tight foreshortenings, are derived from the tradition of Michelangelo, transmitted to Blake by the engravings of Michelangelo's manneristic followers. Strong, definite contours and a steady reliance on a limited set of stereotypes of face, figure, and drapery mark Blake's compositions as they do Flaxman's, but Blake's work is more various and possesses an expressive vigor beside which Flaxman's abstractions pale.

Color plays a crucial role in Blake's work, increasing in importance as his

style matures: he is the only great colorist among the English figure painters of the period. Reflecting his mental visions, his use of color is determined by expressive and symbolical intentions. The radiance or gloom of his quite arbitrary color combinations generally sets the emotional tone of the compositions. But color also has a decorative function. Of great, transparent subtlety in some of his designs, it deepens into resonant, powerful, sometimes violent intensities in others. Watercolor was the chief medium in the earlier illuminated books, supplemented in 1794–96 by color-printing, a form of monotype—offset printing from paintings in a tempera-and-glue medium on boards or metal plates. This process tends to obliterate or at least to weaken the contours of the underlying relief etching, and gives to some of Blake's illuminated pages the look of pure painting in color areas of blurry shape and mottled texture, an effect quite contrary to his often-expressed insistence on clarity of outline.

Most of the copies of *Europe* are color-printed and their plates therefore strikingly painterly in effect. Intense and somber color, achieved by color-printing, also dominates the plates of *The Book of Urizen* (1794), which gives Blake's deeply pessimistic version of the story of Creation. Urizen-Jehovah personifies dogmatic reason. The true Fall is Urizen's creation of matter, which is dramatically represented in several of the plates (Urizen struggling in the waters of materialism, Urizen balancing the firmament) in which the bearded Creator appropriately resembles Michelangelo's Jehovah of the Sistine ceiling.

The culmination of Blake's experiment with color-printing is the group of twelve exceptionally large designs (17 × 21 in., or 43.2 × 53.3 cm., on average) executed for the most part in 1795. These separate, painting-like color prints, finished with pen and watercolor, but without underlying relief etching, may have been conceived by him as a series, though their order is not clear. They carry out —on a larger scale and in purely pictorial terms—the meanings that had preoccupied Blake in his Prophetic Books, but do so for the most part with reference to recognizable biblical or literary subjects that give a clue to their meanings. They are thus, to a degree, self-explanatory and freed from the need of a textual accompaniment, functioning as self-sufficient paintings rather than illustrative plates. Grandly composed, with a structural clarity and dramatic force worthy of murals, they prove Blake's aptitude for monumental design. They also show him in the role of painter rather than printmaker, for the painterly element in them takes precedent over the graphic; they were begun as color designs and given their pen contours only in the final execution.

God Creating Adam (London, Tate Gallery)
This paraphrases Michelangelo's *Creation of Adam* in the ceiling of the Sistine Chapel. In Blake's view, man's bodily creation by God (whom Blake here calls Elohim) was a tragedy, because it amounted to the casting of spirit into the bonds of matter, symbolized by the worm that coils around Adam's leg.
Satan Exulting Over Eve (Tate Gallery)
The symmetrical counterpart to *Adam,* thematically derived from Milton's *Paradise Lost.*
God Judging Adam (Tate Gallery; two other impressions are known)

Jehovah-Urizen, encircled in the "flames of Eternal fury," imposes his law on the submissive figure of Adam, whose features have become assimilated to those of his master.

Nebuchadnezzar (Tate Gallery; two other impressions are known)
The Old Testament king of Babylon is shown in bestial form, reduced to eating grass, perhaps symbolizing the final degradation of man abandoned by both Imagination and Reason. The crawling, bearded figure may have been suggested to Blake by Dürer's *Penance of St. Chrysostomos.*

Newton (Tate Gallery; one other impression is known)
The figure, its pose borrowed from an engraving of one of the ancestors of Christ in Michelangelo's Sistine ceiling, corresponds both in action and in meaning to the Urizen of the frontispiece of *Europe.* Stooping deeply, the creative mind, held captive by Reason, uses a pair of dividers to produce a diagram of matter.

Hecate (Tate Gallery; two other impressions are known)
The beautiful, triple-bodied goddess of spells and charms, a figure suggested to Blake by passages in Shakespeare's *Midsummer Night's Dream* and *Macbeth,* is seated among animals—recalling Circe among the men transformed into beasts by her magic. In Blake's mythology, Hecate symbolized the Female Will, exercising its sinister magic over the material and vegetative nature of the Fallen World.

From earliest childhood, Blake had possessed the gift of spiritual vision. At the age of eight, walking in fields near Dulwich, he had come across a tree filled with angels, their bright wings sparkling from every branch. In later years, visions were the source of his art: he claimed that he did not so much compose his images as copy them from the apparitions that presented themselves to his eye, or rather, to his mind's eye, with utter clarity and sharpness of detail. There is no reason to doubt him, but it is undeniable—as the series of color prints of 1795 shows—that his visions often assumed the character and style of past art, and abounded in quotations, sometimes traceable to the prints of the masters that he had collected in his youth. Vision, for him, was not hallucination but vivid, spontaneous recall. And there is abundant evidence in his work that he generally developed his images gradually, from first pencil sketch to final execution, by methods not unlike those used by more conventional artists.

After the exertion of the Prophetic Books and the large pictorial color prints—all the more heroic for being urgent communications addressed to a nonexistent audience, or at best to a few baffled friends—Blake returned to his more normal and profitable occupation of illustrative engraving. In 1795 he was commissioned to produce large watercolor designs for a luxurious edition of Young's *Night Thoughts.* The project occupied him for two years, during which he painted 537 large watercolors; only 43 of which were actually published, in the form of conventional line engravings enclosing the type-set text of every page, before the scheme was abandoned by the publisher. His friend Flaxman then commissioned him to furnish a series of marginal watercolor decorations for a special copy of Thomas Gray's *Poems* destined for Flaxman's wife. Blake painted 116 watercolors, broader and more sketchlike in manner, fresher in color, and rather more lighthearted in spirit than the plates of his Prophetic Books.

At about this time, he acquired a loyal and generous patron, Thomas Butts,

an administrative clerk in a military office, whose regular purchases were to be Blake's main source of income for the following fifteen years. Butts's first commission, in 1799, was for fifty small pictures of biblical subjects at one guinea each. Blake painted them on canvas or board, in a technique that he misnamed "fresco," believing it to be the technique used by artists of the fifteenth and sixteenth centuries, but that was actually a form of tempera painting, with carpenter's glue as the binding medium. Some thirty-seven of the original total of fifty are preserved in various museums and private collections. The majority are of New Testament scenes, of a traditional kind, rather than original inventions (evidently at Butts's request), though interpreted in ways that suited Blake's personal theology. They come as close as any of his works to being paintings in the common acceptance of the term, and continue the development that, in the course of the 1790s, led him from relief etching to color-printing on paper, and finally to the more fully painterly medium of tempera on canvas.

Blake stopped short of oil painting, which he detested because of its materiality, but his varnished "frescoes" in fact rather resemble oils. Brownish and dark, perhaps from the decay of their pigments, several of them (particularly the night scenes) show an almost Rembrandtesque tonality. The compositions for the most part lack the audacity of Blake's earlier prints and watercolors. The drawing is timid, the definition of the figures often vague, though he used a pen to strengthen the contours.

In the autumn of 1800, Blake was invited by William Hayley, gentleman-poet and somewhat officious patron, to join him in rural Felpham, near Chichester, for the purpose of collaborating in various artistic projects. Blake and his wife spent the following three years in a cottage near the sea—his only experience of country life. He painted a series of decorative portraits for Hayley's library and illustrated several of his host's poems, but soon found his patron's uncomprehending kindness and counsel stifling. His sense of unease and feelings of persecution were brought to a pitch by a quarrel with a drunken soldier who had broken into the garden of his cottage. This resulted in a charge for assault and sedition against Blake, of which a London court acquitted him in 1804.

Tired of Hayley and of Felpham, Blake had meanwhile moved back to London (in 1803). Even while still at Felpham, he had painted watercolors of biblical subjects for Thomas Butts. This now became his main occupation for some time; in 1805, he completed no fewer than forty of these compositions for his patron. The series of biblical watercolors (1800–09) continued, in a different medium and style, the series in tempera on canvas begun in 1799. Over the years, Blake painted some eighty large watercolors of subjects from the Old and New Testament for Butts, who seems to have planned to assemble them in an illustrated Bible. Rather than merely illustrating, these compositions offer Blake's comments on biblical themes. In contrast to the primitivism of the "fresco" paintings, the watercolor designs are of the most accomplished formality, with strong emphasis on two-dimensional patterns and symmetries. The emotional flow of their contours, the rhythmic gestures of their strikingly elongated figures nevertheless convey the intense exaltation of Blake's mental visions. Instead of

simple abstraction, the drawing style tends to an expressive calligraphy that ultimately owes more to a Gothic tradition of linear fantasy than to neoclassical conventions. A particularly impressive group of watercolors deals with fantastical scenes from Revelation, visualized with inspired concreteness, such as the *Great Red Dragon and the Woman Clothed in the Sun* (ca. 1805, New York, Brooklyn Museum), one of Blake's most powerful inventions.

In 1805, the publisher Robert Cromek commissioned Blake to design and engrave a set of illustrations for Blair's philosophical poem *The Grave*. Without consulting Blake, Cromek (who had come to doubt Blake's competence as an engraver) reduced the number of plates from twenty to twelve and entrusted their execution to the skillful conventional engraver Luigi Schiavonetti. Blake suffered a financial loss, but the publication of *The Grave*, in 1808, was a public success —the only one of Blake's career—and a second edition appeared in 1813.

Cromek meanwhile had commissioned Blake to paint Chaucer's *Canterbury Pilgrims* for £20, with a promise that this would be followed by a lucrative commission for the engraving of the design. Blake, suspecting that Cromek would again have his composition engraved by another printmaker, refused to let him have the painting. Cromek thereupon had the subject painted by Blake's friend, Stothard, for a considerably larger sum than he had offered Blake, and promptly engraved in 1809, thus anticipating Blake's own publication. Cromek and Stothard's venture proved a brilliant, lucrative success. Blake was enraged at having been plagiarized and swindled.

Keenly aware of his growing isolation and of the loss of his engraving trade, Blake attempted a final appeal to the public by means of an exhibition. This was installed in the house of his brother James, in Golden Square, Soho, and was mainly composed of his recent experiments in tempera, or "fresco," painting, including the *Canterbury Pilgrims,* and of a selection of his watercolors. The *Descriptive Catalogue* which accompanied the exhibition stated Blake's belief in mental vision as the source of art, his defense of contour design against the "blots & blurs" of such vicious colorists as Titian and Rubens, and his curious notions of art's antediluvian origins. In what seems to have been the only press notice, Leigh Hunt's *Examiner* dismissed the catalogue as "the wild effusion of a distempered brain." Yet, though rather extravagantly expressed, Blake's denunciations of realism and of color merely overstated accepted neoclassical doctrines, and his interest in the primitive origins of art was widely shared by artists both British and French. Very scantily attended, the exhibition, held from May 1809 until the summer of 1810, was a depressing failure.

From the time of his stay in Felpham, Blake had been deeply preoccupied with the poems of Milton. Between 1801 and 1807, he painted several series of watercolors on Miltonic themes, and in 1808 he executed a series of compositions based on *Paradise Lost* in his grandest manner and on an unusually large scale. Out of his meditations on Milton arose the plan for Blake's next-to-last illuminated book—*Milton,* subtitled "To Justify the Ways of God to Man," and dated 1804 (the relief-etched and white-line engraved plates were executed about 1807–09, with further plates added about 1814). The most complete of the four

extant, watercolor-illuminated copies contains fifty pages. The book deals with Milton's descent to earth and spiritual union with Blake, to rectify, in a titanic struggle with Urizen, the error he had committed in his mortal life of fostering a false art. Possessed by Milton's spirit, Blake in his mental strife with Urizen-Hayley at Felpham gains redemption for Milton. The illustrations are mostly full-page, separate from, rather than integrated with, the text. Their style is grand and broad, as if hurried by the momentum of inspiration. The four plates in white-line engraving (including the frontispiece of a classically nude Milton walking toward flames) define forms by tonal modeling rather than outline, and introduce a striking new note into Blake's work. In contrast to the refined thinness of Flaxman's contour designs, his late illustrations have a rough, expressive vigor and a richness of tone and color that can only be considered (though the term may seem blasphemous when applied to Blake) as Baroque.

At about the same time, Blake was also at work on *Jerusalem,* subtitled "The Emanation of the Giant Albion," the last and greatest of his illuminated books; Blake himself thought it "the grandest poem that this world contains." Of larger format than the *Milton* and exactly twice as long, it consists of one hundred pages, evenly divided into four chapters. Though its title page is dated "1804," the earlier plates were etched only in 1807–09, the later ones in 1812–18, and the very last perhaps not before 1820–21. Of the five complete copies extant, only one is fully colored.

The grand theme of this epic poem, couched in biblical language and dark symbols, is the drama of Salvation by which the contradictions inherent in man's fallen state—between mind and body, reason and imagination—are finally resolved. Passing through the darkness of suffering and death, man (Albion) attains forgiveness and redemption, and a fervent union with Christ, splendidly expressed in the plates *Albion and the Crucified Christ* and *The Soul Reunited with God.* In most of the plates, the dark ground is dominant, the figures standing out in the whiteness of the paper or the tonal modeling of white-line engraving. The one fully illuminated copy of the book (Upperville, Va., Paul Mellon Collection) is of the most splendid richness and freshness of color. By itself, this work justifies ranking Blake as the one great colorist among English figure painters of the time and this book as his final achievement of that perfect union of word and image for which he had striven all his life.

After the various discouragements and failures in 1808–09, the artist withdrew into a privacy so complete that the rumor spread that he had died. Very little is known of his life in the ten years between 1809 and 1818. Some of his old friends and helpers had died, or had left him; the publishers no longer employed him. Often he lacked the funds with which to buy the copper plates he needed for the completion of *Milton* and *Jerusalem,* on which he worked intermittently during these obscure years.

At sixty-one, Blake was suddenly drawn from his retirement by artists of a younger generation. John Linnell, later to become a well-known landscape painter but at that time painting portraits and miniatures, applied to him for help in the engraving of portraits. Through Linnell, Blake met John Varley, a water-

color painter of landscape and Linnell's former teacher, and was introduced to a circle of very young artists—Samuel Palmer, Georges Richmond, and Edward Calvert—who in Blake's last years formed an admiring circle around the old prophet, now grown mild and serene. These young men did not think Blake mad. They believed in his visions, and watched him with awe as he held conversations "in prose with demons and in verse with angels." To humor his young friends, particularly Linnell and Varley, both ardent believers in the occult, Blake sketched the portraits of his ghostly visitors, the *Builder of the Pyramids, Richard Coeur de Lion,* and *Queen Maud.* Most spectacularly, he painted the *Ghost of a Flea* (ca. 1819–20, Tate Gallery), the elaboration, in tempera on wooden panel, of a sketch drawn during a spiritualist session with Linnell.

Linnell managed to procure work for Blake. He induced the Reverend Thornton to commission a series of small woodcut illustrations for a school edition of Virgil's *Pastorals,* inspiring Blake to compose bucolic scenes in landscape settings, unusual for him both in technique and subject matter, "visions of little dells, and nooks, and corners of Paradise" (Samuel Palmer) that proved highly influential on his young friends. More important, Linnell himself commissioned the two most significant works of Blake's old age.

The first of these, *The Book of Job,* a series of twenty-two line engravings, was executed in 1825. The original watercolor compositions had been painted for Butts as early as 1805–10. At Linnell's prompting, Blake made tracings of these designs in 1821, and after concluding a formal agreement with Linnell for their engraving and publication, made a set of reduced drawings on which he based the actual prints. The images are set in panels framed by borders that contain symbolical devices and brief passages of text. This amounts to a reversal of the decorative order of Blake's earlier illuminated books—the image is now central, the text marginal.

The series spells out an unorthodox interpretation of the biblical Book of Job. Job's initial complacent piety is presented by Blake as a spiritual bondage to the vengeful, legalistic Jehovah of the Old Testament. In the midst of his torments, Job recognizes in his God the cloven hoof of Satan. He then discovers the true God within himself and achieves redemption through the merciful Christ of the New Testament. The graphic style of the plates owes much to Blake's restudy, encouraged by Linnell, of the work of Dürer, Marcantonio Raimondi, Bonasone, and other Renaissance masters. The densely spaced, expressive lines, very unlike the mechanical hatching work of Blake's earlier reproductive engravings, create both an animated texture and vigorous light-dark contrasts. The effect is totally unlike that of neoclassical linear design, such as Flaxman's, with which Blake was however deeply familiar, having once engraved Flaxman's illustrations of Homer (1805) and Hesiod (1817).

The second of these commissions, and the work that occupied Blake at the time of his death, was the watercolors and engravings illustrating Dante's *Divine Comedy,* begun in 1824 and left unfinished in 1827. Of the watercolor compositions, 102 survive, in various stages of completion; only seven engravings were begun. Three fourths of the illustrations deal with the *Inferno,* and only a rela-

tively few with *Purgatory* and *Paradise*. Why Blake undertook this project, in evident competition with Flaxman's famous Dante illustrations of 1793, is not clear. He disagreed with Dante's notion of divine retribution, which is basic to the entire poem, and he noted his disagreement in several inscriptions. But he did not attempt a general reinterpretation of the *Divine Comedy,* as he had done with the *Book of Job.* In breadth and freedom of handling, in strength and transparency of color, the designs are unsurpassed in Blake's work, and in the sublimity of their conception—not only of the figures but also of their colossal settings of cliffs, seas, and clouds—leave Flaxman's tame inventions far behind.

In ill health during 1826 but still active, busy with his *Dante* engravings and a large "fresco" of the Last Judgment (now lost) until the end, the artist-poet died happily—"composing and uttering songs to his Maker"—on August 12, 1827.

Blake's work, life, and career stand in striking contrast to those of his great contemporaries and intellectual peers, David and Goya, for reasons that had as much to do with the situation of the arts in England as with his personal eccentricities. David and Goya, in their very different ways, had the support of state institutions that sustained them from their first schooling to their final retirement, equipped them for the carrying out of great works regardless of public demand, cost, or profit, and at least tolerated their private experiments. Both Goya and David functioned as court painters, were at times close to the centers of power, enjoyed the visibility afforded by official patronage and public exhibition, and were able to fulfill their artistic ambitions. Both, finally, were supported by a well-established painting culture, the traditions and practices of which they thoroughly understood and which equipped them with great executive facility, enabling them to undertake the most ambitious enterprises, ranging in Goya's case from wall painting to portraiture, from printmaking to tapestry design.

In England, lack of state patronage forced artists to compete as individual tradesmen in a fairly small market. Blake's career was further constricted by the narrowness of his craft training, his aversion to painting in oil and to the more lucrative branches of art, such as portraiture. He existed in a subartistic sphere, lacking institutional support, social connections, the experience of travel and of a direct acquaintance with the works of the masters. His powerful mind and irrepressible will to communicate labored in a void, without encouragement, without audience, without the stimulus of critical discussion or popular response. Reduced to humble commercial work for his living, and lacking a vehicle for the public expression of his ideas, he was driven to the expedient (adopted by other English artists before him) of acting as publisher and adapting his pictorial inventions to the format of the book page.

In his isolation, Blake turned inward to the reality of mental visions, and formed a language of private symbols, incomprehensible to the public. His exclusion from the practical world opened to him an immense world of the imagination, in which he could pursue his ideas radically, unhampered by material difficulties, unchecked by argument or criticism, free from any need to compro-

mise with the demands of public or power—freer, in other words, than his more successful contemporaries to create a pure, idea-centered art.

READINGS

On Neoclassicism in England

D. Irwin, *English Neoclassical Art,* London, 1966, with an extensive bibliography.

F. Cummings and A. Staley, *Romantic Art in Britain* (exhibition catalogue), Detroit, Institute of Arts, 1968, gives concise lives and useful bibliographies.

On Benjamin West

J. Gall, *The Life, Studies, and Works of Benjamin West* (reprint of the original edition of 1820), Gainesville, Fla., 1960.

G. Evans, *Benjamin West and the Taste of His Times,* Carbondale, Ill., 1959.

On James Barry

W. L. Pressly, *The Life and Art of James Barry,* New Haven, 1981.

On Henry Fuseli

J. Knowles, *The Life and Writings of Henry Fuseli,* London, 1831. Lately republished, this remains the basic biography and includes his most important writings.

P. Tomory, *The Life and Art of Henry Fuseli,* New York, 1972.

G. Schiff, *Johann Heinrich Fuessli,* 2 vols., Zurich, 1973, the illustrated catalogue of the entire work.

N. Powell, *The Drawings of Henry Fuseli,* London, 1951, a selection of drawings.

N. Powell, *The Nightmare,* London, 1973, an analysis of Fuseli's most famous painting.

E. Mason, *The Mind of Henry Fuseli,* London, 1951.

F. Antal, *Fuseli Studies,* London, 1956.

On John Flaxman

David Bindman, ed., *John Flaxman* (exhibition catalogue), London, Royal Academy, 1979.

R. Essick and J. LaBelle, *Flaxman's Illustrations to Homer,* New York, 1977.

D. Irwin, *John Flaxman,* London, 1979.

On Blake's Life and Literary Work

A. Gilchrist, *The Life of William Blake,* London, 1863. The basic biography, republished with additions by Ruthven Todd, London, 1942.

Mona Wilson, *The Life of William Blake,* London, 1927. The best modern biography, republished in 1948 and 1971.

G. Keynes, ed., *The Complete Writings of William Blake,* London and New York, 1957.

On Blake's Work as an Artist

A. Blunt, *The Art of William Blake,* New York, 1959.

D. Bindman, *Blake as an Artist,* London and New York, 1977.

M. Butlin, *The Paintings and Drawings of William Blake,* New Haven, 1981.

R. Essick, *William Blake, Printmaker,* Princeton, 1980.

R. Essick, *The Separate Plates of William Blake,* Princeton, 1983.

D. V. Erdman, *The Illuminated Blake,* London, 1975.

F. Damon, *Blake's Job,* Providence, 1966.

A. S. Roe, *Blake's Illustrations to the Divine Comedy,* Princeton, 1953.

5
German Romantics

Philipp Otto Runge, 1777–1810
Caspar David Friedrich, 1774–1840

Philipp Otto Runge, 1777–1810

Runge was born in 1777 in the small harbor town of Wolgast, on the Baltic coast of Pomerania in northeastern Germany, then under Swedish rule. His father, a prosperous grain merchant and shipbuilder, presided over a large family (Philipp Otto was the ninth of eleven children) that was held together by devout but enlightened Protestantism, warm affection, and intellectual interests. The boy's elementary schooling took place in Wolgast, where a local poet and religious enthusiast, G. L. Kosegarten, had some influence on him. In 1795, Runge was sent to the cosmopolitan, commercial city of Hamburg, to be apprenticed to his elder brother Daniel, partner in the brokerage firm of Hülsenbeck, Runge, & Co.

Runge was not gifted for business, but his years in Hamburg proved to be a time of intense mental activity. Profiting from his association with a circle of stimulating friends acquired by his brother, he read voraciously in modern literature, science, and theology, studied the rich collection of engravings owned by one of his brother's friends, and began to take drawing lessons. He toyed with the idea of becoming an art dealer, attended local auctions, and found himself more and more deeply absorbed in his study of drawing. By 1799, Runge felt sure of his artistic vocation. With his father's consent and his brother's assistance, he enrolled in the Copenhagen Academy, the chief art school of the North. Aged twenty-two by this time, older than most beginning students, he had shown no unusual promise to this point except for a remarkable skill in the cutting of paper silhouettes of flowers.

In Copenhagen, the young man studied under two renowned painters, N. A. Abildgaard and J. Juel, and gradually advanced through the regular curriculum, from plaster casts to the study of the posing model and exercises in figural composition. Runge made progress, but was not satisfied with academic study. His best works of this time are the portraits he drew in black and white chalk on brown paper, for his own amusement, in a ruggedly realistic, unacademic manner, such as the *Self-Portrait at the Drawing Table* (chalk, ca. 1800–02, Hamburg, Kunsthalle).

One of his private projects of these years was a many-figured composition, the *Homecoming of the Sons,* i.e., his and his brother Daniel's visit to the family home in Wolgast in 1799. With characteristic audacity, Runge seems to have planned to execute this scene in life size, in the form of a wall painting. At about this time he was given a copy of Flaxman's outline illustrations to Homer, which,

by their severity of style, made a strong impression on him. All his student work until then had consisted of drawings in a fairly stiff, rubbed-chalk manner, of a tepidly neoclassical sort that, as he was beginning to realize, lagged some twenty years behind the current practice of Paris.

Feeling the need of change, Runge in 1801 left Copenhagen for Dresden. On his way, he passed through Wolgast and the nearby town of Greifswald, where he paid a visit to Caspar David Friedrich. In Dresden, he found himself in the midst of the early, vehement ferment of German romanticism, and made the fateful acquaintance of the poet Ludwig Tieck. Tieck in turn introduced him to the writings of Jakob Boehme, the German seventeenth-century mystic whose ideas had earlier left their mark on William Blake. Dresden had a well-established Academy, but Runge chose not to become a student there, but to work independently in the Royal Picture Gallery and sculpture collection. His intention was still to become a history painter. Although he found academic teaching routines stultifying, he had not yet begun to question the underlying principles of the neoclassical academic doctrine.

Toward the end of 1801 he entered a competition, organized by the poet Goethe in Weimar, for the best compositional drawing on an assigned classical subject, *Achilles Battling with the River Scamander,* an episode from Homer that Flaxman had illustrated in 1793. Runge's curiously Baroque drawing not only failed to win the prize but drew a severe comment from the competition jury.

The shock of this disappointment, together with his earlier disenchantment with the Academy and his growing dissatisfaction with the laboriousness of his studies, so painfully lacking in the intellectual excitement he experienced among his literary friends, brought on a crisis. Runge now realized that he had been following a false goal. In letters to his brother Daniel written in the early part of 1802, he expressed the conviction that "in our time, something is about to die." An era was coming to an end; new beliefs, a new sense of life were about to replace the spiritless rationalism of the Enlightenment. The academic quest for Greek beauty, even history painting itself, had lost their point: "What is the use of reviving old art?" The new age needed a radically new art, and Runge, with youthful confidence, was ready to contribute to its creation, though he had not yet produced a single original work of his own, indeed, had not even begun to paint in oil.

Runge's letters of 1802, rather than his awkward student exercises, are his most important early works. They express a powerful mind, fully formed, but as yet unequipped to carry out its grandiose conceptions in practical ways. In them, he outlines a philosophy of art and a theoretical program, defining the future character of his work before he had ever put brush to canvas—a striking instance of an artistic impulse originating in pure thought as opposed to studio experience.

Runge shared the revolutionary impetus of his generation, but without a political direction. The art he envisioned would be one of personal revelation by which he could express his innermost, scarcely utterable intimations of God. In this, he resembled Blake. Unlike Blake, he did not turn away from nature or science, but accepted the physical world as the manifestation of God. In common

with Blake, he thought of art as a vehicle for ideas, and this led him to search for symbols that, being rooted in tradition, would be understood and even appreciated by the broad public, but could also be invested with fresh and difficult meanings. He began to experiment with allegory, to see whether its old vocabulary might be used in new ways that would bring it to life once again and attune it to the modern sensibility.

The special advantage of visual art lay in its power to bridge the gap between idea and matter, between the poetic imagination and the reality of material nature. While Blake had adopted a system of personified abstractions (Urizen/law, Los/imagination, Orc/energy), out of which he composed his dark chronicles of cosmic struggle, Runge was to move in the opposite direction, going from abstraction to increasingly concrete representation, from outline to color, from pen drawing to oil painting. To the form of art that he prophetically described in his letters of 1802 he gave the misleading name of "landscape," to distinguish it from history painting. But the works in which he was later to realize his intentions turned out to be figurative allegories, sometimes composed as decorative patterns, sometimes placed in settings that approach conventional landscape.

In the years 1802–03, Runge attempted his first allegorical compositions in oil. *Triumph of Amor* (1802, Hamburg, Kunsthalle) is conceived as a wall decoration, nearly 6 feet wide, painted in gray monochrome to give the effect of a neoclassical relief frieze. Its theme (suggested by a poem by Herder) is the domination of life by love, represented by an infant Amor who is carried on a shell by winged putti, personifying the Hours, and surrounded by groups of infants intended, oddly, to stand for the "ages of man." *The Nightingale's Lesson* (first version, 1803, lost; second version, 1805, Hamburg, Kunsthalle) is Runge's first oil painting in color. The oval central image represents the Nightingale, who is actually Psyche, seated in an oak tree, teaching the infant Amor to make music.

The intimate, personal reference hidden in these erotic allegories is to Pauline Bassenge, a girl of seventeen with whom Runge had fallen vehemently in love. Courtship and the pursuit of art for a time became fused into one powerful drive: Pauline was the Psyche of *The Nightingale's Lesson,* the inspiration that caused Love to sing—an allusion to Runge's love-stricken efforts to master painting, to demonstrate his professional standing and be allowed to marry Pauline. Their engagement in fact shortly followed the completion of the picture's first version in 1803.

Runge had by this time embarked on what was to be the central enterprise of his brief career, the project of an allegorical cycle, *The Times of Day,* the adaptation of a popular decorative scheme much used for elegant interiors of the period that consisted of playful symbolizations of Morning, Midday, Evening, and Night carried around the four walls of a room. The tradition behind such work extended back to Pompeiian wall painting and Renaissance "grotesque" designs. Runge used this conventional subject in a highly original way to state a philosophical view of the unity of all creation in an endless rotation of life and death. The novelty of his thought lies in the multiplicity of analogies—between

the times of day, the seasons of the year, the ages of man, the unfolding of
biological life, the stages of mental development, and the soul's progress toward
God—which he combines in a fairly simple system of symbolical forms, "hiero-
glyphics," borrowed from the traditional vocabulary of mythology and ornament.

The first version of the cycle, completed in 1803 in the form of large outline
drawings in pen and ink and subsequently (1805) engraved by other hands,
consists of four diagrammatic compositions, each centered on a floral motif—the
rising light-lily of Morning, the drooping poppies of Night—that marks its signifi-
cance as a stage in the cycle. The curving horizon of the earth below, the cloud-
or star-filled skies above, provide a cosmic setting for the figures of children or
genii who, disposed in strictly symmetrical groupings, accompany the rise of
Morning and the fall of Evening with music, play in the abundance of Midday,
and sleep in the thickets of Night. Figures and flowers are woven into geometric
patterns, intricate arabesques traced with the precision of architectural blue-
prints. Each main panel is framed by symbolical devices that comment on its
specifically Christian significance.

Runge intended to translate these designs into paintings of monumental
size, about 30 feet high and 20 feet wide (9.3 × 6.2 m.), and adjusted their internal
proportions by means of precise geometrical and mathematical calculations. For
the time being, however, their painterly execution and enlargement to architec-
tural dimensions remained an unattainable dream—Runge had only a rudimen-
tary grasp of oil painting. He therefore merely published his designs as line
engravings, in which form they bear some resemblance to the stiff linearism of
Flaxman and to Blake's symmetrical compositions (though Blake would have
objected to Runge's calculated regularity).

After his marriage to Pauline in Dresden, Runge moved back to Hamburg.
He was determined to perfect his technique of oil painting, and to this end took
lessons from a local painter named Johann Friedrich Eich. Partly to gain further
experience in this medium, which gave him much trouble, he painted portraits
of members of his family and of their friends. *We Three* (1805, formerly in
Hamburg, Kunsthalle; destroyed in 1931) was a portrait of the newly wed artist,
his wife, and his brother Daniel. It symbolized the emotional bond between the
brothers, shared with the young woman who, standing between them, unites them
by embracing the one and holding the hand of the other. The picture's execution
in dark and opaque colors was vigorous, but its hardness and wooden fixity still
revealed the artist's inexperience.

The Huelsenbeck Children (1805–06, Hamburg, Kunsthalle) represents the
three children of Daniel's business partner. Their robust, fleshy figures, seen in
an infant perspective that causes them to loom into the blue sky, are framed by
symbolical bywork—such as the sunflowers opening to the light—which gives
this portrait the character of an allegory of Morning and of Youth. *The Artist's
Parents* (1806, Hamburg, Kunsthalle) further pursues the symbolism of the Ages
of Man. The monumentally conceived elderly couple, dressed in severe black, a
veritable icon of Protestant rectitude, are set in sharp contrast to the two grand-
children who, lightly dressed and holding fire-lilies, precede them: Age (or Eve-
ning) following Youth (or Spring).

In two further paintings, ostensibly of traditional religious subjects, Runge attempted a similar conversion, or enlargement, to universal significance, and incidentally tested his growing mastery of color. The first of these, *The Rest on the Flight to Egypt* (1806, Hamburg, Kunsthalle), shows Mary and Joseph seated in a wide landscape in the light of early morning. The Christ Child reaches into the sun's first beams. The Nile Valley below still lies in the shadows, and the figures of Joseph and his browsing donkey are dark against the brightening sky; but behind the Virgin and Child rises—like a Blakean vision—a tulip tree with luminous blossoms among which angels make music. The schematic symbols and linear abstractions of Runge's engraved *Times of Day* are here transformed into the concreteness of landscape and substantial figures; the ideas of Morning, Birth, and Light are presented in the vivid reality of visual experience. The painterly execution is notably subtler and freer than that of his earlier pictures. Runge's hope that *The Rest on the Flight* would be acquired by a church in Greifswald was disappointed. He left it unfinished.

The second painting, *St. Peter Walking on the Sea* (1806–07, Hamburg, Kunsthalle), was in fact commissioned by Runge's former teacher, Kosegarten, for a fishermen's chapel that was to be built on the shore of the Baltic. The building project suffered delays, and the large painting (probably intended as a final study for the actual painting that Runge would have liked to execute directly onto the wall of the chapel) remained unfinished. It is of fairly traditional conception and lacks the esoteric symbols of his other works, probably in view of its destination. In the dramatic play of gestures of the apostles in the boat, Runge recalled the pantomime of Leonardo's *Last Supper.* The nocturnal seascape, with its transparent, moonlit clouds, forms an impressive contrast (perhaps intentionally) to the effects of morning light in *The Rest on the Flight.*

In 1806–07, the threatened ruin of the family business, owing to the trade war between England and the French-dominated Continent, caused Runge to return to Wolgast to help his brothers. In October 1806, French troops pillaged Wolgast. Early in 1807, Runge returned to Hamburg to assist his brother Daniel, fallen on hard times. That summer, he suffered a serious illness, perhaps the first manifestation of his ultimately fatal tuberculosis. Despite these obstacles, he persisted in his great plan of carrying out *The Times of Day* in oil paintings of monumental dimensions.

As part of the preparation for this work, Runge made a thorough study of color, examining its physical aspects (as transparent light or opaque pigment), its psychological effects, and its symbolical associations. Inclined to visualize the significance of phenomena in the form of geometric figures (perhaps influenced in this by the diagrams with which Jakob Boehme had illustrated his mystical doctrines), he devised color circles that showed the relationships between the primary colors, indicated their interactions, and gave their scales of intensity and luminosity, ultimately combining these into a three-dimensional form, the color sphere. The equator consisted of the primaries and their derivatives at highest intensity, while the north–south axis registered their gradations from pure white to total black. He thus comprehended in one geometric form, a sphere, the universe of color with all its relationships and every conceivable hue, value, and

tone. Runge corresponded about his findings with Goethe, who had developed his own color theory, and in 1810 published a pamphlet on the color sphere.

Meanwhile, the artist had not lost sight of his great project of a monumental cycle of *The Times of Day,* for which he had furnished the basic design in his line drawings of 1803. But he was able to begin the execution in oil only in 1807, by which time he had changed his mind in various ways. Runge began by painting the first subject in the projected sequence, *Morning,* in the form of a study of relatively small format (ca. 3 ft. 6 in. × 2 ft. 8 in., or 1.1 × 0.8 m.), the so-called *Small Morning,* finished in 1808 (Hamburg, Kunsthalle). His main problem was to flesh out the original, purely linear design with three-dimensional figures in colors, light, and space. Light, in fact, was to be the very theme of his painting.

The central panel now contains a spacious landscape. In the center foreground lies an infant in the sprouting vegetation of the meadow. Like the Christ Child of the *Flight to Egypt,* it opens its eyes and arms to the light. On either side, nude, wingless putti strew roses on the infant. In the distance, the nude figure of Aurora rises from the horizon. Venus-like, she is enveloped by her flaming hair. In the brightening sky behind her, the gigantic form of a radiant blossom is faintly visible. Aurora holds up a tress of her hair like a torch, and from it emerges yet another, more distinct flower, a lily, whose chalice contains a band of angels. Above, the sky shades into a darker blue, the remnant of the night past, in which gleams the morning star.

A zone of marginal, symbolical images surrounds the main picture, separated from it by a heavy frame and filled with figures of distinctly larger scale. In the lower border, the eclipsed sun suggests darkness and death. Along the sides, putti crouch among roots from which spring red amaryllis that continue upward into white lilies. From the lilies angels emerge, who bow to the glory of blueish light that fills the upper border, seeming to emanate from behind the frame of the main panel below. The color scheme of the borders thus resembles the color sphere in its transition from the dark at the bottom to the white at the top and its scale of colors from yellow to red and to blue, which here also symbolize the genesis of life and light from the darkness of the earth, through the germination and growth of the flowers into the brightness of their blossoms and the celestial radiance of the sky.

Morning, "the boundless illumination of the Universe," was to be the first in a series of four panels which Runge envisioned as being 30 feet tall, placed on the walls of a Gothic sanctuary where they would combine, to the accompaniment of music and chanted poems, in a sacred spectacle of operatic complexity. Immediately after the completion of the small version, he began its enlargement, the so-called *Large Morning* (1808–10, Hamburg, Kunsthalle), the central panel of which measures about 5 feet by 3 feet 8 inches (1.6 × 1.1 meters), and was itself intended only to serve as a more developed study for the even larger final wall painting. The composition corresponds essentially to that of the *Small Morning.* Runge's illness in 1810 interrupted the work. It was left unfinished at his death and later (1892) cut up into nine pieces.

These last paintings give evidence of Runge's enormous advance in the

management of color and handling of oils. Though the *Small Morning,* with its central panel and marginal symbols, bears some resemblance to a page from an illuminated manuscript (and hence also to some of Blake's watercolors and to the plates of his *Book of Job*), it departs from graphic design and is in every sense a painting, imaginable as a mural. The *Large Morning* moves a step closer to monumentality, not merely in size but in its general conception. It offers the promise of an alternative to history painting: an art for the expression of religious or philosophical ideas, based on a new vocabulary of symbolical figurations and forms, making use of bold new geometrical and coloristic devices, and addressed, sermon-like, to a large public. A profound mind but, in technical respects, still a learner at the end of his life, Runge achieved only the still slightly primitive beginnings of the new art he had hoped to create. The *Morning,* with its celebration of the start of life, was his last, incomplete achievement, tragically cut short by death.

Seriously ill for most of the year, unable to work during the autumn months, Runge died of pulmonary consumption in December 1810.

READINGS

Runge's letters are among the most interesting documents in the history of nineteenth-century art. They were posthumously published by his brother D. Runge in *Hinterlassene Schriften,* 2 vols., Hamburg, 1840. No full English translation exists to date. Key passages are to be found in L. Eitner, *Neoclassicism and Romanticism,* Englewood Cliffs, N.J., 1970, pp. 143f. The best recent biography and catalogue of the work, fully illustrated, is Jörg Traeger's *Philipp Otto Runge und sein Werk,* Munich, 1975. The only recent English biography and interpretive study is M. Bisanz's *German Romanticism and Philipp Otto Runge,* Dekalb, Ill., 1970.

Caspar David Friedrich, 1774–1840

Friedrich was born in 1774 in the harbor town of Greifswald, on the Pomeranian shore of the Baltic, close to Runge's birthplace of Wolgast and under Swedish sovereignty. His father was a maker of soap and candles. The boy's early years were saddened by the deaths, in quick succession, of his mother (when he was seven), of two sisters, and a brother. At sixteen, he began to take lessons from the drawing master of the University of Greifswald, J. G. Quistorp. His background, training, and early development closely resemble Runge's.

In 1794 Friedrich entered the Academy of Copenhagen, where for four years he gradually rose through the successive stages of the curriculum, starting with the copying of prints and progressing through the sketching of plaster casts to the study of the living model. His schooling was of the kind that normally prepared artists for history painting, but the young Friedrich's personal, irrepressible vocation was for landscape. Among his teachers in Copenhagen there were two, Juel and Lorentsen, who may have furthered this interest and given him some inkling of recent French and English developments. On the whole, academic training seems to have done little for him. When he left Copenhagen for Dresden in 1798, as Runge was to do a few years later, he was still a very immature artist for his age (twenty-four), with barely a notion of oil painting, awkward in his attempts at figure composition, and showing his talent only in the pen-and-wash landscape drawings that he based on his outdoor sketching around Copenhagen.

In Dresden, Friedrich found himself among the powerful, early stirrings of German romanticism, pregnant with radical new ideas in the fields of religion, science, philosophy, and literature. But the Academy, where he attended life classes, still fostered an uninspiring eclecticism. Its teachers of landscape, Zingg and Klengel, encouraged the imitation of the Dutch masters and themselves practiced a pedestrian kind of view painting. Friedrich took advantage of Dresden's famous picture gallery to launch himself on a course of independent study. To earn money, he began to draw careful "prospects," topographical views of the environs of Dresden, neatly outlined with the pen and washed with sepia. At the Academy exhibition of 1799, he showed several of these drawings for the first time.

Friedrich approached color and oils hesitantly and late, becoming a painter purely through his own efforts rather than regular training. His early independent

work consisted entirely of wash or gouache drawings and of etchings. Aside from a group of vigorous portrait drawings in pen and ink or black chalk (including the early *Self-Portrait* of ca. 1800 in the Copenhagen Print Collection), his best works of these years are the large landscape drawings that he composed with the help of sketches gathered during excursions in his native Pomerania in 1801 and 1802. Precisely outlined with pencil or pen, finished off with transparent washes of sepia, and austerely colorless, these landscape drawings—many of them of coastal scenery, with sparse vegetation and large, bare skies—clearly reflect his neoclassical schooling.

Throughout his later life Friedrich would record his direct observations of nature in terms of line rather than color or even tone: the essential truth for him, as for Blake, lay in the contour. His individuality and his stylistic peculiarities can be seen developing in these early drawings of 1800 to 1806—in their vast, vacant spaces, their isolated, silhouetted forms, their atmospheric distances and melancholic moods. The themes that were to preoccupy him during all his later career first appear in them. Topography soon gives way to landscape symbolism. Significant motifs—ruined churches, dolmen tombs, leafless trees—begin to play a dominant role.

Friedrich conceived his landscapes in pairs or sequences. In 1803—the year in which Runge drew his allegorical *Times of Day*—Friedrich composed his own first cycle of landscape drawings (formerly in Berlin, destroyed during World War II) representing at once the times of day, the seasons, and the ages of man, but in forms that are to be read as natural, that is, as actual views rather than as notional allegories. In 1805, he submitted two large landscape compositions in sepia to the annual Weimar Competition, sponsored by Goethe. Luckier than Runge, who had failed in this competition four years earlier, Friedrich was awarded a prize.

For reasons that are not entirely clear, Friedrich quite suddenly began to paint his landscapes in oil some time in the early part of 1807. Considering the importance of color in all his subsequent work, this was a momentous change, comparable to Runge's shift, in 1802, from pure drawing to color. Unlike Runge, who never achieved a full mastery of oil painting, Friedrich took possession of the new medium with miraculous assurance and speed, and from the start proved to be a subtle and profound colorist. His earliest generally accepted paintings in oil are two small landscapes, *Seashore with Fisherman* (1807, Vienna, Neue Galerie), and *Mist (Sailboat Approaching a Rocky Shore)* (1807, Vienna, Neue Galerie), which are meant to be seen as a pair. They translate into fresh and airy color effects of light and atmosphere—sharply defined foregrounds silhouetted against luminous, mist-shrouded distances—that he had previously tried only in monochrome washes. It is possible that the idea of these moody coastal scenes owes something to the example of Joseph Vernet, the eighteenth century's most famous sea- and landscape painter, whose fog-shrouded harbor views had been made popular through engravings.

Two further pairs of landscapes in oil, of larger size and more elaborate execution, date from the same period. *Dolmen in the Snow* (1807, Dresden

Museum) and *View Over the Elbe Valley* (1807, Dresden Museum) present a striking contrast of seasonal states that is clearly meant to have a human application. The cold of winter, the leafless trees, and the prehistoric grave in the one painting, all suggestive of mourning, age, and death, are juxtaposed to the green of living trees and the warm light of summer in the other. Though they contain no overtly symbolical bywork, they invite interpretation, and have been given a religious sense by some commentators (paganism versus Christian faith), a national one by others (the German nation in its organic strength, and in the winter of its military defeat by Napoleon).

Summer (1807, Munich, Neue Pinakothek) and *Winter* (1807, formerly in the same museum, destroyed by fire in 1931) are based on a set of earlier sepia drawings representing the seasons (1803). In the one, a verdant summer setting shelters a pair of lovers, while in the other an old man toils through the snow toward a graveyard near a ruined church. The parallel between nature's seasons and the ages of man would seem rather baldly stated, were it not for the deeply felt reality of both landscapes and the delicacy of their painterly execution.

The great project that mainly occupied Friedrich in 1807–08, and for which his other early paintings may merely have served as preparations, was the translation of one of his sepia landscape drawings into a full-sized altarpiece. The idea of a church painting, not at all routine for an artist of Friedrich's Protestant background, was in the air at the time. In 1806 the poet Kosegarten, friend of Runge and of Friedrich, had approached both artists with the suggestion that they paint an altarpiece for a projected seaside chapel on the island of Ruegen. Runge, in fact, started on the execution of such a painting, using an appropriate biblical subject (*St. Peter on the Sea,* 1806). Friedrich's more radically innovative plan—to use a landscape without narrative content as the object of religious devotion—appears to have been suggested to him by his patron, Count Thun, whose wife had admired a drawing by Friedrich at the Dresden Academy exhibition of 1807. This drawing represented a crucifix atop a mountain peak, surrounded by fir trees and illuminated by the setting sun. Crucifixes on mountains were a common sight in Catholic countries, and Friedrich's composition could be regarded as a pure landscape. But its strong undertone of Christian significance suggested to Count Thun that the image would be appropriate for the decoration of the altar of the family chapel in his castle at Tetschen in northern Bohemia.

In *The Cross in the Mountains (Tetschen Altar)* (1808, Dresden Museum), the mountaintop with its cross juts into view at an undefinable distance. No measurable expanse of foreground relates it to the viewer: it appears as if seen by a bird in flight. Rocks, trees, and crucifix are projected against the infinite depth of the sky behind them. All forms are sharply edged and the picture's derivation from a sepia drawing can still be felt. Even the light-struck clouds have contours, but their vapory layering is brought off with great painterly effect, and their harmony of color and intense luminosity have no parallel in those earlier drawings. The picture's range of colors is narrow, from brown to salmon red, with some very dark green in the firs and some silvery white in the radiance from behind the peak. This restraint, however, does not stem from a beginner's timidity

in the handling of colors; rather, it expresses a sophisticated economy that is also evident in the sparseness of the composition, and even in the application of the paint in smooth transparencies, thinly spread on the canvas, not unlike washes.

The work was completed in December of 1808. On Friedrich's advice, it was given a sculpted, pseudo-Gothic frame, decorated with symbolical devices, somewhat like the symbolical frames that Runge had designed for his *Times of Day*. During the Christmas season, the altar was exhibited to the public in Friedrich's studio. It aroused, besides much favorable attention, the stern disapproval of the influential critic F.W.B. Ramdohr, who, arguing on the grounds of Enlightenment rationalism, objected to the perspectiveless composition, to the use of a landscape as a devotional image, and to what he considered the vague, emotional mysticism of the work. This prompted Friedrich to issue an explanation of its significance. The setting sun, according to him, represents the passing of an old order, that which existed before Christ. The golden figure on the cross reflects the light of the setting sun to the earth. The rock on which the cross stands symbolizes man's faith, and the evergreen firs that surround it signify man's enduring hope for salvation through Christ.

Shortly after completing *The Cross in the Mountains,* Friedrich started work on a pair of even larger landscapes. In the first of these, *Monk by the Sea* (1809–10, Berlin, Schloss Charlottenburg), the small, solitary figure of a man (possibly Friedrich himself) stands on a barren beach in monk's robes. Before him the dark sea is flecked with whitecaps; above is a vast sky, cloud-covered except for an opening into blue, sunlit altitudes. The setting may have been suggested to Friedrich by a particular stretch of beach on Ruegen famous for its impressive melancholy. The contemplative "monk"—sole vertical among the emphatic horizontals of sand, sea, and sky—appears not only alone but lost, afloat in a vacant universe. But if solitude seems the picture's theme, it is worth noting that Friedrich arrived at its radical emptiness only by gradual stages. The sea was, to begin with, enlivened by two sailboats that he later painted over. He also transformed what had been a night sky with moon into dramatic cloud drifts across patches of blue. The coloristic subtlety of this skyscape (which occupies four fifths of the canvas) not only proves Friedrich's newly won mastery of the medium of oil; it also indicates why this mastery was important to him. It allowed him to represent complex processes in nature, changes of light and atmosphere, and hence of color. "Empty" of objects though this painting may appear, it teems with atmospheric and light effects that are the signs of life in nature, in other words, of the presence of God.

The pendant to this painting, *Abbey in the Oak Forest* (1809–10, Berlin, Schloss Charlottenburg), represents a funeral procession of monks in a winter setting, at a Gothic ruin surrounded by the bizarre silhouettes of leafless oak trees. A misty darkness shrouds the earth; a faint, crescent moon appears in the twilight of the sky, which is perhaps meant to suggest dawn, i.e., resurrection. The picture presents not so much a seasonal contrast to the *Monk by the Sea* as its narrative sequel, for it is the monk (presumably Friedrich) who is being buried. In an earlier sepia drawing (ca. 1804), now lost, the barely thirty-year-old artist had already

shown his own funeral. His preoccupation with death seems not to have been a mere morbid fascination but a religious longing for peace and salvation. These two paintings may thus be seen as a comment on life as a form of abandonment (the monk on the barren beach) and on death as a homecoming (the communal ritual amidst reminders of salvation and resurrection). Exhibited at the Berlin Academy in 1810, both made a strong impression and were bought by the king of Prussia. Friedrich enjoyed a moment of fame. He was admitted to the Berlin Academy, received the personal visit of Goethe, and sold several paintings.

The landscapes that Friedrich painted in the period immediately following this success show a steady increase in his powers of painterly execution, and a strengthening of his naturalist tendencies, with a corresponding lessening of the symbolical element. The *Mountainous Landscape with Rainbow* (ca. 1810, Essen, Folkwang Museum) was originally planned as a nocturnal scene. In the sharply illuminated foreground of an otherwise very dark landscape, a wanderer pauses to contemplate the luminous arc of a rainbow that spans the valley before him. The atmospheric phenomenon takes on the aspect of a supernatural apparition. In *Morning in the Riesengebirge* (1810–11, Berlin, Schloss Charlottenburg), an outcropping of rock in the foreground is topped by a crucifix. A young woman, holding onto the stem of the cross, helps her male companion to climb to the summit. A wide panorama of mountainous ridges extends into the far distance. The picture is a revision, in naturalist and topographical terms, of the relatively more abstract, symbolical *Cross in the Mountains* of 1808. Details of the back- and foregrounds are based on precise geological studies drawn by Friedrich on a tour in the Riesengebirge in 1810.

After a hesitant start followed by a very rapid development, Friedrich reached his artistic maturity about 1811. From this time on, his work underwent only slight further changes of theme or style. No less religious than Runge's or Blake's, and equally attuned to things spiritual, it nevertheless belongs to the rising movement of naturalism that was to dominate landscape painting in the early nineteenth century. His landscapes are entirely put together of observed elements, but their general conception is nonetheless "visionary," drawn from an image held in the mind. Friedrich needed the stimulus of visual experience, made innumerable drawings from nature, and stored them up for many years, using them in various combinations when it suited him. But his drawings are purely linear or tonal, and lack those qualities of light, color, and atmosphere that give his landscapes their appearance of intimate truth to nature. He supplied these optical effects in the meditative seclusion of his studio, from inner vision, drawing solely on visual memory and on remembered emotion. Combining observation with introspection, his method of work resulted in that balance of realism and ideality, of objective and emotional truth, which Runge may have had in mind when he spoke of "landscape" as the art of the future—and which Runge himself never fully achieved.

The war of national liberation against Napoleon, and the ultimate expulsion of the French occupation forces from Germany, aroused Friedrich to a high pitch of patriotic fervor. While the fighting raged across Saxony, and the French

alternately evacuated and reoccupied Dresden, he painted landscapes that (somewhat cryptically) expressed a yearning for national deliverance rather than Christian salvation. In *Arminius' Grave* (ca. 1813–14, Bremen, Kunsthalle), a French Cuirassier examines an ancient stone sarcophagus at the mouth of a cave in a rugged forest setting. It is the burial place of Arminius (Hermann), the Germanic chieftain who annihilated a Roman legion in the Teutoburg Forest. As the foreign soldier watches, the lid of the sarcophagus seems to be opening. In *Chasseur in the Forest* (1814, Germany, private collection), a French officer—actually a dismounted officer of the Cuirassiers, Napoleon's heaviest cavalry, rather than a Chasseur—walks into the winter forest. Behind him, a raven on the stump of a tree, double image of doom, croaks his death song. Fir trees, usually a symbol of persevering Christian faith, here signify the unconquerable endurance of the German nation, a natural force in the path of Napoleon's man-made military machine.

In the years of peace and growing disappointment that followed the national victory over Napoleon, Friedrich returned to non-political subjects. His landscapes of the time dramatize the act of contemplation, giving prominence to spectator figures in the foreground who, seen in back view, look intently into the distance, inviting the viewer to participate in their experience. *Two Men by the Sea at Moonrise* (ca. 1817, West Berlin, National Gallery), resumes the theme of the *Monk by the Sea,* though from a different perspective. The silhouetted figures of the men, wearing the "national" beret affected by German patriots, stand side by side in the center of the view. Between them, the moon rises from the sea. The stillness of the scene, its concentration and motionless symmetry create a feeling of religious awe.

Woman in the Sunrise (ca. 1818, Essen, Folkwang Museum) shows a woman standing in an attitude of ecstatic contemplation, her figure surrounded by the reddish rays of the rising sun. And in the *Wanderer Above a Sea of Mist* (ca. 1818, Hamburg, Kunsthalle), the unusually large figure of the Wanderer, seen from the back, monument-like in its fixity, stands on a peak surveying the ranges of mountain crests that emerge from the mist before him.

The religious character of these meditations in nature was made clear by one of Friedrich's disciples, the painter and physician Carl Gustav Carus, who wrote in his *Letters on Landscape Painting:* "Stand on the peak of a mountain, contemplate the long ranges of hills . . . and all the other glories offered to your view, and what feeling seizes you? It is a quiet prayer, you lose yourself in boundless space, your self disappears, you are nothing, God is everything." Landscape painting reveals the divine in nature, and prompts the viewer to participate in God's silent presence in the aspect and the constant change of nature. Art thus becomes a form of worship. While Runge's figurative allegories expressed religious ideas, Friedrich's landscapes recapture experience, and express highly personal, non-dogmatic Protestant religious feeling.

The human reaction to the sublimity or terror of nature is generally acted out by the figures that Friedrich introduces into many of his landscapes. Whereas in Runge's compositions the essential content is always embodied by the human

figure (as in Blake's work), in Friedrich's the landscape carries the theme; the human presence serves only as a psychologically suggestive accompaniment. Two pictures of the time exemplify this point. In *Two Men Contemplating the Moon* (ca. 1819, Dresden Museum), two men in patriotic, "national" costume (probably Friedrich himself and his pupil, the painter Heinrich) stand high on a rocky eminence, surrounded by the skeletons of trees silhouetted against the night sky, in deep contemplation of the moon that rises, radiant, below them. *Chalk Cliffs at Ruegen* (1818–19, Winterthur, Reinhart Collection) is a brightly day-lit scene: the view plunges steeply from the edge of a cliff to the sea far below. In the close foreground, three figures register various emotions, ranging from defiant serenity to abject fear, in reaction to the abyss that confronts them. The sunlit, transparent surface of the sea and the sharp, white, needle-like cliffs rising from the water are executed with particular delicacy and freshness of color.

In 1818, Friedrich surprised his friends by marrying, but domesticity scarcely changed his solitary mode of living. He was appointed a salaried member of the Dresden Academy in 1816, but was not promoted to a professorship. His popularity gradually waned. A form of landscape painting more straightforwardly naturalist, less demanding and austere than his deeply meditated compositions came into fashion and made his work seem obsolete. The Grand Duke Nicholas of Russia, who became emperor in 1825, visited Friedrich in 1820, bought several pictures, and for the remaining years of Friedrich's life was his most substantial patron.

Woman at the Window (1822, West Berlin, National Gallery), an unusual interior, shows Friedrich's wife in back view, looking from the studio window across the Elbe River below. She seems to be standing on the threshold between two worlds, the security and confinement of the domestic interior at her back and the beckoning vastness of nature before her, a situation treated not infrequently in Romantic art and literature.

Throughout the 1820s, Friedrich continued to paint programmatic pairs or series of landscapes, some provided with spectator figures, others dealing with processes of change in nature without human accompaniment. *Four Small Landscapes* (1820–21, Hanover, Landesmuseum) represent the Times of Day purely in terms of natural atmospheric and light effects, without any overtly symbolical features. *Lone Tree in the Morning Light* (1822), and its pendant, *Moonrise Over the Sea* (1822, both West Berlin, National Gallery), represent respectively nature itself in a characteristic and suggestive mood, and the human experience of nature. In *Moonrise,* two women and a man, perched on rocks by the sea, watch two sailing ships approaching across the moonlit water —a scene strongly evocative not only of the end of day but of the end of life itself, and of the hope of a final homecoming. As in many of Friedrich's more overtly symbolical pictures, the composition is strikingly formal. The figures are placed in the exact center, at the point where the convex curvature of the dark rocks of the foreground touches the concave curve formed by the clouds and moon glow above.

Friedrich's most dramatic invention, *Arctic Shipwreck* (1823–24, Ham-

burg, Kunsthalle), shows enormous ice floes pressed into a jagged mound and crushing the wooden hull of a large sailing vessel. Some years earlier, in 1821, Friedrich had painted a similar scene, *Shipwreck in Greenland,* in which the wreck bore the significant name of *Hope.* That picture is now lost, but an echo of it survives in the erroneous title, *The Shipwrecked Hope,* that is sometimes given to the later picture in Hamburg. The subject seems to have been suggested by an illustrated account, published in 1822, of Commodore Parry's polar expedition, during which ships were immobilized but not crushed by the ice. Nature in its most forbidding aspect—cold, hard, overwhelmingly powerful—here appears as the enemy of man, and perhaps as death itself. It is, at any rate, difficult to read a message of religious solace and redemption into this work, which is also one of Friedrich's most "natural." The ice floes of the foreground are splendidly realized in their hard materiality, and there is little of the softer poetry of atmospheric haze or magic light that he brought into many of his landscapes.

The late work shows a marked gain in painterly richness and spatial subtlety. The abrupt contrasts and sharp contours, the attenuated forms and dissonant colors of Friedrich's earlier painting give way to fresher colors, less mannered forms, and greater freedom of handling. It is evident that Friedrich was influenced by the general movement of naturalism. He was closely associated from 1818 onward with the young Norwegian landscape painter J. C. C. Dahl, who painted in oil directly from nature and who may have induced Friedrich to paint oil sketches of clouds, somewhat like those that Constable painted at about the same time.

Serious illness, from 1826 on, increasingly reduced Friedrich's productivity, but not the quality of his work. It also deepened his chronic melancholy and preoccupation with death. He painted several twilit *Cemetery Gates* (Dresden Gallery, Leipzig Museum, and Bremen Kunsthalle) expressive of a deep fatigue with life and, perhaps, hope for a better hereafter. But in the best of his late paintings, the symbolism is unobtrusive and feelings are expressed in naturalist terms, flavored by the strangeness of his individual temperament.

The Large Enclosure Near Dresden (Das Grosse Gehege) (1832, Dresden) is a view, in the fading light just after sunset, looking down from a height, perhaps from a bridge, over the rivulets forming a branch of the Elbe River. In the center, long lines of trees follow a road toward the horizon. In the midsection, a sailboat moves across the shallow water, where the pale gold and blue of the sky meets its reflections in the streams and puddles of the foreground. The very space of this landscape, with its swift recession into the empty distance, powerfully expresses melancholy.

The Stages of Life (ca. 1835, Leipzig Museum) takes up again the composition and meaning of Friedrich's earlier *Moonrise Over the Sea.* At a rocky promontory, an old man who resembles the artist walks toward a group consisting of a man of middle age, a younger woman, and two children. Behind them, a calm sea under a sky filled with the light of early evening bears five sailing vessels— departing or returning to harbor—that seem to mark the various stages in the voyages of life of the foreground figures. The slender crescent of the rising moon

appears in the faint violet of the darkening sky beside the gray silhouette of the large sailboat in the center.

In 1835, Friedrich suffered a serious paralytic stroke from which he recovered sufficiently to paint a few further pictures in oil. But most of the work of his final years consisted of wash drawings and watercolors, among them many funereal subjects, dolmen tombs, cemeteries, open graves, owls perched on the gravedigger's spade. He lived on, half-forgotten, for a few more years, dying in May of 1840.

Friedrich, no less than Blake or Runge, sought after a spiritual reality behind the merely visible and material. But unlike Blake, he did not regard physical nature as an obstruction to spirit. Nature was to him the transparent mask of the Divinity, the way it revealed itself to human sight and feeling. To experience nature in its intimate processes of change was to be in touch with the workings of a universal spirit that also acted in man's own mind, for all reality was one, and man only a detail in the vastness of God's landscape. While Runge's man-centered art (like Blake's) needed human forms, echoing the mythological and religious traditions of the past, in order to deliver its message, Friedrich's paintings recorded personal observations of events in nature. In contrast to Runge's symbolical "landscapes," in which elements of reality—torn from different contexts and detached from direct experience—are arranged like words in a sentence to spell out their meanings, Friedrich's landscapes are topographically and psychologically coherent. They are located in space and time, and deal factually with the phenomena of change in light and atmosphere. But their factual observation has a symbolical point: events in nature are constantly related to events or stages in man's inward life.

Friedrich's historical achievement was to extend the possibilities of landscape painting in two different directions: that of a new form of religious art, capable of expressing unorthodox, Protestant religiosity, and that of a more observant naturalism, tending toward science. What gives authority to Friedrich's work, however, is not merely its emotional depth and intellectual novelty but also —perhaps primarily—its power and subtlety of sheer painting, qualities in which he had no peers among his German contemporaries and which justify ranking him among the great painters of his time.

READINGS

The work of Friedrich presents many problems of dating and attribution, and has become a battleground of conflicting interpretations. The literature has therefore grown to formidable size. Nearly all of it is in German, though recently the steadily mounting interest in Friedrich's painting has prompted the publication of some English and even French studies.

H. Börsch-Supan and K. W. Jähnig, *Caspar David Friedrich,* Munich, 1973, gives the fullest account of the work (drawings, prints, and paintings) in the form of a detailed, well-illustrated catalogue. It also offers a very full documentation and bibliography.

H. Börsch-Supan, *Caspar David Friedrich,* New York, 1974, an abbreviated English

version of the above, concentrates on the biography and on the explication of the main works. It offers a key to Friedrich's symbolical language which is illuminating in part, but suffers from a systematic rigidity that goes far beyond the bounds of artistic probability.

W. Vaughan, et al., *Caspar David Friedrich, 1774–1840,* the catalogue of an exhibition held at the Tate Gallery, London, 1972, contains a useful account of Friedrich's life and development.

6
English Landscape

John Constable, 1776–1837
J. M. W. Turner, 1775–1851

John Constable, 1776–1837

Constable was born in 1776, in East Bergholt, a village situated in the Stour Valley among the rich farmlands of Suffolk. His father, Golding Constable, was a successful agricultural businessman, a wind- and watermiller, owner of large properties, including granaries, loading docks, and the barges that carried his flour to London; his mother, Ann, was the London-born daughter of a prosperous cooper. At the time of John Constable's birth, the family lived in a handsome brick mansion, recently built. Since his older brother was incapacitated by illness, it was expected that John would in time take over the paternal business.

He completed his lackluster studies in 1793 and started working in his father's mills. But his country boyhood had turned his mind into an unexpected direction. Intensely responsive to the beauty of his native region and passionately observant of the seasonal life in its fields and along its rivers, he had developed an entirely unbusinesslike love of nature and a keen eye for landscape. Long before he first held a brush, he was in the habit of picturing landscapes in his mind. In his late teens, Constable began to experiment with painting. A humble village amateur, John Dunthorne, not much older than he, and by profession a plumber and glazier, introduced him to the rudiments of art and took him on sketching walks. Larger perspectives opened to him through an acquaintance with Sir George Beaumont, a prominent art patron and gentleman painter, who had connections in East Bergholt. Constable was allowed to admire the masterworks in Sir George's collection, among which a small landscape by Claude Lorrain, *Hagar and the Angel,* particularly impressed him.

In 1796, during a stay in London on business for his father, Constable met the printmaker and antiquarian John Thomas Smith, who was then etching views of picturesque cottages for his book *Remarks on Rural Scenery.* Constable made some drawings for Smith and was encouraged by him and by other artists he met at this time to start on a course of self-training, copying prints, reading treatises on art, including Reynolds's *Academy Discourses,* and studying landscapes by Gainsborough in nearby Ipswich. But when he came of age, in 1797, he was still undecided about his future, and rather resigned to becoming a miller. Another two years passed before he dared to ask his father's consent to his entry into regular art study.

Assisted by an allowance from his father, he gained admission to the Royal Academy School in London as a probationer. His progress during the next few

years was slow. He submitted to all the required disciplines, including the study of anatomy, of the living model, and of perspective. On his own, Constable sought out and copied landscapes by such masters as the Caracci, Ruisdael, Claude, and Wilson. Hoping to become a painter of landscape, he chose as his mentor an academician of modest talent but high professional reputation, Joseph Farington. In his hours of doubt, he leaned on Farington and Beaumont for advice and encouragement. Constable's academic exercises showed no extraordinary promise, but landscape drawings made in Helmingham, the estate of the Earl of Dysart, and in the Stour Valley in 1800 give an inkling of his future direction and strength.

To try his hand at the most readily salable kind of landscape painting, he produced a house portrait, which is the earliest-known, securely dated oil painting by him. *Old Hall, East Bergholt* (1801, private collection) was commissioned by the owner of this manor house in Constable's home town. It is a timid, awkwardly composed picture, much influenced by the manner of Beaumont, in which only the very prominent, cloud-filled sky shows the awakening of the artist's personal talent. He was ready to sell his picture for the extremely modest price of £3, but was advised by Farington to demand £10.

After three years of study at the Royal Academy School, he finally won his father's consent to his choice of the profession of artist (his younger brother, Abram, had meanwhile replaced him in the family firm). The offer of the position of drawing master at the Windsor military school, an offer which he refused, became the occasion for serious self-examination and a courageous decision. Constable announced this to his Bergholt friend, John Dunthorne, in a letter (1802) that has become famous for the insight it gives into the state of his mind at the start of his career. His academic studies, he wrote, had shown him that "there is no easy way of becoming a good painter." For too long, he had been "running after pictures and seeking the truth at second hand." It was time to return to the rural solitude of Bergholt and devote himself entirely to "laborious studies from nature," in order to achieve "a pure and unaffected representation of the scenes that may employ me." Artificiality and mannerisms were the vices of conventional landscape painting, "but truth in all things only will last. . . . There is room enough for a natural painture [sic]."

By "natural painture" (a misspelling either of the English "painter" or of the French *peinture)*, Constable meant landscape directly inspired by observations in nature, neither raised to sublimity nor embroidered into picturesqueness but taken from common reality, which for the young Constable was synonymous with the familiar countryside around his native Bergholt. He knew that his choice of direction reduced his chances of public success and was likely to prolong his financial dependence on his family. There was little glory in landscape painting, and less profit, least of all in the humble and unpopular kind on which he had set his heart. He seems to have been driven by strong convictions, based on deeply personal experience and remarkably independent of prevailing tastes and critical opinions. Among the painters he is known to have admired and studied—Ruisdael, Claude, Wilson, and Gainsborough—none exemplified "natural" landscape fully and completely. Constable had a vision of nature that made him feel dis-

satisfied even with these masters. Their work fell short of what he had seen and felt in the fields. But he found it difficult to translate his experience into painting. He struggled to free himself from habits of arrangement, from notions of the well-composed view that seemed inseparable from the very idea of landscape. Habits of seeing, unconsciously derived from the traditions of art, continued to influence his efforts at "natural" painting, despite his efforts to rid himself of preconceptions and mannerisms.

Returning to Bergholt in the early summer of 1802, he made good his intention by painting oil studies of Suffolk landscapes. A small studio was put at his disposal near the family home. *Dedham Vale* (1802, London, Victoria and Albert Museum) opens a sweeping view over the Stour Valley as seen from a height. In the distance is the tower of Dedham Church, to the left and right windswept trees. Though it is evidently based on direct visual experience— recorded with great relish for the freshness of the verdure, the sharp, shifting light, the atmospheric distance—this small, seemingly casual study still echoes the formulae of the well-constructed landscape. The silhouetted trees that frame the view resemble, in shape and arrangement, the trees in the foreground of Claude's *Hagar and the Angel* that Constable had admired in Sir George Beaumont's collection.

While pursuing his independent study of landscape, Constable continued his academic training until the end of 1808, by which time he had reached the age of thirty-two. The months of winter and early spring he spent in London, at work and study, exhibiting the results of his labor—usually a few small landscapes—at the Academy's spring exhibition. His summers were dedicated to outdoor sketching, most often in the area around Bergholt, occasionally on visits to country friends or relatives. He supplemented his parental allowance by painting portraits or executing altarpieces for country churches, such as the *Christ Blessing the Children* (ca. 1805, for Brantham), an awkward imitation of Benjamin West, and *Christ Blessing the Bread and Wine* (1809, for Nayland). In 1806, with a stipend from an uncle, he toured the Lake District in the early fall. Its rugged mountain scenery, very unlike the friendly farmlands of Suffolk, made him uncomfortable: "the solitude of mountains oppressed his spirit . . . his nature was social and could not be satisfied with scenery that did not abound in human associations." He nevertheless produced a series of large, very broadly executed watercolors, limited to dark, brownish tones, and somewhat reminiscent of the styles of Alexander Cozens and Thomas Girtin.

By 1809, Constable had greatly progressed in his landscape sketching. His small oils of wide countrysides under strongly colored, atmospheric skies are masterful in their energetic brevity and, despite their lack of finish, wonderfully true to the changing effects of daylight and of weather. The artist's goal of an unaffected, natural landscape painting appears very nearly realized in these rapid impressions of utterly artless scenes.

Constable's acquaintance with the family of Lord Dysart brought him several portrait commissions and occasioned the painting of *Malvern Hall* (1809, Florence, Fondazione Horne), the country seat of the brother of the Countess of

Dysart. An extensive landscape rather than an ordinary house portrait, the picture shows the Hall in the distance, beyond a lake and an expanse of sun-struck lawns, bordered by looming trees. Though it still reflects an eighteenth-century formula commonly used for the representation of country seats, Constable's picture does not seem arranged, nor does it stress merely topographical detail. It has the immediacy of a sudden sight, and resembles, in its breadth of treatment without sacrifice of truth, his more casual nature studies.

A momentous event occurred in Constable's personal life in the summer of 1809: he fell in love with Maria Bicknell, a London girl of twenty-one, the daughter of a solicitor to the Admiralty and granddaughter of the wealthy rector of East Bergholt, Dr. Rhudde. This began a long and difficult courtship of seven years, resisted by Maria's father, and violently resented by Dr. Rhudde. It may have speeded Constable's very slow development toward artistic maturity, by putting him under pressure to prove himself a competent professional, able to support a family. At the same time, it made it more difficult for him to pursue his self-imposed artistic goal of becoming a painter of landscape—the least lucrative branch of art. Common sense and his love for Maria counseled him to shift to money-making portrait painting. He resisted these pressures, at a great cost to himself of happiness and health. In the years between 1809 and 1816, when he finally married Maria, Constable was often plagued by spells of illness, anxiety, and depression.

These years of crisis brought his long apprenticeship to an end, and forced him to enter fully into the competition of professional life. *Dedham Vale, Morning* (1811, Elton Hall, R. G. Proby Collection) was his first attempt at a large exhibition picture. Under a luminous, lightly clouded sky, it offers a wide panorama that includes, in its far distance, the steeples of Dedham, Langham, and Stratford—Constable's world, as seen from near Bergholt, the seat of his family. The shaded foreground is richly furnished with figures and animals, carefully observed and rendered in some detail. Constable was evidently anxious to enliven what, he feared, might strike viewers as a featureless and hence pointless scene. Between two rather slight groups of framing trees, the land opens wide onto a distant horizon. The silvery thread of a river, the diminishing clusters of trees reinforce the effect of vast space, bathed in a clear, mild light. The fresh naturalism of Constable's outdoor sketches appears somewhat attenuated in this studio picture, which gave him much trouble, since it forced him to compromise his principles of "natural painting" for the sake of compositional structure. Exhibited at the Academy, the picture was little noticed; its subtleties failed to impress the public.

In the autumn of 1811, Constable visited Dr. Fisher, the bishop of Salisbury, an old acquaintance and himself an amateur artist. On this occasion, he first met the bishop's nephew, Archdeacon John Fisher, who was to become his most intimate friend and correspondent, his adviser and consoler, and his loyal patron. The anxious years of courtship, embittered by long separations from Maria Bicknell, by fears of a rupture, and by the steady disapproval of her family, were nevertheless a time of rapid progress in which, through outdoor sketching, Con-

stable sharpened his powers of perception and transcription, acquiring that fluent, nervous, but very precise technique of oil painting by which he "unveiled," as he put it, the splendors of color, light, and atmosphere that he found in the humblest settings. During the summer months he painted in the open country, most often along the banks of the Stour, with its dams, docks, and mills, many of them the property of his family and deeply connected with his childhood memories.

Landscape with Boys Fishing (1813, Anglesey Abbey, National Trust) very factually describes a lock near the Constables' mill at Flatford. The disheveled, somewhat incoherent arrangement of the windswept trees relieves the otherwise somewhat prosaic site. Though of relatively large size, its execution is in part quite broad, and seemed "unfinished" to critics. Constable, nevertheless, was able to sell this picture, though for a very small price. It was his first sale of a landscape to a purchaser who was not a close friend or a member of his immediate family.

The most highly valued kind of landscape painting, indeed, the only kind ranked among the higher reaches of art, was the "historical"—the humanized or moralized landscape, enriched by historical, religious, or mythological associations, and thus lifted from mere description of nature to the level of philosophy or poetry. This necessitated distortions of nature's appearance, or artificial arrangements and insertions, such as are very apparent in the allegorical compositions of Runge and more quietly stated in Friedrich's symbolical landscapes. The problem that Constable had set himself was to express the meaning of landscape without violating truth, i.e., without falsifying visual experience. For him, landscape had a human significance that did not need the addition of historical or poetic artifice. This significance could only be expressed through the closest attention to visual fact, to the intimate processes in nature of weather, light, and plant life, which determined man's very existence, on the one hand, and, on the other, to the marks left on landscape by the human presence. For it was the agricultural, the cultivated landscape that held Constable's whole interest and produced in him a deep, quasi-religious, empathetic response. His naturalism, no less than the idealism of the painters of historical landscape, humanized nature; but for him it was the plowed field, the drama of weather, the signs of seasonal change that manifested the connection between nature and man.

The Stour Valley, with Dedham in the Distance (1814–15, Boston, Museum of Fine Arts) is an intimate view from a particular site, the park of the Old Hall at Bergholt, the property of Peter Godfrey, for whose daughter the picture was commissioned, and at the same time a scene of seasonal labor of a very humble kind, the spreading of manure in preparation for winter plowing, a subject scarcely intelligible to a city audience, but meaningful to the artist and to the person for whom the picture was painted. *Ploughing Scene in Suffolk* (1814, private collection; a second version in New Haven, Yale Center for British Art), painted from nearly the same spot, is another of Constable's landscapes that combine observations of weather—a bleak, showery day, in this instance—with an intimate description of seasonal agricultural labor, the plowing of a "summerland" (a field that is to remain fallow during the coming summer).

The freshness of color and light that Constable achieved with great felicity

in his small outdoor sketches was not easily carried into the larger canvases, painted in the studio, that he derived from these sketches. On a few occasions, he sought to overcome this difficulty by executing fairly sizable landscapes in the out-of-doors. *Boat Building at Flatford* (1815, London, Victoria and Albert Museum) represents his father's boatyard near Flatford Mill. The canvas was executed on the site, and may be Constable's earliest effort at painting a picture of larger size (20 × 24¼ in., or 50.8 × 61 cm.) directly from nature. The time of day is the early afternoon: vivid sunlight defines the hull of the barge in dry dock, illuminates the green meadows, and is filtered by the foliage of the tall trees at the left. A litter of precisely observed boat-building tools surrounds the nearly finished barge, factual details that other painters might have omitted as trivial, but that mattered to Constable since they were part of his subject's reality.

His naturalism appears in its full maturity, warmed by possessive affection, in the two small canvases *Golding Constable's Flower Garden,* and *Golding Constable's Kitchen Garden* (both 1815, Ipswich, Borough Council), the one painted in afternoon, the other in morning light, and forming together a wonderfully detailed panorama of the world of Constable's boyhood as seen from an upstairs window in his father's house. The spacious summer skies, with drifting clouds, introduce a sense of nature's immensity into these otherwise snugly confined, domesticated landscapes.

In 1816, Constable's life underwent a drastic change. In May, his father died, leaving him an inheritance that gave him the courage to marry Maria Bicknell in the face of her family's resistance. After spending most of the summer at Wivenhoe Park in Essex, carrying out a commission, he married Maria in London on October 2, his friend Archdeacon Fisher officiating. Their honeymoon was spent in unfamiliar country, on the Dorset coast, in Fisher's vicarage at Osmington.

Wivenhoe Park (1816, Washington, National Gallery) represents an extensive but thoroughly humanized landscape, within which the house figures only as a small, distant shape. The unusually wide angle of view was dictated by the wish of the Park's owner, General Rebow, to include the artificial grotto at the far left and the deer house at the right. Separated from it by sunlit fields on which cows graze, the shaded mirror of the lake, ruffled by a breeze, reflects the cloud-laden, luminous sky above. Compared to the somewhat similar *Malvern Hall* of 1809, *Wivenhoe Park* shows the remarkable enrichment and strengthening of Constable's naturalism from 1815 onward.

During his honeymoon at Osmington, he painted a number of coastal seascapes, some of them, judging by their topographical accuracy and atmospheric precision, directly from nature. In *Weymouth Bay* (1816, London, National Gallery), the sandy, arid spread of the foreground, washed by surf at the left, seems overwhelmed by the immense, curiously massive clouds moving obliquely through the sky. With eyes accustomed to the green fields and friendly horizons of his native Suffolk, Constable sought to characterize the grandiose and somewhat uncomfortable aspect of this, to him unfamiliar, seaside.

After his marriage, worldly cares closed in on Constable even more press-

ingly than before. The rapid growth of his family—Maria bore him seven children in twelve years—demanded that he find buyers for his pictures. He paid a heavy price for his commitment to a form of landscape painting that was unprofitable, unpopular, and without academic prestige. Year after year, he stubbornly presented himself as a candidate for membership in the Academy and was regularly defeated by insignificant competitors. In 1819, he was finally elected to the junior rank of associate, but it took him ten more years to win acceptance as full member in 1829, at the age of fifty-three. At the annual Academy exhibitions, he entered landscapes large enough to be noticed and of sufficiently careful execution to satisfy the public's and the critics' demand for "finish."

Constable found his subjects within an area of only a few miles, in the immediate vicinity of his family's home in East Bergholt (see the map on page 00).

Flatford Mill (Scene on a Navigable River) (1817, London, Tate Gallery) represents a towpath along the Stour River, near one of Golding Constable's watermills. The largest and most painstakingly worked of his landscapes up to that time, it anticipates in its subject matter, crowded composition, and sunny warmth of color the series of even larger Stourside landscapes that were to be his main works in the years following. The particularly rich and airy cloudscape at its upper left contrasts effectively with the masses of sunlit foliage at the right, juicily painted in strong greens and yellows.

By 1817, Constable had fully developed the type of exhibition picture with which he would figure at the annual exhibitions of the Royal Academy in the following decade. His large, carefully composed canvases represent particular sites along the Stour River, generally associated with his father's business and holding special, personal associations for himself. They are based on studies from nature, but were composed and elaborated in his London studio during the winter months. The subjects and their main features grew out of drawings and oil sketches, often of much earlier date. The final, large canvases were thus arrangements rather than "natural" landscapes, and therefore lack some of the freshness of his more spontaneous sketches. He made an effort, particularly in the earlier of these studio pictures, to preserve as much as possible of the "silvery, windy, and delicious" quality of his studies from nature. But the thought of the Academy

exhibition caused him to labor over detail and finish; his public performances seem darker and denser than his airy private works. Their foregrounds are crowded with vegetation, with rustic figures and farm animals. They generally center on a sheet of water, with landings, locks, mills, and the gear of river traffic, surrounded by great masses of dark foliage among which appear the roofs of cottages. Luminous cloudscapes fill the skies. Traces of human industry, as much as the natural indications of season, weather, and time of day, set the character of these scenes. Man and nature do not appear in confrontation, as in much Romantic art, but in quiet harmony. The natural settings seem made to shelter and nourish their inhabitants, they are literally domestic, and what emotions they call up arise from memories of "careless boyhood" and from a sense of comfortable ownership.

The White Horse (1819, New York, Frick Collection) is the earliest of Constable's 6-foot canvases, designed to attract attention at the Academy exhibitions. It represents the ferrying of a tow horse across the Stour. The composition, based on a drawing made in 1814, is unusually agitated and disjointed, its separate parts—the barge, the clusters of trees, the houses and sheds, the browsing cattle—are vividly and independently rendered. Constable prepared a full-scale study (Washington, National Gallery) in which he rehearsed the composition in chiaroscuro—in its larger masses of light and shadow—a procedure that became his regular practice in the preparation of subsequent large exhibition pieces. The brownish tone of terrain and foliage is worked up into a variety of fresher hues, mostly green and yellow, to produce—together with the broad expanse of shiny water in the foreground—an effect of irregular, lush, teeming fertility, splendidly contrasted with the coolly distant, lightly clouded sky. The picture was praised by the critics and bought, for £100, by Archdeacon Fisher.

Stratford Mill (1820, private collection), the second of Constable's 6-foot exhibition pictures, shown at the Academy in 1820, again represents a particular site on the Stour, a papermill a short distance upstream from Dedham. The extensive, serenely peaceful view is closed on the left by a tall screen of trees through which the sunlight filters, while on the right a deep perspective opens up over distant fields—a compositional scheme that Constable repeatedly used in his larger paintings. This picture, too, was bought by Fisher, as a present to his solicitor, John Tinney. It was criticized for its very prominent sky, which prompted Constable to write to Fisher that it would be difficult to "name a class of landscape in which the sky is not the *key note,* the *standard of scale,* and the *chief organ of sentiment.* "

In the fall of 1820 Constable moved his family to Hampstead, where in the following years they spent their summers. His visits to Bergholt after 1817 were few and brief. His favorite sites for outdoor sketching from then on were the great suburban desert of Hampstead Heath, the seaside at Brighton, where he often took his ailing wife and children in the 1820s, and the area around Salisbury, where the hospitable Fishers made him at home. In Hampstead, he became increasingly preoccupied by the drama of weather, the most variable feature in the otherwise monotonous setting of the Heath. During 1821–22, he painted

many studies of sky and clouds, based on precise observation and often inscribed with indications of the time of day, wind, weather, and temperature. Some fifty of these small oil sketches once existed, many of them pure cloudscapes, without any indication of terrain.

Constable's interest in "skying" was based on a scientific interest in the physical and chemical processes that determine weather and of which clouds are the visible symptoms, capable of being classified and systematically interpreted. He may have been familiar with the writings of the pioneer of meteorology, Luke Howard, and certainly knew Thomas Forster's *Researches into Atmospheric Phenomena* (1815). What links his "experiment pictures" with the work of empirical scientists of the time was the recognition of the fact that visible phenomena in nature—such as the formation of clouds—are the manifestations of regular processes, and that their shapes, far from being accidental, have a precise, symptomatic significance. Constable painted these studies not for immediate practical use, but as aids to a deeper understanding of the anatomy of clouds, just as he had once studied the anatomy of the human body. "Painting is a science," he wrote, "and should be pursued as an inquiry into the laws of nature."

Absence from his native Suffolk seems to have lessened his interest in subjects from the Stour Valley. In the autumn of 1820 he planned a large urban panorama, the *Opening of Waterloo Bridge,* commemorating an event that he had witnessed in 1817. But he was deterred from going on with this project by Farington, the experienced politician of the Academy, who advised him to try, instead, another subject like that of *Stratford Mill.* Constable followed this advice and painted *The Haywain* (1821, London, National Gallery), a harvest scene in late summer, seen from close to Flatford Mill, very near the spot from which he took the view of *The White Horse* of 1819. The picture (originally titled *Landscape: Noon*) takes its popular name from the empty hay wagon that is about to cross the ford, to join the harvesters seen in the far distance at the right. Painted in London in the winter of 1820–21, it is based on oil studies dating back to 1814–16. Its compositional scheme, consisting of a screen of tall trees at the left, a watery foreground, and an opening into the far distance on the right, is similar to that which Constable had used for *Stratford Mill.* It may also owe something to Rubens's *Château de Steen,* owned by Beaumont and hence known to Constable, but its general character and the motif of the cottage in its watery setting, embowered in dark foliage, show how much—even after his emancipation from the great masters—his view of nature was still conditioned by memories of Hobbema and Ruisdael.

As was his custom, Constable settled his composition with the help of a full-sized "sketch" (Victoria and Albert Museum), which, very freely brushed in a narrow range of browns, greens, and blues, has the appearance of a nearly monochromatic underpainting, and served as a trial of the picture's distribution of light and shadow. There was little of "natural painting" in Constable's 6-foot canvases. Their effects of sunlight, sky, and foliage, insofar as they derived from observation, were supplied by separate oil sketches. *The Haywain,* no exception, is a mosaic of observations, integrated within a compositional structure. It has

less light and air than his earlier large landscapes; its dominant effect is of dense textures and shaded surfaces. The glorious exceptions to this are the skyscape at the right, the view of the distant, sunlit fields below it, and the light-filtering foliage of the trees in the center.

At the Academy exhibition of 1821, the picture was admired by Géricault and the French critic Charles Nodier. Its reputation soon reached Paris. In 1824, a French dealer by the name of Arrowsmith bought it from Constable, together with two other paintings, took it to Paris, and had it exhibited at the Salon of 1824, where it won a gold medal.

The Haywain marked the beginning of a change in Constable's direction: his early naturalism lost something of its fresh objectivity, his landscapes from this time on became less descriptive. His colors grew darker, his paint heavier, rough slashes of the palette knife replaced his fluent brushwork. Rather than the tranquil recollection of observed nature, his later convases seem to express a vehement emotion. The change was gradual, however; its first signs appeared not so much in the finished version of *The Haywain* as in the full-size sketch in which Constable had plotted its composition. In the years that followed, the difference between the rough sketches and the final canvases steadily decreased.

View on the Stour Near Dedham (1822, San Marino, Huntington Art Gallery), next in the sequence of large Stour landscapes, still shows no very marked change of style. In its general composition—a screen of tall trees at the left, an opening into the far distance at the right, and a foreground of reflecting water—it resembles *Stratford Mill* and *The Haywain.* The very prominent sky bears witness to Constable's recent Hampstead experiments in "skying." The stress on general atmospheric effect, rather than topographical detail, indicates a lessening interest in Stour scenery and a shift to a more generalized naturalism, one that concerned itself with the universal phenomena of light and atmosphere. The full-size sketch for this picture (London, Holloway College) is very roughly brushed in tones of brown and gray. The finished painting was exhibited at the Paris Salon of 1824, where it shared a gold medal with *The Haywain.*

The series of large Stour views was interrupted by a private commission, *Salisbury Cathedral from the Bishop's Grounds* (1823, London, Victoria and Albert Museum), in which the natural forms of trees and clouds provide a dramatic, irregular frame around the precisely ordered structure of the cathedral. The contrast may have a more than purely aesthetic significance. Constable shared the conservative Anglicanism of the bishop, Dr. Fisher, for whom he painted the picture, and it is likely that he saw the cathedral under a stormy sky as the Church of England in adversity. Such a symbolical use of landscape would imply a shift from his earlier bucolic naturalism to a view of nature as a threatening force, not unlike that expressed by Géricault or Delacroix. The painting failed to satisfy the bishop, who, perhaps aware of the artist's intention, wished for a more cheerful sky.

The fifth of Constable's large Stour Valley pictures, *A Boat Passing a Lock* (1823–24, London, W. Morrison Collection), clearly shows the transformation of his style. The dark and massive foreground, with the huge timber structure of the

lock, and the abrupt recession into distance that foreshortens the middle ground into a narrow band, give this composition the appearance of a monumental genre scene, with near objects and figures set against an extensive sky rather than a landscape. Only the tiny steeple of Dedham Church on the far horizon localizes the scene and lends it a personal reference. The execution is broad and bold. To animate the darker passages, Constable sprinkled small touches of white over them, suggestive of scintillations of light from fluttering leaves or drops of dew, a device that in his later works he would carry to an extreme that annoyed critics, who ridiculed it as "Constable snow."

The shift to a powerfully expressive style, with consequent sacrifice of naturalism, was finally accomplished in *The Leaping Horse* (1825, London, Royal Academy), the sixth of his large Stour landscapes. Its foreground represents a raised towpath along the river, at the point where the path crosses a bridge over a floodgate. The view is taken so low that the barge moving down the river is seen from below and the tow horse leaping a barrier on the bridge is in part silhouetted against the sky. Dark foliage, as usual, fills the picture's left side, while on the right a view opens over terrain so radically foreshortened as to form a narrow band, featureless except for the tower of Dedham Church that appears, barely visible, at the extreme right, a last, faint hint at the topographical identity of the scene.

The effect of this landscape is somber and stormy, the handling of the paint rough, the emotional tone one of almost tragic intensity. The spectacular action of the leaping horse introduces into it an impassioned violence of which Constable's earlier, peaceful landscapes had given no hint. The opacity of the darker passages in the timbers and water plants of the foreground and in the trees of the middle distance is hardly relieved by the spots and streaks of dry white paint, "Constable snow," liberally sprinkled over them. But the clouded sky is painted in an entirely different manner, in larger, more transparent touches of a light, almost washlike color. The full-scale sketch (Victoria and Albert Museum) is only marginally rougher than the final canvas.

The signs of stress that mark Constable's work at this time, contributing to his adoption of expressive mannerisms in the place of his former "natural painting," have no very obvious biographical explanation. He had won acclaim at the Paris Salon, his reputation was growing on both sides of the Channel, and he received more commissions than he was willing to take. But he suffered from bouts of anxiety, quarreled with his dealers, and was testy with his friends. Perhaps in response to the criticism that his work had been concerned too monotonously with scenes along the Stour, he reverted to an "inland" subject, as he put it, in his submission to the Academy exhibition of 1826, *The Cornfield* (1826, London, National Gallery), a view from between tall trees along a curving lane toward a field of ripe corn in the distance. More formally composed and very carefully executed, it resembles the agricultural landscapes of his earlier years. The colors are deep and intense, tending to rich browns and greens, with golden highlights in the foliage. The brush strokes, controlled and descriptive, crisply indicate minute details in the weeds, the ears of corn, and the sun-struck edges

of leaves. Constable evidently meant to reply to the critics who had accused him of carelessness and lack of finish.

The delicate health of his wife and bouts of illness among his many children caused Constable to send his family to the seaside resort of Brighton for several successive summer vacations in the 1820s. Here he painted sketches of the sea and beach that ultimately resulted in a large marine subject, his only exhibition picture of a Brighton scene, the *Marine Parade and Chain Pier, Brighton* (1827, London, Tate Gallery). The picture combines in highly original fashion a sky- and seascape with a city view, expressing the contrast (which Constable also described in his letters) between the bustling, fashionable, and to him distasteful, life of the resort and the "magnificence of the sea and its everlasting voice." Closer to direct impressions from nature than the late Stour landscapes, the picture's effect is of great atmospheric subtlety, despite passages of daring palette-knife work.

After a holiday in Flatford in the fall of 1827, his first lengthy stay in his native Suffolk in ten years, he returned to a subject first dealt with in one of his earliest experiments with "natural" landscape painting in 1802: *Dedham Vale* (1828, Edinburgh, National Gallery of Scotland). Twenty-six years after painting this scene from nature (1802, Victoria and Albert Museum), Constable repeated and elaborated it in a strikingly different style. In contrast to that earlier, freely brushed and freshly colored study, this later, much enlarged version is crowded with sharply defined details that hardly vary in clarity of focus from the weeds in the foreground to the steeple in the far distance. This hard precision in the detailing of near and far objects diminishes the sense of atmosphere and natural light, but gives to the picture a disturbing intensity, something of the look of a colored drawing in which even the most minute form has its highlight and edge of shadow. As a concession to public taste, he introduced the narrative touch of a tent with gypsy woman and infant into the picture's foreground.

Dedham Vale, concluding the series of exhibition pictures on Suffolk themes begun in 1811, finally won Constable admission to full membership in the Academy in February 1829. But in the meantime he had suffered a loss that destroyed what happiness this belated recognition might have given him: in November of 1828, his wife died, leaving him, at age fifty-three, a widower charged with the care of seven children aged between eleven years and eleven months.

His deep sorrow aggravated his chronic tendency to anxiety and depression. It also affected his attitude toward nature and art: "I shall never feel again as I have felt," he told his brother Golding, "the face of the world is totally changed to me." He continued his withdrawal from objective naturalism, and turned instead to memory and inward experience. His landscape paintings ceased to be representational in the strict sense; nature now became for him a source of symbols by which he—not unlike Friedrich or Turner—tried to deal with the ideas that obsessed him. A substantial inheritance that had come to him shortly before his wife's death made him more independent of critical or public opinion than he had ever been before, and freed him for the pursuit of his private goals.

Hadleigh Castle (1829, New Haven, Yale Center for British Art) is based

on studies Constable had drawn of this ruin in 1814, during a visit to Southend, at the mouth of the Thames. After his wife's death, that earlier impression of blasted towers over an immense expanse of sea came back to his memory, now charged with a personal meaning. He imagined the ruin "on the morning after a stormy night" as a symbol of the desolation in his own life, and of his hope, with the return of light, for a new beginning. Though based on an actual sight, the scene is no ordinary landscape, and certainly not a "natural" one, but an imaginative vision, arising from inward feeling rather than observed reality. Constable here works as a self-expressive, romantic artist, searching in nature not for objective truth (as he had done, for example, in his "experiment pictures" of clouds), but for signs and portents of human fate. The execution corresponds in the vehemence of its brushwork to the expressive manner of *The Leaping Horse.* The objects are defined by tone and texture rather than by the colors, which are kept within a narrow range of browns and grays (the full-size sketch, in the Tate Gallery, of even more tempestuous execution, is conceived in tonalities of green and blue).

A similar symbolical intention motivated the painting *Salisbury Cathedral from the Meadow* (1831, Lord Ashley of Hyde Collection), in which memories of the Stour Valley—horses pulling a cart through a shallow stream in the middle ground, as in *The Haywain*—are combined with a solemn vision of the cathedral, rising from darkness into a burst of light that breaks through storm clouds. To the left, jagged lightning strikes the roof of the building, while on the right a rainbow—"sign of danger past"—spans the sky. The picture restates with apocalyptic vehemence a theme that had been more quietly suggested in *Salisbury Cathedral from the Bishop's Grounds*—the ancient fabric of the Church of England withstanding the tempest of modern reform—and again reflects the fears and fervent hopes of the conservative artist and of his friend, Archdeacon Fisher. The execution is as nervously elaborate as that of *Dedham Vale* (1828). Flickers and streaks of light sharply pinpoint details of branch and foliage, and a sprinkling of scintillations, "Constable snow," animates the somber-hued foreground.

The darkening of color and increasing emphasis on light-shadow contrasts, or chiaroscuro, in Constable's work of this time may owe something to his preoccupation with the reproduction of his paintings in the form of mezzotint engravings by the printmaker David Lucas, an enterprise begun in 1828 by which he hoped to gain a larger audience for his work. The final publication of the series, *Various Subjects of Landscape, Characteristic of English Scenery,* with a text by Constable, occurred in 1838, after his death.

A painting of exceptional character, the largest canvas in his entire work, *The Opening of Waterloo Bridge* (1832, private collection), occupied him intermittently for thirteen years. His only modern historical subject, it represents an event that he had witnessed in 1817. The Prince Regent is shown in the foreground, embarking at Whitehall, to be rowed to the new bridge, which appears in the distance between the choppy silver of the Thames and the fleecy gray of the sky. Reminiscent in its spaciousness and delicacy of color of his Brighton

picture (1827), and filled with a great deal of bold palette-knife work, the picture was severely criticized for its lack of finish.

In his last years, Constable's productivity declined. A painful ailment, a form of rheumatism, plagued him from time to time. He busied himself with the revision of Lucas's mezzotint copies of his paintings, took an active part in Academy business and in charities, and in 1833, 1835, and 1836 gave a series of well-attended lectures on the history of landscape painting, in the last of which he made the famous statement that "Painting is a science and should be pursued as an inquiry into the laws of nature"—a precept that he no longer observed in his own work. The death of his old friend Archdeacon John Fisher, in 1832, grieved him deeply. Charles Robert Leslie, an American-born painter, from that time on took Fisher's place; there were not many other close friends.

After a final visit to Bergholt in 1835, Constable painted *The Valley Farm* (1835, London, Tate Gallery), the last of his Stour scenes. It represents, in a different view, the cottage near Flatford Mill that he had included in *The Hay-wain*. It is a dowdy picture, painted mostly in tones of brown—all freshness gone, except in some passages of the cloudy sky.

His last completed painting, *The Cenotaph* (1836, London, National Gallery), represents a memorial to Sir Joshua Reynolds, erected by Constable's early benefactor, Sir George Beaumont, in his park at Coleorton. Constable had drawn a pencil sketch of the monument on his last visit to Sir George in 1823. For the painting, he imagined an autumnal setting of leafless trees, the only such landscape in his work in which spring and summer are the perennial seasons. Busts of Michelangelo and Raphael, added by Constable, flank the solitary shrine, whose only visitor is a splendidly antlered stag.

In this fantasy landscape, celebrating departed artists, and perhaps hinting at the death of art itself, Constable symbolically links a funeral monument with an evocation of dormant nature. In his catalogue entry accompanying the picture at its Academy exhibition, he quoted Wordsworth's inscription of the monument, which likens its setting of arching trees to the vaults of Westminster Abbey, the actual burial place of Reynolds, "where death and glory a joint Sabbath keep." The resemblance to C. D. Friedrich's allegorical graveyard imagery is striking.

Active to the end, working on the proofs of Lucas's mezzotints, with a nearly finished exhibition picture, *Arundel Mill and Castle* (Toledo Museum of Art), on his easel, Constable died suddenly of an apparent heart attack on March 30, 1837. His work constitutes, in its earlier part, the finest expression of that movement of empirical naturalism which had its ramifications throughout Europe in the period between 1800 and 1840 and which amounted to an alternative to both neoclassicism and romanticism—by both of which, however, it was influenced: by the one in the matters of style and composition, by the other in those of sentiment and symbolism. Constable came closest to his self-set goal of "natural painting" in his outdoor sketches, especially those of circa 1809–22, which he painted in the settings to which he was partial because they held a personal significance for him: the country around Bergholt, Salisbury, Hampstead Heath, and Brighton. His large exhibition pieces confronted him with two

dilemmas: on the one hand that between spontaneous naturalism and the artifice of composition and finished execution, and on the other that between objective nature study and the urge to self-expression. In his work for the public he followed the traditions of scenic composition from which he was unable to free himself entirely, but the most successful of these paintings are permeated by fresh, naturalist elements, and animated by an invincible expressive energy. He had no significant followers in England, yet the exhibition of a few of his paintings in France in the 1820s had a powerful effect on, among others, Delacroix, and on the young painters who, about 1830, revolutionized French landscape painting, particularly Paul Huet and Théodore Rousseau.

READINGS

Life

The most intimate and, in its way, most authentic life is that compiled by C. R. Leslie, Constable's friend and disciple, the *Memoirs of the Life of John Constable* (first published in 1843; recent edition by J. Mayne, 1951), which is largely composed of letters and lecture notes by Constable. The writings of Constable have been published by R. B. Beckett in *John Constable's Correspondence,* 6 vols., Ipswich, 1962–68, and *John Constable's Discourses,* Ipswich, 1970. A brief, illustrated account based on these sources is to be found in R. Gadney, *Constable and His World,* London, 1976.

Work

K. Badt, *John Constable's Clouds,* London, 1950. Covers the interesting problem of Constable's relationship to the scientific thought of his time.

J. Barrell, *The Dark Side of the Landscape: The Rural Poor in English Painting, 1730–1840,* London, 1984, attempts a sociopolitical analysis of Constable's landscape painting.

J. Fleming-Williams, *The Discovery of Constable,* London, 1984, deals with problems of attributions, copies, and imitations.

G. Reynolds, *Catalogue of the Constable Collection of the Victoria and Albert Museum,* London, 1960 (new edn., 1973), offers a detailed survey of a large portion of Constable's work, including many of his small studies from nature.

G. Reynolds, *Constable, the Natural Painter,* London, 1965, is an excellent general study of the life and work.

G. Reynolds, *The Later Paintings and Drawings of John Constable,* 2 vols., New Haven and London, 1984.

B. Taylor, *Constable,* London, 1963, and M. Rosenthal, *Constable, the Painter and His Landscape,* New Haven and London, 1983, provide useful discussions and interpretations of the work; the latter book contains particularly good illustrations and an up-to-date bibliography.

J. M. W. Turner, 1775–1851

Turner was born in 1775, in Maiden Lane, Covent Garden, in the crowded heart of London. His father was a hairdresser and barber of modest means. His mother suffered from an emotional disorder that resulted in her commitment to Bedlam, where she died insane in 1804. In 1786, when the death of a sister had further darkened this unhappy household, the boy was sent to live with an uncle in the village of Brentford, some ten miles to the east of London, on the banks of the Thames. Here he had his first sight of green fields, attended the local Free School, and gave evidence of a talent for drawing.

Turner made his decision to become an artist about 1789, and began his studies with Th. Malton, a watercolor painter who specialized in architectural subjects. Later in 1789, at age fourteen, Turner was admitted to the Royal Academy School, where he remained a regular student until 1793. Precocious and highly industrious, he began to sell watercolor drawings of architectural monuments to publishers while still a student and, from 1790 onward, regularly exhibited such watercolors at the Academy.

In 1791, he took the first of the summer sketching tours (to Bristol, Bath, and Malmesbury) that from then on became regular, yearly events in his life. Unlike the country-bred Constable, who remained attached to a very few, favorite localities, the rootless Turner needed travel and the variety of scenery it offered. In 1792, he went sketching in South and Central Wales, then in high fashion among landscape painters in search of picturesque subjects. His academic training gradually came to an end about this time, although he continued in sporadic attendance at life classes. In March 1793 he was awarded a prize, the "Silver Pallet" for landscape drawing, by the Society of Arts.

At the Academy exhibition of 1794, Turner showed five watercolors and received his first press notices. He began to receive commissions for drawings to be published, in the form of engravings, by such periodicals as the *Copper Plate Magazine* and the *Pocket Magazine.* His watercolors showed the first signs of a personal sense of the dramatic and grandiose. *Interior of the Ruins of Tintern Abbey* (1794, London, Victoria and Albert Museum) is a tinted drawing of conventional execution, but of masterly conception in its bold magnification of the ruin and its extravagance of decaying masonry and ragged overgrowth.

At about this time (1795–96), Turner regularly frequented the private "academy" of Dr. Thomas Monro, an alienist and a passionate collector, who

employed young artists to copy watercolors in his collection. During evening sessions at Dr. Monro's house at Adelphi Terrace, Turner often worked side by side with Thomas Girtin, exactly his own age and already a proficient watercolorist. Together, they copied watercolors by John Robert Cozens (1752–1797), the greatest landscape painter in watercolor of the previous generation, that had been acquired by Dr. Monro while attending Cozens during the final stages of his mental illness. Turner learned much from Cozens's example, and even more from his work with Girtin, who taught him to apply watercolors directly and in their full intensity, without the customary gray underwashes.

Turner very early set himself high goals: beginning with the humble but lucrative practice of topographical view painting in watercolor, his ambition drove him to enlarge the scope of his work, to attempt imaginative subjects, and to develop a freer, more personal manner. Determined to go beyond watercolor painting to the more demanding and rewarding medium of oil, he began to show works in oils at the Academy exhibitions. His first known oil painting, *Fishermen at Sea* (1796, London, Tate Gallery), is a dramatically moonlit scene of ships contending with high seas, his earliest use of what was to become a favorite image. The picture, bearing witness to Turner's very rapid mastery of a new technique, creates its effect through skillfully contrived contrasts of lights and reflections, that of the cloud-shrouded moon on the glassy, green waves with that of the lantern held in one of the boats. The work owes something to the storm scenes of Joseph Vernet (1714–89), de Loutherbourg (1740–1812), and Wright of Derby (1734–1797), but it also contains elements of personal observation, gathered on a visit to the Isle of Wight in 1795.

More immediately nature-derived, the smaller canvas *Moonlight, a Study at Milbank* (1797, London, National Gallery) is an early instance of Turner's characteristic fondness for painting directly into the source of light, here the disk of the full moon from which descends a river of reflections into the calm, dark water below.

Busy and shrewdly acquisitive, Turner—aged twenty-two—was offered more commissions for watercolors than he could handle. The collector Sir Richard Colt Hoare asked him to paint twenty watercolor views of Salisbury, the beginning of a series of commissions that extended to 1805. Summer sketching tours took Turner to North Wales and the Lake District in 1797, 1798, and 1799, where he particularly sought for grandly "sublime" effects of rugged mountains, rising mists, and low-hanging clouds. His many large watercolors based on these impressions influenced, in turn, the oils which in increasing numbers he now sent to the Academy exhibitions. *Morning Among the Coniston Fells* (1798, London, Tate Gallery) was exhibited with a poetic quotation, from Milton, as was to become Turner's regular practice: "Ye mists and exhalations that now rise. . . . " The painting, of unusual vertical format, in fact dramatizes the ascent of the terrain from a dark foreground with waterfall, through curtains of sunlit haze, to the heights in the blue distance. *Buttermere Lake, Cumberland; a Shower* (1798, London, Tate Gallery), accompanied by a quotation from Thomson's *Seasons*, is a study of evening light after rain. Above the shadowy lake in the

foreground, a "grand ethereal bow" (a rainbow) "shoots up immense," shimmering in the air before the somber silhouettes of distant mountains.

Some time in 1798, Sarah Danby, an actress or singer about Turner's own age, recently widowed and with four children, became his mistress. The liaison, carried on with much secrecy, continued for many years and relieved Turner of any temptation to think of marriage. Mrs. Danby bore him two daughters.

Invited to accompany Lord Elgin to Athens in 1799, as a topographical draughtsman, Turner declined, since the suggested contract would not have allowed him to keep a portion of the drawings. Two important events in his personal life marked his growing independence and professional recognition. He left the family home, made unbearable by his mother's insanity, and set himself up in more presentable quarters in Harley Street. At about the same time, he was elected an associate of the Royal Academy at the unusually young age of twenty-four.

Turner now decided to extend his reach. From his humble beginnings in topographical drawing he had very rapidly progressed beyond mere description to imaginative dramatization. A streak of showmanship in his nature, a taste for the grandiose and impressive guided his work in a direction that was the opposite of Constable's modest "natural painting." Ambitious to enlarge his scope, he advanced from watercolors to oil, from topographical to sublime landscape, and at last—about 1798—to the rarefied heights of historical composition and grand style. In doing this, Turner took on the challenge of measuring himself against two main Baroque traditions highly esteemed by British connoisseurs, that of the classical Italianate landscape and that of the Dutch sea-piece. He accepted these models without question or diffidence, and seems to have regarded himself from the start as a rival rather than an imitator of his great predecessors—Wilson, Claude, Poussin, and Van der Velde.

Aeneas and the Sibyl, Lake Avernus (ca. 1798, London, Tate Gallery) is one of Turner's earliest attempts at presenting a classical subject (taken from Virgil's *Aeneid*) in a landscape composition borrowed from the Claudian tradition. In the foreground, Aeneas encounters the Cumaean Sibyl, who offers him the Golden Bough that will gain him entry into the Underworld, where he seeks his father. The view across the blue waters of Lake Avernus, framed by trees, opens on a sweep of Mediterranean coast under a serene sky. Mood and style echo Claude Lorrain, though Turner's immediate models were a drawing by his patron, Colt Hoare, and a painting by Richard Wilson (1713–1782) in his patron's collection.

The Fifth Plague of Egypt (ca. 1800, Indianapolis Museum), based on Exodus, and representing in fact the seventh rather than the fifth of the biblical plagues of Egypt, was admired by the critics at the Academy exhibition of 1800 as being in "the grandest and most sublime style of composition." Though it contains elements derived from the classical tradition (i.e., from Wilson and Poussin), it is essentially a catastrophe scene of a type highly popular in the late eighteenth century and used particularly by de Loutherbourg and Wright of Derby. The horizontal, weakly structured landscape is dominated by the fiery clouds that fill its sky, an early instance of Turner's gift for pyrotechnical display.

The picture was bought by William Beckford, the millionaire collector, to be hung in his fantasy castle, Fonthill, together with two newly acquired landscapes by Claude.

Dolbadern Castle (1800, London, Royal Academy) is a romantically "sublime" rather than classical landscape, derived from sketches made during excursions to Wales in 1798 and 1799, but given a historical subject by the introduction of some vague foreground figures and a poetic text, perhaps by Turner himself, that refers in exalted language ("How awful is the silence of the waste . . . ") to an incident from the medieval history of Wales, the imprisonment of Prince Owain in Dolbadern Castle.

As if to prove his versatility, Turner followed these historical landscapes with a "sea-piece" in the Dutch manner. *Dutch Boats in a Gale* (1801, private collection), his largest painting to date, was commissioned by the Duke of Bridgewater as a pendant to a seventeenth-century Dutch marine in the duke's collection, William van der Velde's *Rising Gale.* Turner virtually repeated Van der Velde's composition in reverse, but went beyond his model in dramatizing the scene. A sinister storm is blowing from the left, driving heavy clouds across the sky. Against their darkness, the yellow sails of the boats are sharply lit by a burst of sunlight that also falls on the deeply wind-plowed seas in the foreground.

The painting was a great success at the Academy exhibition of 1801. Though Turner continued to earn his living by supplying publishers and collectors with landscape drawings, he had impressively demonstrated by his displays of large works in a diversity of styles that he was no ordinary landscapist, but an artist pretending to the highest reaches of imaginative painting. The Academy recognized his promise in 1802 by electing him to full membership at the early age of twenty-seven—by contrast, Constable, the "natural painter," remained an unsuccessful candidate until the age of fifty-three. For his reception piece, Turner sent the Academy his *Dolbadern Castle.*

The Peace of Amiens in 1802 put a temporary stop to the war with France, enabling Turner and other English artists to visit the Continent. From July to October, he traveled in France and Switzerland, intent primarily on experiencing the grand mountain scenery of the French and Swiss Alps. He drew some four hundred pencil sketches and a score of watercolors of the more "romantic" chasms, peaks, and glaciers encountered on his way—as in the *Mer de Glace, Chamonix* and *The Devil's Bridge, Gotthard Pass* (both 1802, London, British Museum)—exaggerating the fearsome ruggedness of these sites, and using a masterly broad and transparent watercolor technique, the product of his earlier topographical work in Wales and Scotland. He often drew on this store of Alpine studies in later years. On his homeward trip, Turner stopped in Paris for about three weeks to study the enormous art loot from Italy and Flanders that Napoleon had assembled at the Louvre, recording his observations in notes and sketches. From these it appears that he rejected the work of David and his school (with the exception of Guérin's *Marcus Sextus*), admired Titian and the Venetians, and responded with interest, but also with criticism, to Poussin and Rembrandt.

In its combination of nature and museum study, Turner's first Continental

tour epitomized the duality of his art: experience in nature gave it substance; study of past art gave it form, and provided congenial modes for the expression of personal feeling. In the years that followed, he often returned to memories of his travels, casting them in the forms of traditional landscape types, most often the Italianate or the Dutch. *The Festival Upon the Opening of the Vintage of Mâcon* (1803, Sheffield, City Art Gallery) presents a wide, panoramic view of the Saône Valley near Mâcon through which Turner had passed in 1802. Now darkened by age, the picture once was strongly colored. In composition and mood it is strikingly Claudianlike, though Claude was not among the painters who had most impressed him in the Louvre.

Calais Pier (1803, London, National Gallery) records Turner's arrival on the Continent, in 1802, during a storm. The picture is conceived as a Dutch sea-piece, raised to an extraordinary pitch of vehemence by abrupt contrasts of light and shadow, by the pier's vertiginous recession into the distance, and, above all, by the suggestion of heavy matter in turbulent motion: the rolling clouds and heaving seas—like "veined marble," according to one critic—seem formidably massive. Shown in 1803 together with the serene, atmospheric *Vintage of Macon,* this scene of nature in a rage demonstrated Turner's variety of styles and moods.

The Falls of the Rhine at Schaffhausen (1806, Boston, Museum of Fine Arts), based on sketches from the Swiss voyage, is an essay in melodramatic naturalism, and perhaps influenced by de Loutherbourg, a specialist in the Sublime. Turner chose to contrast the awesome spectacle of the waters' rush between jagged rocks with a prosaic assembly of farmers and carts in the foreground. Critics blamed him for his "wild and incoherent composition" and "coarse" use of the palette knife.

Marine painting, long a favorite with British collectors, took on a particular, national interest in the years around 1803–10, when invasion threatened from France and the fleet was England's main defense. Turner's gift for stylistic mimicry enabled him to paint sea-pieces in a manner recalling that of Van der Velde, highly appreciated by English connoisseurs, and at the same time to lend them a note of modern, national significance:

Ships Bearing Up for Anchorage (1802, Petworth House);
The Shipwreck (1805, London, Tate Gallery);
The Battle of Trafalgar (1806, London, Tate Gallery);
The Victory Returning from Trafalgar (1806, New Haven, Yale Center for British Art).

It is likely that the image of the ship—storm-tossed, distressed, or triumphant—came to stand for him as a symbol of personal or national destiny.

Turner's versatility and abundant production were in part the result of his acceptance of traditional models. Unlike Constable, he had no hesitation in taking his subjects and compositional schemes from the masters, using them as the basic material for his exhibition pictures, to be enriched with elements of his own invention or drawn from his well-stocked memory of actual landscapes. His continuous sketching of particular sites and recording of topographical motifs in

the sketchbooks that accompanied him on his travels served as counterweight to imitation and gave his work the character of his personal vision and feeling. He periodically felt the need for the stimulus of fresh nature study.

The years of 1804–13 were a time of renewed, intensive immersion in the life of rivers, estuaries, and harbors, resulting in naturalist paintings quite unlike his historical compositions modeled on the masters. Beside maintaining a house in London, with adjoining gallery for the display of his work to patrons, Turner now acquired a succession of suburban retreats—at first in Hammersmith on the Thames (1806), then farther upstream at Isleworth (1811), and finally at Twickenham, where he built himself a house, Solus Lodge (1813). These retreats beside the river gave him the privacy he needed, and an opportunity for outdoor work. He equipped a rented barge as a floating studio—anticipating such later open-air landscapists as Daubigny and Monet—and from it painted the passing scenery in oils and watercolors, with an immediacy and freshness of effect reminiscent of Constable's nature studies. From these sketching excursions resulted several studio-finished Thames landscapes of particular atmospheric subtlety:

> *Windsor Castle from the Thames* (1804–06, Petworth House);
> *Walton Bridge* (1807, Melbourne, National Gallery);
> *Pope's Villa at Twickenham* (1808, Walter Morrison Collection).

Turner's frequent visits during these years to the country seats of the wealthy landed patrons who liked his work and evidently enjoyed his company —Sir John Leicester at Tabley House (from 1807), Lord Lonsdale at Lowther Castle (from 1808), Lord Egremont at Petworth (from 1808), and Walter Fawkes at Farnley Hall—further stimulated his renewed interest in actual, i.e., ordinary English, rather than artistically "ideal" landscapes. His choice of subjects on such occasions ran to unspectacular themes: topography, house portraiture, rustic genre; and his treatment of them tended to be appropriately realistic.

Sun Rising Through Vapour; Fishermen Cleaning and Selling Fish (1807, London, National Gallery) is a spacious, calm sea-piece, with a genre foreground in the Dutch style. Its stillness strikingly contrasts with the animation of Turner's previous marine paintings. An effect of sunlight, filtered through haze and reflected on water, establishes its theme: the mood of a particular time of day, embodied in a natural phenomenon whose silent grandeur dwarfs human activity. *Ploughing Up Turnips at Slough* (1809, London, Tate Gallery) also contrasts a very distinctly rendered foreground, filled with cattle and rustic laborers, with a sublime atmospheric spectacle, the faint silhouette of Windsor Castle looming enormous in the hazy distance.

Somer-Hill, the Seat of W. F. Woodgate Esq. (1811, Edinburgh, National Gallery of Scotland) gives Turner's version of the house portrait, and is comparable to Constable's exactly contemporary essays in this genre. The difference lies in Turner's emphasis on pervasive effects of light and atmosphere which merge in a harmonious haziness what in Constable's pictures remains crisp and distinct. The sky is delicately defined by merging luminosities, without any clear cloud shapes. The liquidity of the water in the foreground is not insisted on, and is

without the silver sparkle of Constable's ponds and rivers. *Frosty Morning* (1813, London, Tate Gallery) is a description of winter in terms of winter light and atmosphere, without picturesque embellishments: the bare ground, entirely without vegetation, the naked trees, the few figures express the sensation of a bitter frost slowly yielding to the feeble sun, but do so without a hint of pantomime or narrative. Constable's friend, John Fisher, greatly admired this picture, which, in fact, comes close to the unaffected "natural painting" for which Constable strove.

Turner's essays in outdoor painting had marked a brief and rather exceptional episode in his work; he remained, at bottom, a studio painter. His Thames landscapes, in their intimate naturalism and limitation to a particular geographic setting, recall Constable's attempts at "natural painting" in the Stour Valley. But Turner was unwilling to limit himself for long to any one direction. While studying nature on the Thames, he continued to compose imaginary landscapes in the studio, though closely observed effects of atmosphere and weather now entered more prominently into his dramatic compositions. *Snowstorm: Hannibal and His Army Crossing the Alps* (1812, London, Tate Gallery), which was praised by contemporary critics for its "terrible magnificence" and "powerful unison of the moral and physical elements," is not so much a regular landscape as the description of a cataclysm. An enormous cloud forms a dark canopy over the vaguely indicated battlefield. The eye is led through a great vortex of swirling vapor to the far distance where, against a hazy light, the tiny silhouette of Hannibal's elephant appears. Like David's classical histories, Turner's painting carries a modern, national reference. Turner saw a parallel between the struggle of Hannibal's Carthaginian empire against Rome and Britain's war against Napoleonic France. The memory of an actual storm, recently witnessed at Farnley, combined with historical meditations (expressed in lines from a poem of his own composition, *Fallacies of Hope,* which accompanied the picture) and, perhaps, artistic associations (David's *Bonaparte Crossing the St. Bernard,* which he had seen in Paris in 1802?) to form an image of very complex meaning.

An ambitious project on which he embarked in 1807, the publication of a series of landscape prints under the title *Liber Studiorum (Book of Studies),* invited comparison with Claude Lorrain's celebrated series of sepia landscape drawings, the *Liber Veritatis (Book of Truth),* made popular in Britain by Richard Earlom's aquatint reproductions published in the 1770s. Claude had intended his drawings merely as a private record of works completed. Turner's purpose was demonstrative, rather than documentary. His compositions—drawn in pen and wash, and reproduced by himself in outline etchings, to which professional engravers added tone by means of the mezzotint technique—were intended to bring his work to a large audience and to display his mastery of the various forms of landscape, which he somewhat academically grouped under six headings: Historical, Pastoral, "E.P." (Epic or Elegant Pastoral, in the manner of Claude), Mountain, Marine, and Architectural. Intended to run to a hundred plates, the *Liber Studiorum* appeared in fourteen parts, each of five plates, between 1807 and 1819. Public indifference and difficulties with the engravers brought it to a halt after the issuance of the seventy-first plate. Many of the prints were based on Turner's

earlier paintings; others, specially drawn for the series, attest to the strong hold on his imagination of the Claudian ideal of landscape.

In 1814, the British Institution, an association of art patrons among whom Sir George Beaumont—Constable's friend and Turner's sworn enemy—played a leading role, sponsored a competition for the best landscape painting "proper in point of subject and manner" to be a companion to a work by Claude or Poussin. Turner's entry, *Appulia in Search of Appulus* (1814, London, Tate Gallery), based on a subject from Ovid, was adapted both in theme and composition from paintings by Claude with which he was thoroughly familiar. He improved on his models mainly by treating the hazy distance of his background with more precise atmospheric realism. Though his paraphrase of Claude was so close as to verge on copying, in keeping with the terms of the competition, Turner failed to win the prize.

At the Academy exhibition of 1815, the resurgence of the grand manner in his work was made emphatically manifest by two paintings of obviously Claudian inspiration. *Crossing the Brook* (1815, London, Tate Gallery) is a landscape poem composed of Claudian stereotypes, but incorporating elements of English scenery gathered on a recent tour of Devon. The sweeping view between bordering trees downward onto a wide plain that stretches into the misty distance is particularly beautifully realized and caused the critic William Hazlitt to remark that Turner did not represent "the objects of nature but the medium through which they are seen." In one of the girls beside the brook, contemporaries recognized Turner's illegitimate daughter, Eveline.

Dido Building Carthage, or the Rise of the Carthaginian Empire (1815, London, National Gallery) was considered by himself as his masterpiece and bequeathed by him (together with *Sun Rising Through Vapours*) to the National Gallery, with the request that it be hung beside two paintings by Claude, of which one, the *Embarkation of the Queen of Sheba,* was the model on which he had mainly built his picture. This is the most striking instance of Turner's wish not merely to follow but to stand as an equal beside Claude, and perhaps to surpass him. In this painting, he elaborated further on what he saw as an analogy between Carthage and Britain (cf. his *Hannibal* of 1812): Carthage in its rise stands for Britain victorious over Napoleon in 1815. Britain, like Carthage, now faced future dangers, as yet unrecognized, of decline and destruction. (Two years later, Turner painted as a sequel another classical harbor scene, this one illuminated by a lurid sunset: the *Decline of the Carthaginian Empire.*)

Though modeled on Claude's *Embarkation,* Turner's picture is different in visual effect and emotional tone. Its spaces are deeper, its structures more complex; as the Academy's professor of perspective (since 1807), he used this opportunity for a display of his mastery. He also sharpened his picture's drama of light and atmosphere, stressing the sunlight's penetration of the hazy air, the progressive emergence of the buildings from veils of mist, and the river of reflected light on the water. The flooding light that measures the vastness of the view and gives it coherence at the same time carries the picture's keynote of triumphant morning spirit.

In its hidden reference to modern political reality, Turner's *Dido Building*

Carthage is comparable to the subjects from ancient history which David had used as lessons for modern France. But as a landscape painter Turner made his picture's meaning depend less on the historical subject or on classical detail of costume and architecture than on the natural spectacle that he chose as its setting: the sunrise symbolizes the rise of Empire. Past art had given him his image, his own historical reflections suggested a new theme, but it was a deeply relished visual experience that supplied the expressive pictorial form he needed. Light, or the color of light, here for the first time in his work is the chief agent of expression.

Turner's vast production of watercolors for the print trade, his steadiest source of income, advanced the stylistic innovations that began to appear in his work about this time. The technique of building form entirely with color, without outline or shading, grew out of a process by which he worked up his watercolors, the compositions of which he now generally blocked out in broad color areas before introducing into them the defining details of surface and contour. This method is exemplified by the large watercolor *Landscape: Composition of Tivoli* (1817, private collection), which he began by painting a full-size color composition (British Museum) in which he merely suggested the main masses with broad color washes. The finishing into recognizable shapes of such an abstract color composition, or "color-beginning," was accomplished in a rapid process of detailing the individual features by deft hatchings or stipplings with the pointed brush, by the blotting of lights from the wet or scratching into the dry pigment. By these manipulations, which struck those who saw him at work as a kind of magic, Turner transformed the initial, vague color blurs into astonishingly precise illusions of space, air, light, and teeming detail.

The collapse of Napoleon's Empire opened the Continent to English travelers. Turner, busy with work for the engravers, had to wait until 1817 before crossing the Channel again. His second trip outside Britain took him to the battlefield of Waterloo, to Holland, and to the scenic stretch of the Rhine between Cologne and Mainz. One of the results of this voyage was a set of fifty-one watercolors of Rhenish subjects on toned paper and of particularly free and fresh execution. Another was the large canvas *Dort or Dordrecht: The Dort Packet-Boat from Rotterdam Becalmed* (1818, New Haven, Yale Center for British Art), painted in homage to the seventeenth-century Dordrecht painter Aelbert Cuyp, master of luminous water views. This is one of the earliest paintings by Turner to be composed mainly in colors. Its extreme, evenly diffused brightness startled viewers; the heavy boats appear to be floating in light, suspended between the golden sky and its reflection in the water. Constable, not always an admirer of Turner, called *Dort* "the most complete work of genius I ever saw."

In August of 1819 Turner set out on his first voyage to Italy, making stops in Venice, Rome, and Naples, and returning via Florence in January of 1820. In these six months, he produced more than 1,500 topographical drawings in pencil, some 200 of them of large size, and many watercolor sketches of Italian land- and townscapes. *Venice, San Giorgio Maggiore* (1819, watercolor, London, British Museum) exemplifies Turner's drawing with the brush, in transparent, pure

colors, on white paper. *Rome, the Arch of Constantine* and *Naples, View of Mount Vesuvius* (both 1819, London, British Museum) are among the Italian watercolors, some on white, others on gray-tinted paper, that are marked by a special brilliance of blue sky and reflected light, the immediate yield of Turner's impressions of Italian climate and atmosphere.

Few paintings in oil resulted from the Italian voyage. *Rome from the Vatican, Raphael and la Fornarina* (1820, London, Tate Gallery), of unusually large dimensions (ca. 6 × 11 ft.), represents, in a perspectival tour de force, an extensive panorama of Rome as seen from the Vatican loggia. Painted in the year of the three hundredth anniversary of Raphael's death, it sums up Turner's impressions of the cultural riches of Rome, and pays tribute to the Renaissance artist, shown with his mistress amidst a clutter of masterworks, including—prominently—a Claudian landscape which suggests that Turner may have identified himself with Raphael.

The Bay of Baiae, Apollo and the Sibyl (1823, London, Tate Gallery) shows a sweeping view of undulating, sun-parched terrain embracing a deep blue bay. The cluttered foreground, streaked with black shadows (Turner was beginning to use bituminous paints), contrasts sharply with the empty brightness of the sky, into which two umbrella pines thrust their heads, a motif borrowed from Claude. Apollo is shown granting the Cumaean Sibyl the gift of long life, which, because it is not accompanied by the promise of perennial youth, will condemn her to vegetate—like modern Italy—in endless senescence. The picture is an elegy on the transience of man in the midst of nature's eternal splendor.

Turner painted fewer large oils and was a less frequent exhibitor at the Academy during the 1820s than in previous years. In steady demand by publishers, he spent his energies on an enormous output of watercolors, destined to be engraved and published serially, such as the mezzotint series the *Rivers of England* (issued 1823–27) and the *Ports of England* (1826–28). For the most ambitious of these topographical series, *Picturesque Views in England and Wales* (1826–38), he drew a hundred large watercolors that for richness of invention and beauty of execution are unsurpassed among his own or his contemporaries' works. Turner needed the stimulus of fresh experience. The preparatory work for his watercolor schemes called for frequent sketching tours and several trips to the Continent (1821 to Paris and Normandy; 1825 to the Netherlands and the Rhine; 1826 to France and Germany; 1828 to Italy; 1829 to Paris, Normandy, and Brittany) during which he filled his sketchbooks with rapid pencil drawings from which he later chose particular subjects for development into full-fledged watercolors. In doing this, he used much poetic license, imagining effects of storm, sunset, or moonlight to dramatize and sometimes to overwhelm his scene, and composed his colors in a highly personal, expressive manner, with little regard for "truth" to nature. But unlike his oils, which often baffled critics and public by their defiance of conventions and their obscurities, Turner's watercolor designs for the engravers were meant to be—and succeeded in being—popular romantic entertainments which catered for a public whose taste had been formed by the writings of Scott, Byron, and the lesser poets whose verses filled the annuals and

Keepsakes. It was this aspect of his work that gained him a popular success such as Constable never enjoyed.

In their very artificiality, however, Turner's watercolors also served his own private interest by providing occasions for abstract color experiment, divorced from any immediate representational purpose. Side by side with this expressive-abstractionist tendency, a naturalist strain continued, gradually decreasing, in Turner's work of the 1820s. It emerged in his occasional returns to house portraiture, as in the paintings of the residence of William Moffat, *Mortlake, Early Summer Morning* (1826, New York, Frick Collection), and its companion, *Mortlake, Summer Evening* (1827, Washington, National Gallery), both studies of changing light on a lime-shaded, Thames-side terrace at different times of day. A similar directness and objectivity of observation characterizes the pictures of Cowes Castle, with the Regatta in progress, that Turner painted in 1828 for the architect John Nash, and the series of wide landscapes *(Chichester Canal, Brighton Chain Pier, Petworth Lake)* that he painted about the same time for the dining room of his patron and friend, Lord Egremont, at Petworth.

In the late summer of 1828, Turner traveled to Italy for the second time, going straight to Rome, where he shut himself into the studio to paint in oil on canvas, instead of roaming from town to town drawing pencil sketches as he had done in 1819. Before leaving Rome the following January, he exhibited three or more of his paintings, some not quite finished, in his Roman studio to a puzzled and skeptical local audience. *Regulus* (1828, completed 1837, London, Tate Gallery) is a classical harbor scene resembling *Dido Building Carthage* (1815). The subject, from Horace, concerns Regulus, a Roman general defeated by the Carthaginians who was sent by them to Rome to negotiate a peace, but instead urged the Roman Senate to refuse the Carthaginian terms. Unwilling to break his parole, Regulus returned to his captors, who tortured him by cutting his eyelids and exposing him to the sun. The action in the picture's foreground does not include Regulus; it is in the blinding intensity of the central burst of light that Turner suggests the nature of his punishment.

Palestrina—Composition (1828, London, Tate Gallery) was painted in Rome as a companion piece to a landscape by Claude Lorrain in Lord Egremont's collection. Like *Orvieto* (1828, London, Tate Gallery), another of Turner's paintings executed in Rome, this is as its title suggests a composition rather than a landscape taken from nature, and in its triple perspective—the road with bridge at the left, the stream in the center, and the pine-shaded alley at the right—an unusually complex one. The intensely blue Italian sky, with realistically observed clouds, supplies the one element of "nature" in what is otherwise purely a fantasy on Claudian themes.

After his return to England, Turner exhibited *Ulysses Deriding Polyphemus* (1829, London, National Gallery), based textually on Pope's translation of Homer and pictorially on Poussin's *Polyphemus* (Leningrad). The Greek ships are moving toward the rising sun. Ulysses, on the stern of his ship, brandishes a torch at the blinded giant agonizing high above him on the dark cliff. The picture is rich in "poetic" detail: phosphorescent Nereids play about the bow of

Ulysses' ship, and the fiery horses of Apollo are visible in the rising sun. The picture's central symbolism, the victory of light, is carried out in the pyrotechnical illumination of sky and sea, in the splendor of color that owes something to Turner's recent impressions of Titian, and in the somber figure of the sightless giant (recalling Turner's reference to blindness in *Regulus*).

In September 1829, Turner lost his father, who had for thirty years attended to all his daily needs as his intimate companion, housekeeper, business agent, and studio helper, and who, in practical domestic matters, had taken the place of a wife. Turner never quite recovered from this blow. At age fifty-four, he now began to descend into a state of solitude that gradually deepened with the deaths of friends, supporters, and fellow academicians: Walter Fawkes in 1825, Sir John Leicester in 1827, Sir Thomas Lawrence in 1830, and Lord Egremont, his enthusiastic patron and frequent host, in 1837.

Despite these sorrows, some of Turner's works of those years are marked by a quiet serenity and special richness of color. *The Evening Star* (ca. 1830, London, National Gallery, apparently unfinished) is perhaps a "color-beginning" which luckily remained in a state of wonderfully suggestive incompleteness. Painted in translucent washes of oil that have the delicacy of watercolor, it is very simply composed of three horizontal bands: the paling sky, in which the star gleams still barely visible; the dark sea with the star's bright reflection; and the warm sand of the foreground, with the lone fisherman and dog. The picture's quiet intensity of mood calls to mind C. D. Friedrich's *Monk at the Seashore* (1807). *Calais Sands, Poissards Collecting Bait* (1830, Bury Art Gallery) is similarly conceived but more richly furnished, and has a fiery sky recalling that of *Ulysses Deriding Polyphemus.* Turner considered it finished enough to be exhibited at the Academy.

In 1831 he traveled in Scotland, to visit Sir Walter Scott at Abbotsford and to gather material for illustrations of Scott's works. *Staffa: Fingal's Cave* (1832, New Haven, Yale Center for British Art) was suggested by a stormy steamer voyage to the island of Staffa on the Scottish coast. Between a threatening storm cloud that engulfs the setting sun and the cliffs of Staffa shrouded in the white mist of surf, a small steamboat fights the heavy seas, trailing a vane of smoke from its tall funnel. The image of a small boat storm-tossed in the ocean's vastness occurs in several of Turner's late works, and probably was meant to express a sense of mankind's struggle against the elemental might of nature that he shared with other artists of his time—compare Friedrich's *Arctic Shipwreck* (1823–24) and Géricault's *Raft of the Medusa* (1819).

In October 1834 Turner was among the crowds that witnessed the nocturnal fire which destroyed the Houses of Parliament. The grandeur of the sight prompted him to make sketches on the spot (as did Constable, who was also among the spectators). From these, he developed two paintings, both titled *Burning of the Houses of Parliament* (1835, Cleveland Museum of Art; 1835, Philadelphia Museum of Art) and centered on the burst of fire that rose from the burning buildings when the roof of the House of Lords collapsed, a sight that "so struck bystanders that they involuntarily clapped their hands as though they had

been present at the closing scene of a dramatic spectacle." Turner worked up the Philadelphia version from a rough "color-beginning," completing it after its installation at the Academy exhibition, to the amazement of fellow exhibitors.

During 1833, Turner had once again visited Venice, his interest in Venetian themes having revived in the previous year for reasons unknown. From this time on, views of Venice, popular with collectors and critics, played an increasingly important role in his work, gradually replacing his Claudian landscapes. *Venice* (1834, Washington, National Gallery), a picture of very careful execution, brilliant in its evocation of late-summer sunlight and warmth, was perhaps influenced by the great eighteenth-century Venetian view painter Canaletto (whom Turner had included in one of his earlier Venetian scenes) and perhaps also by the English painter Richard Parkes Bonington, recently deceased, whose Venetian subjects were keenly appreciated by English collectors. For the patron who had commissioned *Venice,* Turner painted a pendant picture, representing—by way of striking contrast—an industrial English harbor in the moonlight, *Keelmen Heaving in Coals by Night* (1835, Washington, National Gallery).

The very numerous paintings of Turner's later years for the most part conform, in subject matter and compositional arrangement, to the main types that he had developed over the years: the wide Claudian vista with flanking pines, the agitated Dutch sea-piece, and the blue-skied Venetian *vedute.* The large number and uniformity of these works resulted in part from Turner's method of working up his pictures for sale or exhibition from a large stock of "color-beginnings," lightly stained canvases in which the basic compositional schemes were faintly indicated. These rapid preparations, mere dreams of future pictures, he produced in quantity and stored away for further use, working one or the other of them into an exhibitable composition when it suited him, sometimes completing the process on the walls of the Academy. Many of these color-beginnings, dating from circa 1825–40, survive, for the most part in the Tate Gallery and the British Museum. To modern eyes, they can be more satisfying, in their beauty of pure color and suggestive indistinctness, than the finished paintings into which he converted some of them. The process of that conversion consisted of an imaginative projection of objective forms onto the abstract shapes of the color-beginnings, conjuring illusions of space, light, and solid form from stains of pigment. The novelty of this method was that the resulting image was derived neither from reality nor from art, but from the very process of painting: color, acting on the imagination, guided it toward intelligible form and meaning. It is apparent that Turner first developed this method in connection with watercolor practice, then applied it to painting in oil.

Ship imagery, with symbolical overtones, plays a prominent role in Turner's later work. One such vessel, the *Temeraire,* had been among Nelson's ships of the line at Trafalgar. By the 1830s, these veterans of the Napoleonic wars were being replaced with steamships. Turner, on an excursion on the Thames, encountered the old ship being towed by her scrapper, and conceived a scene of sunset—*The Fighting Temeraire Towed to Her Last Berth to Be Broken Up* (1838, London, National Gallery)—in which the ghostly grayness of the *Temeraire* is

contrasted with the vivid black steamer that tows her, in a way that not only dramatizes the replacement of a former heroic age by a modern technical one, but hints at human obsolescence and death. The picture, in its imagery and meaning, has a close parallel in C. D. Friedrich's nearly contemporary *The Stages of Life* (ca. 1835, Leipzig Museum).

The Fighting Temeraire was the last of Turner's works to win, on being exhibited, a great critical success, partly due to its patriotic appeal. Even its blazing intensity of color, normally the critics' chief complaint, here was found appropriate. But from this time on the progressive dissolution of form in his paintings rapidly passed the comprehension of public and critics. His "whirlpools of color" earned him the reputation of extreme eccentricity and unintelligibility, if not downright madness. It was at this time that John Ruskin, a recent Oxford graduate, took up his defense in *Modern Painters* (the first volume of which was published in 1843), and with passionate argument and gorgeous prose brought Turner more vividly before the public than had any previous exhibition or publication.

In Turner's distinctive late style, the material solidity of sea, land, and vegetation is dissolved in bursts of radiant light, in haze or steam, or in revolving turbulences of fire, smoke, and cloud by which he meant to express the power of the elements. His conception of landscape reflected late-eighteenth-century notions of the "energetic sublime" in nature. Instead of the scenes from myth or history that had constituted the themes of his earlier compositions and raised them to the level of historical landscape, it was the display of natural forces that furnished the essential drama of his late landscapes, in flaming cataclysms and catastrophes, in storms and baleful sunsets. It is noteworthy that in several of his late works he used modern technical and industrial imagery—steamships and locomotives—which more conventional painters avoided as "inartistic."

Slavers Throwing Overboard the Dead and Dying—Typhoon Coming On (1840, Boston, Museum of Fine Arts) is known for short as *The Slave Ship*. At the left, the ship advances into the whitecaps of the storm, while the blood red sun sets behind it. In its wake, the sea—"the noblest that Turner has ever painted," according to Ruskin—teems with fish feeding on the drowning slaves. In 1840, the year of slavery's formal abolition, the subject carried a highly political meaning. Turner's inspiration, however, seems to have come from his favorite poetic source, Thomson's *Seasons,* which (in the part entitled *Summer*) contains the description of a typhoon, with sharks preying on castaway slaves. He may also have read an account of the slave ship *Zong* (published 1839) whose captain had thrown sick slaves overboard so that they could be declared as lost at sea, and hence covered by insurance. Ruskin was given this picture by his father in 1844, but later sold it, finding its subject painful.

Peace: Burial at Sea (1842, London, Tate Gallery) commemorates the death and sea burial of a fellow academician, David Wilkie. Of octagonal shape and predominantly blue color, the picture was paired with *War: The Exile and the Rock Limpet,* similarly shaped and of reddish color, one of several such picture pairs of significantly contrasted themes and colors that Turner painted in

the 1840s. The silhouette of the funereal ship, afloat in the blueish luminescence of night sky and water, was criticized for its blackness, causing Turner (mindful of his symbolical intention) to say that "I only wish I had any color to make it blacker."

The idea of expressing meanings through pure color and light was pursued even more clearly in other twinned paintings of this time. In 1843, Turner exhibited a pair of canvases under the elaborate titles *Shade and Darkness—The Evening of the Deluge,* and *Light and Color (Goethe's Theory)—The Morning After the Deluge—Moses Writing the Book of Genesis* (both in the Tate Gallery), the one more or less abstractly composed in the "negative" hues (in Goethe's terminology) of blue and green, and the non-color of black, the other in the "positive" hues of yellow and red and the panchromatic whiteness of light. In these late, romantic experiments with the psychological and symbolical properties of color, the aged Turner approached unwittingly the earlier color experiments of Philipp Otto Runge (of ca. 1808), with a knowledge of Goethe's color theory forming the sole—very slight—link between them.

Snowstorm—Steamboat Off a Harbor's Mouth Making Signals in Shallow Water and Going by the Lead (1842, London, Tate Gallery) documents a personal experience: "the author was in this Storm the Night the Ariel left Harwich," as Turner put it in his subtitle. Composed of spiraling forms curving around one another into a vortex of steam and water in which the distressed steamboat dimly appears, trailing smoke and ablaze with rockets, this is his quintessential ship-wreck picture. In its cataclysmic setting it recalls *Hannibal* (1812), and in its ship symbolism *Staffa* (1832), that other autobiographical image of human struggle against nature's power. Critics ridiculed the picture as "soap-suds and white wash." Turner angrily insisted on the *reality* of the event, which he had experienced both as an artistic observer and as a potential victim.

After 1828, Turner stopped giving his regular lectures as professor of perspective, having puzzled half a generation of Academy students with the opacity of his verbal and the beauty of his visual presentations, but resigned his professorship only in 1837. He continued to participate in Academy business, and in 1845 briefly acted as president. He also continued his Continental summer travels, visiting Venice for the last time in 1840, and touring Switzerland in 1841, and again in 1842 and 1844, to bring home those watercolors of luminous transparency and nervous, sketchlike execution that Ruskin, who bought many of them, valued above all his works in this medium. At the Academy, where he exhibited regularly, his Venetian views were generally appreciated, since reviewers believed that they understood them, while his more daring compositions were greeted with irritation or ridicule.

At the Academy exhibition of 1844, Turner was represented by seven paintings: three Venetian views, three sea-pieces of the Dutch kind, and *Rain, Steam, and Speed—The Great Western Railway* (1844, London, National Gallery), his last great work. To the right of a hazy panorama of river, fields, and distant town, a train approaches across a bridge, seen in steep perspective from a high point of vantage. The black engine, lights blazing, emerges, sharply dis-

tinct, from behind veils of slanting rain. Just ahead of it, a hare leaps across the tracks. The subject had special significance in 1844, when railway construction and speculation were at their height. The bridge in the picture was recognizable as a recently completed engineering feat, Brunel's Maidenhead Viaduct on the new Great Western line to Bristol and Exeter. To Turner, a constant traveler, the railways were an important innovation, offering speed and comfort, but also marking the passing of an older, more leisurely way of life. The contrast between the relentless, rushing engine and the rain-blurred, rural landscape, with its startled hare, the plowman in the distance, and the solitary angler on the river below, is very pointed. It is noteworthy that Turner, in his old age, did not—like most artists of the time—ignore the industrial era. Strong sensations, even if produced by machines rather than nature, always roused him. According to a credible story reported by Ruskin, his picture was inspired by personal experience: a train ride in a rain storm, during which he stuck his head out of the window to savor the wind of speed.

During the late spring, and again in the autumn of 1845, he traveled to France, his last trip abroad. King Louis Philippe of France, who had known Turner in England, entertained him at the Château of Eu. In 1846, aged seventy-one and still productive, he sent six canvases to the Royal Academy exhibition, including an apocalyptic vision, *The Angel Standing in the Sun* (1846, London, Tate Gallery), accompanied by a verse from Revelation, "And I saw an Angel standing in the sun; and he cried with a loud voice, saying to all the fowls that fly in the midst of heaven, come . . . that ye may eat the flesh of kings, and the flesh of captains, and the flesh of mighty men. . . ." The vortical composition, centered on the figure of the Angel brandishing a sword, powerfully expresses the radiance of the sun, which the unreligious Turner is said to have identified with God, in a setting suggestive of a Last Judgment—as a bringer of death rather than of life.

As his health gradually declined, Turner's activity decreased. He appeared before the public at the annual exhibitions of 1847–50 with a few, last compositions in which he again, with faltering powers, took up old fantasies of Dido, Aeneas, and Carthage. Though an eminently public figure, a man of great fame and wealth, he now withdrew from visibility, ceased to attend Academy functions, left his house and gallery without telling anyone where he might be found, and hid himself in a small rented house in Cheyne Walk, Chelsea, in the care of a Mrs. Booth. He went to the extreme of hiding his identity under an assumed name, calling himself "Mr. Booth," and passing for a retired naval officer.

Turner died in his Chelsea house on December 19, 1851. The doctor who attended him recorded that "just before 9 AM the sun burst forth and shone directly on him with that brilliancy which he loved to gaze on." He was buried in St. Paul's Cathedral, beside Reynolds and Lawrence, as he had wished. In his will, he had bequeathed all his works still in his possession to the nation. This was contested by relatives, on the grounds that Turner was of unsound mind when he made his final testament. The case was settled only in 1856. Turner's works went to the nation; the remainder of his considerable property (which he

had destined for impoverished artists) was distributed to relatives to whom he would have given nothing.

On first meeting Turner in 1840, Ruskin summed up his impressions as follows: "Introduced today to the man who beyond all doubt is the greatest of the age; greatest in every faculty of the imagination, in every branch of scenic knowledge; at once *the* painter and poet of the day, J. M. W. Turner. Everyone had described him to me as coarse, boorish, unintellectual, vulgar. This I knew to be impossible. I found him a somewhat eccentric, keen-mannered, matter-of-fact, English-minded gentleman: good-natured evidently, bad-tempered evidently, hating humbug of all sorts, shrewd, perhaps a little selfish, highly intellectual, the powers of his mind not brought out with any delight in their manifestation, or intention of display, but flashing out occasionally in a word or look."

READINGS

A. J. Finberg, *The Life of J. M. W. Turner,* 2nd edn., Oxford, 1961, is the most detailed biography, but does not attempt any art historical interpretation of Turner's work.

J. Lindsay, *J. M. W. Turner, His Life and Work,* London, 1966, adds further biographical information and makes full use of Turner's neglected writings, but goes rather too far in its confident explanations of Turner's intentions and meanings.

M. Butlin and E. Joll, *The Paintings of J. M. W. Turner,* New Haven and London, 1977, presents a comprehensive, detailed, and fully illustrated catalogue of Turner's paintings, without attempting a coherent interpretation.

A. Wilton, *J. M. W. Turner, His Art and Life,* New York, 1979, combines coverage of selected aspects of Turner's biography and analyses of main tendencies in his work with a summary inventory of the paintings and a particularly useful, illustrated catalogue of the watercolors.

J. Gage, *Colour in Turner, Poetry and Truth,* London, 1969, offers analyses of the work and gives important insights into Turner's methods of work.

J. Gage, *Turner: Rain, Steam, and Speed,* London, 1972, usefully analyzes one key work.

G. Reynolds, *Turner,* London, 1969, gives a very concise overview of life and work.

Royal Academy, London, *Turner, 1775–1851,* a catalogue of the commemorative exhibition of Turner's work, London, 1975, by M. Butlin and A. Wilton. A very convenient guide to a large part of the work. Well illustrated.

British Museum, London, *Turner in the British Museum, Drawings and Watercolours,* a catalogue of the British Museum's large holdings of Turner's drawings and watercolors, by A. Wilton, 1975.

7

French Romantics

Jean-Dominique Ingres, 1780–1867
Théodore Géricault, 1791–1824
Eugène Delacroix, 1798–1863

Jean-Dominique Ingres, 1780–1867

By the end of his long life, Ingres had come to be regarded as the formidable champion of classicism and the arch enemy of everything modern. This reputation was undeserved. As David's pupil in the late 1790s, at a time when David was attempting to reform his own style, Ingres had rapidly progressed beyond his teacher in the direction of radical formal abstraction and developed a manner so individual that to uncomprehending contemporaries it seemed "Gothic" or "Chinese" rather than Greek. Far from floating with the mainstream of Davidian classicism, he chose to spend his early years in Italy in poverty and obscurity, obstinately persisting in work that Paris would not appreciate: a lone rebel as much as any Romantic. His single-minded dedication to an ideal of beauty based on difficult harmonies of line and color, on the music of relationships and the mathematics of form, kept him in isolation. Unlike David, he was blind to politics, cared little for nation, emperor, king, or church, and felt himself to be exclusively an artist, a calling that was to him a form of priesthood. Alone among David's best students, he outlived the school's bankruptcy and emerged, embattled but unimpaired, as one of France's dominant artists in midcentury. All his life, he had disliked the Academy and shunned the Salon, but by a strange irony he was adopted by the establishment in the latter part of his career, and miscast in the role of a conservative. As such he has long figured in the history of art, though his work proclaims him to have been an artist of daring originality.

Ingres was born in 1780 in Montauban, in the South of France, the son of a painter, miniaturist, decorator, and sculptor in the employ of the town. The boy showed an early aptitude for music and drawing, and received his first instruction from his father. His classical education, received in a priest-run school, was scant, a fact that was to have an effect on his subsequent intellectual development.

In 1791, or possibly only in 1793, he began his studies at the Academy of Toulouse. One of his teachers, Joseph Roques, was a former pupil of Vien. He received the normal academic training, and won several prizes. But he also continued to cultivate his musical talent, played the violin in the orchestra of the theater of Toulouse, and seems to have wavered between his artistic and musical vocations. *"Le violon de M. Ingres"* (Ingres's fiddle) has become a common expression for a "strong, second talent."

Ingres went to Paris, accompanied by the son of Roques, in 1797, to enter the studio of Jacques-Louis David. After a period of disgrace following the fall

of Robespierre, David was again at the head of a thriving private academy. When Ingres arrived, he was at work on his *Battle Between Romans and Sabines,* in which he attempted to attain a purer, more "Grecian" style. Reflecting the instability of post-Revolutionary France, David's pupils were divided into several contentious factions. Beside the troop of obediently orthodox classicists, the studio contained, on the one side, some uncouth Bohemians (nicknamed *Crassons,* or pigs) and, on the other, youths of royalist and Catholic leanings (the *Muscadins,* or dandies). Finally, there had sprung up a small band of serious dissidents who aspired to an art more sublimely pure, more authentically classical —or rather, archaic—than their master's. Looking for inspiration in early literature, Homer, the Bible, and the pseudo-Celtic epics of "Ossian," these fervent idealists had visions of a communal life centered on strict observances and rituals. They dressed in ancient Greek costume and let their beards grow, hence the epithets of *Barbus, Primitifs,* and *Penseurs* (Thinkers) by which they were known.

Ingres, though not himself a member of the dissident group, appears to have sympathized with them to a degree; his own early work went beyond David in the direction of linear purity and implied a criticism of David's more moderate classicism. Grave and studious, not at all given to playfulness, he kept aloof from studio pranks. David held him in high esteem, and used him as his assistant in the execution of the *Portrait of Mme Récamier* (1800).

Admitted to the Ecole des Beaux-Arts (the reestablished Academy) in 1799, Ingres prepared himself for the Rome Prize competition. The *Male Torso* (1800, Paris, Ecole des Beaux-Arts), an academic exercise executed in a manner characteristic of David's workshop (scumbled, semi-transparent background and half-shadows over which the highlights are brushed in vigorous, opaque patches), in its precision of contour and subtlety of surface modeling already expressed Ingres's personal talent. It was awarded the first prize for a half-figure *(prix du torse)* in 1801.

Ingres won a second prize in his first try at the Rome Prize of 1800. His competition entry, *Antiochus and Scipio,* is lost. The following year he competed again, and this time won the prize with *The Ambassadors of Agamemnon in the Tent of Achilles* (1801, Paris, Ecole des Beaux-Arts), a work that, while still bearing the marks of David's influence, goes beyond David in its attenuation of the figures, the disjointed frieze composition, and the hard, "primitive" vehemence of red cloak, helmet, and crest. At the same time, the picture shows a contrary tendency in the anatomical realism of details, such as the strongly articulated arms and legs of several of the figures. Flaxman, visiting Paris in 1802, singled out this picture by the still quite unknown artist for special praise, somewhat to David's annoyance.

The unsettled political situation and shortages in the state budget forced a postponement of Ingres's departure for Italy. In the following years he was mainly occupied with portrait commissions. Like other artists of David's school, he was assigned studio space in a disused Capucin monastery, where he shared a cell with the young Florentine sculptor Bartolini. The sculptural monuments in the Musée des Petits-Augustins, works of the Middle Ages and the Renaissance

salvaged from churches pillaged during the Revolution, greatly impressed him and confirmed him in his taste for "primitive" or Gothic style. His studies at the Louvre, where Napoleon had assembled—among other artistic trophies—masterworks by the early Italian and Flemish painters, also served as a corrective to Davidian classicism.

Venus Wounded by Diomedes (ca. 1803–05, Basle Museum) marks an extreme point in Ingres's experimentation with archaizing abstraction. Composition, figure types, and the radical two-dimensionality of the image reflect Flaxman's influence; the horses of the chariot are copied from an engraving of a Greek vase. The effect is deliberately artificial, like that of colored relief. To leave no doubt about his intention, Ingres applied gold leaf to the manes of the horses and to the chariot. Archaic stylization derived from very different sources appears in the *Portrait of Bonaparte as First Consul* (1804, Liège Museum), in the sharp flatness of the red uniform worn by Napoleon and the intricately linear play of folds that—in lieu of shadows—articulate his figure. The hard juxtaposition of strong colors, the crisp contours, and the vividly detailed patterns in carpet, furniture, and costume hint at Ingres's study of the early Flemish masters at the Louvre. By way of contrast, he offers a luminous, atmospheric view of a part of the city of Liège in the window behind the Consular throne.

About this time, Ingres painted his *Self-Portrait* (1804, Chantilly, Musée Condé), posing somewhat defiantly at his easel, a sharp piece of white chalk in his hand (in a repainting, around 1850, he added the dark brown cloak that covers his shoulders).

Ingres's originality as an exacting stylist, a discordant voice in the well-rehearsed chorus of the Davidian School, first became apparent at the Salon of 1806, to which he had submitted three portraits of members of the family of an official of the Empire. The *Portrait of Philibert Rivière* (1805, Louvre), is remarkable not only for its stylistic subtleties—which transform what might have been the banal likeness of an unremarkable individual into a work of rarefied beauty—but also as a document of the elegant sobriety of the post-Revolutionary ruling class, an image of opulence chastened by neoclassical restraint. M. Rivière is shown in a diffuse light against a neutral background. Almost without shadows, his figure is defined by crisp contrasts of color and tone, bounded by sharp contours. Black curls and sideburns frame the smooth, fresh-complexioned face, which emerges from the brilliant whiteness of starched collar and cravat. The dark brown frock coat is sharply silhouetted against the light gray of the breeches and the surrounding areas of color. A few gleams of gold, in the rings, watchfobs, and the carvings and embroideries of the chair, lend a discreet note of luxury to this picture of fastidious self-confidence.

For the canvas of the *Portrait of Mme Rivière* (1805, Louvre), Ingres chose an unusual oval shape. This sets the keynote of the picture, which is composed (in deliberate contrast to the portrait of M. Rivière) as an intricate pattern of elliptical curves. Mme Rivière's body arches against the soft embrace of rounded cushions, scarves, and shawls. Her features, the curvatures of eyebrows, eyelids, mouth, and chin, the dark curls of her hair, and the repeated roundnesses of

necklace, bracelets, and rings, all echo the motif on which the composition is based. This underlying abstract geometry is sumptuously clothed in a great luxury of color, finely chiseled surface modulations, and bursts of pure ornament. From the calculated artifice of these arrangements springs, as if by a miracle, the sensuous, human presence of the doe-eyed Mme Rivière, wholly convincing despite the numerous distortions of anatomy and space that result from the intricate design.

The third of these portraits, *Mlle Rivière* (1805, Louvre), has a format that differs significantly from those of its companions. The vertical oblong of the canvas, its top rounded, frames the slender figure of a girl whose artless pose is complicated only by the loops of the swans-down boa that coils around her body. The perfect egg-shape of her head is set against the intense blue of an open sky above a wide, verdant landscape with river and distant church. Ingres accentuated the fragile adolescence of the girl (who was to die later in the year) by stressing the narrowness of her shoulders and the smallness of her bust in contrast to the long, heavily gloved arms that give her something of the look of a filly.

The Rivière portraits mark Ingres's achievement of a personal style and conscious departure from David's example. This becomes apparent when they are set beside comparable portraits by David, such as those of M. and Mme Sériziat (1795), for example, or that of Mme de Verninac (1799). David conceived his figures sculpturally—as three-dimensional bodies firmly modeled by light and shadow, and situated in fairly deep space. Ingres's nearly shadowless figures are defined by sharply contoured color areas, and held within the plane of the canvas by a network of compositional lines. His method is graphic rather than sculptural, though this is masked by the careful execution in color, the detailed treatment of surfaces, the shallow roundness of flesh, and the undulations of garment folds, all of which tend to create the effect of low relief.

Although the Rivière portraits were overlooked by the critics of the Salon of 1806, a fourth painting, *Napoleon on the Imperial Throne* (1806, Paris, Musée de l'Armée), provoked them to indignant sarcasm. Ingres conceived of this colossal ceremonial portrait, commissioned for the Legislative Assembly, as an icon of superhuman authority. He showed Napoleon, rigidly frontal, seated in the heavy regalia of state on a throne the back of which circles his head like a halo. The traditional imagery of divine omnipotence helped to shape this portrait of the brand-new emperor: there is in it something of Flaxman's *Zeus* and of Jan Van Eyck's *God the Father* of the Ghent Altarpiece (on view in Paris at the time). The static symmetry of the pose and the hard distinctness of garment folds and embroideries struck critics as "gothic." Ingres's intention in dressing the modern usurper in Byzantine pomp was to link him with an authentic monarchial tradition, that of Charlemagne—archaism on this occasion made a political point, though it seems to have been lost on contemporaries.

Ingres had meanwhile set out for Rome, where he arrived in October of 1806 and, as pensioner of the French Academy, was assigned quarters in the Pavilion of San Gaetano on the grounds of the Villa Medici. During the four years of his stipend, he was occupied with studies of the antique and of the masters of

the Renaissance, and with drawings of the churches and gardens of Rome. His range of interests was unusually wide. While he steeped himself in ancient art, he reserved his most fervent admiration for Raphael. His interest in the archaic made him receptive to medieval, Byzantine, and Early Renaissance work that the majority of his fellow students tended to dismiss as merely primitive.

Several of Ingres's most masterly portraits were painted during the early years of his Roman stay. The *Portrait of Mme Duvauçay* (1807, Chantilly, Musée Condé), posed by the Neapolitan mistress of a French diplomat, carries to a point of even greater concentration and intensity the compositional virtuosity of his *Portrait of Mme Rivière*. The colors of the accessories are reduced to an accord of red, gold, and black, calculated to flatter the warm ivory of the young woman's skin. The perfect symmetry of her face is offset by carefully contrived asymmetries in the pose, the chair back, and the satin shawl. The curve of her smiling lips is answered by a multitude of curves and countercurves throughout the picture, a network of harmonizing lines that holds the image in what seems a momentary, almost accidental perfection of balance.

The *Portrait of François-Marius Granet* (ca. 1807, Aix-en-Provence, Musée Granet) represents an artist-friend, bust-length, before a panorama of Rome over which hangs an ominous storm cloud. The expressive face, cradled on an immense collar of sharpest white and backed by the slate gray of the sky, hints at the intensity of emotion that lies, as if harnessed, behind the controlled formality of Ingres's style. The heavy cloak is very broadly painted, without the artist's customary minuteness of touch. The pose derives from the *Self-Portrait* of 1804.

Required to submit samples of his work as pensioner of the Academy to the judgment of its Parisian faculty, Ingres painted several studies of the nude, making them exhibitable by adding narrative detail. *Oedipus and the Sphinx* (1808, Louvre), begun as a simple life study of a male nude posed in pure profile, was subsequently provided with its setting of looming rocks, a baleful, high-bosomed sphinx, and a macabre still-life of human bones and cadaverous foot. The pose is classical, the treatment of the figure surprisingly realistic, the spirit of the whole Romantic.

The Grand Bather (or Valpinçon Bather) (1808, Louvre) stylizes the back of a posing female model with the utmost refinement of contour and color. Except for the shoulders and neck, the figure is illuminated only by the diffuse reflections from the linen of the bed on which she is seated. Perhaps to confound the critics who had accused him of "gothicism," Ingres suggested the internal modeling of the body purely through fine gradations of tone, confining linear arabesques to the bywork of linen and kerchief. This is the first of a series of *Bathers* that extends throughout his long career and in which he expressed his strong sensuality by means of exquisitely restrained and disciplined forms.

At the expiration of his stipend in 1810, Ingres decided to stay on in Rome. He supported himself by painting portraits of high French officials and their wives, including that of Charles Marcotte (1810, Washington, National Gallery), who became one of his earliest patrons. He also drew many fine pencil portraits of members of the French colony, developing a manner of swift and precise

characterization that is entirely his own. Using sharply pointed graphite pencils, he drew the costumes in light outline, lingering over frills and folds, but reserving the more emphatic touches of tone for the heads, accentuating eyes, curls of hair, and the small, sharp shadows of nose, mouth, and chin. The whiteness of the paper gives a strong sense of light to these small portraits, to which Ingres often added views of Roman churches or palaces by way of background.

As his final academic submission, he sent to Paris the huge canvas *Jupiter and Thetis* (1811, Aix-en-Provence, Musée Granet). The subject is taken from Homer's *Iliad:* the beautiful sea-nymph Thetis implores Jupiter (Zeus) on behalf of her son, Achilles. The colossal frontal figure of Zeus, reminiscent of *Napoleon on the Imperial Throne* and influenced, like that painting, by the images of Zeus in Flaxman's illustrations of the *Iliad,* sits impassive on his cloud-borne throne, while Thetis presses her pliant body against his knee and chest, and extends a soft white arm to caresss his beard. Her profile and slightly goiterous throat show some influence from Greek vase painting, but also express a personal ideal of female beauty that recurs throughout Ingres's work. The shadowless body of Thetis, the arabesque described by her gesture, and the cascading folds of her garment mark the most extreme development of his erotically tinged, manneristic classicism.

Napoleon had proclaimed Rome the second city of the Empire and created his infant son king of Rome. He planned an extensive rebuilding of the city, starting with the Quirinale Palace, vacated by the Pope and intended to become the residence of the king of Rome. A team of artists, including Ingres, was recruited for the decoration of the imperial apartments in the palace, based on an iconographic program devised by Vivant Denon, the director of Napoleon's artistic propaganda service. Ingres's share consisted of two large paintings. *The Dream of Ossian* (1813, Montauban, Musée Ingres), originally of oval shape, was to be set into the ceiling of the emperor's bedroom. Influenced by Gérard's *Ossian,* painted for Malmaison in 1801, Ingres's composition shows Ossian asleep, leaning on his harp, while in the dark sky above him appear the shades of his departed kin and comrades in arms. The rather wooden treatment of this dream vision, often cited as proof of his "romanticism," shows, rather, that as a Mediterranean, pagan materialist Ingres found Norse spookery incomprehensible and uncongenial, though he was of course familiar with the current Romantic clichés. He later (ca. 1835) extensively repainted this canvas.

Romulus Victorious Over Acron (1812, Louvre), destined for the empress's apartment, was painted in tempera on an enormous canvas to harmonize with the existing earlier fresco decorations of the room (Old Testament battles). The subject, taken from Plutarch's *Life of Romulus,* inspired Ingres to attempt a severely archaic composition on a monumental, wall-filling scale. He organized the scene as a shallow processional frieze that is centered on the figure of Romulus, sharply silhouetted and patterned, carrying the spoils of his combat with Acron, whose disconcertingly realistic body lies bleeding at his feet. Many, very diverse influences entered into this deeply studied composition: Flaxman's linearism, motifs from Greek vases, Mantegna's *Triumph of Caesar,* and the rearing horse of one of the Quirinale *Dioscuroi.*

Another official commission was given to Ingres by the French governor of Rome, General Miollis. Its subject, *Virgil Reading the Aeneid Before Augustus, Livia and Octavia,* tempted Ingres to undertake a night scene, though in a severely classical style. The original version is now in the Toulouse Museum. A second, partial version (possibly a fragment), in the Brussels Museum, presents the figures of Augustus, Octavia, and Livia only, posed relief-like against a neutral ground. Among Ingres's important patrons was the queen of Naples, Caroline Murat, for whom he had painted in 1808 a *Sleeping Nude Woman* (now lost). Six years later, he was commissioned to paint a pendant, the *Grand Odalisque* (1814, Louvre), a woman of the harem reclining languidly on a couch, in a posture reminiscent of that of *Mme Récamier* in David's portrait of 1800, for which Ingres had painted the accessories. The execution is of steely, heartless perfection, the forms of the body—the curving back and the voluminous hip, the outrageously elongated arm, and the soft nakedness of the crossed legs—of an exquisite perversity bound to confuse and enrage the critics of the Salon, where, in 1819, the *Odalisque* was exhibited. (The Kingdom of Naples had meanwhile disappeared among the ruins of Napoleon's Empire, and the picture remained in Ingres's hands.)

Painted at about the same time but in a totally different style, *Pope Pius VII in the Sistine Chapel* (1814, Washington, National Gallery) presents a modern scene, witnessed by Ingres, with brilliant, objective realism.

The fall of Napoleon and the subsequent collapse of the French governments in Rome and Naples deprived Ingres of all patronage and put him under severe financial strain. For several years, he was reduced to eking out a meager living by drawing pencil portraits of visiting foreigners, for the most part English. He had married a young woman, Madeleine Chapelle, in 1813, who loyally shared his poverty.

Ambitious to excel as a history painter but not gifted either for the thematic development of grand subjects or for large-scale composition, Ingres profited from the fashion (on the rise since ca. 1810) for small, genre-like anecdotal pictures. These were both highly salable and well suited to his talent for intricate composition and minute execution. Filled with conscientiously researched historical detail, his little histories, concerned with actual or imaginary events from the lives of famous men, have the bright distinctness of colored illustrations—rather than miniaturized frescoes, they seem enlarged miniatures: *Raphael and the Fornarina* (1814, Cambridge, Mass., Fogg Museum); *Cardinal Bibbiena Offering the Hand of His Niece to Raphael* (1813–14, Baltimore, Walters Art Gallery); *Paolo and Francesca* (ca. 1814, Chantilly, Musée Condé); *Aretino in the Studio of Tintoretto* (1815, Paris, private collection); *Henry IV and the Spanish Ambassador* (1817, Paris, Petit Palais); and *The Death of Leonardo* (1818, Paris, Petit Palais). Most of these subjects exist in a number of replicas.

In 1817, Ingres at last received an official commission for a large altarpiece, *Christ Delivering the Keys to St. Peter,* for the French church of S. Trinita dei Monti in Rome. Completed in 1820, the painting combines splendid draperies with vapid heads—part Raphaelesque stereotypes, part model studies. It expresses not so much Ingres's personal piety as his compliance with the art politics of the Bourbon Restoration.

For the Salon of 1819, to which he also submitted his *Odalisque* of 1814, he painted a scene of romance taken from Ariosto's *Orlando Furioso, Roger Saving Angelica from the Dragon* (1819, Louvre). Roger, in golden armor, riding a hippogriff—half horse, half eagle—descends from the night sky to spear the sea monster, while Angelica, utterly nude, casts a desperate look at her savior. The composition derives from an antique relief representing Perseus and Andromeda, a very similar subject. The drama of Ingres's picture hinges on the contrast between the bristling, metallic Roger and the fleshy nakedness of Angelica, both brightly illuminated against the lugubrious stage set of cliff and sea. The Salon critics tore both the *Odalisque* and *Roger* to shreds, but the latter picture was bought by the government, a premonition of future favor.

Following an invitation by his old friend, the sculptor Bartolini, Ingres moved to Florence in the spring of 1820. The two friends soon quarreled, and Ingres found himself in worse straits. Fortunately, at this lowest point in his career, he received an important official commission that was to occupy him for nearly four years and to change his life. *The Vow of Louis XIII* (1821–24, Montauban Cathedral) commemorates an event in the dynastic history of France, and hence was of political as well as religious significance. In 1636, Louis XIII had placed his kingdom under the protection of the Virgin of the Assumption. From 1638 until the Revolution, this event had been celebrated as a national holiday. With the restoration of the monarchy under Louis XVIII, the holiday was reestablished to signify the renewal of France's tradition of Catholic monarchism.

For the altarpiece destined for the cathedral of his native town, Ingres adapted an earlier (1638) version of the same subject by Philippe de Champaigne, combining it with features borrowed from several of Raphael's madonnas (the *Sistine Madonna* and the *Madonna da Foligno*). The fusion of a historical portrait (the kneeling king, offering his crown and scepter) and the celestial vision gave the artist great trouble. He made many drawings of posing models in order to transform and integrate his various borrowings. The final result still seems an unharmonious composite—the stylization wavers uncomfortably between Raphael and observed reality. The colors, calculated for dramatic effect and for visibility at a distance, are hot and strident in the picture's upper part.

Ingres accompanied his picture to Paris, and there witnessed its resounding success at the Salon of 1824. Having become accustomed to the most violent critical abuse, he now found himself the object of flattering interest on the part of the official art establishment, which was then in a state of crisis. The disaffection of the younger artists and the rising tide of Romanticism seemed to threaten its very existence. It desperately needed a leader strong enough to replace the exiled David and his discredited followers. In this situation, Ingres, the heretical classicist, appeared in a new light—as the lesser evil, since he evidently believed in antiquity and beauty, and respected principles and authority. Thus he was chosen, despite his unpalatable eccentricities, to restore and represent the "wholesome traditions of great art."

Surprised and flattered by these sudden marks of official favor, Ingres

decided to remain in France. Awarded the Legion of Honor and elected to membership in the Academy in 1825, he opened a teaching studio and became David's heir as the most influential teacher of the unruly young, groomer of Rome Prize winners, and mainstay of what remained of the French School. He may have been unaware of the strategy that had led to his elevation, and was, at any rate, ill-cast in the role of academician, being of very independent mind and temperamentally opposed to academic routine.

Among the important commissions that now came his way was the painting of a ceiling for the newly decorated galleries in the Louvre, the so-called Musée Charles X, for which the Bourbon government had recruited the most prominent artists of France. He was given the ideologically significant subject *The Apotheosis of Homer* (1827, Louvre). Ingres chose to represent the Poet enthroned in front of an Ionian temple, about to be crowned by Fame. At his feet, the artist placed the personifications of the *Iliad* and the *Odyssey,* and around them an assembly of the great painters, poets, and musicians of ancient and modern times. The very static and symmetrical composition, influenced by Raphael's fresco the *School of Athens,* effectively expresses the ideas of authority, hierarchy, and orderly continuity. Culture assumes the form of a royal court or academy, to which the great men of successive periods are admitted through personal recommendation: Apelles introduces Raphael, Virgil leads Dante to the King of Poets. For Ingres, the painting offered an opportunity for an official declaration of faith. Into his ideal academy, he admitted not only the canonical heroes of the classical tradition but also Shakespeare and Tasso.

Some two hundred drawings and more than thirty painted studies served in the execution of the large canvas, in which Ingres painstakingly calculated every detail, but utterly failed to consider its ultimate use as a ceiling panel. At the Salon of 1827, the *Apotheosis of Homer* appeared as the counterweight to Delacroix's anarchical *Death of Sardanapalus.* To contemporaries, the confrontation summed up the struggle between Neoclassicism and Romanticism. Both pictures failed to please, Ingres's work being considered a bore, Delacroix's the incoherent ravings of a lunatic.

The Revolution of July 1830 found Ingres at his post as a national guardsman, protecting, rifle in hand, the paintings of the Italian masters in the Louvre. The liberal monarchy of Louis Philippe favored Ingres, but gave him little employment. He was named first vice-president, then president of the Ecole des Beaux-Arts (1834), but the great commission that occupied him during the early 1830s, the *St. Symphorian* altarpiece for the cathedral of Autun, had been awarded to him in 1824 by the Bourbon government. The official role that he had accepted harmed him with the liberal press, whose reviewers attacked him as a reactionary and exclusive worshipper of the past.

At the Salon of 1832, he gave proof of his actual modernity, though this was not clearly recognized, by his *Portrait of Louis-François Bertin* (1832, Louvre). The subject was a press lord, publisher of the mass-circulation *Journal des Débats,* and a businessman-politician of the sort that constituted the main support for the government of Louis Philippe. After several false starts, Ingres

found the proper pose, and achieved a portrait that transcends its subject. His
M. Bertin seems more than a particular *grand bourgeois;* he embodies the energy,
assertiveness, and materialism of his class in its golden age. The heavy figure sits
low and wide within the canvas, its dark silhouette topped by a massive Roman
head, from the solid flesh of which the features emerge with something of the
fierceness and nobility of an eagle. Aquiline, too, are the acquisitive, clawlike
hands that Bertin firmly poses on his thighs.

At the Salon of 1834, Ingres at last exhibited his *Martyrdom of St. Sym-
phorian* (1826–34, Autun Cathedral), over which he had labored for nearly ten
years. It shows the saint about to be led to the place of his martyrdom, raising
his arms in a gesture of blessing and farewell, and looking back to the walls of
his city from which his mother cries out her exhortations to him. The gesture of
the saint and the disposition of the crowd of Roman soldiers around him recall
Philippe de Champaigne's *Martyrdom of St. Andrew* in Notre Dame. In hundreds
of drawings and a score of painted studies, Ingres investigated every detail of
anatomy and posture; but this excess of painstaking effort resulted in a congested
composition, confused and incoherent in its very density, lacking dramatic effect,
despite the abundant display of over-muscled figures. The range of colors is
extremely limited, tending to tawny yellows, ochres, browns, and muted reds,
with only a few accents of green and blue.

The picture provoked a severe critical reaction at the Salon. Some of this
was directed at the religious subject: it seemed to modern-minded critics that in
an age in which Christianity had lost all its vitality, religious paintings were an
anachronism. The greater the effort of pretending belief, the more hollow the
result was bound to be. The orthodox classicists, in addition, blamed Ingres for
having violated the principles of David in his excessive anatomical realism. The
vast lay public, equally indifferent to religion and to questions of style, ignored
his picture and reserved its admiration for Delaroche's sensational and sentimen-
tal *Execution of Jane Gray.*

Deeply angered, Ingres vowed never again to exhibit any of his works in
Paris and decided that he would return to Rome. Having sought and been given
the post of director of the French Academy in Rome, he closed his thriving
teaching studio in Paris and embarked on a six-year term of teaching and adminis-
trative work at the Villa Medici. But he produced little: a *Portrait of Cherubini*
(1841, Cincinnati Art Museum), a smaller repetition of his *Roger and Angelica*
of 1819 (1839, London, National Gallery), and a *Madonna of the Host* in the
manner of Raphael (1841, Moscow, Pushkin Museum).

The two most important original works of Ingres's second Roman stay are,
first, the *Odalisque with Slave* (1839, Cambridge, Mass., Fogg Art Museum), an
Oriental fantasy, perhaps inspired by memories of Delacroix's *Algerian Women,*
which Ingres had seen at the Salon of 1834. But while Delacroix's atmospheric
harem interior was based on actual experience, Ingres's composition is a purely
artificial product, a resumption of the theme of the *Grand Odalisque* of 1814 and
in fact based, in part, on the (lost) pendant of that earlier painting, the *Sleeping
Woman* of 1808. The strikingly white-skinned, blond nude languorously reclin-

ing, as if hypnotized by the music being played to her by a tawny slave girl, was improvised by Ingres from drawings without the use of a model. The sharply defined figures, bathed in a clear even light, are strangely unrelated to the brightly colored and patterned setting, with its strong geometry of balustrade, column, paneled walls, and ornamented carpet. The vivid, slightly acid colors suggest that Ingres had consulted authentic Islamic textiles and, perhaps, miniatures. A somewhat altered replica, painted in 1842 for the king of Württemberg, is in the Walters Art Gallery in Baltimore.

The second work, *Antiochus and Stratonice* (1840, Chantilly, Musée Condé), treats a subject that David had used in 1774 and of which Ingres had made a drawing in 1807. Antiochus, secretly in love with his stepmother, Stratonice, appears fatally sick. His father mourns at his bedside, but the wise physician, watching Stratonice pass, suddenly understands the true nature of Antiochus' illness. The scene on which this dramatic incident (taken from Plutarch) is staged amounts to the precise, archaeological reconstruction of a Pompeian atrium with the curious addition of a nineteenth-century four-poster bed disguised as an archaic Ionic temple. Every detail of the intricate image has been deeply calculated for narrative impact. The columnar stillness of the innocent Stratonice, standing apart at the left, is effectively set in contrast to the dark violence of the agitated figures around the bed. The picture's rare and dangerous colors, its pale violets, purples, crimsons, cobalt blue, and malachite green emphasize the somewhat uncomfortable delicacy of the subject. Other, later versions of the composition are in the museums of Philadelphia (1860) and Montpellier (1866).

The duc d'Orléans, son of Louis Philippe, who had commissioned the picture in 1834, had it exhibited at the Tuileries in 1840. Its success was great and general. Ingres's return to Paris in 1841 assumed the form of a triumph. His relations with the duc d'Orléans gave him an entry at court. When the duke died in an accident, in 1842, Ingres was commissioned to paint a series of official portraits showing the elegant young prince in full or half-figure. For the commemorative chapels built at Neuilly, the scene of the accident, and at Dreux, where the prince was buried, Ingres was commissioned to furnish a series of designs for stained-glass windows.

Much of the artist's energy during the 1840s went into the ill-starred project of a mural decoration for the château of the duc de Luynes at Dampierre, consisting of two semicircular panels, the one representing the Age of Gold, the other the Age of Iron. He had received the commission in 1839, while still in Rome, but began the composition only in 1842 and the actual execution in oil in 1843. The work progressed very slowly until 1848. Ingres spent five successive summers at Dampierre, about twenty-five miles southwest of Paris, working with several assistants; they prepared some five hundred studies of the nude, which he struggled to integrate into the complex composition.

The theme of the *Age of Gold,* taken from Hesiod and Ovid, was the paradisal existence in timeless leisure and beauty of a mythical, primeval humanity. In Ingres's mind, this took the form of a teeming crowd of ideally beautiful nudes disposed in an idyllic landscape. Embroidering and refining on this theme,

he produced a congested, dreamlike vision of naked bodies that, understandably, dismayed the duke and, particularly, the duchess. A new contract was signed in 1849, but in the following year Ingres withdrew from the project. The deeper reason for this failure was undoubtedly his inaptitude for monumental painting, rooted in part in his preference for small scale and minute finish, in part in his rather literal and limited imagination. Characteristically, the *Age of Gold* was ultimately realized in a picture of small size (1862, Cambridge, Mass., Fogg Art Museum). The *Age of Iron,* on the other hand, was simply abandoned.

The Revolution of 1848 found Ingres on the side of law and order. He accepted an appointment to the Republic's Permanent Commission of Fine Arts, but resigned the following year. In July 1849, the death of his wife threw him into a prolonged state of depression. He believed that his career had reached its end, retired from his professorship at the Ecole des Beaux-Arts, and donated his personal collection of art to the Museum of Montauban. Seeing him helpless and lonely, his friends realized that he must marry again. A second wife was found for him in the person of Delphine Ramel, a relative of Ingres's friend and patron, Charles Marcotte. His new marriage in 1852, at age seventy-two, had an instant, vivifying effect and renewed his self-confidence.

The most significant works in this last period of his life were the formal half-length portraits of society women, such as *Baroness James Rothschild* (1848, Paris, Rothschild Collection), *Princess de Broglie* (1853, New York, Metropolitan Museum), and *Mme de Moitessier Standing* (1851, Washington, National Gallery). The *Viscountess d'Haussonville* (1845, New York, Frick Collection) shows the young woman posed before a mirror in the attitude of Statonice. Her almost childlike head contrasts oddly with the amplitude of her body and especially the fleshy rotundities of her arms. The somewhat dry perfection of the accessories; the cool, rather graphitic colors; and the ponderous, sculptural materiality of the figure are characteristics of Ingres's late style that distinguish the portraits of the 1840s and 1850s from those of 1804–14.

Ingres received the commission for the portrait *Mme de Moitessier Seated* (1856, London, National Gallery) in 1844, but was able to complete it only fourteen years later, after arduous labor. Though he pretended to despise portrait painting, which he considered beneath the dignity of a painter of history such as he wished to be, his portraits of beautiful women brought out his most obsessive perfectionism. He admired in his sitters qualities that reminded him of ancient art: Mme de Moitessier's serene plenitude of neck, shoulder, and arm corresponds to the classical type of Juno, and her pose is borrowed from a famous fresco from Herculaneum. At the same time, the flowered silk of her dress, her bracelets and brooch, and the modish bric-à-brac on the table behind her are represented with almost pedantic materialism and carry the unmistakable, prosaic flavor of the Second Empire. Most remarkable of all is the fact that Ingres achieved in this and the related portraits the monumentality that had always eluded him in his large, many-figured compositions.

His last attempt of that kind, no more successful than the earlier ones, was the *Apotheosis of Napoleon I* for one of the ceilings in the Paris Hôtel de Ville,

commissioned by the government of Napoleon III in 1853. Destroyed in 1871, its composition is preserved in a large oil study in the Musée Carnavalet in Paris. A flattering allusion to the great Napoleon's nephew that Ingres incorporated into his composition brought him into high favor with Napoleon III. At the Universal Exposition of 1855, Ingres—who had steadfastly refused to exhibit at the official Salons after his humiliation in 1834—was given a gallery to himself. He exhibited sixty-eight paintings, in competition with Delacroix, whose works hung in another gallery nearby. The reviews were highly laudatory or at least respectful, though even the most eulogistic hinted that Ingres's work marked the end of a tradition. He was awarded a medal of honor and made a Grand Officer of the Legion of Honor.

Like David, who in his old age had turned to erotic subjects, the aged Ingres returned in several of his late works to the theme of the female nude, reviving motifs from earlier years and dealing with them in a somewhat coarsened, emphatically corporeal manner that gives them an odd, obsessive intensity. His *Venus Anadyomène* ("born of the sea-foam") in the Musée Condé, Chantilly, was the reworking, in 1848, of a composition begun in a more abstractly linear style in 1808.

La Source (The Fountain) (1856, Louvre) has a rather similar history. The torso of the slender frontal nude, very similar in her hip-shot pose to the *Venus Anadyomène,* was painted in Florence about 1820, then left unfinished until about 1855, when Ingres repainted the head and gave the body a more marked sculptural solidity. The urn lifted by the hands that had originally held the humid tresses of the sea-born Venus was added as an afterthought, and so was the setting of grotto and pool, contributed by assistants. The insipid face, with its sightless eyes and parted lips (curiously reminiscent of Greuze), is a characteristic product of Ingres's old age. The picture won almost universal praise, even from critics usually cool to him.

The Turkish Bath (1862, Louvre), also based on earlier designs, and incorporating an entire repertory of earlier motifs, notably the *Grand Bather (Valpinçon)* of 1808, was commissioned by Prince Napoleon, the emperor's cousin, and delivered to him in its original format (vertical oblong) in 1859. Being judged too risqué, it was returned to Ingres, who extensively reworked it and changed it to a circular format, adding strips to both sides that are still visible. The picture was finally sold to a connoisseur of erotica, the former Turkish ambassador Khalil-Bey. The subject of the crowded Turkish bath may have come from several sources, including Lady Montagu's well-known account of her visit to a women's bath in Constantinople (1718), which Ingres is known to have read. The picture's spatial composition is quite irrational: the six figures in the immediate foreground form a compact mass of undulating flesh; those of the background are of much smaller scale and seem to be separated from the foreground figures by a deep but undefined space. The eccentric, unclassical stylization of the plump, smooth, hairless bodies, their emphatic materiality, and the way their flesh is heaped on flesh produce an effect that verges on the comical. Physically vivid but emotionally inert, the scene—despite its exotic bywork—is without mystery or fantasy.

Overcrowded with torpid nudes, it is more apt to induce feelings of claustropho-
bia than of erotic pleasure.

In signing the picture, Ingres proudly noted the fact that he was eighty-two
years old. In this same year, he was appointed to the French Senate. Of short,
strong build, olive-complexioned, with a head of dense black hair only slightly
touched with gray, he enjoyed sturdy good health to the end. Intellectually and
temperamentally, he was the opposite of Delacroix. Authoritarian, irascible,
given to burst of fury and to tears when crossed, Ingres was also an affectionate
friend, and a generous teacher who was loved by most of his students. Of rather
narrow culture, he lacked the alertness and subtlety of mind that distinguished
Delacroix. His imagination responded to concrete experience: he needed the
stimulus of art or of physical reality, and was highly dependent on the model. His
intelligence, which has been unjustly belittled, is evident in the acuteness, econ-
omy, and nervous intensity of his pencil drawings, unsurpassed in his century.

In 1866, he sold the paintings that remained in his studio to the picture
dealer Haro to secure his wife's future, and bequeathed some four thousand
drawings to the museum of his native city of Montauban.

After a brief illness, Ingres died on January 14, 1867, aged eighty-seven.

READINGS

Henry Lapauze, *Ingres, sa vie et son oeuvre,* Paris, 1911, is still the standard mono-
graph.

Robert Rosenblum, *Ingres,* New York, 1967, offers a concise overview and a de-
tailed, well-illustrated discussion of a selection of key works.

Daniel Ternois, *Ingres,* Paris, 1980, is an up-to-date, well-illustrated biography and
survey of the work, with a summary catalogue of all the known paintings.

Georges Wildenstein, *Ingres,* London, 1956, has a brief text; it is a useful, illustrated
catalogue.

Walter Pach, *Ingres,* New York, 1939, contains, in addition to a biography, excerpts
from Ingres's writings and correspondence in English translation.

Amaury-Duval, *L'Atelier d'Ingres,* Paris, 1878 (and a later edition, 1924, but no
English translation), gives an intimate account of the personality and life of Ingres, written
by one of his pupils.

H. Naef, *Die Bildniszeichnungen von Ingres,* 5 vols., Bern, 1978–79, is the monumen-
tal catalogue of the portrait drawings.

A. Mongan and H. Naef, *Ingres Centennial Exhibition,* Fogg Art Museum, Cam-
bridge, Mass., 1967, gives a handy, modest sampling of drawings and some paintings by
Ingres in American collections.

Théodore Géricault, 1791–1824

Géricault's tragically brief career ran its course between the fall of the School of David around 1812 and the rise, in 1824, of the two great antagonists, Ingres and Delacroix, who thereafter divided the scene of French art between them. His *Raft of the Medusa* was the bombshell that broke the quiet of those doldrum years. Yet his aim was not to destroy the tradition of David but to reinvigorate and reconcile its discordant elements, the classical and the realist. Hostile critics branded him a rebel because of his rejection of conventional "beauty," which they mistook for the essence of classicism, and it is true that he sought instinctively for an aesthetic more vital and elevated than the flaccid stereotype to which David's followers had degraded the classical ideal. His teacher, Pierre Guérin, said of him that he "had the stuff of several painters"; in other words, that his talent was more abundant and various than that of his peers. Most of his brief life was spent in ceaseless experimentation. He rapidly explored a wide range of possibilities, from Baroque monumentality to intimate realism, in an attempt to find ways of expressing aspects of modern life as experienced by an individual sensibility. His work remained a fragment, but it contained suggestions that were to be of great influence on future artists.

Théodore Géricault was born in Rouen in 1791, of prosperous parents. His father, a lawyer, owned considerable real estate and was active in the tobacco business; his mother was descended from a well-to-do Norman family.

In either 1795 or 1796, the family moved to Paris, where young Théodore attended the Lycée Impériale, finishing his—not very distinguished—studies in 1808. In the same year, his mother died, leaving him a comfortable annuity. Fond of his father, he was to live all his life in close companionship with him.

Against his father's wishes, Géricault decided to become an artist, and in 1808 he clandestinely entered the studio of Carle Vernet, a well-known, fashionable painter of modern subjects and particularly of horses. Vernet does not seem to have given Géricault any formal training, but merely allowed him the freedom of his studio, to observe, draw, and copy as he pleased. Some of Géricault's earliest preserved studies of horses and soldiers date from the time of his desultory studies with Vernet. At this time he also painted the amateurishly but very temperamentally brushed *Self-Portrait* (ca. 1808, Paris, Aimé-Azam Collection). Two years later, feeling the need for stricter discipline and more regular

training, Géricault entered the private academy of Pierre Guérin, where for about eleven months he practiced figure composition and painted the model. He was an effervescent, impatient pupil. Guérin, who appears to have recognized his talent, treated him with tolerant indulgence. Little of Géricault's work of this period seems to have been preserved. As he gradually withdrew from regular training, Géricault began a program of independent study. This consisted in part of copying the work of the masters at the Louvre—then known as the Musée Napoléon—which was filled with the loot of the campaigns in Italy, Flanders, Germany, and Spain. Expressing his discontent with classicism, he particularly studied Rubens, Van Dyck, Titian, and Rembrandt. Among the painters of his own time, he most admired Gros, whose example encouraged him to try his hand at modern military subjects.

Having rashly decided to submit a large painting to the Salon of 1812, Géricault transformed a simple genre motif, suggested to him by the spectacle of a bolting carriage horse, into a large and dramatic equestrian "portrait." *The Charging Chasseur* (1812, Louvre), improvised, after a few false starts, in the astonishingly short time of four or five weeks, had some success at the Salon. It represents an officer of the imperial guard cavalry on a wildly rearing horse, turning in the saddle to give the signal for the attack with his saber. Very broadly brushed, in warm, harmonious, atmospheric colors, the painting has nothing to do with Guérin or neoclassicism, but owes much to Gros and, ultimately, to Rubens. The horse's frantic leap toward the orange glow of battle, the taut unity of rider and mount, the flash of steel and the wind of speed raise the picture to a level above genre or portraiture: it is an image of victorious attack, highly appropriate to its time. Géricault had painted the work during the weeks of the Grande Armée's advance on Moscow, but monumental, symbolical imagery of this kind did not constitute a recognized class of subject matter. The Salon's catalogue described the *Chasseur* as a "Portrait of M. D." (Dieudonné, the friend who had posed for its face). Much to Géricault's disappointment the government failed to buy his picture at the Salon's close, but he received a gold medal.

He was still only twenty-one years old and this early success did not make him feel overconfident. He spent the following years producing small-scale works, meant to be studies and exercises rather than exhibitable paintings. He painted finely observed horse portraits in the imperial stables of Versailles, filled his sketchbooks with small military subjects, and produced portrait-like studies of brightly uniformed soldiers riding spirited horses. *Twenty-Four Horses in Rear View* (1813–14, Paris, de Noïalles Collection) is typical of Géricault's careful studies of stabled horses. This exceptionally large canvas, crowded with rows of individual horse "portraits," illustrates the intense naturalism of observation and minute refinement of execution that followed the dramatic bravura performance of the *Chasseur*. The silken coats of the horses, their colors and markings, and the supple structures of their legs are indicated with small, meticulous strokes of the pointed brush in liquid, quietly intense colors.

Géricault's brilliant, small-scale paintings of Napoleonic cavalrymen, such as the *Three Mounted Trumpeters* (ca. 1814, Washington, National Gallery), and

the *Trumpeter of the Polish Lancers on a Rearing Horse* (ca. 1814, Glasgow, Art Gallery, Burrell Collection), bear a close resemblance to his studies of horses of the same period. They are not, however, studies from life, but compositional inventions that combine memories of Rubens and Van Dyck with impressions gathered around the barracks and stables of Versailles and recorded in his sketchbooks of the time.

The *Chasseur* of 1812 had represented Géricault's first distinctive style. The studies of horses and of Napoleonic cavalrymen that followed it indicate a further development, a second stylistic phase that brought with it a shift from Baroque vehemence to a refined, descriptive naturalism. The equine and military subjects that he drew and painted around 1813–14 were entirely private works and, unlike similar works by Gros and other painters of modern, "national" subjects, had nothing to do with official propaganda and politics. They are curiously unrevealing of Géricault's reaction to the invasion of France, to Napoleon's last, defensive campaigns, and to the collapse of the Empire. His small pictures of soldiers brightly uniformed and splendidly horsed contain no suggestion of symbolical significance, no hint of pathos.

Little is known of Géricault's life at the time of the Empire's fall in the spring of 1814. Unlike many of his friends and contemporaries, he took no part in the final, popular defense of Paris against the Allies. He may have shared his father's royalist sentiments and, like many Frenchmen, witnessed the defeat of Napoleon with indifference, or even secret relief. The great events of the day left few traces in his work. There is little change of subject matter or style: the uniforms of the Empire simply give way to the very similar uniforms of the Restoration, and Cossacks supplant Mamelukes.

Meanwhile, Géricault continued his self-education, copying the works of the Flemish and Italian masters at the Louvre, now renamed the Musée Royale but otherwise left undisturbed by the victorious Allies. Whereas in his earlier copies he had shown a particular interest in equine subjects taken from the work of Rubens and Van Dyck, his choice now shifted to paintings of dramatic figural subjects by masters of the Italian High Renaissance and Baroque, as in his *Copy of Caravaggio's Deposition* (ca. 1814, Winterthur, Bühler Collection) and the *Copy of Titian's Death of St. Peter Martyr* (ca. 1814, Basle Museum). His own work underwent a gradual change in the direction of a more compact definition of bodies, of darker colors and harsher contours.

The *Signboard of a Farrier* (1814, Zurich, Kunsthaus), painted on rough boards and intended to serve as a shop sign, represents a blacksmith clad in leather apron and holding a heavy hammer, who restrains a huge, rearing draught horse. The physical contest between man and horse is a restatement of the theme of the *Chasseur* but, in contrast to the dynamism and atmospheric colors of that earlier painting, the *Farrier*'s emphasis is on massive, immobile bodies and on heavy, earthen colors. Though only intended as a gift, probably to a farrier of his acquaintance, the signboard was very carefully prepared. The gradual evolution of its composition can be traced in a series of studies in a sketchbook fragment in the Chicago Art Institute.

In the summer of 1814, the recently reinstalled royal government decided to hold a regular Salon the following November. Géricault was unprepared but decided, at the last moment, to re-exhibit his *Chasseur* of 1812 and to paint a pendant picture to be shown with it. In the space of about three weeks he improvised the monumental *Wounded Cuirassier Leaving the Field of Battle* (1814, Louvre), showing a dismounted cavalry officer leading his horse down a slope, away from the battle that rages in the distance behind them. In contrast to the victorious, aggressive *Chasseur,* the *Wounded Cuirassier* reflected the French defeats of 1813–14; exhibited as a pair at the Salon, their significance was unmistakable. Unlike the *Chasseur,* the *Cuirassier* could not be taken for a portrait. It fitted none of the recognized categories of subject matter, being too large for genre, too fragmentary for history painting. It received scant, mainly hostile critical notice; the faulty foreshortening of the horse was particularly singled out for condemnation. Géricault, working under time pressure, had not in fact resolved all the compositional difficulties arising from his adaptation of the dramatic motif of the *Signboard of a Farrier*—the massive figure restraining a fiery horse—to a new and quite different purpose.

Despite its flaws, the *Wounded Cuirassier* marks an advance in Géricault's development. Less felicitous than the *Chasseur,* it is a more forceful and expressive work. The ponderously sculptural style, compact modeling in light and dark, and powerful material realism in the suggestion of gleaming metal, soft cloth, and rough-textured hide, all indicate a turning away from the sweeping dynamism and atmospheric color harmonies of that earlier picture. In sacrificing his former spontaneity and brilliance, Géricault consciously strove for monumentality and emotional power.

Several equestrian subjects and military portraits of about the same date echo the tragic note and somberly sculptural style of the *Wounded Cuirassier.* The *Mounted Trumpeter of the Hussars* (1814–15, Williamstown, Clark Art Institute) exemplifies the change in Géricault's treatment of military genres from his earlier liveliness and brilliance to the melancholy grandeur and stillness of his new manner. *Portrait of a Carabinier* (1814–15, Louvre), and the closely related *Portrait of a Carabinier with Horse* (1814–15, Rouen Museum), both painted from the same model, record not an individual so much as a type—that of the Napoleonic veteran, embodiment of fallen power and frustrated valor. The soldier's forceful physical presence, his armor with its rivets and chains, outweighs what little is revealed of his humanity. Géricault has given him the remote impressiveness of a monument.

The years of 1814–16 were a time of stress and obscure trouble for him. In the summer of 1814, he impulsively enlisted in the elite Royal Cavalry (having evaded conscription in the Napoleonic levies of the war years), moved into barracks in early 1815, and shortly afterward found himself in the escort covering Louis XVIII's flight to Belgium on Napoleon's sudden return from Elba. During the Hundred Days, he sheltered with relatives for fear of arrest. At about this time, he appears to have begun a clandestine, quasi-incestuous love affair with a young aunt, Alexandrine-Modeste Caruel, the wife of an elderly uncle on his

mother's side. The emotional turmoil into which this threw him overshadowed the following years of his life.

The Empire's earlier collapse, in 1814, had not caused a break in Géricault's work. Throughout the First Restoration, he had continued to occupy himself with military and mainly Napoleonic subjects, though in an increasingly monumental and expressive style. But after Waterloo he made an abrupt change, abandoning his favorite subject matter and radically altering his style. His taste of army life may have disillusioned him, or he may have come to realize that after Napoleon's final catastrophe military painting was, for the time being, a discredited art. With sudden decision, he turned his back on modern realism and reached out to the only alternative at hand: the neoclassical grand style that he had rejected in the days of his unruly apprenticeship with Guérin.

Géricault's development during the next three years seems strangely retrograde: from modern to antique subject matter, from naturalism to stereotype, from color and motion to contour and sculptural rigidity. But he did not simply retreat to an obsolete stylistic idiom. Instead of becoming a conforming classicist, he ruthlessly distorted the classical formulae and forged them into a new style that lent itself—better than the comparative realism of his earlier works—to resonant, declamatory statements. Romantic in its intensity, indebted to Michelangelo rather than to David, it was capable of expressing the extraordinary, the terrifying, and the painful. How best to use this powerful new instrument was the question that would occupy him in the years to come.

He began by putting himself through a course of severe self-training, exercising his eye and hand, like a beginning student, by copying engravings and practicing schematic figure composition. The so-called *Zoubaloff Sketchbook* in the Louvre, which he had used initially in the preparatory work for the *Wounded Cuirassier,* documents his sudden shift to classical subjects. Its later pages are filled with scores of small drawings of gesticulating figures in antique costume and with compositional exercises, stiffly outlined with a thick pen and spotted with heavy touches of ink wash. The crowded pages bear witness to the intensity of Géricault's effort to master his new vocabulary. There is no hint of any study from nature. The consistent emphasis is on artificial, schematic forms and constantly repeated stereotypes. The sketches are cramped and crude, but they contain an abundance of energy.

Closely related to these imitative exercises are original fantasies, in an oddly heavy-handed, Michelangelesque contour style, that deal with scenes of cruelty or lust. *Executioner Strangling a Prisoner* (pencil, pen, and wash, ca. 1815, Bayonne Museum) and *Couple Embracing* (pen and wash, ca. 1815–16, Paris, private collection) are scenes of great brutality that express a powerfully erotic imagination. The drawings are executed in a rugged pen-and-wash technique and marked by vehement exaggerations in the gestures and musculatures of the bodies they represent. Nothing in them recalls the painterly refinement of Géricault's work of 1812–14. Their style is entirely graphic, and in its craggy hardness suggestive of sculpture. Géricault did, in fact, experiment with sculpture at this time. His *Satyr and Nymph* (ca. 1815–16, Rouen Museum), roughly carved from

a block of common stone, is in effect the translation of one of his erotic drawings into a three-dimensional medium, in a style strongly influenced by Michelangelo.

A series of vigorous oil studies of nude, male models (in the museums of Rouen, Bayonne, Brussels, Washington, and elsewhere) apply Géricault's sculptural style to paintings of fairly large scale. Their modeling in heavy light-dark contrasts connects them with the *Farrier* and *Cuirassier* of 1814, but they also exhibit the eccentricities of his later contour drawings in their Michelangelesque poses and excesses of bulging muscle. Some of these studies may have been painted by way of rehearsal for the Rome Prize competition of 1816, in which Géricault participated in the hope of winning a stipend for the Villa Medici. He passed the initial test of the compositional drawing, but failed the second round, which called for the painting of an oil study of the posing model. He was thus disqualified from participating in the final, decisive trial, the painting of a large compositional study on the subject *Oenone Refusing to Save the Dying Paris.* For reasons difficult to understand, he nevertheless worked out a composition in a series of drawings (in the museums of Rouen, Bayonne, Orléans, etc.) that are of high interest, since they illustrate the softening and maturing of his "antique manner" at the exactly determinable date of April 1816.

Despite his failure in the Rome Prize competition, Géricault was determined to go to Rome, partly to further his self-education, partly to escape from the torments of his secret love affair. Being wealthy, he was able to pay his own way. He left for Rome in September, stopping in Florence in October—where he sketched Michelangelo's Medici tombs—and arriving in November. Since he did not have a proper studio, he at first confined himself to drawing. The stylistic discipline to which he had been subjecting himself in the previous year now produced its first, splendid results in the form of a series of finished drawings in pen, wash, and white gouache on tinted paper. Most of these treat erotic mythological themes, as did his earlier exercises in a hard contour style. But an Arcadian serenity has here replaced the former violence. The rigor of Géricault's "antique manner" gives way to a suavely fluent design, devoid of the exaggerations of the earlier drawings:

> *Leda and the Swan* (black chalk, pen, wash, watercolors, and white gouache, 1816–17, Louvre);
> *Centaur Abducting a Woman (Nessus and Deianeira)* (pen, wash, and gouache, 1816–17, Louvre);
> *Triumph of Silenus* (black chalk, pen, wash, white gouache, 1816–17, Orléans Museum).

In these works of antique inspiration, which contain traces of the influence of Michelangelo, Raphael, Roman reliefs, and the masters of the Roman Baroque, Géricault approached most closely to classical spirit and form. They mark the farthest extent of his escape from modernity into a realm of pure art.

But his impressions of Roman popular life were at this very time beginning to reawaken his interest in subjects taken from reality. He filled his sketchbooks with finds from his rambles in Roman streets, and actually thought of composing

a picture on a theme from contemporary Italian life. The Roman drawings indicate that he toyed with several subjects, ranging from *Worshippers at the Door of a Church* (Paris, Ecole des Beaux-Arts) to a *Beheading in Rome* (versions in various collections).

During the Roman Carnival of February 1817, Géricault witnessed the traditional race of the riderless Barberi horses in the Corso. The spectacle fascinated him as a lover of horses, as an observer of modern life, and as a painter in search of a grand subject. It inspired him to attempt a fusion of his modern and antique manners in a work of large scale that would deal with observed reality in timeless and monumental forms. He spent the remainder of his Italian stay developing the composition of the *Race of the Barberi Horses,* which he planned to execute in life-size. Of the many drawn and painted studies for this project, only a fraction is preserved. They form a progressive sequence, illustrating Géricault's method of formulating and composing his subject.

He began by dissecting the race into its various phases: the start in the Piazza del Popolo, the race itself, and the capture of the horses at the finish. Having selected the episode of the start of the race, Géricault represented it first in its realistic aspect, as a scene from observed life (paintings in the Walters Art Gallery, Baltimore, and the Lille Museum), then gradually divested the scene of its modern detail and transformed it into a timeless image of men struggling with horses in the setting of an Arcadian landscape (Rouen Museum), and, finally, against a background of classical architecture (Louvre). The theme of a contest between human and animal energies is a restatement of the *Signboard of a Farrier* and the *Wounded Cuirassier;* there can be little doubt that this persistent image held a symbolical, moral meaning for Géricault. The final, masterly oil study for the project (Louvre) combines classical and Baroque reminiscences (the antique *Horse Tamers* of the Quirinale, and G. Coustou's *Horse Tamers,* 1740–45, now in the Paris Champs-Elysées). Before leaving Rome, Géricault traced his composition on a large canvas, but then abruptly abandoned the project. Had he completed it, he would have achieved a work without parallel in its time: a monumental composition without identifiable historical setting or narrative subject.

At the end of September 1817, much sooner than he had planned, Géricault hurriedly returned to Paris, where the woman he loved awaited him. His personal life was approaching a crisis. During November, his young aunt conceived a child by him. He knew that his relationship could not be hidden much longer, and the thought of the inevitable scandal weighed heavily on him.

He had lived in solitude while in Italy, but in Paris he was surrounded by artists and military men, many of them ardent partisans of Napoleon and therefore opposed to the Bourbon government. Their passionate discussions of the political events of the day stirred Géricault's interest and drew him from the absorbtion in matters of art that had held him spellbound in Rome. He was ready to return to the subjects from contemporary reality that he had abandoned in 1815. But memories of Italian life and art still filled his mind for a time. He had not quite given up his intention of using an Italian subject for a painting of heroic style. The composition generally known as *The Cattle Market* (1817, Cambridge,

Mass., Fogg Art Museum), a scene of muscular butchers struggling with cattle, echoes the *Race of the Barberi Horses* in idea and composition. In it, Géricault attempted a synthesis of motifs from classical sources *(Hercules and the Bull)* with Italian genre scenes *(Roman Herdsmen)* and observations more recently gathered in Parisian slaughterhouses.

The last reflections of his Italian impressions are to be found in the three large landscape panels that he painted as room decorations for a friend: *Landscape with Fishermen* (1818, Munich, Neue Pinakothek); *Landscape with Roman Tomb* (1818, Paris, Petit Palais); and *Landscape with Aqueduct* (1818, Norfolk, Va., Walter P. Chrysler Museum). These are pictorial fantasies on Italian themes, influenced by the Baroque tradition of composed, "heroic" landscape and by decorative landscape panels representing the times of day painted by Claude-Joseph Vernet (the father of his teacher Carle Vernet). It is possible that his three landscapes were conceived as a sequence signifying Morning, Noon, and Evening.

Four years had passed since Géricault had last exhibited a painting. He was beginning to be forgotten by the public. Even his friends looked on him as a wealthy dilettante who, not needing to work for a living, frittered away his life in endless experimentation. Géricault was determined to change this situation by making a spectacular appearance at the forthcoming Salon of 1819. Searching for an appropriate subject, he gradually found his way back to contemporary subject matter, and formed the project of treating an actual, sensational event in a grand style. Turning his Italian experience to new advantage, he experimented with the idea of representing exemplary acts of courage or endurance, taken from the history of the recent wars, with the formality and elevation with which he had treated themes from classical mythology. Employing the technique of wash-and-gouache on tinted paper that he had lately used for his drawings of centaurs and nymphs, he now composed such subjects as *Mameluke Unhorsed by a Charge of Grenadiers* (Louvre) and *The Black Standard-Bearer* (Stanford Museum).

Lithography had very recently been introduced to France. Guérin, Géricault's former teacher, and Horace Vernet, his close friend, were among the pioneers of this new and highly popular art. Almost immediately after his return from Italy, Géricault himself began to use lithography for the representation of modern military subjects, some of them—like the *Wounded Cuirassier* of 1814 —scenes of suffering and stoic endurance rather than victory (e.g., the lithographs the *Retreat from Russia,* 1818; the *Cart Loaded with Wounded Soldiers,* 1818; and others). In these works of small format but careful execution, he found a way of reconciling realistic observation with stylistic discipline to achieve the union of the grand and the natural that he hoped to realize on the much more ambitious scale of his projected Salon painting. On the lookout for the proper subject, he scanned the news of the day, thinking for a moment of using the story of a notorious assassination, the murder of Fualdes, ex-magistrate of Rodez, which agitated public opinion in the early spring of 1818 because of its supposed political motivation.

At length Géricault found his subject in the recent shipwreck of a government frigate, the *Medusa,* which had broken up off the west coast of Africa in

July 1816. The incompetent, royalist captain had abandoned 150 of the ship's crew on a makeshift raft which drifted helplessly in stormy seas under a scorching sun for thirteen days, while 135 of the men perched on its timbers fell victim to exposure, murder, hunger, insanity, and cannibalism. An account of the disaster, published by two survivors in November 1817, gave Géricault the idea for the picture that he intended to submit to the Salon of 1819.

In the meantime, a catastrophe of a different sort shattered the peace of his family. The pregnancy of his aunt and his own guilt became evident in the spring of 1818. The family closed ranks to keep the scandal a secret. Géricault's mistress was sent off into the country, while he shut himself up in his studio to begin his great work. His son was born in August 1818, declared to be of parents unknown, and supported by Géricault's father.

In developing the composition of the *Raft of the Medusa* (1818–19, Louvre), Géricault began by exploring the successive episodes that constituted the story of the raft. In an effort to gain a thorough grasp of his subject, he made detailed drawings of the mutiny on the raft, of the outbreak of cannibalism, of the inconclusive sighting of the rescue vessel on the thirteenth day, the approach of a rowboat to the raft, and the final rescue of the survivors. It is noteworthy that he did not treat the scene that was politically the most controversial—the desertion of the raft by the *Medusa*'s aristocratic captain.

In the end, he decided to use the episode of the sighting for his picture, and very gradually constructed its composition, literally building it figure by figure. The successive stages of this process are documented by a chain of compositional drawings and painted studies. In the autumn of 1818, he was ready for the transfer of the fully developed composition to the canvas. In the final, large (ca. 16 × 24 ft., or 5 × 7.5 m.) canvas of the *Raft of the Medusa* (1818–19, Louvre), the raft appears in close view, surrounded by high waves and an overcast sky. From a foreground filled with cadavers and the motionless figures of despairing men, groups of straining, signaling men rise as with one motion, their gestures converging on the point in the far distance which marks the scarcely visible sail of the rescue vessel. The raft is so turned and the men on it so arranged as to force the viewer into a close involvement with the action, compelling his empathetic participation and, at the same time, giving him a vivid experience of the elemental forces —hostile nature in the form of wind, wave, distance, and the inertia of death— which oppose and frustrate the struggling men. Rather than making use of explanatory narrative, the composition delivers its meaning directly by its very structure.

All the figures of the composition were painted from life, but into their conception and expression various influences entered. Most important is that of Gros's *Plague Hospital at Jaffa,* which was certainly on Géricault's mind when he executed the frieze of cadavers and mourning figures that fills the foreground of the *Raft.*

Among the preparatory studies for the *Raft of the Medusa* are several paintings of cadavers, severed heads, and dissected limbs:

Study of Two Severed Heads (ca. 1819, Stockholm, National Museum),
Study of Dissected Limbs (ca. 1819, Montpellier Museum).

Executed with sober realism and entirely devoid of romantic graveyard morbid-
ity, these studies served no directly practical purpose. Géricault seems to have
painted them to sharpen his awareness of the physical and emotional reality of
his subject, and to maintain himself in a state of alert tension during the long labor
of his work.

In the *Raft of the Medusa,* two aspects of his art combined: his incisive
realism and his aspirations to heroic monumentality. The picture represents, on
the thematic as well as the formal level, a fusion of naturalism and stylization,
of factual truth and symbolic allusion. It is one of the few works of modern art
that raises an actual, contemporary event to the height of grand style and timeless
significance.

Badly hung at the Salon, which opened on August 25, 1819, the *Raft*
received a mixed critical reaction. It was praised and condemned on political
grounds, by liberal or ultra-royalist reviewers who seemed equally blind to its
artistic qualities. Disappointed and exhausted, Géricault passed through a time
of physical and emotional sickness. As he had done in 1816, he sought relief in
travel. Seizing on a chance to have the *Raft of the Medusa* exhibited in London
at William Bullock's Egyptian Hall, he accompanied his picture to England in
April of 1820. The exhibition proved to be a popular success; more than fifty
thousand visitors paid to see the picture. He remained in England for nearly two
years, interrupting his stay in the fall of 1820 for a brief visit to Louis David in
exile in Brussels.

After the exertion of the *Raft of the Medusa,* Géricault had renounced
heroic subject matter and grand style, content to devote himself to the description
of common life. The bulk of his English work is of small format and refined
execution. Influenced by English sporting genre and watercolor, it shows a
marked drop in emotional intensity and is sometimes overcast by melancholy or
lassitude. Fascinated with the spectacle of London life, he made studies of the
poor whom he observed in London streets, and used some of these for a series
of lithographs, *Various Subjects Drawn from Life and on Stone,* that was pub-
lished in London in 1821. Such prints as the *Piper,* the *Paralytic Woman,* and
"Pity the Sorrows of a Poor Old Man" deal with social reality without moralizing
or sentimentality. The somber objectivity with which they describe suffering and
human decay in their actual urban settings had no close parallel in French or
English art of the period. Others of his English works are concerned, by contrast,
with the elegant aspects of horsemanship and sport. In the watercolors of these
subjects, he developed a brilliance of color and refinement of finish that is reminis-
cent of his Napoleonic military genres of 1812–14.

Among the few paintings in oil which Géricault executed in England are
several small studies and one large, highly finished picture of horse racing—the
English counterparts of his Roman *Race of the Barberi Horses. The Epsom Downs
Derby* (1821, Louvre) is said to have been painted for his London landlord, the

horse dealer Elmore. Based on impressions of the race, which he had witnessed, it shows the tightly grouped, glossy-coated horses streaking in a "flying gallop" over the green turf. The influence of English sporting paintings, and perhaps of Constable's skies and meadows, is very evident. The execution is precise; the colors, bright and sharp in the silk-clad figures, are subtly atmospheric in the sky and the landscape. The break with Géricault's earlier sculptural and monumental style seems complete.

He returned to Paris in December 1821, in failing health and bad spirits. Within a short time he suffered a series of riding accidents, frittered away much of his fortune in reckless speculations, and behaved like a man bent on destroying himself. Bedridden for some time in 1822, he recovered in the late part of that year and resumed work. Géricault's powers were unimpaired, but instead of focusing them on major works, he spent them in enterprises of small ambition and short duration. He continued to draw lithographs and to paint genre scenes in a style like that of his English work, fresh in color and meticulous in touch, such as the *Postillion at the Door of an Inn* (1822–23, Cambridge, Mass., Fogg Art Museum). The emotional tone of these paintings is set by effects of light, atmosphere, and sky. Landscape plays an increasingly important role in them.

The Lime Kiln (ca. 1822–23, Louvre), depicting the factory in which Géricault had invested much of his money, is the culmination of his suburban, industrial genres, begun in England. It shows draught horses mired in a bleak terrain on the slope of Montmartre beneath the ugly, impressive monolith of the factory. The picture's romantic poignancy derives not from any remarkable features but from the prosaic intensity of its realism. Its seemingly monochrome grayness is, in fact, a blend of many colors—a richness that chooses to conceal itself.

For all but the last years of his life, Géricault had lived comfortably on his inheritance. This had enabled him to work at his pleasure, impelled by artistic ambition rather than the necessity of earning a living, and to follow his own tastes and impulses without giving any thought to the salability of his work. Aside from his three large Salon pictures and the few published lithographs, all his work had been of a personal, experimental, non-commercial kind. This explains the disproportionate abundance of sketches, studies, and unfinished projects, and the small number of finished paintings. The loss of a large part of his fortune in 1822–23 compelled him to work for the market and to suit himself to the taste of collectors and dealers. This accounts for his large production, in 1822–23, of finished watercolors and small oil paintings of pleasing subjects, horse genres for the most part, romantic exotica, and illustrations of currently popular, mostly Byronic, literature.

An exceptional opportunity for work of a more original kind presented itself in the form of an invitation by a medical friend, the alienist Dr. Georget, to paint ten portraits of patients afflicted with different typical delusions, or "monomanias," probably for the purpose of providing a clinical record and diagnostic aid. Only five of these ten portraits are preserved:

Portrait of a Kleptomaniac (ca. 1822, Ghent Museum);
Portrait of a Man Suffering from Delusions of Military Rank (ca. 1822, Winterthur, Oskar Reinhart Collection);
Portrait of a Woman Addicted to Gambling (ca. 1822, Louvre);
Portrait of a Kidnapper (ca. 1822, Springfield Museum), and
Portrait of a Woman Suffering from Obsessive Envy (ca. 1822, Lyon Museum).

These studies constitute a remarkable instance of the convergence of scientific and artistic interests. The severe objectivity of Géricault's physiognomical observations suited the alienist's need for diagnostic documents. Both artist and scientist agreed that visual appearance, even in its slightest, most fleeting aspects, was the clue to an inward state, a symptom to be read and therefore to be recorded with accuracy. The powerful emotional effect of the portraits results not from any imaginative, "romantic" dramatization, but from the intensity and clarity of Géricault's realism. In this respect, his *Portraits of the Insane* resemble his studies of cadavers and dissected limbs (ca. 1819). The portraits have a format—quite un-French—that resembles that of a common English type of casually posed bust-lengths, set against dark grounds and showing the full face, without hands. They resemble portraits of this kind by Sir Thomas Lawrence (whom Géricault had met in London) in their naturalness and animation, their subdued richness of color, and their large, fluent brushwork.

In the early spring of 1823, Géricault's fatal illness—a form of tubercular decay of the spine—became acute. He underwent several operations and remained bedridden throughout the latter half of the year. He bore the pain of his sickness with courage, but suffered from a deep sense of failure: he felt that he had wasted his talent in inconclusive experiment. As he lay on his sickbed, his old ambition to treat a subject from modern life on a hugely monumental scale returned with full force. Too weak for the actual execution of such work, he busied himself with the preliminaries for several large compositions, including *The Opening of the Doors of the Spanish Inquisition* (1823, drawings in various collections), an episode of the Napoleonic wars in Spain; and *The African Slave Trade* (black and red chalk, 1823, Paris, Ecole des Beaux-Arts).

Renouncing the small-scale refinement of most of Géricault's late work, these projects mark his final return to great subjects—of distinctly political, Liberal significance—and grand style. Though realized only in drawings, they equal his *Raft of the Medusa* in ambition. The sharply individualized figures and the fluent coherence of the compositions hint at what might have been the further development of Géricault's art.

After a last, painful crisis, Géricault died on January 26, 1824, at the age of thirty-two.

READINGS

The basic biography and catalogue of work is C. Clément, *Géricault, étude biographique et critique* (3rd, final edn.), Paris, 1879. A recent reprint, with preface and catalogue supplement by L. Eitner, was published in New York in 1973.

L. Eitner, *Géricault, His Life and Work,* London, 1983, is the most recent general overview, with particular emphasis on the genesis of Géricault's main projects.

P. Grunchec, *Tout l'oeuvre peint de Géricault,* Paris, 1978, is a useful summary catalogue of Géricault's paintings.

Particular Works

L. Eitner, *Géricault's Raft of the Medusa,* London, 1972.

C. Martine, *Cinquante-sept dessins de Théodore Géricault,* Paris, 1928; good reproductions of drawings and watercolors in the Louvre and the Ecole des Beaux-Arts.

L. Delteil, *Théodore Géricault (Le Peintre-graveur illustré),* vol. XVIII, Paris, 1924; nearly the entire graphic work of Géricault.

Eugène Delacroix, 1798–1863

Delacroix's activity spans the forty-year interval between David's last and Cézanne's earliest works. When he began, neoclassicism was already moribund, though its lifeless productions still cluttered the Salons. History painting, regarded as the noblest branch of art, languished for lack of vital style and vital ideas. The future seemed to lie with the petty romantics, the specialists in sentimental anecdotes, picturesque vignettes, and exotic trifles. Artists lacked a pictorial language in which to express modern experience. David, Gros, and Géricault had experimented with forms borrowed from the Baroque. Delacroix actually restored the link with tradition. He was the last great European painter to use the repertory of humanistic art with conviction and originality. In his hands, antique myth and medieval history, Golgotha and the Barricade, Faust and Hamlet, Scott and Byron, tiger and Odalisque yielded images of equal power. As he grew older, he felt increasingly drawn to the great Venetians and Flemings, to Veronese and Rubens above all. His preoccupation with them was not a return to the past, but a claim to an authentic tradition, not as imitator but as the legitimate heir.

Delacroix was born in 1798 in Charenton, near Paris, the son of Charles Delacroix, who had served briefly as Minister of Foreign Affairs under the Directory and who was the French ambassador in Holland at the time of Eugène's birth. His mother, Victoire Oeben, came from a family of artists and craftsmen. There are reasons for believing that Delacroix's natural father was Prince Talleyrand, his father's successor in the ministry and a family friend. This unacknowledged paternity was to have some influence on Delacroix's early career. In later life, he came to bear a distinct facial resemblance to Talleyrand.

At age seventeen, Delacroix began to take painting lessons from Pierre Guérin, through whose studio Géricault had briefly and turbulently passed earlier, and in the following year he was admitted to the Ecole des Beaux-Arts, where Guérin was the professor of painting. Guérin's teaching had no deep influence on Delacroix. It was less important for his development than the classical education he had received at the Lycée, or the example of Géricault, whom he met about this time and for whose *Medusa* he posed in 1818. He was, like Géricault, an essentially self-taught artist.

The young Delacroix's "school" was the Louvre, where, even after the removal of Napoleon's art loot in 1815, Rubens, Titian, and Veronese shone

brightly enough to eclipse David. While copying in its galleries, he may have met Richard Bonington as a young man. He certainly met the English-trained watercolorist Raymond Soulier, who introduced him to watercolor painting and perhaps gave him a taste for Shakespeare, Byron, and Scott, the main literary sources of his romanticism.

Delacroix's student work was not brilliant. The early death of his parents and the collapse of the Empire, the social and economic base of his family, deprived him of an income and forced him to seek commissions. He painted a Raphaelesque *Virgin of the Harvest* (1819) for a village church in Orcemont and, with Géricault's complicity, carried out the commission for an altarpiece, *The Madonna of the Sacred Heart* (1821, Ajaccio Cathedral), that had been awarded to Géricault. Neither work showed extraordinary promise.

Delacroix made his first appearance at the Salon with *Bark of Dante (Dante and Virgil Ferried by Phlegias to the City of Hell)* (1822, Louvre). The episode from Dante's *Inferno,* which may have been suggested to him by one of Flaxman's illustrations, was conceived by Delacroix in the manner of the *Raft of the Medusa.* The figures, galvanized into torturous postures, emerge from the bituminous darkness that surrounds them into a faint, slanting light. The pallor of the nude bodies and the muted hues of the costumes combine in a doleful harmony, a portent of Delacroix's future mastery of expressive color. Though it has its place in the history of art as the beginning of a great career, it is still an immature work, uncertain in its handling of reminiscences from Géricault, Rubens, and Michelangelo, incoherent in composition, and in general effect rather like an overblown repoussé relief.

The picture was attacked by critics of the more orthodox kind, but Delacroix received warm private encouragement from Gérard and Gros. Adolphe Thiers, a rising politician and protégé of Talleyrand, wrote a much-noticed review in which he gave it as his opinion that "no picture reveals so clearly the future of a great painter as the one by M. Delacroix." Remarkably, the government purchased the controversial picture though its artist was still totally unknown.

Only two years later, Delacroix's *Massacre of Chios* (1823–24, Louvre) burst upon the Salon of 1824. It represents an atrocity that had recently occurred in the Greek War of Independence. In the foreground of a vast and luminous landscape, the Greek victims and their resplendent Turkish butchers are strewn out in a huge, disordered still-life. An even gray light pours from the sky—which Delacroix had repainted at the last minute, having seen Constable's *Haywain* among the pictures shown at the Salon of 1824—kindling vivid colors in patches of garment and naked skin, and fusing these colors into a sumptuous harmony. The quiet of this scene holds a stronger tension than the conventional pantomimes of academic history painting. A "terrifying hymn in honor of doom and irremediable suffering," as the poet Baudelaire called it, the picture's lustful dwelling on horror and death strikes a note that was to sound throughout much of Delacroix's subsequent work.

A much better painting than the *Bark of Dante,* the *Massacre* surpassed all of Gros's and Géricault's earlier attempts to treat dramatic scenes from

modern history in a monumental format. Unlike Gros's *Jaffa* (1804), which probably influenced Delacroix, the *Massacre of Chios* is a personal statement, a scene of suffering without redeeming heroism or national glory, and therefore— like Géricault's *Raft of the Medusa*—unfit for official use. In spite of this, the government not only awarded it a gold medal but also purchased the picture, though press criticism of this "Massacre of Painting," as Gros called it, had been almost unanimously hostile.

The sale of the *Massacre* paid for a visit to London in May to August of 1825, where, with Richard Bonington and the watercolor painter Thales Fielding as his mentors, Delacroix visited the galleries, met English artists (including Thomas Lawrence), saw Shakespeare acted, and read the English poets. The influence of English painting and literature was to dominate his work for several years. It is evident in a new freshness and gloss of his colors, and in his frequent use of subjects from Scott and Byron. The large *Portrait of Baron Schwiter* (1826, London, National Gallery), painted after his return to Paris, is an essay, perhaps slightly tongue-in-cheek, in the portrait style of Lawrence.

Many of his paintings of the time were of literary subjects, of small, salable format and refined execution. *The Execution of the Doge Marino Faliero* (1826, London, Wallace Collection) is based on a play by Byron, conceived as a Venetian pageant, and painted with a nervous brilliance of touch that recalls Bonington. In size and ambition, it stands out among the small-scale Romantic compositions on historical or exotic themes that occupied Delacroix in the years following his English voyage. The grimness of death is splendidly cloaked in beauty and luxurious display in this picture-poem: beneath the waving banners, the brocaded gowns, and the white marble stairs lies the Doge's headless corpse, neither shocking nor pitiful, a necessary, harmonious part of a stately ceremonial.

The year 1826 brought Delacroix his first state commission. He was one of the very diverse group of artists chosen to paint decorations for a suite of refurbished galleries and rooms of state in the Louvre. The subjects assigned were celebrations of the grand traditions in art, culture, and statecraft (Ingres's *Apotheosis of Homer* formed part of the series). Delacroix's contribution, *Justinian Drafting His Laws,* destined for the room of the Council of State, alienated the critics with its romantic Byzantinisms of jeweled robe and stylized gesture reminiscent of portions of his *Marino Faliero.* (The painting was destroyed by incendiaries of the Paris Commune in 1871.)

A highly personal work, inspired by Delacroix's intense interest in the struggle for the liberation of Greece from Turkish rule, dates from this same year. *Greece on the Ruins of Missolunghi* (Bordeaux Museum) pictures Greece in the form of a young woman in modern Greek dress, pale, her breast half bared, standing on Missolunghi's shattered walls, blown up by its defenders after the fall to the Turks in April 1826. The picture's intention is allegorical rather than historical, but Delacroix, instead of idealizing Greece as a classical divinity, has given her a vividly human appeal, sharpened by her expression of suffering—her despair, as Victor Hugo recognized, arouses not compassion only, but desire. The dark setting, a scene of devastation, is filled with details of emotion-stirring

realism. There is a hint of Gros and Géricault in the blood-streaked boulder in the foreground, in the arm of a dead defender that reaches out from among the tumbled stones, and in the distant, triumphant Moorish soldier, a figure of sinister glamour not unlike the executioner of *Marino Faliero.*

Startling as these paintings were to contemporary taste, they seemed mild compared to the colossal, orgiastic *Death of Sardanapalus* (1827, Louvre), which arrived tardily at the Salon of 1827 as a delayed eruption of irrepressible fury. The subject is taken from a play by Byron which ends with the ritual suicide of the Assyrian monarch, but the voluptuous slaughter of the harem that occupies most of the huge canvas was Delacroix's own contribution to the drama. The picture is an incoherent jumble of magnificent details, held together by grandiose sonorities of red and gold. Nudes worthy of Rubens, a rearing horse, and mounds of precious trinkets surround the pyre from which the king (who bears an unmistakable resemblance to Delacroix) watches their glorious destruction with an air of somber satisfaction.

The *Death of Sardanapalus,* his "second massacre," as he called it, is the frankest expression of Delacroix's "violent, sulfuric" self. Its joy of destruction and fevered sensuality are his Asiatic defiance thrown to the tepid Romantics of the liberal middle class. He paid for his audacity with the temporary loss of official favor.

The years 1827 to 1831 were a difficult but productive period. Delacroix tried his hands at a great variety of projects, at pictures of small size, brilliant color, and romantic subject matter: scenes from history of the kind that Scott, Hugo, and Dumas had made popular; nude "Odalisques" posing in the intimacy of opulent alcoves; Oriental costume pieces; and a series of lithographic illustrations for Goethe's *Faust* (published in 1828). He indulged his Sardanapalian mood in studies of tigers and lions, precursors of the later, more elaborate animal hunts in the manner of Rubens. Under the influence of Gros, he painted turbulent medieval battlepieces such as *The Battle of Nancy* (1828–31, Nancy Museum) and *The Battle of Poitiers* (1829–30, Louvre)—history paintings of moderate scale but sweeping energy, in which picturesquely armored and caparisoned figures clash, or merge into streams of contrasting colors that flow through wide, atmospheric landscapes. The drama of violence, suggested by the movement of densely massed figures, is also the theme of *The Murder of the Bishop of Liège* (1829, Louvre), in which the darkness of an interior space, spotted with flashes of light, contains the swirling crowd.

The Revolution which in July of 1830 toppled the Bourbon king, Charles X, and brought the duc d'Orléans to the throne of France as King Louis Philippe, had a profound effect on Delacroix's personal and professional life. A Bonapartist by family background, he had not been a friend of the deposed dynasty. The new, liberal monarchy of Louis Philippe returned to power a social class and political faction with which Delacroix identified himself. The national tricolor once again replaced the white banner of the Bourbons. The aristocracy of ancient lineage that had sustained the government of Charles X was replaced by the new aristocracy of the sword and the cashbox that Napoleon had fostered and from which

Delacroix was descended. He had been well treated by the Bourbons, but he had good reasons for expecting even more generous sponsorship from the new regime.

During the days of actual street fighting, July 27–29, 1830, Delacroix had been an observer rather than a participant. The emotions and impressions that he experienced on this occasion inspired his one truly popular painting, *Liberty Leading the People* (1830, Louvre). Across a barricade covered with the cadavers of fallen gendarmes and soldiers, the victorious people advances: a worker in leather apron brandishing a saber, a top-hatted citizen holding a musket, two street urchins, and a wounded worker in a blue blouse who, sinking to his knees, seems to address a last prayer to Liberty. She is the more robust sister of *Greece on the Ruins of Missolunghi*—in classical dress, barefoot, her powerful breasts bare, the cap of liberty on her head, a rifle in her left hand and the tricolor in her right—a goddess (perhaps modeled after the Venus of Melos) but at the same time a woman of such impressive physicality that her allegorical presence in no way diminishes the reality of the scene.

There are reminiscences of Gros and Géricault in the details (the foreground cadavers, for instance) and in the entire composition (an echo of the *Medusa* in its motion and structure), and there are signs that Delacroix's style has begun to shift in the direction of greater sobriety. Compared to the relative smallness and hectic agitation of the figures in his paintings of the late 1820s, Liberty and her followers appear more weightily monumental, their gestures more ample. They are modeled with broader brush strokes in subdued, harmonized hues; their execution has become firmer and more compact. The note of romantic morbidity, so pronounced in the work of the preceding years, lessens and, from this time onward, gives way to a more controlled expressive energy.

After the successful exhibition of *Liberty* at the Salon of 1831, the government of Louis Philippe purchased the picture and awarded Delacroix the Legion of Honor. In January 1832, Delacroix accompanied the French ambassador comte de Mornay on his visit of state to the sultan of Morocco. The voyage lasted until July and took him to Tangier, to Meknes (the sultan's capital), Oran, and Algiers, with a side excursion to the southern Spanish cities of Cadiz and Seville. Islamic Africa, its climate, light, and color, and its contrasts of barbaric simplicity and aesthetic refinement, surpassed all his expectations. The African voyage was to play the role in his life that the Italian tour—once obligatory but avoided by him—had played in the lives of neoclassical artists. It opened his eyes to antiquity: instead of the picturesque bric-à-brac of romantic Orientalia, he discovered in Islam authentic survivals of the Homeric age. The classical beauty and dignity for which he had vainly looked among the plaster casts in Guérin's studio he now encountered in the flesh, along dusty roadsides under the African sky. Delacroix filled seven sketchbooks (of which only two survive intact) with observations of Arab life and painted eighteen large watercolors for de Mornay, recording the authentic detail of costume and weapon, stance and gesture. The store of ideas and pictorial motifs that he gathered during these months was to serve him for the remainder of his life.

On his return to Paris, he began a new series of Oriental subjects, not

Byronic fantasies now but recollections of actual experience. One of the earliest and richest of them, the *Algerian Women in Their Apartment* (1834, Louvre), records his impressions of a visit to a harem with the quiet authority of fact rather than the fantasy of romantic genre. The women are represented life-size, in indolent repose. There is no hint of narrative in this scene, most parts of which are based on drawings made in Africa. The dusky interior, the women's warm skins and brightly embroidered garments, cast in half-shadows interspersed with patches of light, come together in a tapestry-like pattern of exotic greens, roses, reds, and dim gold. The sensuous intensity of the painting, achieved without dramatics or pantomime, surpasses that of the sensational *Sardanapalus.* Delacroix has reached his mature style, quieter but grander than his earlier manner, more restrained in color and gesture yet no less expressive.

Watercolors drawn during the African voyage gave him the ideas for two paintings that he elaborated in later years: *The Fanatics of Tangier* (1837, New York, private collection), a scene of turbulent motion stabilized by the solid cubes of whitewashed houses under a bright blue sky; and *Jewish Wedding in Morocco* (1839, Louvre), in which an interior space, firmly framed by white walls, contains an agitated fringe of figures whose costumes and poses have the authenticity of observed life. The experience of Morocco cleansed Delacroix's work of Romantic exaggerations and mannerisms. It impressed him with the superiority of actual experience over purely imaginative effort, and separated him further from the turbulent band of young artists who called themselves the Romantic School.

Romantic impulses had played a role in the work of Prud'hon, Gros, Girodet, and Géricault, and even in that of David himself. But that earlier romanticism had not declared itself openly. It had existed, unacknowledged and unconscious, within the Neoclassical School or in its shadow. When, about 1820, the bankruptcy of that school became manifest, and the feebleness of David's aging lieutenants and the nullity of their orthodox followers turned into a public embarrassment, young dissidents of Delacroix's generation, many of them from the studios of Gros and Guérin, rushed in to fill the void left by the collapse of the old system. Romanticism then made its belated, official appearance in France (having already run its full course in Germany and England) and steadily advanced from Salon to Salon, still timid in 1822, bolder in 1824, triumphant in 1827.

Delacroix, conspicuous from the first by his boldness, was considered the leader of the young school, which was for the most part composed of interesting but minor talents scarcely remembered today: the Brothers Scheffer, the Brothers Deveria, Boulanger, Roqueplan, Sigalon, and others whose work attracted attention for its heretical glamour and exciting modernity. Delacroix initially shared many of their tastes and poses, but as the Romantic movement, victorious in 1830, became popular and fashionable—which is to say agreeable and trivial—he rapidly outgrew his affiliation. The Romantic "battle" had been won too easily. Delacroix, proud and self-critical, did not want to be part of this shallow success.

As he outgrew the enthusiasms of his youth, he became increasingly conscious of an affinity with artists of the past, with the great Flemings and Venetians

above all, and most particularly with Rubens and Veronese. Delacroix's preoccu-
pation was not a retreat from modernity but the expression of a wish to fit his
own work into a grand continuity. Having risen above the modishness of his
immediate period, he sought his place in a larger tradition, and felt himself not
the imitator but the legitimate descendant of Rubens. His later works reflected
his growing interest in traditional subject matter and monumental form. Their
themes were often didactic, their tone oratorical. Rejecting the anarchical subjec-
tivity of the more extreme forms of romanticism, he assumed an ethical position
not unlike David's.

The Justice of Trajan (1840, Rouen Museum), an episode taken from
Dante's Divine Comedy, shows the Roman emperor on his way to battle being
stopped by a woman demanding justice for the murder of her son. Impatient to
continue, the emperor nevertheless stops, in obedience to the law, to hear her
complaint. Though taken from a medieval Christian source, this is a classical
example of virtue, destined to be placed in a court of law. The moral drama of
the subject is suggested by the very structure of the huge composition: the
emperor's advance amid a pomp of standards and trophies is checked by the
mother's gesture; the animated rush of the figures is contained and stilled by the
stable forms of the classical architecture that looms over them.

The Entry of the Crusaders into Constantinople (1840, Louvre), commis-
sioned by Louis Philippe for the Hall of the Crusades at Versailles, represents an
episode of the spoliation of the Byzantine capital in 1204. Its theme is the
destruction of a noble and beautiful civilization by the sinister forces of war, amid
a setting of visual splendor. Delacroix appropriately gave this picture something
of the vast space and disjointed figure groupings of the Massacre of Chios and also
of the looming, ragged silhouettes of Liberty Leading the People. But the picture's
violence is muted by the melancholy harmony of its colors, and held within
bounds by the heavy verticals of the colonnade that closes the view on the left.

In both paintings, Delacroix is concerned with pictorial balance and stabil-
ity. Where in his earlier compositions he had scattered agitated figures in vaguely
defined spaces, he now opposes a solid framework to the dynamic thrust of the
figures. Behind this new concern with the formal problems of monumental com-
position lies the experience gained in the execution of the vast architectural
decorations that occupied him during much of the latter part of his life. The
governments of Louis Philippe and of Napoleon III favored him with a series of
official commissions, beginning in 1833 with the decorations for the Salon du Roi
in the building of the Chamber of Deputies at the Palais Bourbon. Accommodat-
ing himself to a difficult architectural setting, Delacroix developed a program
expressive of the pacific and mercantile rule of the July Monarchy. The pillars
that support the domical hall bear grisaille representations (in oil and wax, rather
than fresco) of the rivers and seas of France, the natural sources of her wealth.
In the friezes below the ceiling and in the coffers of the ceiling surrounding the
skylight, he painted allegories of the functions of government: Justice, Agricul-
ture, Industry, and War. Competing with the massive architecture of the room,
Delacroix attempted to give his figures the salience of high relief.

Before the work was finished, in 1838, he received other large state commissions: that of the *Battle of Taillebourg* (1837, Versailles) for Louis Philippe's Gallery of Battles—in which he oddly paraphrased Rubens's *Battle of the Amazons*—and that of decorating the Library of the Chamber of Deputies in the Palais Bourbon. The powerful protector who entrusted Delacroix with these immense official enterprises at a time when he was still widely regarded as a subversive and immoralist was Adolphe Thiers, who as an obscure journalist had praised Delacroix's youthful *Dante and Virgil,* and had since risen to ministerial eminence.

Thinking perhaps of Michelangelo's frescoes in the Sistine Chapel, Delacroix for the *Library of the Chamber of Deputies* set himself the program of tracing a secular genesis, that of Culture. In the two half-domes at the opposite ends of the long room, he painted, on the one side, Orpheus bringing the arts of peace to mankind, on the other, Attila the Hun destroying Italy and the arts. In a succession of five small domes between these images of the birth and destruction of civilization, he described man's intellectual adventure. The four pendentives that support each dome celebrate the heroes and martyrs of the main branches of knowledge—the Natural Sciences, History and Philosophy, Law, Theology, and Poetry—each personified by a figure from antiquity or Scripture. These figures, painted with the help of assistants after Delacroix's design and careful instructions regarding color, are boldly modeled in color, in some instances without the use of black.

While still at work on this enormous nine-year project, Delacroix undertook yet another, that of the decorations for the *Library of the Senate* in the Luxembourg Palace (1840–46). The subject of the dome, suggested by a passage from Dante, is the presentation of Dante to Homer and the other great men of Greek and Roman antiquity—in other words, the meeting of the modern Christian and the classical pagan cultures. In the half-dome above the window, he painted Alexander the Great causing the works of Homer to be placed in a golden chest. The program of these murals amounts to an act of homage to the classical tradition, similar in spirit—though very different in tone and style—to Ingres's solemn *Apotheosis of Homer* (1827).

The Revolution of 1848 which brought down the government of Louis Philippe did not put an end to Delacroix's official employment. He did not sympathize with the revolutionaries of 1848, as he had with those of 1830, and observed the Socialist agitation and attempts at insurrection that followed with deep suspicion. He longed for tranquility, order, and authority, and welcomed the rise of Louis Napoleon Bonaparte, nephew of the great Napoleon, to the presidency (1848) and two years later, after a *coup d'état,* to the imperial throne as Napoleon III. The restoration of the Empire brought back to privilege and power the Bonapartist elite into which he had been born and for which he felt a deep, though by no means blind attachment.

Delacroix soon received tangible marks of official favor. He was appointed a city councillor of Paris, and continued to receive large state commissions.

One such was the *Apollo Victorious Over Python,* the central panel in the ceiling of the Galérie d'Apollon in the Louvre (1850–51). The subject of the Sun

God's victory over the serpent and its creatures, the progeny of darkness, vapor, and slime, was first conceived in the 1660s by Charles Lebrun as a tribute to the Sun King, Louis XIV. Delacroix gave it the additional significance of the triumph of rational order over the forces of darkness and of the deep—a symbolism that could be interpreted in a purely intellectual or artistic sense or, more topically, as a political reference to the recent victory of authority over Revolutionary chaos.

A second large commission was for the ceiling of the Hall of Peace in the Hôtel de Ville of Paris (1852–54; destroyed by arsonists during the Commune of 1871). The subject, *Peace Consoles Mankind and Brings Abundance,* carried an evident political meaning in the years after the establishment of an authoritarian government by Louis Napoleon. Delacroix's use of classical allegory to allude to a contemporary situation—the return of domestic peace after a period of revolution—recalls David's use of mythical history for a very similar purpose in his *Battle Between Romans and Sabines.*

Of the great painters of the nineteenth century, none was so continuously employed in monumental work, none given so great an opportunity to express himself on the walls of public buildings as Delacroix. His mural paintings stand out as achievements of a totally exceptional kind for a period in which this art had fallen into decay. They prove this nervously excitable and physically frail artist to have had the strength of mind and executive energy to carry out his ideas on immense surfaces without falling into bombast or mere decoration. It had been the ambition of the neoclassicists to create a public art of grand style and high moral purpose; they should have become the century's muralists. But in this they failed, and none more completely than Ingres, for all his gift of constructive and disciplined design. The succession of the great masters of the Renaissance and Baroque fell not to the self-appointed guardians of the great tradition, but to an artist who outwardly answered the stereotype of the romantic egoist, self-absorbed, proud, and solitary, but who was possessed of a strong sense of cultural responsibility, and whose work was in large part public and didactic.

Heavily occupied with his monumental projects, Delacroix produced fewer large Salon pictures after 1841 than in the preceding decades, but he continued to paint a multitude of smaller canvases for private collectors. The range and variety of his subject matter was prodigious, embracing classical themes on the one hand—*Death of Marcus Aurelius* (1845, Lyon Museum)—and episodes from history and literature on the other—*Return of Columbus* (1839, Toledo Museum); *Marfisa and Pinabello's Lady* (1852, Baltimore, Walters Art Gallery, based on Ariosto's *Orlando Furioso*); and *Weislingen Captured* (1853, St. Louis, City Art Museum, based on Goethe's *Goetz von Berlichingen*). Conspicuous among his works until the end of his life remained the Oriental subjects that he continued to derive from his sketches of the Moroccan voyage. *The Sultan of Morocco Surrounded by His Court* (1845, Toulouse Museum) is a reminiscence of the audience given by the sultan to Comte de Mornay's embassy in Meknes of which Delacroix had noted a detailed description in his *Journal. Arab Comedians* (1848, Tours Museum), and *Arabs Skirmishing in the Mountains* (1863, New York, private collection) are two other Oriental recollections.

Though he was not religious in any conventional sense, Delacroix painted religious subjects with genuine intensity of feeling, and was particularly attracted to scenes of suffering and pathos. Among his most notable religious compositions are:

Christ Crucified Between the Two Thieves (1835, Vannes Museum);
Crucifixion (1845, Baltimore, Walters Art Gallery);
Entombment (1848, Boston, Museum of Fine Art);
St. Stephen and the Holy Women (1853, Arras Museum); and
The Way to Calvary (1859, Metz Museum).

He was without doubt the last great master of religious painting in the tradition of the Renaissance and Baroque, a painter whose religious work was meant for churches rather than galleries. It was fitting that the final monumental enterprise of his life should have been destined for a sacred function.

The decorations for the *Chapel of the Holy Angels* in the church of Saint-Sulpice, commissioned in 1849, were executed in 1854–61. The paintings in this chapel consist of a rather feebly realized ceiling panel *(St. Michael's Victory Over the Devil)* and of two murals on the side walls, painted in a mixture of oil and wax directly on the masonry, *Heliodorus Driven from the Temple* to the right and *Jacob Wrestling with the Angel* to the left of the entrance. Within the small space of the chapel, the confrontation of these two images—the punishment of the sacrilegious and the trial of the good man—produces a powerful contrast. *Heliodorus* is dominated by the complex architecture of the Temple, from which the pagan looter is being driven by a celestial horseman and by angels with scourges.

The composition owes much to Raphael's *Heliodorus* fresco in the Vatican, and may also have been influenced by Solimena's more complexly Baroque version of the subject. The colors in the powerfully modeled figures are coldly vivid, tending to sharp blues, violets, and reds. There is evidence that Delacroix applied here his observations of reflected colors and of color changes in the shadows (a color in the light produces its complementary in the adjacent shadows, a phenomenon first described by the chemist Eugène Chevreul). *Jacob Wrestling with the Angel* has a landscape background, taken up largely by a majestic stand of oaks, in deliberate contrast to the architectural setting of *Heliodorus*. The idea for the composition and its setting may have been suggested by Titian's *Death of St. Peter Martyr*, of which Delacroix owned a copy painted by Géricault.

Among the variety of his subject matter, certain images recur with notable frequency, suggesting that they held a special significance for him. He was fascinated by the beauty and cruelty of the great felines (as Géricault had been) and often painted tigers and lions at play (*Young Tiger Playing with His Mother*, 1830, Louvre), attacking their animal or human prey (*Lion and Cayman*, 1855, Louvre), or being themselves attacked by hunters (*Tiger Hunt*, 1854, Louvre, and the *Lion Hunts* of the Bordeaux Museum, 1855, the Boston Museum of Fine Art, 1858, and the Chicago Art Institute, 1861). The inspiration for these pictures came from two quite different sources: Delacroix's actual observation of the animals during frequent visits to the Jardin des Plantes, and his familiarity with Rubens's dramatic hunt pictures. But whatever their origin, their meaning to him

was not unlike that of the "Tyger" of Blake's poem—they stood for a sublime terror in nature.

Another recurrent theme in Delacroix's work is that of melancholic or persecuted genius. This is represented in various historical guises—as *Tasso in the Madhouse* (1839, Winterthur, Reinhart Collection), *Michelangelo in His Studio* (1850, Montpellier Museum), or *Ovid Among the Scythians* (1859, London, National Gallery)—but with evident reference to the plight of the artist suffering from the ignorance or ingratitude of his contemporaries—in other words, to the situation in which Delacroix saw himself.

The image of the distressed boat, finally, of which his *Bark of Dante* (1822), painted under the influence of Géricault's *Raft of the Medusa,* was the earliest instance, occupied him until the end of his life. The motif recurs in connection with different subjects, as *Shipwreck of Don Juan* (1840, Louvre), as *Shipwrecked Men Abandoned in a Boat* (ca. 1846, Moscow, Pushkin Museum), or as *Christ on the Sea of Galilee* (1854, Baltimore, Walters Art Gallery, and nine other versions). The textual reference changes, but the image remains constant. The small craft tossed by the waves seems to have signified to Delacroix, as it did to other painters and poets of the period, the helplessness of man in the indifferent vastness of the universe.

His originality, and his superiority over most of his contemporaries, particularly in the matter of monumental painting, rested in part on his profound mastery of color, both in its physical nature—as light, reflection, and refraction—and its emotional impact. Color was the life and the structure of Delacroix's paintings. He used his insights into the laws of light and color for constructive and expressive purposes rather than strictly representational ones. Almost equally important was his imaginative use of pose and gesture. No other painter of his time put so much meaning into dramatic pantomime, into the movement and clash of figures. He invented a vocabulary of gestures as distinctive and personal as his colors. Often attacked by hostile critics for his supposed inability to draw, Delacroix was in fact one of the great expressive draughtsmen of the nineteenth century. His affinities with the Baroque are especially apparent in his drawings, which aim for the expression of motion, energy, and gesture rather than the delineation of a precise contour. He thought of outline as an emanation from the center of form. His handwriting, a turbulence of whirls and flourishes, is often rough and "incorrect," but achieves greater amplitude and firmness than the drawings of many a laborious classicist.

The latter part of Delacroix's life passed uneventfully in constant application to his work, interrupted by brief periods of rest or travel, and, as he grew older, by increasingly lengthy spells of sickness. He suffered for many years from a chronic bronchial disorder, perhaps of tubercular origin, that ultimately caused his death. Conscious of the limits of his physical strength, determined to achieve his ambitious projects, he led a disciplined, frugal life, withdrawing more and more from the distractions of social life and even of friendship. Lightly built and of elegant bearing, he seemed tall. Dark hair, only slightly grayed, surrounded his sallow-complexioned face, which contained a pair of lively black eyes, narrowed beneath strong shading brows, an upturned nose, and a slight mustache

over a large, bitter mouth. Despite the urbanity of his manners, there was something terrifying in his aspect. The contrast between Delacroix's polished social self and his vehement, thwarted nature struck all who came close to him; Baudelaire likened him to a "volcano artistically concealed beneath bouquets of flowers." Work, in his later years, replaced his other passions and pleasures. He never married, but for more than thirty years maintained a discreet liaison with a distant cousin, the baronesse de Forget, who was also a relative of the empress Josephine. His more intimate domesticity was protected by a devoted housekeeper, Jenny Le Guillou, who looked after his physical wants and kept a watch over his privacy.

In 1855, at the Universal Exposition, thirty-six of his paintings were shown by way of tribute to him as one of the two most eminent living artists of France —the other being Ingres, a selection of whose works was shown in another gallery. At the close of the exhibition, Delacroix received the Great Medal of honor and was made a Commander of the Legion of Honor.

Since 1837, Delacroix had seven times gone through the humiliating ordeal of applying for membership in the Academy (the *Institut*) and been rejected every time. In 1857, on his eighth try, he was finally admitted to this body of distinguished mediocrities, a recognition that he had sought as a matter of principle, not of genuine ambition, for he had a perfectly realistic appreciation of that establishment.

He exhibited at the Salon for the last time in 1859, submitting mainly a group of his late religious canvases. In 1860, twenty-three paintings were exhibited at the Galérie Martinet on the Boulevard des Italiens. Despite his worsening illness, Delacroix continued to work with unabated energy. One of the last paintings that he was able to complete, *Arabs Skirmishing in the Mountains* (April 1863), was a final memory of his African adventure of 1832. He died on August 13, 1863.

In the literature of modern art, Delacroix's *Journals* (preserved for the years 1822–23 and 1847–63) and *Letters* occupy a special place, as the most extensive, intimate, and profound expression of a great artist's thought. They constitute a human document of the highest significance, far more revealing of the artist, his work, his thought, and his period, than any merely historical or critical accounts. In addition to these private writings, Delacroix produced fourteen published articles between 1829 and 1862, on a variety of topics, ranging from essays on Michelangelo, Raphael, and Poussin to appreciations of Gros and Charlet, and to thoughts on *"Le beau, l'idéal, et le réalisme."*

READINGS

Life and Work

R. Escholier, *Delacroix, peintre, graveur, écrivain,* 3 vols., Paris, 1926–29, the most detailed biography; richly documented and illustrated.

R. Huyghe, *Delacroix,* London, 1963.

F. Trapp, *The Attainment of Delacroix,* Baltimore, 1971.

M. Serullaz, *Eugène Delacroix,* New York, 1971, concise, popular, and well illustrated.

T. Prideaux, *The World of Delacroix* (Time-Life), New York, 1966, a popular account of the life and its historical setting.

Specialized Studies

L. Johnson, *The Paintings of Eugène Delacroix, a critical catalogue,* vols. 1–II (1816–31), Oxford, 1981, the beginning volumes of a detailed, authoritative revision of the old standard catalogue by A. Robaut and E. Chesneau, *L'Oeuvre complet d'Eugène Delacroix,* Paris, 1885.

L. Johnson, *Delacroix,* London, 1963, an investigation of Delacroix's theory and use of color.

L. Delteil, *Ingres et Delacroix* (Le peintre-graveur illustré, vol. III), Paris, 1908, a catalogue of the lithographs and etchings.

K. Badt, *Eugène Delacroix, Drawings,* Oxford, 1946.

C. Martine, *Eugène Delacroix, Soixante-dix aquarelles, dessins, croquis,* Paris, 1928, a selection of splendidly reproduced drawings and watercolors.

M. Serullaz, *Les peintures murales de Delacroix,* Paris, 1963, the wall paintings.

J. Spector, *The Murals of Eugène Delacroix at Saint Sulpice,* New York, 1967.

J. Spector, *Delacroix: The Death of Sardanapalus,* New York, 1974.

The Writings of Delacroix

A. Joubin, ed., *Correspondance générale d'Eugène Delacroix,* 5 vols., Paris, 1935–38, the collected letters.

A. Dupont, ed., *Eugène Delacroix, lettres intimes,* Paris, 1954, further letters, not included in Joubin's publication.

A. Joubin, ed., *Journal d'Eugène Delacroix,* 3 vols., Paris, 1950, the standard edition of the *Journals.* English translations of selected passages are given by W. Pach, New York, 1948, and Lucy Norton, London, 1951.

E. Fauré, *Oeuvres littéraires,* 2 vols., Paris, 1923, the essays on art and literature.

G. Mras, *Eugène Delacroix's Theory of Art,* Princeton, 1966.

8

French Landscape

J.-B.-Camille Corot, 1796–1875
French Naturalist Landscape
and the School of Barbizon, 1830–1870
 The Painters of Barbizon
Théodore Rousseau, 1812–1867

J.-B.-Camille Corot, 1796–1875

In France, as elsewhere on the Continent and in England, the cult of nature flourished throughout the eighteenth century and produced, among other manifestations, various kinds of naturalist landscape painting. French artists, like their British contemporaries, sought to free themselves from artistic stereotypes by studying nature in nature, under the open sky and in the light of day, and to record their observations in uncomposed, portrait-like landscapes, using both oils and watercolors. In England, this naturalist current continued steadily into the following century, but in France it was interrupted by the resurgent neoclassicism of the eighteenth century's last decades. A strong, national tradition of severely stylized, historical landscape painting inhibited the further development of naturalism.

During the period of David's dominance, landscape painting—considered to be, at best, of second rank—was officially tolerated only when it conformed to the types established by Poussin, Dughet, and Claude. Direct sketching from nature was practiced only privately; watercolor painting almost ceased. It was only after the fall of the Empire in 1815 that the naturalist tendency again asserted itself in France, in part as a result of English influence. A young artist of English birth, Richard Bonington, who had studied watercolor painting under an English-trained teacher, helped to create in France a vogue for luminous, atmospheric landscapes of an entirely unclassical kind. The exhibition of Constable's landscapes at the Paris Salon of 1824 made a deep impression on French painters of the younger generation, and prepared the way for a virtual revolution that abruptly swept away neoclassical norms and set French landscape painting on the naturalist course that was to dominate it for the remainder of the century. At this crucial juncture, the work of Corot, though essentially personal, represents a French approach to naturalism, still deeply conditioned by a national penchant to classical form.

Corot was born in 1796 in the heart of Paris, in a house on the left bank of the Seine on the corner of the busy rue du Bac, fronting the Louvre across the river. His father was a clothier who had prospered during the revival of luxury trades following the Revolution, but it was his mother, a fashionable dressmaker, who was chiefly responsible for keeping the family business in a flourishing state throughout the years of the Empire and the Restoration. The infant was put in the care of a nurse in a village on the Oise River some twenty miles northwest

of Paris, where he grew into a sturdy and cheerful country boy.

After attending grammar school in Paris, he was sent to a lycée in Rouen in 1807–12. A friend of the family, M. Sennegon, acted as his guardian—a quiet man and lover of nature who often took the boy on meditative evening walks that he long remembered. After two further years in a boarding school near Paris, his formal studies came to an end. They had been far from brilliant, but they left him with a taste for classical literature and its values of harmony and style. At nineteen, Corot was a tall, strong, bashful youth, awed by his father, devoted to his mother, and coltishly playful when among friends his own age.

The young man had thought of becoming an artist, but his father wanted him to be a merchant and apprenticed him to a draper, in whose shop Corot soon demonstrated his incapacity for salesmanship. Placed in another firm under a particularly indulgent manager, he proved to be marginally employable as a deliveryman, though one of a rambling kind, much given to contemplating the sky and inspecting shop windows. His wish to become a painter gradually became stronger. He began to attend evening sessions at the newly founded Académie Suisse, an establishment where, for a fee, would-be artists drew or painted the posing model. In 1817, his father bought a country house with garden at Ville d'Avray on the road to Versailles, about ten miles southwest of Paris. The ponds and forests around this village were to be Corot's summer recreation for the remainder of his life and one of his favorite painting sites.

By the age of twenty-six, Corot was still without a profession. His parents, resigned to his unfitness for business, settled a yearly allowance of 1,500 livres on him, a pension formerly paid to one of his sisters, who had died in 1821. This income set him free: like Constable and Géricault before him, he was now able to launch himself on an artistic career from a base of financial independence. Having established a studio in a house on the Quai Voltaire, a stone's throw from his parents' shop, he first sought advice from a painter exactly his own age, Achille-Etna Michallon (1796–1822), a pupil of David and of Valenciennes, who had recently returned from a stay in Rome as the first laureate of the prize for historical landscape. Corot accompanied Michallon on sketching tours in the Forest of Fontainebleau, but their association was cut short by Michallon's death in 1822.

Corot next turned to Michallon's former teacher, Victor Bertin, a more rigorous classicist, who nevertheless believed in the importance of sketching from nature. Bertin introduced him to the principles of landscape composition as he understood them, impressed on him the importance of drawing, and encouraged him to practice the rapid notation of landscape motifs in oil studies taken on the spot. Corot set up his easel beside the Seine, surrounded by the salesgirls from his mother's shop; he painted in the forests of Fontainebleau and Ville d'Avray, and on sketching jaunts to the Channel coast.

His development was remarkably rapid and sure. The earliest known oil studies—of posing models, such as the *Boy in a Top Hat* (ca. 1823–24, France, private collection), and of landscapes near Ville d'Avray, Saint-Cloud, and Honfleur—already show the familiar characteristics of Corot's personal style in their

modest directness and lucidity, their purity of color and deftness of touch.

With his father's blessing and financial support, Corot left for Italy in September of 1825, having presented his parents with his *Self-Portrait* (1825, Louvre) as a token of gratitude. Painted in thick, rather dark colors, with small touches of the brush, the portrait shows the young artist working at his easel in an intimate and natural pose. During the rainy Roman winter, Corot kept himself occupied painting studies of casually engaged models—country girls from Albano, street urchins, a Franciscan monk—posed artlessly in his little room at the Piazza di Spagna. These small pictures of Italian "types" entirely lack the sentiment and picturesqueness for which Corot's contemporaries, the young French Romantics then in Rome, sought in their far more purposeful sophistication. Corot was on cordial terms with his French colleagues—Victor Schnetz, Leopold Robert, Edouard Bertin, and Caruelle d'Aligny—though these accomplished artists at first treated him with condescension, regarding him as timid and naive.

Rome's treasures of art made little impression on Corot. He was perhaps the only artist of his time to have spent two years in Rome without once visiting Michelangelo's frescoes in the Sistine Chapel. But the Roman townscape, with its cubicular structures of ancient, tawny brick, under blue skies, gave him endless delight. Many of the roughly 150 small oil studies painted during his first Italian stay are of architecture, such as the *View of the Colosseum Through the Arcades of the Basilica of Constantine* (1825–26, Louvre); the *View of the Forum from the Farnese Gardens* (1826, Louvre); and the *View of the Colosseum from the Farnese Gardens* (1826, Louvre). In the early spring of 1826, Corot painted daily in the Farnese Gardens, producing several panoramic views of the Roman ruins below, as seen in the slanting light of early morning *(Colosseum)* or late afternoon *(Forum)*. There is no striving for effect, no dramatic exaggeration in these quiet views, empty of figures. With firm, small touches, applied without flourish, Corot recorded the view before him, making no effort to go beyond the literal, objective truth of what he saw, but savoring this truth so deeply as to give his record of it the intensity of a poem.

Gifted with an instinctive sense of arrangement, and conditioned by the neoclassical lessons of Michallon and Bertin, Corot gave his studies—such as *The Church of S. Trinita dei Monti, Seen from the Villa Medici* (1826–28, Louvre), and the *Ponte and Castel Sant'Angelo, Rome* (1826–28, San Francisco, Legion of Honor)—a seemingly "natural" harmony and balance, free from the constraint of compositional schemes. He paid as much attention to the light and atmosphere of his scenes as to their material features, even when making preliminary drawings in pen or pencil. Unlike his English contemporaries, he did not use watercolor, but painted his nature sketches *(pochades)* in oil, faithful to French neoclassical usage.

During the good-weather seasons of 1826 and 1827, Corot took sketching tours along the Tiber, to Monte Soracte, to the Sabine Hills, Civita Castellana, and Narni, filling his sketchbooks with drawings and painting oil sketches. *Narni Bridge* (1826, Louvre), a summary oil study of small dimensions, was painted on the spot in bold, approximate strokes, but with great color precision in the effect

of warm sunlight on the riverbed, the shadow of the bridge-piers on the water, and the atmospheric recession of the plain toward the blue mountains in the distance.

In the winter of 1826–27, Corot developed this sketch into a considerably larger exhibition piece, *Narni Bridge* (1827, Ottawa, National Gallery of Canada), which he submitted to the Paris Salon. In transforming the study into a Salon picture, he felt it necessary to compose an extensive foreground with figures, and to add picturesque groups of trees to the middle ground at the left, as well as two umbrella pines in the center whose familiar sihouettes provide an elegantly Claudian touch. This conversion of a "natural" into a composed landscape recalls Constable's way of working up exhibition pictures from sketches painted on the spot.

After further excursions, including a trip to Naples in the spring of 1828, Corot left Rome in September of that year, returning to Paris by way of Venice. Back in France, he resumed his yearly routine of study travel in the fair-weather seasons, spending the winters in his Paris studio to work up his outdoor sketches into exhibitable compositions. During 1829, he set up his easel in the vicinity of Paris, in the Forest of Fontainebleau, and in the coastal regions of Normandy and Brittany. *Pont au Change, Paris* (ca. 1830, New York, private collection) records a view of the Ile de la Cîté from across the river with unassuming truthfulness and seizes the cool silveriness of an overcast Parisian day with the same delicacy that he had earlier brought to his studies of the warmer Italian light.

The July Revolution of 1830, which overturned the Bourbon monarchy and replaced it with that of Louis Philippe, disturbed the quiet Corot needed for his work and sent him sketching to Chartres, where he accomplished one of the most serene of his luminous architectural landscapes, *Chartres Cathedral* (1830, Louvre). The finely sculpted form of the cathedral rises, in the aristocratic beauty of its golden stone, from behind a quite banal setting consisting of a mound planted with young trees, a pile of rough stones, a few nondescript houses, and a nearly empty road. The structure of its towers is clearly detailed against the softer, cooler fleeciness of the clouds behind them. It is curious to compare Corot's picture with Constable's contemporaneous *Salisbury Cathedral from the Meadow* (1831), notable for its somber drama and portentous symbolism. *Chartres Cathedral,* by contrast, is merely a shapely and definite structure, dominating its surroundings, confident, simple, and precise. Its poetry has nothing to do with Romantic Gothicism or historical evocation, let alone any covert symbolism. It springs directly from the lovely truth of light and form.

Despite his mastery, Corot still looked on himself as a student. He worked with endless diligence, in nature or in the studio, compiling innumerable drawings and sketches, hesitant to tackle larger-scale work, though he elaborated some of his Italian impressions into Salon pictures (*La Cervara in the Roman Campagna,* 1831, Zurich, Kunsthaus). He often visited the Forest of Fontainebleau with his friends d'Aligny and Edouard Bertin, seeking in its rocky wildernesses for motifs more strong-featured than the agricultural plains of the Ile de France. He may have met the painters of the future School of Barbizon, particularly Théodore Rousseau, about this time.

Corot's unpretentious Salon submissions received little notice and found no purchasers. The first success came at the Salon of 1833, to which he had submitted a *View of the Forest of Fontainebleau* (now lost), representing a cart fording a stream—an evident reminiscence of Constable's *Haywain.* The Salon jury awarded him a second-class medal. In May 1834, Corot set out on a six-month study tour of northern Italy in the company of a painter-friend, with the financial support of his parents. The pair traveled along the Mediterranean coast to Genoa, Pisa, and Volterra, continuing thence to Florence and to Venice, from where, after a stay of three weeks, Corot turned homeward, skirting the North Italian lakes and stopping to work at Desenzano, Riva, and Como. The impressions he gathered in these autumn weeks would remain in his memory for ever after.

The landscape studies from this second Italian voyage, though relatively few in number, are larger, more richly furnished, and more densely brushed than those of the earlier stay. *View of Genoa from Acqua Sola* (1834, Chicago, Art Institute) opens a wide panorama, at a fair distance, across a roughly sketched expanse of foreground. The brilliantly sunlit clutter of roofs, towers, and domes extends, in splendid recession, toward the deep blue of the Mediterranean and the softer blue of the sky. *Volterra, the Citadel* (1834, Louvre) carries the eye across a rise and a valley, the one overgrown with dark scrub, the other crisscrossed by walls and roads, toward the distant, compact fortress on the brow of a hill. The warmth of reflected sunlight in the foreground fades into a silvery brightness in the receding hillsides, backed by the clear blue of a nearly cloudless summer sky. The perspectival sweep of the terrain combines with the gradations of color and light to produce a sense of space that is all the more striking for appearing entirely natural. *View of Florence from the Boboli Gardens* (ca. 1835, Louvre) is the slightly altered revision of a (lost) sketch, painted shortly after Corot's return to France. Between the shaded foreground and the darkling hills in the distance, the city rises from the valley below, its towers and domes grazed by the slanting light of late afternoon.

These spacious views of Italian landscapes maintain a fine balance of physical structure and luminous atmosphere: distance and light, solid form and immaterial color are managed so simply as to appear uncomposed. The objects in them appear as gentle bodily presences bathed in clear air and light. Their execution, in small, steady touches of the pointed brush, is devoid of temperamental flourishes. Corot avoids striking contrasts and dramatic effects. There are no threatening clouds, no rain showers, no lurid sunsets. The processes of weather are not used—as in landscapes by Constable and Turner—to animate these landscapes with suggestions of change and tension. Everything in them expresses Corot's acceptance of nature as a state of peace and harmony.

After his return to France, the artist made a determined effort to go beyond pure landscape to the kinds of subject matter that might bring him greater attention at the Salon. This resulted in a series of compositions on biblical or classical themes, figural scenes in settings derived from his earlier landcape studies. *Hagar in the Wilderness* (1835, New York, Metropolitan Museum) was planned before the second Italian voyage. The figure of Hagar in the shadows of the foreground has genuine pathos and demonstrates Corot's great originality as

a figure painter, remarkably independent of traditional mimetic stereotypes. The
fine landscape setting is a composite of earlier studies from nature: the trees in
the middle distance are from Fontainebleau, the rocks from Italy, the general
effect of the arid "wilderness" from Volterra. *Diana and Actaeon* (1836, New
York, Metropolitan Museum) treats a conventionally classical subject in a quite
personal manner. The nymphs bathing in the brook are of a type—soft-fleshed,
plump, and slightly Rococo—peculiar to Corot, one of the few artists of the time
who created a distinctive model of the female nude. The feathery trees in the
distance, at the left, give a premonition of his late, poetically hazy manner.

Subject-matter pictures, combining landscape with narrative compositions,
henceforth figured regularly at the annual Salons and gradually established Corot
as one of the leading painters of "historical" landscape: a *St. Jerome in the Desert,*
1837, painted for the church of Ville d'Avray; a *Silenus* (1838, now in the
Minneapolis Art Institute); and a *Flight into Egypt* (1840), which the pious artist
gave to the church of Rosny, near Mantes, where his friend Abel Osmond owned
a château.

In working his studies from nature into these stylized and somewhat deco-
rative compositions, Corot faced difficulties similar to those that had confronted
Constable when he painted his exhibition pictures. But Corot solved the problem
of reconciling the actual experience of the eye with the formal requirements of
tradition more easily: in him, the rift between the "natural painter" and the
composer of historical landscapes was not so deep. His early apprenticeship to
neoclassical painters (and perhaps an innate disposition) had bred in him habits
of arrangement that gave formal balance and harmony even to his seemingly
spontaneous sketches from nature, and enabled him to blend various sketches in
one well-ordered, coherent design, without strain or recourse to compositional
formulae. Borrowings from Claude or Poussin, though they are present in his
work, are never so apparent as they often are in the composed landscapes of
Constable and Turner.

Souvenir of Volterra (1838, Washington, National Gallery) is a compilation
of landscape studies from Corot's second Italian voyage, with overtones of Claude
introduced discreetly, without harm to the picture's freshness of visual observa-
tion. An instance of this are the blue shadows on the sunlit road, a pre-Impres-
sionist touch. When not bound to his Paris studio by his projects for the Salon,
Corot was in constant motion, traveling to Normandy, sketching at Ville d'Avray
or in the Forest of Fontainebleau, voyaging on foot, by diligence or railway
through the French provinces or in Switzerland, absorbed in an endless study of
landscape. He was a tireless and enthusiastic worker, strangely undeterred by the
public's total indifference to his paintings. At forty-four he remained still entirely
dependent on his parents, who fondly regarded him as a talentless amateur. He
had not sold a single painting. Some artists had begun to take notice of his work,
but the public's inattention to it was still complete. Although Corot cared little
for money and cheerfully managed to live on his small allowance, it distressed
him that his family should regard him as a failure.

The beginnings of recognition came, at last, at the Salon of 1840, from

which the government bought *The Little Shepherd (Sunset Landscape)* (1840) for the museum of Metz. This evocation of a twilight mood, with its silhouetted shepherd boy piping to the goats browsing among the dark foliage, is, significantly, one of the earliest paintings in what was to be Corot's popular late style. It is an entirely artificial composition, only remotely based on studies from nature, brushed in dusky monochromatic tones that time has darkened further.

At about the same time, a member of the royal family bought yet another painting. Much to his own and to his parents' surprise, Corot was beginning to emerge from obscurity. At the Salon of 1842, his *Italian Landscape,* though very badly placed, was bought by the government for the museum of Avignon. His Salon submission of the following year, the *Destruction of Sodom,* was nevertheless refused, but the rejection aroused protest among artists and critics, an indication of his growing reputation.

Corot was much on the road in these years. He had won the friendship of families in various parts of France, who gladly received him as their houseguest and between whom he set up an annual travel schedule that took him, in the outdoor sketching season, to those parts of France and Switzerland that he found most congenial. In May of 1843, he departed on his third and last Italian voyage, traveling directly to Rome for a six-month stay, during which he took excursions to Tivoli, Genzano, and Lake Nemi. *Marietta* (1843, Paris, Petit Palais), the study of a nude model who posed in the Roman studio of a friend, is painted in thin washes of oil over a rapid pencil drawing on paper. It invites comparison with Ingres's *Odalisque* of 1814, from which, however, it differs in nearly every important respect: in its unpretentious naturalness, the fluent relaxation of the nude body, and the refined simplicity of its color scheme, a blend of tans, ochres, and light grays. The little picture demonstrates Corot's high, seemingly effortless accomplishment as a figure painter.

He brought home relatively few paintings from this Italian stay. But in two outdoor sketches, his naturalism attained its ultimate refinement. *The Gardens of the Villa d'Este* (Tivoli) (1843, Louvre), a panoramic view from a balustrade past cypresses and houses of cubic shape (forecasting Cézanne) into the lilac distance of the Sabine Hills, is a study of early twilight. *The Goatherd of Genzano* (1843, Washington, Phillips Collection), by contrast, is an impression of hot sunlight on a sandy slope, half covered with scrubby vegetation, behind which the houses of the village rise into the summer sky.

On his return to France, Corot resubmitted to the Salon of 1844 his *Destruction of Sodom,* rejected in 1843, and had the satisfaction of seeing it hung. Another of his entries, the hazily poetic *Concert* (Chantilly, Musée Condé), achieved the honor of placement in the Salon Carré, the prestigious main gallery. The following year, he exhibited *Homer and the Shepherds* (1845, Saint-Lô Museum), which shows the bard playing his lyre and singing to three shepherd boys, a subject suggested by a poem by André Chénier. The landscape setting is based in part on sketches of forest trees drawn a few years earlier, but its treatment is more decidedly artificial and "poetic" than that of the backgrounds of the earlier historical compositions. The light-filtering foliage of the trees that

screen out the distance lacks material substance; the stagelike foreground is bathed in a rarefied atmosphere that harmonizes the colors in an accord of silvery greens and blues.

This painting, well received by critics and public alike, marked the beginnings of what was to be the characteristic "lyrical" landscape style of Corot's later years. But the naturalist strain persisted in his work, and at the Salon of 1846 he showed *The Forest of Fontainebleau* (1846, Boston, Museum of Fine Arts), a robustly materialist scene of cattle drinking at a pond, closely based on outdoor sketches. The picture still recalls Constable's influential *Haywain* and also has affinities with the work of Rousseau and Dupré, younger artists whom he encountered at work in the region of Fontainebleau.

In July 1846, the government awarded Corot the cross of the Legion of Honor, to the amazement of his parents, on whom he was still dependent for financial support. But major state commissions now came to him, among them a large *Baptism of Christ* (1847) for the church of Saint Nicolas du Chardonnet in Paris. Delacroix, who saw this picture before its completion, admired its "superb trees."

When his father died in 1847, Corot put a temporary stop to his study travel in order to devote himself to his mother, with whom he lived at Ville d'Avray. The Revolution of 1848 passed him by, as had that of 1830. To the unjuried Salon of 1848, he submitted no fewer than nine paintings, and for one of them was given another second-class medal. The following year, he was made a member of the organizing committee of the Salon. His pictures were beginning to be sought after by collectors and dealers. In 1851, his mother died. Corot was free to travel again. An orphan at age fifty-five, he warded off loneliness by adopting several families —hospitable households in comfortable country seats in various parts of France, where he could enjoy the companionship of men interested in art, the maternal care of women, and the fun of children. Between these surrogate homes in Arras, Mantes, Douai, Marcoussis, and Magny, he traveled in regular, yearly rounds, combining constant landscape study with the pleasures of affectionate conviviality.

From this time Corot's work fell into three main categories: the private work, consisting of studies from nature, both of landscape and the human figure (and including the many intimate, small-scale portraits of friends and relatives with which he repaid them for their hospitality); the public work, historical compositions destined for the Salon; and the commercial work, "lyrical" landscape inventions in a hazily atmospheric style, for which dealers—who had thus far taken no notice of him—now began to press him.

The Port of La Rochelle (1851, New Haven, Yale Art Gallery), one of several studies of that harbor painted by Corot when he resumed his travels, manifests the unbroken continuity of his naturalism—following in the lineage of his Roman views of 1826, of *Chartres Cathedral* (1830), and of the cityscapes of his second Roman stay (1834). But it also indicates a subtle change of direction in its emphasis on light over material substance. The picture is dominated by the fluid silver and gold of the sky, mirrored in the water of the harbor basin, and

reflected in the pale yellow of the luminous structures that enclose it. Corot himself considered this one of his best studies taken directly from nature; it is the first such study that he submitted to a Salon (1852).

At the Salons, Corot made his mark with narrative figural compositions on religious or literary subjects, paintings such as *St. Sebastian Aided by the Holy Women* (1853, Baltimore, Walters Art Gallery), or *Dante and Virgil Entering the Inferno* (1859, Boston, Museum of Fine Arts), in which he placed figures of remarkable expressive vigor and corporeal substance in shadowy dream landscapes, forest settings with views into twilit skies, painted in dusky harmonies of greens, grays, and silvery blues. These landscape backgrounds are purely studio-bred and have only the remotest connection with Corot's nature studies. But they may owe something to his keen enjoyment of the theater and its scenery, and perhaps also to his early delight in the subtly colored silks and gauzes of his mother's millinery shop.

For the market, on which his paintings now began to be in high demand, Corot produced what came to be expected of him—composed, "poetic" landscapes, arrangements of silhouetted trees, distant sheets of water, and crepuscular skies, with foregrounds animated by bucolic or classical figures. *Morning: Dance of the Nymphs* (ca. 1850, Louvre) is an early example of the type. It is a wholly artificial, composed woodland idyll, suggestive of the "mood" of early morning and nostalgically reminiscent of an Italian setting (the Farnese Gardens) seen many years before. Small, rhythmically grouped figures are garlanded across the foreground. The character of the scene is determined entirely by artistic traditions, by the bucolic compositions of Claude Lorrain in particular, and perhaps also by the *fêtes galantes* of Watteau.

In Corot's landscape painting until this time, realism had always been finely balanced by an element of discreet formal stylization. Now this element became detached, in his "poetic" landscapes, from what had been the main, generative base of his work, the direct visual study of nature. Prompted by popular success, Corot composed landscapes from memory, according to formulae that expressed states of feeling recollected in the studio rather than impressions gathered out of doors. In the titles he gave to these pictures, the term *Souvenir* replaced *View of.* . . . The remembered moods of certain favorite sites, Italian or French, became set in stereotypes of clustered trees, effects of water and of sky that could be shifted about at will. Inevitably, this led to repetitions and a gradual attenuation. The great success of these landscape-poems with collectors, who found them more artistic, more complete, and more comfortably traditional than mere studies from nature, tempted Corot into mass production and self-imitation. The taste for eighteenth-century art, strong in the years of the Second Empire, also contributed to the success of these works, which reminded critics of the enchantments of Watteau's dream settings. There is, in fact, something of *Cythera* in the silvery twilights of Corot's lyrical landscapes.

The World's Fair of 1855, at which several of his paintings were exhibited, brought him great success and a gold medal. Two years earlier, the government had bought *Morning: Dance of the Nymphs* for the museum of modern painting

at the Luxembourg Palace. Now Napoleon III put the official seal on the fashion for Corot's landscapes by purchasing his *Souvenir de Marcoussis.*

For half a century, Corot's fame and popularity would rest entirely on his late, composed landscapes. Their romantic suggestiveness, their silvery skies behind translucent foliage became his trademark. The style of these paintings lent itself to imitation. Corot's own large output was augmented by innumerable vulgarizing copies and forgeries. His studies from nature, on the other hand, remained largely unknown, appreciated only by a few collectors. A drastic reevaluation occurred after 1900, when critics, surfeited with his poetic manner, discovered his early sketches and judged their freshness and formal subtlety to be preferable to the sometimes monotonous design of his later dream landscapes. But this estimate is now itself about to be revised, and the qualities of Corot's best composed landscapes, no longer obscured by overfamiliarity, are once again being recognized.

One of the finest and most characteristic of these is the painting known as *Recollection of Mortefontaine* (1864, Louvre). In the shadowy foreground, a young woman, accompanied by two children, reaches up into the branches of a tree, as if to place a bouquet of flowers there. Behind her, another, taller tree spreads its foliage, traversed by the early morning light. The wide lake that fills the middle distance mirrors the sky and the mist-shrouded woods of the far shore. Some of the elements of this composition, the two trees with their oddly twisted branches among them, also occur in other pictures of this period; they are part of a stock of motifs from which he constructed his landscape-poems. Despite the artificiality of this method, the picture still reflects a profound experience of nature, particularly in its subtle truth of light and atmosphere. It is from these gleams of remembered enjoyment in the out-of-doors, rather than from any studio props, that it derives its emotional force.

Corot occasionally combined his "lyrical" manner with subjects taken from reality, generally by composing foregrounds consisting of his characteristic feathery trees through which, as through a screen, he opened the view into sunlit distances dominated by buildings as concrete and as clearly defined as those of his early townscapes.

The masterly precision of observation evident in three paintings from nature—*The Church of Marissel* (1866, Louvre), *The Cathedral of Mantes* (1865–69, Reims Museum), and *The Bridge of Mantes* (1868–70, Louvre)—proves that despite his concessions to decorative or poetic effect, he had lost nothing of his keenness and objectivity of observation. In their breadth of handling, their intensity of light, and their fineness of color and tone, these landscapes have affinities with paintings by Daubigny and the early Impressionists, particularly Monet, who were at that time under Corot's influence.

Various explanations have been put forward to account for Corot's late style. The blurriness of his trees has been attributed to his interest in landscape photography, which, in the early days of long exposures, tended to blur foliage in motion. The striking patterns formed by trees in the foregrounds of some of his landscapes have been interpreted (implausibly) as showing the influence of

Japanese woodcuts. The "Mediterranean" clarity of his early landscapes has been contrasted to the "Nordic" fogginess of his later ones. But his composed landscapes are, in fact, ultimately derived from the idealized, constructed landscapes of the neoclassical tradition in which the young Corot had received a thorough grounding. His "lyrical" manner is a softened classicism, in which tonal contrasts take the place of contour.

Throughout his life, Corot frequently painted figure studies and portraits. The early portraits, generally of small size and somewhat like colored daguerreotypes in appearance, were done as casual gifts to friends and relatives. In his later years, during the 1850s and 1860s, figure painting assumed a more important role in his work, concurrent with the emergence of his late landscape style. The figures in these landscape compositions, though important as setters of theme and mood, are usually of small scale, and it was generally supposed that Corot "could not draw figures." But while in his landscape fantasies he dissolved matter in luminous atmospheres and cultivated a hazy indefiniteness, he pursued a contrary direction in the private figure paintings, in which he subordinated landscape backgrounds to large, portrait-like figures.

Posing young women in Italian costume or in the nude, Corot stressed their physical presence, defining their bodies with sculptural vigor and a strong sense of material substance. Even when the size of the canvases is small, the figures of the women in them—always at rest, shown reading or absorbed in deep thought—have a certain grandeur. At times, he gave them monumental scale (as in the life-size *Agostina,* 1866, of the Washington National Gallery). The influence of Renaissance traditions is strong in these works, though they are free of the historicism of the Salon painters and very rarely give a hint of outright imitation. An exception, in this respect, is the famous *Woman with a Pearl* (1868–70, Louvre), the portrait of an actual young woman of Corot's acquaintance in a pose suggested by Leonardo (the *Mona Lisa*) and Raphael. In type and expression, however, and in its fine tonal modeling, established with a tender but very assured touch, it is an entirely original work.

On a few occasions, Corot attempted the difficult feat of combining large, strongly corporeal figures with a hazily suggestive landscape setting. *La Toilette (Landscape with Figures)* (1859, Paris, private collection) is one such example. The picture is conceived as a poem on the themes of spring and youth. In a woodland setting of trees in early leaf, a young woman sits, nude, at the edge of a pool in which she has bathed. An attendant in Italian costume helps her to adjust her hair, while in the distance a second companion leans on a tree, absorbed in reading a book. The body of the young bather is naively—i.e., naturalistically—rendered in its slightly pudgy, still adolescent softness, in a manner totally innocent of the erotic or heroic affectations of ordinary Salon nudes.

The picture invites comparison with Courbet's *Bathers* (Montpellier, Musée Fabré), which was the scandal of the Salon of 1853 and certainly well known to Corot, whose lyrical naturalism on this occasion may be a reply to Courbet's aggressive realism. And it is noteworthy that Corot succeeded in integrating his solidly modeled nude with its luminous and atmospheric setting,

unlike Courbet, whose fleshy *Bather* had been criticized for clashing with an obtrusive landscape background.

Frequent spells of gout in the years between 1866 and 1870 forced Corot to curtail his travels. Confined to his Paris studio, he devoted himself to painting landscapes from memory and to composing figural subjects. A series of these, dating from circa 1865–70, represents the interior of his studio, in which a young model, dressed in Italian costume and holding a mandolin, is seated pensively before an easel on which stands a framed landscape in Corot's late manner (versions of this composition are in the Louvre, the Washington National Gallery, the Baltimore Museum, and elsewhere). These very firmly painted, dusky interiors convey a sense of melancholy, into which enter memories of youth and of Italy, a faintly erotic sentiment, and perhaps something of the invalid's feelings of captivity. In the cluttered darkness of the studio, the landscape on the easel seems an evocation of remembered sunlight, and the young woman a visitor from another world, perhaps personifying music, youth, and the artist's longing for the free out-of-doors. Corot's "lyrical" landscapes by this time had won enormous popularity. His figural compositions, highly personal in meaning and very remote from Salon conventions, were much less appreciated by critics and collectors.

Around 1870, he fully recovered his health. Despite his advanced age, he painted with undiminished energy, sustained by a robust constitution and a powerful body, oddly matched to the extreme gentleness of his personality. During the months of the Franco-Prussian War and the siege of Paris (1870–71), he remained hard at work in his Paris studio. His large earnings made it possible for him to give generously for the relief of the victims of the war. The civil war that followed the establishment of the Commune drove him from Paris to the quiet of the provincial town of Douai, where he lived with friends and painted one of his masterly late townscapes, the *Belfry of Douai* (1871, Louvre), as subtle in color and firm in handling as any of his landscapes with architecture of the 1830s.

With the return of peace, Corot resumed his migratory life and spent the year of 1872 in incessant travel and outdoor painting. The quality of his last works shows no signs of decline. In his final years, his early, naturalist tendencies strongly reasserted themselves; such paintings taken directly from reality as his *Interior of Sens Cathedral* (1874, Louvre) prove to what degree he preserved his keenness of eye and aristocratic refinement of tone and color until the very end. He died on February 22, 1875, after a brief illness in the winter of 1874–75.

Corot's work links the tradition of French neoclassicism with nineteenth-century currents of naturalism, and ultimately with Impressionism. His influence on the landscape painters of the Impressionist generation was profound. Camille Pissarro and Berthe Morisot were among his pupils; Monet admired him; Daubigny and Sisley sought his advice. Rightly acknowledged to be one of the great painters of his century, Corot has nevertheless been neglected by critics and historians, who have paid more attention to lesser, seemingly more "interesting" talents. The

essentially painterly quality of his best work resists verbal analysis, and the simplicity and profundity of his character have baffled interpreters.

READINGS

The basic biography and catalogue of the work, not available in English translation, is A. Robaut, *L'Oeuvre de Corot, catalogue raisonné et illustré, précedé de l'histoire de Corot et de son oeuvre par E. Moreau-Nelaton,* 4 vols., first published in Paris, 1905, reprinted in 1965. Two *Suppléments* to the catalogue, by A. Schoeller and J. Dieterle, were published in 1948 and 1956.

G. Bazin, *Corot,* Paris, various editions 1942–73 (in French), transcends the clichés of the highly repetitive literature and contains an important chapter on the imitators and forgers of Corot.

M. Hours, *Corot,* New York, 1973, has a concise biographical and analytical text accompanying fairly good plates.

Jean Leymarie, *Corot,* New York, 1979, the most useful recent book in English, contains a fairly substantial text and excellent illustrations.

French Naturalist Landscape and the School of Barbizon, 1830–1870

France's late entry into the European mainstream of naturalist landscape painting occurred around 1820 through the work of a few, very young artists who, after a brief exposure to academic training, resolved to try a new direction. Their dissidence took the form of an emphatic concentration on what had been a minor aspect of neoclassical landscape practice: the direct study of nature, a program not unlike that which Constable had set himself twenty years earlier.

The previous generation of academic neoclassicists—Pierre-Henri Valenciennes (1750–1819), Jean-Joseph-Xavier Bidault (1758–1846), and Victor Bertin (1775–1842), Corot's teacher—had routinely practiced sketching out of doors as a preliminary to formal landscape composition. But their often very vivid sketches from nature were never regarded by them as anything more than private exercises—raw material for the construction of "ideal" landscapes according to a limited set of stock formulae. The difference in intensity between the lively sketches and the pallid finished works did not go unnoticed by their students. These young painters, many still in their teens, among them Paul Huet (1803–1869), Eugène Isabey (1803–1886), and the Englishman Richard Parkes Bonington (1801–1828), who was a pupil of Gros and friend of Delacroix, and hence an adoptive member of the French vanguard, began about 1820 to experiment with the direct transcription in oil and watercolor of landscape impressions, stressing effects of light and atmosphere at the expense of tangible subject matter and formal arrangement. Their concentration on fleeting visual phenomena undoubtedly owed much to British influence, to which France at that time was highly receptive.

English empiricism appeared to young Frenchmen as the modern alternative to the obsolete classical ideal. Notions of English "natural" landscape had been brought to France through pictorial publications by British artists, by the many British visitors to post-Napoleonic France (including Bonington himself), and by the French artists, such as Géricault, who had recently visited Britain. When the landscapes of Constable and other English painters were shown at the Paris Salon of 1824, with sensational effect, landscape naturalism of an English cast had already become acclimatized in France and was being taken up by a number of young, independent, and modern-minded artists.

This situation helps to explain the sudden rise, in about 1830, of a new generation of landscape painters, all born within the decade of 1808–17, nearly all entirely independent of the academic establishment, many of them self-educated or introduced to art through the quasi-industrial crafts of porcelain decoration or commercial printmaking, the most gifted among them being Narcisse Diaz (1808–1876), Jules Dupré (1811–1889), Constant Troyon (1810–1865), Charles Jacque (1813–1894), and Charles-François Daubigny (1817–1878). Their extreme precocity lent a special drama to their appearance on the Parisian art scene; Théodore Rousseau, who was to assume the leading position among them, painted his first naturalist landscapes in the vicinity of Paris at age fourteen.

Their common interests rapidly drew these young artists together: Dupré met Diaz when the one was fourteen, the other seventeen years old; Rousseau befriended Diaz at age nineteen; Dupré and Troyon painted together at Isle-Adam in their very early twenties. As a result, despite differences in background and temperament, these young painters soon developed a remarkably coherent group style. In their first showing, at the liberally juried, post-Revolutionary Salon of 1831, Rousseau (age nineteen), Dupré (twenty), and Diaz (twenty-three) already seemed to constitute a "school," long before the actual development of what came later to be known as the School of Barbizon. Aside from their common love of direct landscape study, they shared an interest in Constable and the English landscape tradition, like their slightly earlier predecessors, Huet and Isabey. But even more profoundly and lastingly influential on their work was the example of Dutch seventeenth-century landscape. Pictures by Hobbema, Ruisdael, Van Goyen, and Potter, available to them at the Louvre, were their main link with tradition, and the authority on which they relied in opposing the Italianate landscape tradition favored by the Academy.

All these painters were in the habit of undertaking wide-ranging study travel during the good-weather season. Italy had formerly been the favorite sketching ground of landscape painters, because there nature conformed to the ideal of classical art, but the young generation of 1830 found inspiration enough in the various regions and climates of France. They preferred the uninhabited, untouched, ruggedly natural countryside, differing in this respect with Constable's fondness for agricultural scenes and with Corot's attraction to architecture. In choosing landscape motifs, they were guided by their individual temperaments and artistic interests. In time, certain sites became identified with the characteristic themes and styles of particular artists. The coasts of Normandy around Honfleur at an early date attracted Bonington, Huet, Isabey, Corot, and others who were partial to effects of weather, vast atmospheric spaces, and the unquiet sea, quasi-English motifs. The flat country north of Paris along the slow-flowing River Oise, between the Forest of Compiègne and Isle-Adam, attracted its own flock of painters, of a rather more "Dutch" tendency, among them Dupré and Daubigny. The largest and most influential constellation of artists, however, converged on the Forest of Fontainebleau and its villages of Chailly and Barbizon.

THE PAINTERS OF BARBIZON

The Forest of Fontainebleau, about forty miles southeast of Paris, had been a royal hunting preserve before the Revolution. It was famous for the variety of its scenery. Parts of the forest consisted of ancient oaks growing wild among rocks and gorges, but other parts were parklike, traversed by straight avenues that had been laid out in the eighteenth century for the convenience of hunting parties from the château of Fontainebleau. To the west of the forest extended a rocky wilderness with scattered stands of birches, and beyond it lay the cultivated plain with the peasant villages of Chailly and Barbizon.

From the late eighteenth century on, the area of Fontainebleau, within easy reach of Paris, was often visited by painters in search of picturesque or grandiose motifs. It was a particular favorite of the Romantics. Corot, introduced to the forest in 1822 by his first teacher, Michallon, returned to it again and again in the following decades. Throughout the 1830s, the number of artists visiting in the summer months grew steadily, putting a strain on the primitive accommodations available in the two villages. Among the regular guests at the inn of Père Ganne in Barbizon were Rousseau, Diaz, Dupré, Troyon, Jacque, and many other painters on their annual sketching tour. Initially, Fontainebleau was only one of several favorite areas for outdoor work, and the artists' stays were sporadic and brief. But in 1836, Rousseau, suffering persecution by Salon juries and critics, began to withdraw from Paris; his visits to Barbizon increased in frequency and length, and so did those of his friends. A seasonal community of artists came into being at Barbizon. In 1848, Rousseau permanently settled in the village (though he did not give up his studio in Paris), and was soon followed by François Millet, Narcisse Diaz, and Charles Jacque, whose exodus from Paris was perhaps spurred by the cholera epidemic of 1849. The term "School of Barbizon" now came to be applied to a loose grouping of like-minded artists, not all of whom actually lived in the village.

Their removal to the country had important consequences for their work. In turning away from the city, Rousseau and his companions put a distance between themselves and the art establishment on which they still depended for their livelihood, in order to immerse themselves in the life of nature far more intimately and continuously than the city-based painters, who gathered their landscape impressions in rapid travel. The distinctive landscape realism developed by the Barbizon painters in their mature works was not a matter of fleeting sensations recorded with instant precision. It consisted, rather, of a searching description of the deeper character of particular sites, discoverable only through long study and close familiarity. Their interest in the slow processes in nature, rather than momentary effects, explains their need for year-round country life and their partiality to a limited number of motifs, to particular trees, rocks, and forest clearings that had for them the appeal of intimate acquaintance.

In their highly personal search for the basic "truth" beneath the objective appearance of landscape, it was perhaps unavoidable that these artists should develop individual traits, and indeed mannerisms, of style and theme. Rousseau's

melancholy sweeps of landscape, often dominated by looming, clustered tree silhouettes in the middle distance, differ strikingly from Dupré's more conventionally massed foliage, or from Daubigny's more succulent verdure in humid fields and along riverbanks. Millet, mainly a painter of peasant subjects conceived in an austerely monumental style, only rarely painted pure landscapes. Troyon and Jacque specialized in cattle.

In the landscapes of the English painters, and in those of Corot and Daubigny, space filled with air and light seems to contain and to illuminate the objects. The Barbizon painters, by contrast, represented matter as solid, dark, and dense. There is little air in their paintings, the light does not flow around the forms, the colors do not vibrate. Their pictures are dominated by dark, rough-textured silhouettes or by caverns of somber foliage. Rousseau's fretted tree clusters and Diaz's forest interiors, in which the shadows devour the scattered spots of light, exemplify the Barbizon painters' insistence on strong tonal contrasts and their sparing use of color. These stylistic features—strangely inconsistent with their basic naturalism—resulted in part from their method of underpainting their landscapes in a dark monochrome and from their lavish use of bituminous blacks and browns. Though begun out of doors, these landscapes usually underwent a laborious process of revision and repainting in the studio, which perhaps deepened their characterization but also dimmed the freshness of the original sight. The color in Barbizon landscapes is their least realistic aspect. Generally rather muted, it sometimes erupts into surprising stridency, as in the rainbows and sunbursts of certain storm scenes by Rousseau and Millet.

The years between 1830 and 1848 during which the citizen-king Louis Philippe governed France were a time of growth and struggle for the Barbizon painters. The early career of Rousseau was particularly difficult. Having exhibited with some success at the Salons of 1831, 1833, and 1834, he was rejected in 1836 and continued to be excluded by adamantly hostile Salon juries until 1848. Corot fared better than his younger friend; his recognition dates from 1846, when he received the cross of the Legion of Honor. The Revolution of 1848 opened the Salons of 1848 and 1849 to the young avant-garde, including Rousseau and the artists soon to be known as the School of Barbizon.

The early reign of Napoleon III continued to favor them, and the Universal Exposition of 1855 brought them resounding critical acclaim. Rousseau's reputation suffered another eclipse between 1857 and 1866, but for Troyon, Diaz, and particularly Corot, the time of popular success and official honors had finally arrived. A second World's Fair, in 1867, secured them international recognition. Important collectors, in the United States, Britain, and Germany, as well as France, began to specialize in their work, and they acquired an effective and devoted dealer in the person of M. Durand-Ruel. Beginning in the 1880s, after the death of most of the Barbizon painters, the demand for their work became intense. For several decades, the paintings of Rousseau and Millet were fought over by millionaires and museums, rising to prices never before reached by modern artists. After 1900, this hectic popularity subsided and gradually gave way to new neglect, which continued until the late 1950s.

The naturalist cause in nineteenth-century literature and art was deeply identified with the movement of liberalism. Though the art of the Barbizon painters was not openly concerned with political subjects, it was rooted in social and cultural dissidence. Most of them sympathized with the radical, i.e., Republican and Socialist, ideologies of their time, and their careers, significantly, were furthered by the revolutions of 1830 (when they made their first public appearance) and 1848 (when they won general recognition). But they took no active part in politics, and instead expressed their discontent by withdrawing from the corruption of the city and from normal middle-class life. Their landscape painting was based not only on the physical reality of nature but also on the social realities of their time. It expressed their opposition to an industrial and mercantile civilization that, as they believed, threatened human dignity and freedom, that ruined the countryside with its railways and turned the forest into cash. By settling in villages, sharing the lives of peasants, and communing intimately with nature, they expressed their longing for an older, simpler form of existence—in harmony with nature and their fellow men.

They knew, however, that this way of life was doomed and that their work as artists would inevitably lead them back to the city and to dependence on the modern institutions—the art market, the Salons, the press—that were most hostile to their outlook. All art existed for and through the city. Realizing that they could not make a complete break, Rousseau and his friends maintained studios in Paris and periodically emerged from the peace of Barbizon to keep in touch with events in the world of art that inevitably affected them. The distance they had to travel was short. Barbizon lay at the threshold of Paris. After 1849, a railway line connected Chailly with the capital. Nor were the hermits of Barbizon without a link with the center of political power; they were treated with more consideration by the authoritarian Empire of Napoleon III after 1850 than had been shown them by the liberal monarchy of Louis Philippe in the 1830s and 1840s. There was something precarious, and perhaps slightly false, in their situation, and it may have been an awareness of the physical and social transience of their chosen subject matter that gave their work a tinge of romantic melancholy.

READINGS

Robert L. Herbert, *Barbizon Revisited,* New York, 1962, the catalogue of an exhibition that was instrumental in resurrecting the School of Barbizon. It contains a concise history of the group and brief biographies of its chief members.

J. Bouret, *The Barbizon School and 19th Century French Landscape Painting,* London, 1973. Useful colorplates.

P. Miguel, *Le paysage français au XIX siècle, 1824–74; L'école de la nature,* 3 vols., Maurs-la-Jolie, 1975. Historical introduction and detailed, illustrated biographies of the principal artists.

K. Clark, *Landscape into Art,* New York, 1976 (and other editions). Chapter 5, "The Natural Vision," gives a historical appraisal of naturalist landscape painting.

Théodore Rousseau, 1812–1867

Among the landscape painters of Barbizon, the figure of Rousseau looms largest, partly because of the sheer superiority of his talent, partly because of a moral grandeur in his character that won him the respect and admiration of this close-knit group. His work encompassed the entire stylistic and thematic range of Barbizon landscape on the highest level, and the course of his career typified the early persecution that these Romantic naturalists were forced to endure, as well as the sudden, fervent appreciation that later came their way—too late for Rousseau himself.

Rousseau was born in Paris in 1812, the son of a clothier who had come from the town of Salins in the Jura region, not far from Courbet's birthplace, Ornans. The boy had a happy childhood, in reasonably comfortable circumstances, and received a good education. At the age of thirteen, he was sent to his father's native province to work for the operator of a sawmill. During his brief employment, he learned to know and love the forests of the Jura. On his return to Paris, he confided to his parents that he wished to become a landscape painter. They consulted a relative, the painter Pau de St. Martin, who took the boy sketching, found him to be gifted, and recommended that he be apprenticed to a painter of historical landscapes, Joseph Rémond.

This proved to be a mistake. Young Rousseau found that he did not profit from Rémond's instruction and soon switched to a distinguished history painter, Guillaume Guillon-Lethière (1760–1832), who was no less academic and classicistic than Rémond, but evidently more helpful. The highly precocious boy in the meantime managed his own education by means of intensive sketching tours in the outskirts of Paris, the park of Saint-Cloud, and the forests of Compiègne and Fontainebleau. His *Telegraph Tower, Montmartre* (1826[?], Boulogne Museum), a finely observed suburban scene painted with precise, small touches, rather in the manner of Corot's landscape studies of the same period, gives evidence of astonishingly precocious mastery (if it is in fact, as reported by the early biographers, the work of Rousseau at fourteen).

During 1827–29, he continued his studies, copying the old masters of landscape at the Louvre while also spending as much time as possible sketching out of doors. In 1829, he made a vain attempt to enter the academic Rome Prize competition. The following year, a tour in the Auvergne region, in south-central France, yielded Rousseau's first distinctly personal landscape studies, executed in

an excitedly expressive style with heavy strokes of almost monochromatic paint, evidently in reaction against his earlier, more cautious naturalism. Recalling Géricault's sketches in their energetic boldness, these paintings attracted the attention of a former friend of Géricault, the painter Ary Scheffer, who, after the Revolution of 1830, held an influential position at the court of Louis Philippe. Rousseau's first Salon entry, *Auvergne Landscape with Fisherman* (1831, Rotterdam, Van der Vorm Foundation), was a composed view, made up of various motifs collected in the Auvergne and executed in Rousseau's new, heavily impasto manner, somewhat reminiscent in its vehemence of Constable's late work.

In 1832 he traveled in Normandy, bringing back studies of sky and sea on which he based his Salon entry of 1833, *Normandy Coast Near Granville* (Leningrad, Hermitage), which received favorable reviews and was bought by Ary Scheffer's brother, Henri. During the same year, Rousseau painted a sweeping panorama, *Paris Seen from the Terrace of Bellevue* (1833, Brussels, Musées Royaux), which, in contrast to the compact earthiness of his Auvergne studies, dramatizes effects of space, light, and drifting clouds, and may reflect some influence by the English painters—Constable and Bonington—that had probably reached him through the intermediary of such French imitators as Huet.

Still in an experimental frame of mind, Rousseau sent a rather "Dutch" landscape to the Salon of 1834, *Edge of the Forest at Pierrefonds* (1833, London, J. Murphy Collection), which had just been bought by the duc d'Orléans on the advice of Ary Scheffer and which, perhaps for this reason, won a third medal at the Salon. The dark mass of trees, with slender, high-lit trunks, that crowns the hilltop in the distance foretells a favorite motif of his later work.

Rousseau in these years led a Bohemian life, quartered in a garret in the rue Taitbout, next door to Théophile Thoré, a writer, philosopher, phrenologist, and future art critic, around whom had gathered a lively crowd of aspiring poets (Gautier, Nerval), artists (Daumier, Jeanron, Nanteuil), Utopian dabblers in politics (Pyat, Sandeau), dandies, and one self-ordained prophet, Ganneau, called the "Mapa," whose creed was based on the ecstatic contemplation of nature and art. Members of the group met at the tavern of Père Lathuille to blaspheme the Academy and the government of Louis Philippe; their volatile association was the frivolous, Bohemian prelude to the artistic community of Barbizon. It is possible that his involvement with these vociferous dissidents earned Rousseau the enmity of the Academy and had some influence on the subsequent persistent rejection of his work by Salon juries.

About this time, Rousseau formed a close friendship with the painter Jules Dupré. Deferring a planned joint study tour in central France, he traveled with other friends to the Alps, returning by way of the Jura, where he conceived the idea for a large composition, *The Descent of the Cattle from the Jura Meadows* (1835, The Hague, Mesdag Museum). Now darkened beyond legibility, this picture cost him a year of concentrated labor. It shows a herd of cows issuing pell-mell from among the pines of a somber forest. The vast size of the canvas, its unusually steep, vertical format, the dark congestion of rocks and animals in its center, and Rousseau's rough handling of the bituminous paint made it easy

for the Salon jury of 1836 to reject what seemed to them a "monstrous" picture.

Ary Scheffer, in protest, gave the work a public showing in his studio, where it was seen and praised by many artists and critics. But the war between Rousseau and the art establishment was to continue for another twelve years, despite the interest shown in his work by the royal family. Rejection by one Salon jury after another in the years from 1838 to 1841 was henceforth to be his lot. He came to be known as *le grand Refusé,* and his case provoked a long and bitter polemic in which artists such as Delacroix, and writers such as George Sand, Gautier, Thoré, and Planche strongly supported him—in vain.

The knowledge that the Salon was closed to him had an effect on Rousseau's choice of themes and formats. He renounced his ambition to carry out landscapes of grand scale, such as the views of Mont Blanc that he had brought back from his recent travels, and began to concentrate on more confined scenes, treated in an intimately naturalistic style. Traveling in search of subjects, he made his first long stays in the area of Fontainebleau, at the hamlets of Chailly (in 1834) and Barbizon (in 1836), and embarked on his study of the life of the forest. The development of his distinctive, personal style can be said to date from this time.

The Forest of Fontainebleau at Bas-Breau (Le Vieux Dormoir) (1836, completed in 1867, Louvre), which was revised and reworked over a twenty-year span, shows a summer resting place for cattle in the cool depths of the forest. The scene consists of a chaos of trees, dappled with sunlight filtering through the dark foliage. Rousseau has recorded nature in an utterly natural state, stressing its irregular forms of growth and decay without concession to conventions of arrangement: inhospitable to the human visitor, but intensely alive in every detail. *The Valley of Tiffauge* (1837–44, Cincinnati, Art Museum) pictures a bog teeming with plant life. To Rousseau, the dark, shapeless murk from which weeds and shrubs rise into the light represented the fertility of the earth and the origins of life; critics, however, ridiculed the picture as "vegetable soup."

The Avenue of Chestnut Trees (1837–40, Louvre), by contrast, presents a formally composed, symmetrical view. The avenue—a living vault shaped by the gnarled, interwoven branches of the trees—forms a deep, perspectival space, speckled with spots of light. The contrasts between the confining solidity of this natural architecture and the wild writhings of the branches of which it is composed, between the bituminous darkness of the foliage and the gleams of color that pierce it, give this man-made "landscape" a stressful intensity which calls to mind paintings by Van Gogh some fifty years later.

A calmer, more objective naturalism began to appear in Rousseau's work during 1842–44, when he often painted—on the advice of his friend Dupré—in the level, sparsely wooded plains of the Berry and Landes regions, in central and southwestern France, rather than in the rugged Forest of Fontainebleau. He developed a new compositional scheme, opening wide horizons behind receding foregrounds covered with dense vegetation. Friezes of trees in the middle distance, darkly silhouetted or illuminated against strongly colored, spacious skies, are the main features of these views. Often, as in *Under the Beech Trees ("Le Curé")* (1842–43, Toledo Museum), and *Spring* (ca. 1843–52, Louvre), they are

executed in small, distinct dots of color that suggest wind-stirred foliage and sunlit, weedy meadows. Though he continued to be absent from the Salons, Rousseau's work was known and admired by many artists and by some critics, who regarded him as a strong, totally independent and therefore controversial individualist, the counterpart (in the more limited field of landscape) of the formidable Delacroix. Thoré, reviewing the Salon of 1845, from which, as usual, Rousseau had abstained, proclaimed him to be the greatest French landscape painter next to Corot.

Rousseau spent the winter of 1844–45 with his friend Dupré at Isle-Adam, north of Paris, painting out of doors and working with unaccustomed speed in an attempt to capture fleeting effects of light and atmosphere—*Frost on the Heights of Valmondois* (1844–45, Baltimore, Walters Art Gallery). The following year, he tried another pre-Impressionist experiment in outdoor painting, *Avenue in the Forest of Isle-Adam* (1846–49, Louvre), a large canvas in which he sought to render the effect of midday sun beating down on the forest. But an anxious perfectionism compelled him to complete the picture in the studio, in two years of exacting labor.

The personality of Rousseau is difficult to fathom. Reserved, proud, irritable, and difficult in matters of business, he was steadfastly loyal to his few intimate friends. His attitude to women was clouded by contradictions. Until 1847, he lived in self-sufficient bachelorhood, when a tragicomedy of errors brought him to the brink of matrimony. The novelist George Sand, with whom he was acquainted, offered him the hand of her adopted daughter, Augustine Brault, together with a substantial dowry. But misunderstandings frustrated the match and caused a rift between himself and his friends, George Sand as well as the innocent Jules Dupré. Deeply embarrassed by this episode, Rousseau was now more than ever ready to seclude himself in the country. While keeping his Paris address, he rented a cottage in the village of Barbizon, transformed a barn into a primitive studio, and for companionship took a poor and ailing woman to be his common-law wife. He was henceforth "the painter of Barbizon."

The Revolution of February 1848, which deposed Louis Philippe, also transformed the academic establishment and its Salon juries. An elected committee of artists, not all of them members of the Academy, took charge of the Salon, to which all entries were to be freely admitted. Rousseau was elected to the committee (together with Delacroix, Ingres, and many others), but took little part in its consultations and did not contribute to the liberated Salon of 1848. He also abstained from political activity, spending most of the year at Barbizon far from the Revolutionary turbulence of Paris.

To make amends for past neglect, the new government, through its Minister of the Interior, A.-A. Ledru-Rollin, awarded Rousseau an important commission on a subject of his own choice. The result was the large and rather formal *View from the Forest of Fontainebleau: Sunset* (1848–49, Louvre). In this painting, the foliage of ancient oaks frames, like the dark proscenium arch of a stage, a view into the sunny distance where cattle graze. Though Rousseau took pains to give the swampy foreground and the disheveled oaks an appearance of casual nature,

the effect is one of calculated arrangement, as was noted by several critics when the picture was shown at the Salon of 1850. Rousseau subsequently painted a pendant picture, showing the same scene in the light of morning, and had the two exhibited side by side, hoping to persuade his critics that his main objective in each was to capture a particular quality of illumination.

At the Salon of 1849, his first in fourteen years, Rousseau showed three paintings, including another *Edge of the Forest at Sunset* and the earlier *Avenue in the Forest of Isle-Adam.* He was awarded a gold medal, but Dupré, who had exhibited nothing, was given the higher distinction of the Legion of Honor. Rousseau was deeply offended and broke with his friend. Dupré's place in his life was taken by Millet, who had settled in Barbizon in 1848. Hard-pressed by lack of money, Rousseau organized a sale of fifty-three of his paintings. Though promoted by the dealer Durand-Ruel, the sale was unprofitable. Most of the buyers were fellow artists.

At the Salon of 1850–51, Rousseau showed seven paintings, including *View from the Forest of Fontainebleau.* On this occasion his friend Diaz received the cross of the Legion of Honor; Rousseau remained undecorated. He resolved not to exhibit again, but was persuaded by Count Nieuwerkerke, the director of the imperial museums, to submit two pictures to the Salon of 1852. *Oaks at Apremont* (1852, Louvre) won a critical and popular success at the Salon and was bought by the duc de Morny, Napoleon's modern-minded half brother, who at that time was also patronizing Courbet. The dark mass of foliage, patterned against the bright, thinly overcast sky, by its contrast to the intense surrounding light effectively suggests the torpid heat and vertical glare of high noon in summer. The picture is a triumph of naturalist observation, but it also announces a contrary direction in Rousseau's work, a tendency toward decorative flattening and pattern-making.

At the Salon's close, he finally received the coveted cross of the Legion of Honor. The following years were an interlude of quiet and relative prosperity in his life. Collectors and dealers, grown accustomed to naturalism at last, showed an interest in his work. Alfred Sensier, a government official and friend of Millet, Frédéric Hartmann, an industrialist, and a number of important collectors gave him commissions, despite his notorious slowness to deliver. Rousseau was able to repair his roof, aid his impecunious friends, and indulge in his passion for collecting ceramics, prints by the masters, and antique medals. He used his influence with highly placed officials, such as the duc de Morny, to plead for the preservation of the Forest of Fontainebleau, which was threatened by commercial exploitation and ill-advised reforestation.

At the art exhibition of the Paris World's Fair *(Exposition Universelle)* of 1855, no fewer than thirteen landscapes by Rousseau were on view, a virtual retrospective encompassing twenty years of work. The critics were friendly, the collectors—many of them foreign—interested. Rousseau was awarded a first-class medal, and for the first time in his life felt himself to be truly appreciated. But a reaction set in almost immediately. His exhibits at the Salons of 1857, 1859, 1861, and 1863 received a mixed critical reaction; the demand for his work

slackened; a second sale of his paintings, held in 1861, produced disappointing results and barely enabled him to appease his creditors. He lived in a state of nervous excitation, shocked by the suicide of a friend in his Barbizon cottage, and depressed by his common-law wife's gradual decline into insanity.

Rousseau worked extremely slowly, repainting his pictures over and over again. His naturalism was the product of profound, meditative study, not of rapid transcription; he entirely lacked spontaneity. Because he was fascinated by the material reality of nature, the dark, dense, complex substance of wood, rock, and earth, he imagined these physical aspects to express an inward life and consciousness. He thought of trees as being human, each an individual, marked by a particular fate and struggle. All nature appeared to him in a constant process of growth and dissolution. Even the physical litter of his foregrounds, the rocks, puddles, and bogs, seems pregnant with half-formed life, as unstable and unquiet as the irregularly cloud-streaked skies above. The pictorial conception of this philosophy of nature as ceaseless activity—very different from either Courbet's still-life realism or the Impressionists' arrested moment—was the teeming agitation of his compositions, the ragged silhouettes of his trees, the bursts of strident color, and his treatment of solid objects in clusters of dots and patches, like molecules in hectic motion. These mannerisms mark such of his later paintings as *Oaks Among Rocks in the Forest of Fontainebleau* (Salon of 1861, Louvre); *Road in the Forest of Fontainebleau: Thunderstorm* (1860–65, Louvre); and *Sunset Near Arbonne* (ca. 1865, New York, Metropolitan Museum).

Rousseau was among the earliest collectors of Japanese woodcuts in the 1860s. Their decorative patterning and flattening of forms and their clear, sharp colors, particularly their blues, appealed to a taste for decorative design that he developed in his later years, in strange contrast to his basic naturalism. A clash between Rousseau's "Dutch" and "Japanese" tendencies led to jarring mannerisms in some of his paintings of the time, disconcerting those of his friends and patrons who expected him to be a thoroughgoing naturalist. Rousseau began *The Village of Bécquigny* (1864, New York, Frick Collection) some time after his visit to Picardy in 1857. Evidently influenced by a Dutch model, Hobbema's *The Avenue, Middelharnis* (London, National Gallery), the picture underwent several repaintings, and very shortly before its exhibition in the Salon of 1864 was given a bright blue "Japanese" sky—much to the distress of its purchaser, Frédéric Hartmann, Rousseau's chief patron.

In ill health and tired, Rousseau exhibited nothing at the Salon of 1865. His new, post-naturalist landscape style was dismissed as a sign of decline by hostile critics. A commission for two decorative panels, from a fashionable collector, Prince Demidoff, and an invitation by the emperor to a weekend at Compiègne restored his spirits. He took advantage of his stay at Compiègne to lobby the empress on behalf of the endangered Forest of Fontainebleau.

Invited to serve as a member of the Salon jury of 1866, Rousseau exhibited three of his own paintings to a rather mixed critical reception. Later in the year, he was elected president of the art jury for the Paris World's Fair planned for 1867. The dealers Paul Durand-Ruel and Brame purchased seventy of his paint-

ings for the large sum of 130,000 francs, relieving him suddenly of all financial cares. A retrospective exhibition at the Cercle des Arts, organized by Brame and Durand-Ruel in 1867, showed 109 of his paintings, covering his entire career. Two further paintings were exhibited at the Salon, and eight in the art section of the World's Fair. At the end of the Fair, he was awarded the Grand Medal of Honor, but—unlike the other members of the jury over which he had presided —failed to be promoted to the rank of Officer of the Legion of Honor. This inexplicable slight was rectified by the emperor himself, in response to an appeal by one of Rousseau's friends, the critic Théophile Silvestre. But the exasperation that the incident caused him had fatally shaken Rousseau's frail health. He died in December of 1867, in the arms of his friend Millet, in his cottage at Barbizon.

Solitary, melancholic, pious without religion, a materialist romantically in love with nature, Rousseau bridged the gap between the lyrical naturalists of the Romantic era and the later, more visually oriented and more materialistic Realists. But his work also contained an element of expressive stylization that anticipated the Post-Impressionist reaction against realism, and was therefore of interest to such artists as Van Gogh. Though he was generally regarded as one of the two or three greatest modern painters of landscape by the end of the nineteenth century, Rousseau's reputation rapidly declined in the first quarter of the twentieth. Once one of the most avidly collected artists, particularly well represented in America, he virtually disappeared from sight for half a century, to be rediscovered only in the 1960s.

READINGS

In the absence of a modern monograph, Alfred Sensier's *Souvenirs sur Th. Rousseau,* Paris, 1872, never translated into English, is the best book on Rousseau and the fundamental source of biographical information. (Unfortunately, it is very rare.) The catalogue, by Marie-Thérèse de Forges, of the Louvre's Rousseau exhibition in 1967 contains additional information and the description of eighty-eight paintings and drawings. See also the sections devoted to Rousseau in Robert L. Herbert, *Barbizon Revisited,* New York, 1962.

9
Realism

Realism
 Social Realism
Honoré Daumier, 1808–1879
Jean-François Millet, 1814–1875
Gustave Courbet, 1819–1877

Realism

Most nineteenth-century artists, the neoclassicists and romantics no less than the self-professed naturalists and realists, claimed for their work a particularly close engagement with reality. They differed in their conceptions of the "real," but generally understood it to mean something like "truth," a matter not merely of likeness but of significance. As old beliefs in supernatural causes waned, the interest in physical nature quickened; a preoccupation with the demonstrably *real* filled the void left by the collapse of religious certitudes. Art, like science, looked to nature for clues to the meaning of human existence. Instead of putting their faith in received ideas, artists increasingly relied on the evidence of their eyes, on their own immediate experience of the material world. In doing this, they believed themselves to be on solid ground.

But the material world, it was clear, did not represent the whole of reality. It was only the outward manifestation of a compelling energy and order, which some still called God, while others preferred to call it Nature. It was to this *core* of reality that a close study of visual phenomena, such as artists were especially well equipped to undertake, could possibly lead. By dealing truthfully with the visible forms of nature, artists strove to give a sense of the invisible forces working in nature, of which the changing aspects of matter were the surface expression. The realist tendency, in art as in science, was prompted by a kind of secular piety, by the search for an all-encompassing order within which mankind would find its place. Exact truth to nature was not merely desirable on aesthetic grounds, it was the necessary prerequisite of meaning.

Thus it was a romantic impulse, contrary to what is commonly supposed, that began the realist current in nineteenth-century art. The empirical objectivity of Constable's studies of cloud formations (1821–22) paralleled the methods of contemporary weather science and demolished earlier stereotypes. Géricault's clinical portraits of insane patients (ca. 1822) were intended to document the researches of a psychiatrist, and in their cool sobriety discredited the raving lunatics of pictorial tradition. Painters and scientists shared the insight that appearances—the precise shape of a cloud, the form and expression of a head— signified natural processes, and therefore were not accidental but held a meaning that could be rendered only by a faithful representation. Observation, rather than the free-roaming imagination, must be the artist's guide. Reliance on old recipes, imitation of the masters, attempts to embellish or poetize reality inevitably led

227

to falsehood, for the meaning of reality was in the particular appearance of things and could not be improved upon by arrangement or idealization. Constable, according to his biographer C. R. Leslie, "thanked Heaven that he had no imagination" and therefore was not likely to be misled into "the vacant fields of idealism."

The empirical naturalism that amounted to an international movement in European art of the 1820s and 1830s chiefly affected landscape painting, to begin with in England, later in Scandinavia and Germany, and last, but most significantly, in France. Its practitioners, who included Corot and the young French painters who had been stirred by the example of Constable, worked independently of one another, but were linked by a common interest in the exact observation of effects of light and atmosphere. Their concentration on the actual optical experience of landscape drew them out of the studio into the open air, and opened their eyes to the fact that reality reveals itself not only in its static, material forms, but, more importantly, in a process of continuous change, in which fugitive effects of light, color, and atmosphere play the leading role. The unaccustomed brightness and intensity of their work at first startled viewers, but soon led to a revolution in landscape painting that rendered the traditional historical landscape, an artificial studio product, entirely obsolete. The brilliant culmination of this development was the Impressionist painting of the 1870s, in which moments of reality are captured with a vivid precision that has not been surpassed since.

SOCIAL REALISM

Of a different character and stemming from other sources was a form of artistic realism that dealt with the facts of human behavior and the particulars of daily life. Art based on social observation had, of course, flourished in earlier periods, and reached high artistic levels in Dutch art of the seventeenth-century, and in the work of eighteenth-century French, English, and Italian painters. All conceivable conditions of humanity had been treated in this long tradition, from the glories of aristocratic high-life to the domestic comforts of the burgher class and the picturesque miseries of urban or rustic paupers. Unlike landscape painting, which had always had a relatively limited popular appeal, and which, in the nineteenth-century, became an increasingly specialized concern, tinged with science and involved with daring technical experimentation, the depiction of scenes from actual life had never lacked a popular audience, even among those not otherwise interested in art. The human interest to which these works spoke was in fact best served by literature and the theater.

The distinctive novelty that the nineteenth-century brought to this well-trodden field was a spirit of quasi-scientific inquiry into the conditions of the various classes of society. This new factual bent provided a link between the otherwise separate interests in nature and society; nineteenth-century landscape painting and social realism shared a common empirical bias. In his account of the paintings shown at the Universal Exposition of 1855, Baudelaire presents a telling vignette of the novelist Honoré Balzac, looking for human interest in a

landscape painting: "The story is told of Balzac that one day he found himself in front of a fine painting representing a melancholy winter landscape, with hoar frost on the ground, a scattering of cottages, and some impoverished peasants. And, after intently gazing at a little house from which a vane of smoke rose in the air, 'How beautiful it is,' he cried, 'but what are they doing in that cottage? What are their thoughts? What are their worries? Has it been a good harvest? No doubt they have bills to pay?' "

The questions Balzac was asking (not unlike those asked by some art historians of the present) were being addressed at the time by a vast literature of fiction and popular sociology, to which Balzac himself had made important contributions. The most telling product of this, perhaps typically middle-class, inquisitiveness about the detail of ordinary lives was the so-called physiologies, essays that analyzed with mind-boggling thoroughness the typical appearance, manners, tastes, and conduct of all the hundreds of subgroups that composed French society. Issued in the form of pamphlets or gathered into books, these essays on social characterization, often flavored with satiric wit, enjoyed a great vogue in the 1830s and 1840s. An immense amount of factual information is contained in this literature, which, placing humanity under the microscope, discriminates with sharp precision not only between main social types—the Grocer, the Nun, the Lawyer, the Society Woman—but enters into the subtler details of sociopsychology in describing the Woman of Thirty, the Suburban Gardener, the Blue-Stocking, the Adulterer, or focuses minuscule distinctions of social style and ambition, such as those that mark off the Frequenters of the Luxembourg Gardens from the Habitués of the Tuileries.

Here, as in empirical landscape painting, we find an attempt to exclude mere imagination, and a distrust of the ideal—that is, of everything that cannot be counted, measured, bought, or sold. Here, too, there is an effort to penetrate the unifying, basic reality beneath the multiplicity of outward appearances, and in describing the social landscape the authors leave little doubt that it is the power of money or property that shape it, just as the physical landscape is shaped by the forces of nature. Among the many artists who illustrated these sketches of modern society, Daumier was incomparably the greatest. His graphic work, the thousands of lithographs that he drew for comic journals in a career of fifty years, amounts to an enormous pictorial elaboration of this literature of social observation and raises what was otherwise a petty genre to the level of great art.

The social observation contained in these sketches, whether literary or graphic, was of high modernity in its emphasis on factual detail, its "realism," but had as yet no clear-cut political significance. It aimed good-natured satire at common human foibles, and was associated with minor journalistic or genre formats, with work of small scale and low prestige.

But there existed as well another, grander tradition of modern realism, in the form of national history painting, of which David and his followers had been the originators. The Revolution and the Empire had systematically used art for the propagation of their ideologies and the commemoration of their achievements. David's *Death of Marat* (1793) and *Coronation of Josephine* (1805–08)

were the early milestones in the development of modern, large-scale history painting. The vast production of battle scenes and ceremonial pictures by the School of David, on behalf of Napoleon and of the subsequent governments of the Restoration and the July Monarchy, continued, on a gradually declining level of quality, a tradition of historical documentation in which factual accuracy, in costumes and settings, made for a somewhat pedantic realism. Officiality and national significance sanctioned these works and justified their large scale: they were designed to function as public monuments. Géricault's *Raft of the Medusa* (1819) burst on its audience as a violation of these conventions, by dealing in the grand format reserved for national history painting with a calamitous event of recent occurrence that was deemed to lack national importance or exemplary morality, and hence should have been treated as mere genre. Géricault's usurpation of a public format for a personal statement marked the beginning of a breakdown of the formal distinction between history and genre, between official purpose and private intention. Other manifestations of the growing freedom of artists to interpret modern reality in their own terms and on a scale hitherto reserved for state-sanctioned work occurred here and there in the post-Napoleonic era: in Goya's scenes of the Peninsular wars (ca. 1814) and such daring monumentalizations of "low" genre as his *The Forge* (1820), as well as in Delacroix's highly individual treatment in *Liberty Leading the People* (1830). The next step was taken by Daumier, in the deceptively modest format of his lithograph *Murder in the Rue Transnonain* (1834), in which the brutal reality of what is presented as an unedited eyewitness account is made to speak for itself and for the artist's personal emotion.

The Revolution of 1848 raised common genre to the dignity of history painting, and politicized realism by directing it from broadly national to specifically social themes. Courbet and Millet treated scenes of labor with a portentous dignity that struck conservative critics and much of the middle-class public as an affront and a threat to established values. More than to the subjects themselves, it was to the unaccustomed harshness of their stylization that vehement objections were raised: in Courbet's *Stone-Breakers* (1849–50) and Millet's *Gleaners* (1857) critics did not recognize reality as they knew it. They understood that these works did not present a neutrally objective view, but were meant to accuse, to attack, and perhaps to subvert the propertied classes of society, and supposed that in their provocative bigness and artistic crudity they were intended to appeal to the "lower" classes, over the heads of the picture-buying public. From this time on, realism, whatever the actual intention of the artists who practiced its various forms, became associated with radical politics. Those who professed it, as did Courbet, were accused of a systematic bias for the ugly and sordid—that is, of a form of treason against truth.

The realist painters did in fact face difficult problems, but not of the kind that their critics had in mind. There was an aesthetic contradiction between the program of objective realism that they had set themselves and the stylistic necessities of picture-making. The unselective reproduction of visual facts could only lead to flat banality, as they well knew. In order to do justice to essential reality

in figural compositions, which, inevitably, involved artifices of arrangement, all the great realists resorted to severe stylization, limited themselves to a few, telling forms, simplified and magnified their figures—in short, took great liberties with visual reality. This was most obviously true of Daumier, who never worked directly from life, but drew a whole world of the most vivid, living reality from the inexhaustible store of his memory. Though his work was entirely modern, his stylistic vocabulary came from Baroque art and became progressively simpler, more powerful, less superficially "realistic" in his later years, when he was still passionately engaged in the political and social causes of the day. Millet conceived his scenes of farm labor in a ruggedly spare style. Like Daumier, he rarely worked from direct observation, but filtered reality through his imagination and memory, and in the end expressed it in forms that have the look of rough-hewn sculpture. Courbet, applying his colors with the palette knife, in broad, undisguised strokes, built figures of preternatural bulk and weight.

A gulf separates these artists, the essential realists, from the much-admired heroes of the Salons, such as Meissonier and Gérôme—clever technicians of eye-dazzling illusionism who, for all their photographic acuity, produced pictures of a peculiar deadness. Their work, long relegated to the storage bins of museums, is currently enjoying a form of resurrection, and sometimes discussed or even exhibited, much to its detriment, in conjunction with that of the more vital artists of the time.

READINGS

The classic account of the beginnings of realism in France, and of the various strands of realism in French painting of the first half of the nineteenth-century, is to be found in L. Rosenthal, *Du romantism au réalisme,* Paris, 1914, of which there exist, unfortunately, no later editions or translations.

L. Nochlin's *Realism,* Harmondsworth (Penguin Books), 1971, gives a concise but comprehensive overview, with stress on thematic material.

Several exhibitions have dealt with the difficult problem of discriminating between the different forms of realism in nineteenth-century painting, generally with a view to rehabilitating its more controversial (i.e., Salon) manifestations. Their catalogues offer interesting historical and pictorial documentations:

Triumph of Realism, an Exhibition of European and American Realist Painting, 1850–1910, Brooklyn Museum, 1967.

The Past Rediscovered: French Painting 1800–1900, preface by R. Rosenblum, Minneapolis Art Institute, 1969.

The Realist Tradition: French Painting and Drawing 1830–1900, catalogue by G. Weisberg, Cleveland Museum, 1980.

C. Rosen and H. Zerner, *Romanticism and Realism: The Mythology of Nineteenth-Century Art,* New York, 1984, offers a critique of recent writings on realist painting.

Honoré Daumier, 1808–1879

Daumier's career is one of the most unusual in the history of nineteenth-century art. He was famous, as France's best-known social and political cartoonist, and yet almost entirely unrecognized in his actual stature—as one of the truly great painters, sculptors, and graphic artists of his age. Even today, despite recognition, the importance of his role as one of the foremost Realist artists of the period is perhaps not fully realized, still overshadowed by his comic genius and penchant for monumental stylization. "There is a lot of Michelangelo in that fellow," said Balzac of him. It was a very perceptive remark, though Balzac may have made it in the spirit of comical hyperbole.

Honoré Daumier was born in 1808 in Marseilles, the son of an eccentric glazier and frame-maker whose life ambition was to gain recognition as a poet. In 1816, the elder Daumier took his family to Paris in order to pursue his doomed literary plans. From the age of twelve, young Honoré had to earn a living. He was briefly the assistant of a book dealer and for a while served as runner *(saute-ruisseau)* for a firm of attorneys.

The boy's strong vocation for art irresistibly asserted itself at an early age, but there was little chance—perhaps fortunately—for regular professional training. Daumier's first drawing master seems to have been Alexandre Lenoir, a famous antiquarian and former director of the Museum of French Sculptural Monuments. Later, he drew the model at the free Académie Suisse and copied sculptures at the Louvre. It is possible that as early as 1822 he experimented with lithography.

In 1825, in order to familiarize himself with the lithographic technique, Daumier worked for the printer Zéphirin Belliard. From 1829, he drew lithographic caricature in the manner of artists then popular—Charlet, Traviès, and Monnier. The 1830 July Revolution brought a temporary relaxation of press censorship, and a multitude of illustrated political journals sprang up. After working for several of these short-lived publications, Daumier in 1831 was employed by a publisher-entrepreneur of genius, Charles Philipon, to draw lithographic cartoons of a sharply satirical and political sort for Philipon's newly founded weekly *La Caricature*. This began Daumier's life-long career (or bondage) as a cartoonist for the weekly or daily press. In the course of this career, he was to draw 3,958 lithographs before the onset of blindness, in the 1870s, put a stop to his work.

232

The early caricatures of Daumier were directed against the king and his government. Despite the relative liberalism of the regime of Louis Philippe—whom Daumier regularly caricatured as pear-headed (the French word *poire* has the slang meaning of fathead) and whom he also lampooned as a quack, assassin, and ape—Daumier's graphic humor soon ran afoul the press police. For a cartoon showing Louis Philippe as *Gargantua,* devouring money and excreting decorations and honors, he was condemned in 1832 to serve a sentence of six months in the prison of Sainte-Pelagie and the clinic of the alienist Dr. Pinel.

After his release in 1833, Daumier continued to draw many lithographs of a political and satirical kind for *La Caricature* and for another publication of Philipon, *Le Charivari.* He very rapidly developed a personal style of caricature, of unsurpassed brilliance, having been briefly influenced by such contemporaries as Charlet (Géricault's friend), Decamps, Grandville, Traviès, and Monnier. Caricature at that time had little prestige and only a brief history in France, whereas in England there already existed a highly developed tradition of social and political comic art that went back to Hogarth and included such gifted specialists as Rowlandson.

Daumier at that time lived among a group of politically radical Bohemians that included the painter Diaz and the sculptor Préault. Probably he even then made some attempts at "serious" painting in oil. Meanwhile, his powerful sculptural talent found expression in a series of caricatural heads of various politicians, observed at the National Assembly and subsequently modeled in clay. Several of these served him for lithographic caricatures, notably the large *Ventre Législatif,* a collective spoof of Louis Philippe's government and prominent deputies, which was published in a special supplement of *La Caricature,* the *Association Mensuelle* (1834). These oversized lithographs include *Ne vous y frottez pas* (a heroic printer resisting press censorship), and *Rue Transnonain* (the aftermath of a brutal police raid during one of the uprisings that took place in Paris and Lyon in 1834). They are among his greatest achievements and among the finest graphic works of the century.

In 1835, the promulgation of severe press laws on August 29 forced the cessation of *La Caricature.* Daumier continued to work for *Le Charivari,* producing on the average two or three cartoons a week on politically non-controversial, social-satirical themes, often in series, such as *Types français.* One of his most successful creations was the series *Robert Macaire,* satirizing the type of the unscrupulous entrepreneur and speculator whom he represented, in more than a hundred different guises, attempting to swindle gullible fellow citizens.

In hundreds of lithographic caricatures, Daumier depicted every facet of Parisian society. Despite its comical intent, his work deserves to be compared to that of Balzac, on the one hand, and to the social realism of Millet on the other (whom he resembled somewhat in the grandeur of his style). For its sheer breadth and power, his work won the high respect of thoughtful critics, including Baudelaire. Among his favorite targets was the petty urban middle class, *Les Bons Bourgeois,* whose eccentricities, manias, and timidities he endlessly and lovingly ridiculed—he deeply identified himself with his victims. Daumier also discovered rich resources of humor in the technical and social progress of his time (the

railways), in high fashion (crinolines), in the vanities and frustrations of artists, of the military, and the social lions of the day. He reserved a particular fondness for the ridicule of the pomposity of lawyers *(Gens de justice)* and poked malicious fun at female emancipation *(Les divorceuses, Les Bas-bleus).*

Though without intellectual pretensions, Daumier frequented a highly sophisticated and modern-minded society of literary men and artists who gathered at the Hôtel Pimodan; this group included Baudelaire, Delacroix, and Daubigny. Daumier lived in an old house on the Quai d'Anjou, in the quiet quarter of the Ile Saint-Louis. In 1840, he married Marie-Alexandrine Dassy, a dressmaker.

The Revolution which overthrew the monarchy of Louis Philippe in February of 1848 opened the Salon for many artists—including Daumier's friends Rousseau and Millet—who had previously been discouraged by the hostility of juries. Daumier did not exhibit at the "free" Salon of 1848, but he entered the competition in March for a monumental allegorical painting, *The Republic.* Daumier's design (in two versions, one now lost) represented the powerful, statuesque Republic "giving nourishment and instruction to her children." It was judged eleventh in a group of twenty entries.

Daumier did not carry this project further, but he was evidently encouraged to devote himself seriously to painting in oil, and produced a number of exhibitable pictures, as well as many more sketches. Some of these deal with Salon subjects, literary and even classical themes treated in a grandly Baroque manner, influenced by Rubens. *The Miller and His Son,* based on the fable of La Fontaine, was exhibited at the Salon of 1849; and *Nymphs Pursued by a Satyr,* the *Drunkenness of Silenus,* and a *Don Quixote* were shown in 1850–51. Self-taught as a painter in oil, Daumier heroically struggled with the technical problems that this medium posed. His work was ignored by the critics, though he won an admirer in the person of the historian Michelet. Among his unexecuted projects of this time is the painting *The Uprising* (Washington, Phillips Collection), an impressive attempt to give monumental form to a modern political subject (to be compared to Delacroix's *Liberty Leading the People* of 1830).

In December 1851, Prince Louis Napoleon, who had been elected president of France, overthrew the constitution and made himself the autocratic ruler of his country. A year later, he assumed the title of emperor under the name of Napoleon III. France became again a country without elective government and without a free press. During the political struggles that preceded the fall of the Republic, Daumier drew some fiercely polemical caricatures, and created his most memorable sculptural work, *Ratapoil* (1851), the image of a Bonapartist bully of the type that terrorized Parisian neighborhoods on the eve of the *coup d'état.*

In the years 1853–57, reduced again to harmless, caricatural drudge work for *Charivari,* Daumier spent his holidays in the village of Valmondois on the Oise River in the company of his friend the landscape painter Daubigny. He also frequently visited Corot, Rousseau, and Millet in Barbizon. His work for *Charivari* revolved around satirical, social themes without political sting, but his graphic style now assumed a simpler, more monumental character, perhaps

reflecting his concurrent preoccupation with painting and the influence on him at this time of Millet's compositions. After 1853, he ceased to exhibit at the Salon, but continued to paint in private, confining himself to small genre subjects.

Overworked, and tired of his endless, ill-paid work for the daily press, Daumier suffered from depression and sickness. He dreamed of devoting himself entirely to painting and sculpture. The decline in the quality of his lithographs began to express his deep fatigue. In March of 1860, he was dismissed from the staff of *Charivari;* his caricatures no longer pleased the public. He now attempted to make a living by painting for private collectors and—perhaps thinking them easier to sell—produced numbers of finished watercolors. The painted work is difficult to arrange in order of date, but it seems probable that many of the intimate, small, sketchlike genre paintings in oil were executed at this time. Collectors in their studies, examining their treasures; artists at work; men rummaging among the portfolios of print dealers—these subjects appealed to Daumier, because he was fond of the eccentric and pungently characterful. He may also have been influenced by his friend Meissonier's highly successful (and stylistically entirely different) pictures of similar scenes. Baudelaire's melancholy poem about strolling entertainers *(Saltimbanques),* published in 1862, perhaps inspired some of the watercolors of acrobats, mountebanks, and sideshow barkers that Daumier produced about this time.

At last, in January 1864, he was offered a new contract by *Charivari* and so resumed his weekly drudgework. His eyesight was gradually failing. Daumier sought refreshment in the country. His relations with the painters of Barbizon continued; he spent summers with Rousseau, and visited Daubigny at Valmondois, a quiet village that appealed to him. Here he rented a small house in 1865 that was to be his home for the remainder of his life.

Poorly paid and in constant financial straits, Daumier continued his production of lithographs for the daily papers, and painted in private. His oils were known only to his friends. The series of paintings and watercolors based on episodes of *Don Quixote* (of which an illustrated edition by Gustave Doré had recently been published) probably came into being at this time (1865–70).

The Franco-Prussian War (1870–71) brought about the collapse of the Empire of Napoleon III and France fell into civil war. A Republican government defended Paris against the Germans. During the siege, Daumier was elected a member of the commission charged with the protection of the collections of the Louvre, and he was one of the artists who protested against Courbet's foolish proposal to destroy the column in the Place Vendôme. After the fall of Paris, a radically left-wing government—the Commune—was formed in the city, while a more moderate Republican government established itself at Versailles. Daumier fled to Arras to escape from the ensuing civil war. Some of his most powerful lithographs date from this time of war and civil strife: stark, tragic, grandiose in their appeal to humanity and commonsense, they are his last great masterworks in this medium. Under the impression of civil war and the persecutions that followed, he sculpted the relief the *Emigrants* (or *Fugitives*). His last great oils also date from about this time: the *Mandolin Player* (Winterthur, Reinhart

Collection) and *Woman Carrying a Child* (Switzerland, private collection) are two works of marvelously powerful and spontaneous execution.

The last years of Daumier's life were overshadowed by poverty, illness, and increasing blindness. In 1874, a gift from his friend Corot enabled him to buy the small house in Valmondois which he had been renting since 1865. In 1877, he was granted a small government pension, and a year later a one-man show of his drawings, paintings, and sculptures was arranged at the gallery of Durand-Ruel, under the presidency of Victor Hugo. Two hundred works were shown, to considerable critical success. There were few sales, however, and the exhibition closed with a deficit. Daumier's government pension was doubled, as a result of protests concerning the official neglect shown him. He underwent an unsuccessful eye operation.

On February 10, 1879, Daumier died after having suffered a paralytic stroke. He was buried at Valmandois. The government agreed to pay the funeral costs, occasioning press comments on its extravagance. They amounted to 12 francs, the price of a good dinner. Daumier's body was later transferred to the Père Lachaise Cemetery in Paris, where it was laid to rest beside the graves of his friends Corot and Daubigny.

READINGS

Life

R. Rey, *Honoré Daumier,* London, 1966.
H. P. Vincent, *Daumier and His World,* Evanston, Ill., 1968.
S. Symmons, *Daumier,* London, 1979.
R. Passeron, *Daumier,* New York, 1981.

The Lithographs

L. Delteil, *Honoré Daumier* (*Le peintre-graveur illustré,* vols. 20–29), Paris, 1906. The complete, illustrated publication of Daumier's immense lithographic work.
F. Saint-Guilhem and K. Schrenk, *Honoré Daumier, L'oeuvre lithographique,* Paris, 1978.

The Paintings and Drawings

K. E. Maison, *Honoré Daumier, Catalogue Raisonné of the Paintings* (vol. 1), *Watercolors and Drawings* (vol. II), London, 1968.
K. E. Maison, *Daumier Drawings,* New York, 1965.

The Sculptures

M. Gobin, *Daumier Sculpteur,* Geneva, 1952 (in French).
J. L. Wassermann, *Daumier Sculpture,* exhibition catalogue, Cambridge, Mass., Fogg Art Museum, 1969.

Jean-François Millet, 1814–1875

Millet's position among the painters of Barbizon was exceptional. He was a figure painter among painters of landscape, a stylist among naturalists, and an interpreter of human reality on the highest level of dignity and pathos among artists of far more modest ambition. His work, even when of small format, has a monumental and symbolical gravity that distinguishes it from the lyrical intimism of his friends working around the Forest of Fontainebleau. He was the rural counterpart of Daumier, to whom he seems related by artistic affinities and social sympathies, though his austere and melancholy character lacked Daumier's geniality and humor.

Millet was the eldest child in a large, closely knit family of farmers living in modest prosperity at the family farm in the village of Gruchy, near Cherbourg in Normandy, where he was born in 1814. His parents, religious and patriarchal, saw to it that he received a good education, acquiring a knowledge of Latin and a life-long interest in literature. The boy showed early signs of artistic talent, and in 1833 was sent to Cherbourg, to study with a local portrait painter, Bon Dumouchel. Two years later he entered the studio of L.-T. Langlois, a former pupil of Gros. At this time he received his first impressions of the works of the great masters, in a Cherbourg collection which included works by Spanish, Dutch, and French painters of the seventeenth and eighteenth centuries.

Provided with a stipend by the city of Cherbourg, Millet went to Paris in 1837 to enrol in the Academy (the official Ecole des Beaux-Arts) as the pupil of the history painter Paul Delaroche. Delaroche was then at the height of his popularity as a meticulous, if artistically rather meager, arranger of dramatic episodes from French and English history. After two years of fairly unhappy apprenticeship, Millet competed unsuccessfully for the Rome Prize, left his teacher, and was deprived of his stipend.

He now set himself up in Cherbourg as a painter of portraits, the only artistic specialty that would produce a living. He managed to have one of his portraits accepted for the Salon of 1840, but another portrait that he had painted on commission for the city of Cherbourg was returned to him as a poor likeness. Having married the twenty-year-old Pauline-Virginie Ono, daughter of a Cherbourg tailor, Millet decided to leave for Paris, where he established himself with his young wife. His work at this time consisted mainly of portraits, executed in

an energetic, highly individual style quite uninfluenced by Delaroche, his former teacher. In the *Self-Portrait* (ca. 1840–41, Boston, Museum of Fine Arts) and the *Portrait of Mlle Ono* (1841–42, Cherbourg Museum), the heads, very sharply lit, are set against dark backgrounds and modeled in rather hard contrasts of light and shadow. The brushwork is dense and smooth, the conception of the sitters severely plain. It is possible that these austere portraits reflect his knowledge of Spanish painters such as Zurbarán. While Millet struggled for a livelihood, Pauline, who was only twenty-three years old, contracted tuberculosis and died. After the death of his wife, Millet moved to Cherbourg, where he took as his companion a servant girl of eighteen, Catherine Lemaire.

In an attempt to reach a wider clientele, Millet now changed his style and subject matter. His touch and colors lightened, and instead of portraits he painted small, agreeably graceful scenes of bucolic or mythological character. His purpose was undoubtedly to make his work salable by appealing to a fashionable taste for Rococo motifs. The bittersweet eroticism of some of his compositions in this vein, such as *L'Amour Vainqueur (Love Victorious)* (1847–48, London, formerly Lord Clark Collection), an erotic allegory, is reminiscent of Prud'hon. *Reclining Nude in Back View* (ca. 1844–45, Paris, Louvre), the earliest known nude by Millet, was executed in his "florid" manner with loose, flecked touches of the brush, in a style not unlike that of other imitators of the Rococo of that time (for instance, Diaz and Tassaert).

To escape the censure of Cherbourg relations, Millet moved with Catherine Lemaire to Le Havre, then returned to Paris. He continued to paint figural compositions of mildly erotic flavor, mainly on traditional, often literary subjects, in a manner that recalls the late eighteenth century. The vigor of his underlying drawings, and of the many chalk studies that accompanied these paintings—for example, *The Lovers* (black chalk drawing, ca. 1848, Chicago, Art Institute)—expresses a different, more serious temper than was demanded by these slight, essentially commercial subjects.

Millet's Salon entry of 1847, *The Infant Oedipus Taken from a Tree* (Ottawa, National Gallery)—a dramatically Baroque composition, rather like a *Descent from the Cross*—was his first work to attract the attention of the critics. Around this time, Millet became acquainted with the animal painter Troyon, and with Narcisse Diaz, who encouraged and perhaps influenced him, introducing him to the dealer Durand-Ruel, who was to play an important role in his later career.

Millet took no active part in the Revolution of 1848. At the "free" Salon later in the year, he was represented by two paintings of entirely dissimilar subject matter, the biblical composition *The Jewish Captivity in Babylon* (now lost), which was severely criticized by the reviewers, and *The Grain-Sifter (Le Vanneur)* (1847–48, United States, private collection), one of the earliest of Millet's scenes of farm labor. The rugged, dramatically high-lit figure of the laborer was much admired by the critics, though the almost brutal roughness of its execution seemed excessive to some. In giving a heroic, quasi-allegorical stature to the toiling peasant, the picture undoubtedly had political implications in 1848. It was purchased for the Republican government.

Millet now became acquainted with several of the artists who were to constitute the School of Barbizon, among them Rousseau, Charles-Emile Jacque, and the sculptor Antoine-Louis Barye; he also met Daumier about this time. Together with Daumier, he competed, unsuccessfully, for the government commission of a monumental allegory, *The Republic.* The government commissioned, instead, *Hagar and Ishmael* (a subject Corot had exhibited at the Salon of 1835). Millet began a composition of two monumental, painfully contorted figures in a desolate, barren setting, received payment for the picture, but did not quite finish it (the canvas is now in The Hague, Mesdag Museum). Concerned for the safety of his family in the face of an outbreak of cholera in Paris, he used the money to establish himself in the village of Barbizon, where he became the neighbor and soon the intimate friend of Théodore Rousseau.

From 1849, Millet specialized entirely in subjects taken from rural life and work. To lessen the risks resulting from his abandonment of lucrative employment and his removal from Paris, he made an arrangement with a friend, Alfred Sensier—a government functionary and art collector—who agreed to keep him supplied with money and help him in selling his work, in return for a share of his output of paintings and drawings.

Scenes from the life of the workers and the poor of city and countryside enjoyed a certain uneasy popularity in the aftermath of the Revolution of 1848, and were for a time favored by the Republican government. The French tradition of such subjects went back to the seventeenth century and the Brothers LeNain, and included the work of the eighteenth-century painter of domestic genre J.-B.-S. Chardin, which was enjoying a revival in the 1840s. Several of Millet's contemporaries, among them the painters Bonvin and Jeanron (who held a high position in the fine arts administration of the Republic), had preceded him into the field of popular genre. He was thus not a pioneer, but he brought a new note of solemnity and melancholy grandeur to his subjects that distinguished him among the painters of social reality and set him apart from Courbet, who was making his public debut at this time.

At the Salon of 1850–51, Millet's *The Hay Bundlers* (1850, Louvre) and *The Sower* (1850, Boston, Museum of Fine Arts) attracted the attention of both friendly and hostile critics, who, recognizing his intention of giving these scenes of ordinary field work symbolical meaning and biblical dignity, reacted with praise or fury depending on the political tendencies of their papers. The peasantry was regarded with apprehension by political conservatives, who feared it as a potential source of civil unrest until it demonstrated its harmlessness by overwhelmingly supporting the autocracy of Napoleon III in 1852. Millet's *Sower*— of which there exists a second version now in Japan (Yamanashi Prefectural Museum), believed by some to be the original—in time became one of the most popular, most often reproduced images of the century. Memorable for the simplicity and eloquence of the Sower's gesture, it came to stand as the emblem of Creative Man.

Courbet's *Stone-Breakers* and *Funeral at Ornans,* also exhibited at the Salon of 1850–51, came under much more bitter criticism for their supposed brutality and sheer ugliness. Courbet and Millet nevertheless became linked in the

minds of critics as the champions of the new realism. Several American collectors (among them the Bostonians W. M. Hunt and W. Babcock) began to take an interest in Millet's work, preparing the way for the enormous popularity it was to enjoy in the United States later in the century.

During the following years, Millet continued to paint scenes of peasant labor, casting them in forms so timeless in their quiet dignity as to remove them from the immediacy of Barbizon to the realms of Homeric epic and biblical story. This deliberate ambiguity of meaning is evident in *Harvesters Resting* (1853, Boston, Museum of Fine Arts), a grandly stylized scene of summer harvest, exhibited at the Salon of 1853, which Millet had intended as a modern version of the story of Ruth and Boaz, influenced, perhaps, by Poussin's famous painting of the subject. Such many-figured scenes were rare in his work of the 1850s, which was destined for the most part for sale by a few friendly dealers, rather than for public exhibition, and therefore kept to small, salable formats. His choice of subjects and of compositional arrangements was highly consistent, tending to scenes of farmyard or domestic work, often performed by a solitary figure, sometimes by a pair.

A particularly numerous group of these small pictures shows young mothers feeding or instructing their children. The tradition that very evidently guided Millet was that of Dutch seventeenth-century genre and its French eighteenth-century sequel, Chardin's idylls of the kitchen, pantry, and nursery. The popularity of these subjects with collectors and dealers probably influenced Millet, but his preoccupation with them also reflected a strong personal interest. The young farmwife who figures in many of these paintings is the idealized portrait of his companion Catherine Lemaire, whom he married in a civil wedding in 1853, by which time she had borne him four children (soon to be followed by five more).

Unlike Courbet's social subjects, most of Millet's scenes of farm life lack polemical bite. They do not describe the harsh and often squalid realities of Barbizon, but rather express nostalgic memories of his youth, spent among the women of the parental farm in Normandy, and celebrate the ideal of a peaceful and fruitful existence in the endless round of the country year. Instead of a political or social view, they seem to reflect a quasi-religious belief in the possibility of a deep harmony between man and nature, a form of secular salvation lost to the hectic civilization of the cities, but still attainable through the wholesome monotony of work in cottage and field. *Man Grafting a Tree* (1855, Munich, Neue Pinakothek), a relatively large painting exhibited at the Exposition Universelle of 1855, presents a peaceful, sunlit farmyard. A young farmer places a graft in the severed trunk of a fruit tree, while his wife, child in arms, watches him. The sense of the picture characteristically contains an echo of classical literature, Virgil's line: "Graft your pear tree, Daphnis, so that your descendants will gather its fruits."

The apparent simplicity of Millet's figures and groupings is in fact deceptive. It resulted from a laborious process of condensation and abstraction that can be traced in his many preliminary drawings. He was a calculating stylist, whose work was never merely improvisational nor guided by rapid impressions but

expressed deeply meditated ideas, based on memory and intensive brainwork. Though his material was ostensibly drawn from reality, he worked in a manner similar to that of the classicists, following the image held in his mind rather than the experience of the moment, and often pursuing his thematic inventions over a period of many years. His work therefore contains a strong element of the stereotypical, particularly in the facial types that he uses for both his male and female figures—inexpressive, impersonal, and of vaguely classical beauty—but also in the forms and gestures that he gives to their bodies.

At the Salon of 1857, Millet exhibited *The Gleaners* (Louvre), which was closely based on a composition that he had earlier (1855) used for an etching. The painting is exceptional in its fairly large size (almost 3 × 4 ft., or 0.9 × 1.2 m.) and in its subject matter, a scene of rural distress and of heavy field work carried out by three haggard women. On a hot day in late summer at the end of the wheat harvest, these women, belonging to the landless pauper class, are shown gathering the meager leftovers of grain among the stubble of the harvested fields, a form of charity granted them by traditional right. Their dark, stooped figures stand in striking contrast to the abundant sheaves and overflowing wagons in the hazy, golden distance: the picture's message is unmistakably about rural poverty. Critics who had remained undisturbed by Millet's earlier celebrations of productive farm work were irritated by what seemed to them a political provocation, a stirring up of issues left unresolved by the Revolution of 1848. They attacked the picture for what they took to be its subversive tendency ("The pikes of 1793 seem to rise up behind these figures . . .") and its exaggeratedly sordid view of peasant life. Millet found defenders among critics on the political left, including Courbet's friend Jules-Antoine Castagnary, who declared the picture to be true and honest, beyond party spirit, and in its truth beautiful as well as poignant: a modern martyrdom, the kind of picture that in a democratic and irreligious age was destined to replace patriotic or religious imagery.

The Gleaners exemplifies Millet's fully mature style. The composition is of grandiose formality, despite the ostensible ordinariness of the scene. The massive, heavily clothed, faceless figures advance in rhythmic unison; their measured spacing and the reiteration of their gestures seems choreographic. Figures and landscape, despite the sculptural treatment of the former and the atmospheric haziness of the other, are splendidly integrated. The painful stoop of the women, the hard angularity of their bodies, and the searching gesture of their hands prove Millet's mastery of expressive stylization. The colors—dustily bright in the landscape setting, muted in the washed-out garments of the women—combine in tender harmonies that relieve the harshness of the subject and lend a conciliatory touch of beauty to the scene.

While *The Gleaners* was on view, Millet received a commission from an American visitor, the painter Thomas Appleton, for what was to become his most popular painting, *The Angelus* (completed in 1859, Louvre). The subject is based on memories of Millet's childhood in Normandy. A young farmer and his wife stand in their field at sundown. The distant church—that of Chailly in the plain of Barbizon—tolls the Angelus, signaling the end of the day's work. The woman

bows her head in prayer "for the poor dead," as Millet's grandmother had once taught him; her husband merely lowers his head in deference to her piety and awkwardly turns his hat in his hands. The figures are silhouetted as stark verticals against the receding horizontal lines of the landscape setting, which are illuminated by the sun's afterglow. The compelling eloquence of their gestures and the poster-like legibility of the composition give the picture its emotional tone and make it memorable. Its execution, very different from that of the much larger and more painterly *Gleaners,* is strikingly like a drawing. The figures, strongly outlined on a brownish ground, are only sparingly touched with color: the dull reds and blues of their clothes are set against the lighter green and blue of the fields and the luminous yellow and rose of the sky. *The Angelus,* hardly a work of plain realism, succeeds not so much in describing material reality as in conveying an inward experience through the attitudes and expressions of its figures. In mood and style, and in its treatment of country piety, it offers a sharp contrast to Courbet's *Funeral at Ornans,* compared to whose robust, absent-minded villagers Millet's praying peasants—physically little more than shadows against the sunset —have an intense emotional presence.

The concentration and simplicity with which Millet treated his delicate subject saved *The Angelus* from mawkishness, but did not protect it from sentimental misreadings by a public eager for spiritual uplift. Though little noticed when first shown in 1865 and again at the World's Fair of 1867, it came to be in high demand in the following decades, was often exhibited, and passed through several collections. Its price rose to record heights. In 1889, *The Angelus* became the object of a sensational competition between the Louvre and a combine of American dealers who, in the end, bought it for the unprecedented price of 580,650 francs. Advertised as the most famous picture in the world, it was sent on a triumphant tour of American cities. In 1909, a French industrialist, in a patriotic gesture, bought it back for the enormous sum of 800,000 francs and gave it to the Louvre. Immediately thereafter, *The Angelus* fell out of fashion and soon became an object of ridicule and satire—for reasons that had as little to do with its artistic quality as those that had made it famous.

During the 1860s, Millet's work began to attract the interest of a widening circle of collectors and critics. Two Belgian dealers, A. Stevens and E. Blanc, engaged him to sell them twenty-five paintings over a three-year span and in the meantime undertook to exhibit his works in Belgium and in France. American collectors continued to support him with occasional purchases. Since he now found it easier to enter his pictures in exhibitions, he began to enlarge their formats and to calculate them for effective public display. At the Salon of 1861, his large *Sheepshearers* (1860, United States, private collection) won him a major critical success. Its two life-size figures, particularly the young woman doing the shearing, exemplify Millet's idealization of peasant types. In her classical beauty, she seems a rustic Athena, with suntanned face, grasping the sacrificial sheep with a large, capable hand.

The year 1863 saw the birth of Millet's ninth and last child. At the Salon his *Man with a Hoe* (1860–62, United States, private collection) caused a noisy

scandal because of the supposed brutality of Millet's portrayal of an exhausted laborer, whom he showed gasping for breath and leaning heavily on his hoe in the midst of the stubble and thistles of the meager field that he has worked. Indignant critics labeled the figure a cretin, an assassin, or "Dumolard" (the name of a notorious murderer). Others saw in the *Man with a Hoe* the martyred laborer, society's victim. An American, Edwin Markham, celebrated him in a poem:

> *Bowed by the weight of centuries he leans*
> *Upon his hoe and gazes on the ground,*
> *The emptiness of ages on his face.*

Millet's personal intention (as expressed in a letter to his friend Alfred Sensier) had been to give a truthful account of the human reality of heavy field work. By way of text for his picture, he quoted a passage from the sixteenth-century essayist Montaigne describing the peasants' stoical endurance of pain, sickness, and death.

In the year of the controversy about the "brutal" *Man with a Hoe,* Millet, in a striking change of mood, painted a scene of awkward and vulnerable adolescence, *The Goose Girl* (1863, Baltimore, Walters Art Gallery), which shows a shepherdess of about twelve who has undressed at the edge of a stream and is about to slip into the cold water. Her timid attitude and thin body, as yet entirely unsensual in its nakedness but perhaps troubled by the first, faintly erotic tremors, invite comparison with the complacent overripeness of Courbet's massive *Bathers* (1853).

The Salon of 1864 brought Millet his first great public success, though this was embittered by yet another critical assault on him. *Shepherdess Guarding Her Flock* (1862–64, Louvre) poses the silhouette of the shepherd girl, leaning on her staff and knitting, against the immense perspective of the plain, paved over with the backs of her grazing sheep. The youth and near-prettiness of the shepherdess won the hearts of the Salon audience, who mistakenly concluded that Millet, formerly addicted to scenes of rural misery, was at last discovering "charm." In fact it was the public's taste that was beginning to accommodate itself to Millet's manner, at least in its more agreeable manifestations.

Bringing Home the New-Born Calf (1864, Chicago, Art Institute), shown at the same Salon, nevertheless came in for biting ridicule. The peasants bearing the calf on a litter were found to be "cretinous," and the solemnity of their demeanor seemed laughable: "Egyptian priests in procession, carrying the sacred Apis bull," mocked the generally liberal poet and critic Théophile Gautier.

Landscape painting played a subordinate role in Millet's work until about 1860, although he always worked out the landscape settings of his figural compositions with great care. Unlike his fellow painters at Barbizon, he seems not to have responded to the particular character of the forests and rocky deserts around Fontainebleau. His "nature," like Constable's, consisted mainly of man-made, agricultural landscapes, many of them memories of his youth in Normandy, others based on impressions gathered around Barbizon. This very limited repertory of motifs was somewhat enriched by studies gathered in the more varied,

hilly countryside around Vichy, in south-central France, where he made several
stays in the 1860s for the sake of his wife's health. His attitude toward landscape
was not that of a wholehearted naturalist. All his paintings and pastels are studio
compositions, though generally based on actual experience in nature and centered
on particular, observed features.

Winter, the Plain of Chailly (1862–63, Vienna, Kunsthistorisches Museum)
opens on a fallow field, empty save for an abandoned plow and harrow, seen in
sweeping perspective that carries the eye to the wide horizon with its sparse,
melancholy silhouettes of tree and tower. Flocks of ravens—avian gleaners—feed
on the leftover grain in the furrows. The seasonal symbolism, with its somber note
of death, is reminiscent of C. D. Friedrich. Van Gogh copied this picture from
a reproduction.

Based on memories of his native Norman village, the view of *The End of
the Village of Gréville* (1865–66, Boston, Museum of Fine Arts) is taken from
behind the last house by the side of the sea. A weatherbeaten elm stands beside
a stone wall from behind which a woman and her child look out over the water,
as the artist recalled having done in his boyhood. Millet saw nature in dramatic
terms and tended to give inanimate objects, such as trees, haystacks, or buildings,
an ominous, quasi-human presence. In personifying and moralizing nature, his
landscapes follow a classical tradition. They are firmly constructed, sometimes
almost sculptural in effect, with emphasis on outline and tonal contrast. The
effects of light and color can be of strident brightness. In several of the later
landscapes there is a mood of exaltation and mystery, and at times an undercur-
rent of violence, that foreshadows the turbulent late landscapes of Van Gogh, who
was an admirer of Millet. One daringly incoherent landscape, *Pasture in the
Auvergne, with Shepherdess Spinning* (1867–69, Chicago, Art Institute)—with its
vertiginous rise to a high horizon on which the silhouettes of cattle, chestnut trees,
and the spinning shepherdess are scattered against a breezy sky with rushing,
ragged clouds—exemplifies the emotional tensions that disturb the formal struc-
ture of some of Millet's late works.

During the latter half of the decade of the 1860s, Millet's reputation steadily
increased. His work was widely exhibited, both at the official Salons and in the
galleries of private dealers in Belgium, Britain, and the United States, where his
work was particularly well received. A Parisian collector, Emile Gavet, became
a generous and steady patron at this time. Gavet's special interest in pastel
drawings (he ultimately acquired some ninety drawings by Millet) was influential
in encouraging the artist to use this medium with increasing frequency in his last
years.

Despite his rural seclusion at Barbizon, Millet maintained a lively corre-
spondence with literary and artistic friends, read the classics, advised his friend
Alfred Sensier on questions of art history and criticism, and formed a modest
collection of prints, antique medals, pottery, and photographs. At the Paris
World's Fair of 1867 he was represented by nine paintings, including *The Glean-
ers* and *The Angelus,* an impressive and well-received showing. In December,
Théodore Rousseau, for nearly twenty years his closest friend, died in Barbizon,

deeply mourned by Millet, who completed several paintings that Rousseau had left unfinished.

Elected Chevalier of the Legion of Honor, Millet traveled in eastern France in the autumn of 1868 and made a brief excursion into Switzerland, his only known trip abroad. Rousseau's former patron, Frédéric Hartmann, commissioned him to paint four pictures, the *Seasons,* based on pastels Millet had already begun for Gavet. Interrupted by the Franco-Prussian War, his work on the series continued until 1874.

After the initial French defeats in the Franco-Prussian War, as the German armies approached the region around Paris, Millet sought refuge in his native Normandy. Here he waited out the siege of Paris and the civil war of the Commune. Unlike Courbet, who played a prominent part in the Commune and its Federation of Artists, Millet refused any kind of association with them. Through the dealer Durand-Ruel, who had emigrated to London during the war, he sent paintings to England for exhibition and sale. The transaction proved successful, and Durand-Ruel continued to be his main dealer for the remainder of Millet's life. In the late autumn of 1871, Millet returned to Barbizon. Frequent exhibitions and good sales of his paintings, in London, New York, Vienna, Brussels, and Paris, signified his final public acceptance.

Landscape painting dominated the work of his last years. Recollections of his childhood, refreshed by impressions gathered during his wartime stay in Normandy, furnished the material for many of the compositions in oil or pastel that he completed after his return to Barbizon. Millet's increasing preoccupation with pastel, a medium that he found congenial because it enabled him to draw directly in color—bridging the gap that normally separates graphic design and painterly execution—produced changes in his technique and style of painting in oil. His range of color lightened and brightened, and he applied his paint in larger, looser strokes, juxtaposing touches of strong color in a manner suggestive of Impressionist technique (though evidently of his own devising).

Two of these landscapes stand out. The sturdy ancient fabric of *The Church of Gréville* (1871–74, Louvre), upon which centered memories of his childhood, assumed for Millet some of the symbolic references—to faith, country, and past —that Salisbury Cathedral held for the aging Constable. Begun in Normandy and finished in Barbizon, the picture is painted in large, expressive touches of intense, optically vibrant colors. The government bought it after Millet's death in 1875, and it became, of all his works, the painting best known to the Impressionists and Post-Impressionists.

The Gust of Wind (1871–73, Cardiff, National Museum of Wales) shows a large tree about to be torn from the soil by the impact of a driving storm. Its trunk and branches are streaming in the wind, its roots lifted from the ground. The whole tree seems about to take flight, while before it a shepherd runs in panic fear, preceded by his flock. The picture undoubtedly symbolizes the disaster that had recently overtaken France. The idea may have come from a famous lithograph by Daumier (1871), which represented France in defeat as a storm-blasted tree, with the legend: ". . . but the roots hold firm." In Millet's somber

vision, the failure of the roots spells the death of the tree.

Among Millet's most ambitious projects of the postwar years was the completion of the series the *Seasons*, begun in 1868. *Spring* (1868–73, Louvre) shows a peasant garden after a shower in early spring. The sun has broken through the clouds and sharply illuminates the blossoming fruit trees in the foreground and the mass of freshly green foliage in the distance. A rainbow arches across the slaty gray of the storm drifting off toward the left, while the brown soil below teems with plant life. In its expression of the joy of reawakening and new growth—of obviously topical significance in France of 1872–73—*Spring* recalls the romantic nature symbolism of an earlier generation, that of C. D. Friedrich and John Constable. Of the other paintings in this cycle, *Summer (Buckwheat Harvest)* is in the Boston Museum of Fine Arts, *Autumn (Haystacks)* in the Metropolitan Museum, New York, and *Winter (Faggot Gatherers)*—which remained unfinished—in the National Museum of Wales, Cardiff.

In 1874, Millet received a government commission for a series of monumental murals of scenes from the life of St. Geneviève for the church of the Panthéon, but ill health prevented him from carrying out more than a few preliminary studies. One of his last finished works is the frenzied, cruel scene *The Bird Nesters* (1874, Philadelphia Museum), showing peasants killing nesting birds by the light of torches. It is a fantastic, nocturnal vision, a fearsome memory of Millet's childhood, in which the drama of light and the ferocity of the hunt combine in an effect of nightmarish violence that contrasts strangely with the dignity and serenity of his earlier pictures of rural life.

Severely ill, Millet on January 3, 1875, married his wife in accordance with the rites of the church (his civil wedding had been performed in 1853). He died on January 20, and was buried at Barbizon, next to Théodore Rousseau. The contents of his studio were dispersed in an auction on May 10–11, 1875.

Millet does not easily fit into the main current of mid-nineteenth-century realism. His work belongs to it chiefly because it consistently dealt with an aspect of contemporary social reality, the lives of peasants. In this point he was, indeed, more consistently a Realist than Courbet, whose preoccupation with social subjects was brief. But in his artistic treatment of reality, Millet was neither strictly modern nor visually objective. His scenes of rural life, largely based on childhood recollections, idealized the condition and appearance of the French peasantry in a highly personal way. Other artists of the time dealt with this subject more literally and factually. Millet, like Daumier, worked from memory—i.e., from the constructive imagination—rather than direct observation. Like Daumier, he had an instinct for grandeur and for the telling gesture, but unlike the genial Daumier, whose stylization aimed at the capture of individuality and tended toward caricature, Millet limited himself to a few, constantly repeated stereotypes. His peasants have the generalized features and heroically blank expressions of public monuments; his compositions raise farmyard routines to timeless significance. The actual modernity and originality of Millet lay not in his choice of themes, nor even in the seriousness and depth of feeling that he brought to them (and that distin-

guished him from the lesser partisans of realism), but in his formal qualities, in the power of his draughtsmanship, the audacity and intelligence of his abstractions, and the concentrated intensity of his pictorial inventions. For these qualities, he ranks in the forefront of the avant-garde of his time.

Millet strongly influenced members of the Impressionist and Post-Impressionist generations, particularly Pissarro and Van Gogh. At the same time he was one of the few truly popular serious painters of the final decades of the nineteenth century, partly because his work seemed to reconcile socially progressive and traditional religious sentiments. Walt Whitman thought Millet "a whole religion in himself. The best of democracy, the best of all well-bottomed faith is in his pictures. The man who knows his Millet needs no creed." The effect of this early popularity on his subsequent reputation was unfortunate. When the initial enthusiasm had passed, his work seemed tarnished by the sentimental excesses of its admirers. Later, Millet suffered the misfortune of being adopted by yet another creed. More than Courbet, he has become the model of twentieth-century Social Realism, as practiced by the academic artists of the so-called Socialist countries. Caricatures of his subjects and his figure types, slightly Russianized or given a Chinese, Albanian, Romanian, or East German accent, are still being produced in abundance. The rediscovery of Millet as a painter, draughtsman, and etcher is meanwhile quietly progressing, stimulated by the exhibitions that marked the centennial of his death.

READINGS

General

R. L. Herbert, *Jean-François Millet,* Paris, Grand Palais, 1975 (in French), and London, Hayward Gallery, 1976 (in English), the monographic catalogue of the centennial exhibition, is the best and most up-to-date general discussion of Millet's work. It includes a full bibliography and list of exhibitions.

A. R. Murphy, *Jean-François Millet,* Boston, 1984, based on the Boston Museum's rich collection of works by Millet, is a useful, very well illustrated complement to Herbert's monograph. It contains, in addition to a bibliography, a selection of hitherto unpublished letters.

Life

A. Sensier, *La vie et l'oeuvre de Jean-François Millet,* Paris, 1881, and

E. Moreau-Nelaton, *Millet raconté par lui-même,* 3 vols., Paris, 1921, continue to be the essential sources. Other biographies, containing little original material, but available in English, have been written by C. Holme (1903), P. M. Turner (1910), J. M. Ady (1910), L. Latourelle (1927), P. Gsell (1928), etc.

Special Studies

L. Lepoittevin, *Jean-François Millet portraitiste,* Paris, 1971.
L. Lepoittevin, *Jean-François Millet: L'ambiguité de l'image,* Paris, 1973.

The Drawings

L. Benedite, *The Drawings of J. F. Millet,* London, 1906.

R. Bacou, *Millet, One Hundred Drawings,* New York, 1975.

The Graphic Work

L. Delteil, *Millet (Le peintre-graveur illustré),* vol. 1, Paris, 1906.

Gustave Courbet, 1819–1877

Courbet was born in 1819 in the small farming town of Ornans, located at the foot of the Jura Mountains, in the old French province of Franche-Comté not far from the Swiss border. His father, Régis, was a modestly prosperous wine grower and landowner, of restless and eccentric temperament, his mother, née Oudot, a quiet, strong-willed, affectionate woman. There were three younger sisters in the family, Zoë, Zélie, and Juliette. The Courbets' style of life was middle class rather than peasant, and not without cultural aspirations.

Coddled by his parents, Gustave—a handsome and intelligent child— spent a happy boyhood in the woods and fields around Ornans, acquiring a taste for the hunt and for physical exercise, a dislike of school, and a deep love of his native region that was to dominate his later life and work. His beginnings bear a certain resemblance to those of Constable. The green valleys of Franche-Comté were to him what the fields and canals of Suffolk had been to Constable: an abiding preoccupation (even in his later years in Paris, where he showed curiously little interest in urban subjects) and a mainspring of his impulse toward realism.

At the age of twelve, Gustave entered the Little Seminary of Ornans, and here he received his first drawing lessons from a former pupil of Gros. Here, too, he formed an intimate friendship with the poet Max Buchon, his cousin, who was to have an important influence on his intellectual development. In the fall of 1837, he moved up to the Royal College in nearby Besançon and briefly became the pupil of a local painter, Flajoulot, who called himself a disciple of David. His parents wanted him to study law, and in late 1839 sent him to Paris in the care of a maternal relative who was a professor of the Law School. But Gustave had already made up his mind to be a painter.

Soon after his arrival in Paris, he entered the studio of the successful academic painter Charles Steuben, who had been a friend of Géricault and whose studio was located in the old rue Hautefeuille, in the heart of the Latin Quarter, where Courbet a few years later was to set up his own studio. His stay with Steuben was brief; he was to declare later that he had never learned anything from this or any other master. With characteristic self-confidence, he decided to become his own teacher and embarked on a course of independent study—painting the posing model at the "free" (teacherless) Académie Suisse and copying the works of the Spanish, Venetian, and Dutch masters at the Louvre. Among the

moderns, he found something of interest in the work of Géricault, Delacroix, and —surprisingly—Ingres.

Courbet accomplished his self-education in six years of intense effort, more strenuous than any ordinary academic training. His progress during these early years is difficult to chart. Many of his early studies are lost, others were later altered or misdated by him. The surviving works vary greatly in quality, style, and execution. *Lot and His Daughters* (begun 1840, Paris, private collection) was one of his early attempts at a narrative composition of fairly large scale. Calculated for exhibition—Courbet submitted it, unsuccessfully, to the Salon of 1844 —the picture seems like a caricature of Salon painting in its hearty crudity of execution and puerile eroticism. But there is energy in its clumsiness, and in the bulky, nude daughter of Lot, lounging in back view at the left, Courbet realized the first of those flesh-mountains that were to be his special delight and the outrage of his critics.

Courbet had little aptitude for the invention and mental elaboration of subject matter, the "poetical" aspect of art that preoccupied not only the disciples of the Academy but also the great artists of the time. The imagination was not the chief organ of his artistic personality. A sensualist, he needed the stimulus of a material presence, and (rather like Géricault in this respect) was most deeply stirred by the tangible reality of things or beings. Thus while struggling with Salon subjects, it was in portraits and landscapes that he discovered his real strength. Relatives and friends served him as models. His earliest attempts at portraiture, such as the *Portrait of Régis Courbet, the Artist's Father* (ca. 1840, Boulogne, private collection), and *Juliette Courbet* (dated 1844, Paris, Petit Palais), are marked by a hard, somewhat primitive literalness.

Courbet's favorite, most deeply loved model was his own self, and it is in the many self-portraits of these early years that he gradually formed his personal style and revealed himself as a master. Theatrical performances rather than simple portraits, they cast him in a succession of dramatic roles, as a man on the verge of madness—*The Desperate Man* (dated 1841, Luxeuil, private collection); as infatuated lover—*The Lovers in the Country* (1844, Lyon Museum); as inspired artist—*The Sculptor* (1844, New York, private collection); and as wounded duelist—*The Wounded Man* (1844, repainted 1854, Louvre). A strong flavor of romantic sentiment still clings to these narcissistic self-dramatizations, to their settings, attitudes, and picturesque costumes. But they also exhibit solid painterly qualities, the fruit of his studies of the masters, and particularly of the Baroque painters of powerful light-and-shadow modeling, Rembrandt, Ribera, and Caravaggio.

Self-Portrait with Black Spaniel (1842–44, Paris, Petit Palais) was the first of Courbet's paintings to be accepted for the Salon (1844). It is a work of very confident execution, compositionally and technically greatly superior to *Lot and His Daughters*. The silhouetting of the figures against a sunlit landscape background amounts to a reversal of his more usual method of modeling figures from the dark ground into the light. But the strongest, most characteristic of Courbet's early works, *Self-Portrait with Leather Belt* (ca. 1846, Louvre), represents the

young artist in melancholy meditation on a statuette after Michelangelo, a volume of engravings, and a piece of drawing chalk in its holder, emblems of art and its traditions. Of large and ruggedly simple construction, head and hands are modeled in strong contrasts of light and shadow, appearing to emerge from the surrounding atmospheric dark into the graduated light of the foreground. The portrait was painted over a copy of Titian's *Man with a Glove* (Louvre), which evidently had some influence on its conception.

Exhibited at the Salon of 1848, *Self-Portrait as Cellist* (ca. 1847, Stockholm, National Museum), the last of Courbet's dramatized self-portraits, understandably reminded critics of Rembrandt, Caravaggio, and Velásquez. In the *Self-Portrait with Pipe* (ca. 1849, Montpellier Museum), Courbet shows his face in radical close-up, smoking—a motif borrowed from the more uncouth of Dutch genre painters. With eyes half-shut and lips closed around the pipe's stem, he wears an expression of mixed melancholy and beatitude: "Christ with a pipe," he called the picture in a letter to a friend.

Of more conventionally Romantic inspiration are two portrait-like figural compositions in outdoor settings that he submitted to the Salon in 1845. *The Guitar Player* (ca. 1844, Bedford, N.Y., private collection), often wrongly called a self-portrait, is in fact the portrait of one of Courbet's friends, most likely the musician Promayet, picturesquely costumed as a troubadour. The picture was perhaps intended as a pendant to *The Sculptor*. It was accepted for the Salon of 1845, unlike *The Hammock* (ca. 1844–45, Winterthur, Reinhart Collection), which the jury refused. Curiously reminiscent of the idylls painted by certain German artists of the time, such as Moritz von Schwind, the picture shows a girl asleep in a hammock, sun-dappled in the green dusk of the forest, her bodice open at the breast. The subject of the sexually attractive woman reduced by sleep or drowse to a state of passivity was often to recur in Courbet's later work.

The 1840s were a time of struggle, during which Courbet's abundant vitality and his buoyancy of spirit enabled him to progress rapidly, despite moments of discouragement. With megalomanic confidence, he felt himself to be strong and gifted enough to face and to overcome the formidable art establishment to which he was by proud choice an outsider. Invigorated rather than exhausted by his work, he had energy to spare for a sociable life. Of exotically handsome appearance, "slim, tall, supple, with long, black hair and a black, silky beard . . . with languorous eyes, a straight nose and low brow," he fancied that he resembled the ancient kings of Assyria. He was attractive to women, and had mistresses, one of whom bore him a son in 1847. But intense self-preoccupation unfitted him for lasting relationships, and he abhorred the "slavery" of marriage on philosophical and political grounds. He shone at the center of high-spirited gatherings, at the Café Momus and other Bohemian resorts, where his escorts consisted of such friends as the painter Bonvin, the musician Promayet, the eccentric scholar Trapadoux, and—toward the end of the decade—the poet Baudelaire and the critic Champfleury.

Determined to conquer the world of art, Courbet submitted paintings to all the Salons from 1841 onward, was rejected in 1841, 1842, and 1843, then had one

painting accepted in each of the three following years. In 1847 all his submissions were refused, but the unjuried Salon of 1848 allowed him to show no fewer than ten paintings. The Revolution of 1848 deposed Louis Philippe and set up the Second Republic. Courbet, who was by family tradition a Republican and by recent conversion a Socialist (of the Fourierist faction), but who also held pacifist views, remained a sympathetic but passive onlooker. Like other young artists, he benefited from the short-lived Republic's liberalization of the Salon and its encouragement of the arts. The year 1848 marked the end of the period of his apprenticeship and of his youthful romanticism; he himself later dated the beginning of his mature, i.e., his "Realist" phase, from this year.

His self-education had laid the early foundations for his later realism. In retrospect, Courbet would describe his artistic formation as that of a radically independent "student of Nature." Spurning academic routines and the advice of teachers, he had "crossed the river of tradition unaided, like a strong swimmer," and emerged, with unimpaired individuality, to confront Nature's truth directly. But the course of his artistic development had, in fact, not been quite so peculiar to himself as he imagined. It followed, rather, in the succession of the self-determined Romantic artists of an earlier generation who, beginning with Géricault, had also been Nature's students in the special sense in which that term applies to Courbet: artists shaped by personal tendencies rather than by any teacher or school. For the "Nature" that formed Courbet's art was not that of the external world—Constable's sunlit fields—but an irresistible inborn appetite, whose promptings led him to the museum in search of congenial work. Here, aided by his great technical facility, he plundered the masters of whatever in their paintings appealed to his instinct—his nature—and called the booty his own.

Courbet made his entry into the world of art in the manner of a "natural genius," of the kind that the late eighteenth century had invented, and there was much in his self-image that derived from the Bohemianism of the period of Storm-and-Stress: his narcissism and rude geniality, his populism and militant materialism, his show of contempt for tradition (on which, at the same time, he depended), and even his liking for the Baroque painters of light and shade. It was from them—Rembrandt, Caravaggio, Ribera, Zurbarán—that he derived his "Realist" painting style, modeling his figures by strong contrasts of light and dark in such a way as to emphasize their corporeal solidity, their weight and material substance. He was, to begin with, essentially a studio painter, though he would in time occasionally set up his easel in the open air like the painters of Barbizon. His "school," at any rate, was the dusky galleries of the Louvre, not sunlit nature, and the technical and stylistic aspects of his realism were developed through the study of the masters and of the posing studio model.

Courbet (unlike Daumier) was not among the painters who took part in the competition instituted by the Revolutionary government for a monumental allegory, *The Republic.* He toyed, instead, with the idea of composing a Hymn to the Revolution *(Chant populaire),* believing his musical talent to be of a high order. The group of friends among whom he now played a leading role met regularly in a Swiss tavern, the Brasserie Andler, in the immediate vicinity of

Courbet's new studio in the rue Hautefeuille. It included, beside Baudelaire and Max Buchon, a number of literary men and journalists, among whom the most influential on Courbet was Jules Champfleury, a writer interested in the psychological and social sources of art. A collector of folk art, knowledgeable about such little-studied subjects as caricature, children's drawings, and popular prints, Champfleury encouraged Courbet to remember his roots in rural society, the solid and wholesome reality of Ornans, his family and friends.

To Courbet, who had never become fully acclimatized in Paris, and who had for some time been searching for subjects on which to exercise his now fully developed Realist style, Ornans did indeed offer an alternative to the hectic artificialities of the metropolis and to his own rather aimlessly Bohemian existence there. The idea of devoting himself to themes taken directly from his personal experience of life among the working population of rural France seemed attractive to him. It is possible, though by no means certain, that the Revolution of 1848 had helped to direct his interest away from the pretentious conventionalities of Salon painting and toward common reality.

To the Salon of 1849, no longer non-juried, Courbet submitted eleven entries, of which seven were accepted, including his largest painting to date, *After Dinner at Ornans* (1848–49, Lille Museum), in which he boldly treated a simple, domestic subject in the heroic dimensions normally reserved for grand historical compositions. Around a table holding the remains of their luncheon three men are seated—Courbet's father, Régis; Couenot, the host of the meal; and the hunter Marlet with his dog—listening to Courbet's friend Promayet playing the violin. From the room's darkness, the figures stand out in sharp relief, modeled by the grazing light. The grave and somewhat heavy realism of the scene is reminiscent of the style of the French seventeenth-century painter of large-scale genres, Louis LeNain (e.g., his *Peasant Repast,* 1642, now in the Louvre, which Courbet may have known). Painted with much bituminous black to deepen its shadows, the work is now in ruinous condition. It is the first of Courbet's "social" subjects, an instant from common life treated with a certain solemnity, and it indicates a shift away from the narcissistic egocentricity of his earlier, Romantic work, but by no means a complete shift, since—though not a self-portrait—the subject is still autobiographical. The picture was admired by artists (Delacroix, and even Ingres) and by critics (Champfleury), and earned a gold medal of the second class.

In the autumn of 1849, Courbet returned to Ornans, where his father had provided a studio for him. Delighted to be in familial and natural surroundings that he loved, he worked hard, but at the same time enjoyed all the pleasures of winter in the country, went hunting, and helped organize a carnival entertainment. His letters to friends express a cheerful mood, certainly not that of an angry critic of society. By the spring of 1850, he had three large pictures ready for the Salon. But the opening of that exhibition suffered unusual delays. Impatient to discover how audiences would react to his pictures, he gave them private exhibition, charging admission, in Ornans, Besançon, and Dijon, before exposing them to the Parisian public in the last days of December 1850.

The funeral of his maternal grandfather Antoine Oudot, in 1848, gave

Courbet the idea for the enormous (10 × 22 ft., or 3.1 × 6.7 m.) *Funeral at Ornans* (1849–50, Louvre); hence his title for it: "History of a Funeral. . . . " The wide panorama of mountains under an overcast sky that forms the background is the actual view from the cemetery of Ornans—another touch of realism. The action consists of the authentic ritual of a Catholic burial. On the left, the pallbearers approach with the coffin. The priest, assisted by his acolytes and vergers, prepares to read the service. The citizens of Ornans, each painted from life, advance in a slow procession. Toward the center, the men have taken their station around the open grave, small-town patricians in their Sunday clothes, among them Courbet's father, the mayor of Ornans, and two friends of the dead man, veterans of the Revolution of 1793. Farther to the right, the women are still moving forward, many of them weeping into their handkerchiefs. They include Courbet's handsome sisters and his mother. In the foreground, the gravedigger kneels at the open grave, ready for the coffin. A dog looks on.

The picture's compactly grouped figures form a solid wall; from the darkness of their mourning clothes, the individual faces emerge with extraordinary intensity. Sky, distant mountains, and the frieze of mourners form three wide horizontals, broken only by the crucifix on a tall staff held by the priest's assistant. The scene has the dignity that one would expect in a painting that so closely concerned Courbet and his family and commemorated an event that to him had the momentous significance of history. But at the Salon, the *Funeral* caused a scandal. The megalomanic dimensions that Courbet had given to what would have been tolerable as a small genre picture seemed to most critics provocatively inappropriate. They ridiculed the "doll-like stiffness" of his figures, comparing them to primitive penny woodcuts, and pretended to be revolted by their ugliness.

Courbet's actual offense was to have dared to present death in its bluntly material aspect, without sentiment or consoling uplift: beyond physical existence, the enormous picture seemed to say, there was only nothingness, the emptiness of the open grave. Even Courbet's friends were made uneasy by this blasphemy and felt it necessary to offer justifications. The philosopher Proudhon described the *Funeral* as a moral lesson about modern man's loss of a Christian belief in the hereafter. Max Buchon and Champfleury, while defending Courbet against the charge of outright socialism, conceded that the squalid ugliness of the men and women in his picture (Courbet's own family and friends!) was by way of comment on bourgeois society. Modern historians have tended to pay closer attention to these accusations and apologies than to the picture itself, in which there is not a trace of primitivism or of intentional ugliness.

Of more obviously political and social significance was Courbet's second entry in the Salon of 1850–51, the *Stone-Breakers* (1849–50, formerly in the Dresden Museum; destroyed during an air raid in 1945), which was suggested to him by a personal experience, an encounter during a walking tour with an elderly, ragged roadmender and his young assistant. They struck Courbet as the *"complete* expression of human misery."* He engaged both to pose for him and painted them in the setting of a hot, dusty roadside as faceless working animals (in rather striking contrast to the sharply individualized mourners in the *Funeral*). Though

much smaller than its companion at the Salon, the life-size *Stone-Breakers* startled viewers by its monumental treatment of a scene from common life.

Both criticized and praised for its supposed Socialist sermonizing, the painting received fewer, and less hostile, notices than the *Funeral,* and by the power of its evocation of material reality won admirers among those who had no political axes to grind. To what extent Courbet's intentions at the time were consciously political is difficult to tell. When asked fifteen years later whether he had meant to make a social protest, he answered ambiguously that "on the contrary, I see in the *Stone-Breakers* a poem of gentle resignation, and they inspire in me a feeling of pity . . . but that pity springs from injustice, and that is how I stirred up, not deliberately, but simply by painting what I saw, what they call the social question."

Together with yet a third large painting, *Peasants of Flagey Returning from the Fair* (1849–50, original lost; later, altered version in Museum of Besançon), and the generally admired *Self-Portrait with Pipe,* Courbet's sensational exhibits at the Salon of 1850–51, while drawing down the critics' wrath, made him famous overnight. The prince-president of the Republic, the future Napoleon III, showed an interest in the *Self-Portrait.* Only lack of funds prevented its purchase for the state.

The *coup d'état* of December 1851 which made Louis Napoleon the dictator of France and led to his "election" as emperor of the French in 1852 drastically changed the climate of the world of art. Although the government of Napoleon III professed and, to a degree, practiced a form of liberalism, it did not tolerate genuine dissent. Appeased by fairly lavish patronage, many artists prudently submitted. Courbet gave himself truculent, nonconformist airs, but henceforth used care in his major paintings to avoid subject matter that could be interpreted as being hostile to the regime.

Some time before the *coup d'état,* he had begun a painting as large as the *Funeral,* but on an urban subject, *The Fire Alarm,* representing a fire brigade setting out at night to fight a blaze. The unfinished canvas (now at the Petit Palais, Paris) offers a view of obscure, turbulent movement in a nocturnal city street, distantly reminiscent of Rembrandt's *Nightwatch.* It is a scene from observed life, true to Courbet's Realist program, but—unlike his rural subjects—contains no personal references and carries a suggestion of heroic and perhaps Revolutionary violence. The idea for it may have come from Proudhon. Courbet stopped working on the picture when the space given him in a Paris fire station became unavailable after the coup of December 1851.

At about the same time, he was occupied with a composition of an "agreeable" kind with which he hoped to disarm his critics. *Young Ladies of the Village Giving Alms to a Cow Girl* (1851, New York, Metropolitan Museum) was, in fact, purchased even before its exhibition at the Salon of 1852 by one of the most powerful politicians of the new regime, Comte de Morny, half brother of Napoleon III. The picture shows Courbet's three sisters—small-town beauties, modishly dressed—pausing on a walk near Ornans to give alms to a ragged peasant girl. The evident, intentional contrast between modest elegance and dire poverty

makes this one of his social subjects (it has been unconvincingly interpreted as an allegory of Charity). But it is also a family picture, delighting in the prettiness of the three young women, and a splendid landscape (the study for it, in the Leeds Art Gallery, stresses this aspect), whose effect of sunlight, freshness of color, and topographical realism anticipates Courbet's pure landscapes of the later 1850s and the 1860s.

For the Salon of 1853, Courbet once again made a special effort at a spectacular presentation, as he had done for that of 1850–51. The changed political circumstances forced him to be careful in his choice of subjects, but he tried to compensate for his political caution by a display of boldness and innovation in other fields. *The Wrestlers* (1853, Budapest Museum), the largest of Courbet's entries, thrusts two huge, heavy-muscled bodies, modeled by the sharp light-and-shadow contrasts of studio illumination, into the foreground of a spacious open-air setting. "The background kills the figures," Delacroix noted in his diary. The subject, a sport event at the racetrack of the Hippodrome in the Champs-Elysées, is daringly novel, although the composition was perhaps influenced by Baroque paintings of the exploits of Hercules.

The Bathers (1853, Montpellier, Musée Fabre), Courbet's first exhibited nude of large dimensions, caused a lively scandal because of the offensive non-ideality of the nude figure stepping from the shallow water and exposing her monumental posterior. The bather dramatically gestures toward her companion, who is undressing at the water's edge and who responds with an equally strong motion of her arms and body. Filtered sunlight, striking through the heavy green foliage, illuminates the figures but does not quite integrate them in their setting. There is a clash, as in *The Wrestlers,* though not quite so apparent, between the studio-derived reality of the massive figures and the fresher naturalism of their landscape background. Proudhon, valiantly but unconvincingly, tried to read an indictment of bourgeois society into the *fesses colossales* of the principal bather. Delacroix, while recognizing the splendid solidity and vigor of their execution, deplored the elephantine insignificance of their gesticulation.

The Sleeping Spinner (1853, Montpellier, Musée Fabre), wrongly said to have been posed by one of Courbet's sisters, shows a buxom girl in a drowse beside her spinning wheel. The picture's dark tonality contrasts strikingly with the open-air settings of *The Wrestlers* and *The Bathers.* It is a masterwork of vigorously materialist execution and robust sensuality. Though it has been very dubiously interpreted as signifying Sloth, it seems in fact to be a human still-life, presenting its subject in the state of passivity and unconsciousness that Courbet found erotically appealing. This was the best liked of his pictures at the Salon, and apparently intended to conciliate his critics and public. Alfred Bruyas, a wealthy patron of the arts from Montpellier in southern France, admired Courbet's paintings at the Salon of 1853 and bought both *The Bathers* and the *Spinner* for his collection. So began a life-long association between the artist, who was soon to need private support, and a cultivated, ideally broad-minded friend of art.

In 1853, Courbet painted a *Portrait of Bruyas* (Montpellier, Musée Fabre), showing his sitter with his hand posed on a volume entitled *La Solution,* a

reference to a book by Bruyas, but—more importantly—also a hint of the role Courbet had in mind for his new patron in the future economy of his life. Claiming total artistic freedom for himself, Courbet realized that he could not count on state patronage, the richest source of funds and the only one capable of sustaining monumental work on the scale of the *Funeral.* But there was an alternative to the slavery of official patronage: the support freely given by liberal-minded patrons such as Bruyas. The mutual accommodation of the free artist and the enlightened private patron was the "solution" that Courbet enthusiastically embraced, and that Bruyas cautiously accepted, as the basis of a free art-economy of the future.

The need for a protective arrangement had recently been impressed on Courbet by a meeting with the imperial government's director of fine arts, Count Nieuwerkerke, during which the director had flatteringly invited him to paint a large picture "in his most vigorous style" for the forthcoming Exposition Univer-selle of 1855 (the Salon of 1854 having been canceled in anticipation of what was to be the most ambitious international show of modern art ever held). There was just a minor condition to be met: Courbet would submit a preliminary sketch for approval and have the finished painting passed by a jury of artists of his own choice. This gave Courbet the opportunity of a ringing declaration of independence. He would not have his work judged by any jury whatsoever, since he was the only fit judge. Rather than make the slightest sacrifice of his artistic freedom, he would withdraw from the official exhibition altogether and show his works in a rival exhibition of his own. The planning for his private exhibition was to occupy him for the following two years and to tie him closely to Bruyas, the most likely contributor of the 40,000 francs needed to cover the costs.

In the winter of 1853–54, Courbet worked in Ornans, painting landscapes and starting one major figural composition, *Women Sifting Grain* (1854–55, Nantes Museum), a scene of farm work posed by his sisters Zoë and Juliette, and perhaps intended as a sequel to the *Young Ladies of the Village,* showing the Sunday almsgivers in their workaday existence. Thus it is a "social" subject but one completely lacking in the pathos, the "misérabilism" of the *Stone-Breakers* (and of Millet's contemporary scenes of farm women at work). The picture, on the contrary, celebrates physical labor in a spirit of joyous sensuality; its brawny young women represent the "triumphant union of vigor and grace," according to a critic of the time. The execution combines a splendid solidity in all physical details with a great subtlety of color and a pervasive, blond luminosity that is exceptional in Courbet's work. The figures of the two women may owe something to Velásquez's *Tapestry Weavers.*

In May of 1854, Courbet traveled to Montpellier, on the Mediterranean coast, for an extended visit to Bruyas, during which he hoped to persuade his patron to underwrite the cost of his projected one-man show. The main artistic result of this voyage, and a document of "La Solution," his compact of mutual support with Bruyas, was the large picture *The Meeting ("Bonjour, M. Courbet")* (1854, Montpellier, Musée Fabre), which represents himself, proudly erect, his "Assyrian" beard silhouetted against the southern sky, encountering his respect-

ful patron, who has come to meet his visitor accompanied by an even more respectful servant and a dog. The staging of the scene may have been influenced by popular imagery of the Wandering Jew greeted by the burghers of a town. It expresses, at any rate, Courbet's view of himself as a free, vagabond artist, carrying with him the instruments of his work but otherwise unburdened by convention, unlike his host, whose frail figure is encased in the somber costume of bourgeois respectability. "Fortune bowing to Genius," according to a reviewer writing in 1855, whose quip comes close to the picture's actual meaning. The prominent landscape setting, with its very extensive, bright sky, its distant horizon, and sun-dappled foreground, is a remarkable painterly achievement. The integration of the figures in the light and atmosphere of a believable outdoor setting surpasses all of Courbet's previous attempts and marks a step toward the open-air figural compositions of Monet and Renoir.

Another painting dating from Courbet's visit to Montpellier records an even grander, quasi-cosmic "Meeting." *The Seaside at Palavas* (1854, Montpellier, Musée Fabre) places the artist-wanderer at the shore of the sea, waving a greeting to Nature herself. The tiny figure confronting an immensity of water and sky recalls Friedrich's *Monk at the Seashore* (1808–09) but is quite devoid of Romantic awe in the face of the sublime. "Oh Sea, thy voice is tremendous," Courbet wrote to a friend by way of commentary, "but it will not drown out the voice of Fame crying my name to the world."

Bruyas proved to be unable to lend the money needed for the private exhibition, and Courbet resigned himself to showing his paintings—fourteen of them—in the official art section of the Exposition Universelle. The centerpiece of this large submission was to be a huge (ca. 12 × 22 ft., or 3.8 × 6.7 m.) composition of a highly personal kind. *The Studio,* subtitled *("A Real Allegory Summing Up Seven Years of My Artistic Life")* (1854–55, Louvre), was begun, after only cursory preliminaries, in Ornans during October 1854. A letter by Courbet to Champfleury, written before the picture's completion, describes his intent. He meant to gather into his studio "all the people who serve my cause, sustain me in my idea, and support my action." More than that, he saw all of society, "the whole world, coming to me to be painted." But society and world were to be only accessories to his real subject—himself. Seated at his easel in the picture's center, Courbet divides its cast into two contrasting groups, as if presiding over a Last Judgment.

To his left, a discordant motley of figures represents "the commonplace life," the nameless masses of the poor, the exploited and their exploiters. Though taken from life, they are types, specimens of society, rather than individuals: a Jew, a priest, two hunters, a veteran of the Revolution, a merchant of used clothes, a laborer and his wife, a circus strongman, a clown, an undertaker. Close to the easel crouches the embodiment of utter distress, an Irishwoman, nearly naked, nursing an infant. On the floor in the foreground lie a plumed hat, a guitar, and a dagger—the "cast-offs of romanticism." Very loosely grouped, the figures are barely related to one another. They sit or stand about, like people in a waiting room—thematic raw material saved up for future use.

Rather more formally arranged, on the picture's right side, are Courbet's backers—the "shareholders" *(actionnaires),* as he oddly called them in his letter —a dark conglomeration of portraits reminiscent of the *Funeral,* among them Bruyas, Proudhon, Champfleury, and Baudelaire. Save for a pair of lovers at the window who are absorbed in one another, Baudelaire who is reading a book, and the small boy who is lying on the floor making a drawing at the feet of the crinolined bourgeoise and her escort, these supporters stand solemnly by, watching their artist at a respectful distance.

Aloof from his surroundings, Courbet, seated at his canvas, performs the act of creation. With his brush raised in a gesture like that of Jehovah in Michelangelo's *Creation of Adam,* he conjures light, sky, and landscape onto the canvas before him, the most luminous area in the otherwise shadowy picture. It is remarkable to find the champion of realism working from the imagination, recreating nature (in keeping with Friedrich's Romantic precept) from inward sight. Behind him stands a nude woman, a "model" according to Courbet, who perhaps signifies Truth, in evident contrast to the corpselike academic lay figure on the other side of the easel. A boy watches the artist-creator with rapt attention, while beside him a white cat plays on the floor.

The fundamental idea of the picture, aside from the simple self-tribute, may be to present the artist as the productive man par excellence, and hence a model to humanity. Working freely, neither exploited nor exploiter, he celebrates the sacrament of artistic creation before his awed audience—the world—and fulfills the ideal of his philosophical mentor, Proudhon, of work transcending itself in art. There are some traces of artistic influence in the conception and form of this enormous composition: something of the effect and thought of Velásquez's confessional self-portrait in *Las Meninas,* and something as well of the idea of Rembrandt's etching *Christ Preaching.* In its pictorial unity, achieved by a masterly handling of the effects of light and space—the entire upper half of the canvas consists of dimly illuminated, atmospheric space—*The Studio* is a stupendous feat of inspired, improvisational painting, and was admired as such by Delacroix and other artists not otherwise enamored of Courbet.

In the spring of 1855, learning that the Exposition Universelle had rejected two of his fourteen entries, the *Funeral at Ornans* and *The Studio,* Courbet renewed his plan for an independent exhibition and within a few months managed to have a temporary gallery of his own constructed near the official Exposition. Over its entrance, he placed a large sign proclaiming *Le Réalisme.* But he did not boycott the government-sponsored Exposition Universelle, which opened on May 15, 1855, and included eleven of his most important works, among them the *Stone-Breakers,* the *Young Ladies of the Village, The Meeting,* the *Women Sifting Grain,* and *The Sleeping Spinner.*

Courbet's own show opened a month later, accompanied by a leaflet that tersely stated his creed: ". . . I have studied, unsystematically and impartially, the old and the modern masters without wishing to imitate the former or the latter . . . but merely to derive from a wide acquaintance with tradition a reasoned and independent awareness of my own individuality . . . to gain skill through knowl-

edge was my intention, to create living art my aim." There were thirty-nine paintings (rather than the advertised forty) in the exhibition, the most important being *The Studio,* the *Funeral,* the *Peasants of Flagey Returning from the Fair, The Bathers,* and *The Wrestlers.* To Courbet's surprise, attendance was sparse, causing him to reduce the admission charge in mid-course.

Physically tired, disappointed, and in uncertain health, Courbet emerged from what he himself apparently saw as the conclusion of a phase in his artistic development with lessened zest for controversy. From 1855 onward, he largely abandoned social subjects, and avoided—except in a few instances—complex subject matter of any kind, to devote himself mainly to hunting scenes, landscapes, and portraits. His abstention from political themes caused the radical critic Thoré-Burger to comment sarcastically: "Noticing that the times were hard, that soldiers and princes were what the public wanted in paintings, [Courbet] shrank back from risk. . . . Though there were never so many stones broken in Paris as now"—a reference to the *Stone-Breakers* and to Napoleon's rebuilding of parts of Paris—"he understood that there was more interest in those who ordered them to be broken than in those who did the breaking. He therefore threw himself into the painting of deer and foxes, to which no one could object."

At the Salon of 1857, Courbet exhibited a picture of somewhat ambiguous meaning which, in part for this reason, greatly agitated the critics. The *Young Ladies on the Banks of the Seine ("Summer")* (1856–57, Paris, Petit Palais) shows two languid young women, a brunette and a blonde, drowsing voluptuously under trees at the river's edge. Their erotic somnolency, their postures, and their provocative display of fashionable clothes in the midst of verdant nature (the brunette has stripped down to her gauzy corset) caused Proudhon to speak of them as kept women, specimens of the moral laxity of the Second Empire, calling to mind "adultery, divorce, and suicide." Other critics saw them as representing idleness and luxury, in contrast to the charity of Courbet's earlier *Young Ladies of the Village.* The splendid still-life opulence of the figures and of their finery—undoubtedly intended by Courbet to be a delight to the eye rather than a subject for moralizing—caused still others to deplore the "soulless materialism" of the picture and to dismiss it as "a cloth bundle . . . a collapsed balloon."

At the same Salon, Courbet also showed two of his hunting pictures, the *Exhausted Doe in the Snow* (New York, private collection), an early example of the kind of winter landscape that was to become one of his specialties, and *The Quarry* (Boston, Museum of Fine Arts), a self-portrait as a hunter in a forest setting, with a powerfully realized foreground still-life of the slain buck's carcass disputed by two hunting dogs. Well liked by the critics and the public, *The Quarry* was followed by a long series of hunting pictures, of strikingly uneven quality.

Exhibitions of his paintings took Courbet to Brussels and to Frankfurt (where his *Funeral* and *Stone-Breakers* had already been shown in 1852). In the latter city, he was given an enthusiastic welcome by local artists and persuaded to stay for nearly half a year. His paintings sold well, and he was kept busy with commissions for portraits and hunting scenes, among them the splendid, large *Hunters' Picnic* (1858, Cologne, Wallraf-Richartz Museum). It is noteworthy

that his form of "realism" was, on the whole, more readily accepted in Germany than in France.

Back in Paris, landscapes, portraits, and most of all dramatic scenes of the forest and the hunt reconciled the public to Courbet's manner. His large *Stag at Bay* (1858–61, Marseilles Museum) and *Battle of Stags* (1861, Louvre) are based in part on his experience in the forests of Germany and Ornans, but also owe much to the English painter Landseer, whose heroic or sentimental animal scenes were then highly popular and whose *Stag at Bay* was well known to Courbet. In need of money to "preserve his artistic independence," he in fact surrendered some of his independence to the public for the sake of money. He exhibited his work widely in local exhibitions—in Montpellier, Nantes, Besançon, Marseilles, and Antwerp.

In 1861, at the request of art students, Courbet opened a studio for forty-two pupils, dedicated to the free pursuit of art rather than formal teaching. In a manifesto addressed to his disciples, he declared that "painting is an essentially *concrete* art and can only consist in the representation of *real* and *existent* things. It is a wholly physical language which uses visible objects instead of words; the *abstract,* invisible and nonexistent, lies outside the scope of painting." And he gave them these "rules": "1. Do not do what I do. 2. Do not do what others do. 3. If you were to do what Raphael once did, you would give up your own existence —suicide. 4. Do what you see and feel." Among the models presented to the fledgling Realists at the studio in the rue Notre-Dame-des-Champs were a bull and a Scottish pony. But Courbet's, and perhaps his students', interest soon dwindled; the studio closed in 1862. The only significant painter to have passed through it was Fantin-Latour.

While staying with friends in the town of Saintes, in southwest France, Courbet composed his last major painting of a polemical subject—drunken parish priests, riding or staggering on foot through a rural landscape—to which he gave the title *The Return from the Conference* and which he unsuccessfully submitted to the Salon of 1863. This rather heavy-handed venture into anti-clerical drollery, embarrassing even to his friends of the left, was later destroyed by a pious purchaser.

Nudes dominate among the later figure paintings of Courbet. From the 1840s on, he had often painted nude models in the studio in poses suggesting sleep or reverie, transforming them into exhibition pictures of "Bathers" by dressing them up with settings of forest pools or cascading springs. In 1864, still in a mischievous mood, he incorporated such a nymph into a satirical allegory, *The Fount of Hippocrene,* aimed at certain modern poets (Lamartine, Gautier, and Baudelaire). This canvas, with which he had hoped to cause a stir at the Salon, was destroyed in an accident, but Courbet managed to finish another picture for the exhibition, not entirely unrelated in subject matter, and of even greater shock value, *The Awakening (Venus Pursuing Psyche with Her Jealousy),* which is now lost. Thinly veiled as a classical subject (the Psyche story from Apuleius' *Golden Ass*), the picture presented two women, life-size, the one, a blonde, asleep on a bed, the other, a brunette, imperiously lifting the bed curtains and preparing to

join the sleeper. It was rejected by the Salon because of its transparent hint at lesbianism. This subject, avoided by painters, was not rare in the literature of the time—Courbet may have taken the idea from a poem by Baudelaire, "Delphine et Hippolyte" (1857). But unlike the poets who had treated the dangerous theme with a certain solemnity, he seems to have found it only stimulating and amusing, an opportunity for flustering friends and foes, his philistine critics as well as his Socialist defenders who had always presented him as a wholesome rustic. The original canvas, which he later modified by placing a parrot on Venus' raised hand, was destroyed in Berlin during World War II; its composition survives in several copies and reductions.

With cynical agility, Courbet turned this moral rebuff into a popular success. His *Woman with Parrot* (1866, New York, Metropolitan Museum), a great favorite at the Salon of 1866, was modeled directly on the nude Psyche in the rejected *Awakening,* but had no lesbian overtones. Very suavely painted, it perfectly conformed instead to the accepted norm of Salon eroticism, as established by such virtuosi of the academic nude as Baudry and Cabanel. Zola commented: "Courbet has done something pretty," a genial sneer. The true sequel to *Awakening* is the frankly lesbian *Sleep* (also known as *Les Dormeuses*) (1866, Paris, Petit Palais), a private commission given him by Khalil-Bey, a Turkish diplomat and collector of erotica, who owned Ingres's *Turkish Bath.* Two women are shown lying on a bed, both profoundly asleep. The brunette embraces with her thigh the hip and abdomen of her blond companion, whose head rests heavily on her breasts.

The execution of the bodies is particularly careful. They are defined by the satin luster of their slightly differentiated complexions, rather than by Courbet's customary strong light-and-shadow relief. Their faces are more highly individualized and expressive than is usual in his work. Both are recognizable as portraits. The blonde was posed by Jo Heffernan, Whistler's model and mistress (and for a time Courbet's also). But the overall effect of the inanimate figures is that of a sumptuous still-life, expressing Courbet's materialist aesthetic, as well as his erotic sensibility, which responded to women reduced by sleep to purely physical presences.

Courbet's emphasis on the objective reality of his erotic scenes, and his exclusion of mystery or fantasy, reduces such scenes to prosaic flesh-painting, saved from declining into mere illustration by their aesthetic quality—the passionate vigor of their painterly execution. An extreme instance of his anti-Romantic objectivity is the picture known as *The Origin of the World* (1866), the close-up portrait of a woman's abdomen. The aesthetic tendency of his materialist realism is illustrated by compositions without definitely erotic significance in which women, treated merely as handsome objects, are incorporated into still-life arrangements. Two such paintings are *The Trellis (Young Girl Arranging Flowers)* (1863, Toledo Museum) and *Girl with Seagulls* (1865, New York, private collection).

From the mid-1850s, landscape painting began to play an increasingly important part in Courbet's work. In *The Studio,* he had shown himself in the

act of painting a large landscape, but this was evidently by way of declaring future intentions rather than looking back to past practice, for he had painted relatively few landscapes up to that time (1855), and none of such large size. His landscape painting reached its highest point in the years between 1864 and 1871.

Courbet's landscapes owe less to tradition than his figure paintings. He took his favorite motifs from his native region, whose wide, horizontal hillsides, closing off the distance, had indelibly impressed themselves on his mind. Their echoes are still to be found in the seascapes of his later years, in which the ocean has the solidity of a mountain range. Though he usually painted under the open sky ("His palette smells of hay," Cézanne once said of him), his landscapes are fairly dark-toned and stress the tangible matter of stone, turf, and foliage rather than the fugitive effects of light and atmosphere. Dispensing with preliminary drawings, he set up his easel without much reflection wherever the prospect pleased him and painted directly in oils, working with speed and relish, making lavish use of the heavy pigment, often stroking it onto the canvas with a flexible steel blade. Courbet's vigorous, highly personal landscape style has affinities with that of the Barbizon painters (with several of whom he was acquainted), though it is simpler, less studied in its compositional arrangements than theirs. He favored compactly structured forms, seen at close range.

About 1863–65, he painted the series the *Source of the Loue* (versions in New York, Zurich, Hamburg, Washington, and elsewhere), views of a cliff face opening into a grotto from the shadowy depths of which flows the river. They amount to impressive inversions of normal landscapes: solid stone takes the place of sky and the distance is walled up in darkness. Winter scenes, which allowed him to transform atmosphere into the highly painterly substance of snow, were particularly congenial to Courbet's talent and became one of his popular specialties.

During visits to the coast of Normandy and the town of Le Havre in 1859, Courbet became acquainted with Eugène Boudin, who was then painting on the beaches of the Channel coast. During the 1860s, he frequently spent the summer months in the fashionable seaside resorts of Trouville and Deauville, carrying out commissioned society portraits and painting seascapes. In 1865, he encountered Claude Monet and James Whistler in Trouville and made a strong impression on them. Pictures of the sea, wide expanses of fresh blue between vacant beach and cloud-mottled sky, came from Courbet's easel in large numbers this summer, rapid improvisations that translate impressions of light and atmosphere into rough applications of pigment with the palette knife. A strong sense of material substance separates these seascapes from the later, light-centered work of the Impressionists.

Proudhon's death in 1865 saddened Courbet and moved him to paint a "historical portrait" of his philosopher friend, *Proudhon and His Family in 1853* (1865, Paris, Petit Palais). Incoherently composed and badly porportioned in its main figure, which sits eerily detached from its surroundings, the picture suffers from having been put together with the aid of various photographs. Thus ended a strange association between a thinker of extremely abstract, idealistic bent, who

—for all his musings about art's "social destiny"—had little feeling and no eyes for painting, and the most solidly earthbound of artists.

At the Paris World's Fair of 1867, Courbet once again showed his work in a special pavilion built at his own expense. His exhibition—comprising about a fourth of his total work, according to the catalogue—amounted to an impressive retrospective. It included 110 paintings, among them a dozen of his large canvases (*Funeral, Stone-Breakers, Bathers, Woman with Parrot,* etc.), beside some forty-eight land- and seascapes, twenty-five portraits, and four flower pieces. The tone of press reviews had by now changed from hostility and ridicule to respect.

Courbet was lionized by the aristocracy and plutocracy of the Second Empire's dying years. Offered the cross of the Legion of Honor in 1870, he ostentatiously refused it. (Daumier, who also declined it at this time, did so quietly.) A young generation of Realist painters in Belgium, Holland, and Germany acclaimed him as their model. He was the star of the great international painting exhibition held in Munich in 1869, accepted a high decoration from the king of Bavaria, and allowed himself to be fêted by young German artists; several of the most gifted among whom (Leibl, Truebner, and Schuch) he influenced so deeply that a new epoch in German art can be said to have begun with his stay in Munich.

In the summer of 1869, Courbet spent a month at the seaside village of Etretat, noted for its picturesque cliffs (Monet was to paint a series of views of these some twenty years later). The result of his visit were two views of the cliffs, one showing them at a distance in a wide, horizontal view (Birmingham, Barber Institute), the other taken at closer range and set in a more vertical format (Louvre). Of both he made a number of replicas, as was now his custom; the ease with which he sold his work tempted him into self-copying on an almost industrial scale. An important new departure were his studies of the breaking surf, the most highly finished of which, *The Wave* (1869–70, Louvre), was painted for the Salon of 1870. If he had heretofore always shown nature in a state of rest, Courbet now produced in this and the many related paintings of the agitated sea impressive images of nature's active and energetic might, as matter in motion. He did not, however, lessen his emphasis on the concreteness and weight of matter that was basic to his realism. On the contrary, the bank of clouds that rests on the horizon has the look of granite, and the rushing sea, crested with white foam, is no less solid than the pebbly beach on which it is about to break.

The start of the Franco-Prussian War, in July 1870, was shortly followed by the defeat of the French armies, the collapse of the Empire, and the siege of Paris by the Germans. Courbet, his political activism reawakened by the long-hoped-for rebirth of the Republic, was appointed to the Arts Commission entrusted with the care of monuments during the siege. As a member of this commission, he recommended the destruction of the Vendôme Column, a symbol of Bonapartism. In April of 1871, he was elected a member of the Commune, the radical government of Paris, then under close siege by troops of the national government based on Versailles. After a bitter defense by the Commune, during which several of the great buildings of Paris were set on fire, the city fell to the

troops of the Versailles government. Courbet, as a member of the Commune and "vandal" of the Vendôme Column, was arrested, put on trial, and condemned to six months in prison.

He was fifty-one years old at this time, but he seemed older, his body bloated by years of overindulgence in food and drink, his hair graying, his once robust health shaken. The imprisonment broke him, and the authorities allowed him to finish his sentence under medical care in a private clinic. While in prison at Sainte-Pélagie, he painted several still-lifes of fruit and flowers—e.g., *Still-Life of Apples, Pears, and Primroses* (1871, Pasadena, Norton Simon Collection), which proved that his work had lost nothing of its sensuousness and vigor. He also painted a *Self-Portrait in Prison* (1871, Ornans Museum), showing himself seated at the barred window, philosophically smoking his pipe. The time of his imprisonment and convalescence was one of surprising productivity. Courbet claimed to have painted and sold no fewer than fifty pictures during these months.

Released in early 1872, he returned to Ornans, where he found his studio stripped. His submissions to the Salon were rejected, but his work continued to enjoy a steady and profitable sale. He was invited to send an important group of paintings to the Vienna World's Fair of 1873, but his nervous and physical constitution had been shattered by worries and steadily declining health. In the spring of 1873, a decree was passed making Courbet financially responsible for the re-erection of the Vendôme Column. Fearing further imprisonment, he went into voluntary exile in Switzerland, settling in the small town of La Tour de Peilz on the Lake of Geneva. In Paris, legal proceedings against him continued, ultimately resulting in confiscations of his property and the imposition of a fine of 323,000 francs to be paid off in instalments.

Courbet worked feverishly to produce pictures for sale in order to meet the state's impossible demand. With the help of three assistants he set up a regular manufacture of paintings, for the most part landscapes based on earlier works, feeble parodies of his style and, in their slipshod repetitiousness, a mockery of realism. But his talent was not yet quite extinguished; flashes of it appear in some of the late paintings that he finished without assistance, particularly in portraits (*Portrait of Régis Courbet, the Artist's Father,* 1873, Paris, Petit Palais), animal pictures (*The Calf,* 1873, Hamburg, private collection), and still-lifes. *The Trout* (1872, Zurich, Kunsthaus) was one of several fish still-lifes painted after Courbet's release from prison. This picture of a giant trout, still hooked, expiring, is a feat of intense realism in its evocation of glistening scales, bloodied gills, and rough gravel. It is also a poignant image of captivity and death—perhaps the last of Courbet's self-portraits.

Cared for by friends, Courbet lived in relative comfort at La Tour de Peilz, charming his visitors with his "urbanity, friendliness, and childlike naivete." He hoped to be able to return to France, pay his fine, and recover his lost property. But his health steadily worsened. Heart and liver desease, aggravated by his enormous drinking, took their toll. For most of 1877 he was an invalid, undergoing painful treatment by quack doctors. He died on December 31 of that year.

* * *

Quite apart from his sporadic political activism, Courbet was a revolutionary force in nineteenth-century art. He did not pioneer any radically new technique; his practice of modeling form in graduated tones, proceeding from the dark underpaint into the highlights, was a conservative one, ultimately derived from Rembrandt and the Spanish masters. His realism was not a matter of pictorial technique alone, but one of his attitude to the subject—whether "social" or merely physical—and of his personal conception of the aim and scope of art. Reality to him was synonymous with palpable, material existence. Truth and beauty resided in matter. Physical experience, strongly savored, was his chief inspiration. He rejected abstract ideality and scorned poetic effects derived from literary associations. Thus he helped to rid painting of time-worn clichés, the artifices and elegant escapisms that had threatened to smother art in the academic-eclectic atmosphere of the mid-nineteenth century.

Superbly plebeian, unafraid of prosaic modernity and contemptuous of taste, Courbet acted as the bull that smashed the china shop of polite art, whether academic or preciously avant-gardist, thus enabling a new generation of artists (including the Impressionists) to concentrate on the problem of expressing visual experience. He was a very uneven painter, sometimes very crude, but at his best as a painter of flesh, fruit, animals, and flowers. Under his hands, clouds and waves turned into firmly shaped, substantial matter. He had a keen relish for paint; the brilliance of his brushwork conceals the stiffness of his drawing. A confident craftsman, unburdened by school lore, Courbet attacked and conquered painting difficulties (in the monumental *Funeral at Ornans* and in *The Studio*) that were far beyond the reach of his more cautious and learned contemporaries.

READINGS

The literature on Courbet is large, but it is mainly concerned with his life and personality, his political involvements, and his artistic intentions, as they have appeared to interpreters grinding the axes of their various ideologies. On his actual painting, those qualities in his work that make him one of the great (rather than merely interesting) figures in nineteenth-century art, comparatively little has been written. The early part of his work, up to 1852, being the more political, has received far more attention than the rest. Basic questions of stylistic development, quality, authenticity, and chronology still remain to be studied.

The Life

G. Mack, *Gustave Courbet,* London, 1951, is still the best balanced and certainly the best written biography in English. It incorporates information drawn from the sources (Claudet, 1878; Ideville, 1878; Gros-Kost, 1880; and Schanne, 1886) and the early biographies (Riat, 1906; Duret, 1918; and Leger, 1929).

J. Lindsay, *Courbet, His Life and Art,* London, 1973.

P. Courthion, *Courbet raconté par lui-même et par ses amis,* 2 vols., Geneva, 1948–50, is a useful compendium of sources and documents.

P. ten-Dosschate Chu, ed., *Courbet in Perspective,* Englewood Cliffs, N.J., 1979, is an anthology of sources and interpretive essays.

The Work

R. Fernier, *La vie et l'oeuvre de Gustave Courbet,* 2 vols., Lausanne and Paris, 1977, gives an illustrated, chronologically arranged catalogue of the work, with summary notes on individual paintings and biographical texts (documentary photographs).

H. Toussaint, *Gustave Courbet* (exhibition catalogue), London, Royal Academy, 1978 (a republication in English of the catalogue of the centennial exhibition at the Grand Palais, Paris, 1977), covers a large portion of the main work, usefully annotated (though the author proposes some fairly unconvincing interpretations: *The Studio,* in her view, is a Masonic allegory).

W. Hofmann, et al., *Courbet und Deutschland* (exhibition catalogue in German), Hamburg, 1978. The catalogue of an exhibition held in Hamburg and Frankfurt, this extensive, interpretive text by various authors complements that of Toussaint, though presenting quite different views. It also discusses the influence of Courbet on German artists of the period.

Special Studies

G. Boas, ed., *Courbet and the Naturalistic Movement,* Baltimore, 1938.

M. Schapiro, "Courbet and Popular Imagery: An Essay on Realism and Naivete," *Journal of the Warburg and Courtauld Institutes,* 1941, pp. 164 ff.

L. Nochlin, "Gustave Courbet's *Meeting:* A Portrait of the Artist as Wandering Jew," *Art Bulletin,* 1967, pp. 209 ff.

A. Bowness, *Courbet's "Atelier du Peintre,"* Newcastle, 1972.

B. Nicolson, *Courbet: The Studio of the Painter,* London, 1973.

T. Clark, *Images of the People: Gustave Courbet and the Second French Republic, 1848–51,* New York, 1973.

10
Academic and Salon Painters

Academic and Salon Painters
 The Academy and the Ecole des Beaux-Arts
 The Paris Salons and Their Juries
 The Salon Painters

Academic and Salon Painters

Around 1890, a group of prominent French artists, dining at the house of an art dealer, debated the question: "Who, in a hundred years, will be thought to have been the greatest painter of the second half of the nineteenth century?" The unanimous verdict, according to an American witness,* was that the paintings most highly valued at the close of the twentieth century would be those of Bouguereau and Meissonier.

History has proven these prophets wrong, but the story reminds us that the contemporaries of Manet, Degas, Monet, and Cézanne saw their world of art in a way quite different from the present view. The artists who are now regarded as the most important of that time were then quite unknown to the broad public, and certainly did not represent the interests and tastes of an audience still fascinated by the stars of the Salon: Bouguereau, Meissonier, Gérôme, Cabanel, Baudry, Bonnat, Bastien-Lepage, Carolus-Duran—the winners of prizes and medals, coddled by the press, honored by the government, sought after by collectors, and enriched by the art market. What is now called the history of nineteenth-century art is concerned only with a minority of artists, a minority that in its time seemed so small and so marginal that it made little impression on the public. Artists now barely known by name, on the other hand, enjoyed an enormous popularity and were generally supposed to be headed for immortality.

A reversal of values and tastes, unprecedented in its speed and quiet thoroughness, suddenly extinguished this galaxy. By 1910, Bouguereau and Meissonier had become irrelevant to the further development of modern art. A host of other prominent artists rapidly vanished from sight along with them, men who had for decades monopolized the official and much of the private art patronage in France, and been genuinely appreciated by the general public—had in fact been the last modern artists to combine officiality with popularity.

Histories of nineteenth-century art now hardly mention these discredited masters, who exhausted all their glory in their lifetime, leaving nothing to posthumous fame. Their omission from accounts of the art of their time creates an awkward gap and falsifies the historical picture of that period. For the Salon painters, or *pompiers* ("firemen," a derisive nickname referring to the helmets worn by figures in neoclassical paintings), not only constituted a vastly more

*H. W. Watrous, in *Modern French Masters,* ed. John C. Van Dyke (London, 1896), p. 93.

numerous population of artists than the thin line of great painters which represents the modern tradition, they also formed a much denser, more coherent succession, in which continuities of style and subject matter are more clearly traceable than in the far more diverse works of the exceptional, independent geniuses through which we now trace the development of nineteenth-century art. Actually that development implies the existence of the hundreds of academic and popular artists, now largely invisible, who formed the broad, continuous terrain from which rose the widely separate peaks of which we are still aware: Courbet, Millet, Manet, Degas, the Impressionists, Cézanne.

To restore the true landscape of late-nineteenth-century art, it is necessary to include its foreground of "normal," which is to say its successful, widely accepted, representative work, that work which expressed the actual tastes, aspirations, and pretensions of the period, and for this was rewarded with popularity. This does not require the rehabilitation of the heroes of the Salon—Cabanel and Gérôme are unlikely ever to be put next to Manet and Degas, despite current attempts to do just that—but their recognition as significant indicators of contemporary attitudes. There can be no doubt that the Salon painters reflected the mentality of their society and period, including all its vulgarities and falsehoods, more closely than the independent painters, since they were less distracted by problems purely of art. There is considerable irony in the fact that recent critics have tried to interpret the highly individual, aristocratic art of Manet as a document of the bourgeois era, when the authentic expression of bourgeois mass culture is abundantly available in populist Salon painting, undiluted by artistic irrelevancies.

Salon painting had a history of its own, worth study for what it reveals of the continuity of studio traditions, the passing of the inheritance of leading academic teachers from one generation to the next. For it was in the academic ateliers that certain conventions of style and technique were transmitted to large numbers of pupils, it was in these ateliers that the tastes were formed and attitudes set that later found expression on the walls of the Salon, where they met the test of public criticism. The various main strands of academic tradition and studio usage can be closely followed in Salon painting, which has a historical development as intricately ramified as that of any major movement in art, but one that has received little attention (see the genealogy on page 283). And while it is a remarkable fact of mid- and late-nineteenth-century French painting that its greatest masters were—without significant exception—dissenters from the academic establishment, who rejected its teaching and were often barred from its Salon, they were nevertheless influenced by that establishment, which provided them with the negative example against which they defined themselves.

THE ACADEMY AND THE ECOLE DES BEAUX-ARTS

As reorganized in 1795 during the Revolution and further modified in Napoleon's reign, the Académie des Beaux-Arts formed a section, or "class," of the national academic establishment, the Institut de France, in its core a literary or linguistic

body, that had subsections devoted to the arts, history, politics, and the natural sciences. The Art Academy proper consisted of forty elected life members: fourteen painters, eight sculptors, eight architects, four engravers, and six musical composers. It was a self-perpetuating body. On the death of an incumbent, candidates for the vacant chair had to propose themselves personally to the membership, a step that some artists found humiliating. The artists who were accepted into the Academy were nearly always elderly establishmentarians, their admission a reward not so much for artistic achievement as for demonstrated orthodoxy. Ostensibly one of the highest marks of distinction, election to the Academy was, in actuality, a favor done by men of remarkable mediocrity to others of their own kind. In the whole course of the nineteenth century, only three painters of the first rank were chosen by their reluctant peers: Gros (as substitute for the exiled David), Ingres (who despised his colleagues), and Delacroix (whose election came so late and with such ill grace that it only deepened his life-long sense of alienation from the academic establishment). The rolls of the Academy otherwise abounded in names now obscure—Le Barbier, Garnier, Lethière, Couder, de Pujol, Muller, Hesse, Merson—and strangely unrepresentative of French painting in one of its great periods.

The Academy in appearance had a merely honorific or advisory function, but it actually operated an intricate system of incentives and constraints, of helpful influence or virtual censorship that deeply affected the schooling and the mature careers of most artists. Academicians advised the government on matters of art policy, official patronage, and state purchases. They sat on the juries that regularly judged student work, awarded medals, and chose the winners of the great Rome Prize contests. They exercised the power of admission to (or rejection from) the Salon exhibitions, and awarded the Salon prizes that set their recipients on the road to prominence. The deepest purpose of the Academy was that of a regulating authority, a brake on the free, potentially chaotic energies of artists, a means for giving a consistent direction to these energies and harnessing them to a national interest.

The Academy did not directly administer the Ecole des Beaux-Arts, the official art school, but its members taught, in their private ateliers, the students preparing themselves for entrance into the Ecole. The choice of a teacher was of fateful importance to the pupil, who henceforth could call himself "the pupil of . . ." and lay claim to the support of his master in competitions, awards, and admissions to the Salon. The training itself was highly formalized, progressing, according to the traditional academic formula, from drawing after prints and casts to studies of the living model, with heavy emphasis on drawing. Each of the master ateliers had its own distinctive recipes and mannerisms, deriving from the particular academic lineage to which its presiding master belonged. To prepare students for the round of qualifying competitions they would face in the Ecole, many of the ateliers were operated as miniature academies, with monthly competitions, awards, and exhibitions of prize-winning work.

Once admitted to the Ecole, students were bound into a rigidly systematic program, designed to advance them step by step toward the ultimate goal of the

Rome Prize. The entire academic curriculum rested on competition. In progressing from its lower to its highest levels, students periodically had to compete in qualifying trials—in figure study, composition, perspective, expression, and painting of the posing model—leading to the final grand contest of the Rome Prize. The preparation for these competitions came to be the main objective of instruction. The process of academic education was strikingly circular: academic professors taught students to develop those qualities of technique and style that would win them the votes of academic judges in academic contests, and in their later careers would earn them the favor of academic Salon juries.

That this closed system must stifle individuality soon became clear to thoughtful observers. "The lure of the Rome Prize and the facilities of the Academy have attracted a crowd of competitors who would never have become painters for the love of art alone," Géricault complained as early as 1822, "but, even assuming that all the young people admitted to the School are gifted with all the qualities that make a painter, is it not dangerous for them to study together for years, exposed to the same influences, copying the same models, and following the same route? How can we expect them to retain any kind of individuality?" Academic training did equip the more gifted students with great executive facility, but it also bred conformity and, by its reliance on well-tried routines, discouraged fresh experience and new ideas.

Although the Academy presented itself as the guardian of art's highest principles, it actually lacked any strong guiding philosophy. The moral fervor that had attended the rise of classicism and the passionate convictions that inspired the battles of the classicists and Romantics had faded away by midcentury and been replaced by a tepid impartiality—a vague commitment to antiquity, the Renaissance, and "nature" (present in the atelier in the form of plaster casts, prints after Raphael, and the posing model), and a tendency to borrow promiscuously from whatever sources happened to suit. Style, no longer a profession of belief, came to mean little more than a costume, to be changed at will. Against this decline into a flabby eclecticism, only Ingres and a few other relics of an outworn idealism raised a futile protest.

It is not surprising that the spirit of the Academy should have repelled some students, and caused them to discontinue their training. Despite the inducements held out to them, few of the most gifted young artists of the century completed the whole course: among the painters of the first rank, only Ingres won the Rome Prize (1801). Géricault and Millet failed in the contest, Delacroix and Corot never competed, Courbet was self-taught, and so, in essence, were Degas, Manet, and the Impressionists, though they all began their studies under private instruction by academic teachers. While their more docile peers shone in academic contests, disaffected students turned to the old masters in the Louvre, especially those disapproved of by the Ecole. Others broke even more radically with academic usage by leaving the studio for the fields and forests in search of actual nature. Though it meant that they had to forego the rewards and career advantages of an academic affiliation, more and more young artists chose to become their own teachers. Some used the facilities of such unofficial establishments as the Acadé-

mie Julian or the teacherless Académie Suisse, where models were available for a fee. A number of sympathetic teachers, aware of the shortcomings of the Ecole, offered instruction based on methods of their own that deviated from the official curriculum. Charles Gleyre (1806–1874), Thomas Couture (1815–1879), and Horace Lecoq de Boisbaudran (1802–1897) in their various ways sought to give greater scope to the development of individual talent, and perhaps because of this attracted some unusually gifted students. In 1863, responding to mounting criticism, the government attempted to reform the Ecole by removing it from the control of the Academy. It abolished the system of preparatory atelier study under academic masters, and placed all the teaching in the Ecole itself, appointing three regular professors for this purpose. But since the system of competitions remained unchanged and the three professors turned out to be arch academics, nothing very significant was accomplished.

In its own terms, the academic establishment was remarkably efficient in forming many hundreds of competent artists, in furthering their careers, and in creating the appearance of a flourishing artistic culture. That many of these artists and much of that culture later turned out to be of low quality does not entirely invalidate them. In their time they made Paris the center of world art, and not in appearance only, for they were a necessary part of the setting from which emerged the authentic great artists of the time. And it can be argued that an important, though unintended, benefit of the Ecole des Beaux-Arts was that it acted as a filter, separating the mass of conforming artists from that much smaller band of independents. It seduced the weak with school triumphs and popular successes, and destroyed them in the end, while it identified, repelled, and strengthened the vigorous, by forcing them to struggle with reality and to find their own way.

The trials and ordeals academic training inflicted on students had the double purpose of developing their technical facility to a very high point and of making them pliable to external demands. Success depended on their ability to perform and to accommodate, as it would in their later careers when success— at the Salon and in the salesroom—depended on their ability to win a public. Unhampered by firm principles, the Academy realistically adjusted itself to its society and prepared its pupils to meet, and even to anticipate, the demands of an audience that consisted not of Golden Age Athenians or Renaissance Florentines, but of modern, middle-class shopkeepers, professionals, money men, and bureaucrats, many of them recently enriched and of no very profound literary and artistic education. The official occasions on which the artists met their public were the periodic Salons, vast exhibitions of recent work, screened by academic juries, at which hundreds of artists competed for notice and for sales.

THE PARIS SALONS AND THEIR JURIES

Held every two years until 1833, and annually thereafter (except for a brief return to the two-year system between 1852 and 1863), the Salons fulfilled an important function in a time when an art market was only beginning to come into being and

when dealer-sponsored exhibitions were still unknown. The character and size of the Salons changed greatly in the course of the nineteenth century. Under the old monarchy, they had been the exclusive showcase for work by members of the Academy. The Revolution opened them to all artists, the Empire turned them into triumphal displays, of truly Napoleonic scale, proclaiming the unity and energy of the French School under David's leadership. In the following decades, the Salons became the battlefield of the emerging movements of Romanticism, Naturalism, and Realism. By midcentury, they had grown so vast and various as to baffle the most attentive viewer. In the last years of the century, the Salons degenerated into showy bazaars of art, pretentious society entertainments, without definite character or style.

The Salon of 1785, at which David exhibited the *Horatii,* comprised some 324 works, including 197 paintings by 44 painters affiliated with the Academy, three of whom were women. The Revolution's opening of the Salons to all artists caused an immediate increase in the number of exhibited works. By 1795, the total had risen to 735, including 535 paintings by 178 painters, 21 of whom were women. The highly political Salons of the Empire surpassed all previous exhibitions: at the Decennial Salon of 1810, an occasion of special importance since it was intended as a grand review of the fruits of ten years of imperial art policy, 526 artists exhibited 1,124 works, including 872 paintings by 400 painters, 70 of whom were women. In the more liberal climate of the Restoration and the July Monarchy, the biennial and later yearly Salons grew at a still more rapid rate:

> *1827:* 1,820 works, including 1,365 paintings;
> *1846:* 2,412 works (out of a submission of about 5,000), 1,833 paintings;

and the pace accelerated further during the Second Empire:

> *1857:* 3,487 works, including 2,715 paintings;
> *1868:* 4,213 works, including 2,587 paintings;
> *1870:* 5,434 works, including 2,991 paintings.

After the Franco-Prussian War of 1870–71, these totals declined somewhat:

> *1874:* 3,657 works, including 1,852 paintings;

but soon rebounded:

> *1880:* 7,289 works, including 3,957 paintings.

In 1880, the government withdrew from the official management of the Salons, which were henceforth administered by an elective body of artists, the Société des Artistes Français, controlled by members of the Academy. From this group, a somewhat more liberal splinter detached itself, the Société Nationale des Beaux-Arts. Starting in 1890, each of these associations operated its own exhibition, so that Paris thereafter boasted two Salons:

> *1890* (Société des Artistes Français): 5,301 works, including 2,480 paintings;
> *1890* (Société Nationale des Beaux-Arts): 1,409 works, including 911 paintings.

Exhibitions of the work of living artists, under academic or private auspices, were also held in other European capitals, but none rivaled the Paris Salons in size, prestige, and publicity. The phenomenon of these enormous shows, following one another in rapid succession, has no parallel in the history of art. It reflects the terrifying, almost industrial productivity of the academic establishment, reacting to the stimuli of government support and mass demand. As the Salons grew in size, new quarters had to be found. The Salon carré of the Louvre had sufficed for the original Academy exhibitions, but during the Empire and Restoration the swelling flood of canvases began to invade the adjacent galleries, displacing parts of the museum's permanent collection and giving rise to complaints. After the Revolution of 1848, attempts were made to find larger quarters, at first in the temporarily vacant palace of the Tuileries (1849), later in improvised galleries in the nearby Palais Royal (1850 and 1852). In 1857, the exhibition was moved to the huge Palais de l'Industrie in the Champs-Elysées, left over from the World's Fair of 1855, an appropriate setting in which the Salons continued to be held until 1897.

Admission was charged on weekdays, but Sundays were free, and often brought as many as 50,000 visitors on a fine day. In 1876, 518,892 visitors were counted during the Salon's three-month run, a figure that gives a measure of its popularity. By comparison, the first exhibition of the painters later known as the Impressionists in 1874 drew an attendance of only 3,500. Though independent exhibitions, organized by dealers or by artists, gradually gained in importance during the latter part of the nineteenth century, the Salons remained throughout the most important and popular shows of contemporary art, and the most effective means for reaching a large public.

Getting their work exhibited was a career necessity for a rapidly increasing multitude of Academy-bred artists; exclusion from the Salon could mean obscurity and poverty. Salon juries found it more difficult from year to year to cope with the steadily rising numbers and the worsening quality of submissions. By midcentury, the selection process had become a farce. Jurors had to review their annual lot of some 5,000 to 6,000 canvases (and further hundreds of sculptures, drawings, prints, and architectural designs) literally at a trot, barely glancing at the entries lined up in endless rows, judging them roughly by type rather than quality, and only taking care not to reject, by mischance, the work of a colleague or favorite pupil.

Salon juries were an invention of the Revolution. Previously, when the exhibitions were still the exclusive prerogative of the Royal Academy, there had been no need for selection, since the work of academicians was accepted as a matter of privilege. When the Revolution opened the Salon to all artists, causing a dramatic increase in the number of submissions, the need for a screening mechanism became apparent. The early juries were composed of amateurs and public officials as well as artists, which had the beneficial effect of neutralizing the professional jealousies and vengeances of academic jurors. During the Empire, juries at any rate had little influence, since all important decisions rested with the director of the Museum. The Salon at that time had not yet become the arena

for the battles of conflicting movements: there was only one school, that of David, which was still regarded simply as the French School. Rejections by Salon juries were fairly rare and did not hinge on matters of faction or doctrine. In the years of the Restoration (1814–30), when the rising Romantic generation challenged the declining School of David, juries still used their power with remarkable impartiality. They understood, and no doubt deplored, the threat posed to the Academy system of such subversive works as Géricault's *Raft of the Medusa* (1819), Delacroix's *Massacre of Chios* (1824) and *Death of Sardanapalus* (1827), but did not prevent their exhibition. Though they included a rather prominent share of officially commissioned religious or monarchical work, the Salons of the Restoration still represented the full range of contemporary French art.

The Revolution of 1830 brought a change of system, ostensibly by way of liberal concession to the artists, but amounting in fact to a tightening of control by the Academy. The lay members were eliminated from the jury, which was henceforth staffed exclusively by senior academicians. The new order put power into the hands of conservative professionals, who saw it as their mission to resist modernist tendencies. The enormous increase in the annual submissions gave them an opportunity, indeed a mandate, to use their judgment in making sweeping cuts: in 1846, of a total of about 5,000 works submitted, they accepted 2,412 —less than half. It was from this time that jury decisions took on a partisan character and aimed at the systematic exclusion of certain artists or of entire artistic directions. The early victims of this party spirit were the painters of naturalist landscape, Théodore Rousseau foremost among them, whose consistent exclusions from the Salons of the 1840s scandalized independent observers.

Reducing the Salons to manageable size was clearly not the true objective of the juries: the exhibitions in fact continued to grow apace, obviously with their connivance. Nor were their rejections necessarily designed to safeguard quality. They fell mainly on young, serious, non-academic artists, whose fault was that they sought new solutions to artistic problems, of a kind that bored the public and annoyed the Academy. While the juries inflicted their severity on these outsiders, they showed themselves to be highly tolerant of patently mediocre work and of popular trifles, so long as they met the test of academically careful execution. Prompted by economic and political motives, the juries aimed neither at trimming nor at improving the Salon, but at reshaping it in a form more useful to themselves and their constituencies. Having created a glut of artists in its schools, the Academy was under pressure to provide them with an outlet for their work, a marketplace in which they could present themselves to purchasers. To bring a large enough clientele into this market, it was necessary to tolerate, or actually to cater to popular taste.

The overproduction of art for which the Academy was responsible could only be absorbed by the broad, moneyed middle class. The Salon became the emporium (some called it the house of prostitution) in which the official art establishment wooed the paying public with work specifically designed for the purpose—with "Salon art." The liberal monarchy of Louis Philippe (1830–48) provided the appropriate social climate and the necessary financial backing for

what amounted to a practical, mutual accommodation between a new audience looking for visual entertainment and a body of academic artists ready to make all the necessary compromises. Louis Philippe was himself a typical member of the new audience. Personally fond of art so long as it served some useful, educational, moral, or patriotic purpose, he valued it mainly for its content, its ability to convey "truth," and cared little for its aesthetic qualities.

Through his own and his government's purchases from the Salons, and through a program of public works on which many millions were spent during his reign, Louis Philippe supported scores of artists, including a few great ones (Ingres, Delacroix, and Corot), and many now forgotten. The Luxembourg Museum, dedicated to contemporary art, was enriched by his annual purchases, some based on the king's personal choice, from among the works of favorite Salon painters. The great showpiece of Louis Philippe's art policy, however, was the popular Gallery of Battles installed in the Palace of Versailles as a kind of permanent Salon of patriotic painting.

The huge, popular Salons of the era of Louis Philippe, like such other new mass media as boulevard theaters and serialized novels, were products of a commercialization of culture in which audience appeal came to be rated above artistic quality. Academic juries did little to defend art against its progressive vulgarization. Their verdicts rarely went against public opinion, and generally merely echoed the ridicule or indignation with which ignorant audiences greeted unfamiliar and difficult works. Serious artists of established reputation gradually abstained from exhibiting, not wanting to have their paintings lost among so many mediocrities. The Salons began to earn the bad reputation in which they were held, at first by disappointed artists, later by demanding critics, and finally by a growing part of the public itself.

The Revolution of 1848 temporarily abolished the admission jury, but this resilient body promptly resumed its position at the entrance to the Salon. Its conduct under the Second Empire (1852–70) was more flexible than it had been during the previous reign. Presided over by an intimate of the court of Napoleon III, the Comte de Nieuwerkerke, it sought to repair old injustices and to give itself the appearance of tolerant modernity. Rousseau, Millet, and the landscape painters were welcomed to the exhibitions and, once exposed to the public, soon became popular. Even Courbet, though truculently resistant to polite overtures, was treated with consideration, and only hesitantly refused admission on those occasions when he insisted on making a show of his contempt for the clergy and conventional morality. The younger generation fared less well. Manet, eager to be shown and not nearly so provocative as Courbet, was nevertheless treated more severely. In this, the jury members gave proof of a fine instinct: they understood, correctly, that Manet's breaches of aesthetic form posed a more fundamental threat to Salon art than Courbet's noisy blasphemies. But while their rejection of Manet included an element of appreciation, simple inattention and incomprehension caused them to refuse, among hundreds of others, such obscure and marginal young artists, so obviously out of tune with public taste, as Monet and his friends, or such crude primitives as Cézanne.

The increasing severity of the jury during the early 1860s gave rise to protest in 1863, when about half of the submissions were refused. In order to allow the public to judge for itself, the government of Napoleon III arranged the exhibition of some eight hundred rejected works—including paintings by Manet, Pissarro, Whistler, and Jongkind—in a gallery adjacent to the Salon. The experiment of the Salon des Refusés resulted in a resounding public endorsement of the jury. It nevertheless raised the possibility of free exhibitions, as alternatives to the monopoly of the official Salon, and thus contributed to a development that ultimately rendered the Salon obsolete.

Exhibitions had occasionally been held under private auspices, by individual artists, by artistic or charitable societies, or by dealers. David privately exhibited his *Sabine Women* in 1799, when the Salon was barred to him for political reasons. Horace Vernet, in 1822, showed his censored paintings in a "Salon" of his own. Ingres had a selection of his work exhibited at the Bazar Bonne-Nouvelle in 1846, in defiance of the Salon. On the occasion of the Exposition Universelle of 1855, Courbet—two of whose paintings had been rejected by the official Salon—gave himself a large one-man retrospective in a private pavilion, in direct competition with the official retrospectives given to Ingres and Delacroix as part of the regular exhibition. He repeated this costly venture at the time of the Paris World's Fair of 1867, and was imitated by Manet. In showing substantial selections of their work in specially constructed temporary galleries, both artists were seeking for better exposure than they could get at the crowded Salon.

By this time, commercial galleries were beginning to give sales exhibitions to their artist-clients. Louis Martinet, one of the earliest of the exhibiting dealers, in 1863 showed fourteen of Manet's most important paintings to date, at a time when Manet had difficulty in having any of his works accepted by the Salon. The showrooms of such dealers as Goupil, Beugniet, Durand-Ruel, and Tedesco in the final years of the Empire gave artists the opportunity of presenting their work more fully and under better conditions than at the Salon. It is not surprising that a growing number of artists, particularly those uncertain of being accepted by the Salon, or those who had come to detest the visual chaos of the Salon, considered private or dealer-sponsored exhibitions an attractive alternative. But for the large public and its favorite artists, the official Salons remained the most significant and prestigious events in the world of art—the only exhibitions that mattered.

The final three decades of the century, following the brief interlude of War and Commune, were the time of Salon art's final ripeness and prosperity. They were also the time in which a split occurred, then hardly noticeable, between the artists in the mainstream of modern art as it then seemed, the great stars of the Salon and their followers, and a marginal scattering of artists in their thirties or forties, who had tried their luck at the Salon, had largely failed, and now began to withdraw, leaving the Salon to "pure" Salon art. Manet continued to submit his work to the Salon until the end of his life, suffering rejections in 1874, 1876, and 1877. Degas and Pissarro ceased to submit after 1870, and so very nearly did Monet, who only exhibited once more, in 1880, when he was driven by desperate

need, and thereafter turned his back on the Salon. Renoir, on the other hand, despite his affiliation with the Impressionist group, frequently submitted work and from 1878 onward was regularly accepted, ceasing to exhibit at the Salon after 1883, except for one submission in 1890. Only Cézanne, the least acceptable of artists by Salon standards, stubbornly persisted in sending his paintings to the jury year after year, gathering fifteen rejections between 1863 and 1886, and being accepted only once, in 1882, on a vote of privilege by a juror friend. The series of independent exhibitions, held between 1874 and 1886 by the painters who came to be known as the Impressionists, was a counter-manifestation, easily overlooked at the time, but of deep significance in marking the parting of the ways between a minority of artists seriously engaged with problems of art, undistracted by popularity, and a thriving but futureless majority that had found its entire fulfillment in the irrelevancies of Salon success.

THE SALON PAINTERS

Salon painting constitutes a distinctive nineteenth-century type to which virtually all artists of note, avant-gardists as well as *"pompiers,"* made some contribution. Géricault's *Raft of the Medusa* (1819), Delacroix's *Death of Sardanapalus* (1827), Courbet's *Stone-Breakers* (1849–50), and Manet's *Déjeuner sur l'herbe* (1863) were Salon paintings: they owed their existence and something of their format and style to that institution, its conventions and circumstances. The Salon was a condition and an opportunity to which all artists had to submit if they wished their work to be seen. Some found the Salon format entirely congenial; their view of art was deeply conditioned by the Salon—these were the true Salon painters. Others held the Salon in more or less open contempt, and adjusted to it only just so much as was necessary to gain admission, sometimes with scarcely disguised cynicism—witness Courbet's sardonic bow to Salon clichés in *Woman with Parrot* (1866). As the quality of the exhibitions declined into bland populism in the latter part of the century, the honors of the Salon became more and more repugnant to serious artists, particularly as less compromising exhibition opportunities were becoming available. They began to shun the Salon, leaving it to its specialists and popular favorites. The final decades of the century saw the triumph of *pure* Salon painting, a spectacle of such showy brilliance that not a few of its enthusiasts mistook it for the dawn of a new Renaissance.

As a collective enterprise, involving hundreds of artists, Salon painting did not spring into existence overnight. It was the product of a gradual development that spanned several generations and encompassed several distinct phases. Nor did the Salon painters form one body; they were divided, rather, into distinct factions or tribes, whose lineage can be traced back through at least four generations. The genealogical chart (page 283) gives a schematic, very much simplified diagram of three main school traditions that, between them, accounted for a large proportion of Salon painting. Each, it will be noted, issues from one of the dominant neoclassical masters of the period around 1800, David, Regnault, and Vincent, and descends through an intermediate generation of influential teachers

—Gros, Ingres, and Drolling of the tribe of David, Guérin, Hersent, and Picot of those of Regnault and Vincent—into a first generation of Salon specialists, and beyond this, steadily branching out, into a second and third.

It was in the second of these generations that Salon painting attained its classic height with a veritable galaxy of painters, including Couture, Gérôme, Baudry, Breton, Bonnat, Meissonier, Cabanel, and Bouguereau, more lavishly rewarded with official prizes, honors, Grand Crosses, and First Medals than any other comparable age group of painters in the history of French art. Though all practiced the same kind of pictorial entertainment, they were not bound to any one style or artistic doctrine. Their work was entirely shaped by its function and by the circumstances of its exhibition: it had to please a large and diverse audience and attract attention amid the eye-dazzling competition of the hundreds of pictures that crowded the Salon. In its opportunistic variety and stylelessness, Salon painting resembled such other sub-artistic specialties of the time as the best-selling novel and the popular stage play.

Interesting subject matter and a strong plot were the keys to Salon success; beside them, purely painterly qualities mattered little. Salon celebrities vied with dramatists and novelists as storytellers. Paul Delaroche (1797–1856) perfected the technique of compressing history into stagy anecdotes, borrowing his material from popular literature, and exploited the then fashionable interest in English history in such trend-setting Salon pictures as *The Princes in the Tower* (1831), *Cromwell Contemplating the Corpse of Charles I* (1831), *The Execution of Lady Jane Grey* (1834), and *Strafford Led to Execution* (1837). In the variety and sensationalism of his subjects, Léon Gérôme (1824–1904), a pupil of Delaroche, surpassed all his rivals at the Salon—murder in the Roman Senate and carnage in the gladiatorial arena; luscious nudity at the slave auction or in the harem bath; Bonaparte contemplating the Sphinx, and Molière breakfasting with Louis XIV —all served equally well for his carefully plotted picture-plays, graced with sex, spiced with gore, and polished into waxwork lifelikeness by a technique that his admirers took for realism.

More limited in his range of subjects, Ernest Meissonier (1815–1891) treated anecdotal genres and historical vignettes with a dry minuteness of detail that owed much to seventeenth-century Holland, and perhaps even more to Daguerreotype photography. He, and scores of like-minded painters, worked for an educated and common-sensical middle-class audience that looked to art for education or emotional adventure, and in either case insisted on factual truth, or at least its appearance. Pictures were read like newspapers, by viewers who expected solid information from them, before venturing an opinion or feeling.

If the intimate, small-scale realism of Meissonier expressed a bourgeois taste, the grand style practiced by such painters as Cabanel, Baudry, and Bouguereau suited the pretensions of a new plutocracy and the somewhat nervous pomp-and-circumstance of shaky Imperial or Republican governments. Of large format and on grand themes, in keeping with the palatial architecture favored by the newly rich and newly powerful, their work was meant to evoke a continuity of tradition, linking the modern millionaire with authentic princes of the Renais-

Genealogy of the Salon Painters

sance, or, more plausibly, with the cultured financiers of the Pompadour era. Alexandre Cabanel (1824–1888), whose *Triumph of Flora* ceiling in the Louvre (1869) is a fair imitation of Tiepolo's cloud-borne apotheoses, made sensational appearances at the Salon with his *Nymph Ravished by a Satyr* (1861) and *Birth of Venus* (1863), troublingly sensuous nudes reminiscent of Boucher. Napoleon III, an amateur of this genre, bought both pictures, and the very critics who had condemned Manet's "immoral" *Déjeuner sur l'herbe* praised Cabanel's elegant contours and academic purity of style. Paul Baudry (1828–1886), an ardent admirer of Raphael, Correggio, and Titian, specialized in scenes from the loves of the gods. Mme de Païva, the Second Empire's most expensive courtesan, appropriately commissioned him to paint the ceiling of her salon, and Charles Garnier, the architect of the new Opera, chose him to decorate its grand foyer with a teeming multitude of splendid nudes personifying musical drama and its mythical origins.

Nothing could have been farther from the realities of nineteenth-century life, or from the actual interests of the general audience, than these endless parades of nymphs, goddesses, and graceful allegories. Nor was there much conviction in the Salon painters' attempts at classical ideality; grand scale and triumphant gestures could not conceal their intellectual and emotional poverty. Their true appeal, and secret justification, was the erotic pleasure they gave to an audience hemmed in by sexual taboos. The nudes that postured as Venuses or Nymphs, freely exhibiting charms ordinarily hidden, gave artistic sanction to voyeuristic curiosity, and thus fulfilled a hygienic function, as the peep show and aphrodisiac of the Salon. They also afforded artists opportunities for the display of academic refinements of sensuality—provocative poses, teasing half-conceal-ments, clever insincerities. For the actual purpose of these works could not be admitted: a pretense of ideality and stylistic elevation had to be maintained for morality's sake. Hypocrisy, often an element in Salon art, here became an impera-tive. Independent artists who, like Manet, violated the rule of dishonesty were punished for their presumption.

The supreme master of Salon eroticism was William Bouguereau (1824–1905), who brought to this specialty a very considerable painting talent and a gift for stylistic mimicry. His compositional arrangements, and even the poses and facial types of his figures, echoed a wide range of traditional models, encompass-ing Raphael, Boucher, and Flaxman among others, but his nudes preserved a disconcertingly modern air, reflecting all too vividly the actual studio models that had posed for them—mid-nineteenth-century Parisiennes with the characteristic features and mannerisms of their kind. Bouguereau's style is a thin veneer beneath which conflicting intentions keep a precarious balance: academic life study, imita-tion of past art, and a personal flair for sentimental showmanship. The famous *Birth of Venus* (1879) exemplifies his grandest manner. It is a living picture, posed by studio nudes impersonating Raphael's *Triumph of Galatea*. The sea-borne divinities, strikingly realistic in every detail of their nacreous bodies, seem frozen into artistic attitudes, displaying their sexuality absent-mindedly, as if wrapped in dreams. Their penetrating smiles and rapturously upturned eyes remind us of

Bouguereau's much admired gift for sentimental pantomime, which he put to good account in what amounted to his second specialty, the painting of Virgins, affectionate mothers, and big-eyed waifs.

The Salon painters' eagerness to serve all segments of their by no means uniform audience prompted them to develop a great variety of subject-matter specialties, each destined for a particular public. The Islamic Orient provided a whole school of painters with perennially popular motifs. The aftermath of the Franco-Prussian War produced a vogue for patriotic military subjects. There were specialists in animal scenes, society portraiture, and humorous genres. There were some who dwelt on scenes from modern life, generally in a sensational or sentimental vein. Descriptions of the life of the rural poor, which Millet had brought into fashion, inspired a host of imitators, foremost among them Jules Breton (1827–1906), who improved on Millet's austere manner by introducing charm and sentiment into their pictures.

It is futile to weigh the works of these skillful specialists on the same scales as those of artists who were entirely absorbed in painting problems. What divided Gérôme and Bouguereau from Manet and the Impressionists was a disagreement about the fundamental aims of art. While painters such as Cézanne, at heavy cost to themselves, struggled with their medium, the Salon painters profitably studied their public. Their talent and training enabled them to address this public in a manner that was immediately comprehensible to it, and deeply attuned to its current tastes and sentiments. To them, their craft of painting was an instrument, secondary to their ability to build effective plots and to capture the interests and affect the feelings of a volatile audience. Expert technicians, they knew that they must not bore laymen with the technicalities of painting. Their execution was careful and unobtrusive, largely invisible to Salon visitors, who were encouraged to look into their paintings as through a pane of clear glass, untroubled by the complicated artifice that had been contrived for them. In short, they fell victim to a belief that, as artists, they must rise above mere painting to higher things, and be poets, dramatists, philosophers. It was a delusion that ruined them as painters, but that assisted their short-lived success.

The execution of the best Salon painters, often described by admirers as flawless, is also generally rather flavorless. Energy is not a quality to be looked for in their work, but minuteness of finish and a dry expertness of handling were the expected, and appreciated, mark of their mastery: smoothness was the morality of their art, to paraphrase Ingres. There is little development of style and technique in Salon painting, compared to the striking changes in avant-garde work between 1860 and 1900. Only the subtlest nuances of execution distinguish a Bouguereau of 1865 from one of 1895. Salon artists differed in manner as they differed in subject matter, but the differences between them are of little interest; it is not rewarding to compare the painting surfaces of a Gérôme with those of a Cabanel in detail, for while there are differences in paint structure, both seem equally dead. It was perhaps in the nature of academic training that its most accomplished graduates should have looked on themselves as being finished painters. Their work, at any rate, tended to remain static, in marked contrast to

the continuous search and self-renewal that characterized the careers of Cézanne or Monet. It is true that some Salon painters, in the last decades of the century, gave spice to their work by small, planned audacities—a bit of slapdash here, a little burst of temperament there. It even became fashionable among the last generation of Salon painters to toy with danger by introducing a touch of Manet into their academic recipes or by indulging in a toned-down Impressionism.

What experiment there was in Salon painting pertained almost entirely to the treatment of subject matter. In this point, comparison between Salon and avant-garde work reveals the limited range of the latter. While Salon painting touched on every conceivable human concern, though generally with painful insincerity, the painters of optical phenomena, and particularly the Impressionists, dealt only with relatively few areas of human experience, and found some entirely intractable.

READINGS

Though attempts to rehabilitate the fallen idols of the Salon have been in full swing for nearly two decades, they have thus far failed to produce any coherent historical analysis of Salon art, let alone a convincing reassessment. The sheer fun of kitsch and camp has inspired some fairly lightweight publications. A number of the main *pompiers,* Gérôme, Bouguereau, and Couture (but for some reason not Meissonier), have received adulatory treatment from scholars who would rank them among the great masters of the nineteenth century, for reasons which they do not clearly articulate. Formerly derided by progressive critics as arch-bourgeois, the phenomenon of Salon painting is now being taken up sympathetically by critics of Marxist tendencies, as well as by anti-modernists or anti-elitists reacting against what has come to be described as the "myth" of the avant-garde. Future histories of modern art will have to consider the role of the Salon in nineteenth-century art and culture, of which it was an important manifestation, but the proper key to an understanding of that role has yet to be found.

General

L. Rosenthal, *Du Romantisme au Réalisme, 1830–48,* Paris, 1914. Still the best history of the beginnings of late-nineteenth-century art. Not available in translation.

J. Sloan, *French Painting Between the Past and Present, 1848–70,* Princeton, 1951.

L. Nochlin, *Realism,* Harmondsworth, Middlx., 1978.

The Second Empire: Art in France Under Napoleon III, exhibition catalogue, Philadelphia Museum of Art, 1978.

Le Musée du Luxembourg en 1874, exhibition catalogue, edited by G. Lacambre and J. Rohan-Chabot, Paris, Musées Nationaux, 1974.

Equivoques: Peinture française du XIX siècle, exhibition catalogue, edited by O. Lépine, Paris, Musée des Arts Décoratifs, 1973.

G. P. Weisberg, *The Realist Tradition; French Painting and Drawing, 1830–1900,* exhibition catalogue, Cleveland Museum of Art, 1980.

Academy, Salon, and Pompier Painting

J. Lethève, *Daily Life of French Artists in the Nineteenth Century,* New York, 1968.

A. Boime, *The Academy and French Painting in the Nineteenth Century,* Oxford, 1971.

J. Harding, *Artistes Pompiers: French Academic Art in the 19th Century,* London, n.d. (1979).

A. Celebonovich, *Some Call It Kitsch: Masterpieces of Bourgeois Realism,* New York, n.d.

Individual Studies

A. Boime, *Thomas Couture and the Eclectic Vision,* New Haven, 1980.

R. Isaacson, *William Bouguereau,* exhibition catalogue, New York Cultural Center, 1974.

William Bouguereau, 1825–1905, exhibition catalogue, Montreal Museum of Fine Arts, 1984.

G. M. Ackermann, *The Life and Work of Jean Léon Gérôme,* New York and London, 1986.

11
Edouard Manet, 1832–1883

Edouard Manet, 1832–1883

The mind and work of Manet contain a seeming contradiction. He considered himself and was recognized as a Realist and Modernist. Zola wrote of him in 1880: "His key position in the transitional period through which our French School is now passing will some day be recognized. He will stand out as its most acute, most interesting, most original figure." And Manet himself declared that his aim was to be a Realist—*"être de son temps et faire ce qu'on voit"* was his motto. Yet few artists of any period have been so dependent on tradition, so much influenced by the example of the masters of the past, so much given to borrowing, copying, and adapting. Of no other progressive artists of the latter half of the nineteenth century can it be said that a large part of his work was inspired by suggestions from past art, rather than by personal invention or direct experience. Manet's modernity, his sense of contemporary reality took visible form against a background of tradition. In nearly all his work, the present trails echoes of the past.

Edouard Manet was born into a Parisian family of the propertied upper middle class. His father was the chief of personnel in the Ministry of Justice, his mother the daughter of a diplomat. In utter contrast to the rural and provincial backgrounds of such other exponents of realism as Courbet and Millet, Manet's roots were in the urban, cosmopolitan, cultured upper layer of French society.

He began his formal schooling in 1842 at the private Collège Rollin, where he was an undistinguished student, except in his drawing classes. Here he met Antonin Proust, who was to be his life-long friend, his protector, and biographer. He was encouraged by an uncle who was an amateur painter to visit the museums, and developed a lively, precocious interest in the arts.

On completing his secondary education in 1848, Manet disconcerted his parents by declaring his wish to become an artist. His father wanted him to study law. By way of compromise and delay, the boy was persuaded to apply for admission to the Naval Academy, but failed the entrance examination. In 1849, he was sent on a cruise to Brazil aboard a training ship. On his return, he was again refused admission to the Naval Academy. His father now consented to let him study art.

At eighteen, Manet became the pupil of Thomas Couture (1815–1879), an artist still young, anti-academic, and assertively individualistic, who was widely

regarded as one of the strongest talents in the French vanguard. Couture's huge *Romans of the Decadence* had been the sensation of the Salon of 1847. Though he eventually became highly critical of him, Manet remained Couture's pupil for six years and profited in many technical and stylistic ways from his example. The young artist's early development was rapid in one respect, extremely gradual in another. He very soon developed great technical facility, but was hesitant to use his precocious mastery for the expression of his own ideas. As he emancipated himself from Couture, he turned to the paintings of the masters at the Louvre as his models and—like Géricault and Delacroix before him—tried to learn their secrets by copying. His self-administered training was practical and craftsman-like. It bypassed the theoretical academic curriculum and directly attacked difficult painting problems under the guidance of favorite old masters, thus developing his executive ability before awakening his powers of original invention.

Manet's choice of models and his interpretation of them give the earliest hint of his personal bent. His preference went to the Dutch (Hals), Spanish (Velásquez), and Venetian masters (Giorgione and Titian). Among his extant copies are:

Tintoretto's Self-Portrait (1854, Dijon Museum),
Delacroix's Bark of Dante (1854, Lyon Museum),
Velásquez's Little Cavaliers (ca. 1855, Oslo, Tryggve Sagan Collection),
Titian's Venus of Urbino (1856, Paris, private collection).

In 1852, a son was born to Suzanne Leenhoff, a music teacher with whom Manet (now aged twenty) had entered into a discreet liaison. He was at that time a young man of elegant appearance and graceful manners, gregarious, fastidious in his choice of company, in touch with modern ideas and tastes, though not at all a self-conscious intellectual and even less an alienated Bohemian. True to his class and family traditions, he held moderate republican and anti-clerical beliefs.

During 1853, he traveled in Holland and Germany, and later in Italy, visiting museums; in 1857, he visited Italy again. In the meantime he had set up a studio, together with a friend, the animal painter Comte Albert de Balleroy. Without neglecting his more mundane social life, Manet extended his circle of acquaintances, among artists and writers. In 1855, he paid a respectful visit to Delacroix; in 1857, he met the painter Fantin-Latour, and not long after, he befriended the poet Baudelaire, who was to be the defender and in some instances the inspirer of his early work.

Manet's first, ambitious try at a Salon entry, *The Absinthe Drinker* (1858–59, Copenhagen, Ny Carlsberg Glyptotek), is unconventional in its subject, the somber figure of a Bohemian derelict leaning against a light-struck wall, part of the wreckage of urban society (the model was an eccentric alcoholic, Collardet). A study in the pathos and "heroism" of modern life of which Baudelaire had recently written, the picture may have been suggested by a particular poem, "Le vin des chiffonniers (The Rag-Picker's Wine)" in Baudelaire's *Fleurs du mal* (published in 1857), though Manet himself later claimed that he had merely "painted a Parisian character with technical simplicity." But the picture's general

effect is neither simple nor Parisian. Its image paraphrases a type made famous by Velásquez, that of his "philosophers," realistic, if rather grandly staged portraits of beggars and vagrants, ironically labeled with the names of classical authors and philosophers. The execution, with its abrupt contrasts of light and shade, still owes a debt to Couture—who detested the picture, not so much for its technique as for the squalor of its subject. Manet submitted it to the Salon of 1859, but it was refused by the jury.

As if hesitant to risk outright originality, Manet in his early work consistently expressed himself through the medium of borrowed, traditional imagery to which he managed to give a personal and modern note. Counting on his viewers' recognition of his sources (generally familiar works by seventeenth-century masters, such as Velásquez, Murillo, and Rubens), he put the emphasis not on his subjects so much as on his witty and slightly parodistic transformation of them. The technical brilliance of his execution enabled him to carry off this dangerous game which, besides bringing old originals to startling, slightly scandalous new life, was perhaps intended to point up by contrast the sterile traditionalism of ordinary Salon painting.

With a touch of irreverence, Manet based some of his adaptations not on the originals but on indifferent reproductions published in popular histories of art, such as Charles Blanc's *Histoire des peintres.* The *Boy with Cherries* (ca. 1859, Oeiras, Gulbenkian Foundation) and *Boy with Dog* (ca. 1860, Paris, private collection) are imitations of a Spanish picture type—street urchins feasting or at play—made famous by Murillo. Manet had them posed by studio models. The youth who sat for the *Boy with Cherries* is supposed to have been a studio assistant, Alexandre, who some time later in a fit of despair hanged himself in Manet's studio (an episode around which Baudelaire composed a prose-poem in *Le spleen de Paris*). *Fishing at Saint-Ouen* (ca. 1860–61, New York, Metropolitan Museum) comprises a medley of borrowed motifs from landscapes by Annibale Carracci and Rubens, serving as a setting for two figures in seventeenth-century costume: Manet and Suzanne Leenhoff, in the guise of Rubens and his wife, Hélène Fourment (taken from a reproduction of a painting by Rubens in Vienna). This art-historical fantasy suggests that Manet identified himself with the artists he imitated. (A parallel instance of self-projection into the life of an admired artist of the past is Manet's small picture *Velásquez in the Studio,* ca. 1860, in a Parisian private collection.)

For the Salon of 1861 (none was held in 1860), Manet planned an ambitious history painting, the *Finding of Moses,* hoping to succeed with a safe, biblical subject where he had failed with his *Absinthe Drinker* in 1859. But he abandoned this project in mid-course, developing only the main figure of his original composition, the nude daughter of Pharaoh crouching at the edge of a stream, and converting it into *A Nymph Surprised by a Satyr* (1860–61, Buenos Aires, National Museum). In this form, the canvas was exhibited in St. Petersburg in 1861. The large nude, modeled on a *Bathing Suzanna* by Rubens, was posed by Manet's companion, Suzanne Leenhoff. In the process of developing this large, sharply front-lit nude within a sketchily indicated forest setting, he gradually simplified

and flattened its forms until he achieved an effect that strikingly foretells that of the young woman in the *Déjeuner sur l'herbe* of 1863. The head of the leering Satyr was later painted out.

To Manet's great satisfaction, the jury of the Salon of 1861 accepted both of the pictures that he submitted in place of the *Finding of Moses.* The first, *Portrait of the Artist's Parents* (1860, Louvre, Musée d'Orsay), startled Salon critics by its dour unsentimentality. The dark figures of husband and wife seem psychologically unrelated, the seated father staring somberly ahead, the mother standing behind him with eyes downcast. A blue ribbon and a sewing basket filled with brightly colored skeins of wool—a splendid still-life—illuminate this otherwise joyless portrait. The heads are firmly modeled in sharply defined areas of tone, in a style still reminiscent of Couture.

The Spanish Singer (1860, New York, Metropolitan Museum) by contrast enjoyed a critical success at the Salon and was awarded an honorable mention. The picture is a very solid, life-size study of a posing studio model, dressed up in odds and ends of Spanish costumes and playing a right-handed guitar with his left hand. The sharp, cool colors, the extremely vigorous handling, the radical flattening of broad areas (as in the black jacket), and the suppression of half-tones indicate the growing influence of Velásquez. Manet confessed that he had "thought of the masters of Madrid, and of Hals, too" while painting *The Spanish Singer.*

Critics and young fellow artists took note of the appearance of a distinctive new talent. The vigor and freshness of his painting, a certain tartness in its savor made him stand out from the Salon's humdrum. Manet found himself looked on as the leader of a young avant-garde—"Manet's gang." The widespread craze for all things Spanish, stimulated by Napoleon III's marriage to a Spanish noblewoman, Eugénie de Montijo, which only briefly touched the early work of Courbet and Millet, had a deeper, longer-lasting effect on Manet. The years of 1861–64, a time of experimentation and lively productivity, marked the height of Manet's Hispanicism. Under the spell of Goya's etchings after Velásquez, he made etchings after his own compositions, deepening his understanding of the work of both Spaniards in the process. The arrival of a troupe of Spanish dancers in 1862 and their performances at the Hippodrome provided him with subject matter for paintings in which he was able to express both his delight in authentic Spanish costumes and his fascination with the stage.

The sketchlike, fluently brushed *Spanish Ballet* (1862, Washington, Phillips Collection) shows the company of Mariano Camprubi, spotlit on stage. It recalls the traditional type of stage tableau known as *Parade,* of which Watteau's *Italian Comedy* (1720, Washington, National Gallery) is a famous example. *Lola de Valence* (1862, Louvre, Musée d'Orsay) represents the star of Camprubi's company of dancers. The swarthy, somewhat masculine beauty poses in a brightly flowered bolero skirt, which provoked a contemporary critic to describe the picture as "a medley of red, blue, and yellow—a caricature of color." The background, originally neutral, was later (probably in 1867) transformed by Manet into a view of the stage seen from behind the scenery. Baudelaire provided his

friend's painting with an equivocal quatrain, celebrating Lola as the possessor of "Le charme inattendu d'un bijou rose et noir."

Several of Manet's paintings of this time are in the nature of costume pieces, portrait-like figure studies in which the picturesque Spanish accessories, rather than the physiognomy or action of the model, set the tone and provide the semblance of a theme. *Young Woman in Spanish Costume Reclining on a Couch* (1862, New Haven, Yale University Gallery) shows a plump young woman—believed to be the mistress of Manet's friend the caricaturist and photographer Nadar—lounging on a red sofa in a tight-fitting masculine Spanish costume. In pose and general effect, the picture seems designed to recall Goya's *Maja vestida* (ca. 1802, Madrid, Prado).

Mlle Victorine in the Costume of an Espada (1862, New York, Metropolitan Museum) was posed by a professional artist's model, Victorine Meurent, who contributed her face and body to several of Manet's paintings between 1862 and 1875. Stylistically his most daring and individual work to date, this is yet another picturesquely "Spanish" studio arrangement, calculated for the aesthetic and erotic appeal of a pretty young woman dressed in male costume. Her figure, composed of flattened, sharply contrasted areas of black and white accented by touches of gold, lilac, and salmon red, is set without any effort at spatial illusion against the background of a bullfight scene, sketchily copied after Goya.

The technical and stylistic influence of Velásquez however remained dominant in Manet's work of the 1860s. His choice of subjects, his figural arrangements, the character of model study or of portrait that clings to all his larger paintings, his handling of tone and color, all recall the Spanish master. Inspired by a casual experience, a street encounter with an itinerant café singer, *The Street Singer* (1862, Boston, Museum of Fine Arts) was posed by Victorine Meurent in the studio. The singer, eating cherries from a paper bag and holding her guitar, is shown stepping suddenly through the shuttered doors of a café. The speed of her motion causes her crinoline to swing around her legs, a bell of delicately toned, gray-beige cloth. Though it is ostensibly a scene from life, like the *Absinthe Drinker,* this is in fact a set-piece, calculated for the Salon, and in its monumentality and the impressive staging of its subject reflects Manet's acquaintance with Velásquez's full-length portraits.

The Old Musician (1862, Washington, National Gallery) is Manet's earliest attempt at a large, many-figured composition. It presents ragged children and two men grouped around a seated, elderly man with patriarchal beard who holds a violin. The figures form a disconnected frieze, posing separately and motionless, unrelated by gesture or glance. Several of them are quotations from other works of art: the girl at the left comes from a scene of gypsy life by an obscure contemporary; the boy wearing a straw hat, in the center, is adapted from Watteau's *Gilles;* the Musician himself is copied in part from the statuette of a Greek philosopher; and the top-hatted man at the right is a repetition of Manet's own *Absinthe Drinker.* The group as a whole echoes peasant scenes by the seventeenth-century French painters Louis and Antoine LeNain and, most importantly, the famous *Drinkers* by Velásquez.

The meaning of this medley of borrowings is obscure. Antonin Proust believed that Manet had simply posed beggars from a nearby slum in a casual pastiche of Velásquez. More recently, it has been suggested that its unifying theme is the plight of the uprooted slum population of quarters lately demolished in the course of Napoleon III's rebuilding of Paris, and that the Old Musician (for whose face a gypsy organ grinder posed) more particularly symbolizes the Artist dispossessed by modern society. But for a work of social realism on the theme of urban misery, the cheerful rural setting with its distant hills seems strangely inappropriate, and the composition as a whole, resonant with echoes of past art, unfocused in its message and mood. It is, rather, by its painterly qualities, its fine accord of silvery hues and graduated tonalities, that the picture achieves both visual unity and emotional force.

Manet's early work (1859–62) was dependent on the traditional world of art, on theater, museum, and studio, and reflected ordinary reality only at second hand. Its inspiration came from the work of the masters rather than from common life, and its originality consisted not so much in the discovery of new subjects as in the refashioning of old ones. His exasperated replies to critics, and Zola's defensive explanations of his work, created an impression—long prevalent—of an artist totally absorbed in painting problems, and indifferent to subject matter except as a pretext for picture making. Recent interpretations, on the contrary, have emphasized the references to contemporary reality and to social issues in his work, and have searched his borrowings from the old masters for allusions to modern situations. Rather than as a "pure painter," Manet now tends to be seen as a Realist who shared many of the attitudes of such socially aware artists as Daumier, Courbet, and Millet.

The actual truth lies somewhere between these opposing views, though probably somewhat closer to the first than to the second. Manet was, above all, a painter, not a pamphleteer. His artistic conscience outweighed other concerns, which is not to say that he was indifferent to social or political questions. But he did not believe that it was the function of painting to serve as a vehicle for ideas from other spheres, and he rejected narrative or didactic subjects as a matter of principle. The morality of art lay not in its message but in its form, not in the choice of a subject but in its handling. Thus the actual content of his work is not to be read in its apparent subject matter—often a mere borrowing—but can be discovered in its personal tone, in the music of its forms and colors.

The earliest of Manet's purely modern paintings, *Concert in the Tuileries* (1862, London, National Gallery), records his social and intellectual world in a way that invites comparison with Courbet's autobiographical allegory, *The Studio* of 1855. The setting is an afternoon concert in the gardens of the Tuileries, the residence of Napoleon III. The fashionable crowd—top-hatted men, crinolined women, and a few dressed-up children playing on the graveled walks—forms a bright, sun-dappled mosaic beneath the green foliage. Among the many recognizable portraits are those of Manet himself (at the far left), the Comte de Balleroy, the sculptor and writer Astruc, the composer Offenbach, the poet Baudelaire, the critic Champfleury, and the painter Fantin-Latour. The lumi-

nous, animated scene effortlessly combines precise visual observation with a high degree of social insight. The tradition that underlies it reaches back to the pictures of elegant sociability in public places by such eighteenth-century artists as Saint-Aubin and Debucourt.

The year 1863 was a turning point in Manet's life. In February, fourteen of his most important paintings to date were given public exhibition in the Galérie Martinet, exposing nearly all of his early work to critical inspection. Later in the year, he submitted three paintings to the Salon jury (including *Mlle Victorine in the Costume of an Espada* and *Déjeuner sur l'herbe*), only to have them all rejected. In May, simultaneously with the opening of the regular Salon, the government of Napoleon III sponsored an exhibition of the rejected paintings (Salon des Refusés) in an adjacent gallery, since the rejection of 2,783 entries out of a total submission of about 5,000 had caused criticism of the jury's severity. Manet's *Déjeuner* (under its original title *The Bath*) was one of the most controversial pictures in this special exhibition. In October that same year, he married his companion of many years, Suzanne Leenhoff.

The idea for *Le Déjeuner sur l'herbe (The Picnic)* (1863, Louvre, Musée d'Orsay) may have grown out of Manet's earlier, abortive project, the *Finding of Moses,* which had centered on the nude figure of Pharaoh's daughter, later transformed into his *Nymph Surprised,* the evident precursor of the *Déjeuner.* The subject of this picture—a sylvan picnic enjoyed by a pair of well-dressed men and two young women, one of them entirely nude—was suggested by one of the Louvre's most famous paintings, the *Pastoral Concert* (1508–10), then believed to be by Giorgione. Its composition is closely copied from yet another source, Marcantonio Raimondi's engraving of Raphael's lost *Judgment of Paris,* and it is probable that Courbet's *Bathers* (1853) and *Young Ladies on the Banks of the Seine* (1857) were also in Manet's mind when he grappled with the problem of giving his scene an effect of outdoor light. Victorine Meurent sat for the nude; her male companions were posed by Manet's brother, and by his brother-in-law, Leenhoff.

The intense row raised over the *Déjeuner* by Salon reviewers has probably been taken more seriously by art historians than it deserves. The indignation of public and critics was mainly directed against the picture's "immorality," its introduction of nudity into a scene from common life. Artistic nudity was entirely acceptable—there were several remarkably nude nudes among the most admired paintings of the Salon of 1863, including Cabanel's *Birth of Venus* and Baudry's *The Pearl and the Wave.* But when such nudity descended from the remotely aesthetic to the practical, social sphere, from Olympus to everyday sex, its presentation in art or literature became offensive. Manet, who understood the taboos of his society, cannot have been unaware of this; he must have had an inkling of what would be the consequence of his modernization of a subject that was tolerable in historical art, but repugnant to conventional morality when encountered in life. The fact that he almost immediately repeated his offense with the *Olympia* suggests that he did so quite deliberately.

The *Déjeuner*'s stylistic daring, its sharp, shadowless silhouetting of the

nude, the flatness of its figures, the crispness of its color contrasts and what—to eyes accustomed to the brownish tonalities of Salon paintings—seemed the stridency, coldness, or "sourness" of its prominent areas of blue or green hue, all scandalized the critics nearly as much as its supposed indecency.

Not many months after the *Déjeuner,* Manet completed *Olympia* (1863, Louvre, Musée d'Orsay), but cautiously he withheld the picture for two years, submitting it to the Salon only in 1865, under its newly devised title, an allusion to a name commonly used by fashionable prostitutes and to a poem written for the picture by his friend Astruc ("When tired of her dreams, Olympia awakens . . . "). Again, there was vehement protest and condemnation at the exhibition, for reasons both moral and artistic.

Manet had borrowed his image from a hallowed Renaissance tradition: that of Venus reclining in splendid nudity in a landscape (Giorgione) or on a couch (Titian, Velásquez), and understood to be the likeness, in mythological disguise, of some quite earthly courtesan. More recently, Boucher, Goya (*Nude Maja,* ca. 1802), and Ingres (*Grande Odalisque,* 1814) had continued this tradition. Manet daringly brought it up to date by giving his goddess—posed by Victorine Meurent—the character of a modern Parisian prostitute, coolly triumphant in the lap of luxury.

Nude except for a thin black ribbon around her neck, a bracelet, and satin slippers, his *Olympia* was meant to recall Titian's *Venus of Urbino* (1536). But her alert posture, her challenging gaze, the defiant gesture of the hand firmly clasped over her sex, and the prosy modernity of her taut, short, practical body made this association seem blasphemous. Manet clearly took pleasure in teasing philistine sensibility and hypocrisy: *Olympia* is an impudent picture, both in subject and in execution, and its impudence accounts in part for its vitality, its verve of handling, and hence its style. Recent interpretations have stressed the picture's treatment of the theme of prostitution as its main point, but it is clearly something other than, and more than, a social document. Manet, as Zola pointed out in his defense of him, was too serious an artist to lose himself in subject matter. He used the opportunity his subject offered him for painterly exploration, a deeply meditated arrangement of color harmonies and contrasts, setting the light cream of the nude against the white and pink satin of the couch, and against the dark brown skin of the attendant who offers the bouquet.

Manet's pictorial treatment produced deeper outrage than his reference to prostitution, for breaches of style and taste in matters of art are less easily forgiven than moral offenses. Olympia's body is bathed in a cool, clear light and sharply edged by the narrow shadows that lie along its contours. The internal modeling is so subtle and faint as to make it appear as a flat shape—"like a figure in a deck of cards," according to contemporary wits, or like a figure from a Japanese woodcut, according to more recent opinion. It is possible that the sharp, flat patterns of Japanese colored woodcuts, then about to come into fashion, encouraged Manet to radicalize a manner that had already appeared in his earlier work and that may have originated in the practice of his teacher, Couture, who had taught him to model form with sharp juxtapositions of patches of light and shadow.

Surprisingly, in view of the setbacks and scandals of the preceding year, the Salon jury of 1864 accepted Manet's two submissions, a monumental *Dead Christ with Angels* (New York, Metropolitan Museum), his second attempt at a traditional religious subject and perhaps intended to mollify his critics (who nevertheless attacked it vehemently), and yet another Spanish fantasy, an *Episode of a Bullfight* (1864), which today survives in two separate fragments, the *Bull Ring* (New York, Frick Collection) and the *Dead Bullfighter* (Washington, National Gallery). The picture originally consisted of the very solidly painted, life-size study of the prone figure of the bullfighter, with a rather improvisationally sketched and small-scale background of the bull ring, showing a raging bull and matadors. Manet had copied his main figure from the painting of a dead warrior *(Orlando muerto),* which at the time was attributed to Velásquez and on view in a Parisian collection. In providing it with a setting, he mismanaged the perspective (as he had done in the similarly conceived *Mlle Victorine in the Costume of an Espada*): the huge foreground figure seemed ridiculously out of scale with the tiny bull in the distance, a fact gleefully seized upon by the critics, one of whom described it as a "wooden toreador killed by a rat." Realizing the incoherence of his composition, Manet applied his scissors and cut it in two.

At about this time, Manet attempted to free himself from the limitations of studio-based figure composition by experimenting with panoramic outdoor scenes taken from modern life, a direction he had first tried in his *Concert in the Tuileries* of 1862. The shift not only involved a widening of his visual scope into landscape-like, atmospheric spaces in which figures dwindled into distant, indistinct forms, it also brought a quality of spontaneity and brevity into his handling that foreshadows Impressionism. The *Horse Race in the Bois de Boulogne* (1864), the original canvas of which was cut up by Manet in 1865, survives as a composition mainly in a finished watercolor (Cambridge, Mass., Fogg Art Museum). The view is sharply divided into two parts: at the right, the racetrack forms a deep corridor of space along which the horses approach in a headlong dash, while at the left spectators watch from behind a railing that extends in endless perspective into the far distance. The originality of this composition, with its contradictory directional pulls, its atmospheric fusion of figures and setting, and its daring suggestion of speed, amounts to a striking departure from the waxworks stillness of Manet's normal, studio-posed compositions. He returned to his subject again in 1867 (Chicago, Art Institute) and around 1871 (Washington, National Gallery).

The *Battle of the Kearsarge and the Alabama off Cherbourg* (1864, Philadelphia Museum of Art) was based on accounts of a recent naval engagement between a Union warhip and a Confederate raider, fought in sight of the French coast (but not witnessed by Manet). The picture—a historical seascape —shows the cannonading ships high on the horizon above a wide expanse of agitated blue water. Its execution in broad, somewhat muted areas of color has some affinities with Courbet's roughly contemporaneous land- and seascapes.

At the Salon of 1865, Manet was represented by his *Olympia* and by his last try at a religious subject, *Jesus Mocked by the Soldiers* (1865, Chicago, Art Institute). A flood of critical abuse immediately descended on both pictures, on

the "horrible" *Jesus* no less than on the "gamy" *Olympia*. It is probably true that the very viciousness of the clamor helped to make him famous. But Manet, more tender-nerved than Courbet, did not relish this kind of fame and for once came near despair, despite Baudelaire's words of consolation. To lift his spirits and to remove himself from further persecution, he decided to visit Spain in the late summer. Here at last he saw in reality what he had so often painted from the imagination. To his friends in Paris he sent letters filled with admiration of the works by Velásquez and Goya that he found at the Prado.

Refreshed and uplifted by new optimism, despite a touch of cholera in the fall of 1866, Manet set to work again armed with the inspiriting memory of Spanish art and life. *The Fifer* (1866, Louvre, Musée d'Orsay), which he unsuccessfully submitted to the Salon of 1866, went beyond his earlier works in its audacious suppression of bodily relief and background space. In its general design and painterly handling, it reflects his recent impressions of Velásquez; the red-trousered figure is curiously reminiscent of Goya (*Don Manuel Osorio,* 1788), and in the bright patterning there is evidence of Manet's continuing interest in the Japanese woodcut. Critics were to refer to the Fifer contemptuously as "knave of diamonds," but a young journalist, Emile Zola, came to the defense of this and other paintings by Manet in the pages of *L'Evénement,* and was sacked for his presumption.

Outlawed by the establishment as a fomenter of scandal, Manet was nevertheless beginning to have a following among progressive artists and literary men, whose gathering place in the mid-1860s was the Café Guerbois, near the Place Clichy. They formed a clique, more decorous, but in other ways comparable to that which had earlier gathered around Courbet at the Brasserie Andler. The position that Courbet had held at the head of the avant-garde of the 1850s gradually was taken by Manet in the 1860s. Among the devotees of the Café Guerbois were Fantin-Latour, Whistler, Degas, Monet, Bazille, Renoir, the photographer Nadar, the critics Duranty and Armand Silvestre, and the poet and sculptor Astruc.

In the *Portrait of Zacharie Astruc* (1866, Bremen, Kunsthalle), the sitter, placed to the right of center against a dark background, is flanked by a mirror which reflects a view of the room before him that includes Mme Astruc in back view—a reminiscence of the background of Titian's *Venus of Urbino.* The picture, which did not please its subject and remained in Manet's possession, is sketchlike in part, and evidently unfinished.

Woman with a Parrot (1866, New York, Metropolitan Museum) was first shown in Manet's private exhibition in 1867 and subsequently admitted to the Salon of 1868, where it drew the usual savage reviews. A painting without subject matter—though it has been unconvincingly suggested that the young woman in the rose peignoir who holds a bouquet of violets to her face may symbolize the sense of smell—this sumptuous human still-life (posed by Victorine Meurent) offered little for the critics' bile and was therefore dismissed tartly as "ugly" and "badly painted." It is, in fact, one of the most accomplished and sophisticated of Manet's paintings, and it is quite natural that the aristocratic distinction of its

bearing should have remained invisible to the reviewers and art rabble of the period.

Zola, undaunted, wrote a long article praising and explaining Manet's work for *La Revue du XIX siècle,* which was republished, later in the year, in the form of a book, the first on Manet.

Learning that he was not among the artists who were to be invited to exhibit at the World's Fair of 1867, Manet decided—like Courbet—to mount his own exhibition. His private pavilion, located near the entrance to the Fair, contained fifty paintings, the product of eight years of work, including nearly all his major paintings up to that time. The critical and public response was one of amused hostility. As Paris celebrated the World's Fair, the news was received that the emperor Maximilian, the puppet monarch whom Napoleon had installed in Mexico while the United States was distracted by civil war and whom he had later conveniently abandoned, had been shot by insurgents on June 19. Fascinated by newspaper accounts of the event, Manet decided to treat it in a large history painting, a genre by that time considered obsolete.

Four canvases mark the successive stages of *The Execution of Maximilian* (1867): (1) A large (ca. 6½ × 8½ ft., or 1.9 × 2.6 m.) unfinished sketch in the Boston Museum of Fine Arts, Manet's most immediate and emotional statement of the subject, in which the roughly defined figures wear Mexican costume. The moment Manet chose to represent, clearly inspired by Goya's *Execution of Hostages* (ca. 1814), was that at which the execution squad discharges its rifles at Maximilian and his two companions. (2) A second, equally large but more highly finished canvas that was later cut up into the three fragments now in the London National Gallery. The soldiers in this version are more correctly dressed in uniforms of the French type. The execution takes place in an open landscape. (3) A third, small sketch, in the Copenhagen Ny Carlsberg Glyptotek, in which the execution is set in a courtyard in front of a wall. (4) The final canvas, the largest in the series (ca. 8½ × 10 ft., or 2.6 × 3.1 m.), now at the Mannheim Kunsthalle, which was intended for exhibition but not shown in France during the Empire, owing to the political delicacy of the subject.

In developing his composition, Manet faced the difficulty of giving monumental and permanent form to a dramatic but visually shapeless and unbeautiful event from the pages of the daily press. Like Géricault, who had faced a similar difficulty in developing the *Raft of the Medusa,* he collected factual documents to establish the truth of his subject; like Géricault, he leaned on tradition—on Goya's example—to give it artistic form. His essentially undramatic, coolly objective temperament led him to view the execution with increasing detachment, as a pure sight, in which animation seems suspended and all feeling stilled.

The jury of the Salon of 1868 accepted the *Woman with a Parrot,* and the *Portrait of Emile Zola* (1867–68, Louvre, Musée d'Orsay), which Manet had painted as a gesture of gratitude to his defender. The rather stiffly patterned, planar arrangement of the figure and its setting attest to Manet's abiding interest in Japanese art, as do some of the objects in the picture: the folding screen, and the Kuniaki print, stuck into the wall rack, together with a photograph of

Olympia and an engraving of Velásquez's *Drinkers*—reminders of common causes and past battles.

About this time began Manet's friendship with a young painter of great beauty and intelligence, Berthe Morisot (1841–1895), a former pupil of Fantin-Latour and an acquaintance of Monet and the other young painters who were to be known as the Impressionists. Though Manet had already met Monet in 1865 (because of the similarity of their names, absent-minded reviewers had sometimes confused them, to Manet's intense annoyance), it was through Morisot that he was introduced to the intimacy of this group, which was to have an important influence on his later work.

During his annual seaside vacation in Boulogne, Manet conceived the idea for his *Luncheon in the Studio* (1868, Munich, Neue Pinakothek), which is in part a posed portrait, in part a monumental domestic genre, distantly reminiscent in its pregnant stillness of Courbet's *After Dinner at Ornans* (1849). The composition is centered on the adolescent figure of Léon Koëlla, Suzanne's (and probably Manet's) son, leaning nonchalantly against a table with the—superbly painted—remains of an oyster lunch. In the background, at the left, is a servant girl bringing coffee in a silver pot; at the right, the dark figure of a bearded man, smoking a cigar. An arrangement of studio props, a helmet and exotic swords, fills the lower foreground, animated by a small cat grooming itself—the only moving thing in the picture. There are for once no quotations from past art, nor is there a hint of any human interest that might connect these separate figures. The picture is a visual feast, a still-life of superbly well-painted delicacies and luxurious stuffs among which human beings seem merely to exist in a state of thoughtful, perhaps melancholy, satiety. It was accepted for the Salon of 1869, as was *The Balcony* (1868–69, Louvre, Musée d'Orsay), the idea for which had also occurred to Manet during his stay in Boulogne. Posed by Berthe Morisot and a pianist friend, Fanny Claus, backed by the massive figure of the painter Antoine Guillemet and by Léon Koëlla half-hidden in the shadows behind them, the picture is a last bow in the direction of Spain and of Goya, whose *Majas on a Balcony* (ca. 1808–10) it clearly echoes—Manet was familiar with the composition through a recently published print.

Berthe Morisot, who was to marry Manet's brother Eugène in 1874, posed for several portraits at this time, among them the full-length *Repose: Portrait of Berthe Morisot* (1870, Providence, Rhode Island School of Design), and the fine, bust-length portrait of circa 1869, now in the Cleveland Museum.

At the outbreak of the Franco-Prussian War, Manet sent his family to the Pyrenees and enlisted in the army, as an artillerist, later as a lieutenant in the General Staff. In February of 1871, after the fall of Paris, he left the city and stayed for a while in Bordeaux, returning shortly before the final collapse of the Commune in May. He may have witnessed scenes of street fighting and of executions, though his various compositions *The Barricade* seem merely to be adaptations of his *Execution of Maximilian.*

In 1872, the dealer Durand-Ruel bought twenty-four paintings from Manet, who had heretofore hardly sold any of his works. On this occasion, Manet

put prices on several important canvases that Durand-Ruel had not bought: *Olympia,* 20,000 francs; *Déjeuner sur l'herbe,* 25,000 francs; *Concert in the Tuileries,* 6,000 francs; and *Execution of Maximilian* (presumably the final version, now in Mannheim), 25,000 francs. During the summer, Manet traveled in Holland, where he was much impressed by the paintings of Frans Hals. A reflection of these impressions is to be found in *Le Bon Bock* (1873, Philadelphia Museum of Art), the portrait of a lithographer friend, seated with pipe and beer in the brownish dusk of a café. Its careful execution, restrained colors, and rather conventional geniality won him a considerable, unaccustomed success at the Salon of 1873. In the autumn of that year, Manet met the poet Mallarmé, who in time would replace Baudelaire and even Zola in Manet's intimate circle, and whose portrait he painted in 1876. He also won an important new patron in the person of the singer Faure, who in 1873 bought five paintings from him.

The years 1873–74 were the period of Manet's closest personal and artistic involvement with the painters, only slightly younger than he, who were soon to become known as the Impressionists. He had first met Monet and Degas in the mid-1860s, and shortly after become acquainted with Sisley, Renoir, Bazille, and Cézanne. As the central figure in their gatherings at the Café Guerbois, he was generally considered to be the head of the young school. The war scattered this group, but it gradually re-formed, in 1871, at the Café de la Nouvelle Athènes in the Place Pigalle. Manet was still regarded as its leader, but when the younger members began, in 1873, to make plans for independent group shows, he declined to participate and continued to send his pictures to the official Salons. For he felt that he was about to receive the recognition that had eluded him for so many years, and believed, reasonably, that the Salons would give him larger and more influential audiences than the private exhibitions of obscure dissidents. Thus he put a distance between himself and the activities of the Impressionists, while remaining on cordial terms with them.

But, always inclined to experiment, Manet was willing to learn from his younger colleagues. His painting underwent a noticeable change in this period. Already in 1868–69 he had begun to try painting out of doors, covering small canvases such as *The Departure of the Folkestone Boat* (1869, Philadelphia Museum of Art) and *Croquet Players* (1873, Frankfurt, Staedelsches Kunstinstitut) with swift hatchings, in scattered, distinct strokes of the brush, whereas formerly he had applied his colors in larger, smoothly brushed areas.

Subject matter of the kind favored by the Impressionists, scenes of sport, of country pleasures and casual entertainments, now began to play a larger role in Manet's work. He improvised more freely, and painted rather fewer of the large exhibition pieces, those calculated, dazzling performances with which he had wooed the uncomprehending public year after year. Direct visual study rather than composition, the stimulus of fleeting experience rather than the appeal of past art occupied him increasingly. But not exclusively. Manet never gave himself wholeheartedly to Impressionism; the human figure never lost its dominance in his work, arrangement was never entirely superseded by nature study. His *Masked Ball at the Opera* (1873, Washington, National Gallery) is a scene of

fashionable nocturnal amusement, painted in the short, nervous brush strokes of his Impressionist manner. It recalls the press of top-hatted men and brightly dressed women of the *Concert in the Tuileries* and is, like that earlier picture, a collective portrait of Manet's society, in a sense an extended self-portrait.

The *Railroad* (1873, Washington, National Gallery) combines the carefully posed portrait study of Victorine Meurent, who here makes her last appearance in Manet's work, with the rather more lightly and sketchily defined figure of a girl in white dress, who stands looking through iron grilles down to the tracks where a lingering cloud of steam indicates the recent passing of a train. The picture illustrates a moment of transition in Manet's work. Its foreground figures still belong to his earlier, studio-bound phase. The vision of the railroad beyond the grille (an approach to the Gare Saint-Lazare where Monet was to paint his locomotives in 1877) is a vivid piece of Impressionist painting, strikingly convincing in its suggestion of drifting, light-filled smoke.

Manet spent the summer of 1874 at his country house in Gennevilliers, across the Seine from Argenteuil, where Monet had taken lodgings. The two painters, sometimes joined by Renoir, often worked together along the river. Manet's rapid sketches of summer life at Argenteuil, some of them evidently intended as preparations for a major composition, bear witness to his younger colleagues' influence on him. There can be no doubt that Monet's (and to a lesser degree Renoir's) example at this time, as seen in *The Monet Family in the Garden* (1874, New York, Metropolitan Museum) and *Monet in His Painting Boat* (1874, Munich, Neue Pinakothek), strongly affected Manet's practice.

Spurred on by the joy of discovery, and by his flair for stylistic assimilation, he rapidly absorbed as much of Impressionism as was useful for his own purposes. A new intensity of light—unmistakably that of the open sky rather than the studio —now brightened his canvases. The forms in them are defined by a lively play of color and light, without the intervention of contours or dark shadows: Manet was never to return to the dusky studio atmospheres of his earlier paintings. This increase in luminosity was accompanied by a loosening of the brushwork; the colors, applied in rapid, separate touches, form agitated surfaces. Spontaneous handling, vivid color and light combine in an effect of striking immediacy—of life directly captured. Yet this brief immersion in Impressionist plein-air painting did not fundamentally change Manet's outlook. He used Impressionism "artistically," as a borrowed effect, much as he had earlier used Spanish motifs or paraphrases of Velásquez.

The sequel of his improvisational studies at Argenteuil was two large, formally composed figure arrangements which clearly derived from a type Manet had already developed in his *Luncheon in the Studio* of 1868 and in *The Railroad* of 1873, and to which he was to return frequently in his later work. It is a type to which the old-fashioned term "conversation piece" fairly applies: figures presented in very close view, generally paired, in meditative companionship, inactive and with only the slightest hint of inward life, as if resting after a meal or pausing in intimate talk.

Argenteuil (1874, Tournai Museum) presents a man and a woman posing

in light summer clothes, seated side by side in very close frontal view, impassive, except for the slight emotional bond implied by the man's gesture and turn of head. A grid of vertical and horizontal elements, echoed in the contrasted striping of the man's and the woman's costumes, holds the figures in a carefully balanced design. Despite its artificial construction, the picture has been described as the most "Impressionist" of Manet's larger works; but its Impressionism is mainly in its brilliant surface, in the nearly shadowless sun-brightness of its colors, particularly in the patch of very blue water (much criticized at the time) and the shimmering view of Argenteuil on the far shore, as well as in the choppy brushwork by which Manet enlivened the stillness of his composition. The picture was shown at the Salon of 1875, to the usual accompaniment of critical abuse.

Boating (1874, New York, Metropolitan Museum), painted at about the same time, strikingly differs from *Argenteuil* in arrangement and handling. Its pair of figures—the woman half-reclining, the man seated somewhat above her in an alert posture—is asymmetrically crowded toward the left but balanced by the dark, curving shape of the boat that contains them and carries them toward the right. A horizonless expanse of blue, reflecting water forms the background. The few large shapes that comprise the spacious design are clearly and rather un-Impressionistically defined by firm contours and crisp color contrasts. The paint is applied in smooth, blended strokes, quite unlike the broken brushwork of *Argenteuil*. Despite its daring composition and very light color key, the picture has the look of a particularly careful performance, designed for exhibition. Manet nevertheless waited until 1879 before submitting it to the Salon, where it was roundly panned by the reviewers.

In the spring of 1875, Manet drew a series of lithographic illustrations for his friend Stéphane Mallarmé's translation of Edgar Allan Poe's poem *The Raven*. The small *Portrait of Mallarmé* (1876, Paris, Musée d'Orsay) which he painted a few months later presents, in the extreme casualness of its pose, its lightness of tone and roughness of finish, a curious, quasi-Impressionist counterpart and contrast to his earlier, formal *Portrait of Zola* (1868). In the autumn, Manet traveled to Venice in the company of the painter of modish genres, Degas's friend James Tissot (1836–1902). Here he painted several views of the Grand Canal, luminous sketches, of Impressionist spontaneity, and nearly his last farewell to Impressionist plein-air painting.

The extraordinary hostility of the art establishment toward Manet continued throughout the later 1870s. At age forty-five, he was both famous and persecuted, excluded from the official honors and critical favors that, unfortunately, meant much to him. With dogged optimism, he tried again and again to win acceptance, and was constantly rebuffed. The treatment which this artist of impeccable good manners received from the arbiters of public taste was, oddly, much harsher than that given to the rude Courbet. In 1876, all his Salon submissions were rejected; in 1877, one of his two submissions was rejected, the other savaged by the reviewers. In 1878, temporarily discouraged, he submitted nothing. In 1879, the jury finally relented and accepted his two submissions, as it did again the following year. In 1881, Manet at last won a medal of the second class

—a distinction often awarded to younger and less remarkable artist—which guaranteed the acceptance of his future Salon submissions.

Signs of change appeared in Manet's work of the later 1870s, following his withdrawal from outright Impressionism: a new interest in social observation, hints of narrative content, and an increasing psychological subtlety. His preferred format continued to be that of the portrait-like "conversation piece," but his settings now specified the reality of Parisian popular or fashionable life in boudoir, café, or concert hall. It is probable that he was aware of Degas's recent preoccupation with similar subjects, and that the example of Degas now supplanted that of Monet. Traces of Degas's influence, at any rate, can be found in his compositional arrangements, more tense and complex than before, and in the occasional note of emotional drama in the gestures and expressions of his figures. While he had formerly found it convenient to use artist's models, dressed in picturesque costumes and posed in attitudes borrowed from tradition, he now gave up such studio artifices, preferring to paint men and women who actually belonged to the society whose normal existence he wished to describe and who, by their facial types and expressions, their bearing and dress, gave authenticity to his scenes from modern life.

Nana (1877, Hamburg, Kunsthalle) was suggested by one of Zola's novels. It is a scene of elegant prostitution, posed by an authentic member of the profession, the beautiful Henriette Hauser, mistress of the Prince of Orange (and therefore nicknamed "Citron"). She is standing at a mirror, powder puff and lipstick in hand, and throws a sweetly vacant glance at the viewer, while behind her, at the picture's extreme right, her top-hatted client waits on the sofa. In contrast to *Olympia* and her pagan nudity, with echoes of Titian and Venus, *Nana* is a study in fashionable modern underwear. The witty composition separates and at the same time links her and her visitor, from whose body, bisected by the picture's edge, the sofa seems to reach out with a golden arm to enfold Nana's corseted waist, a touch of understated drama—and humor.

Skating (1877, Cambridge, Mass., Fogg Art Museum) was posed by the same Henriette Hauser, in fur-trimmed sport costume, at the skating rink in the rue Blanche, a fashionable resort for social display and casual assignations. It is the portrait of a beauty-type then in its high vogue, in the appropriate setting of a modish amusement; in spirit and format, it anticipates Toulouse-Lautrec's cabaret scenes. The rapid, audaciously negligent brushwork merges figures and setting in an agitated color surface, nearly without indication of body and space, but instinct with energetic movement.

The cafés of Paris were centers of relaxed, extra-domestic sociability. Much of Manet's life was spent in the congenial atmosphere of favorite cafés that offered him stimulating company and acquaintance with women of a class not formally accepted in society. For artists interested in the picturesque variety of urban life, the café was an inexhaustible source of observations. Degas, with his flair for novel motifs, had discovered this somewhat earlier, and may have stimulated Manet's entry into this field. In *The Plum* (ca. 1878, Washington, National Gallery), Manet presents a solitary young woman at a marble-topped table who

has fallen into a revery over her uneaten brandied plum. The setting may be Manet's own preferred café, the Nouvelle-Athènes, which had already furnished the background of Degas's slightly earlier *Absinthe* (1876). The deeply bored, waiting woman, undoubtedly a common sight, tempted Manet to go beyond personal appearance and social type to the expression—rare in his work before this time—of an inward experience.

In several of his paintings of 1878–79 he represented *café-concerts,* musical or theatrical entertainments in beerhalls, which enabled him to cast his figures in the role of absorbed spectators, a state that suited his penchant for inactive poses. The relatively small canvas *Café-Concert* (1878, Baltimore, Walters Collection) presents two such passively attentive figures in front view, evidently watching a performance, though a stage with singer appears, oddly, behind them.

In a larger composition, Manet planned to arrange two groups of spectators facing one another across a table, with a stage visible between them in the distance. But before he had completed this canvas, he cut it into two parts, probably the last time he performed such a bisection, and made two separate pictures of it, the left half becoming the painting known as *At the Café* (1878, Winterthur, Reinhart Collection), and the right half as *Corner in a Café-Concert* (1878, London, National Gallery). Of this second fragment, he later painted a variant replica, *Girl Serving Beer* (1879, Louvre, Musée d'Orsay), showing the principal figure, a waitress with beer glasses, in closer view.

Besides these large exhibition pictures, Manet painted a number of smaller improvisational subjects, among them several views into the street behind his studio, light-filled and vividly Impressionist sketches, one of which, *Rue Mosnier with Flags* (1878, Upperville, Va., Paul Mellon Collection), records the flutter of *tricolores* on the national holiday for the World's Fair of 1878. In both oil and pastel—a medium to which he became strongly attracted in his last years—he executed several intimately erotic subjects, among them the famous portrait-like model study known as *The Blonde with Bare Breasts* (ca. 1878, Louvre, Musée d'Orsay), and the pastels *Woman Adjusting Her Garter* (1878, Copenhagen, Ordrupsgaard Museum), and *Woman in the Tub* (ca. 1879, Louvre, Musée d'Orsay), the latter posed by Méry Laurent, a fashionable beauty who was the friend of Merimée and the consolation of Manet's last years.

Toward the end of 1878, Manet felt the first symptoms of the illness that would lead to his early death, a form of progressive paralysis that affected his legs and gradually made it difficult for him to walk or stand. The attacks of pain and spells of lassitude interfered with his painting and caused him to give more of his time to small-scale work in the physically less strenuous media of pastel and watercolor. But his productivity and the quality of his painting, astonishingly, suffered no decline; the late, large oils are among his most subtle and profound works.

In the Conservatory (1879, Berlin, Staatliche Museen) continues the series of Manet's conversation pieces. It was exhibited at the Salon of 1879, together with *Boating,* of which—with its suggestion of an indoor "landscape"—it can be considered as a kind of pendant. Against a background of lush greenhouse

vegetation, a young woman sits stiffly erect on a wide bench, half-turned toward a bearded man who stands beside her, leaning over the bench's back. Both are elegantly and rather formally dressed (the picture was posed by M. and Mme Jules Guillemet, owners of a fashion shop). They seem caught in a moment of silent reflection, their attitudes hinting at a situation of some tension and complexity. The separateness and reserve implied by their postures is furtively denied by the unconscious convergence of their hands in the picture's center. Everything here suggests ambiguity or conflict: between nature and fashion, formality and feeling, isolation and intimacy. The composition's stable geometric structure, in which the horizontals and verticals of the bench play an important part (reminiscent of Manet's *Balcony* of 1868), holds in emotional pressures. The execution is unusually controlled, and in parts rather dry.

Chez le Père Lathuille (1879, Tournai Museum), painted at about the same time as *In the Conservatory,* is more dynamically composed and more loosely brushed. In the strong light of a summer noon, a couple face one another over dessert in a restaurant garden. The primly upright figure of the young woman seated in profile on the right is enveloped by the wide, grasping reach of her heavy-featured male companion, whose urgency is manifest in the garish yellow of his coat. This intimate contest of aggression and resistance is being watched at a distance by a waiter who has discreetly stopped on the sunlit path among the flowers of the garden. It is the most explicitly narrative of Manet's compositions, and the one in which figure and setting, form and light are most convincingly brought together and made to serve a common expressive purpose.

Well connected with leading politicians and high officials of the Republic —among them Gambetta, Clemenceau, and his old friend Antonin Proust (who was appointed Minister of Fine Arts in 1881)—Manet had reason to believe that he might be considered for an official commission. The prospect of executing monumental paintings on modern subjects momentarily appealed to him. In July of 1879, he proposed to the Prefect of the Seine a series of murals for the newly restored city hall of Paris, in which he would represent the public and commercial life, the "stomach," as he put it, of the city: "its markets, railways, bridges, subterranean installations, race tracks, and public gardens." The proposal was not taken up.

During April 1880, Manet was given a one-man exhibition comprising twenty-five paintings in the tastefully decorated rooms of the journal *Vie moderne.* The press reviews were favorable on the whole. Meanwhile two of his paintings, *Chez le Père Lathuille* and a *Portrait of Antonin Proust,* drew mixed reviews at the Salon. His health grew worse during the year. Reluctantly following his doctor's advice, he moved to Bellevue on the western outskirts of Paris for the summer and early fall, to follow a regimen of hydrotherapy. Bored in the country, and homesick for his studio and his friends, he amused himself by painting garden scenes and still-lifes. These small paintings, often intended as gifts, are of the finest observation and most delicate painterly execution. Generally the portrait of a single fruit or vegetable—melon, lemon, peach, or pear— or studies of bundled asparagus, or of fruits gathered in small piles, they exemplify

Manet's sublimated realism, which stressed subtleties of shape and color rather than material substance, and in this way differed profoundly from the realism of Courbet.

For the Salon of 1881, Manet had prepared the painting the *Escape of Rochefort* (Zurich, Kunsthaus), a "historical" seascape somewhat in the manner of his earlier *Kearsarge and Alabama* (1864), but changed his mind and instead submitted a more conventional portrait of the former communard and highly controversial publicist (Hamburg, Kunsthalle), together with the large, semi-serious portrait *Pertuiset, the Lion Hunter* (São Paolo Museum). The Salon of 1881 was the first to benefit from a ministerial decree which provided for a jury freely elected by artists. This fairly liberal body used the opportunity to award Manet a second-class medal, thus repairing an old injustice and giving him the privilege of automatic admission to future Salons.

After an unsuccessful rest cure in Versailles during the summer and fall of 1881, Manet returned to Paris, where rumors about his illness had begun to circulate. He made a point of appearing in society and of showing himself, in radiant good humor, at his favorite cafés. The appointment of his friend Antonin Proust to the Ministry of Fine Arts finally brought him the long-wished-for decoration of the Legion of Honor. He accepted it with undisguised pleasure.

The last months of 1881 were a time of restless activity, during which he mainly devoted himself to portraits, producing, besides other works, no fewer than fourteen pastel portraits, nearly all of women of exceptional beauty. The erotic mainspring of Manet's art is evident, in his late work, in an obsessive preoccupation with female beauty and elegance. His painting, in which since 1868 he had tended to cast women in central and men in marginal roles, now became more openly a form of courtship. In his personal life, the need for the affection of women assumed a poignant urgency after the onset of his illness. For him, the chief source of pleasure and beauty in life, and hence in art, was the excitement of erotic attraction, not in its outright sexual form so much as in its social and aesthetic sublimations. In his portraits, he tried to express that quality in the beauty of certain women which held the secret of their attraction, a quality of appearance, so far as he was concerned, rather than of action, thought, or feeling —for which reason his work is sometimes said to lack "depth." His painter's eye, guided by affection, was always directed to the individual nuance, to the particular stimulant of his attraction; hence his dependence on the specific model, hence also the portrait character of his work, so different from the repetitive stereotypes of Renoir, the other great eroticist among French painters of the time.

From these essentially private works developed a more formal project, that of a series of four portraits of beautiful young women of the Parisian *demi-monde,* each to represent by her physiognomy and her costume one of the seasons of the year. Only two of these allegorical portraits were completed. *Jeanne (Spring)* (1881, New York, H. P. Bingham Collection) was posed by the actress Jeanne de Marsy in a dress and hat carefully chosen for her by Manet. The picture's breezy animation and the somewhat nervous brilliance of its colors and brush-work accord with the sitter's temperament and with her allegorical character of

Spring. *Autumn* (1881, Nancy Museum) is the portrait of Manet's intimate friend, Méry Laurent, then thirty-two years old, wearing a dark, fur-trimmed coat which contrasts, no doubt intentionally, with her very fair complexion and blond hair. The sky blue tapestry behind her, with its firework of embroidered blossoms, is like an emanation from the spirit of this woman, who was famous for her gaiety, generosity, and joy of life.

In the autumn of 1881, Manet began the last of his Salon compositions, *Bar at the Folies-Bergère* (1881–82, London, Courtauld Institute Galleries), the culmination of his café scenes of the 1870s, and at the same time a synthesis of his earlier, monumental figure style (e.g., *Luncheon in the Studio,* 1868) and his later, quasi-Impressionist figural arrangements with luminous, atmospheric backgrounds (*The Railroad,* 1873, and *Argenteuil,* 1874). The young barmaid stands, as if in a dream, between the table covered with bottles in front of her and a large mirror behind her, in which the hall with its chandeliers and distant crowd appears in blurred reflection, and in which the barmaid herself is seen again, in back view, turned toward a customer. She wears the uniform of her establishment, a dark blue, tight-fitting, low-cut jacket that compresses her body into a stylish hourglass shape. Supporting herself with both arms on the low table before her, she confronts the viewer in a posture of submissive invitation, but her eyes are averted in an expression of thoughtful sadness. An actual barmaid, Suzon, posed for the picture, and also for one of Manet's finest pastels (Dijon Museum). The spatial inaccuracies in the relationship between the main figure and the mirror image behind her have often been commented on. Manet, in arranging this ambiguous composition of corporeal forms and mere reflections, was evidently not troubled by its incoherence; he had used the device of the space-creating mirror once before, in his *Portrait of Zacharie Astruc* (1866).

At the Salon of 1882, *Spring* was a popular favorite, while *Bar at the Folies-Bergère,* with its "mirage," puzzled public and critics alike. During the early part of 1882, Manet continued to draw pastel portraits, including several of Méry Laurent and of her beautiful Viennese friend, Irma Brunner (Louvre). The state of his health steadily deteriorated. A summer stay at Rueil gave him the opportunity of painting several outdoor views of the garden and the sunlit facade of the rented villa, but he was now severely hampered by his paralytic illness, had difficulty in walking, and felt the physical effort of painting.

Back in Paris in the fall, Manet still mustered sufficient optimism to think of future projects and strength enough to paint his last portraits, still-lifes, and flower pieces of the bouquets sent to him by Méry Laurent. But in April of 1883 gangrene developed in his left leg. Its amputation was carried out on April 19. Eleven days later Manet died.

In January 1884, a memorial exhibition at the Ecole des Beaux-Arts, accompanied by a catalogue with a preface by Zola, paid a final tribute to the artist who was beginning to be recognized as one of the greatest of modern French painters.

* * *

During the 1860s Manet's work was at the forward edge of modernity, as Courbet's had been in the 1850s. In the 1870s, Degas and the Impressionists drew abreast of him, but his visibility caused the public and some critics to consider him, wrongly, as the leader of the moderninst "gang." He was one of the last great painters whose work derived from the tradition of the masters, as he was also one of the last to cling to the discredited system of the Salons. The very opposite of a conscious revolutionist, he was eager for recognition and grateful for honors, but the irresistible force of a great talent compelled him to go his own way. Highly impressionable and open to influence, he transformed, rather than imitated, his models. He reworked and revitalized the tradition of the masters in which he had educated himself. He cleansed realism of its bituminous shadows and lightened the weight of its materialism. He learned much from the Impressionists, but applied their lesson to a form of figure composition that was entirely his own. A great stylist rather than a naturalist, Manet helped to free painting from its bondage to subject matter, to rid it of the burden of literature, sentiment, and "poetry": he purified it and brought out its painterly essence. At the same time, he was never indifferent to human or material reality, nor was he at all inclined toward formal abstraction. The driving force in his art was a vigorous, but highly refined sensuality; his painting was the sublimation of intense physical experience.

READINGS

The catalogue by F. Cachin, C. S. Moffett, and M. Melot of the Manet exhibition, held in Paris (Grand Palais) and New York (Metropolitan Museum) in 1983 contains—in addition to a well-illustrated chronological presentation of a large part of the work with sensible commentary—an inclusive bibliography (p. 540). The accompanying texts, biographical tables, and translated letters, though breaking little new ground, make this the most useful general text for English-speaking readers.

Life

P. Courthion and P. Cailler, *Portrait of Manet by Himself and His Contemporaries,* London, 1960, offers a serviceable selection of the biographical sources (E. Zola, *Manet, étude biographique et critique,* Paris, 1867; A. Proust, *Edouard Manet, Souvenirs,* Paris, 1913; Th. Duret, *Histoire d'Edouard Manet et de son oeuvre,* Paris, 1926; E. Moreau-Nelaton, *Manet raconté par lui-même et par ses amis,* 2 vols., Paris, 1926). George Moore's *Confessions of a Young Man* and *Modern Painting,* available in various editions, contain eyewitness accounts of Manet's circle at the Café de la Nouvelle-Athènes.

For general biographical and pictorial accounts,

G. Jedlicka, *Manet,* Zurich, 1941, still one of the best general treatments of Manet's life and of his artistic personality and work, unfortunately is available only in the original German edition. See also:

Lane Faison, *Edouard Manet,* New York, 1954;

G. Bataille, *Manet,* New York, 1955;

H. Perruchot, *Manet,* London, 1962;

P. Courthion, *Manet,* New York, 1962; and

J. Richardson, *Edouard Manet,* London, 1967 (republished in 1982).

Work

D. Rouart and D. Wildenstein, *Edouard Manet, Catalogue raisonné,* 2 vols., Geneva, 1975, is the fully illustrated, up-to-date general catalogue of Manet's work, superseding the earlier publication by P. Jamot and G. Wildenstein (1932).

S. Orienti (preface by P. Pool), *The Complete Paintings of Manet,* New York, 1967, offers a very summary listing, with very small illustrations, but is inexpensive and available in a large edition. See also:

J. Rewald, *Manet Pastels,* Oxford, 1947;

A. de Leiris, *The Drawings of Manet,* Berkeley, 1969; and

J. C. Harris, *Edouard Manet, Graphic Works,* New York, 1970.

Special Studies

Since the 1950s, a large number of interpretive studies have been published. In reaction against the earlier literature, which had stressed the formal aspects of Manet's work, these recent studies trace his sources in iconographic traditions or attempt to unriddle the possible symbolical or social meanings in certain of his paintings. As a result, Manet's early work has received disproportionate attention, to the neglect of the equally (or possibly more) original and important later work.

N. G. Sandblad, *Manet, Three Studies in Artistic Conception,* Lund, 1954.

G. H. Hamilton, *Manet and His Critics,* New York, 1969.

A. C. Hanson, *Manet and the Modern Tradition,* New Haven and London, 1977.

B. Farwell, *Manet and the Nude,* New York, 1981.

T. Reff, *Manet, Olympia,* New York and London, 1976.

T. Reff, *Manet and Modern Paris,* exhibition catalogue, Washington, D. C., National Gallery, 1982.

T. J. Clark, *The Painting of Modern Life: Paris in the Art of Manet and His Followers,* New York, 1985.

12
Edgar Degas, 1834–1917

Edgar Degas, 1834–1917

Despite his close personal relationship with several of the Impressionist painters, and despite his participation in most of the Impressionist group exhibitions from 1874 onward, Degas was never himself an Impressionist in outlook, style, or technique. Of all the artists of his time who considered themselves to be Realists or Modernists, he was the one most deeply immersed in the study of modern life in all its aspects: no other artist comes close to him in the diversity and profundity of his inquiry into the different classes of urban society, their occupations, manners, and appearance. Yet he remained aloof from all ideological involvements, and jealously guarded his personal independence in matters political, social, and artistic. His art teaches no lesson; it expresses an intense curiosity about mankind, but remains objective and distant. For all its precision and seeming spontaneity of observation, it is not at all a mere imitation of life, but a deliberate, deeply calculated reconstruction. Its truth and energy—and its artistic morality—derive from an intellectual discipline of design that has its roots in the classical tradition, in the example of Ingres, above all, but that was intelligently attuned to a wide variety of suggestions from other sources, ranging from the Japanese colored woodcut to photography. A wide-awake mind and a great contempt for the facile, sentimental, popularly progressive or ingratiating—in other words, for all the favorite vulgarities of his period—shaped his conduct. Unlike Courbet, Degas cared very little for public attention; unlike Manet, he despised the Salon and its transient glories; unlike Millet, he was unwilling to share his emotions with an audience. It was lucky for him that throughout his life he rarely lacked money.

Edgar Degas was born in 1834 in Paris, to a comfortable and cultivated family. His father, Auguste, was the head of the French branch of the family bank, founded by his grandfather René-Hilaire de Gas, who had emigrated to Naples during the French Revolution. His mother, born Célestine Musson, was the daughter of a New Orleans cotton broker. The de Gas family maintained widely ramified connections among the financial and aristocratic elites of France, Italy, and the United States. After the early death of his mother, Edgar's father —a man more interested in music and the arts than in business—undertook his further education. Through his friendship with important collectors of art, he

gave the boy an early exposure to paintings, and unwittingly prepared him for his artistic vocation.

At the Lycée Louis-le-Grand, young Degas received a solid humanistic education and distinguished himself in Latin, history, and drawing. He formed friendships with the sons of wealthy, upper-middle-class families (Rouart, Valpinçon, Halévy), who were to be the mainstays of his social life in later years. Upon graduation, he was allowed to install a studio in the paternal apartment. At his father's wish, he briefly and listlessly enrolled in law school, then resolutely turned to the study of art. In 1853, he began to copy in the Print Room of the Bibliothèque Nationale and to take art lessons, first with the painter F. J. Barrias, then with Louis Lamothe, a former pupil of Ingres.

After a year, Degas felt ready to enter the official Ecole des Beaux-Arts, where he submitted, though not for long, to a conventional course of training, drawing after prints, plasters, and the posing model. The academic routines stimulated rather than bored him. While at the Ecole, he formed friendships with his fellow students Fantin-Latour and Léon Bonnat. Through an acquaintance of his father, the collector Valpinçon, he met the aged Ingres, who advised him: "Draw lines, young man, and still more lines, both from life and from memory!" Like all ambitious art students of the time, Degas supplemented his formal schooling with a program of self-education that took him to the Louvre for frequent copying sessions before the old masters. He thus created his own artistic ancestry, his private "school," showing a particular preference for the Italian Renaissance, and most of all for those painters who practiced a severely formal, classicizing or archaizing style. The Exposition Universelle of 1855, which prominently featured the work of Ingres and Delacroix, beside that of the fashionable French and English painters of the day, gave the young Degas an opportunity to sample the hectic variety of contemporary art. He found Ingres most congenial, admired certain aspects of Delacroix's work, and remained unimpressed by the showy virtuosity of the Salon painters.

Degas's earliest independent work was portraits, including a remarkable series of self-portraits in which he appears to probe his personal identity and at the same time to declare his artistic allegiance. *Self-Portrait* (1855, Louvre) shows him at age twenty-one, somewhat sullen and sad-eyed, very formally suited and cravated, holding a pencil in a pose consciously derived from Ingres's youthful *Self-Portrait* (1804, Chantilly, Musée Condé).

The years of 1856 to 1859 were largely spent in two lengthy study tours in Italy, during which Degas visited relatives in Naples and Florence and made stays at the French Academy in Rome, where he befriended the painters Gustave Moreau and Léon Bonnat. These years, which he later spoke of as "the most extraordinary" of his life, were a time of intense study, during which he completed his self-education, drawing in the galleries, making life studies at the Academy, and sketching the street life and landscapes of Italy. While staying in Naples in 1857, he painted a highly accomplished portrait of his grandfather, *René-Hilaire de Gas* (Louvre). A year later, on the occasion of a long visit with the family of his aunt, Baroness Bellelli, in Florence, he began his first large-scale

composition, *The Bellelli Family* (completed 1862, Louvre). The nearly life-size figures of the baroness, her two young daughters, and her husband—a Neapolitan politician of liberal bent, living in unhappy exile in Florence—are posed in a well-lit, quietly elegant interior. Their general disposition recalls Ingres's pencil portraits of family groups, but in the way Degas hints at their emotional relationships—by their glances, body turns, and junctions—he displays his own precocious mastery of expressive composition. The dark silhouette of the baroness (in mourning for her father, René-Hilaire de Gas) envelops the figure of one of her daughters, while the other detaches herself and leans toward the baron, who is seated opposite them, sunk into an armchair, his back to the viewer. The picture's design is at once formal and dramatic. What at first glance appears as merely visual description gradually reveals itself as a searching insight into the complex tensions within a divided family.

The many preparatory studies for this painting illustrate the calculating thoroughness of Degas's method. He left nothing to chance, but was careful to hide the artificiality of his approach. His skill in bringing together a multitude of intimate observations into an expressive, firmly structured, and yet seemingly "natural" design was an inheritance from the classical tradition, received through Ingres and strengthened by a selective study of the masters. His own sharp curiosity about human situations contributed the element of a personal and essentially modern realism that was to shape the content of his art.

On his return to Paris, Degas established himself in a studio in the rue Madame, and for the five years following devoted himself mainly to history painting based on traditional themes from the Bible, antiquity, and medieval history in an apparent effort to go beyond portraiture to the kind of work with which he might compete for recognition at the Salon. It is noteworthy that at this point he approached these subjects with less distaste than other progressive painters of his generation. His attempts at history painting were, at any rate, more respectful of their subject matter than Manet's much freer transformations and modernizations (e.g., *Finding of Moses* and *Déjeuner sur l'herbe*). The four main compositions that resulted from this effort show a remarkable variety of treatment and style, underlining their experimental character.

Jephtha's Daughter (begun ca. 1859, left unfinished in 1864, Northampton, Smith College Museum) deals with a rare Old Testament subject, the story of Jephtha, son of Gilead, who had vowed to sacrifice his daughter in the event of victory over the Ammonites. The large, turbulently Baroque composition owes an evident debt to Delacroix, but also recalls Ingres's *Martyrdom of St. Symphorien.*

Spartan Boys and Girls Exercising (Les Filles Spartiates) (ca. 1860, London, National Gallery) interprets a scene from classical antiquity in an unclassical manner. Its sharply drawn, awkward adolescent bodies bear no resemblance to any of the artistic clichés then current, but they are not simply "realistic," as has been claimed. Their attenuated forms and strained gestures are stylized in ways that expressed Degas's personal sensibility (and that were to reappear in his later studies of dancers). Within an ostensibly classical context their peculiarity jars,

and this shock was undoubtedly intended to vivify the subject. The wide, relief-like frieze composition distantly echoes David's *Battle Between Romans and Sabines* and contains—according to a note by Degas—reminiscences of a drawing by Pontormo. But, contrary to Salon usage and the practice of such fashionable modernizers of antiquity as Gérôme, it is non-narrative, unheroic, unsentimental, and devoid of historical pedantry. At the same time, it carries an erotic flavor, faint but not entirely sublimated, as is true of many of Degas's works.

Semiramis Building the City of Babylon (ca. 1861, Louvre), suggested by an opera performance in 1860, is an exercise in rarefied stylization, a blend of Flaxman and Raphael in a visionary city- and landscape setting. Unusually romantic for Degas, the composition has affinities with works by Puvis de Chavannes and Gustave Moreau. Of the many drawings Degas made for this work, the Louvre alone preserves forty. *The Sufferings of the City of Orléans (Scene of War in the Middle Ages)* (1865, Louvre) by contrast is of extremely incoherent design and in its profusion of pseudo-medieval detail recalls the costume pieces that Degas's friend James Tissot was painting at the time. The ostensible subject—feudal lords wantonly killing peasants—may conceal a reference to recent historical events that had a special significance for Degas: the violence suffered by New Orleans, home of his maternal family, during its occupation by Union troops. It is an exquisite and rather morbid picture, in which the agonizing victims are shown, quite unhistorically, as nude, beautiful, and female. Painted on paper, the picture was exhibited as a "drawing" at the Salon of 1865. This first public appearance marked the end of Degas's occupation with history painting.

He had in the meantime made the acquaintance of Manet about 1862, and become a member of the circle of artists and critics that regularly met at the Café Guerbois. Whether it was Manet's example that persuaded Degas to abandon historical for modern subjects is not clear. Degas at that time had already begun, independently, to explore a particular modern genre, that of horse-racing scenes, and preceded Manet into this field. Sporting subjects had been introduced to France from England earlier in the century, and had been developed by such French Romantics as Géricault. Their attraction was popular and non-academic; they combined vital drama with high fashion, middle-class modernity with aristocratic style. To Degas, they offered an escape from stale tradition into a world of vivid, personal experience.

Start of the Horse-Race (1860–62, Cambridge, Mass., Fogg Art Museum) is said to represent Epsom in England, where, in 1821, Géricault had conceived the idea of his *Epsom Downs Derby* (Louvre). Degas was familiar with English sporting prints, knew the work of Géricault, and had witnessed races in Normandy and at Longchamp. *The Gentlemen's Race: Before the Start* (1862, reworked ca. 1880, Louvre) shows the silk-clad riders on their glistening horses in the setting of a suburban landscape, its horizon studded with smoking factory chimneys. The dense cluster of horses and riders moving toward the start seems entirely uncomposed and "natural," but in fact betrays, in every detail of gesture, attitude, and motion, Degas's deep familiarity with the characteristic aspects of

the scene. The striking authenticity of his picture is not the product of direct transcription, but of careful choice and arrangement.

For his second Salon entry, Degas daringly translated a racing subject into a monumental, quasi-historical composition, *The Injured Jockey (Steeple Chase Scene)* (1866, Upperville, Va., Mellon Collection), in which the horses, seen at very close range, streak across the picture above the body of the fallen jockey (posed by Degas's brother René). It is an uncomfortably cruel subject, and in this respect resembles several of his more traditional history paintings. Degas later began to rework the picture, but finally left it in an unfinished state.

The enlargement of Degas's social sphere during the 1860s particularly affected his portrait painting. His realist tendencies found their most natural outlet in a form of intimate portraiture that gave full scope to his gift for psychological observation. In his early years, he had restricted himself to self- and family portraits; now he extended his range to include friends or colleagues whose appearance interested him. But his portrait painting continued to be an entirely personal matter. He chose his sitters for reasons of his own, painted them for his own amusement, and felt free to interpret them as he pleased.

Manet Listening to His Wife Playing the Piano (1865, Tokyo, private collection) takes a penetrating look into a domestic situation. In a warmly lit interior, Manet is shown lounging on a sofa in an attitude of some discomfort, or perhaps boredom, facing the plump back of Suzanne Leenhoff, who is seated at the piano. Unhappy with the appearance of his wife in this picture, Manet cut the canvas across her figure, an act of vandalism that led to a quarrel with Degas. *Woman with Chrysanthemums (Mme Hertel)* (1865, New York, Metropolitan Museum) is centered on a splendid floral still-life and allows only a marginal position to the young woman who sits in deep thought to one side, looking away and shielding the lower part of her face with her hand, as if to guard the privacy of her feelings. The exuberant physical presence of the flowers is like an emanation from the mind of the elusive sitter. It is possible that Degas knew Courbet's *The Trellis* (1863), which somewhat similarly combines flower still-life and portrait, but is quite different in conception. Painted in diluted oils on paper (like *Sufferings of Orléans* of 1865), *Woman with Chrysanthemums* has something of the effect of a drawing in colors, anticipating Degas's later pastels.

This portrait initiates a series of deceptively casual portraits of women in domestic settings, many of them acquaintances met in the circle around Manet. They are, for the most part, dramatizations rather than mere representations, arranged in such a way as to give the effect of private situations in which their subject is caught, unaware, by the painter's eye:

> *Mlle Dubourg* (1866, Toledo Museum) presents the sitter—the future wife of Degas's friend the painter Fantin-Latour—somewhat uncharacteristically in a responsive, conversational pose.
> *Mme Gaujelin* (1867, Boston, Isabella Stewart Gardner Museum). Degas's Salon entry in 1869.
> *Mme Gobillard-Morisot* (1869, New York, Metropolitan Museum), the portrait of Berthe Morisot's sister, whose attractive plainness fascinated Degas and inspired

him to portray her in a highly stylized, light, evanescent manner, using blond
dilutions of oil that have the transparency of watercolor.

Mme Camus (Mme Camus en Rouge) (1870, Washington, National Gallery), one
of the most beautiful of Degas's intimate portraits, shows the sitter bathed in the
reddish light from a fireplace, wearing a red dress, and silhouetted against red
wallpaper. The magic of this atmospheric setting and the suggestion of a very warm
interior (which justifies Mme Camus's use of a fan) lend a sensuous and mysterious
aura to her shadowy figure in its low-cut dress.

It seems to have given Degas a particular pleasure to subject women who at-
tracted him to this probing, half-covert observation, by which he was able to
establish a bond of intimacy with them that he would otherwise have been too
shy to attempt. For all their seeming objectivity, these portraits have an undertone
of romantic sentiment that distinguishes them from the placid, still-life-like por-
traits of Courbet and from Manet's epicurean celebrations of beautiful women.

Degas was familiar with Japanese woodcuts and with photography. He
occasionally used photographs as aids in composing portraits. It has been sug-
gested that the off-center placements and marginal croppings that occur in many
of his portraits derived from Japanese or photographic models, but this is proba-
bly true only in a very general sense. Degas's visual imagination, fortified by a
powerful memory and a wide knowledge of art, had no need of direct imitation
or quotation. *The Print Collector* (1866, New York, Metropolitan Museum) is the
portrait-like study of a social type. The unknown subject, shown in an informal,
conversational attitude (somewhat like that of *Mlle Dubourg* of the same year),
is framed by a sharply patterned background setting that includes a display of
printed papers in a frame, very similar to the rather more clearly "Japanese"
arrangement that forms the background of Manet's later *Portrait of Emile Zola.*

James Tissot (1866, New York, Metropolitan Museum) shows Degas's
friend, the painter of fashionable genres and portraits, seated in a curiously
twisted pose before a wall hung with pictures, one of which—a portrait by
Cranach—obtrusively asserts itself just behind him, causing him to lean to one
side as if yielding to its presence. This may merely be Degas's joke on his friend,
but it introduces a vital tension into the picture, which sets it apart from Manet's
rather stiff *Portrait of Emile Zola,* on which it may have had some influence.

Edmondo and Teresa Morbilli (1867, Boston, Museum of Fine Arts), the portrait
of Degas's sister and her Neapolitan husband, who was also the painter's cousin,
seems at first sight to be rather formally posed. But its emotional equilibrium is
disturbed, as if accidentally, by the sudden, anxious gesture of Teresa, who raises
her left hand to her face, while reaching with her right to grasp the shoulder of
her stolid husband. This painting may have been exhibited at the Salon of 1867.

Degas and his father both loved music, frequented the opera, and enjoyed
the friendship of musicians. It was quite natural that the world of music should
enter into Degas's paintings, and particularly in its professional aspect, that of
the performing artist at work. The tenor Pagans, an opera singer, occasionally
performed at the houses of friends, including those of Degas and Manet. The
portrait *Degas's Father Listening to the Singer Pagans* (ca. 1869, versions in the

Louvre and in the Boston Museum of Fine Arts) contrasts the performer's action and expression with the deep absorption of Degas's father.

The late 1860s were a time of experiment and diversification, during which Degas explored for the first time a range of subjects that were to be important in his later work. He tried his hand at landscapes, painted his first *Laundresses,* and produced his earliest pictures of the stage. *Mlle Fiocre in the Ballet "La Source"* (1867–68, Brooklyn Museum) presents the fantasy world of a stage performance without identifying it as such, as Degas was to do later by contrasting the fictitious reality of the stage with the actual reality of the auditorium or the orchestra. The romantically exotic subject—a Persian princess, cooling her feet in a stream, while an attendant plays to her on a dulcimer and a horse drinks at the water's edge—is represented literally, in all its physical detail, as many studies for it indicate. The large canvas was shown at the Salon of 1868. Dissatisfied with its dark tonalities, Degas retouched it after the exhibition and again in the 1890s.

The Orchestra of the Opera (1868–69, Louvre) is centered on the figure of Désiré Dihau, a close friend of Degas, playing his bassoon among the musicians in the orchestra pit. Of the brightly lit stage above, only the legs and skirts of the dancers are visible. A cartoon by Daumier (1852), contrasting the prosaic professional reality of the orchestra pit with the heroic fiction of a stage performance above, may have suggested the idea of Degas's painting, which is in effect the extended portrait of a working artist.

Degas's interest in literature, and particularly in contemporary literature, his ability to visualize narrative, and his continuing willingness to accept suggestions from literature are all illustrated by the enigmatic painting known under the title *Interior* (1868–69, Philadelphia, Henry P. McIlhenny Collection), which has sometimes—mistakenly—been called *The Rape,* because of its hint of violence or coercion. The picture's actual subject seems to have been taken from a novel by Zola, *Thérèse Raquin,* that contains an episode—the loveless wedding night of a pair who have killed the woman's first husband—which in nearly all details matches Degas's scene. The atmosphere of the lamplit room, the precise description of its furniture, and the attitudes of the figures—the young woman cowering half-dressed in a chair, her companion leaning against the door as if to bar it— are a triumph of concrete visualization. More important still, they are formally beautiful, and at the same time in the highest degree expressive.

At the outbreak of the Franco-Prussian War, Degas joined an infantry regiment, but a defect of vision—a blind spot in his right eye—first discovered at this time, caused him to be transferred to the artillery, in which he served throughout the siege of Paris. During the civil war of the Commune (March–May 1871), he sought shelter with his friends the Valpinçon family, in Normandy. In the fall of 1871, he paid a brief visit to London. *Portrait of Hortense Valpinçon* (ca. 1871, Minneapolis, Art Institute), painted during Degas's rest from war service at the Valpinçons' estate at Ménil-Hubert, resumes the eccentric compositional format of *Woman with Chrysanthemums* (1868). It is one of several children's portraits painted by Degas at this time that show his interest in their early,

still faint expressions of individuality. *Carriages at the Races* (1871–72, Boston, Museum of Fine Arts) records an outing of the Valpinçon family. In its combination of a wide, sun-bleached landscape with portraiture, it illustrates Degas's cautious approach to Impressionism which, somewhat earlier (1869), had already produced a series of landscape studies in which Degas seemed to experiment with effects that he had observed in paintings by Monet and Renoir. The off-center placement of the carriage containing the Valpinçon family, and the radical cropping of the composition at the right, are calculated to give the effect of an entirely casual, uncomposed view, while in fact focusing attention on the human interest of the scene.

Upon returning to his accustomed life in Paris, Degas again took up the theatrical subjects that had occupied him earlier, painting stage performances as seen over the heads of spectators and musicians—for example, *The Ballet Robert le Diable* (1872, New York, Metropolitan Museum) and *Musicians in the Orchestra* (1872, Frankfurt, Staedelsches Kunstinstitut). But he also began at this time to study ballet dancers in their private, professional world, not performing to an audience, but exercising under the eyes of their instructors in the rehearsal rooms of the opera. With a sociologist's inquisitiveness, and a keen eye for the characteristic in appearance and behavior, he observed the short, strong-legged, adolescent dancers in their gauzy skirts, practicing their steps and flexing their bodies at the bar. *The Dancing Class* (1871–72, New York, Metropolitan Museum) and *The Dance Foyer at the Opera* (1872, Louvre) describe with great exactness the space and light of the practice rooms, their furnishings and atmospheres, and give an entirely objective view of the practicing dancers, their businesslike instructors, and the elderly musicians who accompany their drill, without embellishments or exaggerations. The execution is refined and assured, the brushwork of the utmost simplicity and precision.

In October 1872, Degas, accompanied by his brother René, embarked for America on a lengthy visit to their maternal family in New Orleans. René had earlier married one of his American cousins, Estelle Musson (whose previous husband had recently been killed in battle in the Civil War). Estelle was blind, and perhaps for this reason enjoyed the special sympathy of Degas, whose sight had been deteriorating since 1870 and one of whose reasons for undertaking the voyage may have been to give his eyes a rest. While in New Orleans, Degas lived with his maternal uncle, Michel Musson, a cotton broker.

Portraits in an Office—The Cotton Exchange, New Orleans (1873, Pau Museum) pictures one of the rarest subjects in all art: a business office in full operation. Michel Musson sits in the foreground, sampling cotton. In the spacious, light-filled office, salesmen talk to their customers, accountants attend to their ledgers, René de Gas reads a newspaper, Achille de Gas, another brother, leans against a partition. The prosaic everyday of business is presented with a sharp objectivity that has scarcely a parallel in painting. Degas here goes a step beyond the social realism of Courbet, Millet, and Manet in the precision of his observation, and equals the most minutely descriptive passages in the novels of Zola and the de Goncourts. The seemingly photographic factuality causes one to

overlook the picture's sophisticated design, its "Japanese" perspective, produced by an oblique angle of view from a height above the figures that silhouettes them against the expanses of floor and wall. As an extended portrait, a thoroughly modern subject, and an example of social observation, *The Cotton Exchange* offers an extremely instructive parallel to Courbet's *The Studio* (1855). In 1878 it became the first of Degas's works to enter a French museum.

During his stay in New Orleans, Degas also painted individual portraits of members of his American family, attempting as usual, in spite of domestric distractions and adverse conditions (the Southern light hurt his eyes), to go beyond mere likeness to a deeper characterization of his sitters and their milieu:

> *Estelle Musson (Mme René de Gas) with a Vase* (1872–73, Louvre) gives a hint of his sister-in-law's blindness by the gesture of her right hand, which explores the back of her chair with the tips of its fingers.
>
> *Estelle Musson (Mme René de Gas)* (1872–73, Washington, National Gallery), executed in a nearly monochromatic harmony of grayish white and light peach, emphasizes the young woman's black hair and dark, unseeing eyes.
>
> *Pedicure* (1873, Louvre), posed by Estelle's daughter, Joanne Balfour, shows the small girl, wrapped in a towel, having her toenails trimmed by a pedicurist. A scene of intimate hygiene, observed with intense curiosity, and a very unusual setting for a familial portrait, it gives a foretaste of Degas's later, similarly intrusive studies of women in the privacy of their bath.

Returning to Paris in the spring of 1873, Degas resumed his customary work habits. He embarked on several new series: of racetrack pictures—*Racehorses at Longchamp* (1873–75, Boston, Museum of Fine Arts), of ballet rehearsals—*Ballet Rehearsal on the Stage* (1873–74, versions in the Louvre and the Metropolitan Museum), and of laundresses. He continued his evenings at the Café Guerbois, and participated in the discussions between his painter friends—Monet, Renoir, Pissarro, and Cézanne—that resulted in the formation of an independent society of artists and the planning of a collective, dissident exhibition to coincide with the Salon of 1874. His personal life, meanwhile, underwent an important change through the illness and death of his father and the failure of the family bank, events that dealt a blow to his personal security and artistic independence. Since he felt that the honor of his family was involved, he used his personal property to pay family debts, and for the first time in his life was under some pressure to sell his works.

Despite these financial reverses and the fact that he now risked to lose much by breaking with the official Salons (which had been more hospitable to him than to his associates), Degas energetically participated in the planning of the independent group show, to be held on the premises of the photographer Felix Nadar in the Boulevard des Capucines, which later came to be known as the First Impressionist Exhibition. He was motivated entirely by the belief that artists had to break free from the restraints of the Salons in organizing their exhibitions, and did not regard his friends as constituting a movement or himself as a "member." His own designation for himself and for his friends was that of "Independent."

This term expresses the extent and limit of his agreement with them and, at the same time, his refusal to commit himself to any particular cause.

Manet, whom he admired, though not uncritically, chose not to participate in the projected exhibition, which led to a cooling of Degas's social relations with him and his circle.

From Monet and the landscape painters of the group, Degas was separated by fundamental differences of interest and of practice. Unlike Manet, he never went through an Impressionist phase. In associating himself with the group show of the future Impressionists, he was seeking for an alternative to the despised Salon: a partnership of modern-minded artists, without rules or program—an elite of talented individuals, not a movement or party. He proved to be an effective, if not always an easy ally, and next to Pissarro the most reliable participant in the long series of Impressionist exhibitions. Of the eight held between 1874 and 1886, Degas missed only the seventh.

He exhibited ten paintings at the group show of 1874, including *Carriages at the Races* (1871–72, Boston, Museum of Fine Arts) and *The Dancing Class* (1871–72, New York, Metropolitan Museum). His works fared better with the press critics than those of most of his colleagues.

Degas's distinctive form of realism, combining sharp psychological and social observation with a method of composition calculated to heighten expressiveness while appearing spontaneous and natural, is represented by a group of pictures that seem part portrait, part narrative genre. An early example of this type is the small painting known under the title *Sulking* (or *The Banker)* (1869–71, New York, Metropolitan Museum), in which a young woman is seen leaning across a littered desk, as if to address herself to the bearded man behind it who, with furrowed brow, averts his face. It has been suggested that this may be the illustration of a literary text (like the *Interior* of 1868–69), but no source has been found. The picture may be a deliberately staged pictorial drama, or a portrait dramatized (the male figure was posed by Degas's friend Duranty), a study in expressive pantomime charged with an apparent, but unexplained, significance. Manet's later dramatized portrait groups (such as *In the Conservatory,* 1879) appear to have been influenced by Degas's compositions of this kind.

Absinthe (1876, Louvre), posed by two friends of Degas, the painter Marcellin Desboutin and the actress Ellen Andrée, in a corner of the Café de la Nouvelle-Athènes, is presented as a "scene from life" in the manner of Zola. The staging of the scene is masterful in its suggestion of a sight casually encountered in passing. The deeply bored couple—the woman boozily self-absorbed, her male companion straining away from her, sunk into a depression of his own—are seen at an oblique angle from above, across a pattern of tabletops that distances the figures in their corner. The resemblance to Manet's later dramatic portrait genres *(In the Conservatory* and *Chez le Père Lathuille,* both 1879) is evident, though the comparison also brings out the more deeply calculated artifice of Degas's arrangement and the greater audacity of his asymmetrical design.

Place de la Concorde (ca. 1876, formerly Berlin, Gerstenberg Collection, but lost in World War II) is one of the very few scenes of Parisian street life in

Degas's work. In the brightness of sunlight reflected from the vast expanse of pavement that fills most of the picture space, the engraver Comte Lepic and his two small daughters are about to cross the Place de la Concorde—slight, fleeting silhouettes, tilting in opposite directions, radically cropped by the picture's lower edge. The effect is that of a view from a window onto passing figures, seemingly uncomposed, yet in their contrary motions suggestive of conflicting purposes, of disunity and separateness.

Asymmetrical arrangements, boldly patterned settings, and surprising angles of vision also mark Degas's more straightforward portraits of the late 1870s, of which the two most memorable are those of the novelist and critic Edmond Duranty (pastel on canvas, 1879, Glasgow Art Gallery and Museum) and that of the Italian art critic Diego Martelli (1879, Edinburgh, National Gallery of Scotland). After 1880, portraiture became rare in his work.

The decade 1875 to 1885 marked the peak of Degas's creative energy. For its variety of thematic invention and technical experiment, his work of these years has no parallel in its period. Like Manet, Degas in his later years increasingly developed his ideas in sequences of compositional variations rather than focusing them on single, culminating exhibition pictures. Of the main thematic series—the scenes of the ballet, of the racetrack, the music halls, brothels, millinery shops, and laundries—that of the ballet dancers is the most extensive, accounting for about half of his lifetime output of some two thousand oils and pastels. As audacious in their design as in his dramatic portrait genres, Degas's dance pictures deal for the most part with the workaday routines of training and rehearsal carried out by the "rats" of the ballet, flat-chested and strong-legged girls in their teens, the anonymous proletariat of the dance. Less frequently, they represent the actual stage performance, usually as seen from the wings—i.e., from the point of view of the working performers. Interested in the characteristic, intimately professional aspects of the ballet, Degas studied every nuance of gesture and attitude, never prettifying or sentimentalizing his dancers, but rather emphasizing the strain and effort of their work, and the violence done to their bodies by the discipline of the dance.

His larger compositions are inventions based on individual studies of typical poses and groupings. They do not record the performance styles of particular dancers, nor do they exactly represent the actual practice rooms or stages. Their striking realism—of illumination, space, and action—is the product of calculated artifice. Examples are:

> *Dancers at the Practice Bar* (1876, New York, Metropolitan Museum);
> *The Rehearsal* (1874, Glasgow Art Gallery and Museum), the picture seen in Degas's studio by Edmond de Goncourt, who commented in his journal on "the graceful twisting and turning of the gestures of these little monkey girls"; and
> *The Ballet Class* (ca. 1880, Philadelphia Museum of Art).

Troubled by his worsening eyesight in the late 1870s, Degas turned from oil painting to the less strenuous medium of pastel (as Millet had done, though for different reasons). But it may also have been his love of experimentation that

led him to devise complicated recipes, mixtures of diluted oils with pastel and watercolor, to heighten the brilliance of his colors. At the same time, he enthusiastically practiced etching, aquatint, and lithography, and after 1874 particularly cultivated the technique of monotype, which he had learned from his friend Comte Lepic. The process of monotype—in which the image is brushed in printer's ink or some other oily pigment onto a metal plate from which impressions (usually only a single fair one) can be imprinted on paper in an etching press—combines the spontaneity of sketching with the graphic finality of printmaking. Degas at first used this extremely flexible medium to test figural compositions, but soon was stimulated by its ease of handling and wide range of effects to improvise highly original subjects in monotype, going beyond his usual repertory. Starting with scenes of the ballet, some of which he finished off elaborately in pastel, he went on to nocturnal popular concerts *(café-concerts),* to scenes of prostitution in cafés and bordellos, such as the *Café-Concert at Les Ambassadeurs* (pastel on monotype, ca. 1877, Lyon Museum) and *Women in a Café, Boulevard Montmartre* (pastel on monotype, 1877, Louvre), and to intimate studies of women in the bath or in bed.

Among the most remarkable, and beautiful, of these vivid and entirely unconventional observations are the scenes of life in the brothels, some sixty of them, which for the most part show the small, plump, middle-aged women lolling about nude on their sofas in bored expectation of their clients. The innocent obscenity of their poses is observed with the same sharp eye for the workaday of the absorbed practitioner that Degas brought to his backstage views of the ballet. *The Birthday of the Madam* (pastel over monotype, ca. 1879, present location unknown) and *Three Women Seated on a Divan* (pastel over monotype, ca. 1879, Amsterdam, Rijksmuseum) are just two examples of the genre. There is an element of caricature in these scenes, but not a trace of satire or hostility; it is apparent that they aroused Degas's curiosity to the highest degree, yet evidently without troubling his sexuality. There is some evidence that several of the more explicit subjects were destroyed after Degas's death by his brother René. Brothel subjects figured prominently in the literature of the time, but there is no indication that the monotypes refer to any literary text. Degas did, however, project a series of illustrations in monotype for a collection of short stories by his friend Ludovic Halévy, *La famille Cardinal* (1880–83), but these concern the world of the stage rather than of the brothels. It may be noteworthy that in the work of Degas the subject of prostitution appears only in the monotypes.

Degas began to make sculptural sketches in wax sometime in the 1870s, chiefly as an aid in the study of the motion of horses. It is possible that he may have been familiar with Muybridge's photographic studies of animal motion. About 1878, he embarked on the ambitious project of the two-thirds life-size statuette of a young ballet dancer, the so-called *Little Dancer of Fourteen* (original wax at the Louvre), for which he made a nearly full-scale study showing her nude in 1878, and which he completed—with its startling muslin tutu, linen bodice, real ballet slippers, and real hair—for the Sixth Impressionist Exhibition in 1881. The use of actual fabrics was probably intended to remove the figure from the

moribund conventions of marble and bronze, but it also reflects Degas's penchant for mixing media. The adolescent body of the dancer, angular and tense in its strained posture, her bony shoulders and gaunt face give her a strange resemblance to the patient, sexless women who toil in Millet's pictures, but also recall Degas's own *Spartan Boys and Girls Exercising* (ca. 1860). The suggestion of a secret pleasure in the appearance of a young body scarred and aged by a profession supposed to give aesthetic, if not erotic, delight troubled visitors to the exhibition and caused the critic Paul Mantz to speak of Degas as an artist who, "if he maintains this style, will make a place for himself in the history of the cruel arts."

Throughout the 1880s and 1890s, Degas continued to sculpt statuettes in wax or clay, generally of small size and rough execution, representing horses, dancers, and women bathing. These sculptural sketches are closely related to the studies in pastel or charcoal dating from the same period, in which he made his models assume complicated and sometimes painful postures. He did not have these sculptures cast in bronze, since he apparently cared little for their preservation; as a result, only a relative few of them are preserved.

Degas had been a leading organizer and participant in all of the six "Impressionist" Exhibitions held between 1874 and 1881, frequently at odds with the actually Impressionist contingent (Monet, Renoir, Pissarro, Sisley), who were aware of his disagreement with their basic attitudes and working methods, and who resented his championing of artist friends (such as Forain, Raffaelli, Cassatt, etc.) of whom they disapproved. Dissension within the group led Monet and Renoir to abstain from the Fifth and Sixth Impressionist Exhibitions, in 1880 and 1881. In 1882, it was Degas's turn to abstain, because his friends had been excluded.

In the early 1880s, two "social" themes, scenes of laundresses ironing shirts and of milliners selling or arranging hats, particularly occupied Degas. The series of paintings and pastels on these themes express his fascination with the character and beauty of professional activities, something that had also played a role in his study of jockeys, dancers, and prostitutes. They have no social message, such as one would suppose in works by Courbet or Millet. Degas' interest, rather, seems aesthetic and his attitude one of acute curiosity, comparable to that of a botanist observing specimens with a practiced eye. "Laundry girls with bare arms," in the steamy atmospheres of their work places, had been the occasional subjects of pastels and oils since 1869. When Edmond de Goncourt visited Degas in 1874, he found him at work on pictures of washerwomen and was impressed by his knowledge of the "technicalities of the different movements in pressing and ironing." *Woman Ironing, Seen Against the Light* (ca. 1882, Washington, National Gallery) exemplifies these works. But *Two Laundry Women* (ca. 1884, Louvre; variants in Pasadena, Norton Simon Collection, and Paris, Durand-Ruel Collection) is the ultimate, most complete statement of the theme. Degas contrasts the gesture of boredom and fatigue of the laundress at the left with the concentrated effort of the girl ironing at the right. An exquisite tenderness of atmosphere and light graces the potentially squalid subject.

A new interest for Degas, stimulated by visits to fashion and hat salons in the company of the American painter Mary Cassatt, was the world of the millinery trade. During 1881–83, he produced some twenty large pastels showing women assisted by shop girls trying hats before mirrors, of which *At the Milliner's* (pastel, 1882, New York, Metropolitan Museum, said to have been posed by Mary Cassatt), *At the Milliner's* (pastel, 1882, Lugano, Thyssen-Bornemisza Collection), and *At the Milliner's (Girl Arranging Hats)* (oil, ca. 1882, Chicago, Art Institute) are typical. The figures are presented in close view, often at a steep angle from above, their faces averted or given little prominence: all the emphasis is on the turns of the heads, the positions of the arms and motions of the hands of the women deeply absorbed in self-inspection, and on the professional mannerisms of the shop girls in attendance. The flowered hats that play a prominent part in these scenes express Degas's delight in beautiful artifice: they may be his answer to the "natural" landscapes of the Impressionists and to Manet's late still-lifes of flowers and fruit.

Around 1885, at age fifty, Degas began to feel old and apprehensive of failure. The weakening of his sight made him fear that his artistic career was coming to an end and that he must renounce many long-cherished plans for the future. He narrowed the range of his subject matter to a relatively small number of themes—jockeys, dancers, bathers, and occasional portraits—often reworking his earlier ideas, and restricting himself to the study of posing models. His style and manner of execution underwent a marked change: the figures, seen in closer view, become larger and heavier, their contours more strongly marked, their handling broader and bolder. Pastel replaced oil as his chief medium, and brought with it a technique of vigorous, graphic modeling, with strokes of color that define the bulk and relief of his figures in a way that corresponds to his manner of sculpting in wax. His sense of touch came gradually to compensate for the failure of his eyes.

Among the most powerful of the works of Degas's later years are the large charcoal-and-pastel studies of women bathing, drying themselves after the bath, having their hair combed, or being served a cup of tea. The motif of women tubbing in secluded interiors first occurred in several monotypes (1880–84) and etchings *(Woman Getting out of the Bath,* ca. 1882). Seven large pastels of this subject were shown at the Eighth (and last) Impressionist Exhibition in 1886, on which occasion Degas observed that "the nude hitherto has always been represented in poses that presuppose an audience," and that it was his intention to show his bathers moving naturally, oblivious of observers, "as if seen through a keyhole." The memory of Ingres's *Valpinçon Bather* (1808) may have been in his mind.

In his earlier scenes of bathers (ca. 1882–86)—such as *The Cup of Tea* (pastel, 1883, London, Niarchos Collection), *Nude Having Her Hair Combed* (pastel, 1885, New York, Metropolitan Museum), and *The Tub* (pastel, 1886, Louvre)—the interiors are described with their furnishings, their particular qualities of light and space, and the nudes, generally shown in full figure, are often attended by maids. The poetry of these quiet scenes, which are always situations rather than mere compositions, is that of an intimate privacy witnessed by an

unseen observer. The bathers, mature, fleshy women of a type entirely unlike that of the adolescent dancers, assume postures of stretch, twist, and stoop quite without parallel in the long tradition of the artistic nude. The colors are both fresh and strong, decorative in overall effect and at the same time strikingly lifelike, particularly in their suggestion of naked skin—Courbet's nudes, in comparison, sometimes resemble painted cement.

In the later bathers (ca. 1887–1908), the figures are in closer view, the space around them reduced. The powerfully sculptural bodies are defined by parallel striations of pastel. Half-blind, Degas visibly struggled with his materials. The signs of this effort, together with the monumentality of the figures and the heightened resonance of the colors, give a tragic exaltation to such late pastels as *Nude Stepping into the Bath Tub* (ca. 1890, New York, Metropolitan Museum), *Woman Leaving the Tub, Drying Herself* (ca. 1894, Tel Aviv Museum), and *Bather Drying Her Hair* (ca. 1905–07, Pasadena, Norton Simon Collection), calling to mind the surge in expressive power that marked the old age of Rembrandt and Goya.

Legend pictures the aging Degas as a seclusive, misogynous ogre, but until well into the 1890s he in fact led a fairly sociable life, increasingly restricted, it is true, to a circle of old family friends in whose town and country houses he was a welcome guest. A formidable individualist, feared for his sharp wit, he enjoyed the company of young women and children, and had a talent for play and pantomime. In the family of Henri Rouart, an artist, engineer, and manufacturer, he found his adoptive home. Though his eyes were weak, his body remained robust, and his moderately tall, solid, bearded figure apparently thrived on movement and travel. In 1886, he visited Naples, in 1887 Spain and Morocco. In 1890 he adventured in a horse-drawn carriage around Burgundy, accompanied by the sculptor Bartholomé, and in exceptionally good humor. From this voyage resulted a series of landscape studies in monotype and pastel, highly exceptional in his work, which Durand-Ruel exhibited in 1892—in the only one-man exhibition Degas received during his lifetime.

Having long been interested in, and perhaps influenced by, photography, he became an enthusiastic amateur photographer about 1895, and over several years took many carefully posed portrait photographs of friends and of himself, besides making photographic studies of models posing in the nude or in ballet costume.

Struggling against the progress of his blindness, Degas courageously persisted in working on his series of dancers and bathers, and on a few last portraits. He devised methods for duplicating and correcting his designs by means of tracings and counterproofs. His lines, formerly so subtly nuanced, gradually assumed an almost brutal heaviness, his figures a rough simplicity verging on abstraction. But his colors, applied in superimposed hatchings that lend a surprising transparency to the normally opaque medium of pastel, retained their freshness and complexity to the end. Throughout his career, he had been a consummate technician and a discreet graphic stylist who shunned showy mannerisms. The large and rough execution of his late pastels, which calls attention to itself, amounts to a break—though surely not an entirely voluntary one—with his

earlier practice. His last works look strangely "modern." By about 1905, they begin to show signs of a partial loss of control in occasional failures of placement and losses of coherence. Hands and faces become shapeless; what remains is the sense of telling gesture and motion. Around 1908, Degas ceased to draw.

His last years were overshadowed by the deaths of close relatives and friends. The Dreyfus affair, in which Degas took a chauvinistic and anti-Semitic stand, alienated him from old friends and fellow artists. He found some consolation in the formation of a large collection of paintings and drawings, chosen with characteristic discrimination, and including a wide range of works extending from those of his early idols, Ingres and Delacroix, to those of his contemporaries, Manet, Pissarro, Sisley, Cassatt, Morisot, and Cézanne, and even of the younger generation—Gauguin and Van Gogh. But he owned no painting by Monet. Having given much of his inheritance away in the 1870s to assist his brothers in their commercial ventures, he had lived not uncomfortably, but in fairly modest circumstances. Since the later 1880s, his works had begun to sell well and brought him a good income. After 1900, the prices paid for his painting rose spectacularly. He was indifferent to popular success, and reacted with sardonic amusement when he learned that at the Rouart sale in 1912 his *Dancers at the Bar* (1876, New York, Metropolitan Museum) had brought 478,000 francs, a near-record sum.

On September 27, 1917, Degas died.

Among the Modernists of his generation, Degas represented the tradition of expressive and aesthetic composition rather than the current of naturalism. He loved art, and took a cautious view of nature: "We can never know whether Nature will return our love" was one of his skeptical sayings. Precise observation documented every detail of his compositions, but the conception of the whole resulted from calculation, and its execution from memory, rather than from immediate impressions. His delicate eyes prevented him from painting out of doors, but he preferred in any case the quality of artificial light and the fictional nature of stage scenery and flowered hats. He distrusted spontaneity, and achieved his effects of seemingly casual realism by dint of study and method—in this respect, his way of working was the opposite of Monet's Impressionism. He believed, like Ingres, that art was rooted in morality or conscience, i.e., in difficult choices and principle-based decisions, not in an impartial acceptance of sense experience: "Art is sacrifice, it consists of renunciations."

READINGS

Life

R. McMullen, *Degas, His Life, Times, and Work,* Boston, 1984, a detailed, readable account of the life, based on a comprehensive study of the sources.

M. Guérin, *Degas Letters,* Oxford, 1947.

Glimpses of Degas's personality, behavior, and opinions are to be found in, among others, A. Vollard, *Degas, an Intimate Portrait,* New York, 1927; D. Halévy, *My Friend*

Degas, Middletown, Conn., 1964; P. Valery, *Degas, Manet, Morisot,* New York, 1960; L. W. Havemeyer, *Sixteen to Sixty, Memoirs of a Collector,* New York, 1961.

Works

P. A. Lemoisne, *Degas et son oeuvre,* 4 vols., Paris, 1946–49, the basic catalogue of the paintings, pastels, and monotypes.

F. Minervino and F. Russoli, *Opera completa di Degas,* Milan, 1970, a concise catalogue, mainly based on Lemoisne, with tiny illustrations. Neither "complete" nor factually reliable, but of some usefulness as a rough index.

T. Reff, *The Notebooks of Edgar Degas,* 2 vols., Oxford, 1976, the thoroughly annotated thirty-seven sketchbooks in the Bibliothèque Nationale, covering the period of ca. 1853 to ca. 1886. Important documents of Degas's sources, his stylistic development, and his working methods.

G. Adriani, *Edgar Degas, Pastelle, Ölskizzen, Zeichnungen,* Cologne, 1984. Good plates.

E. P. Janis, *Degas Monotypes,* Cambridge, Mass., 1968.

J. Adhémar and F. Cachin, *Degas, the Complete Etchings, Lithographs, and Monotypes,* New York, 1975.

J. Rewald, *Degas Sculpture,* New York, 1956.

C. W. Millard, *The Sculpture of Edgar Degas,* Princeton, 1976.

General Monographs

D. C. Rich, *Degas,* New York, 1951.

P. Cabanne, *Edgar Degas,* Paris, 1960.

I. Dunlop, *Degas,* New York, 1979. Profusely illustrated.

Special Studies

L. Browse, *Degas Ballet Dancers,* London, 1960.

J. S. Boggs, *Portraits by Degas,* Berkeley, 1962.

T. Reff, *Degas, The Artist's Mind,* New York, 1976.

13
Impressionism

Impressionism

 The Term "Impressionism"
 Antecedents
 Development
 Method
 Fluctuations in the Reputation of Impressionism

Claude Monet, 1840–1926

Pierre-Auguste Renoir, 1841–1919

Alfred Sisley, 1839–1899

Camille Pissarro, 1830–1903

Impressionism

THE TERM "IMPRESSIONISM"

In April of 1874, a group of thirty artists, including Boudin, Cézanne, Degas, Monet, Pissarro, Renoir, and Sisley, organized an exhibition of their paintings in the studio of the well-known photographer Nadar, on the Boulevard des Capucines in the heart of Paris. Most of these artists were fairly young (Boudin, the oldest, was fifty, Renoir, the youngest, thirty-three years old) and as yet unrecognized. They had little to hope for from the official organs of patronage and from the juries of the annual Salons. Their exhibition was conceived as a gesture of independence and of self-help. While in retrospect this event appears momentous, its impact at the time was small. About 3,500 visitors saw the 165 exhibited paintings (compared to the ca. 450,000 visitors to the Salon of that year), and the majority of these came to laugh and mock, having been prepared for the hilarious experience by scattered press notices that almost unanimously treated the exhibition as a joke. One of the more humorous reviews, by Louis Leroy writing in *Charivari* (a comic journal that until a short time before had counted Daumier among its collaborators), belabored the title of one of Monet's paintings, a harbor scene with rising sun, that the artist had labeled *Impression, Sunrise.* Playing around the word "Impression" with clownish journalistic irony, the clever Leroy ended by dubbing the whole exhibition as "Impressionist." He meant by this term of abuse to describe the unfinished, haphazard, slovenly look of many of the paintings. The term stuck, being taken up by the public and by the artists themselves; it has come to be the accepted designation of an entire main current in late-nineteenth-century art.

The origin of the term, in a slapdash gesture by a shallow critic, has itself the character of an "impressionist" improvisation as Leroy would have understood the word. It does not carry any very precise meaning, and it is futile to try (as some have done) to give it a concrete significance. It is nothing more than a convenient, vague, suggestive, and therefore slightly misleading label that has often been loosely applied to various forms of modernity in late-nineteenth-century art that were practiced by a great many quite individual artists, who never formed a coherent "movement" and never formulated a doctrine.

The original group of thirty artists who showed their work at the First "Impressionist" Exhibition of 1874 differed in too many ways to be com-

prehended under one label. The subsequent Impressionist Exhibitions, seven in all (1876, 1877, 1879, 1880, 1881, 1882, 1886), further increased this divergence. While in 1874 a naive observer, startled by the unfamiliarity of the work exhibited, might understandably see it all as representing a common direction, by 1886 even the hasty Leroy would have noticed its thematic, stylistic, and technical diversity. But this was already present in the First Impressionist Exhibition of 1874. Leaving aside various minor contributors, it is possible to distinguish three separate directions: that of Degas, that of Monet, and that of Cézanne. The first of these was based on calculated selection and refined arrangement (Degas), the last aimed for expressive energy and powerful pictorial construction (Cézanne). The second, represented by Monet and a very few close followers, by contrast to these others, stressed the direct perception of "nature," mainly in the form of landscape, and sought, by means of a rapid but precise technique, to approach as closely as possible to the truth of visual experience. The term "Impression," misapplied to all three of these tendencies, does not fit either Degas's or Cézanne's method and style. It derives, by no means accidentally, from the title Monet had given one of his paintings, and has an unquestionable aptness when used to describe Monet's approach to landscape. Quite properly therefore it has come to be used, in a more discriminating way than formerly, to designate the particular direction in painting of which Monet was the leader and the sole wholly consistent practitioner. This included painters who were close to him in varying degrees during parts of their careers: Renoir, Sisley, Pissarro, and, somewhat more remotely, Morisot, Guillaumin, and Caillebotte. Reflections of "Impressionism" —i.e., of the influence of Monet and his friends—appeared briefly in the work of some older artists, such as Manet (ca. 1869 and intermittently in the 1870s), and of younger men such as Van Gogh, Gauguin, and Signac.

But the full range of the kind of painting for which the term "Impressionist" has come to be adopted is exemplified only by the progressive development of Monet's work from about 1865 until the early years of the twentieth century. Of his followers, Sisley was perhaps the most consistent Impressionist, though he too deviated very considerably in the 1880s and 1890s. In the lives of Renoir and Pissarro, Impressionism was only a phase, more or less vehemently repudiated when its end had come (around 1883). If there ever was such a thing as an Impressionist "movement," it was small and of short duration. But such was the importance of the work created then by this handful of artists that it changed the course of Western art.

ANTECEDENTS

Impressionism was an outgrowth of the international Naturalist movement of the earlier nineteenth century. Its affinities with the English tradition (Constable, Bonington) are quite marked, and for a good reason: English naturalist landscape painting had become acclimatized in France in the 1820s and 1830s. Jongkind and Boudin, who particularly influenced Monet, were important links with that tradition. Corot and the Barbizon painters, themselves affected by English mod-

els, provided a further connection with earlier, essentially Romantic traditions of naturalist landscape. Among the painters of the preceding generation, Daubigny in particular anticipated characteristic aspects of Impressionism. From Constable and Bonington, via Huet, Corot, Rousseau, and Daubigny, on the one hand, and via the open-air painters in oil and watercolor, Boudin and Jongkind, on the other, multiple strands of continuity led to Impressionism, raising along the way most of the questions to which the Impressionists were to address themselves: the matter of direct nature study; of rapid work under the open sky; of an art based on immediate observation that excluded as nearly as possible all preconceptions, all literary and symbolical allusions, all embellishments and compositional arrangements.

The Impressionism of Monet and his friends had its birth in the Forest of Fontainebleau around 1863–65. An important difference, of attitude, outlook, and method, however, separated the young Impressionists from the Barbizon painters at the very outset. The piety, the brooding seriousness, the tragic note so marked in much Barbizon landscape painting was lacking in the work of the Impressionists. Lacking, too, was the highly individualist quality, the romantic flavor in Barbizon painting, the expression of an intensely personal attachment to particular sites, to particular places or moods in nature. The Impressionists brought to landscape the detachment of modern city dwellers. Their style of life was urban or suburban. They did not try to merge with nature or to join their fates with those of the tillers of the soil. Railroads, steamers, and bicycles suited their need for rapid passage from site to site. They had no desire to settle in secluded communities, preferring villas to farms, gardens to potato fields, the liveliness of semi-urban riverside resorts to rustic solitudes.

DEVELOPMENT

Brief and rapid though the development of Impression was, and made complex by the variety of individual temperaments and talents that contributed to it, a succession of stages can be broadly distinguished.

First, the formative period of 1863–69, in which the Impressionist style detaches itself gradually from the influences of Barbizon, Courbet, and Manet. A sober factuality of statement, a certain dryness and distinctness of definition, a moderate colorism, and a persistence of relatively dark tonalities mark the work of Monet, Renoir, Pissarro, and Sisley in these years. Figure painting, even of large scale, holds its own beside landscape. Around 1869–70, a bolder approach to effects of light and color becomes apparent, particularly in paintings by Monet. The touches of the brush are generally smaller, and less descriptive of the shapes of objects (though in some paintings by Monet the colors are laid on in large, flat areas of intense hue). The period 1871–76 marks the full efflorescence of Impressionism and the time of greatest stylistic unity among the members of the group. Landscape dominates. It is often treated in a radiantly luminous way, in small, vivid touches of intense colors that give a strong, sensuous suggestion of matter: of the liquidity of water, the motion of foliage, the quality of sunlight. Despite

the breadth of treatment and the diminution of tonal contrasts, the illusion of tangible objects in spatial relationship to one another strongly persists.

About 1877–82, the colors become more strident and less descriptive of states of illumination or atmosphere. A new tension enters into Impressionism. On the one hand, powerful material structures—rocks, houses, railway stations —are allowed to displace the subtler, fainter shapes of organic nature; on the other, an intense, diffuse scintillation of disembodied color may veil the appearance of reality. A bolder, more expressive "handwriting" animates the surfaces of the paintings, forming a fabric of color, less traversible to the eye than the atmospheric spaces in the earlier landscapes. After 1882, the divergent tendencies in Impressionism lead to conflict, not only between the individual members of the group (who from now on increasingly go their separate ways) but even within the work of each of the painters. Having reached the limits of intuitive, spontaneous naturalism, some of the artists tend to retreat to firmer, more representational, more conventionally structured imagery, others try to advance further in the direction of radical form-dissolution, most vacillate between retreat and advance. It is a time of uneasy experiment, very different from the confident mastery of Impressionism's classical phase around 1872–75. From the late 1880s onward, a tendency toward decorative design begins to run counter to the original naturalist direction of Impressionism. Elements of stylistic artifice, an echo of *art nouveau*, appear even in the work of Monet (see, for example, the series *Poplars Along the Epte* of 1891).

Despite these changes of style and feeling, certain underlying attitudes remained fairly constant throughout the development of Impressionism. One of the aspects of Impressionism that most disturbed contemporaries was its indifference to ideas and intellectual notions, or to what in today's jargon would be called "relevance." The materialist premise of Impressionism—that the basis of painting was visual experience, and that the optical facts of vision, light, and color were paramount and sufficient for art—excluded a wide range of themes and subjects. It excluded subject matter drawn from the imagination, from literature, or from history. It excluded, as well, the statement of political, social, or religious beliefs. It prevented the artist from functioning, in any straightforward way, as a commentator or critic of society. In this respect, Impressionism differed importantly from the work of the so-called Realists—Courbet, Millet, Daumier—and from the social observation of Manet or Degas. It even differed from the realist or naturalist vanguard literature (the Goncourts, Zola, etc.) and its polemic on behalf of various forms of social and cultural liberation. Thus the matter of sexual emancipation, a crucial vanguardist issue of the time, was beyond the scope of Impressionism, since its technique and style were unsuitable for the treatment of erotic subjects.

The Impressionists for the most part held advanced, sometimes radical, political views, but these had no apparent influence on their work. It could be said (and has been said) that the highly personal, "unregulated" vision of reality recorded in their painting amounts to an assertion of personal liberty, and hence has political overtones. But it is apparent that this libertarian bent remained

rather narrowly confined to strictly artistic practice. Compared to the active radical involvements of such older artists as Courbet and Daumier, on the one hand, and to the equally active conservatism or patriotism of such popular or official artists as Vernet, Meissonier, and Gérôme, the Impressionists maintained a remarkably neutral position.

Observant receptivity and an alert open-mindedness marked their attitude toward reality. Unlike earlier painters of landscape, unlike the Barbizon painters, for instance, they refrained from rearranging or consciously composing their motifs. Their painting was an immediate response to experience rather than a deliberate ordering or transformation, though in effect it inevitably ordered and transformed the raw facts of sight to a degree—but this interference was discrete, it resulted from unconscious selection or from technical necessity rather than from rules or value judgments. The modifications that the artists' individual temperament imposed upon their vision of reality, keeping it from being mechanically objective, appeared chiefly in such features as the greater or lesser warmth of light, the sweetness or acerbity of colors, the density or softness of matter, the spaciousness or limitation of the view. In these respects, the different masters of Impressionism developed marked stylistic identities. It is interesting to compare paintings of the same landscape motif by Monet and Renoir, or Sisley, or Pissarro. Despite their common striving for "truth," their very different personalities acted as filters to their sense of sight, causing their works to differ in characteristic ways. Least apparent in the years between 1869 and 1875, these differences increased sharply after 1877.

The devising of "interesting" subjects was one of the most pressing concerns of nineteenth-century painters. The success of their work depended in large part on the cleverness of the thought expressed in it, in other words, on its dramatic, poetic, or historical theme and the effectiveness of its staging. A main reason for the persistent unpopularity of the Impressionist painters up to 1890 was their *slighting of subject matter.* Since their material was entirely drawn from direct observation and from the normal range of their personal experience, their paintings could not tell stories, and therefore seemed insignificant, ordinary, and without interest to a public expecting to be entertained. Though very limited in its range, however, Impressionist painting did have subject matter. Domestic genre, portraits, still-lifes, and landscape constituted the thematic repertory of Impressionism. All subjects were necessarily of the present, and many had a particular, intimate relevance to the artists' personal lives—to their families, houses, gardens, their favorite walks, their sports and entertainments. Where "nature" was the main theme, in landscapes, figures tended to be subordinate or absent. But the object of visual experience in Impressionist painting was hardly ever the static existence of matter. Impressionist landscapes were not compositions made up of things so much as observations of *processes:* the drama of weather, the flow of water, the movement of light through atmosphere, the scintillations of light on foliage, the pulse of street traffic. The role that narrative subjects and "human interest" had played in conventional art shifted, in Impressionist painting, to the spectacle of physical nature in its endless change.

The view of the world that is reflected in Impressionism, and that can be said to constitute its underlying philosophy, is a refined materialism that sought fulfillment in an immersion of the self in the visual pleasures of a reality unembellished by moral, sentimental, or literary associations. This concentration on the visual required a special aptitude for seeing—a gift that few possess—and at the same time entailed the sacrifice of many cherished traditional values. It also made high demands on the aesthetic sophistication of artists and their public. It called for a degree of detachment and emotional harmony that is difficult to attain, and for a deliberate, self-indulgent cultivation of the senses that only a cultivated and leisured class can afford. Such an elite did, fortunately, exist within the educated upper middle class of late-nineteenth-century Europe. Disenchanted with romantic strivings, weaned from piety or idealism, tired of political conflict, and bored with conventional art, some few demanding individualists mainly from this class found in Impressionism a fresh and modern form of beauty, and at the same time an escape from the stuffiness of urban life to the health and innocence of nature. But for the artists themselves, living in difficult circumstances, hard-pressed by want, the proper attitude of detachment was often difficult to maintain. After the serenity of the early 1870s, signs of tension and a note of pathos increasingly appeared in later Impressionist painting.

METHOD

Accused by hostile critics of having brutalized reality, the Impressionists in fact made every effort to go beyond earlier art in capturing the subtleties of visual experience. They understood that sight consists of a patchwork of light and color sensations which the mind interprets as objects in space. Representational art had always addressed itself to the understanding, rather than dealt with the raw sense data of sight, and had sought to facilitate the work of recognition by a variety of conceptual devices: linear definitions, tonal gradations, suggestive formal arrangements. These did not resemble what the eye really saw, but accommodated mental expectations; long familiarity had caused them to be equated with reality. Sharp outlines and black shadows do not occur in nature, but pictures without sharp outlines and black shadows did not look "natural": the look of nature in art was in part the product of conventional artifices. Any very striking disturbance of these artifices tended to disorient the public and to irritate it as an attack on good sense, if not on nature itself. Even the controversial Realists, Courbet and the Barbizon painters, in this matter remained on the side of tradition.

The Impressionists dared to go further. They attempted a much closer approximation to the actual sensations of light and color in visual experience than had been tried before, and thereby incurred the wrath of the critics. Through their experiments in open-air painting, they became aware of the transitory nature of visual reality—of the fact that objects, seen under natural conditions, change in appearance from moment to moment, owing to constant changes of light and atmosphere. This insight had an important effect on their method and technique. To get the truth of visual effect they desired, it was necessary to work directly

in nature (not from memory in the studio) and to work with speed. Preliminary drawings, detail studies, tonal underpainting, and other such aids to execution employed even by Realist artists were of no use to them. Their work by necessity assumed the character of rapid sketches. The earlier naturalist painters (Constable, Turner, Corot, etc.) had, of course, also sketched from nature. But while these artists had used their (usually small-scale) sketches as personal documents and as preliminaries, the Impressionists looked on the capture of visual experience in sketches of picture size as the full realization of their intention. Precise drawing, high finish, profuse detail in their view were not merely irrelevant to optical truth but actually detrimental. Impressionism was said to lack design, and to be rough and incomplete; but the truth for which these painters aimed was one of light, color, and motion, and in this matter their work showed greater precision than that of their more tradition-bound predecessors. It is true, however, that they did not always adhere strictly to the principle of direct work from nature, but sometimes "corrected" their paintings in the studio, as can be observed in Monet's later work.

Their problem was to render, in opaque pigments, the brilliance and purity of light-borne color. They realized that all vision consists of positive color experience, and therefore progressively eliminated from their paintings the non-colors with which painters had traditionally represented shadows, i.e., black, gray, and gray-brown. Illuminated objects tending toward yellow or orange in the most brightly lit passages, the complementaries of these light-colors, blues and violets, must be the shadow-colors. Since mixing pigments neutralizes their intensities and reduces their hues to muddy, low-keyed tones of dark brown, greens, and grays (the somber colors of traditional landscape, so unlike the actual brightness of sun-filled nature), the Impressionists developed a method of using colors pure, setting unblended strokes of intense color side by side, in such a way as to combine visually when seen at a distance. In this way, purely optical color mixtures could be produced, comparable to the mixtures of colored light that constitute ordinary sight. Thus they came to define objects by color accents rather than by outlines or light/dark contrasts. The Impressionist painting was a tissue or mosaic of vivid color touches—resembling in this the retina of the eye and its color-sensitive nerve ends. The dissolution of the image into separate strokes had the additional virtue of giving to the picture surface a suggestion of movement and vibration. It not only made it possible to deliver complex mixtures of color in their full purity and brightness, but made these stabs of color, these scintillations of light shimmer and tremble, overcoming to a degree the unnatural stillness of painted nature.

The approach of the Impressionist painters to the difficult task of translating the visual impression into a painted image was intuitive, not systematic or scientific. They trained themselves in seeing precisely, and in transcribing their sight with brevity and speed, by the most direct and simple color equivalents, avoiding retouchings or corrections. The instantaneous, quasi-instinctive response—however incomplete or rough—held more precision, they found, than the measured or calculated (intellectual) analysis. Unlike the later Neo-Impres-

sionists, they did not count their touches or quantify their color mixtures.

They gave to their canvases the all-over brightness of the field of vision, not "framing" the view (as the Barbizon painters frequently had done) nor focusing it on some privileged feature, some compositional center. The image within the canvas was not obviously structured or composed, nor was it bound to the format of the canvas. An excerpt from endless nature, it implied that its light and space continued beyond the edges of the picture (see the figure below).

FLUCTUATIONS IN THE REPUTATION OF IMPRESSIONISM

During the 1870s, the work of the Impressionists was liked by few and sold at extremely low prices to a very limited clientele, a sophisticated and modern-minded public. This consisted largely of financiers and men of business: bankers (Louis Cahen d'Anvers, Charles Ephrussi, George Grimpel, Paul Berard), merchants (Ernest Hoschedé), publicists or journalists (George Charpentier), profes-

Framed and Composed View

Open View (Monet)

sionals (Drs. Gachet, de Bellio, Emile Blanche), civil servants (George Rivière, Victor Chocquet), artist friends of independent means (Gustave Caillebotte), and, very occasionally, enthusiasts of moderate wealth and without social ambition ("Père" Tanguy, Eugène Murer). The public sales at which Impressionist paintings were sold at the time (a first sale in 1875, a second sale in 1877, and the sale of the Hoschedé Collection in 1878) prove that on the free market they commanded very small prices, and that these prices actually declined in the course of the 1870s.

What sustained the artists were purchases by dealers such as Durand-Ruel, and occasional commissions, notably portrait commissions. Throughout the 1880s, owing in part to better press criticism, interest in the Impressionists increased. The artists, in their turn, showed themselves to be more compliant to public taste and more willing to submit to the system of official patronage, notably the juried Salons. Renoir, because of his agreeable personality and his skill as a portraitist, enjoyed a fair measure of prosperity. But compared to the high reputation of Meissonier, Bonnat, Carolus-Duran, Bouguereau, Gérôme, and other painters now held in relatively low esteem, the Impressionists seemed insignificant —a fad, confined to a tiny, eccentric minority.

By the later 1890s, this situation had changed considerably. At the sale of the Théodore Duret Collection in 1894, fairly high prices were paid for their work (though the subsequent sale of the Tanguy Collection showed a marked drop). In 1900, a painting by Sisley rose to the very high price of 43,000 francs. Impressionism at that time had ceased to be controversial; it had also ceased to be in the forefront of modernity and was about to be bypassed by younger artists. The protest which boiled up around the bequest of the Caillebotte Collection of Impressionist paintings to the Luxembourg (then the state museum of modern art) was a final, partial victory of the academic rearguard, led by such painters as Gérôme. The "national shame" of total acceptance of the gift was averted, only a portion of the bequest becoming the property of the state—but that portion was even then evaluated at 400,000 francs.

After 1900, the Impressionists were in demand by collectors everywhere, in Germany and the United States as well as in France. The English responded much more cautiously. But between 1910 and 1920, Impressionism ceased being a highbrow taste: in success, it had definitely become old-fashioned, though the millionaire demand (particularly for Renoir) continued strong—Duncan Phillips, in 1923, paid $200,000 for the *Luncheon of the Boating Party* by Renoir, roughly $5 million in terms of today's (1986) currency. In the period of Cubism and Expressionism, the influence of Impressionism on artists was at its low ebb, but popular interest remained high, abetted by an abundant production of colored reproductions. Impressionist painting, once decried as a form of mental derangement or cultural subversion, was seen in the rosy light of nostalgia as something clean and wholesome. It offered a standard of health and sanity, against which the craziness of later forms of modernity could be measured.

After 1945, with the advent of Abstract Expressionism, certain aspects of Impressionism, particularly the later work of Monet, became quite "modern"

once more. The publication of Rewald's *History of Impressionism* and of other serious works, and the success of a number of large exhibitions in the 1950s, brought it to its present status as the most widely appreciated, and consequently most sought-after (and expensive) phenomenon in Western art. There are signs that this vogue, too, may not last forever.

READINGS

John Rewald, *The History of Impressionism* (4th edn.), Greenwich, Conn., 1973, is the standard work. It contains a very complete, classified, and annotated bibliography on Impressionism in general and on its chief artists. Rewald's emphasis is strongly biographical. He traces the lives and relationships of the Impressionist painters in great detail, but touches only occasionally on matters of style and thematic significance.

Phoebe Pool, *Impressionism,* London, 1967, though brief and popular, gives a good survey of the general stylistic development of Impressionism and of the artistic individualities that constituted the Impressionist group.

L. Venturi, *Les archives de l'impressionisme,* Paris and New York, 1939. An important collection of letters by Renoir, Monet, Pissarro, Sisley, and other key figures of the Impressionist circle.

L. Nochlin, *Impressionism and Postimpressionism (Sources and Documents),* Englewood Cliffs, 1966. A useful, concise selection of documents, with analytical commentary.

M. Blunden, *Impressionists and Impressionism,* New York, 1976. A selection of biographical documents, both literary and pictorial.

Not included in Rewald's bibliography are the following recent publications:

Kermit Champa, *Studies in Early Impressionism,* Yale, 1973.

B. Dunstan, *Painting Methods of the Impressionists,* New York, 1976.

R. Cogniat, *A Dictionary of Impressionism,* London, 1973.

H. Adhemar, *Catalogue complet du Musée du Jeu de Paume,* Paris, 1973.

R. Shiff, *Cézanne and the End of Impressionism,* Chicago, 1984.

See also the catalogues of exhibitions held in recent years in celebration of the First Impressionist Exhibition in 1874:

Centenaire de l'Impressionisme, Paris, Grand Palais, 1974 (shared by the Metropolitan Museum in New York).

The Impressionist Epoch (text by C. R. Baldwin), New York, Metropolitan Museum, 1974.

Cent ans d'Impressionisme (text by G. Bazin and J. Rewald), Paris, Galérie Durand-Ruel, 1974.

R. Brettell, et al., *A Day in the Country: Impressionism and the French Landscape,* Los Angeles County Museum of Art, 1984.

Charles S. Moffett, et al., *The New Painting, Impressionism, 1874–1886,* San Francisco, Fine Arts Museum, 1986.

Claude Monet, 1840–1926

Monet embodies Impressionism. The other painters who made up Impressionism's fluctuating ranks were swayed by his compelling example, but followed his lead for relatively brief periods and merely up to a point. Only in Monet's own work did Impressionism attain the character of a consistent method, fully explored in all its dimensions; only in his long career can it be seen as a style progressively evolving according to its inner logic. The strength of his talent and the tenacity of his will predestined him for leadership. Single-minded, hard, egotistical, and enduring, he pursued his goal and carried with him other, more pliant temperaments—"a man in a crowd of eunuchs," in Zola's rather vehement phrase.

Monet's art was entirely based on actual experience, owing less to tradition than that of any other major artist of the time. Millet, Manet, and Degas had started in the museum and built on their knowledge of the old masters. Even Courbet, for all his rebellious posture, was steeped in tradition. Monet never had to react against idealism, romanticism, and history painting; they seem not to have existed for him. Indifferent to religious or humanistic notions, he had no use for symbolism and allegory, was bored by poetry, and kept his political opinions (republican and anticlerical) strictly separate from his art. His roots went back to early-nineteenth-century naturalism, but only to that central strain in it that was concerned with direct, objective observation; he did not share the Barbizon painters' elegaic moods and cosmic exaltations. Though only a few years younger than Manet and Degas, he belonged to a different generation, one no longer touched by romanticism. His modernity was matter-of-fact, devoid both of Baudelairean glamour and of the stylistic sophistication of Manet and Degas.

Claude Monet was born in Paris in 1840, the son of a small business man. About 1845, the family moved to Sainte-Adresse, a suburb of Le Havre, where the elder Monet entered into a partnership with a brother-in-law, M. Lecadre, who was in the wholesale grocery and ship's provisions trade. The milieu in which the child grew up was mid-bourgeois, without cultural or artistic pretensions.

While still a schoolboy, Monet gave proof of a precocious talent for drawing. He particularly delighted in drawing caricatures, in imitation of illustrations in popular comic journals. Some of his works, exhibited for sale in a local frame shop, attracted the attention of Eugène Boudin (1824–1898), a painter of land-

scapes and seascapes who, still quite young himself, was working along the coasts of Normandy. Boudin encouraged the boy, and advised him to try sketching out of doors. Monet was at first unimpressed by Boudin's unpretentious beach scenes, since he had acquired a taste for more showy work, but after he had accompanied Boudin on some sketching jaunts his eyes were suddenly opened to the beauty of truthful painting. This, he later said, decided his destiny.

In 1858, at the age of eighteen, Monet submitted a painting to an exhibition sponsored by the town of Le Havre. The following year, he applied for a grant from the municipality to enable him to study in Paris. His application was denied, but with some help from a sympathetic aunt, and his father's reluctant consent, he went to Paris on his own, supporting himself for the time being with money he had earned by his caricatures.

Armed with letters of introduction from Boudin, he established himself in Paris, frequented the free Académie Suisse to draw the model, visited the Salon —where he admired the work of Daubigny, Troyon, and the Barbizon painters —and was an occasional guest at the Brasserie des Martyrs, the favorite haunt of Courbet's followers. He met the animal and landscape painter Constant Troyon, who, surprisingly, advised him to become a pupil of Couture, the former teacher of Manet. With a band of young painters encountered at the Académie Suisse (and perhaps including Pissarro), he went on a landscaping excursion to Champigny-sur-Marne.

Called up for military service in 1861, Monet chose to serve with the Chasseurs d'Afrique in the French colony of Algeria. Here he fell sick with typhoid fever and was sent home, and discharged, thanks to his family's intervention, after a year's service. During his convalescence, he painted out of doors in the area of Le Havre, sometimes with Boudin and with a new acquaintance, the Dutch-born landscape painter J. B. Jongkind, whose luminous, open-air water-color studies made a strong impression on him. He was later to say of Jongkind that he "was my *real* master, he opened my eyes."

The family now agreed to allow Monet to become a painter and promised to support him financially, provided that he put himself into the hands of a recognized master. A cousin by marriage, the genre painter Toulmouche, was appointed his guardian in Paris. In the winter of 1862–63, Monet became a pupil of Charles Gleyre, a Swiss-born history painter of eclectic, classicizing bent, who had little to offer him, but in whose studio he made the acquaintance of Frédéric Bazille, Alfred Sisley, and Auguste Renoir—the original core of the future Impressionist group.

Among Monet's earliest preserved paintings from 1862–64 are several still-lifes and flower arrangements, practice work painted in the studio, in which there appear few traces of his experience with landscape painting, or of the influence of Boudin and Jongkind. The solid materialism, somber tonalities, and fairly stiff handling of, for example, the *Still-Life with Carafe, Wine Bottle, and Bread* (ca. 1862, Chicago, Leigh Block Collection) and the *Still-Life (Quarter of Beef)* (ca. 1864, Louvre, Musée d'Orsay) rather reflect the impression that Courbet's Realist manner had made on him. He was to become personally acquainted with Courbet in 1864.

In the spring of 1863, Monet, accompanied by his friend Frédéric Bazille, painted for the first time in the Forest of Fontainebleau. The following spring, he again worked in the forest, lodging at Chailly, in the company of Bazille, Renoir, and Sisley, his fellow pupils in Gleyre's studio, which the master had decided to close once and for all in December 1863. *Road in the Forest with Wood Gatherers* (1864, Waltham, Mass., Brandeis University Art Collection) closely resembles in motif and style scenes of peasant labor by Millet, suggesting that Monet was familiar with Millet's work, although he does not seem to have met him. *The Road from Chailly to Fontainebleau* (1864, Lausanne, private collection), a study painted on the spot, in its overall lightness and its cool freshness of color indicates Monet's relative independence of the Barbizon tradition at this early stage. It is entirely unlike Rousseau's forest scenes, with their masses of bituminous dark, their sparkly, high-lit foliage and spots of bright sky. The precise observation of a particular time of day, in the color of the light and the angle of the cast shadows, already show Monet preoccupied with transient phenomena in nature.

In the summer and fall of 1864 Monet returned to Normandy, to paint along the Seine estuary in the vicinity of Le Havre and Honfleur, where he was joined by Boudin and Jongkind. The main product of this painting campaign was several open-air studies of the harbor area and of a street in Honfleur: *Rue de la Bavolle, Honfleur* (1864, versions in the Boston Museum of Fine Arts and the Mannheim Kunsthalle). During the following winter, Monet—on bad terms with his family and therefore penniless—shared Bazille's studio in Paris, and here worked up the open-air sketches of the previous summer into two fairly large exhibition pieces: *The Seine Estuary at Honfleur* (1865, Pasadena, Norton Simon Foundation) and *The Pointe de la Hève at Low Tide* (1865, Fort Worth, Kimbell Art Museum). Monet, as a matter of course, still made a distinction between his summer and his winter work, i.e., between the studies that he painted directly from nature and the pictures destined for exhibition, arranged and enlarged revisions of the original studies, which he painted in the studio. His method was one that landscape painters had used since Constable's time, with the difference that Monet's final canvases preserved the main features of his preliminary studies with relatively little change. The outdoor studies appear more unified in their consistent breadth of handling and overall luminosity. The fully developed pictures are of comparatively tight execution, less harmonious in general effect and slightly labored in detail: one senses in them Monet's effort to meet the public's expectation of finish. Yet even in their somewhat hardened final versions, these two sea- and landscapes offer splendidly vivid touches of visual realism, as for instance in the watery glitter of the beach in the foreground of *Pointe de la Hève*. Exhibited at the Salon of 1865, they were praised by the critics for their subtlety of tone, their justness of observation, their fresh "sincerity."

In his early forest scenes and seaside views, Monet alternated between two main traditions of French landscape naturalism—the terrestrial of the Barbizon School, and the marine of the Channel coast (stemming from Bonington, Huet, Isabey, and carried on in his day by Boudin and Jongkind). These two strands, the one earthbound, the other wedded to light and air, were ultimately to merge

in Monet's mature work and to shape, between them, the course of Impression-
ism. On his coastal landscapes, the influence of Jongkind was for the time being
paramount, outweighing that of Boudin. In his forest views, Monet seems closer
to Corot and Daubigny. But he had not yet committed himself entirely to land-
scape; his heart at the moment was set on large-scale figure painting, with the
Salon in view and the example of Courbet and Manet before him.

By the late spring of 1865 he was back in the Forest of Fontainebleau,
projecting a very large composition of picnickers, modishly dressed, in a summer
woodland setting. His immediate inspiration was Manet's *Déjeuner sur l'herbe,*
which he had seen in 1863, but he had in mind to produce a painting of truly
monumental dimensions, something on the scale of Courbet's *Funeral at Ornans*
and *The Studio.* His ambition was to achieve a work of a kind that had no
precedent: a wholly modern subject, composed of life-size figures, giving the effect
of a scene taken directly from common reality and preserving the freshness of a
landscape painted out of doors.

He began by painting studies of the forest setting, choosing a view down
the long perspective of the road from Chailly to Fontainebleau, the so-called *Pavé
de Chailly,* seen at different times of day (versions in the Louvre and in Copenha-
gen, Ordrupsgaard Samling). He then painted, still out of doors, individual figures
of his composition (a study of the two figures at the extreme left of the group of
picnickers is in the Washington National Gallery). In September, he completed
(in the studio) a large *Study for the Déjeuner sur l'herbe* (1865, dated 1866,
Moscow, Pushkin Museum), which shows five crinolined women and their fash-
ionably dressed escorts standing or reclining, loosely grouped, around the sun-
dappled tablecloth on which their meal is spread. The scene contains no echoes
from traditional art, it seems casually uncomposed. The integration of the figures
in the ample space and in the light of their setting is managed with apparent ease.
The colors, laid on in broad, undisguised touches, reinforce the sense of daylight
filtering through foliage and animating the view with its shifting scintillations.

Monet started work on the enormous final canvas—measuring roughly 15
\times 20 feet (4.8 \times 6.2 m.)—during October of 1865, in Bazille's Paris studio. He
labored over it all winter, hoping to submit it to the Salon of 1866, where it would
undoubtedly have created a sensation, if only for its provocative size. But what
had worked well in the sketch now confronted him with insurmountable difficul-
ties on the large canvas. The animation and coherence of the brushwork did not
survive translation into monumental scale. What had been flickers of light in the
sketch grew into inert patches of color; the figures stiffened, the fluent life of the
sketch hardened into a kind of solemnity, inappropriate to the spirit of the subject.
In mid-March Monet stopped, and left the canvas unfinished, most noticeably in
the faces and hands. Rolled up and stored away for many years, it was partly
ruined by damp, and now survives in two fragments—a tall, vertical strip, con-
taining the three figures at the left side of the composition (Louvre, Musée
d'Orsay), and a roughly square portion cut from its center, *Déjeuner sur l'herbe*
(fragment, 1865–66, Paris, Eknayan Collection). The broad, powerful patchwork
of colors shows Monet struggling to reconcile naturalist effect with the stylistic
requirements of mural size. The unfinished canvas nevertheless contains passages

of great subtlety, such as the extended arm of the central figure, whose warm skin is visible through the gauze of its sleeve.

Having failed in this heroic effort, but still determined to participate in the forthcoming Salon, Monet rapidly improvised (in four days, according to some accounts) a life-size portrait of Camille Doncieux, his companion and future wife. *Camille (The Green Dress)* (1866, Bremen, Kunsthalle) is a splendidly solid piece of materialist realism, worthy of Courbet, who at this time aided Monet with his encouragement. The darkness of the background, into which her fur-trimmed coat seems to disappear, accentuates Camille's pale, masklike face and the splendid silken flow of her green skirt. While moving away, she turns her head as if to face the viewer, in an attitude which, though quite natural, dramatically animates this portrait—in striking contrast to Manet's serene *Woman with Parrot,* which also figured at the Salon of 1866. Monet's picture won favorable reviews from the same critics who savagely denounced Manet's entry.

Monet meanwhile had not given up his project of painting a large figural composition out of doors. In the late spring of 1866, he took a house with garden in Ville d'Avray, a Paris suburb, and here began *Women in the Garden* (1866–67, Louvre, Musée d'Orsay), resuming in a picture of smaller dimensions (about 8½ × 6½ ft. [2.6 × 1.9 m.], or roughly the size of Manet's *Déjeuner sur l'herbe*) the problem that he had set himself in his earlier colossal canvas. The composition consists of four women in light summer costume grouped asymmetrically, in a revolving pattern, around a tree beside a garden path. Camille posed for all the figures in the painting, which was executed in the sunlight, out of doors (Monet had a trench dug in the garden, into which he lowered the canvas while painting its upper portions). The reflection of sunlight from the white dresses is extremely bright: flattened by the light against the dark foliage, the figures form an animated design. The fusion of colors—including some fairly strong greens in the half-shaded face of the main figure and violet in the shadows that fall on her dress —bears witness to Monet's intensive and unprejudiced study of the effects of daylight. Though the idea of carrying out naturalist experiments with light and color in a picture so large and formally composed involved serious difficulties, and perhaps a contradiction, Monet in his *Women in the Garden* achieved a solution more radical than anything attempted in this direction by either Courbet or Manet. It is not surprising that the Salon jury of 1867 should have refused it.

The rejection was a serious setback for Monet, who had entertained high hopes for his picture's success in the year of the Paris World's Fair. He exhibited it, instead, in the window of a picture dealer, then sold it to Bazille.* His repeated disappointments over large-scale figure paintings now prompted Monet to abandon these strenuous, lengthy, and therefore costly efforts, and to devote himself to smaller, more spontaneous outdoor painting. The rejection thus had a far-reaching effect on his further development.

In the spring of 1867, he set up his easel on a balcony on an upper floor

*In 1876, after Bazille's death, it was acquired by Manet, after whose death Monet bought it back. In 1921, the French government purchased it from him for 200,000 francs, to atone for the blunder of the jury of 1867.

of the Louvre to paint a series of cityscapes, directing his attention equally to the broad, atmospheric vistas of distant skylines under clear or lightly clouded skies, truthful evocations of city weather, and to the busy foreground of traffic in the streets below him. In these panoramically inclusive views—such as *The Garden of the Princess* (1867, Oberlin College Museum), *The Quay of the Louvre* (1867, The Hague, Gemeentemuseum), and *Saint-Germain l'Auxerrois* (1867, West Berlin, National Gallery)—the individual forms are reduced to color patches, approximate in form but very precise in hue and tone. The bustling flow of life within the permanence of an architectural setting provides the drama of these pictures: over the abiding landscape of the city, with its churches and clustered roofs, the transient daylight works its changes, while the even more fleeting movement of pedestrians and vehicles dissolves tangible reality into a flow of indistinct spots.

The year 1867 was one of great emotional and financial stress for Monet. Camille was pregnant, but Monet's father adamantly refused financial aid. Totally out of funds, Monet sought shelter with his family at their seaside home in Sainte-Adresse, leaving Camille in Paris. Painting in the bright summer sun on the nearby beaches—*Beach at Sainte-Adresse* (1867, Chicago, Art Institute)—he suffered a spell of eye trouble.

Terrace at Sainte-Adresse (1867, New York, Metropolitan Museum) is a summer idyll reminiscent of Boudin's beach scenes. The view is taken downward, from the Monets' seaside house, across its garden terrace on which Monet's father and other relatives enjoy the afternoon sun, toward the Channel, alive with marine traffic. The flowers growing in the foreground are painted as vivid dots of pure color. The terrace with its slanting shadows is rendered in emphatic perspective, while the distant sea—framed by poles with fluttering flags—forms a wall of opaque, non-reflecting blue. The picture combines a strongly patterned, "Japanese" design with a lively texture of separate color touches, suggestive of distance, atmosphere, and light in a manner that foreshadows Impressionism.

In August, Camille, who had been left in the care of a medical acquaintance, gave birth to a son, Jean. Unable or unwilling to marry Camille, and denied parental assistance so long as he maintained this irregular bond, Monet struggled to support his companion and their child. During 1867–70 he was forced to live a migratory life, moving from one rural lodging to the next, repeatedly evicted for nonpayment of rent, hounded by creditors, and humiliated by the necessity of having to pester his friends, chiefly Bazille, for the money he needed to keep himself and his small family alive.

Early in 1868, he completed two marine paintings for the Salon, only one of which was accepted. Later that spring he stayed briefly in the village of Gloton, near Giverny, where Zola had found him rooms. Here he painted *The River (The Seine at Bennecourt)* (1868, Chicago, Art Institute), which marks a further step toward Impressionism. Sunlit houses and blue sky are reflected in the mirror-smooth flow of the river behind a screen of tree trunks and foliage in whose shadow sits a woman in light summer dress. The image is entirely composed of spots or areas of strong color, without contours or tonal modeling. The subject,

with its mood of summer vacation, its hint of excursion and sport, is characteristic of what would come to be recognized as an Impressionist attitude—suburban and middle-class, descriptive without story, intimate without sentiment or ulterior significance. While the picture gives the impression of being directly taken from reality, it is in fact the product of considerable (studio) revision. The figure of the woman is an improvisation, inserted for compositional reasons into the completed landscape.

The serene cheerfulness of Monet's landscapes of this time does not at all express his actual state of mind. Destitute, unable to sell his work, rejected by his father and a burden to his friends, he did not know from one week to the next whether he would be able to feed and shelter his family. In June of this year, after an eviction, he momentarily lost courage and appears to have attempted suicide. Yet no trace of this despair clouds the sunniness of his paintings. Finally an unprofitable exhibition of several of his seascapes in Le Havre, followed by a forced sale, unexpectedly turned to his advantage. A local collector, Louis Gaudibert, who had bought some of Monet's paintings at the sale for scandalously low prices, sought his acquaintance, offered to compensate him, and commissioned him to paint the portrait of his wife. *Portrait of Madame Gaudibert* (1868, Louvre, Musée d'Orsay) recalls the *Camille,* but is painted in lighter tones of subtly harmonized beiges and grays. A costume piece rather than a portrait in the strict sense, it bears witness to Monet's discriminating eye for women's fashion.

His financial condition now improved, Monet settled somewhat more comfortably than usual at Etretat, on the Normandy coast, where he spent the fall and winter. His pleasure in the unaccustomed security and warmth of family life is reflected in two domestic interiors that he painted at this time, the small, intimate *Dinner* (1868, Zurich, Bührle Foundation), and the large *The Luncheon* (1868, Frankfurt, Staedelsches Kunstinstitut), centered on the brilliantly lit, nicely appointed table, covered with attractive edibles, behind which Camille attends to baby Jean, while a well-dressed visitor leans against the curtained window, and a uniformed maid (surprising touch!) emerges from the kitchen door. The composition, based on an obliquely downward angle of view, is discreetly managed in such a way as not to disturb the casual realism of the scene. The execution, in broad, flat touches of relatively dark but strong colors, still owes something to Courbet, but at the same time expresses a more finely nuanced, sensuous relish that is entirely Monet's own. Submitted to the Salon of 1870, the picture was refused.

During the winter of 1868–69, Monet painted snow landscapes out of doors, as he had already done two years earlier, producing one great masterpiece, *The Magpie* (1869, French private collection), a study of afternoon light on fresh-fallen snow, traversed by a snow-covered fence with a gate on which sits the bird, a spot of dark. Unlike Courbet's winter pictures, with their massive loads of white, Monet's *Magpie* entirely avoids the non-color of white and delivers its brilliant illusion by means of shadows of the most tender blue and illuminated passages of very light yellow and pink. Their extraordinary precision of color

notation, achieved by intuitive approximation rather than any system or "science," causes Monet's landscapes of this period to appear as the crowning achievements of a naturalist tradition that goes back to Constable.

Monet sent this picture to the Salon of 1869, together with a seascape. Their rejection came as a serious blow, for all his recently earned money was now spent. Bazille hospitably lent him his Paris studio, and in the evenings Monet shared in the conviviality of the Café Guerbois, a rather quiet witness to the verbal fireworks ignited by Manet's and Degas's more assertive friends.

For the summer, he settled his family at Saint-Michel, near the riverside suburban resort of Bougival, some five miles west of Paris. Renoir lived nearby with his parents and occasionally brought food to Monet, who, in begging letters to Bazille, described his situation as desperate: "no bread, no wine, no fire to cook on, and no light." Monet also lacked paints, a circumstance that threw him into a rage of frustration, for he had plans for a large outdoor scene of holidaymaking at a riverside bathing establishment and restaurant known as La Grenouillère (literally, "Frog Pond," though *grenouille* also had the slang meaning of "tart"). Two sketches for this project survive; a third was destroyed in Berlin during World War II. The large final canvas, which might have become the sequel to *Déjeuner sur l'herbe,* was evidently never begun.

The surviving sketches for *La Grenouillère* (1869, New York, Metropolitan Museum, and London, National Gallery) show groups of bathers and elegant strollers at a distance, seen across a wide foreground of rippling water on which empty rowing boats are bobbing. In the cool, encroaching shade of late afternoon, the water has taken on a blueish, silvery gloss, giving an extraordinarily convincing effect of liquidity. Beyond the river, a screen of trees reflects the warm light of the setting sun. The brushwork is large and undisguised, the colors applied in broad, abrupt touches, but the relationships of colors and tones are so exactly observed that despite its surface roughness the picture compellingly gives the sense of an actual experience. The terse concreteness and truth of Monet's work becomes apparent when it is compared to Renoir's studies of La Grenouillère, painted from virtually the same spot and at the same time, which seem by contrast fuzzily insubstantial.

It is important to realize that even at this time, when he had so nearly achieved what has come to be called the Impressionist style, Monet still distinguished between preparatory studies from life, such as the various sketches of La Grenouillère, and their final synthesis in a fully realized exhibition picture (of which *The Luncheon* of 1868 is an example). It was the rejection of this last painting by the Salon jury of 1870 that perhaps completed his disillusionment with the Salon system, and hence with the tradition of the "finished" studio picture, making him concentrate on paintings taken directly from nature and carried to a point of sufficient completeness out of doors.

During the winter of 1869–70, Monet continued to live and work at Saint-Michel near Bougival, occasionally painting in the company of Pissarro, who lived in Louveciennes close by—*The Road to Louveciennes, Effect of Snow* (1870, Chicago, private collection). Both his Salon entries were rejected (causing Daubigny, a member of the jury, to resign in protest), but Monet's likeness was present

at the Salon, in Fantin-Latour's *A Studio in the Batignolles Quarter* (1870, Louvre), which shows Manet at his easel, surrounded by friends and admirers, among them Monet, Renoir, and Bazille.

In June, Monet married Camille in a civil ceremony, with Courbet as one of his witnesses. Soon afterwards he stored his canvases with Pissarro at Louveciennes and—having received a modest dowry—went to spend the summer at the seaside resort of Trouville in Normandy. Here he encountered Boudin, and accompanied him to the beaches and boardwalks, to paint in the breezy out-of-doors. *Camille Monet on the Beach at Trouville* (1870, London, National Gallery) is one of a group of small, very broadly painted portraits of Camille in summer dress and with sun umbrella, seated on the beach in brilliant sunlight. *Roches Noires Hotel at Trouville* (1870, Louvre, Musée d'Orsay) turns the horizontal frieze format typical of Boudin's beach scenes into steep verticality and deep perspectival recession, lending to this view of a fashionable boardwalk a liveliness further intensified by the flutter of flags against the fresh blue sky.

On July 19, France declared war on Prussia. Unlike Degas and Manet, Monet avoided military duty. When Prussian armies invaded France after the defeat at Sedan, he left for England, joined some time later by his wife and son. In London, he encountered Pissarro and Daubigny, among other French refugee artists. Daubigny introduced him to his dealer, Paul Durand-Ruel, who had been the champion of the Barbizon painters and was to become the tireless promoter of the Impressionists. Through Durand-Ruel, Monet managed to exhibit some of the canvases that he had brought with him from Trouville, but his work was little noticed. Together, Monet and Pissarro looked at paintings and watercolors by Constable and Turner, were impressed by them, but found much to criticize in the English painters' excessive romanticism and their failure to introduce color into shadows. The not very numerous pictures of Monet's English exile are marked by an atmospheric breadth and grayness, seen, for example, in *Green Park* (1871, Philadelphia Museum of Art) and *The Thames and the Houses of Parliament* (1871, London, National Gallery) that evidently reflect his observations of London's climate.

He spent the summer in Holland, in the town of Zaandam, near Amsterdam, perhaps in the company of Daubigny. Of notably stronger and warmer color than his English views, Monet's Dutch townscapes show much experimental variety. Two distinct manners appear in them: the definition of forms by means of broad, flat strokes of rather strong color on the one hand, and on the other the suggestion of light and atmosphere by means of small scintillations of color, inscribed on the canvas in rough and agitated touches. Several of his Dutch views are dated 1872, although he had returned to Paris by the end of 1871, and it has been suggested that some of his pictures of Amsterdam may date from a later stay in 1874.

Blue House at Zaandam (1871, London, private collection);
Canal at Zaandam (1871, Louvre, Musée d'Orsay);
The Zuiderkerk at Amsterdam (1871?, Philadelphia Museum of Art).

By mid-November of 1871, Monet was back in Paris. Together with Boudin, he made the courageous gesture of sending New Year's greetings to Courbet, who had just been released from prison. The rapid postwar recovery of France was having a stimulating effect on the art market. Monet's sales, to a growing number of private collectors and to the dealer Durand-Ruel (who bought thirty canvases in 1872 and thirty-four in 1873), earned him a good income and enabled him to rent a comfortable house with garden at Argenteuil, an industrial suburb on the Seine northwest of Paris. Here he was to remain until 1878, in modestly luxurious circumstances, keeping two servants and a gardener. He worked much along the Seine and in his own garden, often in the company of Renoir, Sisley (1872), and Manet (1874).

In the spring of 1872, he traveled to Rouen, where he painted an unusual industrial landscape, *Stream at Robec* (1872, Louvre, Musée d'Orsay), an "ugly" scene of factories beside a polluted stream, recording it objectively, without a note of protest. The following year, during a visit to Le Havre, he painted from a window overlooking the harbor a rapid study of the early morning sun glowing orange through a blueish fog shrouding the vague forms of masts, cranes, and factory chimneys. *Impression: Sunrise* (1873, though dated 1872; Paris, Musée Marmottan),* with its transparent tones and faint, silhouetted shapes, is not very typical of Monet's work of the time either in motif or in treatment. It recalls Whistler's *Nocturnes,* several of which were shown in 1873 by Monet's dealer, Durand-Ruel. When exhibited in its turn in 1874, the picture's provocative sketchiness and its title (intended to suggest that it should not be seen as a description of its subject, but as the record of a momentary visual sensation produced by the sun rising through mist) drew the critics' wrath and led to the coining of the derogatory label "Impressionism" to describe the work of Monet and his friends.

At Argenteuil, the proximity of the Seine provided Monet with an inexhaustible abundance of subjects. Many of the roughly 260 paintings produced during his six-year stay are either riverside landscapes, dominated by tall skies, or outright waterscapes in which the drama of the seasons, with its changes of light and weather, is mirrored in the flow of the river, as, for example, in *The Seine at Argenteuil* (1872, Louvre, Musée d'Orsay), and *The Promenade, Argenteuil* (1872, Washington, National Gallery). The marriage of sky and water, the dissolution of matter in liquid reflections, and its transformation into splinters and scintillations of colored light deeply suited his way of seeing and painting. He adapted his brushwork to the capture of transient optical sensations, varying the shape, thickness, and size of his touch, sometimes dotting, sometimes wiping his colors, and working them into lively textures. In order to be able to paint directly on the water, in every kind of weather, he outfitted a studio boat, perhaps in imitation of Daubigny's famous floating studio.

Tokens of affectionate family life and cheerful domesticity appear discreetly in some of the landscapes and garden scenes of the Argenteuil period. *The*

*The picture, stolen in 1985, was still missing in 1986, at the time of this writing.

Luncheon (1873, Louvre, Musée d'Orsay), a painting of exceptionally large size which Monet described as a "decorative panel," represents a table casually but elegantly set in the garden: it is the sunlit, out-of-doors pendant to the indoor *Luncheon* of 1868 (Frankfurt). Little Jean plays by himself beside the deserted table, near which a handbag, a sun umbrella, and a straw hat suspended from a branch indicate the recent presence of Camille, who may be one of the two women visible in the distance behind a bed of geraniums. *The Field of Poppies* (1873, Louvre, Musée d'Orsay) shows Camille followed by Jean walking through a sea of tall grass dotted with a profusion of wild poppies. In one of the last of a series of garden pictures of Argenteuil, *Gladioli* (1876, Detroit, Institute of Arts), Camille, dressed in blue and holding a green umbrella, stands behind a bed of flowers, a fireworks of red and yellow dots bursting from a rough pattern of green slashes. While still descriptive of light and space, the picture surface has become a texture of distinct color accents, equally large and bright regardless of their descriptive function or their position in space.

During the latter part of 1873, Monet and a group of like-minded artists —essentially the circle of the Café Guerbois, but without its principal, Manet— began to plan an independent exhibition that would offer to the public a fair showing of the kind of modern and "naturalist" painting not likely to be accepted by the official Salon. Monet took a leading part in the preparatory work of recruitment and negotiation, strongly seconded by Degas, Pissarro, and Renoir. The independent exhibition, scheduled to open shortly before the official Salon, was to be understood as a deliberate gesture of dissent, not merely a kind of Salon des Refusés. Its participants were to refrain from submitting work to the regular Salon. Suitable premises for the exhibition were found in a gallery on the fashionable Boulevard des Capucines recently vacated by the photographer Nadar. *View of the Boulevard des Capucines* (1873, Kansas, William Rockhill Nelson Gallery of Art), and its pendant in the Pushkin Museum, Moscow, present the view from Nadar's gallery at the time of Monet's preparations for the group show.

Held in April and May of 1874, the exhibition in the Boulevard des Capucines included 165 paintings. Its principal contributors were Monet (who showed twelve pictures), Degas (ten), Renoir (six), Pissarro (five), Cézanne (three), and Berthe Morisot (nine). Their work constituted a core around which was grouped that of a very diverse assortment of artists, old and young, known and unknown, by no means all of whom would later be classified as Impressionists. Manet and Jongkind refused to show with their friends. Press criticism was almost wholly hostile. A satirical review of the exhibition by Louis Leroy, published in the humorous periodical *Charivari,* led to the sarcastic dubbing of Monet and his friends as "Impressionists," the term being taken from Monet's *Impression: Sunrise.* The catchy, half-appropriate designation stuck, and was in time accepted by some of the artists for convenience' sake. About 3,500 visitors saw this first Impressionist exhibition (compared to the Salon's 450,000). Some paintings were sold, but the venture ended with a painful loss for its organizers.

During the following summer, Monet painted at Argenteuil, frequently in the company of Renoir and Manet, and of one of his neighbors, Gustave Cail-

lebotte, a wealthy engineer and shipbuilder and the owner of several yachts. A highly gifted painter, Caillebotte became an ardent collector of the work of Monet and Renoir, and one of their main supporters during the crisis years of the later 1870s. Both Manet and Renoir painted portraits of the Monet family in their garden at Argenteuil; Manet during this summer painted *Monet in His Painting Boat* (Munich, Neue Pinakothek). This was one of the most productive periods in Monet's life, and the one in which he most decisively influenced his friends, even the somewhat skeptical Manet. Many of his paintings of this time have a special, joyous brightness of color and intensity of light. His naturalism reached its most sensuous refinement in these evocations of the river's liquid silver at Argenteuil, with its reflections of clouds and sails, and its border of sun-warmed foliage on the far shore.

A road bridge and a railway bridge—*The Road Bridge at Argenteuil* (1874, versions in the Louvre, Musée d'Orsay; Munich, Bayerische Staatsgemäldesammlung; Washington, National Gallery; etc.); *The Railway Bridge at Argenteuil* (1874, versions in the Louvre, Musée d'Orsay; Philadelphia Museum of Art [Johnson Collection]; etc.)—were the two most conspicuous man-made features of the riverscape at Argenteuil, terminating the view to the east and west. Monet had always tended to introduce stable, rectilinear forms—roads, buildings, bridges—into the compositions of his landscapes. The bridges of Argenteuil, abiding presences amidst the flow of water and drift of cloud, put a limit to the exuberant naturalism of his river views. Unlike conventional landscape painters, who rejected railways as ugly intrusions into nature, he accepted them, with his customary observant frankness, not to display his modernity, but because they were an undeniable part of his landscape and of his life, dependent as he was on the train connection to Paris. It has become commonplace to interpret signs of industrial civilization in Monet's landscapes as deliberate social comments, stern reminders of modern realities and their threat to "bourgeois" summer peace. But that is a tendentious exaggeration. To his unprejudiced eye, steel girders and smokestacks were no more offensive or portentous than the steamships with which he animated the horizons of his seascapes.

An instance of Monet's objectivity and detachment in the face of fairly grim reality is his *Unloading Coal* (1875, Paris, private collection), a scene of hard industrial labor beneath the dark iron span of a bridge at Asnière, near Argenteuil. The shadowy silhouettes of the stevedores form a pattern of repeated verticals against the diagonals of the gangplanks. It is a somber scene, but its treatment is entirely formal, almost decorative in effect, and lacking in any overtly social message.

Yet the overcast skies and confined, dark-toned landscapes that frequently occur among Monet's works of 1875–78 may indeed reflect a worsening of his situation and mood. France's prosperity of 1872–73 was followed by a sharp downturn in 1874. Durand-Ruel stopped buying, and Monet's financial situation became precarious once again. The artists of the Impressionist group tried to bolster their revenues by courting private collectors and organizing public sales. One such sale, arranged by Monet, Renoir, Sisley, and Morisot in March 1875, produced mediocre results. At another, in April 1876, Monet managed to earn

2,020 francs, a godsend in an otherwise lean year. A second public exhibition of the Impressionist group in the spring of 1876—comprising 252 paintings by twenty artists, including Monet (eighteen), Degas (twenty-four), Pissarro (twelve), Renoir (fifteen), Sisley (eight), and Morisot (fifteen)—attracted fewer visitors than the first and drew scathing reviews, but Monet sold a large picture of Camille in Japanese costume—*La Japonaise* (1876, Boston, Museum of Fine Arts)—for the surprisingly large sum of 2,000 francs.

Among the collectors showing an interest in Monet's work at that time was the wealthy textile merchant Ernest Hoschedé, who owned a château at Montgeron. On Hoschedé's invitation, Monet spent the fall and early winter (1877) at Montgeron, painting four large decorative panels for his patron. He may have become the lover of Mme Hoschedé at this time. During the following winter (1877), he took a studio in Paris, and here began to paint a series of views of the Saint-Lazare railway station, well known to him as the terminal of the line that served Argenteuil. Manet had used the overpass leading to this new station as the setting for his *The Railway* (1873), and Monet's friend and patron Caillebotte had recently painted figures posed before its steel girders. Monet approached the station as a landscape painter, setting up his easel in the switchyard amidst moving engines and clouds of steam, or entering the great hall of the station itself to observe the arrivals and departures of the smoke-shrouded locomotives. *The Saint-Lazare Railway Station* (1877, Louvre, Musée d'Orsay) shows the vast structure of steel and iron filled with filtered noonday sunlight, while the companion painting (in the Fogg Art Museum, Cambridge, Mass.) presents the same view in the blueish light of an overcast morning or late afternoon.

The series of railway station pictures is the urban, industrial counterpart of the rural and natural riverscapes that Monet had painted in Argenteuil. Seven of his Saint-Lazare views were shown at the Third Impressionist Exhibition, held in 1877, and were greeted with enthusiastic praise by Zola: "one can hear the rumble of the oncoming trains and see the smoke billowing beneath the vast canopy. That's where painting is today . . . our artists must discover the poetry of railway stations, as their fathers found that of forests and rivers." But for Monet, these were to be a farewell to industrial and technical modernity; nothing of the kind occurs in his later work.

The bankruptcy, in August 1877, of his patron Hoschedé speeded the decline of Monet's finances. Pressed by creditors and threatened by property seizures, he gave up his house in Argenteuil, leaving behind, as security to cover his debts, the rolled-up canvas of his *Déjeuner sur l'herbe.* At the beginning of 1878, he settled in Paris, where, in March, Camille gave birth to their second son, Michel. Her health, already weakened, now deteriorated rapidly.

During the summer, Monet painted in the city. The occasion for the profuse display of tricolor flags seen in *Rue Saint-Denis on the National Holiday, June 30, 1878* (Rouen Museum), whose flutter fills the narrow perspective of the street, was the celebrations accompanying the World's Fair of 1878, the first such festivity since the war of 1870–71. Manet at this time painted a rather similar view of a flag-bedecked street.

In the late summer, Monet moved his family to the village of Vetheuil

overlooking the Seine, where they were joined by M. and Mme Hoschedé, their six children, and two servants. Distracted by this uncomfortably crowded domesticity—eight children and four adults, not counting servants—Monet barely paid attention to his participation in the fourth group show of the Impressionists, in April 1879, letting Caillebotte assemble his entry of twenty-nine pictures for him. Camille's condition steadily worsened; Mme Hoschedé managed the house and both families, while Monet, unable to paint, made desperate efforts to raise money from friends and patrons. On September 5, Camille died. Monet, mourning at her bedside, surprised himself "in the act of automatically searching for the sequence and gradation of colors that death had imprinted on the immobile face. Tones of blue, yellow, gray. . . ." And distracted from his grief by his painter's eye, he painted *Portrait of Camille on Her Deathbed* (1879, Louvre, Musée d'Orsay), as a faint vision of an emaciated face, beneath gauzy veils over which reddish lights and pale blue shadows play.

During the extremely severe winter that followed, Monet painted still-lifes indoors, until a spectacular thaw on the frozen river in early 1880 provided him with an absorbing new motif, the *Breaking Up of the Ice,* of which he painted a series of studies (versions in the Louvre; Lille Museum; Gulbenkian Foundation; and elsewhere) in a restricted range of muted colors. Sky and river merge around vaguely indicated shorelines in these loosely structured views, which show no signs of human life. Expanses of grayish, glassy-smooth water are paved over with ice floes, indicated by touches of heavy pigment that suggest the body and texture of these floating fragments.

In the winter of 1879–80, Monet decided to abstain from participation in the forthcoming Fifth Impressionist Exhibition and, instead, to submit his work to the official Salon, following the example of Renoir, Sisley, and Cézanne, who had already submitted work to the Salons of 1878 and 1879, abrogating their agreement of 1874 to shun these exhibitions. Of Monet's entries, two large river views, only one, *Lavacourt* (1880, Dallas Museum), was accepted, and badly hung. While still considering himself as one of the Impressionists, he admitted that the bonds of friendship and artistic practice that bound him to the group had been loosened. His life had changed since Camille's death. Mme Hoschedé now managed with a competent hand both their domestic economy and their large joint families. The sales of his paintings were increasing, thanks to Durand-Ruel's efforts. A new order and stability gradually came into his life, allowing him the comforts and self-indulgences that had always been important to him. The painting *Monet's Garden at Vetheuil* (1881, Washington, National Gallery) offers a glimpse of his new domesticity and brightening mood. It shows the stairs of his back garden leading to the river below, framed by a profusion of sunflowers. His younger son, Michel, stands at the top of the stairs, and at their foot Mme Hoschedé's youngest child, Jean-Pierre, who was perhaps Monet's natural son. The picture's large format suggests that it may have been intended for the Salon.

But Monet, beginning to sell more regularly and at better prices through Durand-Ruel, no longer needed the Salon to bring him to the public's attention, and in fact never exhibited there again. He also refrained, once again, from joining

the Impressionist group in their Sixth Exhibition in the spring of 1881. And it was only at the insistence of Durand-Ruel that in 1882 he consented to exhibit once more, for the last time, with the Impressionist group. This Seventh Impressionist Exhibition, from which Degas and his friends had been excluded, was dominated by Monet and his most congenial followers (Renoir, Pissarro, Sisley, and Morisot) and appeared as the purest manifestation of Impressionism to date.

In December of 1881, Monet once more moved his family, this time to Poissy, closer to Paris. But Poissy did not suit him, and after little more than a year he made a final move, in 1883, to what was to be his permanent home, the village of Giverny, further to the west along the course of the Seine, midway between Paris and Rouen. Here he rented a comfortable house with large garden, which he later bought (1890) and around which he created the private landscape that in his last years was to be his favorite painting ground.

The 1880s were for Monet a time of critical redirection and difficult change which he met with characteristic determination, redoubling his experimentation and varying his style. The views he took of landscape motifs became more eccentric, the arrangements and croppings more radical, the colors stronger, and the brushwork more agitated. Throughout the decade, he undertook annual painting campaigns that usually lasted from the late winter into the early fall and nearly always took him to one of France's coastal regions—to Normandy in 1881 (Fecamp and Trouville), 1882 (Pourville near Dieppe), 1883 and 1885 (Etretat); to Brittany in 1886 (Belle-Ile); to the Riviera in 1884 (Bordighera) and 1886 (Antibes). In 1889 he visited, exceptionally, the inland rivers of the Berry region (Creuse Valley).

He reacted strongly to the general visual and emotional character of his chosen sites and adjusted his style—pictorial design, color range, and brushwork —to each. His Norman and Breton rockscapes—*The Cliff Walk, Pourville* (1882, Chicago, Art Institute); *The Customs House, Varengeville* (1882, several versions: Philadelphia Museum of Art; Rotterdam, Boymans–van Beuningen Museum; etc.); and *The Church at Varengeville* (1882, several versions: Washington, Phillips Collection; Houston, H. L. Smith Collection; etc.)—present abrupt, quasi-architectural structures, often seen at very close range, with sudden, plunging

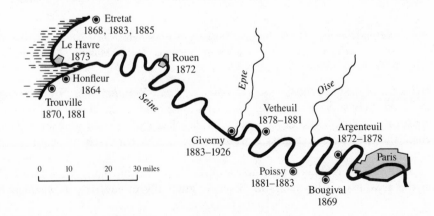

views of the distant sea. Since the dominant visual impression, even of these spectacularly massive features, was one of light and color, and since light and color underwent constant change while Monet confronted his chosen site, he developed the practice of carrying forward five or six canvases of the same motif, working on each for about half an hour and going on to the next as the light changed. This serial technique resulted in several, fairly extensive picture sequences, each recording the progressive transformation of a favorite site by the changing light of day. Among the most impressive of these series are those titled the *Cliffs at Etretat,* one of them centered on the natural arch of the Manneporte (*Cliffs at Etretat: Manneporte,* 1883, New York, Metropolitan Museum and other versions), another on the nearby Needle and Porte d'Aval (*Cliffs at Etretat: Needle and Porte d'Aval,* 1885, Williamstown, Clark Art Institute, and other versions).

The most dramatic of these coastal scenes were painted during a stay, in 1886, among the storm-beaten, rocky promontories of Belle-Ile, a small island off the coast of Brittany. Here it was the raging sea, blue and foam-flecked, breaking against the dark granite of the shore that mainly occupied his attention. Nature in these studies takes the form of an immense conflict of forces: Monet's Belle-Ile paintings—*Rocks at Belle-Ile (La Côte sauvage)* (1886, several versions, Louvre, etc.); *Needles at Port Coton* (1886, several versions, Copenhagen, Ny Carlsberg Glyptotek; Moscow, Pushkin Museum; etc.)—represent what in the eighteenth century would have been called the "energetic sublime." While painting at Belle-Ile, he met, by chance, Gustave Geffroy, who was to become his close friend, sympathetic critic, and biographer.

Very different in structure and color from the rugged coastal scenes of Normandy and Brittany are the paintings Monet brought home from two productive painting excursions to the Mediterranean in 1884, when he worked in the area of Bordighera and Cap Martin, and 1888, when he painted around Antibes and Juan-les-Pins. The effect of the southern sun on the colors of the sea, sky, and distant mountains caused him to shift into a lighter, more brilliant range of azure, cobalt, orange and golden yellow, applying his pigments in small strokes that form a vibrant, even-toned surface. Foreground screens of trees provide contrast and articulation, their trunks and branches frame hazy, sun-drenched distances:

> *Bordighera* (1884, Chicago, Art Institute);
> *Old Fort, Antibes* (1888, Boston, Museum of Fine Arts);
> *Antibes Seen from La Salis* (1888, several versions, Toledo Museum; New York, J. S. Wohl Collection; etc.).

His series of views of the Creuse Valley—e.g., *Eaux-Semblantes at Fresselines on the Creuse* (Boston, Museum of Fine Arts)—painted in the spring of 1889, by contrast are somber and densely material, brushed with excited touches of dark color that powerfully suggest a wilderness of rocks traversed by scintillating streams.

In the intervals between these annual painting campaigns, Monet worked in the area around his home in Giverny, gradually discovering its distinctive

qualities of light and atmosphere. His studies of flowering fields, fruit trees in blossom, and morning mists dissolve material reality into bright color tissues:

Field of Poppies near Giverny (1885, Boston, Museum of Fine Arts);
Spring in Giverny (ca. 1886, Williamstown, Clark Art Institute);
Blossoming Trees at Giverny (1886, London, Courtauld Institute Galleries).

During the 1880s, Monet's work was becoming well known through exhibitions, not only in France but also—thanks to Durand-Ruel's efforts—in Brussels, London, and New York. Monet no longer had to court individual collectors, but was able to consign his paintings in large lots to dealers of his choice. Unsentimental in business matters, he did not spare the loyal Durand-Ruel the pressure of competition from rival dealers, such as Georges Petit and Boussod-Valadon. The prices of his paintings rose rapidly. In 1890, he was able to buy the large house in which he had lived at Giverny for the past eight years. Two years later, he married Alice Hoschedé. His mode of life and work now underwent a marked change. He gave up his long, annual painting trips and began to concentrate on limited motifs encountered in the close vicinity of Giverny.

For a retrospective exhibition that the Galérie Georges Petit gave him in 1889, together with the sculptor Rodin, Monet grouped his recent landscapes in series, by sites—Antibes, Belle-Ile, Creuse—to emphasize the fact that they yielded their full meaning only when seen together, since each gave only a partial and transitory impression of its subject.

In the past, he had often painted multiple versions of a particular view, recording its transformation by varying conditions of weather and light. In the summer of 1890, he started on a more systematic experiment in serial painting, using as his theme a common feature of the agricultural landscape immediately adjacent to his house: grainstacks (French, *meules,* usually mistranslated as "haystacks") in a harvested field. During the following fall and winter, he painted some twenty-five versions of this motif, comprising several subseries, one of them featuring two stacks in perspective view, others single stacks to the left or right, seen close-up or in the middle distance: *Haystack* (actually *Grainstack*) (1890–91, several versions, Boston, Museum of Fine Arts; New York, Metropolitan Museum; Chicago, Art Institute; Zurich, Kunsthaus; etc.). Fifteen of these canvases were shown by Durand-Ruel in May 1891, praised by the critics, admired by the public, and sold within a few days at prices ranging between 3,000 and 4,000 francs.

The significance of the series lies neither in its compositional arrangements nor in its unchanging subject (though recent interpreters have—unconvincingly —described the *Haystacks* as "sheltering forms" symbolizing "man's triumph over time"). Its meaning, or "plot"—for sequentiality makes for dramatic effect and brings into painting a narrative element—is the progressive transformation of a rather simple sight by changes in the color, intensity, and direction of light. Seen as a whole, the series makes a comment on reality, locating it in transient experience rather than permanent objective existence. But perception of the outer world is not purely visual: just as the color of sunlight changes, so does the

emotional state of the perceiving individual. Inward tensions, excitements, lassitudes *color* vision and affect the appearance of reality. In his *Haystacks,* Monet maintained a subtle balance between objective description and emotional expression.

During 1890–91, he produced a second series, in which he traced the effect of light in the course of a day on a line of poplars bordering the meandering Epte River near Giverny: *Poplars Along the Epte River* (1891, several versions, New York, Metropolitan Museum; Philadelphia Museum of Art; London, Tate Gallery; etc.). Fifteen of these canvases were exhibited by Durand-Ruel in 1892. Painted from his floating studio, the slender, regularly spaced stems, silhouetted against the sky and reflected in the water below, form grid patterns of calculated stylistic effect. The formality of these arrangements and their exquisite, nacreous color harmonies give them a decorative quality, with overtones of the then fashionable *art nouveau.*

Monet's third series is the most original in his choice of motif: the reflections of the brightening and waning of daylight, from cool dawn to the orange and blue of sunset, on the Gothic facade of Rouen Cathedral (1892–93, though the canvases are dated 1894; several versions, New York, Metropolitan Museum; Boston, Museum of Fine Arts; the Louvre; Washington, National Gallery; etc.). The series, painted in two campaigns in early 1892 and 1893 (during which Monet changed position twice, moving from a room directly opposite the cathedral to windows somewhat farther to the right), presents the facade at such close range that its deeply furrowed masonry fills the entire canvas. With the movement of the sun across the sky, the facade comes to life in a constantly changing play of light and shadows and in successive waves of color, from deepest blue to dazzling yellow. These colors are applied in small, dense strokes that form a distinct surface texture: it is as if the cathedral's structure were veiled by a gauzy tissue. The intensity, vibration, and harmony of the colors, while drawn from visual observation, exalt rather than represent nature; there is little left, in these grand orchestrations, of Impressionism's original objectivity. All the paintings in the series were extensively reworked from memory in the quiet of Monet's studio in Giverny. Twenty of them were exhibited by Durand-Ruel in 1895, to enthusiastic praise from critics (Clemenceau spoke of "a revolution without gunfire"). They sold rapidly, despite the very high price—15,000 francs—which Monet put on them.

During the later 1890s, Monet continued to produce thematic picture series focused on particular sites. A trip to Norway in 1895 resulted in a sequence of snowscapes, *Mount Kolsaas,* and in 1896–97 he painted the extensive series *Mornings on the Seine,* calm, spacious compositions in blueish monochrome. The meditative concentration on particular, limited motifs that characterizes these paintings has little in common with the variety and instantaneity of Monet's Impressionism of the 1870s. A quiet brush stroke, muted colors, and a sense of large, harmonious design make them appear as the precursors of his later mural compositions, and explain Degas's sneering dismissal of some of these works as those of a "skillful, but not profound decorator."

In the fall of 1899, and again in the winters of 1900 and 1901, Monet paid painting visits to London, working on views of the Thames. His initial vantage point was a room with balcony in the Savoy Hotel, from which he had a view of Waterloo Bridge on the left and of the Charing Cross Bridge, with the Houses of Parliament in the distance, on the right. Later he also painted from a room in St. Thomas's Hospital, on the south bank of the river, directly opposite the Houses of Parliament. The series in the end numbered more than a hundred canvases, proof of his phenomenal speed and energy of work, despite growing eye troubles and occasional moods of discouragement. Three motifs constitute the subjects of these paintings:

Charing Cross Bridge (1899–1903);
Waterloo Bridge (1899–1903); and
The Houses of Parliament (1901–04).

The theme of bridges may recall Argenteuil, but the fog-laden skies, the faint, reddish winter sun, and the ghostly silhouettes of distant buildings bear no resemblance to the breezy, silvery freshness of the river views of 1874. The London paintings, thoroughly reworked during 1902–04 in the studio at Giverny, are for the most part sumptuous color fantasies, the product of careful and gradual indoor work rather than of spontaneous study from nature. Yet, ironically, several of them resemble *Impression, Sunrise* (1873), the picture that gave its name to Impressionism, owing perhaps to a shared, distant influence by Turner and Whistler. A group of thirty-seven Thames views was exhibited by Durand-Ruel in 1904.

On the invitation of the American painter John Singer Sargent, Monet and his wife visited Venice in the fall of 1908. Suffering from the beginnings of a serious impairment of vision caused by cataracts and from general discouragement with his work, he found his health and spirits much improved by his pleasure in the beauty of the Venetian light and atmosphere. He rapidly painted various views of canals and palazzi which he later (1909–12) elaborated in the studio at Giverny. It appears that he did not return to Venice in 1909, as he had planned (and as has often been claimed). His Venetian views resume, in glowingly intense, deep-toned colors, the motif of light reflected from richly articulated facades, the theme of the *Rouen Cathedral* series, with the difference that the Venetian architectures are themselves mirrored in water:

The Grand Canal (1908–12?, Boston, Museum of Fine Arts);
Palazzo Dario (1908–12?, Chicago, Art Institute); and
Palazzo da Mula (1908–12?, Washington, National Gallery).

On his return to Giverny, Monet revised his Venetian canvases extensively from memory. He was not entirely satisfied with them, but did exhibit twenty-nine of the pictures at the Galérie Bernheim-Jeune in 1912, to resounding critical acclaim.

In 1893, Monet had extended his garden at Giverny by successive purchases of land and started on the construction of a large pond, fed by a stream, and

spanned at one end by a "Japanese" bridge. Much of his energy from this time on would go into the creation of this elaborately planted water garden, a private, artificial landscape which became his favorite painting site in his last years—a miniature of nature, arranged to his needs and tastes.

From about 1895, he often painted the pond in his garden in its setting of lush vegetation. A series of ten such canvases, all of square format and centered on the graceful arc of the Japanese bridge, were shown by Durand-Ruel in 1900, under the title *Le Bassin aux Nymphéas (The Water-Lily Pond).* The shimmering surface of the water in these paintings is seen at a normal angle of vision, giving them a strong sense of spatial recession. In his paintings of the following years, Monet took his view at closer range and painted down into the water: its reflecting surface, spotted with water-lilies, is made to fill the entire canvas, with little suggestion of bordering terrain. These "waterscapes" *(paysages d'eau),* as Monet called them, are transparent mirrors that reflect the sky, clouds, and distant trees, and at the same time lead the eye into the depth beneath their surface. Monet painted many versions both of the *Water-Lily Pond (Bassin aux Nymphéas)* (1898–1900, Paris, Louvre, Musée d'Orsay; New York, Metropolitan Museum; Chicago, Art Institute; Princeton University, Art Museum; etc.) and of the *Water-Lilies (Nymphéas, Paysage d'Eau)* (1902–08, Paris, Louvre, Musée d'Orsay; Caen, Musée des Beaux-Arts; Dallas, Museum of Fine Arts; Dayton Art Institute; Hartford, Wadsworth Atheneum; Denver Art Museum; etc.). Forty-eight of these *Nymphéas* were exhibited by Durand-Ruel in 1909.

As early as 1898, Monet had thought of combining a series of such water-scapes into one wall-filling frieze which, carried around the walls of a room, "would give the illusion of an endless whole, of water without horizon or shore," and offer the viewer "a refuge of peaceful meditation in the midst of a flowering aquarium." This project, which was to occupy his last years, was in some ways the final consequence of his earlier method of serial painting: instead of recording nature's constant change in a cinematographic sequence of pictures, he would now embrace its infinite unity in one panoramic image.

For these mural compositions, Monet abandoned his normal, moderate formats (averaging 26 × 32 inches, or 66 × 81 centimeters) for large panels, measuring from 6 × 7 feet to 6 × 20 feet (1.9 × 2.2 meters to 1.9 × 6.2 meters). As his canvases grew larger, his field of view narrowed. His monumental water-scapes offer relatively short-range foregrounds without distances. This increasing closeness of view, combined with an enormous expansion of format, may have had something to do with his declining eyesight, which confined the range of his vision and made him look at near objects as if through a magnifying glass.

The death of his wife in 1911, and his fear of approaching blindness, threw Monet into a depression, from which he was roused by the hope of still achieving a great decorative ensemble on the theme of his *Nymphéas.* The size of his projected canvases made it necessary to build a new, larger studio. Begun in 1914, this was finished in 1916. By this time, Monet was no longer able to paint out of doors in the broad daylight, but had to confine himself to the early morning and evening hours, working on his large panels indoors and from memory or the

imagination. At the time of the Armistice of 1918, he offered his old friend Clemenceau, then the all-powerful premier of France, the gift of two of his panels by way of commemoration of victory, with the suggestion that they be placed in the Musée des Arts Décoratifs. Clemenceau and other friends persuaded him to increase his patriotic donation to include the whole of his cycle of waterscapes, and offered to house these in a specially designed museum. Monet agreed.

There now began a torturous process, in which Clemenceau—meanwhile out of office—had to coax a reluctant bureaucracy into providing a suitable space, while encouraging his mercurial, often discouraged, and nearly blind friend to persevere in his work. An emplacement for the paintings was at length constructed in the Orangerie of the Tuileries near the Louvre. Monet's sight was partially restored by an operation in 1923. After several crises and near-capitulations, he completed the last panels in 1925. The two frieze-compositions of *Les Nympheas* (1916–25, Paris, Musée de l'Orangerie) line the curving walls of two separate galleries of oval shape, each containing four sections of painted frieze, composed of panels measuring ca. 6.6 × 6.6 feet (2.1 × 2.1 meters) or 6.6 × 14 feet (2.1 × 4.4 meters). The long, panoramic sections are composed as vast, continuous images, very loosely structured by shifts in color harmony and tone in Gallery I, by framing tree silhouettes in Gallery II. The resonant colors do not give the illusion of actual space and light, but are interwoven into shimmering textures. Like sumptuously patterned hangings, of a size that exceeds the field of vision, they engulf the viewer in a color bath. The brushwork that animates their surfaces with sweeping strokes and dense scumblings does not so much record things seen as express an urgent excitement and effort. Descriptive truth is not the issue in these final, monumental statements of a life-long observer of nature. The aged Monet, battling blindness and facing death, looks inward and paints remembered light and color from his memory's depths.

The long preparatory work that preceded these ultimate realizations is preserved in part (Monet destroyed the many canvases that did not satisfy him) in the form of trial pieces and alternative paintings. The Cleveland, St. Louis, and Kansas museums share the parts of a large, dismembered triptych, *Water-Lilies* (1916–26); the Zurich Kunsthaus has a large panel, *Les Iris* (1916–23); others are in the E. Beyerle Collection at Basle, the Carnegie Institute, Pittsburgh, the Musée Marmottan, Paris, and various private collections.

During the winter following the completion of *Les Nympheas,* Monet's health failed and he ceased to paint. He died on December 5, 1926.

Though the roots of Impressionist attitude and practice can be traced back to Constable and to the naturalist landscape painters of the early nineteenth century, particularly to their outdoor sketches, Monet can be said to have transformed the art of painting (something that could not well be claimed for Manet or Degas). He carried representation to its extreme limits, attempting to shorten the gap between perception and painterly re-creation to the briefest possible distance. Directness and speed of work, combined with the utmost precision of color observation, were the essentials of his painting throughout most of his career.

Intent on arresting the fleeting moment, on capturing effects of light and color of very short duration, he worked rapidly, intuitively, without preliminary studies. His art was based on observation rather than invention. Like a hunter, he stalked nature, alert to every opportunity, quick to seize the telling aspect in the swift flow of change. He needed the stimulus of physical reality, and respected his perceptions. He rarely embellished, idealized, romanticized, or made more "interesting" what his eyes saw. The quality of his art rests on the candor of his transcriptions: never, perhaps, had a landscape painter looked at nature with a more intelligent eye, never had the distance between eye and hand been so short, the equivalence of perception and painted image been so close.

Yet, though true to fact in his work, Monet was not coldly objective. His paintings—particularly in the latter half of his life—expressed a passionate temperament, striving for goals nearly beyond reach, dogged, aggressive, sometimes violent, but preserved by his inborn tact and fundamentally harmonious disposition from the pitfalls of sentiment, eccentricity, or mannerism which his followers, even Renoir, were not always able to avoid. Thus he produced, at the end of his life, works of truly revolutionary novelty, departing from (or evolving beyond) Impressionism, and extending the scope of painting from the easel format to that of a monumental, environmental art.

READINGS

General

The comprehensive publication of Monet's work, life, and correspondence is D. Wildenstein's *Claude Monet, biographie et catalogue raisonné,* Paris and Lausanne, of which the following volumes have thus far been published: I, *1840–1881* (1974); II, *1882–1886* (1979); and III, *1887–1898* (1979).

More modest in scope and detail, but excellent in its interpretations, is W. Seitz, *Claude Monet,* New York, 1960.

J. Isaacson, *Claude Monet, Observation and Reflection,* Neuchâtel, 1978, attempts an analysis of the main stages of Monet's development and offers useful comment on particular paintings.

R. Gordon and A. Forge, *Monet,* New York, 1983, a sumptuously produced book with many excellent colorplates and documentary photographs, presents, in addition to a general biographical and interpretive text, a large selection of excerpts from Monet's letters and contemporary reviews.

Biographical

When fully published, D. Wildenstein's *Claude Monet, biographie et catalogue raisonné* (see above) will be the most complete and most richly documented life of Monet.

Of the earlier biographies, G. Geffroy, *Claude Monet, sa vie, son temps, son oeuvre,* 2 vols., Paris, 1924, and M. de Fels, *La vie de Claude Monet,* Paris, 1929, are still the most useful. C. M. Mount's *Monet, a Biography,* New York, 1967, one of the few lives in English, suffers from grotesque overwriting and extreme biases. The best account of Monet's complex relationships with fellow artists is still to be found in J. Rewald's *The*

History of Impressionism, 4th edition, New York, 1973, which also contains a very useful critical bibliography.

Special Studies

S. Levin, *Monet and His Critics,* New York and London, 1976.

J. Isaacson, *Monet: Le Déjeuner sur l'Herbe,* New York, 1972.

G. Seiberling, *Monet's Series* (dissertation), Garland Publishing, New York and London, 1981.

G. H. Hamilton, *Claude Monet's Paintings of Rouen Cathedral,* London, 1960.

C. Joyes, *Monet at Giverny,* New York, 1976.

D. Wildenstein, et al., *Monet's Years at Giverny: Beyond Impressionism* (published on the occasion of the exhibition of Monet's late work at the Metropolitan Museum in 1978), New York, 1978.

D. Rouart and J. D. Rey, *Monet, Nymphéas,* Paris, 1972.

Pierre-Auguste Renoir, 1841–1919

Only a part of Renoir's work can be classified as "Impressionist." For a decade (1867–77), at a crucial moment in Impressionism's early development, he closely seconded Monet, who was then, as always, its leading figure. Renoir's vigorously individual talent, drawn temporarily into Monet's orbit, helped to give the character of a movement to what otherwise would have seemed as one artist's solitary way. Yet by temperament and outlook he was never wholly in agreement with the soberly empirical approach chosen by Monet. Far more of a romantic and traditionalist, he admired Delacroix, Rubens, and Titian, and looked back to Raphael and Ingres with envious respect. What basically separated him from Monet was his wholehearted dedication to figure painting, beside which landscape held only a relatively minor place in his work.

Renoir was moved by an instinctive humanism, not by the curiosity of a naturalist: the sensuous appeal of living creatures, the erotic aura of body and face, interested him more than the transient spectacles of atmosphere and sunlight. His choice of forms and colors was guided by expressive and aesthetic intentions, by taste and feeling, rather than the pursuit of visual truth. His efforts to adapt Impressionist technique—a product of direct nature study—to the demands of large-scale figure composition resulted in his most ambitious works, yet did not in the end satisfy him. In his effort to extend the range of Impressionism, he gradually removed himself from it altogether. But his early contributions were so important, so individual, and of such high quality that it is impossible to think of Impressionism without considering Renoir's part, though throughout much of his long life he followed a different direction.

Renoir was born in 1841 in the town of Limoges, in south-central France, the son of a tailor of modest means. The family moved to Paris in 1844. Auguste attended a Catholic school and sang in the choir of Saint-Eustache, whose director, the composer Charles Gounod, tried in vain to persuade the boy's parents to allow him to study music. Instead, for practical reasons and because he had shown some aptitude for drawing, he was apprenticed, at age fifteen, as a porcelain painter in the china works of Lévy Brothers. He learned to decorate plates, teapots, and vases with figural and floral designs in the pseudo-Rococo style then in fashion. In the evenings, he attended a free drawing school.

When the firm of Lévy Brothers failed, in 1858, the young Renoir had

gained enough experience to work on a larger scale, as a decorator of shutters and wall panels. But his ambition went beyond commercial employment. He wanted to become a serious artist, and in 1860 began to train his eye and hand by copying paintings in the Louvre. His choice of models—Rubens, Boucher, Fragonard, and Delacroix—gave evidence of his early penchant for colorism and Baroque animation. In the following year, he entered the private atelier of Charles Gleyre, who practiced a high-flown, eclectic style that combined neoclassical formality with romantic sentiment. Shortly thereafter, he also won admission to the official Ecole des Beaux-Arts. In the course of the year, Claude Monet, Alfred Sisley, and Frédéric Bazille joined Renoir in Gleyre's studio. Renoir soon became not merely their close friend but the intimate sharer of their aspirations and discoveries.

At the Ecole, where he participated in the regular academic contests, Renoir was judged a mediocre student. Nor did he find much encouragement in the teaching of the melancholy Gleyre, a laborious perfectionist who could give little to his pupils beyond the rudiments of technique and a grounding in academic model study. But Renoir and his new friends had already seen enough of Courbet's and Manet's work to sense that their master belonged to a moribund tradition. The future that beckoned to them called for a fresh and personal look at reality, and escape from the studio into the out-of-doors. By way of antidote to their academic schooling, Renoir and his fellows went to paint in the Forest of Fontainebleau in the spring of 1863, perhaps at the instigation of Monet, who already had some experience in outdoor sketching.

While beginning to deviate from the strictly academic path, Renoir kept his professional career in view, and this, by necessity, had to lead through the Salon. His first submission, in 1863, failed, but in 1864 his *Esmeralda Dancing,* a Romantic subject taken from Victor Hugo's *Notre Dame de Paris,* was accepted. He judged his picture more harshly than the jury, and after the exhibition destroyed it. About this time, Gleyre closed his teaching studio. Left to fend for himself, Renoir continued his studies of the old masters at the Louvre, and of landscape at the Forest of Fontainebleau, as his own teacher. To make ends meet, he sought portrait commissions. *Portrait of Mlle Romaine Lacaux* (1864, Cleveland Museum of Art), one of his earliest preserved works, gives proof of impressive mastery, despite some compositional flaws. Its even lightness of tone, its blond harmony of grays, flesh colors, whites, and reds, and the charming simplicity of its characterization show a remarkable freedom from the portrait stereotypes of the time.

But portrait painting provided a chancy income at best. When his parents, with whom he had been living, moved to Ville d'Avray in 1865, Renoir became dependent on his more affluent friends for food and shelter. Fortunately, he had an agreeable disposition, and a gentleness and modesty of manners that attracted sympathy. He was a well-liked guest, and learned, as a matter of self-preservation, to cultivate those graces that brought him friendship and help. In 1865, he shared the apartment of Alfred Sisley, son of a substantial merchant, and after Sisley's marriage in 1866 moved to the studio of his wealthy painter friend Frédéric Bazille, where he was soon joined by the equally needy Monet. At about this time,

he met another helpful friend in the person of Jules Le Coeur, a painter of sizable
fortune, who owned a house at Marlotte on the edge of the Forest of Fontaine-
bleau, as well as residences in Paris and on the Channel coast. As Le Coeur's
guest, Renoir often worked in the region of Fontainebleau. Here he encountered
Courbet, and tried his hand at forest scenes, using the palette knife in Courbet's
manner—*Jules Le Coeur in the Forest of Fontainebleau* (1866, São Paulo, Museu
de Arte). Through Le Coeur he met Lise Tréhot, then aged sixteen, who in the
following years became his favorite model and his mistress.

The Salon of 1865 accepted two of Renoir's pictures, including a *Portrait
of William Sisley* (1864, Louvre, Musée d'Orsay), the father of his friend Alfred.
But in 1866 his chief submission—a nude bather and a fashionably dressed
woman in a forest setting, a subject clearly inspired by Courbet's *Bathers* of 1853
—was rejected. The culminating work of his Fontainebleau period, characteris-
tically, is not a landscape but an interior scene composed of nearly life-size figures.
At the Inn of Mère Anthony (1866, Stockholm, National Museum) records Re-
noir's Bohemian sociability at Marlotte. The identity of the figures shown
grouped around the table is not quite certain. Sisley, wearing a hat, is seated at
the right; the beardless man facing him across the table has not been properly
identified; Le Coeur stands at the back; Nana, "the beautiful maid," clears the
table; the dog Toto, famous for his wooden leg, lies in the foreground, looking
out of the picture. There is historical significance in the prominent display of the
newspaper *L'Evénement:* Zola's defense of Manet and Monet had just appeared
in its pages. The caricatures on the wall at the back represent Henri Murger, the
author of *Scènes de la vie de Bohème,* a title that could also serve for this picture.
The figures seem too large for the space they occupy, a pervasive compositional
tendency in Renoir's work. The color range is severely limited. The contrast
between the flat black of the costumes (reminiscent of Manet) and the intense
white of apron, tablecloth, and newspaper rather overpowers the more subtly
differentiated tonalities of the faces, the fleecy dog, and the dusky setting.

Back in Paris, where he continued to share Bazille's studio, Renoir painted
an intimate portrait of his host at work—*Frédéric Bazille at His Easel* (1867,
Louvre, Musée d'Orsay). For the Salon of 1867, he produced a life-size study of
the nude, posed by Lise Tréhot, and given the appearance of a mythological
subject by the addition of suggestive accessories: *Diana the Huntress* (1867,
Washington, National Gallery). The idea for this composition may derive from
a painting (1838) by Renoir's former teacher, Gleyre. Though he made every
effort to make the picture acceptable, giving his figure a graceful pose and taking
pains over its execution, it remained too much the very physical representation
of an actual, fleshy nude, heavy in the hip and big of foot, to sway the particularly
severe Salon jury of 1867. The brushwork is of extreme subtlety. The sharply
illuminated skin is brought to life by a complex blending of colors, applied in
overlapping transparencies. There is very little tonal modeling; the nacreous, rosy
body presents itself as a flat, clearly contoured silhouette. It bears a closer resem-
blance to the nude in Manet's *Déjeuner sur l'herbe* than to Courbet's *Nude with
Parrot* to which it has sometimes been compared. But there is something of

Courbet in the landscape setting and the foreground still-life, executed in part with the palette knife, in rough applications of paint.

Perhaps as a respite from Salon painting, Renoir in the spring of 1867 followed the example of Monet in painting views of Paris, treating them as panoramic landscapes, with much emphasis on transient effects of sunlight and atmosphere, and on the bustle of street life. These are the earliest of his works that give a foretaste of Impressionism. *The Pont des Arts* (1867, Los Angeles, Norton Simon Foundation), a view of unusual width, resembles Monet's cityscapes of the same period, though it is rather more sunny and airy. The shadows of a bridge and of passers-by, themselves invisible, cast on the pavement in the foreground amount to a daringly original observation of a kind not common in Renoir's work.

During the summer, spent in the Forest of Fontainebleau, he returned to the project of an exhibition picture. Evidently under the influence of Monet's *Women in the Garden* (1866–67), he posed his companion dressed in white muslin against dark foliage. The style and execution of *Lise with a Parasol* (1867, Essen, Folkwang Museum) present a remarkable contrast to the slightly earlier *Diana.* The colors are held to a very limited range: white, black, and the dark green of the background dominate. The shaded head under its slanting hat is illuminated from below by reflections from the sunlit dress; the warm skin of the arms shows faintly through the transparent sleeves; the brilliant whiteness of the dress is animated by blue shadows traversed by faintly yellow or rose lights. Of more restrained and suave execution than Monet's far more radical *Women in the Garden,* this painting addresses the same problem: the monumental figure posed in the natural light. It was received, and badly hung, in the Salon of 1868.

Lise Tréhot posed again, in a strikingly less formal manner, for the half-length *Summer, a Study* (also known as *The Gypsy*) (1868, West Berlin, National Gallery), which shows her in close view, seated in the shade of a leafy bower, her hair open, her blouse slipping from her shoulders, her hands clasped in the lap of her skirt, which is brightly striped in yellow and red. The picture is not so much a portrait study as the evocation of a moment of summer heat and sensuous abandon. The robust informality of the young woman's pose, and the attractive, somewhat animal physicality of her presence, recall Courbet. The painterly execution of the figure, however, has the delicacy and firmness characteristic of Renoir's brushwork of that time; the foliage of the background, by contrast, is very broadly sketched. The picture was accepted for the Salon of 1869.

During 1867–68, an extremely productive period, Renoir's work as yet followed no consistent direction. As a studio painter, with his eye on the Salon, he evidently found Manet's example useful, and also took hints, mainly of a technical sort, from Courbet. He was, at the same time, fully aware of Monet's experiments in outdoor painting, and in his own land- and cityscapes depended on Monet, even to the point of imitation. Curiously, he did not apply the lesson of his open-air landscape studies to the landscape backgrounds of his figure paintings, but treated them in a quite personal, arbitrarily decorative manner. In these years, he shared Bazille's studio, located in the rue de la Condamine, in the

vicinity of the Café Guerbois, the meeting place of the circle of artists and writers of which he was himself a member.

The Engaged Couple (also known as *The Sisley Family*) (1868, Cologne, Wallraf-Richartz Museum) is a fictive family portrait, actually posed by Lise Tréhot and Alfred Sisley, somewhat in the style of *carte de visite* photographs. The bulky figures crowd the relatively small canvas. They are shown in an even, almost shadowless studio light, which brings the colors to a fairly strident intensity. In overall effect, they seem closer to Manet's full figures, such as the *Fifer* and *Woman with Parrot* (both 1866), than to the most nearly comparable works of Courbet. The garden setting is of vaporous shapelessness, suggestive neither of actual space nor of daylight.

In the spring of 1869, Monet returned to Paris from Etretat on the Channel coast, where he had spent the winter, and for a while lodged with Bazille and Renoir. For the following summer, Renoir put up at his parents' home in Louveciennes, while Monet found quarters nearby at Saint-Michel, adjacent to Bougival on the Seine. It was a time of close personal association for them. Renoir supplied his friend with food, and together they worked along the Seine, where Monet had found a subject for a projected large-scale composition, along the lines of his *Déjeuner sur l'herbe,* in the modish open-air sociability at La Grenouillère, the popular riverside restaurant and bathing establishment near Bougival. Working next to one another, the two painters sought to capture the effect of brightly dressed crowds moving in a setting of overhanging foliage and of flowing water reflecting the late-afternoon light.

La Grenouillère (1869, Stockholm, National Museum; related studies in the Pushkin Museum, Moscow, and the O. Reinhart Collection, Winterthur) shows Renoir painting under Monet's immediate influence and attempting Monet's method of rendering objects and light reflections by distinct color touches—sharing in an experiment in optical form dissolution of the kind that was to lead to Impressionism. The closeness of the two painters on this occasion makes apparent the difference between them. Compared to the sharp sense of visual truth in Monet's studies of La Grenouillère, the result of precise color observation, Renoir's superficially quite similar studies seem agreeable approximations, guided by a taste for harmonious combinations rather than by an effort at visual objectivity.

Following his own main interest, Renoir sought to apply the technique of defining form with scattered touches of color and light scintillations to figural compositions, and achieved in *The Promenade* (1870, Edinburgh, National Gallery of Scotland, on loan), an original, seemingly unposed scene—a gentleman helping a lady dressed in white through sun-speckled undergrowth—in which (by contrast to the *Engaged Couple* of 1868) figures and landscape setting are integrated in a common texture of color and light. In his two submissions to the Salon of 1870, both of which were accepted, he did not push innovation this far. *Bather with Griffon* (1870, São Paulo, Museu de Arte) presents Lise as a monumental nude, in the traditional posture of *Venus pudica,* shielding her nakedness with one hand, while with the other holding her discarded costume, which, falling in

a silken cascade along her thigh, forms a nest at her feet for her diminutive dog. Her body is modeled by the raking light in strong relief, a sculptural effect that is the opposite of the shadowless flatness of Renoir's *Diana the Huntress* of 1867, and for once closer to Courbet than to Manet. Behind her appears the figure of a recumbent, fully dressed woman, half lost in the dark foliage, and a glimpse of water with rowing boat, perhaps distant echoes of Courbet's *Young Ladies on the Banks of the Seine* (1857).

Woman of Algiers (1870, Washington, National Gallery), Renoir's other submission to the Salon of 1870, is strikingly different in feeling and style. Lise, wearing a richly embroidered Algerian costume, is seen lounging in a harem setting, strongly (and probably intentionally) reminiscent of Delacroix's *Algerian Women in Their Apartment* (1834). Thus Renoir managed in his two exhibition pictures of 1870 to span the range of Salon eclecticism, from quasi-classical nudity to quasi-romantic exoticism.

At the start of the Franco-Prussian War, in July 1870, Renoir was declared fit for military service but was not drafted until October, after the defeat at Sedan and the fall of the Empire. He spent the remaining months of the war in cavalry school in the South of France, far from the fields of battle. After a serious bout of dysentery, he was discharged in February 1871 and returned to Paris, where the civil war of the Commune was about to begin. While Paris burned, he sheltered with his parents at Louveciennes outside the beleaguered city. With the return of normalcy after the collapse of the Commune in late May, he very rapidly resumed his accustomed routines.

The war had interrupted Renoir's development without changing its direction. During the following years—a time of rapid recovery and fugitive prosperity for France—he continued to work on two distinct levels, painting experimentally in close association with Monet, but concentrating his main efforts on exhibition pictures of impressive size, and of a style and subject matter calculated not to shock Salon juries. Far from being more liberal than the juries of the Empire, however, those of the recently established Republic were particularly severe. Renoir's submission for the Salon of 1872, *Parisian Women Dressed as Algerians* (1872, Tokyo, Museum of Western Art), a large, staged harem scene again indebted to Delacroix's *Algerian Women,* painted with obvious erotic relish but kept in a curiously subdued tonal range, was rejected by the jury. The same fate befell his entry for the Salon of the following year, the huge *Morning Ride in the Bois de Boulogne* (1873, Hamburg, Kunsthalle), a life-size portrait of an elegant equestrienne mounted on a glossy bay horse at the full trot and accompanied by a boy on a pony, a subject perhaps inspired by Renoir's recent stint in the cavalry. The brushwork of this calculated speciment of Salon painting is of the most careful smoothness, the colors keyed to a narrow range of tans, greens, grays, and blacks. Renoir's self-denying effort to impress a conservative jury with grand design and masterly finished resulted, ironically, in a work of striking, almost neoclassical austerity that was bound to irritate the jurors. The picture was subsequently shown at the Salon des Refusés held in 1873, on the tenth anniversary of the earlier, more celebrated one of 1863.

Entirely apart from these periodic bids for public visibility, Renoir eagerly continued his private studies of a more experimental kind, often in collaboration with Monet. The example of Monet's landscape studies had introduced him to a new way of painting in which the aim was to approximate the luminosity, intensity, and vividness of direct eye experience. This new optical method, a refinement of realism, lent itself best to rapid outdoor sketching, to the pursuit of fugitive effects of daylight, changing atmospheres, distant forms in motion. It was less appropriate to portraiture, still-lifes, and figural subjects. Renoir was not by basic bent a naturalist; the direct transcription of visual experience was not his primary interest, but he was quick to see the purely painterly possibilities Monet's example offered him. Rather than the achievement of an illusory truth to nature, he sought an enrichment of formal means, a liberation from the pedantry of contour, the triteness of subject matter, the deadness and dirtiness of academic color. His own mastery was stylistic and technical; he was eminently an artificer. The new way of painting that he was developing under Monet's influence, with its stress on spontaneity, luminous color, and suggestive indistinctness, had a charm for him that was independent of any further utility. Its beauty was self-sufficient. The challenge was to apply it to a range of subjects—intimate, modern, and emotionally stimulating—that suited his temperament.

Renoir's personal life underwent some changes in the early 1870s. Lise Tréhot, his model and mistress since 1866, left him to get married. Bazille, his closest friend and perennial host, had died in the war. Renoir acquired a studio and apartment of his own in 1871, and began to lead a somewhat less migratory existence. Through Monet, he became acquainted with Durand-Ruel, who was beginning to make large purchases from Monet, Sisley, Degas, and Pissarro in 1872, but cautiously bought only two pictures from Renoir, one of them the *Pont des Arts* of 1867. Though Durand-Ruel's support increased somewhat in the following years and Renoir recruited some other patrons, he continued in a state of chronic insolvency throughout the 1870s.

The development of his personal style at this time can be measured by the difference between his *Pont des Arts* and a painting of similar subject matter, *The Pont Neuf* (1872, Washington, National Gallery). While the colors of the earlier picture were clear and definite, applied in precise, descriptive strokes, those of the later one are broken and complex, veils of various hues scumbled over one another. The colors are no longer "local," they do not closely adhere to the forms they describe, but seem to radiate from them and to interpenetrate in a constant play of reflections, yellowish or reddish in the illuminated parts, blue in the shadows. The rapid, nervous brushwork keeps the colors in motion and heightens the liveliness of the scene: the light in it seems an active, energetic presence. This heightened intensity of light and motion accompanies a rapid recession of the picture space from the sunlit foreground, across the narrowing bridge, to the shaded row of houses in the distance. The lively pattern of silhouetted figures, each trailing a shadow, converges in a jostling crowd on the bridge's crest. A sky alive with clouds corresponds to the terrestrial bustle below. There is an evident tension in this cityscape between objective observation and a joy in activity, in

the stir of life, a subjective emotion leading to exaggeration and, in the end, to mannerism.

In the summers of 1872 and 1873, Renoir made repeated lengthy stays at the Monets' comfortable house at Argenteuil, painting side by side with his friend along the river or in the Monets' garden. His small, very spontaneous landscape studies—such as *The Gust of Wind* (1872, Cambridge, England, Fitzwilliam Museum) and *The Duck Pond* (1873, Dallas, private collection)—at times go beyond Monet's in their dissolution of form in vivid color textures. Not many of these open-air paintings are pure landscapes; most, like the *Monet Painting in His Garden at Argenteuil* (1873, Hartford, Wadsworth Atheneum), contain some element of genre or informal portraiture. Renoir also painted some intimate portraits of his friends, in a technique that in its breadth and spontaneity owes something to his landscape studies, among them *Mme Monet Reclining on a Sofa* (1872, Lisbon, Gulbenkian Foundation) and *Claude Monet Reading* (1872, Paris, Musée Marmottan).

During 1873, Renoir joined with Monet, Pissarro, and other artists of the circle of the Café Guerbois to form an independent association for the purpose of sponsoring jury-free exhibitions, in direct challenge to the official Salon. As one who had been excluded from the Salons of 1872 and 1873, Renoir had good reasons for wishing to take part in this undertaking. The initial exhibition was scheduled to open on April 15, 1874, on the Boulevard des Capucines. Renoir helped with the installation of the 165 pictures submitted by the association's thirty members. His own work was represented by six oils and one pastel. Though he was spared the savage press criticism lavished on most of his colleagues, the outcome of this first "Impressionist" exhibition was a disappointment to him. Only one of his pictures, *The Theater Box,* was sold after the show, and at a low price. In the end, the exhibition produced a deficit, which the participating artists had to share.

The Theater Box (La Loge) (1874, London, Courtauld Institute Galleries) is the portrait study of a model, transformed by some slight additions—the front ledge of the box, the background figure of a gentleman peering through his opera glasses—into a "scene from life": a fashionable beauty displaying herself at the theater. The subject, reminiscent of Degas, is straightforwardly presented, without the daring obliquities and croppings by which Degas gave to such scenes the look of casually observed reality. Radiant with a brightness that seems to emanate from the young woman's skin, intensified by the black striping of her dress, this human still-life, of great painterly refinement, was calculated to please. Even otherwise hostile critics responded to its appeal, though they found it lacking in depth: "one of those women with pearly white cheeks and the light of some banal passion in her eyes," as one reviewer put it, "attractive, worthless, delicious, and stupid."

The Dancer (1874, Washington, National Gallery), also shown at the group exhibition of 1874, is a posed studio composition, closer to Manet's costume pieces than to Degas's probingly realistic studies of the ballet. The figure is painted in misty transparencies of cool silver and gray; it floats like a vapor in

undefined space. The diversion of Impressionist technique from its original natu-
ralist to a decorative function is evident here. The breadth and openness of the
brushwork, the indefiniteness of the forms, the diffuse light have no descriptive
purpose, but are used for aesthetic effect.

In the summer of 1874, after the exhibition's close, Renoir again worked
with Monet at Argenteuil on the Seine, occasionally in company with Manet,
Sisley, and Caillebotte, painting *Camille Monet and Her Son Jean in the Garden
at Argenteuil* (1874, Washington, National Gallery; Manet's version of the same
subject is in the Metropolitan Museum, New York). He also painted Monet
fishing in the river—*Fishing with Rod and Line* (1874, private collection) and,
with Monet by his side, sketched sailboats at the landing—*The Seine at Argenteuil*
(1874, Portland Art Museum). It was a time of relaxed sociability and of compan-
ionable outdoor work in which Monet played the leading role. Emboldened by
his friend's example, Renoir brushed audaciously free and luminous views of
sunny fields and woods, such as *In the Tall Grass* (1874, Paris, Louvre, Musée
d'Orsay), and *Path in the Forest* (1874, New York, private collection).

In the mid-1870s, France suffered a serious economic crisis which affected
all artists, and particularly those who, like Renoir, lived on the edge of poverty.
Durand-Ruel, overstocked and short of funds, temporarily stopped his purchases.
To put some money into their pockets, Renoir, Monet, Sisley, and Morisot
organized an auction of their paintings in 1875. This produced a near-riot, and
very poor returns. The lowest prices of all were paid for Renoir's pictures, but
the sale, by way of unexpected benefit, brought him the acquaintance of Georges
Charpentier, the influential publisher, whose wife presided over a literary and
artistic salon. Rejected by the official establishment, without personal resources,
and not very successful in reaching the paying public through private exhibitions
or sales, Renoir had to find other ways of attracting purchasers. The opportunity
of meeting an affluent, culturally ambitious, modern-minded clientele through his
acceptance into the society of the Charpentiers was therefore of great importance
to him.

He was anxious to please. Of humbler background than his artist friends,
he tried harder than they to ingratiate himself with the new social and cultural
elite of the Republic, then in the throes of reconstruction after the disasters of
1870–71. Slight of build, nervously mobile, highly gregarious, and at the same
time modest and affectionate, Renoir had social charm and a gift for friendship.
He did not share the Bohemians' contempt for the art-sustaining middle class,
and was willing to accommodate his patrons' tastes and interests since, to a
degree, they resembled his own.

Quite logically, he turned to portrait painting, for which he was suited by
both talent and social disposition, and which promised an escape from his chronic
poverty. The roster of his portrait sitters and patrons in the 1870s gives an insight
into the composition of the audience for modern art, and in particular for Impres-
sionist painting at the time of its full development. It included, initially, men with
a background in finance, industry, or commerce (Ephrussi, Deudon, Duret, and
Dollfus), in publishing (Charpentier, Houssaye), and in medicine (Drs. de Bellio,

Blanche, and Gachet). It also comprised some artists of private means (Caillebotte, Rouart), cultivated civil servants (George Rivière of the Ministry of Finance, Victor Chocquet of the Customs Service), as well as a handful of enthusiasts of small means and few social pretensions, such as the color merchant Tanguy and the poetic pastry cook Murer. In various ways, these men supported Renoir, by admitting him to their social and family circles, inviting him to their country houses, publicizing his work, and encouraging others to buy his pictures.

At the second exhibition of the Impressionist group, held in 1876, twelve of Renoir's fifteen exhibited works were portraits. Renoir had met Victor Chocquet, a passionate collector, some time in 1875 and soon became his friend. Chocquet commissioned portraits of his wife, his daughter, and himself. In the *Portrait of Victor Chocquet* (ca. 1875, Cambridge, Mass., Fogg Art Museum), he is posed before a framed study by Delacroix, the painter whom he—like Renoir —most admired. The portrait is executed in an unusual technique of small color touches that graphically model the features, hair, and beard. The intimacy with which Renoir addressed his friend's alert face, with its intensely luminous eyes, expresses the warmth of feeling that bound the artist to his patron (and makes for an interesting comparison with the gaunt energy of Cézanne's roughly contemporary portrait of Chocquet, whom he had met through Renoir).

In his more experimental work of this time, Renoir struggled with the problem of representing large-scale figures in the natural light of the out-of-doors, to him the fundamental challenge in Impressionism. While in the controlled, diffuse light of the studio the human body's form and structure could be studied and selectively recorded, the intensity and constant change of direct outdoor light disrupted and fragmented them, or merged them with neighboring shapes. Developed in landscape study, the Impressionist method was geared to the recording of light effects, and largely indifferent to plastic form. Renoir, nonetheless, made a determined effort to apply this method to figural composition. In the garden of his Montmartre studio, he posed a nude model in the mottled sunlight beneath shading foliage. His *Study (Nude in the Sunlight)* (1875, Louvre, Musée d'Orsay) renders the flow of light over naked skin by lively color transitions that run from sharp white in the highlights to smoky blues in the shadows and fusions of warm yellows and pinks in the half-shaded parts. The colors are made to merge with one another in overlapping transparencies. The result is a kind of human landscape in which the solid forms of head, shoulder, and breasts are decomposed by the vivid play of light and color over them, an effect very different from that of Renoir's earlier, compact, studio-lit nudes (*Diana the Huntress,* 1867, and *Bather with Griffon,* 1870).

The clothed body, divided into color areas and hence less coherent than the nude, lent itself better to Impressionist treatment and to integration in outdoor settings. In several paintings, Renoir studied the effect of broken sunlight on casually grouped figures. The dark suits of the men, the light dresses of the women, the warmth of the partly sunlit faces come together in a careless disarray suggestive of harmless popular amusements. Impressionism in these paintings amounts to a genial form of social observation, one that has very little in common

with Degas's inquisitional probings. *The Swing* (1876, Louvre, Musée d'Orsay) has a luminous, blueish half-shadow over which patches of yellow or reddish light are loosely scattered. The effect seems "true" to visual experience; but the light patterning also has a decorative character, and the dominance of blue with accents of pink and gold is clearly a deliberate color scheme, a matter of taste and choice rather than objective visual study.

The crowning achievement of this phase in Renoir's work is the *Ball at the Moulin de la Galette* (1876, Louvre, Musée d'Orsay), one of his most ambitious and original works, and the culmination of his Impressionist figure painting. The setting is a popular Montmartre restaurant and outdoor café in which, on a sunny afternoon, holidaymakers are drinking and dancing. It is a scene from actual life, not unlike Manet's *Concert in the Tuileries* (1862), though, significantly, it represents a different layer of society—young artists, their models and girlfriends, mingling with a working-class population. Renoir gathered the studies for this fairly large canvas (4½ × 6 ft., or 1.3 × 1.9 m.) on the spot, and had friends pose for the main figures, but the total composition, too large and complex to be taken directly from observed life, was developed in the studio. The rapid perspectival recession from the large figures grouped in the immediate foreground to the dancers in the middle distance and the indistinct crush in the far background pulls the various groups into one swirling motion. The effect of the whole is that of an agitated crowd in which the separate identities of the figures and their corporeal solidity are blurred by the unquiet, patchy light that falls on them. The idea of treating figures as a colored mass in motion—as if they were a field of flowers or a flowing stream—is very bold, and represents Renoir's most determined effort to extend the range of Impressionism to include large-scale figure composition. Despite the impressive achievement of his *Moulin de la Galette,* he never went beyond this point in his further work. The picture marks the limit beyond which he chose not to carry his experiment.

In the third (1877) exhibition of the independent artists, who now called themselves Impressionists, Renoir, who had taken a leading part in its organization, exhibited twenty-one works, including *The Swing* and *Moulin de la Galette.* The public's hostility seemed to have lessened, but the press, with the exception of a few declared partisans, was as savage as ever. The sale held by the artists after the exhibition's close netted Renoir the usual low prices, nor was there much comfort in the results of sales of the Faure and Hoschedé collections early in 1878. Discouraged by what seemed to him the failure of independent exhibitions, he decided to return to the official Salon once more. His submission, *The Cup of Chocolate* (1877, Detroit, private collection)—a handsome and rather restrained portrait study of a favorite model, "Margot"—was accepted for the Salon of 1878. Renoir described himself as "pupil of Gleyre" in the catalogue.

An important commission shortly followed on this success. *Mme Charpentier and Her Children* (1878, New York, Metropolitan Museum), a portrait of large dimensions (ca. 5 × 7 ft., or 1.6 × 2.1 m.), the result of some forty sessions, epitomizes the luxurious and tasteful style of the moneyed elite of postwar France. It also shows Renoir in the role of accomplished court artist, in the lineage of the

eighteenth-century masters, thoroughly at ease with his patrons, fully sympathetic to their mode of life, and able to enter into their personalities with all the warmth of his gregarious nature. The composition is based on a diagonal that leads from the foreground figures of the prettily dressed children playing with their drowsing dog into the elegant room, bright with its red-and-gold Japanese tapestries, and comes to rest on the handsomely matriarchal Mme Charpentier, amply gowned in black silk. The material opulence, the color splendor of setting and costumes are brought off by an extremely refined and cleverly varied execution, smoothly transparent in some parts, frothily lavish in others. There is little of Impressionism in the painting, strictly speaking, though the shadowless scattering of its main forms and its overall color intensity bear witness to Renoir's grounding in Impressionist style.

The circle of his patrons rapidly expanded; in Paul Bérard, businessman and diplomat, met at the Charpentiers, he acquired a particularly congenial friend and admirer. Renoir was to be a frequent guest at the Bérards' large country estate in Wargemont, Normandy. The Fourth Impressionist Exhibition was held in 1878. Feeling increasingly secure in the support of his newly won private clientele, Renoir decided to abstain, and to exhibit once again at the official Salon. Here he showed four portraits, including the full-length portrait of an actress, *Mlle Jeanne Samary* (1878, Leningrad, Hermitage) and his large *Mme Charpentier and Her Children,* and for once achieved a resounding critical success. His friend the collector and critic Théodore Duret published the first book on Impressionism (*Les peintres impressionistes,* 1878), and in it paid particular tribute to Renoir as a painter of women: "his rapid, light brush strokes give an effect of grace, of abandon . . . his women are enchantresses."

In June of 1879, he was given a one-man exhibition in the premises of the journal *La Vie moderne,* owned by Charpentier. Later in the summer, he stayed with the Bérards at their Norman estate of Wargemont, and here painted *Mussel Fishers at Berneval* (1879, Merion, Pa., Barnes Foundation), an exercise in a form of sweetened social subject realism that had been domesticated at the Salon by such popular artists as Bastien-Lepage and Jules Breton. Against a view of the sea and a rocky coast, three pretty children stand smiling, holding one another by their hands, while an older girl, in heavy working clothes, a mussel basket on her back, thoughtfully watches them.

The picture was shown at the Salon of 1880, together with the more typical *Sleeping Girl (Girl with Cat)* (1880, Williamstown, Clark Art Institute), a studio-posed portrait of a young model feigning sleep in an upholstered chair, a sleeping cat on her lap, a flowered straw hat on her head, her thin blouse in suggestive disarray around shoulders and bosom. In the dark setting, the red of the chair and the blue of the girl's skirt stand out with glowing intensity, as if illuminated from within.

In these paintings destined for the Salon, Renoir appears to be experimenting with a variety of new subjects, and with new ways of presenting them, that are distinctly non-Impressionist. What appears like a move toward compromise was perhaps a nervous reaction against the alienation from public taste that

Impressionism had brought, and an experiment in assimilation, in which elements of Impressionism—audacity of color, and a certain Bohemian insouciance, part charm, part cheek—are combined with reassuring hints of a tamer Salon modernity. In genre paintings of this time, such as *After Lunch* (1879, Frankfurt, Staedelsches Kunstinstitut) and *Place Clichy* (ca. 1880, on loan to Fitzwilliam Museum, Cambridge, England), Renoir took up motifs that had earlier been used by Manet and Degas, treating them in his own softer, more ingratiatingly sensuous style. His most distinctive contribution was a matter of mood and temperament, a special sympathy with the cheerfulness of youth, and a relish for the relaxed, erotically warmed pleasures of the table, of festive dress, and agreeable, undemanding female company. There are echoes of the eighteenth century in his scenes from modern life, reflections of the somewhat Rococo indulgences of an upper class about to recover from the terrors of war and revolution.

He did not, in the meantime, abandon Impressionist outdoor painting, but spent part of his free time in the summer months sketching scenes of boating along the Seine—*Oarsmen at Chatou* (1879, Washington, National Gallery)—using a choppy, vividly colorful manner that recalls the river views he had painted around Argenteuil in 1874. By way of respite from the chore of commissioned portraiture, Renoir conceived the plan of a large composition recording the private Sunday pleasures of his sportsmen friends and their female companions at a favorite riverside restaurant terrace at Chatou: *The Luncheon of the Boating Party* (1880–81, Washington, Phillips Collection). Begun in the open air, the picture retains something of the freshness of filtered daylight and a sense of wind and water. Its many-figured composition resembles the foreground groups of the *Moulin de la Galette,* but the figures are larger, more distinct, and more deliberately placed than those of the earlier picture. The social milieu, too, has significantly changed. Besides its sprinkling of actresses and models, the ornaments of this feast, it includes several of Renoir's wealthy friends and society patrons, the publicist and financier Ephrussi, the engineer and amateur painter Caillebotte, and Baron Barbier, a playboy. The young woman caressing a griffon, in the foreground at the left, is Aline Charigot, who had recently become Renoir's companion and was eventually to be his wife. Instead of the pervasive blue of the *Moulin,* it is the white of the tablecloth and of the men's rowing shirts that holds the composition together. All the colors are keyed to an even lightness. The still-life of fruit, bottles, and sparkling glasses that occupies most of the center is a dazzling piece of illusionist painting, next to which other passages, particularly the bodies of the male figures, seem somewhat cottony and shapeless. The carefree animation of the scene, the cloudless youth and attractiveness of its holidaymakers, and the cheerfulness of its color-accords give it the anachronistic charm of a *fête galante.*

Durand-Ruel in 1881 began to increase his purchases; for the first time in his life, Renoir had more money than he needed for bare survival. He decided to spend some of it on travel, and following the advice of friends (and perhaps the example of Delacroix) visited Algeria in the early spring. His brief North African stay in February to April produced a relatively small number of paint-

ings, nearly all of them landscapes or panoramic crowd scenes—*Arab Festival* (1881, Paris, Musée d'Orsay).

The Sixth Impressionist Exhibition was meanwhile being mounted in Paris. Renoir again abstained, and instead sent two portraits to the Salon. In October 1881 he left on his second big voyage of the year, this time to Italy, accompanied by Aline Charigot. From Venice he proceeded to Florence and thence to Rome, Naples, and Sicily. He had started out in a mood of self-doubt. What he saw of the work of the Renaissance masters, Raphael above all, and of ancient frescoes deeply moved him, but also filled him with unease about his work. The monumental painting of the great Italians and the "simplicity and grandeur" of the ancients gave him a sense of his own weakness, the slightness of his training, and his lack of discipline. Impressionism, he complained in letters to friends, had caused him to squander his time and talent. At the age of forty, he still had not learned to draw! The lesson of Ingres—Impressionism's antithesis—came often to his mind. But in the views of Italian cities that he painted on his voyage—*Piazza San Marco, Venice* (1881, Minneapolis, Institute of Arts) and *Vesuvius, Morning* (1881, Williamstown, Clark Art Institute)—hoping to find a ready market for them on his return, he continued in his customary, broadly Impressionist sketching style.

While boating on the Bay of Naples, it occurred to Renoir to repeat the experiment of posing a nude model in the full light of day. The result, a painting known as *The Blond Bather* (1881, Williamstown, Clark Art Institute), in its difference from the earlier *Nude in the Sunlight* (1875), gives a measure of his withdrawal from Impressionism and his search for a clearer, more definite design. The bather's ample figure is modeled by a brilliant white light that casts shadows of faint blue and rose on her skin. The strongly illuminated body is set against a background of sea and cliffs that is itself of the lightest, most vaporous blue, but it does not merge with these surroundings. Rather, it stands out distinctly, its forms delicately drawn by an unbroken contour.

During his stay in Palermo, in January 1882, Renoir painted a *Portrait of Richard Wagner* (Louvre, Musée d'Orsay) for which the composer had reluctantly granted him a session of thirty minutes. On his way back to Paris, he visited Cézanne at L'Estaque, painted some landscapes, fell seriously ill with pneumonia, and was nursed back to health by Cézanne. To recover his strength, he made a second stay in Algeria (March–April), during which he painted a number of studio-posed figures in Arab costume. A Seventh Impressionist Exhibition was meanwhile being prepared in Paris. Renoir hesitantly allowed the inclusion of twenty-five of his works (among them *The Luncheon of the Boating Party*), mainly to oblige Durand-Ruel, who had recently suffered business reverses, but at the same time declared his intention of continuing to show at the Salon.

All the Impressionist painters went through a period of discontent with their work in the early 1880s, but none reacted more vehemently against his own Impressionist past than Renoir. In his dissatisfaction with Impressionism's concentration on fugitive effects and its consequent neglect of structure and definition, its indifference to permanence and "grandeur," he agreed with Cézanne. But he expressed his reaction in a different, consciously conservative way, still under

the influence of his recent impressions of Italian monumental painting. Renoir's preoccupation with traditions of figurative art is apparent in the series of large compositions of dancing couples that he painted shortly after his return from Italy, one of them an individual canvas, *Dance at Bougival* (1882–83, Boston, Museum of Fine Arts), the other two a thematic pair, *Dance in the City* (1882–83, Louvre, Musée d'Orsay) and *Dance in the Country* (1882–83, Louvre, Musée d'Orsay). Though these are scenes from modern life, differentiated by time of day, locale, and mood, Renoir does not seem to have intended social realism in them. In composing his figures in individual, statuesque pairs, bounded by clear contours and formed by areas of strong local color with little interior shading, he seems to have aimed for something akin to the quality of large and readable design that he had admired in the wall paintings of ancient and Renaissance Italy. The manner of execution and choice of colors are still not unlike those of *The Luncheon of the Boating Party,* with perhaps a little less liveliness of handling. Aline Charigot posed for *Dance in the Country;* a girl of seventeen, the future painter Suzanne Valadon, modeled the female dancers in the other two panels.

Renoir's reaction against Impressionism reached a critical stage in 1883. He destroyed a number of recently completed pictures and tormented himself with curiously retrograde stylistic experiments, in some instances going to the anti-Impressionist extreme of drawing his compositions in heavy ink contours on the canvas before executing them in oils. His most radical work of the period, *The Children's Afternoon at Wargemont* (1884, West Berlin, National Gallery)—a domestic portrait of the three daughters of Renoir's friend and patron Paul Bérard—places their figures in a harshly angular, flat pattern of contrasting, sharply contoured color areas (reddish-brown, white, and strident blue), all of equal brightness and intensity. The heavy and rather dry pigment is laid on in opaque, inert patches. The stiffness of the handling, strikingly different from Renoir's usual nervous vivacity (witness *Mme Charpentier and Her Children*), expresses a self-imposed constraint typical of this period in his life.

The stressful uncertainty apparent in Renoir's work of the mid-1880s may, in part, reflect his growing isolation from the companionship of the Impressionist group. Though he remained on good terms with most of his former associates, particularly Monet, with whom he traveled in the South of France in 1883, his ties to them were loosened, partly by increasing divergences of opinion and practice, partly by geographic separation. With the exception of Degas, all moved away from the immediate vicinity of Paris: Monet to Giverny in 1883, Pissarro to Eragny in 1884, and Sisley to Moret in 1882. Cézanne rarely left Aix, and Renoir himself began to spend part of every year in the country.

By 1885, he had systematized his anti-Impressionism into a distinct style, to which he would refer, in later years, as his *"manière aigre"*—his sour, or harsh, manner. It was a style based on linear design and arbitrary color choices, on studio arrangements and stereotype figures. Starting from a very precise drawing on the canvas, he would paint with thin brushes in desiccated pigments, producing a dense mesh of strokes that gave his picture something of the hard finish of fresco work. His choice of colors tended to a limited range of blues, purples, acid

green, and very light flesh tints. Everything in this method was a denial of Impressionism, of its spontaneity, freedom, and naturalism, and at the same time a renunciation of the particular strengths of his own talent. The contrast between the new and Renoir's earlier, softer and more painterly manner is tellingly evident in the large canvas *The Umbrellas* (ca. 1881 and ca. 1885, London, National Gallery), in which the two children at the lower right, painted about 1881, still show the loose, feathery brushwork characteristic of his pre-Italian work, while the umbrellas above and the figures at the left, added around 1885, have the sharp contours, hard surfaces, and the dulled, blue-gray coloration characteristic of the *manière aigre.*

In his struggle to attain both strength and precision, the qualities that he had found lacking in his previous work, Renoir wavered between various possibilities: a severely formalized classicism—*Girl Braiding Her Hair* (1885, private collection); a supple, draughtsman-like manner that, combined with light color washes, gives the effect of watercolor—*Nursing; Aline and Her Son Pierre* (1885, different versions, the definitive one on loan to the Art Museum of St. Petersburg, Florida); and a harshly dissonant post-Impressionism, of which the most striking example is the *Bather Arranging Her Hair* (1885, Williamstown, Clark Art Institute), a study of the nude that in the labored finish of its figure, the rigid angularity of its pose, and the tempestuous roughness of its purely decorative landscape background seems like a *fauve* parody of Ingres's *Valpinçon Bather,* with which it has often been compared.

His friends and patrons, by and large, did not approve of his change of style. Nor did Durand-Ruel, who, hard-pressed by business reverses at the time, sharply cut back his purchases. New responsibilities contributed to Renoir's anxiety. In 1885, Aline Charigot, his companion, whose existence he had kept a secret from all but his closest friends, gave birth to their first child. Renoir had in the meantime started work on a large painting which he seems to have intended as a kind of manifesto against the formlessness of Impressionism. He labored over it for nearly three years.

The Bathers (1885–87, Philadelphia Museum of Art) combines three nude "nymphs" in a composition of calculated artificiality. The idea for it came from a fountain relief in Versailles by the sculptor François Girardon (1628–1715). Contours of the most meticulous precision define its figures, the result of many preparatory studies in which Renoir, like a latter-day Flaxman or Ingres, progressively stylized the anatomies of his models so as to abstract from them all unnecessary individuality or sense of matter. Painted in thin, densely fused brush strokes, with very light flesh colors, on an ivory-colored ground on which a landscape setting has been loosely sketched in accents of blue and yellow, the bathers form an arabesque, disembodied and spaceless, suspended in a decorative frame. The picture resembles a lightly tinted drawing, an appearance curiously at odds with its large size and its aspirations to monumentality.

The completion of this triumph of rarefied stylization, in every respect a denial of Impressionism, seems to have released the tensions under which Renoir had been working for some time. After this climactic—and terminal—effort of

stylistic self-renewal, he relaxed into a more natural and congenial manner, returning not to his earlier Impressionism, but to the broad, richly chromatic painting style that he had developed up to 1883. Having suffered through a crisis of doubt, he apparently resigned himself to being himself. There were some last flickers of experimentation. Two visits to Cézanne at Aix, in 1888 and 1889, produced pictures in which Renoir seems to be toying with ideas received from his friend, such as the *Mont Sainte-Victoire* (1888 or 1889, New Haven, Yale University Art Gallery). In other paintings of the period—e.g., *Washerwomen* (ca. 1888, Baltimore Museum of Art), he tried a technique of short, separate color strokes reminiscent of the pointillism then practiced by Seurat and Pissarro, a method he is known to have disliked. But these were minor stirrings that had no effect on the steady flow of Renoir's work in the latter part of his career. The copiousness and uniformity of this production, extending over thirty years, are in striking contrast to his former nervous changeability.

Beginning in 1890, Durand-Ruel greatly increased his purchases. Financial security now changed the pattern of Renoir's life. In 1890, he married Aline and settled into a more regular domesticity. Physically frail, he began, at age fifty, to feel and to look old. From about 1894, he was plagued by painful attacks of arthritic rheumatism. The illness progressed irresistibly, despite his various efforts to find relief in treatments and warm climates. His years passed uneventfully, in a fairly regular rhythm of seasonal travel. Renoir maintained a home and studio in Paris, changing his quarters from time to time, but not so frequently as in former years. He often spent his summers in his wife's native village of Essoyes (Champagne), where he eventually bought a house. In the cold season, he made long stays in the South, in the area of Grasse, in Cannes and Le Cannet, and finally, in 1907, acquired an estate at Cagnes. He traveled, less frequently, outside France—to Spain in 1892, to Germany in 1896 (where he was bored by the Wagner Festival at Bayreuth, and later looked at pictures in Dresden), and to Holland in 1898.

In 1890, Renoir exhibited at the Salon for the last time. But he was no longer dependent on the publicity that the Salon offered. His work was in increasing demand, and, thanks to Durand-Ruel's activity, received frequent exhibitions —in Belgium, England, the United States, and Germany, as well as in various French cities. The French government made its first purchase from him in 1892; six further paintings became the nation's property in 1896, when the collection of Renoir's friend Caillebotte was accepted by the Luxembourg Museum.

In his later years, Renoir—like Degas and Monet—tended to develop favorite subjects in series of pictures. His work no longer centered on individual stellar performances that sum up the strivings of an entire period, as his major paintings of the 1870s and 1880s had done, but unfolded in picture sequences that addressed the same motif over and over again, with only slight variations. The whole of his late work narrows down to a few strands of subject matter. Aside from portraits and occasional landscapes, it consists of portrait-like genre compositions and of studies of the nude, the famous "Bathers."

In the 1890s, the genre scenes predominated: young women, fashionably dressed, grouped in comfortably middle-class interiors, reading or playing the

piano, or less often seated in sunlit gardens or orchards. The attractive, unassuming modernity of these pictures made them popular, and apparently highly salable. It was one of these, *Girls at the Piano* (1892, Louvre, Musée d'Orsay), that was bought by the government in 1892 and became the first of his paintings to enter a French museum. Renoir, characteristically, repeated it four times in oil, and once in pastel.

The theme of the nude "Bather," central to his work after 1900, was first formulated by him in such earlier paintings as the *Blond Bather* of 1881 and the *Bather Arranging Her Hair* of 1885. The female body in a state of repose seemed to him the noblest of subjects, and he treated it with great simplicity, without narrative embroidery or any hint of symbolism. With only slight variations of pose, his young models, girls in their late teens, are shown at knee-length, in very close view, calmly seated, their hair open, often entirely inactive or languidly occupied with a towel. Classical traditions of the nude, and perhaps the specific example of Rubens, contributed to Renoir's development of this type, but its unvarying features indicate a highly personal taste. Though posed by different models, these youthful bathers closely resemble one another—round-faced, wide-eyed, their small noses tilted up, their large mouths vaguely smiling:

Bather Arranging Her Hair (1893, Washington, National Gallery);
Bather (ca. 1895, Paris, Musée de l'Orangerie);
Bather (ca. 1903, Vienna, Kunsthistorisches Museum; another version, identical in pose, is in a private collection in Devon, Pa.).

The repetitiousness of this image appears to have impressed it on the public, and to have helped to give it a certain popularity, not unlike that of Degas's *Dancers,* but some critics found it monotonous. The execution, in blond harmonies of flesh color, is caressingly supple in the bodies, and rather more bold in the sketchily suggestive backgrounds.

There is a progressive development of type, style, and technique in the sequence of the *Bathers,* but it is rather gradual. Renoir's delight in the rotund architecture of shoulder, breast, hip, and thigh led him to enlarge, and in the end to exaggerate enormously, the bodies of his nudes, while proportionately reducing the size, and interest, of their heads, as is apparent in the *Bather Drying Her Leg* (1910, São Paulo, Museu de Arte). The color schemes of his late nudes tend to an increasing warmth, a marked and in the end wearisome, dominance of oranges, pinks, and yellows, only slightly relieved by touches of blue in the backgrounds. The brushwork is remarkably firm and controlled, considering the state of Renoir's hands, by that time painfully crippled by arthritis.

A lesser series of *Reclining Nudes,* nearly of life-size, accompanied that of the *Bathers.* Derived from an allegorical composition, *The Source* (1895, Merion, Pa., Barnes Foundation), they are, for some reason, more restrained in treatment and color, more "classical" than the *Bathers* and contain distant echoes of Titian's recumbent Venuses. Several of them—e.g., *Nude on the Cushions* (1907, Louvre, Musée d'Orsay)—were posed by Gabrielle, maid of the Renoir family and for many years his favorite model.

In 1908, Renoir—besides many other portraits—painted a *Portrait of Am-*

broise Vollard (1908, London, Courtauld Institute Galleries), showing him exam-
ining a plaster statuette by Maillol. It was, in fact, the dealer Vollard who some
years later persuaded Renoir to try sculpture, having shrewdly discerned a sculp-
tural quality in his *Bathers.* After some attempts at modeling with his own failing
hands, Renoir received the help of a skilled technician, Richard Guino, who,
under his direction, translated several paintings into clay sculptures. The main
source of motifs for these sculptures was a composition of the *Judgment of Paris*
(1908, private collection), which was itself based on a painting by Rubens. Of this
composition, Renoir painted a second version in 1913 (Hiroshima Museum), in
which he slightly altered the central figure of Venus. From this figure was derived
the statuette *Venus Victorious* (1913), modeled in clay by Guino and cast in
bronze, a work of consciously classical style, though in its physical type—short-
legged and broad-hipped—representative of Renoir's personal ideal. A year later
Guino enlarged the sculpture into a bronze slightly larger than life, and con-
tributed to it a note of academic correctness that probably went beyond Renoir's
intentions.

Degas, somewhat earlier in his career (in the 1870s) and in a more directly
personal manner, had also explored the possibilities of sculpture, and it is indica-
tive of the difference between the two artists that in Degas's hands sculpture was
an instrument for exploration, particularly of motion, while in Renoir's work it
was the final expression of a tendency toward static monumentality. A preoccupa-
tion with the timelessly classical theme of the nude more particularly links Renoir
with Cézanne (his nearest relative among the artists of his generation, despite the
differences of outlook, style, and method that separated them), and to a lesser
degree with Degas. *Venus* and *Bathers* were subjects so completely drained of any
particular content by centuries of conventional use that they could be made to
serve any artistic purpose—neutral motifs, equally available to academics, to the
petty modernists of the Salon, and to the profounder conservatives of the avant-
garde, such as Cézanne and Renoir.

These subjects offered themselves to two quite different approaches: to one
which exploited their formal, aesthetic possibilities and allusions to classical
traditions, and to another which used them for more personal, expressive ends
and stressed their erotic content. Renoir was attracted to both, and went far in
both directions, but in the very end, in a number of final statements, opted for
the radical expression of private erotic interests. The last of his *Bathers,* such as
the *Seated Bather* (1914, Chicago, Art Institute), are mountains of pink and
orange flesh whose bulk crowds the picture space. The smallness of their heads
emphasizes the enormity of their bodies, tapering from shoulders and breasts to
the wider spread of hips and voluminous thighs. Yet the execution of these
powerful, almost visionary images of the female nude still has the caressing
delicacy of touch that is the intimate mark of Renoir's sensuousness.

The man who painted these tributes to the sexual power of women was by
now an invalid of seventy, devastated by paralytic illness, a skeleton in a wheel-
chair, incapacitated in all bodily functions except those that enabled him to
continue painting. By 1909, he had lost the use of his legs and had to be carried

or moved in a wheelchair; three years later, he was no longer able to stand and had become utterly dependent on the help of the women in his household. But he persisted in his painting with remarkable cheerfulness and courage, asserting by the vitality of his work a tenacious hold on life.

Recognition had in the meantime come to him, through international exhibitions, praise from artists and critics, and a rapidly rising demand for his work. In 1900, he was represented in six exhibitions—in Paris, New York, Munich, and Berlin. In 1913, the last year of peace before World War I, he figured in twenty-eight exhibitions, including the Armory Show in New York—ten of them in Germany, seven in the United States, four in Austria-Hungary, the others in France, England, Italy and Belgium. His paintings sold at considerably higher prices than those of Monet. In 1907, *Mme Charpentier and Her Children* was bought by the Metropolitan Museum for the then extraordianry price of $63,000. In Maurice Gagnac, an industrialist, and Albert Barnes, a manufacturer of medicines, Renoir acquired two indefatigable collectors. Gagnat in time bought 150, and Barnes 180 of his paintings.

The years of the war were a time of great anxiety for him. Two of his sons served, and both were wounded. In 1915, his wife died. Renoir continued to paint: landscapes, still-lifes, nudes, and portraits, including one of his dealer friend Ambroise Vollard, his bulky figure graced by a spangled bullfighter's costume—*Ambroise Vollard Dressed as a Toreador* (1917, Tokyo, Nippon Television Network Corporation). The Armistice lifted his spirits and inspired him to attempt a final large painting, in the lineage of the great *Bathers* of 1885–87. Working in the garden studio of his estate at Cagnes, which allowed him to pose his models out of doors, he painted *The Bathers* (1918–19, Louvre, Musée d'Orsay). Two immense, recumbent nudes, nearly life-size, are stretched out, one above the other, on a field of strong yellow, green, and blue, sketchily suggestive of a Mediterranean site. The intense orange of their flesh, glistening in the light, seems to flow in waves across their bodies, modeling the swell of breasts, belly, and thighs. No thought of realism, no anxiety about style inhibited Renoir as he worked, close to death, on this last, powerful statement of what mattered most to him in art and life, indifferent now to the modern world, forgetful of the recent war, oblivious of public, patrons, and critics. In contrast to the strained, pseudo-classical formality of the *Bathers* of 1885–87, a picture of virtually identical dimensions, this final *Bathers* is a work of intense, unimpeded self-expression which Renoir himself (according to his son Jean) regarded as the culmination and summing up of a lifetime of searching.

He returned to Paris for the last time in the summer of 1919. The Louvre had recently bought one of his paintings. Renoir had himself carried through the galleries, to see his painting, and to pay his last respects to the old masters. He died, in his estate of Les Collettes at Cagnes, in December 1919, aged seventy-eight.

Renoir's reputation, great at the end of his life, did not suffer the decline that often follows an artist's death. He remained the most widely popular of the artists of

the Impressionist generation, and was, with Cézanne, the artist who most directly influenced the men of the younger generation, among them the sculptor Maillol and the painters Denis, Bonnard, and Matisse. But his reputation was not uncontested, and his actual role in the art of his time has since been subjected to very diverse interpretations; his post-Impressionist work, in particular, has divided the critics, to some of whom it has appeared as the progressive decay of a great talent. Most recently, Renoir has been denounced by some authors as a courtier of the moneyed bourgeoisie and as one who exploited the sexist appetites of that class, an accusation that, in view of the late *Bathers,* seems misdirected. It is noteworthy, at any rate, that of all the Impressionists only Renoir seems to have retained the ability to shock. The essential character of his work remains still to be defined—he is the least well-published major artist of his period.

READINGS

General

B. E. White, *Renoir,* New York, 1984, an extremely well illustrated monograph, detailed in its biographical coverage, but quite brief in its treatment of the actual work and its stylistic development.

Arts Council of Great Britain, *Renoir* (catalogue of the exhibition held in 1985–86 in London, Paris, and Boston, with contributions by J. House, A. Distel, and L. Gowing), New York, 1985. The most useful recent coverage in English of Renoir's work and life. Well illustrated.

W. Pach, *Renoir,* New York, 1950.

Life

A. André, *Renoir,* Paris, various editions, 1919–28, reminiscences of a friend.

J. Baudot, *Renoir, ses amis, et ses modèles,* Paris, 1949, reminiscences of pupil of Renoir.

M. Drucker, *Renoir,* Paris, 1944.

J. Renoir, *Renoir, My Father,* New York, 1962, pertains chiefly to the last decades of Renoir's life and offers glimpses of his intimate personality and of his working methods.

G. Rivière, *Renoir et ses amis,* Paris, 1920, reminiscences of a friend who was close to Renoir in the early part of his life.

A. Vollard, *Renoir,* Paris, 1920, anecdotal reminiscences of a friend and dealer.

Work

F. Daulte, *Auguste Renoir, catalogue raisonné de l'oeuvre peint,* vol. 1, *Figures, 1860–90,* Lausanne, 1971 (a partial catalogue of Renoir's figure painting).

F. Daulte, *Pierre-Auguste Renoir, Watercolors, Pastels, and Drawings in Colour,* London, 1959.

P. Hasaerts, *Renoir Sculptures,* New York, 1947.

J. Rewald, *Renoir Drawings,* New York, 1958.

A. Andre and M. Elder, *L'atelier de Renoir,* 2 vols., Paris, 1931.

W. Gaunt and K. Adler, *Renoir,* Oxford, 1982.

Alfred Sisley, 1839–1899

The work of Sisley is more limited in subject matter and stylistic range than that of the other Impressionists. It assumed its characteristic features in the early 1870s, and maintained them, without drastic change, until the end. Sisley was not so much an innovator as a cautious follower, though one of a markedly individual bent, sustained by a profound, calmly stable disposition. Landscape was his sole interest, to which he devoted himself with steady persistence, confining himself to a relatively few motifs and compositional formats. His painting was the direct expression of his temperament, rather than of deliberate experimentation or problem solving. He had little need for travel, and apparently less desire for sociability than his fellows. His landscapes, and even his urban scenes, convey a sense of solitude. The human presence in them is insignificant; one looks in vain for scenes of holidaymaking or of open-air entertainments such as abound in the work of Renoir and Monet. Sisley's early landscapes had affinities with Corot's lyrical naturalism, perhaps owing to a similarity of attitude rather than to conscious imitation. Reflections of Monet's energetic example appear from time to time throughout Sisley's work, always tempered by the mildness of his own manner, and transformed by the serene clarity of light and color that sets his landscape painting apart from that of his colleagues.

Sisley was born in Paris in 1839, of well-to-do British parents; his father was an importer of artificial flowers. The family lived in the style of the cultivated upper middle class, giving young Sisley a taste for literature and music. Of his early years, very little is known. In 1857, when he had reached the age of eighteen, he was sent to London to prepare himself for a business career. Instead, he developed an interest in art, perhaps stimulated by impressions of English landscape painting. By the time of his return to France, in 1862, he had made up his mind to become an artist, and apparently met with no opposition from his parents. Later in the same year, now aged twenty-three, he entered the private teaching studio of Charles Gleyre, and at the same time enrolled in the official Ecole des Beaux-Arts. At his teacher's studio, he met and befriended Renoir, Monet, and Bazille. Nothing remains of his student work. In the spring of 1863, he followed Monet, Renoir, and Bazille in their exodus from Gleyre's studio, and for a season immersed himself in the Forest of Fontainebleau.

Sisley was particularly close to Renoir at this time, but little else is known of his personal life. After the final closing of Gleyre's studio in 1864, he embarked

on a course of self-training. The scarcity of work from this period is not easy to explain; it has been supposed that he painted little, since he was not pressed by financial need, but it is also possible that he destroyed his immature work. The high quality of the few surviving early paintings makes it seem likely that there once were more than are now known.

In the summers of 1864–66, Sisley painted out of doors in the area of Saint-Cloud, and made frequent visits to Marlotte near Fontainebleau in the company of Renoir (who commemorated one of these occasions in *At the Inn of Mère Anthony,* 1866). Sisley's landscape studies of this time show, not surprisingly, the influence of the Barbizon painters. *Alley of Chestnut Trees at La Celle de Saint-Cloud* (1865, Paris, Petit Palais) is executed in strong, rather dark-toned colors, laid on the canvas in a rough texture of brush strokes. The general effect is reminiscent of Rousseau's woodland scenes, but also not unlike that of Monet's Fontainebleau landscapes of the same year.

At the Salon of 1866, Sisley exhibited two canvases, *Village Street in Marlotte* (Buffalo, Albright-Knox Gallery, and Tokyo, Bridgestone Museum), cheerless perspectives of somber, squat peasant houses, their masonry indicated by a rough, structured impasto that distantly recalls Courbet. More clearly than these fairly awkward starts, the *Still-Life with Dead Heron* (1867, Louvre, Musée d'Orsay) gives proof of the awakening of a powerful painting talent. A work of intense physical realism, it is at the same time a masterly tonal arrangement in its subtle juxtaposition of the blue and gray of the dead bird's extended wings with the velvety dark of the background and the whitish gray of the cloth laid out before it, on which lie the bodies of two small birds of black and white plumage. Sisley worked on this still-life in the studio of Bazille, who was painting his own version at the same time (and was portrayed by Renoir in the act of painting it). Possibly under the influence of Manet, all the escapees from Gleyre's atelier were trying their hand at still-lifes in the years of 1864–68.

From about 1866, Sisley lived with his companion, Marie Lescouezec, in the close vicinity of the Avenue de Clichy and the Café Guerbois, the gathering place of the painters and critics who gravitated around Manet. Sisley appears to have been an infrequent and fairly reticent witness to their discussions. A son, Pierre, was born to the Sisley menage in 1867, and in the summer of the same year Sisley made a lengthy stay with Monet at Honfleur. The Salon of 1868 accepted his submission—yet another *Alley of Chestnut Trees at Saint-Cloud* (1867, Southampton Art Gallery)—evidently through the intercession of Daubigny, a member of the jury. In 1868, he again painted in the area of Fontainebleau, perhaps in preparation for the Salon of 1869, which, however, rejected his entry. Of his work of these years, too little survives to indicate the course of his development. There remains only one dated painting, *View of Montmartre* (1869, Grenoble Museum), which opens a view, across a greensward planted with wire-thin, leafless saplings, onto a melancholy horizon of suburban houses. A sky of clear, light blue appears, timidly, through the grayish overcast, which is touched by the faint rose of a sunrise or sunset. There are echoes of Corot in this picture, but its note of urban desolation, strongly conveyed by the flat, muted colors, belongs to another, later age.

At the Salon of 1870, Sisley was represented by two cityscapes of a totally different style. The change in his work which they herald must have occurred, perhaps abruptly, some time in late 1869 or very early 1870. Abandoning his Corot-inspired tonal manner, Sisley suddenly appropriated something of the technique of painting in vivid, contrasting color touches that Monet and Renoir had been developing since 1867 and had brought to a high point in their studies *La Grenouillère* in the summer of 1869. His two exhibits of 1870, *The Canal Saint-Martin* (1870, Louvre, Musée d'Orsay) and *Barges on the Canal Saint-Martin* (1870, Winterthur, Reinhart Collection), are studies of light-diffusing atmospheres over wind-ruffled water. Both, in varying degrees, show a marked increase in the luminosity and intensity of his colors. In the painting of the Musée d'Orsay, a fine blue haze veils the forms and softens the scintillations of yellowish light on the water. In the canal scene in Winterthur, the local colors of the houses and barges are flat and definite, while a brisk, choppy brushwork in the water gives the effect of liquid reflections. A glimpse of coalmen carrying their burdens up sloping planks contributes a (very discreet) note of social observation.

The outbreak of the Franco-Prussian War in the late summer of 1870 brought his work to a temporary halt. Though, as an English citizen, Sisley was exempt from military service, his hitherto comfortable existence was devastated by the war. His father suffered bankruptcy, fell ill, and died, leaving him penniless. To escape from the civil wars of the Commune in 1871, and to live more cheaply, Sisley moved his family to Louveciennes, about six miles to the west of the city, where Pissarro had lived for some time and where Renoir briefly stayed after his army service. From this time on, his life was to be a constant struggle with poverty, waged in modest lodgings in riverside villages or small towns at some distance from Paris. He was now forced to paint for a living. The number of his paintings dramatically increased about 1870; the following decade was to be his most productive period, and perhaps his best.

Early Snow in Louveciennes (ca. 1870, Boston, Museum of Fine Arts) is the first of many winter townscapes painted in these years. Patches of snow on roofs and along the curving road leading into the village—a typical feature—lend a special intensity to the surrounding colors: the soft green of the trees still in leaf, the caramel-beige of the terrain, and the tender blue of the sky.

Sisley developed his full stylistic and thematic range very rapidly in the postwar years of 1872–74, finding his subjects in the surroundings of Louveciennes and the nearby river towns of Port Marly, Bougival, Argenteuil, and Villeneuve-la-Garenne, all situated on the low banks along the winding, slow-flowing Seine. Unlike most of his painter friends, he felt no need then or in later years to travel far in search of scenery. The spacious but nearly featureless river valleys with their nondescript towns gave him all he wanted. He did not look for grand sights or dramatic moods. His work constantly expressed his grateful acceptance of an unspectacular nature, experienced within familiar, closely limited localities. Its variety of effect and feeling reflects the cycle of the seasons. The special qualities of light and atmosphere that go with winter, spring, summer, and fall were the actual theme of his landscape painting. Light and atmosphere are the active element that animates Sisley's views and gives them a striking reality,

the reality of a vividly experienced moment in the flow of time. To this essentially visual perception, the material forms in landscape are subordinate—floating cloud and flowing water, sunlit houses and shady foliage are mere reflectors of light, which receive their color and their character from the action of the sun and the intervention of the atmosphere.

The Ile Saint-Denis (1872, Louvre, Musée d'Orsay) typifies the spacious river views that make up much of Sisley's work. The picture is filled with a cool spring light that seems suspended in a faint haze. The wide expanse of land and water provides a passive stage for the active, transient phenomena of weather. In its patient empiricism, and its concentration on the subtle processes of light and air, Sisley's landscape studies of this kind bear a resemblance to Constable's—a fact that was noted by his friends, who commented on the "Englishness" of his work.

Buildings play an important role in many of his paintings, usually structures that are in themselves insignificant—nondescript suburban houses, bridges, waterworks—but are made splendid by the sunlight that falls on them. Both the *Bridge at Villeneuve-la-Garenne* (1872, New York, Metropolitan Museum) and *The Waterworks at Marly* (1873, Copenhagen, Ny Carlsberg Glyptotek) illustrate Sisley's acute perception of the qualities of sunlight, bright in the one, diffuse in the other, and his skill in contrasting its liquid reflections on flowing water with its warm luminosity on light-struck masonry.

For Sisley, the early 1870s were a time of close relationship and frequent collaboration with Monet, Renoir, and Pissarro, all of whom lived and worked along the Seine within easy reach of one another. During 1872–74, he occasionally painted in Argenteuil, where Monet then lived and where Renoir often visited. It was in these years, more than in any other period, that the Impressionists (not yet so called) formed a group, pursued similar goals, and presumably influenced one another. A pervasive lightness, freshness, and intensity of color, a special liking for riverine scenery, and a lively, mottled brushwork were common to all. Monet was the leading spirit among them, strongly influential on Renoir; what influence he may have had on Sisley is less clear. Sisley's work of this time, at any rate, has an unmistakable individuality. It is recognizable by its delicacy of color, especially in the blues of sky and water, and by its subtle tonal fusions, which give to his landscapes, even to the most brightly sunlit, the appearance of being overlaid by a transparent film or haze. In his very consistent choice of motifs, Sisley seems independent of Monet, who was notably more various and experimental. His landscapes show a steady preference for certain pictorial structures, large skies, wide horizons, deep spaces, emphasized by perspectival features —roads or river courses—in the foregrounds and by suggestions of spatial recession in the cloud-layering of the skies. In the absence of any subject-matter interest or conspicuous genre detail, the painter's sensation before the motif constitutes the sole theme and contributes the "lyrical" note often remarked in Sisley's work.

In the spring of 1874, he was one of the original instigators—together with Monet, Pissarro, Degas, and Renoir—of the independent exhibition at Nadar's

gallery in the Boulevard des Capucines. He exhibited five canvases, including *The Waterworks at Marly,* received his share of sarcastic criticism, but sold somewhat better than his colleagues. In the following summer, after the exhibition's closing, he paid a visit to England at the invitation of one of his patrons, the singer Faure. He spent little time in London (where he painted *Charing Cross Bridge,* anticipating Monet's series of 1899–1903), but found motifs on the banks of the Thames at Hampton Court that are strikingly similar to his accustomed Seine subjects. *Bridge at Hampton Court* (1874, Cologne, Wallraf-Richartz Museum) resembles in choice of view the *Bridge at Villeneuve-la-Garenne* of 1873, though it differs in its light and effect of atmosphere. *Regatta at Moleseye* (1874, Louvre, Musée d'Orsay) is an exceptional record of an actual event, very rapidly sketched on a dark, purplish-gray ground, evocative of a humid, overcast day. The flags, the sparkle of light on the river, and the lines of the rowing boats are summarily indicated by touches of light color, in a manner reminiscent of Constable's small oil studies.

After his return to France, Sisley moved from Louveciennes to nearby Marly-le-Roi. His finances were in disarray. Durand-Ruel, to whom he had been introduced by Monet or Pissarro in 1872, and whose purchases had been his main support during 1872–73, had been hard hit by the recession of 1874 and forced to suspend his business arrangements with the Impressionists. Sisley joined with Monet, Renoir, and Berthe Morisot in an attempt to raise money by means of a private auction. Despite efforts made on his behalf by such friends as Duret, Chocquet, and Caillebotte, he realized only 2,445 francs for the twenty-one canvases that he sold, a very low price. In April of 1876, he showed eight paintings in the second exhibition of Independent Artists, held that year in Durand-Ruel's gallery, but did not sell anything. Undiscouraged, he continued to record the changing seasons along the banks of the Seine at Marly and among the neighboring villages.

The Seine at Port-Marly, Sand Heaps (1875, Chicago, Art Institute) is one of several views of a bend of the Seine, with barges being loaded, that seems to have had a particular attraction for Sisley. The coolness of the light in sky and water, and the thinness of the foliage beyond the river, suggest a day in early spring. *Watering Place at Port-Marly* (1875, Zurich, Bührle Collection), by contrast, embodies the warm light and resonant colors of summer. Sisley had a special fondness for winter scenes, and every year painted village streets in the snow, as in *The Place du Chenil, Marly, in the Snow* (1876, Rouen, Musée des Beaux-Arts), often achieving a striking truth of color and light effect in the gray skies and the dark silhouettes of trees laden with snow.

Many of Sisley's subjects are neither of the open country nor of the city, but of the melancholy zone that lies between. They express the pathos of suburban marginality. Nature in them appears impoverished and threatened by the encroaching metropolis, and perhaps for that reason has a special, poignant beauty. An inundation of the bleak quays of Port-Marly, in the winter of 1876, gave Sisley the idea for a series of paintings that records the unusual sight of a row of houses engulfed by a rising expanse of water: *Flood at Port-Marly* (1876, two main

versions, both in the Louvre, Musée d'Orsay; a variant of one of these in the Rouen Musée des Beaux-Arts). The overcast sky sheds an even, baleful light over the reflecting waters, creating a splendid harmony of blue, gray, and silver hues, shot through with golden lights. The chalky facades of the houses and the dark, leafless trees seem, surprisingly, to float in this seascape, accosted by small barges that have replaced the traffic of the former streets. One may wonder whether the image of floodwaters, rising inexorably and threatening human habitations—a subject that occurs several times in his work—attracted Sisley because of its symbolical suggestiveness.

In 1877, he sent seventeen paintings to what was now officially called the Third Impressionist Exhibition. His financial distress was still acute. Durand-Ruel, momentarily insolvent, had again stopped his purchases. Sisley was forced to appeal to those few patrons who had sustained him in the past: the publisher Georges Charpentier, the critic Théodore Duret, and the art-minded pastry cook Eugène Murer, Renoir's friend, whose Wednesday dinners, in a restaurant on the Boulevard Voltaire, were a boon to impecunious artists.

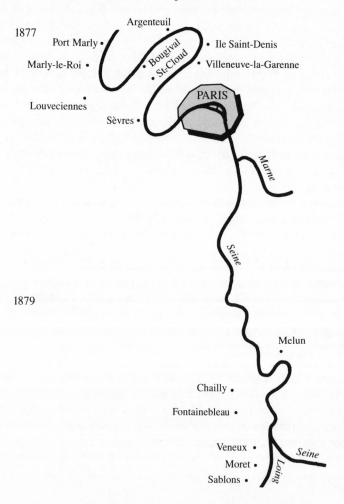

In the fall of 1877, Sisley moved from Marly-le-Roi to Sèvres, more urban and industrial than his previous houses, a fact reflected in many of his paintings of the following years. Hoping to reach a wider audience, he decided in 1879 to submit his paintings once again to the official Salon, but was refused. Evicted for non-payment of rent, he was forced to change his lodgings at Sèvres, and at the end of the year made the far-reaching decision to remove himself from the vicinity of Paris, and from his favorite painting grounds, to the rural remoteness of Veneux-Nadon, near Moret on the Loing River, two hours by train southeast of Paris.

This change of setting was to have an effect on Sisley's personal life and on his work by separating him further from his friends and from the art life of the metropolis. While Monet and Pissarro settled to the northwest of the city, Sisley chose the opposite direction, going as far as the southeastern edge of the Forest of Fontainebleau. It was a withdrawal from sociability, perhaps tinged with the bitterness of disappointment. His work of the following years reflected his new environment: that of a small, provincial, still beautiful town, entirely unaffected by industry and surrounded by flourishing countryside. The theme of suburban melancholy now disappears from Sisley's work, and so, strangely, do the winter scenes once so prominent in it.

The 1880s also brought stylistic changes, most apparent in a lessening of the naturalism characteristic of his paintings of the 1870s, a partial loss of the striking visual truth in effects of sunlight, of flowing water, and drifting cloud that had been their distinctive quality. He now strove for a greater strength of color and energy of handling. The former delicacy of tone gave way to more pronounced contrasts, the Corot-like tenderness of touch to a deliberate, sometimes obtrusive roughness of execution. The spontaneous variety of execution in Sisley's later paintings often declines into habitual mannerisms—into a tendency to dot on the colors in scattered scintillations or "pointillist" textures, or, at the other extreme, to apply them in flat, pale washes, as seen in the *Fields at By* (1880, Baltimore Museum of Art) and *Saint-Mammès, Cloudy Weather* (ca. 1880, Boston, Museum of Fine Arts). Foreground screens of trees, transparent to the light, or covering the sky with a lively color pattern, became a common feature in his later landscapes.

An annual retainer paid him by Durand-Ruel assured Sisley a modest living, but his pictures did not sell well. The 1880s were a difficult period for him, as they were for all the Impressionists, and though it would be an exaggeration to speak of a "crisis" in his work of the time, it is clear that a particularly felicitous phase in his development had come to an end, leaving him in a state of uncertainty and tension. His work of the 1880s is uneven, and has always been less highly valued than that of the 1870s. It is a noteworthy fact that only a very few of his many landscapes of the period have entered public collections to this day.

Undaunted by lack of recognition, Sisley worked on, remarkably persistent in his concentration on a very few motifs that must have wearied even his friends and his loyal dealer, Durand-Ruel. In 1882, he was represented—for the last time —in the (seventh) group show of the Impressionists, with an array of twenty-seven paintings. Durand-Ruel, who had supplied most of these from unsold stock,

the following year gave Sisley a one-man exhibition, composed of some seventy works, but made no sales. The bankruptcy of his chief financial backer had meanwhile put Durand-Ruel himself into a difficult position and forced him to stop his purchases, depriving Sisley of his one dependable source of income. Uncomfortable at Veneux, Sisley moved first to Moret, in 1882, then to nearby Sablons the following year, and finally to Moret again, where he settled permanently in 1889. Despite these cares and distractions, the volume of his work did not decrease. The years 1884–86 were among the most productive of his career, yielding, for example, *Small Meadows at By in the Spring* (ca. 1882–85, London, Tate Gallery) and *Springtime: Aspen and Acacias* (1889, Louvre, Musée d'Orsay). In contrast to the serene naturalism of his earlier work, Sisley's paintings of the 1880s and 1890s are marked by a stressful intensity: expression competes with description. The colors become sharper, more emotional. They are applied in a vehement calligraphy of curved brush strokes that forms dense textures in the grassy foregrounds and in the foliage of trees.

These changes in manner and in feeling may have had personal roots, but they correspond to similar developments in the contemporary work of other Impressionists, notably Monet. Whether they reflect mutual influences, or simply mark a stage in the general development of Impressionism, it is apparent that the tendency to a more emphatic expressiveness was shared to a greater or lesser degree by all the painters of the group. In keeping with Sisley's calmer temperament, it did not take so radical a form in his work as in that of Monet, nor did he allow the agitation of his paint surfaces to deny spatial depth or to dissolve solid forms. He resisted abstraction and decorative flattening, and to the end insisted on the objective reality of light, space, and matter. Color, in his landscapes, never loses its descriptive function.

Like Monet, Sisley often returned to favorite sites and painted numerous variations of particular motifs. Several thematic series run through his late work, and in fact constitute its main bulk: long, perspectival river views at Saint-Mammès, framed by rows of houses; the bridge and towers of Moret seen from across the Loing River; lines of slender poplars along the curving course of a canal. *The Loing Canal* (1892, Louvre, Musée d'Orsay), with its pale trees against an evening sky, and its shadows of mauve and lilac, is strongly reminiscent of certain paintings in Monet's series *Poplars Along the Epte River* (1891), of which fifteen canvases were exhibited, in 1892, in Durand-Ruel's gallery, where Sisley very likely saw them.

Another motif that may have been suggested to him by Monet is that of *Haystacks, with Moret in the Distance* (1891, Douai Museum), or *Haystacks at Moret* (1891, Melbourne, National Gallery of Victoria). But Sisley's few paintings of this subject represent different haystacks in various kinds of light. They do not, like Monet's famous *Haystacks* of 1890–91, concentrate on the progressive changes of light on individual haystacks; in other words, they have little to do with Monet's far more probing investigation of light and color phenomena.

More closely related to Monet's experimentation are the twelve canvases the *Church at Moret* (1893–94, versions in the Rouen Museum, the Detroit Art

Institute, the Paris Musée du Petit-Palais, the Bucharest Museum, and several private collections), which form Sisley's most extensive and coherent series. As in Monet's series *Rouen Cathedral* (1892–93, the canvases dated 1894), the church is represented in the light of various times of day. But, unlike Monet, Sisley studied his church over a longer period of time, in different seasons and under different weather conditions. While Monet painted the facade of Rouen Cathedral head on and at very close range, reducing it to a light-reflecting surface, Sisley took his stand at some distance from his church and viewed it at an angle, so that it appears as a substantial, three-dimensional body within a surrounding space.

Beginning in 1893, his productivity began to falter, perhaps because of a gradually deepening sense of discouragement. Monet and Renoir, by this time, had achieved a great critical and financial success, but Sisley still had difficulty in selling his work. He had made valiant efforts to reach the public. From 1890 on, he sent his pictures to the annual Salons organized by the conservative Société Nationale des Beaux-Arts in the Champ de Mars, but sold little, and only earned a wounding review by his former friend Octave Mirbeau. In 1893, he quarreled with his loyal dealer, Durand-Ruel, and sent his work to be exhibited at the rival gallery of Boussod-Valadon. In 1897, Georges Petit gave him a large, retrospective exhibition (146 paintings and 6 pastels) in his elegant premises. But the press remained silent and there were no sales. Sisley then resigned himself to obscurity.

In May of that year he paid his last visit to Britain, spending most of the summer and early fall on the coast of South Wales, near Cardiff, painting the first and only seascapes of his career: *Langland Bay, Morning* (1897, Berne, Kunstmuseum) and *Welsh Coast, South-West Wind* (1897, Rouen, Musée des Beaux-Arts). Back in Moret, he made a futile attempt to acquire French citizenship. He had for some time suffered pains which he believed to be neuralgic, but which turned out to be the early symptoms of cancer. In October 1898, his wife died. Sisley, knowing that he was himself fatally ill, had given her his devoted care until the end. Toward the end of January 1899, he asked Monet to pay him a final visit. He died the following week.

The posthumous sale of his studio, held several months later, realized surprisingly high prices. At the sale of the collection of Sisley's friend Adolphe Tavernier, in early 1900, one of the versions of *Flood at Port-Marly* (1876) brought the record price of 43,000 francs. Recognition had finally come.

Sisley remains the least well understood of the main Impressionists. His qualities are purely those of great painting. He lacks the kinds of interest—of subject matter, technical experiment, and biographical drama—that draws the attention of critics and historians, and therefore has suffered the relative neglect that has befallen such artists of the highest rank as Corot whose work happens not to lend itself to verbalization. His landscapes of the 1870s are universally admired, but his later work has often drawn sharp criticism, even from observers of good will and good eye, such as Pissarro, who called it "commonplace, forced, and disordered," while praising the earlier *Flood at Port-Marly* as a great masterpiece.

READINGS

F. Daulte, *Alfred Sisley, catalogue de l'oeuvre peint,* Lausanne, 1959, catalogues and illustrates 884 paintings by Sisley in chronological order; it also offers a biographical outline and a comprehensive bibliography. The brief introductory text does not go deeply into Sisley's artistic development and historical position. The projected companion volume on the pastels and drawings of Sisley has not appeared.

No detailed biography of Sisley is as yet available. G. Geffroy, *Sisley,* Paris, 1923, is mainly interesting for its account of a visit by the author to the aging Sisley in 1894.

Good reproductions, particularly of Sisley's later work, are scarce. The following recent publications contain useful material:

Bern, Kunstmuseum, *Alfred Sisley* (exhibition catalogue), Bern, 1958.

R. Cogniat, *Sisley,* Paris and New York, 1978.

R. Shone, *Sisley,* London, 1979. An intelligent, brief appreciation; good colorplates.

R. Nathanson, *Alfred Sisley* (exhibition catalogue), London, 1981.

Camille Pissarro, 1830–1903

Pissarro's position among the Impressionists is pivotal. He was the oldest of the group, and his beginnings were still involved with earlier Romantic traditions. His very gradual artistic maturation was deeply influenced by the painters of Barbizon, by Daubigny, Millet, and above all by Corot. During the heroic years of Impressionism, it was Pissarro who, putting his own interests aside, constantly struggled to keep the group together and who—alone among his friends—faithfully supported every one of its exhibitions. Within the group, he was able to overcome seemingly insuperable differences of outlook and temperament, not merely as a mediator but as an artistic collaborator, welcomed on the one hand by Cézanne and, on the other, by Degas. Of the original Impressionists, Pissarro had the greatest influence on developments beyond Impressionism: Cézanne, Gauguin, Signac, and Van Gogh, in varying degrees, benefited from his guidance at crucial moments in their careers. More than any of his peers, he followed a consistent political philosophy. His work was grounded in a world view—social anarchism—to which it gave a genuinely artistic expression, never declining into simple polemic. Less richly endowed than some of his friends, not quite equal to the powerful painting talents of Monet or even Sisley, nor to the inventive audacities of Degas, the "humble and colossal Pissarro," as Cézanne called him, achieved a profound, highly personal work by balancing the conflicting naturalist and stylistic tendencies in his makeup, aided by his lucid, self-critical intellect.

Camille Pissarro was born in 1830, in the town of Charlotte Amalie, on the island of St. Thomas, a Danish colony in the West Indies. His parents, owners of a profitable general store, were French, though they were of Portuguese-Jewish origin. Camille started school on St. Thomas, but at the age of twelve was sent to France to attend a boarding school in Passy, a suburb of Paris. Toward the end of his six years of schooling, he developed an interest in drawing.

In 1847 he returned to the island to start his apprenticeship in the family shop, but soon discovered that he had no aptitude for business. To while away his boredom, he filled sketchbooks with his observations of the scenery and street life of St. Thomas. By chance, he made the acquaintance of an itinerant Danish painter, Fritz Melbye, in 1851, who, though only four years older than Pissarro, was already an experienced professional, specializing in exotic landscapes. When, in the fall of 1852, Melbye traveled on to Venezuela, Pissarro went with him,

seizing the opportunity to escape from the confinement of family and job into the adventurous freedom of an artist's life.

During his two-year stay in Caracas with Melbye, he continued his self-training by drawing in pencil, pen, and watercolor whatever caught his interest on rambles around Caracas. Though he had a strong sense of artistic vocation, his talent developed very slowly. The drawings of these years in Venezuela have a certain naive vigor, but give as yet no sign of extraordinary promise.

In 1853, his younger brother died, and his family pleaded with him to return to St. Thomas. Pissarro reluctantly complied in the fall of 1854, and spent another year helping in his father's business, in return for which he was promised support for a period of art study in Paris. In September 1855 he was able at last to sail for France, whither his mother and sisters had already preceded him. He arrived in Paris in November, barely in time to visit the great Exposition Universelle before its close. This included the first truly international exhibition of contemporary art ever held—an enormous show of some five thousand works by more than two thousand artists from twenty-eight countries. Pissarro, emerging from deepest provincial isolation, suddenly faced the bewildering diversity of world art.

It is not likely that he found his bearings in this immense, confusing offering within the three or four days at his disposal, but his brief exposure left some lasting impressions. Past, present, and future forms of modernity presented themselves at once, and contradicted one another. The awestruck beginner was given a choice between a dozen conflicting movements, and invited to compare the works of Ingres, Delacroix, Corot, Rousseau, and Millet with those of a host of far more popular favorites—Decamps, Vernet, Meissonier, Couture, and Gérôme —who shared in the shower of medals and promotions to the Legion of Honor that marked the occasion.

Aside from the fact that from the very start Pissarro's personal interest was fixed on landscape painting, he seems not to have committed himself to any very definite direction. In obedience to his father's exhortation to seek the best professional schooling, he enrolled in the official Ecole des Beaux-Arts with several teachers of essentially academic tendency. But his real mentor appears to have been the Dane Anton Melbye (brother of Fritz Melbye), who was established in Paris as a marine and landscape painter. Through Melbye, Pissarro met Corot, who gave him encouragement and advice: "Go into the country: the Muse is in the woods!"

The first landscapes painted by Pissarro in France, of which *A Cove at St. Thomas* (1856, Upperville, Va., P. Mellon Collection) is typical, were nostalgic evocations of the West Indies, executed in brownish monochrome and conceived in a conventional, late Romantic style which, curiously, gives no indication of his personal knowledge of tropical scenery. Very little of Pissarro's work of the late 1850s has been preserved. What remains shows him to have been an essentially self-trained artist, guided by the example—and perhaps the personal advice—of Corot, and influenced by what he knew of Courbet's and Daubigny's stylistic and technical innovations, but relying mainly on his own practical experience in

painting out of doors around Paris and along the Seine. Begun late, his development progressed slowly: at the age of nearly thirty, he was still a beginner. Much burdened by the demands of his parents and relatives, he was nevertheless able to gather a circle of artistic acquaintances, particularly among the followers of Courbet, whom he probably encountered at this time in the convivial setting of the Brasserie Andler. It was very likely in this milieu that he began to form what were to be his life-long political convictions—republican and anti-clerical, based on the humanitarian, socialist secularism born of the Revolution of 1848. He never renounced his Danish citizenship.

On one of his painting expeditions into the countryside around Paris, Pissarro became acquainted with another student of landscape, Isidore Piette, a well-to-do amateur painter and owner of an estate at Montfoucault in Brittany. The two became close friends; later Piette was to play an important role in Pissarro's life as his confidant, frequent host, and supporter in hard times.

In 1859, Pissarro felt confident enough to submit a painting to the Salon. His *Montmorency Landscape* was accepted, and listed in the catalogue as by a "pupil of A. Melbye." The picture is lost, but there are others of this time that show him still trying to combine fresh observation with effects of illumination and of tonal silhouetting that recall Corot. While painting out of doors in the good-weather season, Pissarro conscientiously continued his more conventional training by drawing the posing model at the free Académie Suisse. It was here that, some time in 1859, he first met Monet, recently arrived from Normandy.

Pissarro fell in love with a maid in his parents' household—Julie Vellay, a country girl of twenty-one. She became pregnant in the latter part of 1860, and subsequently had a miscarriage. His parents, on whom he depended financially, opposed a marriage on both social and religious grounds. Pissarro continued to live with Julie, unmarried and on bad terms with his family, who now reduced their support to small, periodic handouts. This crisis had a drastic but ultimately beneficial effect on Pissarro's life. It led to the founding of a family of his own, and to his emancipation from conventional society. Julie, whom he married only years later (1871), against further parental resistance, ultimately bore him seven children. Family and freedom were to sustain him through the hardships of his later life.

It was now urgently necessary that Pissarro should establish himself as a professional. The pictures he sent to the Salon of 1861 were rejected, and the same fate befell his submissions in 1863. Along with other victims of the jury—among them Manet, Whistler, Jongkind, and Cézanne—Pissarro courageously chose to have his paintings included in the Salon des Refusés. Here one of them caught the friendly eye of the critic Castagnary, who commented on its debt to Corot.

The birth of his first son, Lucien, made it imperative to find healthy but inexpensive quarters, if possible in a congenial rural setting. After a summer visit to his friend Piette in Brittany, Pissarro settled his family in the village of La Varenne-Saint-Hilaire, on the banks of the Marne, some fifteen miles to the southeast of Paris. Except for relatively brief visits to the city, he was henceforth to spend most of his life in a rusticity that suited both his temperament and his

purse. He continued to make determined efforts to gain entry into the Salons, the only way of bringing himself to public and critical notice. He succeeded in 1864 with two landscapes, and again had two landscapes shown in 1865.

The Tow Path (1864, Glasgow Art Gallery and Museum), one of his Salon pictures of 1864, is of remarkably stark and simple construction. The sloping riverbank with its sun-streaked path in the foreground is set as a dark, sharply defined silhouette against the long horizontal of the opposite shore. The effect still recalls Corot, but a Corot of uncharacteristic harshness, compactness, and geometry. *Banks of the Marne at Chennevières* (1865, Edinburgh, National Gallery of Scotland), one of his exhibits at the Salon of 1865, indicates a sudden, far-reaching change in direction. The view opens into deep space across a broad expanse of water. The distant, converging shores seem suspended between the blue sky and its blue reflections in the river below. Fresh colors, rather than light-dark contrasts, suggest space and light, and give a vivid material presence to the houses and verdure of the riverbank. The crisp definition of objects and the somewhat unquiet brightness of the colors suggest the influence of Charles Daubigny (1817–1878) rather than that of Corot. Passages of palette-knife work in the foreground hint at yet another possible influence on the impressionable Pissarro, that of Courbet.

During 1865, Pissarro's father died, and Julie gave birth to a daughter, Jeanne. Irregular subsidies from his mother and from Julie's family barely kept them in food. Pissarro had virtually no income from the sale of his paintings. Julie did field work at harvest time. The catalogue of the Salon of 1866 no longer identified Pissarro as a pupil of Corot, as had those of 1864 and 1865. His sole exhibit of that year, *Banks of the Marne, Winter* (1866, Chicago, Art Institute), signals a retreat from the luminous, atmospheric naturalism and fluent handling of his previous Salon entries. It depicts a desolate, snowless plain into which a road, bordered by spindly trees, juts from the left at an awkward diagonal toward the hillside with its scattering of houses in the distance. The somber greens and browns that dominate the view are massed in flat areas of solid color, without regard to the subtler complexities of light and surface. The Salon reviewer (Rousseau), who praised the picture for its "brutal truth," evidently responded to its emotional impact rather than its visual realism. There are as yet no intimations of Impressionism's advent in its austere plainness and somber tonalities, but it shows the signs of an artistic individuality: the emergence of Pissarro's personal manner preceded that of his Impressionism.

He had meanwhile moved his family to Pontoise, a small town on the Oise River about eighteen miles northwest of Paris, where they were to stay for the next three years. The surrounding agricultural country, and particularly a hillside below with clustered buildings known as l'Hermitage, delighted him and became his favorite painting site. Pissarro's work at this time gained in assurance and energy. The expressive tendency that had slowly grown in it since about 1864 rose briefly to a high pitch of intensity. Following the example of Courbet, he lavished his paint on the canvas with the palette knife, building his forms in strong colors with slabs of heavy pigment. His impassioned roughness of execution, in works

of fairly large size such as the *Still Life* (1867, Toledo Museum of Art), actually went beyond Courbet and perhaps owed something to Cézanne, with whom he seems to have worked occasionally in 1866–67. When his submissions to the Salon of 1867 were rejected, along with those of Monet, Renoir, Sisley, and Cézanne, Pissarro participated in an abortive attempt to bring about another Salon des Refusés or to organize an independent group show.

Despite these disappointments, Pissarro had a highly productive season in 1867, during which he achieved his first masterworks, the culmination of his pre-Impressionist phase, in a series of four large landscapes taken from the environs of Pontoise. Control and balance mark the style of these deeply calculated landscapes. Maintaining his newly won energy, but moderating its truculence, Pissarro sought in them to reconcile natural forms with man-made order, structured space with surface pattern. His very theme appears to be agri-*culture,* the mastery of nature by peaceful human labor. In *The Jallais Hillside near Pontoise* (1867, New York, Metropolitan Museum), geometric contours bound the free growth of plant life; cubical houses and rectangular fields impose their clear-cut shapes on the irregular masses of foliage and the gentle undulations of the hilly terrain. The veiled afternoon light casts its long shadows, giving a palpable solidity to the rises and declivities of the land, and animating the view with the immediacy of a thing seen at a particular time. The colors, rich in their limited range, strong in their restraint, contribute to the calm grandeur of the landscapes by their harmonies of deep green in the shaded foliage, tender green in the meadows, brown and gold in the fields. Applied in broad strokes of the loaded brush, they both define the objects in the picture and compose an animated design on its surface.

There is still much of Corot in the motif—that of houses seen against a hillside, as in Corot's *Ville d'Avray, the Cabassud Houses* (1835–40, Louvre)— and also something of Daubigny, who had painted the same site in 1866 (Bremen, Kunsthalle). But the solidity and breadth of the picture, its disciplined concision and quiet strength of feeling, are Pissarro's own.

Owing to Daubigny's advocacy, this painting and another of the series, *Hermitage at Pontoise* (ca. 1867, New York, Guggenheim Museum), were shown at the Salon of 1868. Zola, in an enthusiastic review, praised their truthfulness and dwelled on the "indescribable feeling of epic grandeur" they inspired— "never before have paintings appeared to me to possess such overwhelming dignity." The Salon's catalogue no longer identified Pissarro as anyone's pupil: he now had earned an independent reputation. The Salon juries of 1869 and 1870 accepted his submissions without demur, but he still had great difficulties in finding purchasers, and was reduced to selling his pictures, at shameful prices, to a particularly tight-fisted dealer, the famous "Père" Martin.

During 1869, Pissarro moved to the suburban village of Louveciennes, about fifteen miles west of the city, on the road to Saint-Germain-en-Laye. Monet and Renoir already lived in this area, and it is likely that Pissarro made the move in order to be able to work more closely with his friends. Having matured in relative isolation, under the influence of older artists (Corot and Daubigny), he

now entered into a very different, radically modern milieu. Together with Monet and Renoir, he painted along the Seine in the area around Bougival, and often made the short trip with them to Paris to join in the gatherings around Manet at the Café Guerbois. Here he witnessed the lively debates for and against open-air painting that pitted Manet and Degas against Monet and his friends. Pissarro's good-natured tolerance enabled him to stay on good terms with all, and even to begin a friendship with the waspish Degas.

The ideas to which he was exposed at this point affected his working methods, and hence his style. Before coming to Louveciennes, Pissarro had painted oil sketches out of doors, but executed his exhibition pictures in the studio, basing them on his sketches. He now began to follow Monet's lead in attempting to carry out the entire work in direct confrontation with the motif, completing his picture on the spot, so far as possible, and omitting the preliminary sketch, but also attempting to preserve something of the fresh spontaneity of a sketch in the finished picture. This practice, pioneered by Daubigny, had not been unfamiliar to him before this time, but it seems to have been the example of Monet's experimentation in 1869 that now caused Pissarro to adopt it. His own share in what can be considered as Impressionism's true beginning unfortunately remains obscure, since nearly all his paintings from the crucial year of 1869 perished in the Franco-Prussian War. In the fairly numerous paintings that remain from 1870, the new method and style already appear fully developed.

River views, common in the work of Monet and Renoir at this time, are rare in Pissarro's. He was partial to suburban scenes, and particularly favored long perspectival views down roadways bordered by rows of trees and houses. In both *The Versailles Road, Louveciennes, in the Rain* (1870, Williamstown, Clark Art Institute) and *The Stagecoach at Louveciennes* (1870, Louvre, Musée d'Orsay), the colors are light but of subdued intensity; the skies are overcast, the pavements covered by snow or rain, reinforcing the mildly desolate look of these banal sites. The pictures tend to be of fairly small size, appropriate to outdoor work, and of rapid, sketchlike execution. Small, irregular brush strokes cover their surfaces with an unquiet, mottled color texture, suggestive of evanescent effects of light and atmosphere, and very unlike the broad slabs of even pigment that lent sculptural substance to Pissarro's large Pontoise landscapes of 1867.

The most ambitious painting from this time, exceptional not only in its large size and vertical format but also in its subject matter—part portrait, part genre, in an outdoor setting—is *Louveciennes, the Road to Versailles* (1870, Zurich, E. G. Bührle Foundation). This is a document of Pissarro's semi-rural domesticity, perhaps influenced by Monet's *Women in the Garden* of 1867. Julie Vellay, his companion, wearing a severe black dress, stands in the small, shaded front garden, their daughter Jeanne beside her, talking to a neighbor across a low fence. To the right, strollers walk along the brightly sunlit village road. The strong diagonal of the fence, continued by the long perspective of the road, sharply divides the picture into a darker and a lighter zone, the former painted with evenly compact colors, the other in a more freely Impressionist manner.

The outbreak of the Franco-Prussian War in July 1870 did not immediately

affect Pissarro, a Danish citizen. But when the rapid advance of the German armies threatened to make the area around Paris a field of battle, he hastily moved his family to the shelter of his friend Piette's farm in Brittany, leaving most of his possessions behind. In Brittany, Julie gave birth to a daughter, who shortly died. France, meanwhile, faced defeat by the Germans, and beyond that the prospect of civil war. At the end of his courage, Pissarro decided to escape with his family to the security of England. In early December, they crossed the Channel and found a temporary home in Lower Norwood, a comfortable middle-class suburb on London's southern edge.

In London, he met other refugees from France, among them the painters Daubigny and Monet, and the picture dealer Paul Durand-Ruel, who had recently opened a gallery in Bond Street. Together with Monet, he looked, not uncritically, at paintings by Crome, Constable, and Turner, and was perhaps influenced by them, though not to the point of imitation. Like Monet, he painted London views, such as *The Crystal Palace, London* (1871, Chicago, Art Institute) and *Lower Norwood, from Sydenham Hill* (1871, Fort Worth, Kimbell Art Museum), concentrating on their topographical and social features whereas Monet sought to capture effects of light and atmosphere that struck him as "English."

Lordship Lane Station, Upper Norwood (1871, London, Courtauld Institute Galleries), which shows the view down the curving track, a train coming on, is the earliest Impressionist railway picture, anticipating both Manet and Monet. The idea for it may have been suggested by Turner's *Rain, Steam, and Speed* (1844), which Pissarro had seen in the National Gallery. All of Pissarro's English landscapes show a brightening of light and a very marked naturalist refinement of atmospheric colors. While in London, he sold several paintings to Durand-Ruel, and made an unsuccessful attempt to show at the Royal Academy exhibition. The paintings which he did manage to exhibit in Durand-Ruel's gallery and in the International Exhibition at the South Kensington Museum received little notice. He was anxious to return to France, but before leaving London, he finally married Julie, with his mother's grudging consent.

Back in Louveciennes in late June 1871, Pissarro found his house devastated and its contents, including the bulk of his work (some 1,500 pictures according to his estimate), scattered or lost. He nevertheless resumed painting with great confidence and enthusiasm, continuing in the free, loosely structured manner that he had developed since 1869 and maintained through his English exile. His seasonal landscape studies of this time—which included luminous snow scenes, atmospheric river views, village streets—*Entrance to the Village at Voisins* (1872, Louvre, Musée d'Orsay)—and gardens in flower—*Orchard in Bloom* (1872, Washington, National Gallery)—are executed in fresh colors, with a delicacy of touch that was perhaps the lingering trace of Corot's influence.

In the summer of 1872, Pissarro moved his family back to Pontoise. The change of location had an apparent effect on his painting. The hillsides around the Hermitage tempted him to resume the more solidly, materially structured landscape studies that he had painted here in 1867–68. He was soon joined at Pontoise by Cézanne and by other painter friends (among them Guillaumin and

Beliard) who looked to him for guidance, and whose admiration and emulation served as a stimulus to his own work. Cézanne in particular, while being decisively influenced by Pissarro at this point, also gave something in return. He encouraged him, by his own example, to attempt to summarize the diffuse complexity of landscape in simpler, more forceful and legible forms. Structure once again became one of Pissarro's main concerns. He emphasized the geometry of sharp-angled houses in his middle distances and gave space itself a regular, measurable shape by bounding it with well-defined planes in such landscapes as *The Sente de Justice* (ca. 1872, Memphis, Brooks Memorial Art Gallery) and *The Oise near Pontoise* (1873, Williamstown, Clark Art Institute). In other paintings, however, he relied on the more purely optical effects of subtly modulated tones and colors, as he did, most audaciously, in *Hoar Frost* (1873, Louvre, Musée d'Orsay), in which a fairly shapeless rise of fallow land, diagonally traversed by a road, is given definition by the long, faint shadows cast on it by a row of trees that are not themselves in the picture.

The rapid economic recovery of France during the immediate postwar years of 1872 and 1873 stimulated the art market and enabled Durand-Ruel to make regular, substantial purchases from Pissarro, Monet, and most of their colleagues. At the sale of the Hoschedé Collection, in early 1874, Pissarro's landscapes brought surprisingly high prices. There was reason to suppose that a public had come into being that was ready to accept the new painting. But the juries of the official Salons barred access to that public: a liberal alternative was needed, and this could only take the form of an independent, jury-free group show organized by the participating artists. In the spring of 1873, the idea of such a show—which had already been the subject of fruitless discussions in 1867—was revived by Monet and his friends. Pissarro enthusiastically participated in the organizational preparations, and proposed a corporative association, based on a charter—the model he had in mind being that of the bakers' union of Pontoise.

The exhibition was ultimately held from April 15 to May 15, 1874, at the studio-gallery of the photographer Nadar in the Boulevard des Capucines. Pissarro showed five canvases, including *Hoar Frost,* which was singled out for special sarcasm by Louis Leroy of *Charivari,* who on this occasion unwittingly made art history by labeling the exhibiting painters "Impressionists." "The critics are devouring us," Pissarro wrote to his friend Théodore Duret, who had advised against the exhibition. "I am going back to my work—that's better than reading. One learns nothing from them." His income from the exhibition amounted to only 130 francs, less than his share of its cost.

For Pissarro, who had generously given his energy and time to this effort of collective self-help, since it agreed with his beliefs in a form of artisan socialism, the financial setback came as a serious blow. The brief postwar recovery had suffered a sudden collapse. Durand-Ruel, overstocked and short of funds, stopped his purchases. Struggling to support his family, Pissarro had moments of deep discouragement. His daughter Jeanne had died in March and his wife was pregnant with their next child. At forty-five, bald, with an enormous gray beard that made him look much older than his years, he had already taken on the appearance

of a biblical patriarch. Together with Cézanne, of whom he painted a memorable portrait at this time (1874, now in an English private collection), he explored landscape motifs around Pontoise, continuing—in lighter colors and with greater breadth of handling—the structural style that he had developed in his studies at the Hermitage in 1867–68. Cézanne's proximity can be felt in some paintings of the period, such as *The Climbing Path at the Hermitage, Pontoise* (1875, Brooklyn Museum), in several of which Pissarro reverted to the use of the palette knife.

From 1874 until 1877, he spent part of each summer or early fall at the farm of his friend Piette, at Montfoucault in Brittany. The paintings that resulted from these visits differ appreciably in manner and in subject matter from his Pontoise landscapes, owing perhaps to special qualities in the local climate and topography to which he responded with characteristic sensitivity, and also to the deep rusticity of Montfoucault, quite unlike the small-town air of Pontoise. The colors of these Breton scenes, laid on in large flourishes, have a special, confident strength, in some cases born of fantasy rather than observation. The compositions are loosely constructed, and a conspicuous element of bucolic genre enters into the foregrounds: women guarding cows, men plowing or sowing—motifs reminiscent of Millet. There is an unmistakable note of lyrical artifice and arrangement in these landscapes, some of which Pissarro evidently worked up or recopied in the studio, rather than painting them directly from nature. *Farm at Montfoucault* (1874, Geneva, Musée d'Art et d'Histoire) exemplifies the more naturalist strain among these works, and *The Watering Place at Montfoucault* (1875, Birmingham, Barber Institute) the more synthetic.

To make up for the demise of the association that had organized the "Impressionist" Exhibition of 1874, Pissarro, Cézanne, Guillaumin, and some friends formed a new group, *L'Union,* in 1875, through which they hoped to advance the interests of non-academic artists cooperatively, in the manner of a labor union. But when, in 1876, the Impressionist core group, led by Monet, prepared a second exhibition, Pissarro again joined with them. (*L'Union* vanished quietly the following year, with the resignation of its chief members.) Twelve paintings by Pissarro figured in the Second Impressionist Exhibition. The critics were again sharply divided, and for the most part hostile, but they included some distinguished authors—Mallarmé, Zola, Duranty, and Burty—whose reviews, rising above the natter of art journalism, were intelligently favorable.

Financially, the exhibition of 1876 was a failure, and did nothing to relieve Pissarro's chronic distress. The year was nevertheless one of energetic productivity, for him as well as all the other Impressionist painters: the climax of that brief period of convergence of aim and practice which gives meaning to the term "Impressionism." The assured ease of Pissarro's mastery as a "natural" painter, to use Constable's expression, appears in *The Harvest* (1876, Louvre, Musée d'Orsay), which was painted at Montfoucault in an extraordinarily fluent, deceptively simple style. More complex in conception and execution—i.e., in their spatial arrangements and intricate color combinations—are several landscapes painted in 1877, at a time when Pissarro and Cézanne were once again working together. In the large landscape known as *The Côte des Boeufs at the Hermitage,*

Pontoise (1877, London, National Gallery), the view is screened by a row of tall, leafless trees, behind which appear white, red-roofed houses nestled against the hillside. The colors are dotted on in minute touches, so small and so densely spaced that they neutralize one another and merge into a shimmering blondness. The pale brown of the trunks and branches, vibrating against the cool blue of the sky and patches of green in the foreground, evokes the chill light of a winter day.

Similar in the disposition of screening trees and distant houses, but of a higher intensity and warmth of illumination, *Red Roofs, View of a Village in Winter* (1877, Louvre, Musée d'Orsay) is dominated by the strong orange and yellow of the sun-struck fields and trees, the even stronger red of the roofs, and the contrasting sharp white shapes of the gabled houses. The brushwork forms a dense texture of small, separate touches that, seen at a distance, emits a diffuse glow. Both these landscapes figured in the Third Impressionist Exhibition, held in 1877. Painted at about the same time, but only exhibited at the Fourth Exhibition, in 1879, *Spring, Plum Trees in Blossom* (1877, Louvre, Musée d'Orsay) differs in color key and handling, in response to a different seasonal mood. The houses on the hillside are shrouded behind a froth of white scintillations—the blossoms of the flowering trees—that float like foam on the deeper greens and blues of the distant forms.

Impressionism, in these paintings, had lost something of its original, fluent spontaneity and become an effortful, deeply calculated method, but one that was capable, when successful, of yielding work of powerful concentration and vitality. Some of Pissarro's paintings of this time rank among his and Impressionism's finest achievements. He was, nevertheless, deeply dissatisfied; 1877–79 were years of intense emotional strain and self-doubt, overshadowed by constant money worries, and embittered by the humiliation of having to peddle his work, at pitiful prices, among a small circle of reluctant patrons. Much time was wasted on futile business in Paris. He painted less, and with diminished joy. His weariness was aggravated by the death of his friend and consoler Piette, and by discord in his own family; but aside from these domestic woes, he suffered from a loss of confidence in his work. Nearly fifty years old, he began to question the fundamental assumptions and practices of Impressionism, a few years before Renoir, Sisley, and even Monet experienced similar doubts.

In his search for new directions, Pissarro turned to the graphic media, drawing in gouache or pastels, and, following Degas's lead, to printmaking. He began by copying, in etchings with drypoint and aquatint, some of his recent landscape paintings, intending them for a publication planned by Degas, a journal to be called *Le Jour et la Nuit.* But his concentration on graphic work, his occupation with black-and-white media, with line and tone, and with two-dimensional design, inevitably brought him from the out-of-doors into the studio, shutting him off from the direct experience of nature, the visual sensation basic to Impressionist painting. As a result, the share of "natural" landscape in his work declined, and that of arranged compositions increased. Figures, from having played a very small role in his landscapes, now came to dominate many of his canvases, either singly or in genre scenes strongly reminiscent of Millet. By 1882,

his figure compositions equaled his landscapes in number and importance. Nearly all represent young women, of uncommon sweetness and gentility, at farm labor or in dreamy repose.

The Shepherdess (Young Peasant Girl with a Stick) (1881, Louvre, Musée d'Orsay) resembles Pissarro's landscapes of the late 1870s in the dense color grain of its grassy slope, but this merely serves as background for the main motif, the lounging figure of a girl. The view is taken from above and at close range, a feature common to many of Pissarro's rustic genres, and perhaps influenced by his recent observation of Degas's compositional habits. The girl's vaguely idealized face and her angular, attractively clumsy body seem derived (though Pissarro denied this) from the familiar stereotype of Millet's adolescent peasant women.

At the Seventh Impressionist Exhibition of 1882, where this painting was shown, Pissarro's new style appeared, fully developed, in some twenty-six figural compositions in oil or gouache, out of a total submission of thirty-six works. Perhaps in reaction against the complexity of his earlier landscapes, he now aimed for clear and relatively simple arrangements, setting strongly contoured figures against shallow backgrounds. In devoting himself predominantly to figural sub-jects, he largely renounced plein-air naturalism. Conceived in the studio, with the help of models whom, in his somewhat improved financial condition, he was now able to afford, and executed in a laborious technique, his peasant scenes of the early 1880s lack—and perhaps avoid—any sense of immediate visual experience. This is apparent even in *Peasant Women Resting* (1881, Toledo Museum of Art), which he called "Figure Study in the Open Air, Effect of Sunlight," and which, with its tight color texture and stiffly patterned composition, has a calculatedly decorative air. It lacks precisely the Impressionist responsiveness to shifting light and breezy atmosphere—the "open air" and "effect of sunlight" promised by Pissarro's title.

The same holds true for other outdoor scenes of this time, such as *Woman and Child at a Well* (1882, Chicago, Art Institute), and *The Pork Butcher* (1883, London, Tate Gallery), taken from the life of the farming population around Pontoise, but so gently and handsomely stylized as to remove from them the sting of social realism. Though he spent most of his life in the country, Pissarro was never of the country. His view of the peasantry, represented in his work by young women of somewhat impersonal charm, is no more realistic than that of Corot; Degas's contemporary observations of the urban scene are incomparably more incisive and harsh. But it was to Degas that Pissarro looked for compositional and graphic devices, experimenting with oblique downward views, abrupt fore-ground-background juxtapositions, and flattened or radically cropped forms in such domestic idylls as *The Little Country Maid* (1882, London, Tate Gallery), or with linear and spatial abstractions in his larger, somewhat poster-like compo-sitions, such as *The Poultry Market, Gisors* (1885, Boston, Museum of Fine Arts).

Cézanne paid his last painting visit to Pontoise in 1882. His place among the disciples of Pissarro had meanwhile been taken by Paul Gauguin, who was in the final stages of his transformation from businessman into artist and had been an energetic participant in the battle of factions that preceded the Seventh Impres-

sionist Exhibition. Gauguin spent the summer of 1882 with Pissarro at Pontoise; and when, later in the year, Pissarro moved his family to the nearby village of Osny for reasons of health, Gauguin joined him there.

In the spring of 1883, Durand-Ruel, with Pissarro's reluctant consent, arranged a one-man exhibition, Pissarro's first, which earned him some compliments but no sales. Although he now received a fair, and fairly steady, annual income from Durand-Ruel (14,000 francs in 1883), his financial situation remained precarious owing to the large size of his family. The oldest son, Lucien, was despatched to London to study English and the ways of business. Pissarro meanwhile made a stay of two months in Rouen, painting in the old town and in the harbor, and managing to finish thirteen canvases. Shortly thereafter, the Pissarro family once again moved house, but now for the last time, leaving cramped quarters at Osny to settle in a large house with garden in the village of Eragny, on the Epte River, near the market town of Gisors. The recession that had begun in 1882 continued, affecting the sale of paintings, and forcing Durand-Ruel to reduce his purchases. His payments to Pissarro fell to 10,000 francs in 1884 and to 9,000 in 1885. Pissarro had to resume his distasteful rounds of collectors and small dealers, offering his pictures at bargain prices.

His situation was not made easier by his involvement at about this time with a new, daringly radical movement. For several years, he had gradually drifted away from Impressionism, reacting—not unlike Renoir and Cézanne—against what he had come to see as its lack of clarity and structure, its undisciplined subjectivism. In trying to overcome these weaknesses, he had developed a more rigidly systematic manner, a pictorial language better suited to the representation of stable forms than to the capture of fugitive appearance. At bottom, this expressed a withdrawal from naturalism, and a growing interest in stylistic possibilities of a kind that the Impressionists had formerly rejected.

A group of younger artists at this juncture entered Pissarro's life who, though still at the start of their careers, had gone through a similar reaction against Impressionism, and were about to formulate a revision of its principles, based on a definite method and a scientific theory. The leading intellect and strongest talent among these newcomers was Georges Seurat, barely twenty-six years old when Pissarro met him, but so persuasive that he made the older artist an instant convert and for some years a follower. From his readings of the work of the American Ogden Rood and other color theorists, Seurat had come to recognize the important difference between light colors and pigment colors, which is that colored lights, as experienced by the eye in nature, come together in intense and pure combinations, while colored pigments, mixed on the painting surface, neutralize and diminish one another. Since visual experience is conveyed by colored light, as the Impressionists had well understood, painting ought to strive for the greatest attainable purity and intensity of color.

The Impressionists had tried to approximate effects of natural light by means of the traditional practice of mixing colors on the palette, and as a result had lost much of the luminosity for which they aimed. Seurat believed that by applying modern color science to their work, rather than proceeding by intuitive

approximation, painters ought to be able to achieve something closer to the actual visual experience. To this end, he began to experiment, about 1883, with painting in separate accents of strong, unmixed colors, setting them down on the canvas in measured quantities of distinct strokes. Seen at a distance, these grains of pure color were to blend in the beholder's eye—at least in theory— and to produce, by the proper dosage of component colors, any desired hue, its intensity undiminished, and in fact enhanced by the contrasts between the interacting colors. That this theory of optical fusion was not borne out by practical experience, that the separate colors, even at a distance, remained visible as distinct, vibrant scintillations, and that the resultant effect was not at all that of natural light or of sunlit forms, but rather of sumptuously artificial color tissues, was probably apparent to Seurat. For all his interest in the science of optics, his fundamental pursuit seems not to have been that of a naturalist, but of a stylist.

Neo-Impressionism, as the new method came to be called, was not so much a scientific extension of Impressionism as an aesthetic reaction against it. Pissarro, responding with enthusiasm to the dogmatic clarity of Seurat's theory, thought it to be "a new phase in the logical advance of Impressionism"—a "scientific" phase, in contrast to the "romantic" one in which Monet, among others, still persisted. There was a political element in the attraction that Neo-Impressionism held for Pissarro. The leading painters in that movement, Seurat, Signac, and Luce, were committed Anarchists. Pissarro, who until 1885 had considered himself a Socialist, followed them in their progressive politics, as he was willing to follow them in their scientific aesthetic: his political radicalization accompanied his artistic conversion. He saw to it that Seurat and Signac were prominently represented at the Eighth Impressionist Exhibition, in 1886, probably contributing to the decision of Monet, Sisley, and Renoir to abstain. Of the original core group, only Pissarro, Degas, and Berthe Morisot participated in this last Impressionist exhibition. The paintings which Pissarro exhibited on this occasion proclaimed his alignment with the Neo-Impressionist faction. *Apple Picking* (1886, Kurashiki, Japan, Ohara Museum) re-casts an earlier version of this subject (1881, New York, W. B. Jaffe Collection) in his new style, systematizing the brushwork and flattening the composition into a more rigidly formal pattern. *View from My Window, Eragny* (1886, Oxford, Ashmolean Museum) is executed in a more radically pointillist style, probably owing to a later reworking. Its harshly linear and angular design, and its heavy texture of mechanically placed color dots proclaim Pissarro's emancipation from "romantic" Impressionism, though the effect, with its emphatic green-orange color juxtapositions, is stiffly formal, decorative rather than "scientific."

Pissarro's involvement with a group of very young, radical, and as yet unaccepted artists cast a shadow on his relations with the older Impressionists. His experiments with the new manner displeased Durand-Ruel, discouraged collectors, and delayed critical and public recognition of his work at a time when the other veterans of the Impressionist battle were beginning to enjoy the fruits of victory. His confidence in the rightness of the Neo-Impressionist method gradually waned. He never quite brought himself to use it rigorously, and in

practicing color division showed a partiality to color harmonies, rather than to contrasts, that betrayed his lingering affinity with "romantic" Impressionism.

Ile Lacroix, Rouen, Effect of Fog (1888, Philadelphia Museum of Art) is based on a print made in Rouen in 1883, in other words not on direct visual observation. Its subject, nevertheless, is a diffuse atmospheric phenomenon, a vast air space filled with luminous mist, into which jut the sharp silhouettes of a distant factory with smoking chimney and, in the left foreground, the dark form of a barge. The surface of the canvas is covered with regularly shaped and spaced color strokes, of rather mechanical application, but these are so closely blended and so close to one another in hue that they fuse in a pearly irridescence, instead of setting off pointillist vibrations. The picture's subtlety in recalling a visual experience in nature hints at Pissarro's eagerness to return to a more unrestricted, sensuous form of landscape painting.

He began to tire of Neo-Impressionism as early as 1888, though he did not finally abandon it until 1891. His special frustration was the tedium of pointillist execution, which he found to be irreconcilable with the "fullness, suppleness, liberty, spontaneity, and freshness of sensation that are basic to our Impressionist art." The laborious slowness of pointillism not only went against his temperament, it drastically reduced the productivity on which he depended for his livelihood. During the roughly five years of his Neo-Impressionist phase his annual output fell to about fourteen canvases, as compared to an average of forty in previous years.

The period of 1889–95 was one of anxiety and stress for Pissarro, who, having reached the age of sixty, was still troubled by unresolved artistic problems and at the same time found it as difficult as ever to support his large family. In the midst of this crisis, Durand-Ruel prudently cut back his purchases, but by good luck Pissarro discovered a new supporter in the dealer Théo van Gogh, of the firm of Boussod-Valadon, who for a while became his chief source of income.

The bulk of his painting in this time of his gradual withdrawal from Neo-Impressionism consisted of landscapes and rural genres, executed in a manner that, in its broader, more fluent brushwork and avoidance of the dot, recalled the work of the early 1880s. Nothing in these tranquil scenes gives a clue to his continuing involvement with anarchism, but there survives a private document of his political beliefs, in the form of a series of twenty-eight allegorical cartoons, entitled *The Social Turpitudes* (Geneva, D. Skira Collection), which was composed in 1889 for his English nieces, Esther and Alice Isaacson. Drawn with the pen in a free, slightly crude graphic style that seems unrelated to his paintings of the period, they pillory the injustices of the capitalist system and "the most shameful ignominies of the bourgeoisie," starting with a sinister evocation of Capitalism Triumphant and ending with a scene of battle on the barricades. This extraordinary series is the most vehement—and almost the only—artistic statement of Pissarro's revolutionary anarchism, reflecting a close familiarity with the literature and pictorial propaganda of that movement. He refrained, on the whole, from giving expression to his political ideas in his public work, since he held the sensible and humane view that a painter's most effective contribution to his

society lay in his work's artistic quality rather than in its political message.

His return to a moderate Impressionism, at the height of a strong collectors' demand for Impressionist paintings, brought Pissarro back into the market of art and to a form of commercial promotion from which his choice of an unpopular style had temporarily excluded him. His work was underpriced. Dealers, sensing an opportunity, now began to court him, and Durand-Ruel approached him with the offer of a large retrospective exhibition. Held in early 1892, this exhibition, consisting of seventy-one works and de-emphasizing his Neo-Impressionist period, proved to be a critical and popular success. At its close, Durand-Ruel bought all the unsold pictures. His payments to Pissarro that year totaled 23,000 francs. This came as a godsend, since it enabled Pissarro to buy—with the additional help of a loan of 15,000 francs from Monet—the house in Eragny which his family had been renting since 1884 and from which a change of owners threatened to drive them.

In 1890, he had briefly visited London, bringing back several views of the city. In the late spring and the summer of 1892, he made a second, longer stay in England, painting in London and in Kew, and helping his son Lucien through the difficulties of a marriage arrangement opposed by the bride's parents. These visits may have given him a fresh appetite for a kind of painting that he had not practiced for some time, that of cityscapes. Genre and landscape had been his nearly exclusive occupation for two decades, save for very brief ventures into urban subjects during a stay in Rouen in 1883 and the two recent trips to England. His painting meanwhile had become more and more studio-based, partly for stylistic and technical reasons, partly because a recurrent inflammation of his eyes, starting in 1887, becoming acute in 1891, and necessitating an operation in 1893, interfered with his painting out of doors. Many of his later landscapes and garden scenes were painted from behind the windows of his house in Eragny.

In 1893, Pissarro broke the customary pattern of his rural life by making a long stay in Paris, where he installed himself in a room on an upper floor of a hotel to paint the busy street life in the Place Saint-Lazare and the Place du Havre below his windows. *Place du Havre, Paris* (1893, Chicago, Art Institute), with its bird's-eye view of urban thoroughfares alive with the flow of traffic, represents a form of cityscape that was not new to Impressionist painting. Monet had pioneered the type in 1873, in the different versions of his *View of the Boulevard des Capucines.* For Pissarro, such panoramic, plunging vistas of city life, painted from the lofty vantage of a hotel room, came to play a dominant role in the work of his last decade. It was in these cityscapes, rather than in the landscapes and rural genres that continued to play a large role in his work, that he made his return to a form of Impressionism very close to that which he had practiced in the early 1870s.

His late landscapes, by contrast, lacked this freshness of observation, and tended to a laboriousness of execution and a schematic sameness of arrangement that bear witness to his continuing retreat from naturalism. These qualities are even more apparent in many of his rural genres of the 1890s, highly formalized compositions of young women at farm labor, such as *Haymaking, Eragny* (1899,

Ottawa, National Gallery of Canada). Most of them are clearly products of the studio, based on stock motifs gathered from earlier studies, though there are some exceptional pictures—e.g., *The Gardener, Afternoon Sun, Eragny* (1899, Stuttgart, Staatsgalerie)—which are observed rather than composed, and in which the figures are convincingly integrated into light-filled settings.

Thus Pissarro's late work divided into two quite different directions: the renewed Impressionism of his cityscapes on the one hand, realistic and modern in inspiration, and on the other, the idealizing trend that appears in many of his landscapes and bucolic idylls. The city, paradoxically, brought out his naturalism, while nature and farm life tempted him into stylistic artifice. *Two Young Peasant Women in Conversation* (1892, New York, Metropolitan Museum) exemplifies this manneristic tendency, not only in the artful naiveté of its figures and the decorative contrivance of its composition, but in the sophisticated and thoroughly de-natured refinements of its colors, which suggest neither light nor body or atmosphere, but sustain the picture's poetic "mood."

In the various compositions of *Bathers* that occupied Pissarro in 1894–96, among them a number of prints and such paintings as *Bather in the Woods* (1895, New York, Metropolitan Museum) and *Female Bather* (1895, Washington, National Gallery), the quasi-romantic, retrospective attitude in his late work found its most telling expression. Innocent of any direct study of the nude, these dreamlike visions of young women washing themselves in shadowy forest streams recall memories of Barbizon and Millet, and may perhaps also owe something, though not much, to Cézanne's contemporary *Bathers.* Pissarro chose for them the dark-toned, heavily textured colors that he had used for his figure paintings of the early 1880s.

In March of 1893, Durand-Ruel gave him another exhibition, and at year's end paid him the large sum of 28,600 francs. From this time on, a nearly unbroken series of exhibitions of Pissarro's work, in France, Belgium, England, and the United States, brought him ever-increasing recognition and a fair, though irregular, income. The demands of his large family, including five sons in need of steady subsidies, kept him under continuous financial strain. With Durand-Ruel, his principal dealer, whose commercial strategies he distrusted, and whom he, as an enemy of capitalism, regarded as an exploiter of artists, he played a skillful cat-and-mouse game, always alert to the possibility, now that his work was in demand, of playing dealer against dealer. Within his family he reigned as a benign patriarch, and with his great gift for encouraging young talent guided all of his sons toward artistic careers, much to the distress of his long-suffering wife, Julie.

Following years of anarchist violence, culminating in June 1894 in the assassination of President Carnot, Pissarro, known for his anarchist sympathies and suspect to some of his neighbors in Eragny, had reason to fear arrest and prudently extended a planned stay in Belgium by several months, waiting for the crisis to pass.

Though he now owned a comfortable country house, with studio and garden, in Eragny, Pissarro—perhaps tired of rural nature—spent much of the remainder of his life in cities, absorbed in the spectacle of traffic on rain-glistening

pavements as he had formerly been in that of sunlit meadows. In 1896, he made two lengthy stays in Rouen for the purpose of painting the urban landscape, and in particular the industrial scenery along the town's busy harbor. He found hotel rooms commanding views of the river, its quays and traffic-laden bridges, and of the opposite shore with its factories, gasworks, and railway stations. His views, from a height and at an angle, were determined by his fixed position of vantage. Preferring gray days, he painted in a broad, fluent, wholly Impressionist technique (in which no vestige of pointillism or of his earlier, dense paint textures survives), stressing reflections of light on flowing water and wet pavements. In such panoramic views as *The Boildieu Bridge, Rouen, Damp Weather* (1896, Toronto, Art Gallery of Ontario), the vanes of drifting smoke, the movement of ships and rush of distant traffic give an impression of bustling life, observed with a certain detachment from above: a kind of God's-eye view of the modern world, perhaps appropriate for a patriarchal Anarchist.

Pissarro's emphasis on an "ugly" aspect of urban industry, though not yet a matter of universal acceptance, was no longer controversial nor necessarily fraught with political meaning. Monet, Cézanne, and Sisley had thoroughly explored similar subjects in the early 1870s. Though these harbor views represent the battlefields of capitalism, and were perhaps seen in this light by Pissarro, he chose to represent them with great objectivity in their optical effect, as plays of light, color, and atmosphere—far closer to the direct visual impression than many of his rural landscapes.

Monet's series *Rouen Cathedral* (1892–93), which Pissarro had seen on exhibition in 1895 and greatly admired, may have inspired his several views of the same cathedral, painted from a window of his hotel in the spring of 1896. Anxious to avoid the appearance of imitation, however, and perhaps to assert his preference for firmer structures, he conceived his motif in an entirely different manner. In *Roofs of Old Rouen, Gray Weather* (1896, Toledo Museum of Art), the massive building is presented as a distant, complex shape, outlined against the sky, quite unlike Monet's partial close-up views of the light-reflecting facade.

Returning to Paris in 1897, Pissarro embarked on a series of views of the busy commercial streets around the Gare Saint-Lazare and of the grand boulevards, painting from the upper floors of adjacent hotels. Most of these paintings show the tree-lined canyon of the Boulevard Montmartre, at different times of day or night, its pavement dotted with pedestrians and vehicles, or crowded with festival parades. Monet had occasionally painted such bird's-eye views of the urban landscape twenty years earlier (cf. his *Rue Saint-Denis on the National Holiday, 30 June 1878*). Pissarro now made a far more sustained exploration of the human climate of the city and of the powerful energies channeled by its streets. If he had rarely painted rivers in earlier years, unlike the other Impressionists, he now made up for this neglect by concentrating on the great artificial rivers that Haussmann had carved into the architectural landscape of Paris. He approached these vistas with a landscape painter's interest in the physical geography of the site, the boulevards' monstrous perspectives along tall, metal-roofed apartment buildings, their bases awash with teeming traffic, and he noted the

modifications of these settings by light and weather, the mood changes of the urban landscape. Both *Boulevard Montmartre, Winter Morning* (1897, New York, Metropolitan Museum) and *Boulevard des Italiens, Morning Sunlight* (1897, Washington, National Gallery) illustrate Pissarro's return to Impressionist attitudes and techniques in their fluent speed of execution, their sense of light, and their extraordinary precision of color observation, qualities very unlike those of his laborious, pigment-encrusted landscapes of the late 1880s.

If he attached particular political meanings to these scenes—and it is very possible that he did—Pissarro exercised great reticence in expressing them. In his choice of settings, he showed himself partial to the great commercial thoroughfares rather than the quieter residential quarters. He treated them with the objective sobriety of a geographer, noting their characteristics without exaggeration or pointed commentary. His view, from an altitude and at a distance, both magnified the scene before him and diminished its direct emotional impact. Human society resolves itself into a scattering of minute paint marks, no more distinct than the population of an ant heap.

A grave illness of his eldest son, Lucien, prompted him to visit England in the early summer of 1897. Later in the year, another of his sons, Felix, died in London, unattended by Pissarro, who was too exhausted to cross the Channel again. At the beginning of the following year, he moved to a new setting, that of the Grand Hôtel du Louvre, overlooking the Place du Théâtre Français and the long perspective of the Avenue de l'Opéra. This was a more modern and more elegant quarter than that of the bustling boulevards, a fact to which he responded with pleasure: "These Paris streets that people have come to call ugly . . . are so silvery, so luminous, so vital." Among the most original of his cityscapes are several views of the square directly beneath his windows, titled *Place du Théâtre Français* (1898, Los Angeles County Museum), that show it as an indefinite expanse of pavement across which figures and vehicles move in an irregular, vaguely directional drift. These panoramas without middle or borders are literally window-views, openings through which a fragment of city life is glimpsed as it flows past.

During the summer of 1898, Pissarro again painted in Rouen, and besides several harbor scenes produced one masterwork, the uncharacteristically picturesque view of a medieval street leading to the many-towered cathedral, *La Rue de l'Epicerie, Rouen* (1898, New York, Metropolitan Museum). For his next series of urban views, he radically changed his approach, painting the vast open spaces of the gardens of the Tuileries—*Tuileries Gardens* (1900, Glasgow Art Gallery)—and the Place du Carrousel of the Louvre from a distant apartment in the Rue de Rivoli. It was no longer the street and its life that interested him, but the atmosphere and light of the city. His long-range views of the Tuileries and Louvre are no ordinary cityscapes, but landscapes distantly bordered by urban features, and features of an exceptional kind—palatial structures. It is clear from Pissarro's references to these paintings in his letters that he meant them to be handsome views that would appeal to his patrons.

He was at last beginning to benefit from the general vogue of Impression-

ism. The city views proved highly salable. Prices for his paintings fluctuated between 5,000 and 8,000 francs by 1900; in the following year, individual canvases attained prices up to 15,000 francs. Pissarro's income in 1900, counting only the payments made to him by Durand-Ruel, came to 44,000 francs. Having paid for his house in Eragny, he was now able to rent apartments and hotel rooms in Paris whenever it suited him and to spend annual painting vacations in Normandy. Relieved of the most pressing anxieties, he was nevertheless troubled by private worries. His general health and eyesight were deteriorating. The Dreyfus affair and the wave of anti-Semitism which it raised caused him pain and disrupted old, cherished friendships, particularly those with Renoir and Degas. His relations with Durand-Ruel and other dealers still remained tense, since they tended to set prices on his paintings that he considered to be too low. Yet despite advancing age and private annoyances, he continued to work with pleasure and ease, having found a range of subjects that never ceased to interest him. These last years of his life were also the most productive. He completed more than a painting a week on the average, not counting pastels, gouaches, and prints.

He changed his Parisian painting base twice more: in 1901–02, he worked from an apartment at the tip of the Ile de la Cité, in the Place Dauphine, from which he commanded spacious views across the square of the Vert Galant with its equestrian statue onto the wide river and the low silhouette of the Louvre in the far distance. Painted for the most part in the winter, views such as *The Louvre, Morning, Effect of Snow* (1901, London, National Gallery), dominated by water and sky, are the most atmospheric, luminous, and dematerialized of his cityscapes, and the least urban.

During the summers of 1901 and 1902, Pissarro painted in the harbor town of Dieppe, initially from his hotel window, which gave him a view of the church of Saint-Jacques and the surrounding market square—*The Church of Saint-Jacques, Dieppe* (1901, Louvre, Musée d'Orsay)—later from a rented space in the fish market that looked out to the busy harbor. Seaports had a strong attraction for him; the change of scene and its contrast to Parisian milieux stimulated him. In his choice of motifs and in their treatment, he followed the practice he had developed during his painting campaigns in Rouen in 1896 and 1898.

He returned to the Place Dauphine apartment in 1903, and here painted his last *Self-Portrait* (1903, London, Tate Gallery), which shows him in his work room, wearing his hat, his bust silhouetted against the window behind him—his eye on the world from which he was then painting views of the Pont-Neuf below. The following spring, Pissarro made his final move, to a hotel on the Quai Voltaire on the Left Bank from which he surveyed the Seine and a wing of the Louvre on the opposite shore. It was from this location that he executed his last views of Paris, among them *The Pont Royal and the Pavillon de Flore* (1903, Paris, Musée du Petit Palais), with undiminished vigor, in broad strokes of rather thick, finely nuanced colors.

In the summer Pissarro undertook his last painting campaign to Le Havre, where between early July and late September he completed no fewer than eighteen pictures of the inner and outer harbors, and of the great jetty. Shortly after his

return to Paris, while preparing to move to yet another apartment from which to paint views of the city, he caught a cold which led to complications. Wrongly treated by a homeopathic practitioner, Pissarro contracted blood poisoning. He died on November 13, 1903, at the age of seventy-three.

Half a year after Pissarro's death, Durand-Ruel presented his work in a great retrospective exhibition, comprising 132 paintings, pastels, gouaches, and prints. There was a general sense among the survivors of his generation and among the younger artists that a central presence, quiet but deeply influential, had left the stage of art. More than any other painter of his time, Pissarro had fulfilled the role of guide and teacher. Gauguin, who had quarreled with him, admitted, "He was one of my masters, and I will not deny him," and Cézanne signed himself "Pupil of Pissarro."

READINGS

The Work

The standard catalogue of Pissarro's paintings, pastels, and gouaches is L. R. Pissarro and L. Venturi, *Camille Pissarro, son art, son oeuvre,* 2 vols., Paris, 1939, a fully illustrated reference source, not entirely complete or accurate, but still indispensable.

L. Delteil, *Pissarro, Sisley, Renoir (Le peintre-graveur illustré,* vol. XVII), Paris, 1923. The graphic work.

R. Brettell and C. Lloyd, *Catalogue of the Drawings by Camille Pissarro in the Ashmolean Museum,* Oxford, 1980. The most inclusive publication of drawings by Pissarro.

Pissarro's Letters

J. Rewald, *Camille Pissarro, Letters to His Son Lucien,* New York, 1943 (reprinted 1972, 1981). A fundamental source for the life and thought of Pissarro.

J. Bailly-Herzberg, *Correspondance de Camille Pissarro,* vol. 1 (1865–85), Paris, 1980. The first volume of the French publication of Pissarro's entire correspondence.

The Life

A. Tabarant, *Pissarro,* New York, 1925.

R. E. Shikes and P. Harper, *Pissarro, His Life and Work,* New York, 1980. A detailed, well-documented, illustrated account.

General

J. Rewald, *Pissarro,* New York, 1963. A general survey of the life and work, with a detailed discussion of a selection of key works, illustrated in colorplates.

C. Lloyd, *Pissarro,* New York, 1981. An analysis of the work, accompanied by excellent colorplates.

C. Lloyd, et al., *Pissarro* (catalogue of the exhibition held in 1980–81 at the Hayward Gallery, London, the Grand Palais, Paris, and the Boston Museum of Fine Arts). Essays by J. Rewald, R. Brettell, F. Cachin, A. Diestel, and others.

14
Paul Cézanne, 1839–1906

Paul Cézanne, 1839–1906

Cézanne is the great exception among the painters of the Impressionist generation. The objective openness to reality that they achieved, or at least sought, was foreign to his nature. His attitude was, at bottom, a moral one; he did not simply accept the data of visual experience, but subjected them to a rigorous process of selection and rearrangement, guided by an inward sense of order and value rather than by the laws of physical nature. Though he began as an anarchical romantic, contemptuous of authority, he gradually submitted to a self-imposed discipline more consistent and severe than that of the most orthodox academic. From a youthful, somewhat frenzied admiration of Delacroix, he steadily moved toward a serene and noble classicism, reminiscent of Poussin, but in fact the product of his own unrelenting efforts.

Paul Cézanne was born in 1839 in the drowsy little town of Aix-en-Provence, some fifteen miles north of Marseilles, the son of a prosperous manufacturer and exporter of felt hats who later became part owner of the local bank. The elder Cézanne, shrewd and stingy, was not well liked in the town. He had married his wife, a woman of the working class, several years after the birth of Paul and of the older of his two daughters. The family lived rather apart from the clannish society of Aix. Its popularity was not enhanced by what was regarded as the ostentatious purchase in 1859 of the Jas de Bouffan, a handsome estate some distance to the west of the town.

Young Paul Cézanne received a good classical education in the public schools of Aix, and here formed enthusiastic friendships with two schoolmates, Emile Zola, the future novelist, and Baptistin Baille. The three friends roamed the wooded hillsides and the banks of the Arc River, their imaginations exalted by readings in Hugo and de Musset, and by high-flown dreams of literary and artistic destinies.

Zola left for Paris in 1858. Cézanne meanwhile enrolled in the University of Aix as a law student, in obedience to his father, and in his spare time followed his own bent by taking lessons at the Drawing Academy of Aix. His determination to become an artist gradually hardened and put a stop to his listless law studies. He spent much time sketching, both in and out of doors. In 1861, against the advice of his drawing teacher, he wrung from his father permission to go to Paris to study painting. Rather than trying for admission to the official Ecole des Beaux-Arts, he entered the free Académie Suisse, where he spent his days paint-

ing the posing model. He was encouraged by Zola, whose portrait he attempted, and noticed by Camille Pissarro. But frustrated by his lack of facility and perhaps by his want of an experienced teacher, he soon lost heart and returned to Aix, resigned to becoming an employee in his father's bank.

Cézanne's former ebullience revived swiftly. He passionately desired to be an artist, and used every opportunity to desert his drudge work at the office for model sessions at the Drawing Academy. In November of 1862, he again left for Paris and, supported by a paternal allowance, resumed his studies at the Académie Suisse. On his father's prompting, he made a halfhearted application for admission to the official Ecole des Beaux-Arts, but was refused.

Cézanne's earliest painting ventures—large, decorative compositions destined for the rooms of the paternal country estate, the Jas de Bouffan—express a naive enthusiasm for grand, traditional art, and a young amateur's courage in tackling projects beyond his technical reach. Among them are four large panels, *Allegories of the Seasons* (ca. 1860, Paris, Musée du Petit Palais), quaint poetic fantasies, curiously Gothic in their frail slenderness and of a thin, shaky execution that gives them the look of large tinted drawings. He signed them, ironically, "Ingres, 1811." These experimental, half-humorous efforts have all the awkwardness but also the naive vigor of beginner's work, yet they are remarkably free, despite their dependence on prints and book illustrations, of the stereotypes that generally mar such early efforts.

Among these early paintings which, as yet unaffected by formal training, reveal something of Cézanne's basic talent, one of the most original is the larger-than-life *Portrait of Louis-Auguste Cézanne* (ca. 1860, London, National Gallery), which shows the bulky figure of his father perched on a fragile chair, cap on head, reading a newspaper. The execution seems almost ostentatiously crude, especially in the bright red, unperspectival floor and the muddled brushwork of coat and trousers; but the face, shaped by heavy, wirelike contours, is memorable in its distinctive ugliness.

It is in a somewhat later series of portraits that Cézanne's growing assurance becomes apparent. A first *Self-Portrait* (ca. 1861, Paris, R. Lecomte Collection), showing him still beardless, is an awkward copy of a photograph, but it is followed shortly by the powerful, impressively sculptural *Self-Portrait* of circa 1865 (Paris, R. Lecomte Collection) in which he appears heavily bearded and prematurely bald. In the same bluntly compact style he painted several other portraits, *Uncle Dominique* (ca. 1865–67), presenting him in various guises costumed as a monk (New York, I. Haupt Collection), wearing a blue cotton cap (New York, Metropolitan Museum), or sporting a black cap with visor (New York, H. Bawick Collection). The heads and busts in these portraits are ruggedly shaped, by broad strokes of the palette knife, in heavy shards of black, gray, white and tan colors, enriched with sparing touches of rather more delicate greens and reds. Their passionate, even brutal energy of execution expresses Cézanne's temperamental exuberance at that time. But this exuberance was, even then, held in check by an instinct for structural solidity that asserted itself whenever he faced concrete reality, as he did in his portraiture.

There is a hint of Courbet's influence in these otherwise strongly personal works. Of Cézanne's recent academic studies, his labors in the model room of the Académie Suisse, hardly a trace can be detected, and it is only in rare instances, such as the painting *The Negro Scipio* (1866, São Paulo, Museu de Arte), a quite unacademic, still-life-like portrait of a muscular back modeled by the light, that these school exercises can be seen to have affected his independent work.

Of the same period, but entirely different in style and feeling from these massive and solemn portraits, are Cézanne's dramatic figural compositions of horrific or erotic subjects. These small, very freely brushed scenes are the product of his turbulent imagination, and have nothing to do with any study of visual reality. In them, the timid and sexually inhibited Cézanne day-dreams of orgiastic lovemaking and of physical violence, of abductions, rapes, assassinations, and grim autopsies. The agitated figures that enact these scenes derive from the pencil copies of sculptures and paintings with which Cézanne filled his notebooks during visits to the Louvre. His romantic exaltation was stirred by the melodramatics of Baroque artists and, nearer his own time, by those of Delacroix. In his naive imitations he further exaggerated these qualities, sometimes to the point of caricature. *The Orgy* (1864–66, Paris, private collection) groups small, convoluted figures around the steep perspective of a table that seems to recede into the blue sky. The suggestion of columns to one side and of an enormous drapery above give the scene a festive and monumental touch. There is something of Veronese in the general effect, and something of Delacroix in the gorgeous harmonies of blue, gold, and red, while the subject as such may owe something to Couture's *Romans of the Decadence.*

The Murder (1867–70, Liverpool, Walker Art Gallery), by contrast, is painted in somber monochromes, as is the equally lurid *Autopsy* (ca. 1867, Paris, private collection), in which a bald and bearded man, not unlike Cézanne, appears to be delving into a cadaver. The picture is said to have been intended for the hospital of Aix. *The Abduction* (dated 1867, London, J. M. Keynes Collection), in which a bronzed athlete strides through a dark landscape holding the pale body of a nude woman, is the most romantic, Delacroix-inspired of the erotic fantasies that preoccupied Cézanne, expressing (in Zola's phrase) "a chaste man's passion for the flesh of woman."

The vein of violence and passion that runs through Delacroix's work may have had an influence on the content of Cézanne's dramatic compositions, which uncomfortably combine cruelty and lust, but which also possess a certain quaintness and perhaps an element of parodistic humor. It is possible that Cézanne meant to poke fun at some of the grander themes he touched on, particularly in his variations on Manet's *Déjeuner sur l'herbe* and *Olympia,* which, in their crudity, suggest that they are to be taken as sarcastic commentaries, rather than imitations. *Déjeuner sur l'herbe* (ca. 1869, Paris, R. Lecomte Collection) and *Idyll (Don Quixote on the Barbary Coast)* (1870, Paris, private collection) were both inspired by Manet's *Déjeuner sur l'herbe. A Modern Olympia* (1870, Paris, private collection) attempts, as the title seems to imply, a modernization of Manet's— entirely modern—*Olympia,* perhaps by bringing it down from serene aestheticism

to the vulgar reality of a brothel scene. A second version, dating from circa 1873, is in the Louvre (Musée d'Orsay); it transfigures the subject by the use of an Impressionist color scheme.

A Bohemian swagger was part of Cézanne's personal manner in the late 1860s, his period of Storm and Stress, when, by his brusque deportment and unkempt appearance he made himself conspicuous in the rather more urbane company of the Café Guerbois centered on the fastidious Manet. Something of this attitude of bourgeois-baiting probably entered into his choice of subjects and into his cultivation of a rough style, of that *facture couillarde* ("plucky handling") on which he prided himself. Yet he expected his pictures to be exhibited, and made submissions to the Salons of 1864, 1865, 1866, 1867, 1868, and 1869, only to be rejected. His persistence became legendary; he seems rather to have gloried in these refusals.

Romantic fantasy pictures mark a distinct and fairly lengthy phase in Cézanne's work. As a group, they are characterized by an obsessive quality, a persistent, repetitious insistence on certain ideas, without noticeable clarification or progress. They have nothing in common with Manet's masterly variations on themes from tradition, or with Monet's sustained, focused exploration of visual reality. Their colors remain confined to a narrow range of dark, intense hues, striking in their contrasts and sometimes refined in a way that hints at an instinctive or calculated choice. The treatment of figures, their movements and foreshortenings, gives every sign of struggle. It is difficult to know what was Cézanne's aim, and hence how far short of his intentions these stunted images fell. But that they indicate a dead end and a failure seems evident.

The same cannot be said for his early portraits and still-lifes, which, by contrast, show a steady development and increase in mastery. It is in these paintings, produced during his annual stays in the quiet and seclusion of Aix, that his artistic maturity first declares itself. Their large formats and stable design indicate both confidence and control, their sober execution a calming of his nervous impetuosity. Romantic excess gives way to an economical concentration of energy and painterly effects that makes for stability, but also for a certain rigidity. These large, frontal, strongly patterned portraits have (as has often been observed) an almost Byzantine quality.

Portrait of Cézanne's Father Reading L'Evénement (1868–70, Washington, National Gallery) poses the figure centrally in a tall armchair that is turned slightly sideways, offsetting the overall symmetry. The large but controlled brushwork, less emotional, more constructive than that of the small fantasy scenes, gives the figure solidity, without strain or excess. *Portrait of Achille Emperaire* (1867–70, Louvre, Musée d'Orsay) shows its sitter in the same armchair, in strict, frontal symmetry. The manner of execution is markedly different from that of the *Portrait of Cézanne's Father,* graphic rather than sculptural, drawn with strongly emphasized black contours that give it something of the look of Daumier's lithographs. The colors, applied with the brush rather than the palette knife, are dark but intense, dominated by the strong blue of the sitter's robe. The raking light brightens them, without however giving salience to the figure. The enormous

head of Cézanne's crippled painter friend is sharply individualized and set in painful contrast to the frailty of the stunted body. The short figure's virtual enthronement on the tall armchair may involve a sardonic play on the sitter's name: Emperaire = Empéreur. Cézanne submitted the portrait to the Salon of 1870. It was refused.

His effort to curb his temperament and to achieve a calmer, more controlled compositional order gradually produced impressive results. *Girl at the Piano (The Overture to Tannhäuser)* (1868–70, Leningrad, Hermitage) combines two portraits in one composition: Cézanne's sister Marie, at the left, is penned between the upright piano on which she is playing and a massive, rectangular bench behind her on which her mother sits knitting. Both figures—the one in profile, the other in frontal view—are flattened into silhouettes and made to inhabit distinct compartments of space, defined by the rigid lines of the furniture. The flat, relatively light colors emphasize alike the firmness of the compositional structure and its two-dimensionality. Lively patterns in the wallpaper and the covers of an armchair, and vigorous striping in the carpet, enliven what otherwise would have been a rather spare design. It is not surprising that Matisse, thirty years later, should have expressed a particular liking for this picture.

Paul Alexis Reading to Zola (1869–70, São Paulo, Museu de Arte), a much larger work, is unfinished; the body of Zola is merely suggested by a few rapid brush strokes. It has nevertheless a very lucid and spacious structure, composed of large, rectangular forms. The execution is calm, the surface smooth, the colors fairly thin and in part transparent.

Sometime in 1869, Cézanne formed a liaison with Hortense Fiquet, a nineteen-year-old working-class girl. For the next seventeen years, she was to be, in effect, his common-law wife, although he carefully concealed her existence from his father and only dared to marry her after his father's death in 1886. When war broke out between France and Prussia in July 1870, Cézanne avoided military service, and for a time went underground with Hortense in the village of L'Estaque outside Marseilles on the Mediterranean coast. The rocky hills along the sea tempted him to paint several landscapes, such as *L'Estaque, Melting Snow* (1870–71, Paris, private collection). Their still rather somber and limited color range and agitated handling link them with the style and mood of his dramatic figure compositions. Unlike portraiture, which apparently had a calming effect on him, landscape stirred more subjective emotional reactions, calling forth his *"couillarde"* manner, with its lavish applications of paint and distinctive rolling brush strokes.

Cézanne, accompanied by Hortense, returned to Paris after the fall of the Commune, in the spring of 1871. They settled in a small apartment in a drab, industrial street opposite the Halle aux Vins, of which he painted a somber view from their window (1872, Paris, private collection). The war had scattered his friends; the circle of the Café Guerbois was slow in drawing together again. Trying to live with his unacknowledged companion on his modest bachelor's allowance, Cézanne suffered chronic, severe shortages of money that became all the more worrisome when it was found that Hortense was pregnant.

Anxious and unsettled though this period was, it was also a high point in his artistic development, marked by a handful of masterworks, the culmination of his effortful beginnings and a premonition of new directions. *The Black Clock* (ca. 1870, London, S. Niarchos Collection) still recalls the heavy brushwork and dark monochromy of Cézanne's earlier work. But the arrangement of this still-life, with its measured contrasts of light and dark, of geometric and organic forms, indicates a new mastery. Its powerful gravity and almost menacing physical presence have an extraordinary intensity of expression, the result of passionate observation that, rather than dramatizing its objects, seems to petrify them. The huge conch shell, with its coral mouth and warty protuberances, forms a disquieting contrast to the black tombstone cube of the clock. The strongly shaded folds of the tablecloth have the weight of sculptured marble.

A portrait of Cézanne's friend Gustave Boyer—*Portrait of Boyer (Man with a Straw Hat)* (1870–71, New York, Metropolitan Museum)—is painted in a narrow range of grays, blacks, muted browns and yellows. The face is modeled in vigorous contrasts of light and shadow, with an assurance, an economy of effort and subtlety of color that is without precedent in his earlier work.

In January 1872, Hortense gave birth to a son, Paul. Uncomfortable in Paris, and unable to bear the expense of city life, Cézanne followed the advice of his friend Pissarro, and moved with his family to the small town of Pontoise, some fifteen miles northwest of Paris, where Pissarro had been living since his return from England. Of Cézanne's artist friends, the patient and generous Pissarro was the one with whom he felt most at ease. He respected his experience and sought his advice. During his stay in Pontoise in 1872, and in nearby Auvers, where he moved in 1873, he painted in the fertile, green countryside, often in the company of Pissarro. His immersion in outdoor painting—in a humid, atmospheric, northern landscape setting very unlike the dry country around Aix—and the example of Pissarro's painstaking observation of subtle visual effects in nature produced a deep change in Cézanne's outlook, and consequently in his painting. The example of Pissarro taught him a lesson of humility and self-effacement before nature. It drew him out of himself, into an intense contemplation of external reality, and involved him with painting problems that could be overcome only by objective study. He now tried to paint landscape as experienced by the eye, i.e., as light and color, following in this the direction indicated by Pissarro and Monet. But he was not uncritical of his mentors, and recognized that their concentration on optical qualities entailed a sacrifice of corporeal form and substance, something he was unwilling to undertake.

Cézanne's use of color now underwent a radical change. To do justice to the luminosity and subtlety of the colors he observed in nature, he began to apply his oils in small touches of varying tone and hue, instead of applying them heavily, in broad strokes of the palette knife or the charged brush. *The House of the Hanged Man* (ca. 1873, Louvre, Musée d'Orsay), painted in Auvers, exemplifies his new technique of building form with small color touches, though in parts of the canvas—the sky and the light-struck wall of the house—the paint is still plastered on with sweeps of the palette knife. The overall effect is one of luminous,

atmospheric color, keyed to an even, harmonious intensity. The compositional structure is nevertheless very solid, and there is considerable emotional tension in the dramatic plunge of space between the looming masses of house and rocky slope that leads the eye down across the roofs of the village into the blue distance beyond.

View of Auvers (ca. 1874, Chicago, Art Institute) offers a panoramic view over a scattering of houses that recedes in a wide curve toward the level horizon. The colors are more intense and at the same time more evenly luminous, applied in free scumblings in the green foliage of the foreground and middle distance, and set in sharp facets in the roofs and walls of the houses, which, by their directions and diminishing size, give a vivid impression of receding space.

Through Pissarro, Cézanne renewed acquaintance with Dr. Paul-Ferdinand Gachet, a sometime member of the circle of the Café Guerbois, who had his practice in Paris but lived in Auvers. Dr. Gachet found Cézanne lodgings in Auvers, took a warmly admiring interest in his work, and bought several of his paintings. In Dr. Gachet's hospitable house, Cézanne painted still-lifes and experimented with etching. He painted a second version of his Manet parody, *A Modern Olympia,* for Gachet.

Another important acquaintance made at this time, through Pissarro, was that of the color merchant Julien Tanguy, who had recently established his shop in Paris, rue de Clauzel. A generous friend to his customers, "Père" Tanguy befriended Cézanne and accepted his paintings in exchange for canvas and paint. It was in Tanguy's shop that the unexhibited work of Cézanne could be seen, and was in time discovered by young artists who bought their supplies there. In his humble way, Tanguy was Cézanne's first dealer-patron.

When the painters around Monet and Degas in 1873 began to lay plans for an independent exhibition and to draw up lists of artists to be invited to participate, Pissarro insisted that Cézanne be included. At the exhibition held in April–May 1874, in the gallery of the photographer Nadar, Cézanne was represented by three canvases, including *The House of the Hanged Man* and the scandalous *Modern Olympia.* The critics singled these out for particularly contemptuous ridicule, but a discriminating collector, Count Doria, bought *The House of the Hanged Man.*

Sometime in 1875, Cézanne was introduced by Renoir to Victor Chocquet, a civil servant of modest means, and a passionate collector of the works of Delacroix. Chocquet, who had already bought one of Cézanne's compositions, *Bathers,* from Père Tanguy, became from this time on one of Cézanne's most active supporters. The early *Portrait of Victor Chocquet* (ca. 1875, Cambridge, England, V. Rothschild Collection) resembles *The House of the Hanged Man* in style and color range. The strikingly elongated face is shaped by small touches of fresh, finely harmonized color, but the execution is tense and effortful, the piling up of paint uneconomical, bearing witness to Cézanne's still laborious struggle with his new method.

The somewhat later *Portrait of Chocquet Seated* (ca. 1877, Columbus, Ohio, Gallery of Fine Arts) is of an entirely different style, and remarkably more

assured. Figure and setting are geometrically composed, in a pattern of horizontal and vertical shapes that is based on the lines of the furniture and of the picture-covered wall in the background. The clear, luminous colors, harmonized around an accord of blue, yellow, and red, have the warmth of sunlight—a touch of nature in an otherwise severely formal arrangement. Stylistically related, and of about the same date, the *Portrait of Madame Cézanne in a Red Armchair* (1877, Boston, Museum of Fine Arts) also illustrates Cézanne's limited acceptance of Impressionist influence, confined in this instance to a vivid effect of daylight, brought about by a masterly use of colored reflections and shadows, that seems to belong to another order of reality than the patterned, highly stylized figure of Hortense.

While during the years of his involvement with Impressionism Cézanne chose his motifs mainly from the concrete, outer reality of landscape, still-life, and portrait, he occasionally returned to subjects from his inner vision in which he allowed his private emotions, deeply repressed on the whole, the relief of a partial outlet. Entirely unrelated to his study of visual reality, these fantasy subjects, generally of erotic content, declare their source in dreams of love and art by their conspicuous anti-naturalism. The nudes in them are not suggestive of fleshly human presences, but of remembered motifs from traditional art, deliberately distorted or stunted so as to leave no doubt as to their artificiality. The themes are for the most part mythical or allegorical, foreign to the iconography of Impressionism, but in their treatment, their lightness of color and liveliness of touch, the Impressionist influence is clearly apparent. It is probable that Cézanne intended to develop some of these subjects—a *Temptation of St. Anthony;* an *Apotheosis of Delacroix;* an allegory, the *Triumph of Woman*—into exhibitable Salon paintings. The composition known as *Love Play (Bacchanal)* (ca. 1875–79, New York, A. Harriman Collection) exists in two oil and one watercolor versions. Exceptionally overt in its sexuality, it shows four nude men attacking—or merely sporting with—four nude women in a stylized landscape setting. The colors are light, kept to a narrow range of cream, blue, and green; the figures are roughly outlined with the brush. The effect is that of a high-spirited decoration, not heavily charged with erotic feeling. The wrestling nudes, the leaping dog, the ragged foliage and fleecy sky are woven into a lively texture, spaceless and insubstantial, in which the figures appear no more weighty than the sketchy clouds.

For Cézanne's future development, the most significant of these projects were the various *Bathers*—groups of male or female nudes in landscapes, strictly segregated by sex—that he composed in the years between 1873 and 1879. During these years, Cézanne restlessly shuttled back and forth between the region around Paris and his native South. What domestic life he had was divided between his parents in Aix and his clandestine family, which he moved about from domicile to domicile. He was deeply attached to his son, but cool toward Hortense, whom his friends, with jovial contempt, referred to as *la boule* ("the ball"). At the age of forty, he still lived on a parental allowance, resembling in his long dependence (and long-delayed adulthood) both Constable and Corot. He did not participate

in the Second Impressionist Exhibition (1876), for reasons unknown, but made a submission to the Salon, which was, as usual, rejected. During the following summer, he sought the tranquillity and seclusion of L'Estaque to paint coastal seascapes. *L'Estaque* (ca. 1876, New York, Bernhard Foundation) is the earliest in a series of sweeping views from a height, across red roofs "like playing cards," over the blue sea with its high horizon and crown of distant mountains.

Invited to participate in the Third Impressionist Exhibition, in the spring of 1877, Cézanne submitted a dozen paintings and three watercolors. The public's reaction to the exhibition was less vehement than on previous occasions, but the press, as hostile as ever, took particular aim at Cézanne. Chocquet vigorously defended his friend, and a small journal, launched on this occasion by the friends of the Impressionists, dared to assert that "Cézanne is a Greek of the great period . . . and the ignorant who laugh before his *Bathers* to me seem barbarians criticizing the Parthenon." Cézanne appears to have been neither surprised nor discouraged by the reception of his work. He had gained confidence in himself and was convinced, as he wrote to his mother in 1874, "that there will come a time when I shall come into my own."

He spent the year of 1877 painting in the region around Paris, before returning to the South in the winter, where he again faced the embarrassment of having to hide Hortense and little Paul from his father. By mischance, his father, who was in the habit of opening his mail, intercepted letters that betrayed their secret. Cézanne stubbornly lied his way out of this trouble, fearing that his father would cut his allowance from 200 to 100 francs on the grounds that this was sufficient for a single man. To support Hortense and their child, he was again forced to borrow money from Zola.

There was no Impressionist exhibition in 1878. Cézanne that year submitted a picture to the Salon, and was rejected as a matter of course. When the Fourth Impressionist Exhibition was being organized for 1879, he politely refused to participate. Instead, he made his annual submission to the official Salon and received his annual rejection. Impressionism and the example of Pissarro had transformed his work, but had not made him an Impressionist. It had brought him from the studio into the open air, had concentrated his attention on motifs from nature, had taught him that color was the basis of form, and set free his instinctive colorism. But it did not convert him to the rapid touch and spontaneous handling of the Impressionists. He was conscious of the demands of the picture plane and format, and regarded the image not as an opening into boundless space, but as a material surface limited on all sides. Above all, he was passionately concerned with the physical presence of objects, with their weight and substance: how to fix these on the flat painting surface while remaining true to their objective reality was the problem that increasingly absorbed him.

Impressionism thus affected Cézanne in two different ways: it drew him into the disciplined study of external reality and at the same time made him aware of the fundamental problems of image-making. It did not so much liberate as harness his talent and temperament. It did not lead him—as it led others—to form-dissolution, but to a fresh affirmation of form, complicated by the contrary

demands of Impressionism's optical analysis. How to combine analysis with synthesis, dissolution and reconstitution, atmospheric realism and architectural structure became the tormenting, insoluble problem on which he spent his unceasing efforts.

The period 1879–82 marked an important transition in Cézanne's development, the first unfolding of his mature personal style. His still-lifes, landscapes, and portraits of this time are recognizable by certain persistent features: a flattening of pictorial space by a tilting up of receding planes, such as the tops of tables in still-lifes or the foregrounds in landscapes; a tendency to organize objects or landscape features into conspicuous patterns; and a technique of applying his paint in densely spaced, oblique hatchings that do not shape the objects so much as bind them to the surface of the canvas in a consistent color texture. These various devices retain a descriptive function. The images they create still demand to be read as concrete forms contained in space and light, but they can also be seen as colored shapes on a surface.

Still-Life with Compotier (1879–82, Paris, R. Lecomte Collection), particularly when compared to the heavy light-dark modeling of *The Black Clock* (ca. 1870), illustrates the direction of Cézanne's development during the intervening decade. It is keyed to a dusky harmony of blues, from the transparent depths of which other colors emerge with muted intensity. The strong horizontal of the uptilted tabletop and the symmetrical spread of the red and green apples that form the base of the arrangement are answered by the elongated, unperspectival rims of the white compotier and the glass beside it, but countered by the long, descending diagonal of the negligently folded napkin, reinforced by a knife precariously projecting from the table's edge.

A similar subtlety of structure and resonance of color marks the landscapes of this period, *The Small Bridge (Bridge at Maincy)* (ca. 1882, Louvre, Musée d'Orsay), and *The Turning Road* (1879–82, Boston, Museum of Fine Art), as well as the portraits and compositions of bathers, such as *Three Women Bathers* (1879–82, Paris, Musée du Petit Palais), and the *Self-Portrait* (1879–82, London, Tate Gallery).

Through the good offices of a friend, the painter Antoine Guillemet, who was a member of the Salon jury, Cézanne was finally able to satisfy an old ambition. One of his paintings, a portrait (unidentified), was admitted to the Salon of 1882. Obscurely hung, it attracted no notice. In the autumn he returned to Aix, where, prompted by hypochondriacal fears of an early death, he made a will, naming his mother and son, but omitting Hortense.

From the autumn of 1882, for a period of about three years, Cézanne secluded himself in the South, living with his mother and sister in Aix, while Hortense and Paul remained in Paris. Still only in his forties, he now bade farewell to his youth. A love affair, the details of which remain obscure, brought a last, evidently violent emotional disturbance into his life in 1885. When it was over, he resigned himself, and by several acts of renunciation and accommodation won the security and peace that he needed for his work. Early in 1886, he ended his long friendship with Zola, from whom he had gradually become estranged and

whose novel *L'Oeuvre,* with its portrayal of a failed painter closely resembling himself, had offended him. Shortly thereafter he married Hortense, his companion of fifteen years, less for love than to legitimize their child and placate his family. The death of his father, in October 1886, finally gave him psychological independence and the assurance of an ample income for life.

From Aix, Cézanne sent his annual submissions to the Paris Salon, and was invariably refused. This period of withdrawal was not however a time of discouragement but one of tenacious work, in which he achieved what he had long sought —a reconciliation of nature study and pictorial construction. Much of his time was spent at L'Estaque, where his studio commanded a view of the Bay of Marseilles. Renoir visited him here in 1882, and again, together with Monet, in 1883. These were the years of Impressionism's crisis, when the leading painters of the group, who had minimized their differences of outlook during the common struggles of the 1870s, were beginning to go their separate ways. Personal expression, rather than visual objectivity, now came to play a larger role in their work, calling into question the empirical basis of Impressionism, and, incidentally, making Cézanne's highly individual position appear less eccentric than it had before.

The changeless grandeur of the southern landscape, little affected by the seasons in its clarity of contour and warmth of color, inspired a series of panoramic coastal views, taken from his studio above the bay:

> *The Sea of L'Estaque* (1883–85, Louvre, Musée d'Orsay);
> *The Gulf of Marseilles Seen from L'Estaque* (1883–85, New York, Metropolitan Museum);
> *The Bay from L'Estaque* (ca. 1886, Chicago, Art Institute).

The essential character of these land- and seascapes is summed up in a few large areas of resonant color: the pale blue sky, separated by a zone of mountains from the deeper blue of the sea, to which the orange and green of the houses and fields in the foreground present a vivid contrast. The brushwork is uniformly dense, the colors are evenly assertive. Stripped of the complexities of fugitive appearance, sky, sea, and land, the near and the far, are welded into a design that seems as stable and flat as a wall, and that perfectly fits the picture plane, yet gives a strong sense of material reality and light-filled space. In these paintings, both rich and bare, Cézanne's intention "to make something solid and durable of Impressionism" seems fully realized.

Another favorite painting site in these years was the estate of his brother-in-law Maxime Conil, at Belleville, which offered a wide view of the Arc Valley rising toward the silhouette of Mont Sainte-Victoire in the distance, a landscape both spacious and, in its shapely forms, sculptural. In two related versions of Mont Sainte-Victoire (1885–87, New York, Metropolitan Museum and London, Courtauld Institute Galleries), trees in the immediate foreground frame or divide the view. Their branches, in the London picture, fill the sky and caress the contour of the mountain, binding it into the picture plane. There is no firm footing at the base, the eye plunges immediately into distant, compartmented fields below

whose oblique and horizontal outlines, converging toward the left, give an effect of spatial recession, brought to a stop by the tall silhouette of the mountain. Near and distant shapes have equal weight in the composition and come together in the design of the picture surface.

A pervasive, warm light glows from the yellowish underpaint, over which the sharp green accents of the fields and the softer purplish-blues of the mountain are brushed in transparent strokes that fan out from the contours and grow lighter and thinner toward the centers of the forms which they define. The effect resembles that of watercolor, a medium much used by Cézanne at the time and evidently influential on his technique in oil painting. The calm serenity of these landscapes seems timeless. There are no figures in them, no signs of weather or season. Without mood, sentiment, symbol, or indeed any very pointed human associations, they are objects of aesthetic contemplation, being themselves the product of a deeply meditated effort to translate the teeming complexities of nature into an enduring and harmonious pictorial order.

A similar purpose motivated Cézanne's occupation with still-lifes, equal in importance, in the 1880s and 1890s, to his landscape painting. Still-life offered him the advantage of a more complete control; it enabled him to construct, in the studio and at his pleasure, the motifs for which in his landscape painting he had to search in nature. In his still-lifes, he used his compositional ideas with sovereign freedom, combining artificial with natural objects in close-up tabletop arrangements that he generally enlivened with draperies and patterned backdrops.

A fine example is the *Still-Life with Fruit Basket* (1888–90, Louvre, Musée d'Orsay). Seen at very close range and at a steep downward angle, fore- and background are tilted up, and their shapes brought into the vertical picture plane. The objects that crowd the table—a negligently folded napkin, some fruit, a painted porcelain sugar bowl and matching creamer, a ginger jar, and a large woven basket heaped with pears—are in a state of perfect but precarious balance. Some lean slightly to the left, some tip forward, others lean back. It is evident that in observing these objects, Cézanne repeatedly shifted his point of view, both sideways and vertically, to reveal certain shapes that interested him—the round opening of the jar, for instance, and the wide arc of the basket handle—but that could not be shown simultaneously in normal perspective. The resulting distortions of space and shape he incorporated into his design with masterful skill. The final arrangement, with its manifold correspondences and contradictions, is held together by tensions that resolve themselves in an ultimate equilibrium. The colors, too, individually strong and potentially dissonant, come together in a fine, slightly muted harmony.

Cézanne's arrangements of edibles and kitchen crockery recall seventeenth-century Dutch and eighteenth-century French still-life traditions, but differ from them in that they neither reflect actual domestic life nor spell any moral or social message. Unlike Manet's vividly sensuous or Courbet's powerfully physical still-lifes, they are not, strictly speaking, works of realism, but artificial constructions, exercises in the composition of stylized forms, in accordance with self-imposed

rules of great difficulty. What prompted Cézanne to give a more prominent role to the relatively "minor" genre of still-life painting than did any of his great French contemporaries is not clear. Critics have debated the question of whether he was entirely guided by conscious aesthetic decisions, or worked more spontaneously and intuitively, following the promptings of his eye and hand, or was even influenced by some abnormality of vision. This last seems unlikely, but that his persistent search for ways of imposing order on conflicting forms had psychological as well as aesthetic causes is highly probable. The intensity of his effort and the impressive gravity of his still-lifes suggest that there was more at stake in them than the solution of purely formal problems or the overcoming of representational difficulties. Their dissonances and tenuous balances may be the expression of his own inner tensions and his struggles to resolve them.

The still-lifes themselves give clues to the kinds of problems that Cézanne posed for himself. Some are of spare and sober construction, based on dominant horizontal and vertical elements with few countervailing diagonals, such as the *Still-Life with Peppermint Bottle* (1890–94, Washington, National Gallery), and the *Still-Life with Onions and Bottle* (1896–98, Louvre, Musée d'Orsay). In others, such as the *Still-Life with Basket of Apples* (1890–94, Chicago, Art Institute), he introduced destabilizing, irrational features (generally draperies) to obscure the supporting structure and introduce a dynamic imbalance, causing objects to slide at an oblique or to cascade into the foreground. The late still-lifes tend to be opulently furnished, their colors dark and and heavy, their arrangements of an almost Baroque animation. The *Still-Life with Curtain and Flowered Pitcher* (ca. 1899, Leningrad, Hermitage) and the *Still-Life with Apples and Oranges* (ca. 1899, Louvre, Musée d'Orsay) fall into this category.

In the sixth decade of his life, Cézanne, now married and financially independent, resumed his lengthy annual stays in Paris and renewed his relations with such artists of his own generation as Renoir, Rodin, and Monet, to whom he paid a visit in Giverny in 1894. But his morbid shyness and his suspicion of even the most cordial human gestures, rooted in an abnormal fear of being "caught," made him an unpredictable, sometimes brutally uncivil companion, and gradually separated him from his oldest friends, including Pissarro and Renoir. Their place was taken by a number of younger artists and writers—among them the painter Emile Bernard, the poet Joachim Gasquet, and the critic Gustave Geffroy—who in various ways discovered his works, sought him out in his obscurity, and published appreciative articles about him. Very gradually, his paintings gained visibility: *The House of the Hanged Man* was shown at the Paris World's Fair of 1889; a group of avant-gardist Belgian artists began to include him in their annual exhibitions; several of his paintings were offered to the state collections of modern art at the Luxembourg Museum in 1895, as part of the Caillebotte bequest, and in the same year an ambitious young art dealer, Ambroise Vollard, gave him a one-man exhibition in his new gallery.

In 1897, the death of Cézanne's mother resulted in a settlement of her estate by which he lost the Jas de Bouffan, to which he was deeply attached and which was important to him as a place of work. With his sister as his housekeeper, he

moved to smaller quarters in Aix. His wife and son remained in Paris.

Among Cézanne's works of the 1890s, portraits and figural compositions are conspicuous both by their number and their impressive formality. The distinction between actual portraits—such as the long series *Portraits of Mme Cézanne* dating from around 1890–95—and portrait-like studies of posing models, both amateur and professional, is difficult to draw, for Cézanne showed little interest in the personalities of his sitters. Domestic servants, gardeners, peasants, wife, and son contributed mainly their physical selves, in what must have been a martyrdom of endurance. The numerous portraits of Hortense apparently owe their existence to her willingness to sit still and silent for long spans of time: they, and other portraits of this period, are in effect human still-lifes. Their sitters, often posed frontally, at knee length and in monumental repose, are fitted into shallow spatial settings that are articulated by pieces of furniture, wall segments, and, occasionally, patterned hangings. As in the still-lifes, the forms are modeled by systems of colored strokes which, starting from the contours, spread in a web of transparent touches across the canvas. The interpenetration of these pigment layers—thin in the early 1890s, heavy in the later paintings—harmonizes the colors at the same time as it structures the picture surface. In this intricate process, every decision had consequences both for the design and the color balance of the whole, requiring constant calculations and reconsiderations, and forcing Cézanne to work at an agonizingly slow speed.

Work on the *Portrait of Gustave Geffroy* (1895, Louvre, Musée d'Orsay), begun at Cézanne's own suggestion, took about three months, during which Geffroy posed daily for several hours. In the end, Cézanne left it partly unfinished, declaring that it surpassed his strength. Its effect, however, as is the case with many of his "unfinished" paintings, is one of harmonious completeness. The general conception of the portrait, that of an intellectual at work surrounded by books and artistic bric-á-brac, recalls such earlier paintings as Manet's *Zola* (1867–68) and Degas's *Duranty* (1879), which may have had some influence on Cézanne. In its obliquity of view, its pattern of contrasting diagonals, it is one of the most delicately complex of his compositions, and demonstrates the similarity of construction between his portraits and still-lifes.

The *Portrait of Joachim Gasquet* (1896, Prague, Narodni Galerie), by contrast, presents its subject in extremely close view, without intervening foreground, and at a striking leftward slant that gives it an unusual, expressive urgency. Unfinished, with much bare canvas showing, it is painted in thin, watercolor-like transparencies, very broadly applied, that model the face with their bright contrasts of purple, red, yellowish, green, and light blue hues. The *Portrait of Ambroise Vollard* (1899, Paris, Musée du Petit Palais), according to Vollard, who left a possibly somewhat embroidered account of its genesis, required 115 sessions before Cézanne abandoned it, unfinished, declaring that he was "not dissatisfied with the shirtfront." The pose is rigidly frontal, the contours unusually sharply drawn and stiffly angular, the overall tonality very dark, partly as a result of its labored execution, in the course of which Cézanne built up his paints—originally thin and transparent—into heavy layers.

Besides such actual portraits, Cézanne painted portrait-like studies of anon-ymous domestics, or of peasants engaged for the purpose, endowing them with the same somewhat rigid monumentality and, oddly, allowing them a rather more pronounced individuality than he gave his friends. An example of this kind is the *Woman with Coffee Pot* (1890–92, Louvre, Musée d'Orsay), comparable, in pose and setting, to the *Portrait of Vollard.*

In the two main versions of his *Card Players,* Cézanne composed rustic figures in groups or pairs, in scenes reminiscent of traditional genre, but without any hint of episodic or dramatic narrative. Each version exists in several composi-tional variants that spell a development—a progressive clarification and concen-tration. The more elaborate version, in two variants—*Card Players* (1890–92, Merion, Pa., Barnes Foundation) and *Card Players* (1890–92, New York, Metro-politan Museum)—presents a many-figured scene in a well-defined interior: three card players, two of them facing each other in strict profile across a table, the third in front view between them. Two onlookers watch their quiet game in the larger (Barnes Foundation), only one in the smaller (Metropolitan Museum) version. The first of these variants gives a spacious and inclusive view of the scene; the second reduces the space, brings the figures closer, and increases their relative size. Though rougher in execution, it seems to be the more developed of the two. In it, the imposing, statuesque monumentality of the group is most fully realized.

The second main version of the subject reduces the scene to two players seen in profile view facing one another. The setting—a window framing a vaguely indicated landscape—is darker and less spacious than in the first version, the figures more alert and slender, and, by comparison, of an almost Gothic vertical-ity. The *Card Players* (1890–92) of the J. V. Pellerin Collection, Paris, was presumably the earliest of the series, followed by the increasingly more broadly stylized (and less portrait-like) variants in London (Courtauld Institute Galleries) and Paris (Louvre). In its concentration on the physical confrontation of the two immobile and expressionless players, this second version carries a heightened sense of contained energy. The men's looming physical presence gives the scene an emotional weight that transcends the everyday subject.

The *Card Players,* though composed of interacting figures rather than of unrelated objects, is a calculated formal arrangement, no less artificial than Cézanne's still-lifes. It derives its expressive force, its actual content, not from its subject but from its formal qualities. That Cézanne should have invested such strength of feeling in material seemingly so slight has caused some critics to suspect the presence of further, hidden intentions. Attempts have been made to probe beneath the surface of the image for deeper layers of meaning, for allusions to Cézanne's early conflicts with his father, to his rivalry with Zola, or to his own artistic activity. Such imaginative interpretations, necessarily beyond verification, remain a question of personal belief. What private fantasies, unconscious or half-conscious motivations entered into Cézanne's struggles for pictorial realiza-tion—in his landscapes and still-lifes as much as in his figural compositions—can only be guessed at. The results speak for themselves: the expressive energy that animates Cézanne's work must have been fed by sources more fundamentally

human than his genius for formal arrangement, central though this was to the greatness of his art.

Slightly earlier than the *Card Players,* the composition known as *Mardi Gras* (1888, Moscow, Pushkin Museum) contains a hint of dramatic action and therefore offers more positive grounds for a thematic interpretation. It presents two figures in carnival costume, a Harlequin, believed to have been posed by Cézanne's son, and a Pierrot, traditional figures of the annual popular festivities, held in Aix as elsewhere in France. Harlequin, flamboyantly checkered red and black, struts haughtily toward the right, holding a baton under his arm, unaware of the white Pierrot who follows him in a crouching stoop, as if plotting some mischief and perhaps intent on seizing the baton that Harlequin proudly carries. The figures' pantomime, itself unusual for Cézanne, is made more emphatic still by a grotesque enlargement of their arms, hands, and feet. The particularly careful execution of the fairly large canvas, in uniformly dense, blended, opaque colors, underlines its apparent importance for Cézanne, who, as has been suggested, may have identified himself with Harlequin—vulnerable, persecuted, but unbowed.

Cézanne spent the last years of his life in a quiet and solitary retirement at Aix that was only rarely interrupted by trips to the North. In 1904 and again in 1905, he paid visits to Paris and painted in the Forest of Fontainebleau. A diabetic illness gradually weakened his heretofore vigorous constitution. At age sixty, he looked, and apparently felt, older than his years, but his mind was as keen as ever and his appetite for work undiminished. Timid in matters of everyday living, fearful for his independence and security, he assumed defensive positions in political and religious questions. He looked with suspicion and distaste on the liberal movements of the time, took an anti-Dreyfus position, and allowed his sister to lead him back into the fold of the Church. It is probable that his political conservatism and churchly piety were not merely manifestations of old age, but —as in the somewhat parallel case of Degas—expressed a deeper-going faith in tradition, stability, and order, and were thus not unrelated to his strivings as an artist.

Cézanne's work during these years enjoyed increasing recognition in France and abroad. Exhibitions in Brussels (1901), Vienna (1903), and Berlin (1904), as well as Paris and Aix; important purchases by French dealers (Bernheim) and German museums (Berlin, Essen) presented him to a widening and ever more sympathetic audience. Like the aged Blake, he attracted a following of young artists, among them Emile Bernard, Maurice Denis, and Ker X. Roussel, who were eager to discover his thoughts on art and later recorded his conversations or published his letters, thus preserving, at least in broad outline, Cézanne's theories of art.

To compensate for the loss of the Jas de Bouffan, Cézanne tried to purchase the wooded estate of Château Noir overlooking the road to Tholonet, east of Aix, long one of his favorite painting areas. Failing in this attempt, he had a studio building constructed at Chemin des Lauves, in the hills east of Aix, from which he had a fine view of Mont Sainte-Victoire.

Still-lifes and portraits are relatively rare among the works of his last years. Among his many landscapes, two entirely dissimilar motifs predominate. On the one hand are the spacious, compactly sculptural portraits of Mont Sainte-Victoire, a conical mass profiled against the sky, and, on the other, the enclosed, skyless close-ups of boulders and rockface, as in the views of Bibémus Quarry, or of dark forest interiors, as in the scenes from the park of the Château Noir.

In contrast to the serenity and balance of Cézanne's "classical" landscapes of the mid-1880s, with their muted color harmonies and subtle tonal transitions, his late views of Mont Sainte-Victoire (1902–04, Philadelphia Museum of Art; 1904–06, Zurich, Kunsthaus; and 1904–06, Kansas City, William Rockhill Nelson Gallery of Art) appear at first sight violent and arbitrary in their intensity of color and brutal in the abruptness of their handling. Their rough patchwork of vertical, horizontal, and diagonal color slashes resolves itself, at a distance, into the semblance of a wide terrain, defined by zones of dark blue foliage interspersed with the yellow, angular shapes of houses and rising toward quieter layers of green from which the softer blue and lilac of the mountain rears into a turbulent sky. The whole has the appearance of an agitated high relief in which, instead of tonal contrasts, juxtapositions of strong color both model the solid forms and suggest spatial recession.

Quite different from these large views, in color, design, and emotional tone, are the closed and often twilit forest interiors, painted in the Forest of Fontainebleau or the park of the Château Noir about the same period:

Forest Scene (1898–99, San Francisco, Fine Arts Museums);
Mill Stones in the Park of Château Noir (ca. 1900, Philadelphia Museum of Art);
Grounds of the Château Noir (1900–04, London, National Gallery).

There the dominant effect is one of relative darkness, tending to depressive blueish-grays in some, to animated brownish-orange hues in others. Though dark in tone, the colors have considerable inward intensity. They are not applied in distinct, contrasting strokes, as in the views of Mont Sainte-Victoire, but in gradual fusions, with little contrast from area to area and something of the density of a textile weave. The shallow, obstructed spaces of these landscape interiors— without sky, sunlight, or atmosphere—are articulated by stony ridges and slender tree trunks which, by their irregular slants, bring a note of instability and conflict into the compositions.

A heightened emotional intensity marks Cézanne's late work, particularly his landscapes, varying in its expression between truculence and melancholy. This new urgency of feeling, sometimes disrupting the formal order of his compositions, also noticeably affected the style of his last portrait studies for which, by preference, he posed working-class men and women of his acquaintance. In the *Old Woman with Rosary* (1900–04, London, National Gallery), Cézanne has placed the bulky, stooped figure in three-quarter view, fingering her rosary, head bowed in prayer, her unseeing eyes fixed at some point in space before her. The painting is executed in heavy layers of dark paint, except for the face, which, brushed in transparent, yellowish oils, seems masklike within the ridges of built-

up pigment that surround it. The darkness of the canvas, reminiscent of Rembrandt's shadowy settings, adds to the pathos of this portrait, which—most unusually for Cézanne—seems to probe beneath the physical presence into a state of mind.

Among Cézanne's last works is a series of portraits of his gardener Vallier, for the most part posed out of doors in the new studio at Les Lauves. The profile position of Vallier in the Chicago version—*Portrait of the Gardener Vallier* (1904–06, formerly Chicago, L. B. Block Collection)—places his massively pyramidal figure against a dark, heavily worked ground that is unusual for Cézanne. The gravity and blunt dignity of the figure, and the simplicity of its pose, exemplify the emphasis on expressive features (rather than complex formal arrangements) characteristic of Cézanne's old-age style. The dark strength of the colors and the labored execution, with its piling up of paint and its emphatic repetition of brush strokes, combine to suggest a great intensity of purpose, an almost desperate striving, the excitement of which loosens the artist's customary formal control.

Nudes posing in landscape settings, thematically identified as "Bathers," were a life-long preoccupation of Cézanne. In every period of his development, from the early 1870s onward, he persisted in his experimentation with groupings of male or female nudes, nearly always segregated by sex. His abiding interest in these purely imaginary scenes, quite unrelated to his occupation with motifs from concrete reality (i.e., landscapes, portraits, and still-lifes), may have had its roots in nostalgic memories of boyhood play on the banks of the Arc River: an early pen drawing in a letter to Zola (1859) records such a bathing scene. The subject originally must have been tinged with erotic feelings. The theme of the *Bathers* is not unrelated to Cézanne's youthful sexual fantasies, but this element was displaced from the beginning by a severe concentration on its formal aspects and stylistic problems: the long history of Cézanne's treatment of this subject, fraught for him with potentially dangerous meanings, is a remarkable instance of artistic sublimation.

The pictorial form which he gave to his compositions of *Bathers* derived from his impressions of past art. Paintings by Titian, Poussin, and perhaps Boucher helped him to place the subject in a timeless, Arcadian context, far removed from personal experience. It is noteworthy that Cézanne, always dependent on direct eye-experience when painting landscapes, portraits, or still-lifes, composed his *Bathers* entirely from the imagination, or from memories of early model studies and sketches of sculptures drawn in the Louvre. His avoidance of nude, female models, so evidently useful in carrying out difficult, many-figured compositions, was partly based on considerations of propriety, and perhaps on deeper anxieties, but it was also motivated by his fundamental conception of his subject as a vision of an ideal existence, not a scene from ordinary reality. Lifelike realism therefore was to be avoided; Cézanne intentionally stressed the artificiality of his compositions by giving his figures schematic and unnatural forms. Charmless and individually insignificant, they are merely shapes within an ordered whole which, by its harmonies of color and form, was to express his idea

of calm well-being, a well-being won at the sacrifice of physical desire.

Some 140 drawings, watercolors, and oil studies, spanning three decades, led to the three large canvases of bathers painted between 1900 and 1906 that are the culminating achievements of Cézanne's last period. Both the *Women Bathers* of 1900–05, in the Barnes Foundation, and the *Women Bathers* of 1900–05, in the London National Gallery are of exceptionally large size (Barnes Foundation version 52 × 81½ in., or 1.33 × 2.07 meters; London version 51 × 77 in., or 1.3 × 1.95 meters). Their colors, in the darker passages, are applied in the heavy, opaque layers characteristic of Cézanne's late work. A powerful, unearthly blue fills the skies and pervades the contours and shadows. The bulky nudes, heavy in body and angular in pose, are modeled in reddish-yellow and lemon-yellow hues. The two versions share many figural motifs and resemble one another in their effortful execution and relatively high degree of finish. Compositionally, the London version appears to be the more clearly resolved. In the Barnes Foundation version, the figures dominate and crowd the setting, their division into two lateral groups barely suggested. The picture in London enlarges the landscape setting and integrates it with the frieze of figures, now more clearly arranged in two corresponding groups.

The triumphant resolution of the problems addressed in these penultimate trials Cézanne accomplished in the *Women Bathers* of 1904–06 (Philadelphia Museum of Art), his largest painting (82 × 99 in., or 2.08 × 2.51 meters) and final masterwork. Different in this respect from the other two large versions, its composition has the geometric regularity and axial symmetry of an architectural structure. Beneath a solemn arch formed by trees converging toward the middle and framing a triangular expanse of sky and distant landscape, two groups of bathers, their interlocking bodies gathered in pyramidal clusters, face one another from the left and right of the foreground across the picture's vacant center. The figures, of relatively small scale within the lofty space, maintain statuesque attitudes, suggestive neither of movement nor of any particular activity. The stillness of the scene and its remoteness from ordinary life are underlined by the orchestration of its colors in accords of blue and green, alternating with the blond and reddish tan of the nude bodies. Applied in transparent, watercolor-like washes, leaving much canvas bare, the colors merge in an atmospheric blend that is both light, but not with the light of common day, and intense, but without the weight of matter. The apparent spontaneity of execution that distinguishes this largest canvas in the series from the others may be due to the fact that it was left unfinished. It is nevertheless complete, in the sense that all its parts are evenly realized. Whether or not its seemingly effortless serenity would have given way to the laborious gravity of Cézanne's late, expressive manner had he been able to work on it further is impossible to tell.

His final statement of the theme of *Bathers* gives the full measure of his distance from Manet's *Déjeuner sur l'herbe* (1863) or from Renoir's *Grand Bathers* (1885–87), not to mention the works of a purer, optical Impressionism, such as Monet's riverside scenes at Argenteuil (1874). The pictorial formality, and even the expressive intention, the quasi-moral elevation, of this culminating work place

Cézanne, surprisingly, in the lineage of neoclassicism. His *Bathers* are closer in spirit to Ingres's *Golden Age* (1843) than are Renoir's more superficially Ingrist *Bathers*.

Enfeebled by his diabetic complaint, Cézanne nevertheless remained fully active, using his new studio at Les Lauves for work on his large canvases, and continuing his regular painting out of doors, *"devant le motif."* The painters Maurice Denis and Ker X. Roussel visited him in January 1906, and later in the year a German museum official, K. E. Osthaus, called on him to buy two paintings for the Folkwang Museum in Essen. After recovering from an attack of bronchitis in August, Cézanne resumed his outdoor work, was caught in a heavy rain in October, and suffered a physical collapse from which he did not recover. He died in his apartment in Aix on October 22, 1906. A memorial exhibition of fifty-six of his paintings at the Paris Salon d'Automne in 1907 made a profound impression on a young generation of artists, not only French but German and English as well. But Cézanne had no direct followers, despite his enormous influence during the first two decades of the twentieth century. His work was quarried for ideas and stylistic motifs (which in the hands of imitators often hardened into clichés). The French Fauves and Cubists, the German Expressionists, and modernist painters in Britain and Italy as well, were importantly furthered by his example in going in their various direction. But none continued in his line and on his level to pursue the goal of a pictorial art combining high formality with deeply felt personal expression, constructive logic with passionate nature study.

READINGS

General

M. Schapiro, *Paul Cézanne,* New York, 1952, remains the most useful general introduction to Cézanne's work, its visual qualities and its meanings.

R. Fry, *Cézanne, a Study of His Development,* London, 1927 (2nd edn. 1952), despite its early date, is a still fresh and highly perceptive assessment of the distinctive stylistic character of Cézanne's work.

K. Badt, *The Art of Cézanne,* Berkeley and Los Angeles, 1965, offers a controversial but extremely interesting interpretation of Cézanne's motivations and guiding ideas.

Life

G. Mack, *Paul Cézanne,* London and New York, 1935.

J. Rewald, *Paul Cézanne, a Biography* (2nd edn.), New York, 1968.

Of the biographical sources, J. Rewald, ed., *Paul Cézanne, Letters,* New York, various editions (1937, 1941, 1983), is important and accessible to English-speaking readers. J. Wechsler, *Cézanne in Perspective,* Englewood Cliffs, N.J., 1975, offers selections from recollections of contemporaries and from later critical writings about Cézanne. Among the accounts of Cézanne's acquaintances, the following are noteworthy: E. Bernard, *Souvenirs sur Paul Cézanne,* Paris, 1926; J. Gasquet, *Paul Cézanne,* Paris, 1926; and A. Vollard, *Paul Cézanne,* New York, 1926.

Work

L. Venturi, *Cézanne. Son art et son oeuvre,* 2 vols., Paris, 1936, is the standard, fully illustrated catalogue of Cézanne's paintings. It will soon be supplanted by the forthcoming enlarged and revised catalogue by John Rewald.

A. Chappuis, *The Drawings of Cézanne: A Catalogue Raisonné,* 2 vols., Greenwich, Conn., and London, 1973.

J. Rewald, *Paul Cézanne. The Watercolors,* New York, 1983.

G. Adriani, *Cézanne Watercolors,* New York, 1983.

Special Studies

E. Loran, *Cézanne's Compositions* (2nd edn.), Berkeley and Los Angeles, 1970.

G. Berthold, *Cézanne und die alten Meister,* Stuttgart, 1958.

W. Rubin, et al., *Cézanne: The Late Work,* New York, 1977 (the monographic catalogue of an exhibition held at the Museum of Modern Art).

Index

Abbey in the Oak Forest
(Friedrich), 113–14
Abduction, The (Cézanne), 423
Absinthe (Degas), 307, 324
Absinthe Drinker, The (Manet),
292–93, 295
*Achilles Battling with the
River Scamander* (Runge),
104
*Achilles Dragging Hector's Body
Around the Walls of Troy*
(Hamilton), 77–78
Acis and Galathea (Gros), 37
*Aeneas and the Sibyl, Lake
Avernus* (Turner), 140
*Aeneas Recounting the
Misfortunes of Troy Before
Dido* (Guérin), 47
African Slave Trade, The
(Géricault), 182
After Dinner at Ornans
(Courbet), 253, 302
After Lunch (Renoir), 380
Age of Gold (Ingres), 167–68
Age of Iron (Ingres), 168
Agostina (Corot), 209
*Agrippina Landing at Brundisium
with the Ashes of Germanicus*
(West), 78
Albion and the Crucified Christ
(Blake), 95
Alexander Lenoir (David), 30
*Algerian Women in Their
Apartment* (Delacroix), 166,
189, 373
Allegories of the Seasons
(Cézanne), 422
Allegory of Madrid (Goya),
66–67
*Alley of Chestnut Trees at La
Celle de Saint-Cloud* (Sisley),
390
*Alley of Chestnut Trees at
Saint-Cloud* (Sisley), 390
Ambassadors of Agamemnon, The
(Ingres), 158
*Ambroise Vollard Dressed as a
Toreador* (Renoir), 387
America, a Prophecy (Blake), 90
*Amor, Stung by a Bee, Complains
to Venus* (Gros), 37

*L'Amour Vainqueur (Love
Victorious)* (Daumier), 238
Andromache and Pyrrhus
(Guérin), 46
Andromache Mourning Hector
(David), 19, 20, 24, 45
*Andromache Mourning the Death
of Hector* (Hamilton), 77–78
Angels Adoring the Name of God
(Goya), 59
Angel Standing in the Sun, The
(Turner), 153
Angelus, The (Millet), 241–42,
244
Antibes Seen from La Salis
(Monet), 360
Antiochus and Scipio (Ingres),
158
Antiochus and Stratonice (David),
18, 167
Antiochus and Stratonice (Ingres),
167
Antoine Mongez and His Wife
(David), 29
Apollo Victorious Over Python
(Delacroix), 191–92
Apotheosis of Delacroix
(Cézanne), 428
Apotheosis of Homer, The
(Ingres), 80, 165, 186, 191
Apotheosis of Napoleon I (Ingres),
168–69
Apple Picking (Pissarro), 411
Appulia in Search of Appulus
(Turner), 145
Arab Comedians (Delacroix), 192
Arab Festival (Renoir), 381
*Arabs Skirmishing in the
Mountains* (Delacroix), 192,
195
Arctic Shipwreck (Friedrich),
116–17, 149
*Aretino in the Studio of
Tintoretto* (Ingres), 163
Argenteuil (Manet), 304–5, 310
Arminius' Grave (Friedrich), 115
Arrival at the Town Hall (David),
27, 28
Art (Prud'hon), 51
Artist's Parents, The (Runge),
106

Arundel Mill and Castle
(Constable), 136
Assumption of the Virgin
(Prud'hon), 53
Atala (Girodet), 53
Attack on the Stage Coach, The
(Goya), 61, 62
At the Café (Manet), 307
At the Inn of Mère Anthony
(Renoir), 370, 390
At the Milliner's (Degas), 328
*At the Milliner's (Girl Arranging
Hats)* (Degas), 328
Aurora and Cephalus (Guérin),
46
Author Dreaming, The (Goya),
63
Autopsy (Cézanne), 423
Autumn (Goya), 61
Autumn (Haystacks) (Millet),
246
Autumn (Manet), 310
*Auvergne Landscape with
Fisherman* (Rousseau), 218
Avenue, Middelharnis, The
(Hobbema), 222
*Avenue in the Forest of
Isle-Adam* (Rousseau), 220,
221
Avenue of Chestnut Trees, The
(Rousseau), 219
*Awakening, The (Venus Pursuing
Psyche with Her Jealousy)*
(Courbet), 261–62

Balcony, The (Manet), 302, 308
Ball at the Moulin de la Galette
(Renoir), 378, 380
Balleroy, Comte Albert de, 292
Ballet Class, The (Degas), 325
Ballet Rehearsal on the Stage
(Degas), 323
Ballet Robert le Diable, The
(Degas), 322
Balzac, Honoré, 228–29, 232,
233
Banks of the Marne, Winter
(Pissarro), 402
*Banks of the Marne at
Chennevières* (Pissarro), 402
Baptism of Christ (Corot), 206

443

*Baptism of the King of Cashel by
 St. Patrick* (Barry), 79
Bar at the Folies-Bergère (Manet),
 310
Barges on the Canal Saint-Martin
 (Sisley), 391
*Bark of Dante (Dante and Virgil
 Ferried by Phlegias to the
 City of Hell* (Delacroix), 185,
 194
Barnes, Albert, 387
Baroness James Rothschild
 (Ingres), 168
Barra (David), 24, 47
Barricade, The (Manet), 302
Barry, James, 78, 79–83
Barye, Antoine-Louis, 239
Bas-bleus, Les (Daumier), 234
Basire, James, 86–87
*Bassin aux Nymphéas, Le (The
 Water-Lily Pond)* (Monet),
 364–65
Bastien-Lepage, Jules, 379
Bather (Renoir; 1895), 385
Bather (Renoir; ca. 1903), 385
Bather Arranging Her Hair
 (Renoir; 1885), 383, 385
Bather Arranging Her Hair
 (Renoir; 1893), 385
Bather Drying Her Hair (Degas),
 329
Bather Drying Her Leg (Renoir),
 385
Bather in the Woods (Pissarro),
 414
Bathers, The (Courbet), 209,
 256, 260, 264, 297, 370
Bathers, The (Renoir), 383–84
Bathers series (Cézanne), 414,
 427–29, 438–440
Bathers series (Renoir), 384–88
Bather with Griffon (Renoir),
 372–73, 377
Bathing Suzanna (Rubens), 293
*Battle Between Mars and
 Minerva* (David), 18
*Battle Between Romans and
 Sabines* (David), 35, 40, 158,
 192, 318
Battle of Aboukir (Gros), 35–36
Battle of Austerlitz (Gérard), 41,
 43
Battle of Nancy, The (Delacroix),
 187
Battle of Nazareth, The (Gros),
 35–36
Battle of Poitiers, The
 (Delacroix), 187
Battle of Stags (Courbet), 261
Battle of Taillebourg (Delacroix),
 191
Battle of the Amazons (Rubens),
 191
*Battle of the Kearsage and the
 Alabama Off Cherbourg*
 (Manet), 299, 309
Battle of Trafalgar, The
 (Turner), 142

Baudelaire, Charles, 228–33, 235,
 259, 261, 262, 292–95, 303
Baudry, Paul, 282, 284, 297
Bayeu, Francisco, 58–60, 62
Bay from L'Estaque, The
 (Cézanne), 431, 433
*Bay of Baiae, Apollo and the
 Sibyl, The* (Turner), 147
Bazille, Frédéric, 303, 346, 347,
 349, 350, 352, 353, 369, 374,
 389, 390
Beach at Sainte-Adresse (Monet),
 350
Beaumont, Sir George, 123–25,
 136, 145
Beheading in Rome (Géricault),
 177
Belfry of Douai (Corot), 210
Belisarius Begging Alms (David),
 19, 42
Bellelli Family, The (Degas), 317
Bérard, Paul, 379, 382
Bernard, Emile, 436
Bertin, Edouard, 201, 202
Bertin, Victor, 200, 201, 212
Bidault, Jean-Joseph-Xavier, 212
Bird Nesters, The (Millet), 246
Birthday of the Madam, The
 (Degas), 326
Birth of Pandora (Barry), 81
Birth of Venus (Bouguereau),
 284–85
Birth of Venus (Cabanel), 284,
 297
Black Clock, The (Cézanne),
 426, 430
Black Standard-Bearer, The
 (Géricault), 178
Blake, Robert, 88
Blake, William, 82, 83, 85–99,
 104, 109, 116, 118
*Blind Belisarius Carrying in His
 Arms His Youthful Guide Who
 Has Been Bitten by a Snake,
 The* (Gérard), 42
Blind Man's Bluff (Goya), 61
Blond Bather, The (Renoir), 381,
 385
Blonde with Bare Breasts, The
 (Manet), 307
Blossoming Trees at Giverny
 (Monet), 361
Blue House at Zaandam (Monet),
 353
Boat Building at Flatford
 (Constable), 128
Boating (Manet), 305, 307
Boat Passing a Lock (Constable),
 132–33
*Boildieu Bridge, Rouen, Damp
 Weather, The* (Pissarro), 415
Boisbaudran, Horace Lecoq de,
 275
Bologna, Giovanni da, 41
*Bonaparte Crossing the Great St.
 Bernard* (David), 27, 34, 144
*Bonaparte Pardoning the Rebels
 of Cairo* (Guérin), 45

Bon Bock, Le (Manet), 303
Bonington, Richard Parkes, 1
 185, 199, 212, 213, 218, 33(
 337
Bonnard, Pierre, 388
Bonnat, Léon, 316
Book of Job, The (Blake), 96,
 109
Book of Urizen, The (Blake),
Bordighera (Monet), 360
Boucher, François, 298, 438
Boudin, Eugène, 263, 335–37,
 345–48, 353, 354
Bouguereau, Adolphe William
 271, 282, 284–85
*Boulevard des Italiens, Mornin
 Sunlight* (Monet), 416
*Boulevard Montmartre, Winte
 Morning* (Pissarro), 416
Boy in a Top Hat (Corot),
 200–201
Boy with Cherries (Manet), 29
Boy with Dog (Manet), 293
*Breach in the City, the Mornin
 after a Battle, A* (Blake), 87
Breaking Up of the Ice (Mone
 358
Breton, Jules, 285, 379
Bridge at Hampton Court
 (Sisley), 393
*Bridge at Villeneuve-la-Garenn
 (Sisley), 392, 393
Bridge of Mantes, The (Corot)
 208
Brighton Chain Pier (Turner),
 148
*Bringing Home the New-Born
 Calf* (Millet), 243
*Brutus in the Atrium of His
 House, after the Execution o
 His Sons* (David), 21–22, 45
*Brutus Swearing to Avenge the
 Death of Lucretia* (Hamilton
 78
Buchon, Max, 254
Builder of the Pyramids (Blake
 96
Bullfighter José Romero, The
 (Goya), 63
Bull Ring (Manet), 299
Bulls of Bordeaux (Goya), 73
Burning of Moscow (Gros), 36
*Burning of the Houses of
 Parliament* (Turner; Clevela
 Museum of Art), 149–50
*Burning of the Houses of
 Parliament* (Turner;
 Philadelphia Museum of Ar
 149–50
*Buttermere Lake, Cumberland,
 Shower* (Turner), 139–40
Butts, Thomas, 92–93

Cabanel, Alexandre, 282, 284,
 297
Café-Concert (Manet), 307
*Café-Concert at Les
 Ambassadeurs* (Degas), 326

Caillebotte, Gustave, 336, 355–58, 376, 384
Calais Pier (Turner), 142
Calais Sands, Poissards Collecting Bait (Turner), 149
Calf, The (Courbet), 265
Camille (The Green Dress) (Monet), 349, 351
Camille Monet and Her Son Jean in the Garden at Argenteuil (Manet), 376
Camille Monet and Her Son Jean in the Garden at Argenteuil (Renoir), 376
Camille Monet on the Beach at Trouville (Monet), 353
Canal at Zaandam (Monet), 353
Canaletto, (Giovanni) Antonio, 150
Canal Saint-Martin, The (Sisley), 391
Canterbury Pilgrims (Blake), 94
Capitulation of Madrid (Gros), 36
Capricci (Tiepolo), 60
Caprichos (Goya), 62, 67, 70, 71, 73
Caravaggio, Michelangelo Merisi da, 251, 252
Cardinal Bibbiena Offering the Hand of His Niece to Raphael (Ingres), 163
Card Players series (Cézanne), 435
Carracci, Annibale, 293
Carriages at the Races (Degas), 322, 324
Cart Loaded with Wounded Soldiers (Géricault), 178
Carus, Carl Gustav, 115
Cassatt, Mary, 328
Castagnary, Jules-Antoine, 241
Cathedral of Mantes, The (Corot), 208
Cattle Market, The (Géricault), 177–78
Cemetery Gates (Friedrich), 117
Cenotaph, The (Constable), 136
Centaur Abducting a Woman (Géricault), 176
Cervara in the Roman Campagna, La (Corot), 202
Cézanne, Paul, 205, 263, 279, 281, 285, 286, 303, 336, 355, 377, 381, 382, 384, 386, 388, 399, 405–7, 414, 418, 421–41
Chalk Cliffs at Ruegen (Friedrich), 116
Chamonix (Turner), 141
Champaigne, Philippe de, 164
Champfleury, Jules, 253, 254, 259
Chapel of the Holy Angels, Delacroix's decorations for, 193
Chardin, J.-B.-S., 239, 240
Charging Chasseur, The (Géricault), 172–74

Charigot, Aline, 380–84
Charing Cross Bridge (Monet), 363
Charing Cross Bridge (Sisley), 393
Charity (Goya), 60
Charles III, King of Spain, 57, 60
Charles IV, King of Spain, 62, 65, 66
Charlet, Nicolas Toussaint, 232, 233
Charpentier, Georges, 376, 379
Chartres Cathedral (Corot), 202, 206
Chasseur in the Forest (Friedrich), 115
Château de Steen (Rubens), 131
Chez le Père Lathuille (Manet), 308, 324
Chichester Canal (Turner), 148
Children's Afternoon at Wargemont, The (Renoir), 382
Chocquet, Victor, 377, 427, 429
Christ Blessing the Bread and Wine (Constable), 125
Christ Blessing the Children (Constable), 125
Christ Crucified Between Two Thieves (Delacroix), 193
Christ Delivering the Keys to St. Peter (Ingres), 163
Christ Expiring on the Cross (Prud'hon), 53–54
Christ on the Mount of Olives (Goya), 70
Christ on the Sea of Galilee (Delacroix), 194
Christ Preaching (Rembrandt), 259
Christ Rejected by the Jews (West), 79
Church at Moret (Sisley), 396–97
Church at Varengeville, The (Monet), 359–60
Church of Gréville, The (Millet), 245
Church of Marissel, The (Corot), 208
Church of S. Trinita dei Monti, Seen from the Villa Medici, The (Corot), 201
Church of Saint-Jacques, Dieppe, The (Pissarro), 417
City on a Rock (Goya), 69, 71
Claude Monet Reading (Renoir), 375
Cliffs at Etretat: Manneporte (Monet), 360
Cliffs at Etretat: Needle and Porte d'Aval (Monet), 360
Cliff Walk, Pourville, The (Monet), 359–60
Climbing Path at the Hermitage, Pontois, The (Pissarro), 407
Clothed Maja, The (Goya), 65–66

Clytemnestra Contemplating the Murder of Agamemnon (Guérin), 46
Colossus (or Panic) (Goya), 69
Complaint of Job, The (Blake), 87
Comte de Turenne (David), 30
Comtesse Regnault de Saint-Jean d'Angély (Gérard), 43
Concert in the Tuileries (Manet), 296–97, 299, 303, 304, 378
Conflagration (Goya), 62
Constable, John, 117, 123–38, 140–44, 146, 147, 149, 185, 202, 204, 206, 212, 213, 218, 227, 228, 243, 246, 336, 337, 353, 392, 393, 405, 407
Copy of Caravaggio's Deposition (Géricault), 173
Copy of Titian's Death of St. Peter Martyr (Géricault), 173, 174, 176, 177
Corinne at Cape Miseno (Gérard), 43
Corner in a Café-Concert (Manet), 307
Cornfield, The (Constable), 133–34
Coronation, The (David), 27, 28
Coronation of Charles X (Gérard), 44
Coronation of Josephine (David), 35, 36, 229–30
Coronation of Maria de Medici (Rubens), 28, 35
Corot, Jean-Baptiste Camille, 199–211, 213–15, 217, 220, 228, 234, 236, 239, 274, 336–37, 348, 389–91, 397, 399–403, 405
Côte des Boeufs at the Hermitage, Pointoise, The (Pissarro), 407–8
Countess Altamira and Her Daughter (Goya), 61
Count François of Nantes (David), 29
Count Fries and His Family (Gérard), 43
Couple Embracing (Géricault), 175
Courbet, Gustave, 209–10, 221, 222, 235, 239–40, 242, 245–47, 249–67, 274, 279–281, 294, 296, 300, 302, 309, 311, 315, 319, 320, 323, 329, 337–40, 346, 348, 351, 353, 354, 370–71, 373, 390, 400–3, 423
Couture, Thomas, 275, 291–92, 423
Cove at St. Thomas, A (Pissarro), 400
Cozens, Alexander, 125
Cozens, John Robert, 139
Creation of Adam (Michelangelo), 259
Cromwell Contemplating the Corpse of Charles I (Delaroche), 282

Croquet Players (Manet), 303
Crossing the Brook (Turner), 145
Cross in the Mountains, The
 (Tetschen Altar) (Friedrich),
 112–14
Crucifixion (Delacroix), 193
Crucifixion (Goya), 60
Crucifixion of St. Peter
 (Michelangelo), 86
Crystal Palace, The (Pissarro),
 405
Cupid and Psyche (David), 30
Cupid Seller, The (Vien), 6
Cup of Chocolate, The (Renoir),
 378
Cup of Tea, The (Degas), 328–29
Customs House, Varengeville,
 The (Monet), 359–60
Cuyp, Aelbert, 146

Dahl, J. C. C., 117
D'Aligny, Caruelle, 201, 202
Dance at Bougival (Renoir), 382
Dance Foyer at the Opera, The
 (Degas), 322
Dance in the City (Renoir), 382
Dance in the Country (Renoir),
 382
Dancer, The (Renoir), 375–76
Dancers at the Practice Bar
 (Degas), 325, 330, 385
Dancing Class, The (Degas), 322,
 324
Dante and Virgil (Delacroix),
 191
Dante and Virgil Entering the
 Inferno (Corot), 207
Daphnis and Chloe (Gérard), 43
Daubigny, Charles François, 143,
 208, 210, 234–36, 337, 348,
 352–54, 390, 399, 400, 402–5
Daumier, Honoré, 229–37, 239,
 245, 246, 264, 321, 424
David, Jacques-Louis, 5–7, 10,
 17–48, 97, 141, 144, 146, 157,
 160, 163, 164, 184, 192,
 229–30, 273, 280, 318
Da Vinci, Leonardo, 107, 209
Dead Bullfighter (Manet), 299
Dead Christ Mourned by the
 Virgin, The (Girodet), 38, 40
Dead Christ with Angels (Manet),
 299
Death (Gérard), 44
Death of Cato, The (Guérin),
 44–45
Death of Earl Goodwin, The
 (Blake), 87
Death of Ezekiel's Wife, The
 (Blake), 87
Death of General Wolfe (West),
 79
Death of Hector (Hamilton), 19
Death of Leonardo, The (Ingres),
 163
Death of Marat (David), 229–30
Death of Marcus Aurelius
 (Delacroix), 192

Death of Patroclus (David), 18
Death of St. Peter Martyr
 (Titian), 193
Death of Sardanapalus
 (Delacroix), 165, 187, 278, 281
Death of Seneca (David), 18
Death of Socrates (David), 21,
 26, 45
Death on a Pale Horse (West), 79
Debucourt, Philibert Louis, 297
Decline of the Carthaginian
 Empire (Turner), 145
Dedham Vale (Constable; 1802),
 125
Dedham Vale (Constable; 1828),
 134–35
Dedham Vale, Morning
 (Constable), 126
Degas, Edgar, 274, 280, 303,
 306–7, 311, 315–31, 336, 355,
 357, 359, 362, 365, 374, 375,
 378, 380, 382, 385, 386, 399,
 404, 408, 409, 411, 417, 434
Degas's Father Listening to the
 Singer Pagans (Degas), 320–21
Déjeuner sur l'herbe (Cézanne),
 423
Déjeuner sur l'herbe, Le (Manet),
 281, 284, 294, 297–98, 303,
 317, 348, 349, 370, 423, 439
Déjeuner sur l'herbe, Le (Monet),
 348–49, 352, 357, 372
Delacroix, Eugène, 80, 132, 137,
 165, 166, 169, 171, 184–96,
 220, 230, 234, 250, 253, 255,
 256, 259, 273, 274, 278, 280,
 281, 316, 317, 368, 369, 373,
 377, 380, 421, 423
Delaroche, Paul, 166, 237, 238,
 282
Denis, Maurice, 388, 436, 440
Departure of Regulus, The
 (West), 78
Departure of the Folkestone Boat,
 The (Manet), 303
Descent of the Cattle from the
 Jura Meadows, The
 (Rousseau), 218–19
Descriptive Catalogue (Blake), 94
Desperate Man, The (Courbet),
 250
Destruction of Sodom (Corot),
 205
Devil's Bridge, Gotthard Pass,
 The (Turner), 141
Diana and Actaeon (Corot), 204
Diana and Apollo Killing the
 Children of Niobe (David), 18
Diana Imploring Jupiter
 (Prud'hon), 52
Diana the Huntress (Renoir),
 370–71, 373, 377
Diaz, Narcisse, 213–15, 221, 233,
 238
Diderot, Denis, 4
Dido Building Carthage, or the
 Rise of the Carthaginian
 Empire (Turner), 145–46, 148

Dinner (Monet), 351
Dioscuroi, 162
Disasters of War, The (Goya),
 67–70
Disparates (or Proverbs) (Goya),
 70–71
Divine Comedy (Dante; Blake,
 illustrator), 96
Divine Comedy (Dante; Flaxman,
 illustrator), 84–85, 97
Divorceuses, Les (Daumier), 234
Doctors of the Church (Goya), 59
Dog Buried in Sand (Goya), 71
Dolbadern Castle (Turner), 141
Dolmen in the Snow (Friedrich),
 111–12
Don Manuel Osorio (Goya), 61,
 300
Don Quixote (Cervantes;
 Daumier, illustrator), 235
Don Quixote (Daumier), 234
Dort or Dordrecht: The Dort
 Packet-Boat from Rotterdam
 Becalmed (Turner), 146
Dream of Ossian, The (Ingres),
 162
Dream of Reason (Goya), 63
Drinkers (Velásquez), 295, 302
Drouais, Jean-Germain, 19–21
Drunkenness of Silenus
 (Daumier), 234
Duchess of Alba Dressed as Maja,
 The (Goya), 63
Duchess of Alba in a White Dress,
 The (Goya), 63
Duck Pond, The (Renoir), 375
Duke and Duchess of Osuna and
 Their Children, The (Goya), 61
Dupré, Jules, 206, 213–15,
 218–21
Durand-Ruel, Paul, 215, 222–23,
 236, 238, 245, 302–3, 329, 343,
 353, 354, 356, 358, 359,
 361–64, 374, 376, 380, 381,
 383, 384, 393, 395–97, 405,
 406, 410–14, 417, 418
Duranty (Degas), 434
Duranty, Edmond, 325
Dürer, Albrecht, 86, 92, 96
Duret, Théodore, 379
Dutch Boats in a Gale (Turner),
 141

Early Snow in Louviciennes
 (Sisley), 391
Eaux-Semblantes at Fresselines
 on the Creuse (Monet), 360
Edge of the Forest at Pierrefonds
 (Rousseau), 218
Edge of the Forest at Sunset
 (Rousseau), 221
Edmondo and Teresa Morbilli
 (Degas), 320
Edward and Elenor (Blake), 88
Elysium, or the State of Final
 Retribution (Barry), 80
Embarkation of the Duchess of
 Angoulême, The (Gros), 37

Embarkation of the Queen of Sheba (Claude), 145
Emigrants (or *Fugitives*) (Daumier), 235
End of the Village of Gréville, The (Millet), 244
Engaged Couple, The (also known as *The Sisley Family*) (Renoir), 372
Enthronement, The (David), 27
Entombment (Delacroix), 193
Entombment of Atala, The (Girodet), 40
Entrance to the Village at Voisins (Pissarro), 405
Entry of Henry IV into Paris (Gérard), 43
Entry of the Crusaders into Constantinople, The (Delacroix), 190
Episode of a Bullfight (Manet), 299
Epsom Downs Derby, The (Géricault), 180, 318
Equestrian Portrait of Count Potocki (David), 18–19, 27
Escape of Rochefort (Manet), 309
Esmeralda Dancing (Renoir), 369
Estelle Musson (Mme René de Gas) (Degas), 323
Estelle Musson (Mme René de Gas) with a Vase (Degas), 323
Europe, a Prophecy (Blake), 90, 92
Evening Star, The (Turner), 149
Executioner Strangling a Prisoner (Géricault), 175
Execution of Hostages (Goya), 301
Execution of Lady Jane Grey, The (Delaroche), 166, 282
Execution of Maximilian, The (Manet), 301–303
Execution of the Doge Marino Faliero, The (Delacroix), 186
Execution of the Hostages, The (The Third of May, 1808) (Goya), 68
Exhausted Doe in the Snow (Courbet), 260
Falls of the Rhine at Schaffhausen, The (Turner), 142
Camille Cardinal, La (Degas), 326
Family of Charles IV, The (Goya), 65, 66
Family of the Infante Don Luis, The (Goya), 61
Fanatics of Tangier, The (Delacroix), 189
*Fantin-Latour, Ignace, 316
*Farington, Joseph, 124
Farm at Montfoucault (Pissarro), 407

Fates, The (Goya), 71
Fatherland (Gérard), 44
Faust (Goethe; Delacroix, illustrator), 187
Female Bather (Pissarro), 414
Ferdinand VII, King of Spain, 66, 69, 72
Festival Upon the Opening of the Vintage of Mâcon, The (Turner), 142
Fielding, Thales, 186
Field of Poppies, The (Monet; 1873), 355
Field of Poppies near Giverny (Monet; 1885), 361
Fields at By (Sisley), 395
Fifer, The (Manet), 300, 372
Fifth Plague of Egypt, The (Turner), 140–41
Fighting Temeraire Towed to Her Last to Be Broken Up, The (Turner), 150–51
Finding of Moses (Manet), 293, 297, 317
Fire Alarm, The (Courbet), 255
Fisher, John, 126, 128, 130, 135, 136
Fishermen at Sea (Turner), 139
Fishing at Saint-Ouen (Manet), 293
Fishing with Rod and Line (Renoir), 376
Flatford Mill (Scene on a Navigable River) (Constable), 129
Flaxman, John, 83–85, 87, 88, 90, 92, 96, 97, 103–4, 160, 162
Flight into Egypt (Corot), 204
Flight of the Witch Asmodea (Goya), 71
Flood at Port-Marly (Sisley), 393–94, 397
Forest of Fontainebleau, The (Corot), 206
Forest of Fontainebleau at Bas-Breau, The (Le Vieux Dormoir) (Rousseau), 219
Forest Scene (Cézanne), 437
Forge, The (Goya), 69, 230
Fount of Hippocrene, The, 261
Four Small Landscapes (Friedrich), 116
Francisco Bayeu (Goya), 63
Frédéric Bazille at His Easel (Renoir), 370
Friedrich, Caspar David, 104, 110–19, 136, 244, 246, 258, 259
Frochet, Prefect of the Seine, 51, 52
Frost on the Heights of Valmondois (Rousseau), 220
Frosty Morning (Turner), 144
Funeral at Ornans (Courbet), 239–40, 242, 254, 255, 257, 259, 260, 264, 266, 348
Funeral of Patroclus (David), 18
Fuseli, Henry, 81–83, 88, 90

Gachet, Paul-Ferdinand, 427
Gagnac, Maurice, 387
Gainsborough, Thomas, 124
Gardener, Afternoon Sun, Eragny, The (Pissarro), 414
Garden of the Princess, The (Monet), 350
Gardens of the Villa d'Este, The (Corot), 205
Gargantua (Daumier), 233
Garnier, Charles, 284
Gauguin, Paul, 336, 399, 409–10, 418
Gavet, Emile, 244
Geffroy, Gustave, 360
General Gérard (David), 30
Genius Guided by Study (Prud'hon), 52
Gens de justice (Daumier), 234
Gentlemen's Race, The: Before the Start (Degas), 318–19
Gérard, François-Pascal, 39, 41–44, 162, 185
Géricault, Théodore, 84, 132, 171–84, 212, 218, 227, 230, 250, 274, 278, 281, 301, 318
Gérôme, Léon, 231, 282, 285, 318
Ghost of a Flea (Blake), 96
Gilles (Watteau), 295
Giorgione, Il, 292, 297, 298
Girardon, François, 383
Girl at the Piano (The Overture to Tannhäuser) (Cézanne), 425
Girl Braiding Her Hair (Renoir), 383
Girls at the Piano (Renoir), 385
Girl Serving Beer (Manet), 307
Girl with Seagulls (Courbet), 262
Girodet, Anne-Louis de Roucy-Trioson, 33, 38–41, 43, 46, 84
Girtin, Thomas, 125, 139
Gladioli (Monet), 355
Gleaners, The (Millet), 230, 241, 242, 244
Gleyre, Charles, 275, 346, 369, 370, 389
Glory (Gérard), 44
Goatherd of Genzano, The (Corot), 205
God Creating Adam (Blake), 91
God Judging Adam (Blake), 91
God the Father (Van Eyck), 160
Golden Age (Ingres), 440
Golding Constable's Flower Garden (Constable), 128
Golding Constable's Kitchen Garden (Constable), 128
Goncourt, Edmond de, 327
Goose Girl, The (Millet), 243
Goujon, Jean, 21
Goya y Lucientes, Francisco José de, 57–73, 82, 83, 97, 230, 294, 295, 298, 300–2
Grain-Sifter, The (Le Vanneur) (Millet), 238

Grand Bather, The (or Valpinçon Bather) (Ingres), 161, 169
Grand Bathers (Renoir), 439–440
Grand Canal, The (Monet), 363
Grand Odalisque (Ingres), 163, 164, 166, 205, 298
Grave, The (Blair; Blake, illustrator), 94
Greased Pole, The (Goya), 61
Great Red Dragon and the Woman Clothed in the Sun (Blake), 94
Greece on the Ruins of Missolunghi (Delacroix), 186–88
Greek Girl Garlanding a Bronze Vase (Vien), 6
Green Park (Monet), 353
Grenouillère, La (Monet), 352, 372, 391
Grenouillère, La (Renoir), 372, 391
Greuze, Jean Baptiste, 169
Gros, Antoine-Jean, 33–37, 40, 67, 84, 172, 173, 184, 273
Grounds of the Château Noir (Cézanne), 437
Guérin, Pierre-Narcisse, 44–48, 141, 171, 184
Guillaumin, Jean Baptiste Armand, 336, 405–7
Guillemet, Antoine, 430
Guillon-Lethière, Guillaume, 217
Guino, Richard, 386
Guitar Player, The (Courbet), 251, 255
Gulf of Marseilles Seen from L'Estaque, The (Cézanne), 431, 433
Gust of Wind, The (Millet), 245–46
Gust of Wind, The (Renoir), 375
Gypsy, The (also known as *Summer, A Study*) (Renoir), 371

Hadleigh Castle (Constable), 134–35
Hagar and Ishmael (Millet), 239
Hagar and the Angel (Claude), 123, 125
Hagar in the Wilderness (Corot), 203–4
Hals, Frans, 292, 294, 303
Hamilton, Gavin, 19, 20, 77–78
Hammock, The (Courbet), 251, 255
Hannibal Surveying the Italian Plains from the Alps (Goya), 58
Hannibal Swearing Never to Make Peace with Rome (West), 79
Hartmann, Frédéric, 221, 245
Harvest, The (Pissarro), 407
Harvesters Resting (Millet), 240
Hasta la muerte (Goya), 69
Hay Bundlers, The (Millet), 239

Haymaking, Eragny (Pissarro), 413–14
Haystacks (Monet), 396
Haystacks, with Moret in the Distance (Sisley), 396
Haystacks at Moret (Sisley), 396
Haystacks series (Monet), 361
Haywain, The (Constable), 131–32, 135, 136, 185, 203, 206
Hecate (Blake), 92
"Hector" (David), 18
Hector's Farewell to Andromache (Hamilton), 77–78
Heliodorus Driven from the Temple (Delacroix), 193
Henry IV and the Spanish Ambassador (Ingres), 163
Hercules and Diomedes (Gros), 37
Hercules and the Bull (Géricault), 178
Hermitage at Pointoise (Pissarro), 403
Hippocrates Refusing the Presents of Artaxerxes (Girodet), 38–39
Hoare, Colt, 140
Hoar Frost (Pissarro), 406
Hobbema, Meindert, 213, 222
Hogarth, William, 233
Homecoming of the Sons (Runge), 103
Homer and the Shepherds (Corot), 205–6
Homer Reciting His Verses to the Greeks (David), 25
Homme machine, L' (La Mettrie), 4
Horse Race in the Bois de Boulogne (Manet), 299
Horse Tamers (Coustou), 177
Horse Tamers (of the Quirinale), 177
House of the Hanged Man, The (Cézanne), 426–27, 433
Houses of Parliament, The (Monet), 363
Huelsenbeck Children, The (Runge), 106
Huet, Paul, 137, 212, 213, 337
Hunters' Picnic (Courbet), 260

Iachimo and Imogen (Barry), 81
Idyll (Don Quixote on the Barbary Coast) (Cézanne), 423
Ile Lacroix, Rouen, Effect of Fog (Pissarro), 412
Ile Saint-Denis, The (Sisley), 392
Iliad (Homer; Flaxman, illustrator), 84, 103–4, 162
Impression: Sunrise (Monet), 335, 354, 355, 363
Infant Oedipus Taken from a Tree, The (Millet), 238
Ingres, Jean Auguste Dominique, 80, 84, 159–70, 186, 205, 220, 250, 253, 262, 273, 274, 280,

Ingres *(cont.)*
285, 298, 316, 317, 328, 330, 381, 383, 440
Injured Jockey, The (Degas), 319
Interior (Degas), 321, 324
Interior of Sens Cathedral (Corot), 210
Interior of the Ruins of Tintern Abbey (Turner), 138
In the Conservatory (Manet), 307–8, 324
In the Tall Grass (Renoir), 376
Iris, Les (Monet), 365
Iris and Morpheus (Guérin), 46
Isabey, Eugène, 212, 213
Italian Comedy (Watteau), 294
Italian Landscape (Corot), 205

Jacob Wrestling with the Angel (Delacroix), 193
Jacque, Charles-Emile, 213–15, 239
Jaffa (Gros), 186
Jallais Hillside near Pontoise, The (Pissarro), 403
James Tissot (Degas), 320
Japonaise, La (Monet), 357
Jean-Baptiste Isabey and His Daughter (Gérard), 42
Jeanne (Spring) (Manet), 309–10
Jephtha's Daughter (Degas), 317
Jerusalem (Blake), 95
Jesus Mocked by the Soldiers (Manet), 299–300
Jewish Captivity in Babylon, The (Millet), 238
Jewish Wedding in Morocco (Delacroix), 189
Jongkind, Johan Barthold, 336, 337, 346, 347, 355
Joseph of Arimathea (Blake), 86
Joseph Recognized by His Brothers (Girodet), 38
Journals (Delacroix), 195
Judgment of Paris (Raphael), 297
Judgment of Paris (Renoir), 386
Judith Slaying Holofernes (Goya), 71–72
Jules Le Coeur in the Forest of Fontainebleau (Renoir), 370
Juliette Courbet (Courbet), 250
Jupiter and Thetis (Ingres), 162
Justice (Gérard), 44
Justice and Divine Vengeance Pursuing Crime (Prud'hon), 52
Justice of Trajan, The (Delacroix), 190
Justinian Drafting His Laws (Delacroix), 186

Keelman Heaving in Coals by Night (Turner), 150
King Lear Weeping Over the Body of Cordelia (Barry), 81
Knife Grinder, The (Goya), 69

Landscape: Composition of Tivoli (Turner), 146
Landscape with Aqueduct (Géricault), 178
Landscape with Boys Fishing (Constable), 127
Landscape with Fishermen (Géricault), 178
Landscape with Roman Tomb (Géricault), 178
Landseer, Sir Edwin Henry, 261
Langland Bay, Morning (Sisley), 397
Langlois, L.-T., 237
Larévellière-Lépeaux, Member of the Directory (Gérard), 43
Large Enclosure Near Dresden, The (Friedrich), 117
Large Morning (Runge), 108–9
Last Communion of St. Joseph of Calasanz, The (Goya), 70
Last Judgement (Michelangelo), 35, 40
Last Night of Troy, The (Guérin), 47
Last Supper (Leonardo da Vinci), 107
Laundresses (Degas), 321
Lavacourt (Monet), 358
Lawerence, Thomas, 186
Leaping Horse, The (Constable), 133, 135
Le Coeur, Jules, 370
Leda and the Swan (Géricault), 176
Leibl, Wilhelm, 264
LeNain, Antoine, 239, 295
LeNain, Louis, 239, 253, 295
Lenoir, Alexandre, 232
Leocadia Standing at a Tomb (Goya), 71–72
Leonardo da Vinci, 107, 209
Leonidas at the Pass of Thermopylae (David), 26, 27, 29, 30
Lepelletier de Saint-Fargeau on His Funeral Bier (David), 24, 42
Leroy, Louis, 335, 336, 355, 406
Leslie, Charles Robert, 136
'Estaque (Cézanne; ca. 1876), 429
'Estaque, Melting Snow (Cézanne; 1870–71), 425
etters (Delacroix), 195
etters on Landscape Painting (Carus), 115
iber Studiorum (Book of Studies) (Turner), 144–45
iberty Leading the People (Delacroix), 188, 190, 230, 234
iber Veritatis (Book of Truth) (Claude), 144
rary for the Chamber of Deputies, Delacroix's paintings or, 191
utenant Legrand (Gros), 36

Light and Color (Goethe's Theory)—The Morning After the Deluge—Moses Writing the Book of Genesis (Turner), 152
Lime Kiln, The (Géricault), 181
Linnell, John, 95
Lion and Cayman (Delacroix), 193–94
Lion Hunts (Delacroix), 193–94
Lise with a Parasol (Renoir), 371
Little Country Maid, The (Pissarro), 409
Little Dancer of Fourteen (Degas), 326–27
Little Sheperd, The (Sunset Landscape) (Corot), 205
Loing Canal, The (Sisley), 396
Lola de Valence (Manet), 294–95
Lone Tree in the Morning Light (Friedrich), 116
Lordship Lane Station, Upper Norwood (Pissarro), 405
Lorrain, Claude, 123–25, 140–42, 145, 147, 148, 204, 207
Lot and His Daughters (Courbet), 250
Lot and His Daughters (Goya), 65
Louis Philippe, King of France, 216, 218, 220, 233, 278
Louis XVI and His Family Seeking Refuge at the Convention on 10 August 1792 (Gérard), 42
Louis XVIII, King of France, 37
Louis XVIII Leaving the Tuileries on Napoleon's Return from Elba (Gros), 37
Loutherbourg, Philippe Jacques de, 139, 140
Louveciennes, the Road to Versailles (Pissarro), 404
Louvre, Morning, Effect of Snow, The (Pissarro), 417
Love Play (Bacchanal) (Cézanne), 428
Love Reduced to Reason (Prud'hon), 50
Lovers, The (Millet), 238
Lovers in the Country, The (Courbet), 250
Lower Norwood, from Sydenham Hill (Pissarro), 405
Lucas, David, 135, 136
Luncheon, The (Monet), 351, 352, 354–55
Luncheon in the Studio (Manet), 302, 304, 310
Luncheon of the Boating Party, The (Renoir), 343, 380–82

Mme Barbier-Valbonne (Gérard), 43
Mme Buron (David), 17–18
Mme Camus (Mme Camus en Rouge) (Degas), 320
Mme Charpentier and Her Children (Renoir), 378–79, 382, 387

Mme Daru (David), 29
Mme David (David), 29
Mme de Moitessier Seated (Ingres), 168
Mme de Moitessier Standing (Ingres), 168
Mme de Pastoret (David), 23
Mme de Sorcy-Thélusson (David), 23
Mme de Verninac (David), 160
Mme d'Orvilliers (David), 23
Mme Gaujelin (Degas), 319
Mme Gobillard-Morisot (Degas), 319–20
Mme Monet Reclining on a Sofa (Renoir), 375
Mme Récamier (David), 26, 43, 163
Mme Récamier (Gérard), 43
Mme Sériziat (David), 25, 160
Mme Tallien (Gérard), 43
Mme Trudaine (David), 23
Mlle Dubourg (Degas), 319, 320
Mlle Fiocre in the Ballet "La Source" (Degas), 321
Mlle Jeanne Samary (Renoir), 379
Mlle Rivière (Ingres), 160
Mlle Victorine in the Costume of an Espada (Manet), 295, 297, 299
Madonna da Foligno (Raphael), 164
Madonna of the Host (Ingres), 166
Madonna of the Sacred Heart, The (Delacroix), 185
Madrid Sketchbook (Goya), 63
Magpie, The (Monet), 351–52
Maillol, Aristide, 388
Majas on a Balcony (Goya), 63, 302
Maja vestida (Goya), 295
Male Torso (Ingres), 158
Mallarmé, Stéphane, 303, 305
Malvern Hall (Constable), 125–26, 128
Mameluke Unhorsed by a Charge of Grenadiers (Géricault), 178
Mandolin Player (Daumier), 235–36
Manet, Edouard, 272, 279–81, 284, 285, 291–312, 315, 317–20, 324, 325, 348, 349, 354–57, 365, 370–73, 375, 376, 378, 380, 390, 404, 405, 423–24, 434, 439
Manet Listening to His Wife Playing the Piano (Degas), 319
Man Grafting a Tree (Millet), 240
Manuel Godoy (Goya), 65, 66
Man with a Glove (Titan), 251
Man with a Hoe (Millet), 242–43
Marat (David), 24, 47

Marcus Aurelius Distributing Food and Medicine in a Time of Famine (Vien), 6
Mardi Gras (Cézanne), 436
Marfisa and Pinabello's Lady (Delacroix), 192
Marietta (Corot), 205
Marine Parade and Chain Pier, Brighton (Constable), 134
Marino Faliero (Delacroix), 186, 187
Markham, Edwin, 243
Marquesa de la Solana (Goya), 63
Marquesa de Pontejos (Goya), 61
Marriage of Heaven and Hell, The (Blake), 89
Mars Disarmed by Venus and the Graces (David), 30–31
Martelli, Diego, 325
Martyrdom of St. Andrew (Champaigne), 166
Martyrdom of St. Symphorian (St. Symphorien) (Ingres), 166, 317
Mary, Queen of Martyrs (Goya), 60
Masked Ball at the Opera (Manet), 303–4
Massacre of Chios (Delacroix), 185, 190, 278
Massacre of the Mamelikes (The Second of May, 1808) (Goya), 68
Matisse, Henri, 388
Mayer, Constance, 52, 53
Meadow of San Isidro (Goya), 61, 62
Meeting, The ("Bonjour, M. Courbet") (Courbet), 257–59
Meeting of Napoleon and Francis II of Austria (Gros), 36
Meissonier, Jean Louis Ernest, 231, 235, 271, 282
Melbye, Anton, 400
Melbye, Fritz, 399–400
Men Fighting with Clubs (Goya), 71
Mengs, Anton Raphael, 57–59, 61
Men Reading a Letter (Goya), 71
Mercury (Bologna), 29, 41
Mer de Glace (Turner), 141
Meurent, Victorine, 298, 300, 304
Michallon, Anchille-Etna, 200, 201, 214
Michelangelo, 35, 40, 86, 90, 91, 92, 175, 176, 232, 259
Michelangelo in His Studio (Delacroix), 194
Milkmaid of Bordeaux (Goya), 72
Miller and His Son, The (Daumier), 234
Millet, Jean-François, 214, 215, 221, 223, 230, 231, 233–35,

Millet *(cont.)* 237–48, 257, 274, 279, 285, 294, 315, 327, 345, 347, 399, 408
Mill Stones in the Park of Château Noir (Cézanne), 437
Milton (Blake), 94
Mist (Sailboat Approaching a Rocky Shore) (Friedrich), 111
Modern Olympia, A (Cézanne), 423–24, 427
Modern Painters (Ruskin), 151
Modo de volar (Goya), 69
Mona Lisa (Leonardo da Vinci), 209
Monet, Claude, 143, 208, 210, 258, 263, 264, 279, 280–81, 286, 302–4, 306, 322, 324, 327, 336, 369–76, 382, 389–93, 395–97, 399, 401, 403–7, 411, 413, 415, 426, 431, 433
Monet Family in the Garden, The (Manet), 304
Monet in His Painting Boat (Manet), 304, 356
Monet Painting in His Garden at Argenteuil (Renoir), 375
Monet's Garden at Vetheuil (Monet), 358
Monk at the Seashore (Friedrich), 149, 258
Monk by the Sea (Friedrich), 113, 115
Monnier, Henri Bonaventure, 232, 233
Monro, Thomas, 138–39
M. Joubert (David), 23
M. Sériziat (David), 160
Montmorency Landscape (Pissarro), 401
Mont Sainte-Victoire (Cézanne; 1885–87), 431–32
Mont Sainte-Victoire (Cézanne; 1902–04), 437
Mont Sainte-Victoire (Renoir), 384
Moonlight, a Study at Milbank (Turner), 139
Moonrise Over the Sea (Friedrich), 116, 117
Moreau, Gustave, 316, 318
Morisot, Berthe, 210, 302, 336, 376, 393, 411
Morning Among the Coniston Fells (Turner), 139
Morning: Dance of the Nymphs (Corot), 207–8
Morning Ride in the Bois de Boulogne (Renoir), 373
Mornings on the Seine (Monet), 362
Mortlake, Early Summer Morning (Turner), 148
Mortlake, Summer Evening (Turner), 148
Mountainous Landscape with Rainbow (Friedrich), 114

Mounted Trumpeter of the Hussars (Géricault), 174
Mount Kolsaas (Monet), 362
Murder, The (Cézanne), 423
Murder in the Rue Transnona (Daumier), 230, 233
Murder of Bishop Liège (Delacroix), 187
Murillo, Bartolomé Esteban, ?
Musicians in the Orchestra (Degas), 322
Mussel Fishers at Berneval (Renoir), 379

Naked Maja, The (Goya), 65,
Nana (Manet), 306
Naples, View of Mount Vesuvi (Turner), 147
Napoleon at the Battle of Arco (Gros), 34
Napoleon at the Battle of Eylc (Gros), 36
Napoleon at the Battle of the Pyramids (Gros), 36
Napoleon Bonaparte, 11, 26–3 34–37, 40–41, 52–53, 66, 68 114–15, 162
Napoleon III, Emperor, 216, 239, 294
Napoleon in His Study (David 29
Napoleon on The Imperial Throne (Ingres), 160, 162
Napoleon Receiving the Keys t Vienna (Girodet), 40
Napoleon Visiting the Plague Hospital at Jaffa (Gros), 35 36
Narni Bridgbe (Corot; 1826), 201–202
Narni Bridgbe (Corot; 1827), *Natural History of the Soul* (I Mettrie), 4
Nebuchadnezzar (Blake), 92
Needles at Port Coton (Monet 360
Negro Scipio, The (Cézanne),
Nemesis Bringing Crime and ! Before the Throne of Justice (Prud'hon), 52
Ne vous y frottez pas (Daumie 233
Newton (Blake), 92
Nightingale's Lesson, The (Runge), 105
Nightmare (Fuseli), 82
Night Thoughts (Young; Blak illustrator), 92
Nightwatch (Rembrandt), 255
Nocturnes (Whistler), 354
Normandy Coast Near Granvi (Rousseau), 218
Nude Bather (Gros), 34
Nude Having Her Hair Combe (Degas), 328–29
Nude Maja (Goya), 298
Nude on the Cushions (Renoir 385

Nude Stepping into the Bath Tub (Degas), 329
Nude with Parrot (Courbet), 370
Nuptials of Hercules and Hebe (Prud'hon), 52
Nursing: Aline and Her Son Pierre (Renoir), 383
Nymph Ravished by a Satyr (Cabanel), 284
Nymphs Pursued by a Satyr (Daumier), 234
Nymph Surprised by a Satyr, A (Manet), 293–94, 297

Oaks Among Rocks in the Forest of Fontainebleau (Rousseau), 222
Oaks at Apremont (Rousseau), 221
Oarsmen at Chatou (Renoir), 380
Oath in the Tennis Court, The (David), 23, 24, 28
Oath of Brutus (Hamilton), 20
Oath of Horatii, The (David), 20–21, 78
Oath of the Tennis Court (David), 42
Odalisque with Slave (Ingres), 166–67
Odyssey (Homer; Flaxman, illustrator), 84, 103–4
Oedipus and the Sphinx (Ingres), 161
Oenone Refusing to Save the Dying Paris (Géricault), 176
Oise near Pontoise, The (Pissarro), 406
Old Fort, Antibes (Monet), 360
Old Hall, East Bergholt (Constable), 124
Old Horatius Defending His Son Before the Roman People, The (David), 19–20
Old Musician, The (Manet), 295–96
Old Woman with Rosary (Cézanne), 437–438
Old Women and Time (Goya), 69
Olympia (Manet), 297–303, 306, 423–24
Opening of the Doors of the Spanish Inquisition, The (Géricault), 182
Opening of Waterloo Bridge, The (Constable), 131, 135–36
Orchard in Bloom (Pissarro), 405
Orchestra of the Opera, The (Degas), 321
Ordeal of Queen Emma, The (Blake), 88
Orgy, The (Cézanne), 423
Origin of the World, The (Courbet), 262
Orlando muerto (attributed to Velásquez), 299
Orvieto (Turner), 148

Ossian Playing the Harp (Gérard), 39, 43, 162
Ossian Receiving the Shades of French Heroes (Girodet), 39–40, 43
Ovid Among the Scythians (Delacroix), 194

Palazzo da Mula (Monet), 363
Palazzo Dario (Monet), 363
Palestrina-Composition (Turner), 148
Palmer, Samuel, 96
Paolo and Francesca (Ingres), 163
Paradise Lost (Milton; Blake, illustrator), 94
Paralytic Woman (Géricault), 180
Paris and Helen (David), 21, 29, 42
Parisian Women Dressed as Algerians (Renoir), 373
Paris Seen from the Terrace of Bellevue (Rousseau), 218
Pastoral Concert (attributed to Giorgione), 297
Pasture in the Auvergne, with Shepherdess Spinning (Millet), 244
Path in the Forest (Renoir), 376
"Patroclus" (David), 18
Paul Alexis Reading to Zola (Cézanne), 425
Pavé de Chailly (Monet), 348
Peace: Burial at Sea (Turner), 151–52
Peace Consoles Mankind and Brings Abundance (Delacroix), 192
Pearl and the Wave, The (Baudry), 297
Peasant Repast (LeNain), 253
Peasants of Flagey Returning from the Fair (Courbet), 255, 260
Peasant Women Resting (Pissarro), 409
Pedicure (Degas), 323
Peintres impressionistes, Les (Duret), 379
Penance of Jane Shore, The (Blake), 88
Penance of St. Chrysostomos (Dürer), 92
Pertuiset, the Lion Hunter (Manet), 309
Pestilence, or the Great Plague of London (Blake), 87
Petworth Lake (Turner), 148
Phaedra and Hippolytus (Guérin), 45, 47
Philip IV as a Hunter (Goya), 61
Philipon, Charles, 232, 233
Philoctetes on the Island of Lemnos (Barry), 80
Philosophy (Prud'hon), 51

Piazza San Marco, Venice (Renoir), 381
Picturesque Views in England and Wales (Turner), 147
Piette, Isidore, 401, 407
Pilgrimage of San Isidro (Goya), 71–72
Pilgrimage to Cythera, A (Watteau), 207
Piper (Géricault), 180
Piroli, Tommaso, 84, 85
Pissarro, Camille, 210, 247, 280, 324, 336, 337, 339, 346, 353, 355, 357, 359, 374, 375, 382, 384, 391, 392, 395, 397, 399–418, 422, 426, 427, 429, 433
"Pity the Sorrows of a Poor Old Man" (Géricault), 180
Place Clichy (Renoir), 380
Place de la Concorde (Degas), 324–25
Place du Chenil, Marly, in the Snow, The (Sisley), 393
Place du Havre, Paris (Pissarro), 413
Place du Théâtre Français (Pissarro), 416
Plague Hospital at Jaffa (Géricault), 179
Pleasure (Prud'hon), 51
Ploughing Scene in Suffolk (Constable), 127
Ploughing Up Turnips at Slough (Turner), 143
Plum, The (Manet), 306–7
Poems (Gray; Blake, illustrator), 92
Pointe de la Hève at Low Tide, The (Monet), 347
Polyphemus (Poussin), 148
Pont au Change, Paris (Corot), 202
Pont des Arts, The (Renoir), 371, 374
Ponte and Castel Sant'Angelo, Rome (Corot), 201
Pont Neuf, The (Renoir), 374–75
Pont Royal and the Pavillon de Flore, The (Pissarro), 417
Poor Family, The (Goya), 61
Pope Pius VII in the Sistine Chapel (Ingres), 163
Pope's Villa at Twickenham (Turner), 143
Poplars Along the Epte River series (Monet), 338, 362, 396
Pork Butcher, The (Pissarro), 409
Port of La Rochelle, The (Corot), 206–7
Portrait of a Carabinier (Géricault), 174
Portrait of a Carabinier with Horse (Géricault), 174
Portrait of Achille Emperaire (Cézanne), 424–25

Portrait of a Kidnapper (Géricault), 182

Portrait of a Kleptomaniac (Géricault), 182

Portrait of a Man Suffering from Delusions of Military Rank (Géricault), 182

Portrait of Ambroise Vollard (Cézanne), 434, 435

Portrait of Ambrose Vollard (Renoir), 385–87

Portrait of Antonin Proust (Manet), 308

Portrait of a Woman Addicted to Gambling (Géricault), 182

Portrait of a Woman Suffering from Obsessive Envy (Géricault), 182

Portrait of Baron Schwiter (Delacroix), 186

Portrait of Bonaparte as First Consul (Ingres), 159

Portrait of Boyer (Man with a Straw Hat) (Cézanne), 426, 430

Portrait of Bruyas (Courbet), 256–57

Portrait of Camille on Her Deathbed (Monet), 358

Portrait of Cézanne's Father Reading L'Evénement (Cézanne), 424

Portrait of Charles III as a Hunter (Goya), 61

Portrait of Cherubini (Ingres), 166

Portrait of Chocquet Seated (Cézanne), 427–28

Portrait of Christine Boyer (Gros), 34–35

Portrait of Constance Mayer (Prud'hon), 52

Portrait of Count Floridablanca (Goya), 60

Portrait of Don Sebastian Martinez (Goya), 62

Portrait of Emile Zola (Manet), 301–2, 305, 320

Portrait of Fournier-Sarloveze (Gros), 36

Portrait of François-Marius Granet (Ingres), 161

Portrait of General Bonaparte (David), 27

Portrait of General Lasalle (Gros), 36

Portrait of Gustave Geoffroy (Cézanne), 434

Portrait of Henri de La Rochejaquelein (Guérin), 47

Portrait of Hortense Valpinçon (Degas), 321–22

Portrait of J.-B. Belley (Girodet), 39

Portrait of Joachim Gasquet (Cézanne), 434

Portrait of Lavoisier and His Wife (David), 21

Portrait of Louis-Auguste Cézanne (Cézanne), 422

Portrait of Louis-François Bertin (Ingres), 165–66

Portrait of Mme Anthony and Her Two Children (Prud'hon), 51

Portrait of Madame Cézanne in a Red Armchair (Cézanne), 428

Portrait of Mme Duvauçay (Ingres), 161

Portrait of Madame Gaudibert (Monet), 351

Portrait of Mme Récamier (David), 158

Portrait of Mme Rivière (Ingres), 159, 161

Portrait of Mme Verninac (David), 26

Portrait of Mlle Romaine Lacaux, The (Renoir), 369

Portrait of Mallarmé (Manet), 305

Portrait of Mlle Ono (Millet), 238

Portrait of M. Anthony (Prud'hon), 51

Portrait of M. Sériziat (David), 25

Portrait of Philibert Rivière (Ingres), 159

Portrait of Pope Pius VII (David), 29

Portrait of Régis Courbet, the Artist's Father (Courbet; 1840), 250

Portrait of Régis Courbet, the Artist's Father (Courbet; 1873), 265

Portrait of Richard Wagner (Renoir), 381

Portrait of the Artist's Parents (Manet), 294

Portrait of the Empress Josephine (Prud'hon), 52

Portrait of the Gardener Vallier (Cézanne), 438

Portrait of the Infante Don Luis (Goya), 61

Portrait of Victor Chocquet (Cézanne), 427

Portrait of Victor Chocquet (Renoir), 377

Portrait of William Sisley (Renoir), 370

Portrait of Zacharie Astruc (Manet), 300, 310

Portraits in an Office—The Cotton Exchange, New Orleans (Degas), 322–23

Portraits of Mme Cézanne (Cézanne), 434

Portraits of the Insane (Géricault), 182

Ports of England (Turner), 147

Postillion at the Door of an Inn (Géricault), 181

Potter, Paulus, 213

Poultry Market, Gisors, The (Pissarro), 409

Poussin, Nicolas, 140, 141, 204, 240, 421, 438

Préault, Antoine Auguste, 233

Presentation of the Eagle Standards (David), 27–29, 41

Priestess Burning Incense on a Tripod (Vien), 6

Princes in the Tower, The (Delaroche), 282

Princess de Broglie (Ingres), 168

Prince Yussupov (Gros), 36

Print Collector, The (Degas), 320

Procession of the Inquisition (Goya), 71

Progress of Love in the Heart of a Young Girl, The (Vien), 6

Promenade, Argenteuil, The (Monet), 354

Promenade, The (Renoir), 372

Proudhon, Pierre Joseph, 254–56, 259, 260, 263

Proudhon and His Family (Courbet), 263–64

Proust, Antonin, 291, 296, 308, 309

Proverbios (Goya), 69

Prud'hon, Pierre-Paul, 49–54, 238

Psyche Carried Off by Zephyr (Prud'hon), 53

Psyche Receiving Cupid's First Kiss (Gérard), 42

Puvis de Chavannes, 318

Pygmalion and Galatea (Girodet), 41

Pylades and Orestes Brought Before Iphigenia (West), 78

Quarry, The (Courbet), 260

Quay of the Louvre, The (Monet), 350

Queen Eleanor, from Her Effigy in Westminster Abbey (Blake and Basire), 87

Queen Maud (Blake), 96

Quinta del Sordo (House of a Deaf Man) (Goya), 71

Racehorses at Longchamp (Degas), 323

Race of the Barberi Horses (Géricault), 177

Raft of the Medusa (Géricault), 149, 171, 179, 185, 186, 194, 230, 278, 281, 301

Railroad, The (Manet), 304, 316 357

Railway Bridge at Argenteuil, The (Monet), 356

Raimondi, Marcantonio, 297

Rain, Steam and Speed—The Great Western Railway (Turner), 152–53, 405

Ramdohr, F. W. B., 113

Rape of the Sabines (Poussin), 21

Raphael, 86, 90, 91, 147, 161, 164, 166, 176, 284, 297, 368, 381
Raphael and the Fornarina (Ingres), 163
Ratapoil (Daumier), 234
Raven, The (Poe; Manet, illustrator), 305
Reclining Nude in Back View (Millet), 238
Reclining Nudes series (Renoir), 385
Recollection of Mortefontaine (Corot), 208
Red Roofs, View of a Village in Winter (Pissarro), 408
Regatta at Moleseye (Sisley), 393
Regnault, Jean-Baptiste, 44
Regulus (Turner), 148, 149
Rehearsal, The (Degas), 325
Rembrandt, 86, 141, 251, 252, 255, 259, 266
Rémond, Joseph, 217
René-Hilaire de Gas (Degas), 316
Renoir, Pierre-Auguste, 258, 281, 303, 304, 322, 327, 335–37, 339, 343, 346, 347, 352–57, 359, 368–392, 397, 403, 404, 411, 417, 431, 433, 439–440
Repose: Portrait of Berthe Morisot (Manet), 302
Republic, The (Daumier), 234
Rest on the Flight to Egypt, The (Runge), 107, 108
Retreat from Russia (Géricault), 178
Return from the Conference, The (Courbet), 261
Return of Belisarius (Guérin), 45
Return of Columbus (Delacroix), 192
Return of Marcus Sextus, The (Guérin), 45, 47, 141
Revolt of Cairo, The (Girodet), 40–41, 68
Reynolds, Sir Joshua, 78, 79, 82, 85, 87, 123, 136
Richard Coeur de Lion (Blake), 96
Rising Gale (Van der Velde), 141
River, The (The Seine at Bennecourt) (Monet), 350–51
Rivers of England (Turner), 147
Road Accident, The (Goya), 61
Road Bridge at Argenteuil, The (Monet), 356
Road from Chailly to Fontainebleau, The (Monet), 347
Road in the Forest of Fontainebleau: Thunderstorm (Rousseau), 222
Road in the Forest with Wood Gatherers (Monet), 347
Road to Louveciennes, Effect of Snow, The (Monet), 352–53

Robert, Leopold, 201
Robert Macaire (Daumier), 233
Roches Noires Hotel at Trouville (Monet), 353
Rocks at Belle-Ile (La Côte sauvage) (Monet), 360
Rodin, Auguste, 433
Roger Saving Angelica from the Dragon (Ingres), 163, 166
Roman Herdsmen (Géricault), 178
Romans of the Decadence (Couture), 292, 423
Rome, the Arch of Constantine (Turner), 147
Rome from the Vatican, Raphael and la Fornarina (Turner), 147
Romulus Victorious Over Acron (Ingres), 162
Rood, Ogden, 410
Roofs of Old Rouen, Gray Weather (Pissarro), 415
Rouen Cathedral series (Monet), 362, 363, 397, 415
Rousseau, Théodore, 137, 202, 206, 213–23, 234, 235, 239, 244–46, 278, 279, 337, 390
Roussel, Ker X., 436, 440
Rowlandson, Thomas, 233
Rubens, Sir Peter Paul, 28, 35, 86, 172, 173, 187, 190, 234, 293, 368, 369, 385, 386
Rue de la Bavolle, Honfleur (Monet), 347
Rue de l'Epicerie, Rouen, La (Pissarro), 416
Rue Mosnier with Flags (Manet), 307
Rue Saint-Denis on the National Holiday, June 30, 1878 (Monet), 357, 415
Ruisdael, Jacob van, 124, 213
Runge, Philipp Otto, 84, 103–9, 111–15, 118, 152
Ruskin, John, 151, 153, 154

Sabine Women Stopping the Battle Between Romans and Sabines, The (David), 25, 26, 51, 280
Sacrifice to Pan (Goya), 58
Sacrifice to Vesta (Goya), 58
Saint-Aubin, Andreas Nicolai de, 297
St. Bernard of Siena Preaching Before King Alfons of Aragon (Goya), 60
Saint-Germain l'Auxerrois (Monet), 350
St. Jerome in the Desert (Corot), 204
Saint-Lazare Railway Station, The (Monet), 357
Saint-Mammès, Cloudy Weather (Sisley), 395
St. Michael's Victory Over the Devil (Delacroix), 193

St. Peter Walking on the Sea (Runge), 107, 112
St. Rochus Interceding for the Plague Stricken (David), 19
St. Sebastian Aided by the Holy Women (Corot), 207
Sts. Justa and Rufina (Goya), 70
St. Stephen and the Holy Women (Delacroix), 193
St. Symphorian (Ingres), 165
St. Theresa (Gérard), 44
Salisbury Cathedral from the Bishop's Grounds (Constable), 132, 135
Salisbury Cathedral from the Meadow (Constable), 135, 202
Salon du Roi, Delacroix's decorations for, 190
Sanlucar Sketchbook (Goya), 63
Sappho, Phaon and Cupid (David), 29
Sargent, John Singer, 363
Satan Exulting Over Eve (Blake), 91
Satirical Portrait of Mlle Lange as Danae (Girodet), 39
Saturn Eating One of His Children (Goya), 71–72
Satyr and Nymph (Géricault), 175–76
Scene of the Deluge, A (Girodet), 40
Scenes from the Life of St. Louis (Guérin), 47
Scenes from the Life of the Virgin (Goya), 59
Scheffer, Ary, 218, 219
Scherzi (Tiepolo), 60
Schnetz, Victor, 201
School of Athens (Raphael), 165
Sculptor, The (Courbet), 250
Sea at L'Estaque, The (Cézanne), 431, 433
Seashore with Fisherman (Friedrich), 111
Seaside at Palavas, The (Courbet), 258
Seasons (Daumier), 245, 246
Seated Bather (Renoir), 386
Seine at Argenteuil, The (Monet), 354
Seine at Argenteuil, The (Renoir), 376
Seine at Port-Marly, Sand Heaps, The (Sisley), 393
Seine Estuary at Honfleur, The (Monet), 347
Self-Portrait (Cézanne; 1861), 422
Self-Portrait (Cézanne; ca. 1865), 422
Self-Portrait (Cézanne; 1879–82), 430
Self-Portrait (Corot; 1825), 201
Self-Portrait (David; 1791), 23
Self-Portrait (David; 1795), 24–25
Self-Portrait (Degas; 1855), 316

Self-Portrait (Friedrich; ca. 1800), 111
Self-Portrait (Géricault; 1808), 171
Self-Portrait (Goya; 1815), 69
Self-Portrait (Ingres; 1804), 159, 161, 316
Self-Portrait (Ingres; 1850), 159
Self-Portrait (Millet; 1840–41), 238
Self-Portrait (Pissarro; 1903), 417
Self-Portrait as Cellist (Courbet), 251
Self-Portrait at the Drawing Table (Runge), 103
Self-Portrait in Prison (Courbet), 265
Self-Portrait with Black Spaniel (Courbet), 250
Self-Portrait with Leather Belt (Courbet), 250–51
Self-Portrait with Pipe (Courbet), 251, 255
Seller of Marionettes (Goya), 62
Semiramis Building the City of Babylon (Degas), 318
Sensier, Alfred, 221, 243, 244
Sente de Justice, The (Pissarro), 406
Sermon of St. Denis, The (Vien), 6
Seurat, Georges, 384, 410–11
Shade and Darkness—The Evening of the Deluge (Turner), 152
Sheepshearers (Millet), 242
Shepherdess, The (Young Peasant Girl with a Stick) (Pissarro), 409
Shepherdess Guarding Her Flock (Millet), 243
Ships Bearing Up for Anchorage (Turner), 142
Shipwreck (or Flood) (Goya), 62
Shipwreck, The (Turner), 142
Shipwrecked Men Abandoned in a Boat (Delacroix), 194
Shipwreck in Greenland (Friedrich), 117
Shipwreck of Don Juan (Delacroix), 194
Sieyès (David), 30
Signac, Paul, 336, 411
Silvestre, Théophile, 223
Sisley, Alfred, 210, 303, 336, 337, 339, 343, 346, 347, 354, 356, 357, 359, 369, 370, 372, 374, 376, 382, 389–99, 411
Sisley Family, The (also known as *The Engaged Couple*) (Renoir), 372
Sistine Madonna (Raphael), 164
Skating (Manet), 306
Slavers Throwing Overboard the Dead and Dying—Typhoon Coming On (The Slave Ship) (Turner), 151
Slaying of Camilla (David), 19

Sleep (Les Dormeuses) (Courbet), 262
Sleeping Girl (Girl with Cat) (Renoir), 379
Sleeping Nude Woman (Ingres), 163, 166
Sleeping Spinner, The (Courbet), 256, 259
Sleep of Endymion, The (Girodet), 38–40, 46, 50–51
Small Bridge, The (Bridge at Maincy) (Cézanne), 430
Small Meadows at By in the Spring (Sisley), 396
Small Morning (Runge), 108–9
Smith, John Thomas, 123
Snowstorm: Hannibal and His Army Crossing the Alps (Turner), 144, 145, 152
Snowstorm—Steamboat Off a Harbor's Mouth Making Signals in Shallow Water and Going by the Lead (Turner), 152
Social Turpitudes, The (Pissarro), 412
Somer-Hill, the Seat of W. F. Woodgate Esq. (Turner), 143–44
Songs of Innocence and of Experience (Blake), 89
Soulier, Raymond, 185
Soul Reunited with God, The (Blake), 95
Source, La (The Fountain) (Ingres), 169
Source, The (Renoir), 385
Source of the Loue (Courbet), 263
Souvenir de Marcoussis (Corot), 208
Souvenir of Volterra (Corot), 204
Sower, The (Millet), 239
Spanish Ballet (Manet), 294
Spanish Singer, The (Manet), 294
Spartan Boys and Girls Exercising (Les Filles Spartiates) (Degas), 317–18, 327
Spring (Goya), 61
Spring (Millet), 246
Spring (Rousseau), 219–20
Spring, Plum Trees in Blossom (Pissarro), 408
Spring in Giverny (Monet), 361
Springtime: Aspen and Acacias (Sisley), 396
Staffa: Fingal's Cave (Turner), 149, 152
Stag at Bay (Courbet), 261
Stag at Bay (Landseer), 261
Stagecoach at Louveciennes, The (Pissarro), 404
Stages of Life, The (Friedrich), 117–18, 151
Start of the Horse-Race (Degas), 318

Steuben, Charles, 249
Still Life (Pissarro), 403
Still-Life (Quarter of Beef) (Monet), 346
Still-Life of Apples, Pears, and Primroses (Courbet), 265
Still-Life with Apples and Oranges (Cézanne), 433
Still-Life with Basket of Apples (Cézanne), 433
Still-Life with Carafe, Wine Bottle and Bread (Monet), 346
Still-Life with Compotier (Cézanne), 430
Still-Life with Curtain and Flowered Pitcher (Cézanne), 433
Still-Life with Dead Heron (Sisley), 390
Still-Life with Fruit Basket (Cézanne), 432
Still-Life with Onions and Bottle (Cézanne), 433
Still-Life with Peppermint Bottle (Cézanne), 433
Stone-Breakers (Courbet), 230, 239–40, 254–55, 259, 260, 264, 281
Stour Valley, with Dedham in the Distance, The (Constable), 127
Strafford Led to Execution (Delaroche), 282
Stratford Mill (Constable), 130–32
Straw Dummy, The (Goya), 62
Stream at Robec (Monet), 354
Street Singer, The (Manet), 295
Strolling Actors (Goya), 62
Studio, The ("A Real Allegory Summing Up Seven Years of My Artistic Life") (Courbet), 258–60, 262–63, 266, 296, 323, 348
Studio in the Batignolles Quarter, A (Monet), 353
Study (Nude in the Sunlight) (Renoir), 377, 381
Study for the Déjeuner sur l'herbe (Monet), 348
Study of Dissected Limbs (Géricault), 180
Study of Two Severed Heads (Géricault), 180
Sueños (Dreams) (Goya), 63
Sufferings of the City of Orléans, The (Scene of War in the Middle Ages) (Degas), 318, 319
Sulking (The Banker) (Degas), 324
Sultan of Morocco Surrounded His Court (Delacroix), 192
Summer, a Study (also known *The Gypsy*) (Renoir), 371
Summer (Buckwheat Harvest) (Millet), 246
Summer (Friedrich), 112

Sun Rising Through Vapour;
Fishermen Cleaning and
Selling Fish (Turner), 143, 145
Sunset Near Arbonne (Rousseau),
222
Suveé, Joseph-Benoit, 17
Swing, The (Goya), 61
Swing, The (Renoir), 378

Tanguy, Julien "Père," 427
Tapestry Weavers (Velásquez),
257
Tasso in the Madhouse
(Delacroix), 194
Tauromaquia, La (The Art of
Bullfighting) (Goya), 70
Telegraph Tower, Montmartre
(Rousseau), 217
Temptation of Adam and Eve
(Barry), 80
Temptation of St. Anthony
(Cézanne), 428
Terrace at Sainte-Adresse
(Monet), 350
Testament of Eudamidas
(Poussin), 19
Thames and the Houses of
Parliament, The (Monet), 353
Theater Box, The (La Loge)
(Renoir), 375
Thoughts on the Imitation of
Greek Works in Painting and
Sculpture (Winckelmann), 8
Three Ladies of Ghent (David),
30
Three Mounted Trumpeters
(Géricault), 172–73
Three Women Bathers (Cézanne),
430
Three Women Seated on a Divan
(Degas), 326
Tiepolo, Giovanni Battista,
57–60, 284
Tiger Hunt (Delacroix), 193–94
Times of Day (Prud'hon), 51
Times of Day, The (Runge),
105–6, 109
Tissot, James, 305, 318
Titian, 141, 193, 292, 298, 300,
306, 368, 385
Toilet of Venus (Velásquez), 66
Toilette, La (Landscape with
Figures) (Corot), 209
Tormentor Laughing at the Tears
He Has Caused (Prud'hon), 51
Toulouse-Lautrec, 306
Tow Path, The (Pissarro), 402
Traviès de Villers, Charles
Joseph, 232, 233
Tréhot, Lise, 370–74
Trellis, The (Young Girl
Arranging Flowers) (Courbet),
262, 319
Triumph of Amor (Runge), 105
Triumph of Bonaparte, or
"Peace," The (Prud'hon), 51
Triumph of Caesar (Mantegna),
162

Triumph of Flora (Cabanel), 284
Triumph of Galatea (Raphael),
284
Triumph of Silenus (Géricault),
176
Triumph of Woman (Cézanne),
428
Trout, The (Courbet), 265
Troyon, Constant, 213–15, 238,
346
Trumpeter of the Polish Lancers
on a Rearing Horse
(Géricault), 173
Tub, The (Degas), 328–29
Tuileries Gardens (Pissarro), 416
Turkish Bath, The (Ingres), 169,
262
Turner, Joseph Mallord William,
138–54, 203, 204, 353, 405
Turning Road, The (Cézanne),
430
Twenty-Four Horses in Rear View
(Géricault), 172
Two Laundry Women (Degas),
327
Two Men by the Sea at Moonrise
(Friedrich), 115
Two Men Contemplating the
Moon (Friedrich), 116
Two Old Men (Goya), 71
Two Old People Eating Soup
(Goya), 71
Two Young Peasant Women in
Conversation (Pissarro), 414

Ulysses Deriding Polyphemus
(Turner), 148–49
Umbrellas, The (Renoir), 383
Uncle Dominique (Cézanne), 422
Under the Beech Trees ("Le
Curé") (Rousseau), 219–20
Unhappy Family (Mayer and
Prud'hon), 51
Union of Love and Friendship,
The (Prud'hon), 50
Unloading Coal (Monet), 356
Uprising, The (Daumier), 234

Valadon, Suzanne, 382
Valenciennes, Pierre-Henri, 212
Valley Farm, The (Constable),
136
Valley of Tiffauge, The
(Rousseau), 219
Valpinçon Bather (Ingres), 328,
383
Van der Velde, William, 140–
142
Van Dyck, Sir Anthony, 172,
173
Van Gogh, Vincent, 219, 223,
244, 247, 336, 399
Various Subjects Drawn fom Life
and on Stone (Géricault), 180
Various Subjects of Landscape,
Characteristic of English
Scenery (Constable), 135
Varley, John, 95

Velásquez, Diego Rodriguez de
Silva, 60, 61, 66, 251, 257,
259, 292–95, 298–300, 302
Velásquez in the Studio (Manet),
293
Venice, San Giorgio Maggiore
(Turner), 146–47
Venice (Turner), 150
Ventre Législatif (Daumier), 233
Venus Anadyomène (Ingres), 169
Venus and Adonis (Prud'hon), 53
Venus Mourning Adonis (Goya),
58
Venus of Urbino (Titian), 298,
300
Venus Rising from the Sea
(Barry), 80
Venus Victorious (Renoir), 386
Venus Wounded by Diomedes
(Ingres), 159
Vernet, Claude-Joseph, 171, 178
Vernet, Horace, 280
Vernet, Joseph, 111, 139
Veronese, Paolo, 190
Versailles Road, Louveciennes, in
the Rain, The (Pissarro), 404
Vesuvius, Morning (Renoir), 381
Victory Returning from Trafalgar,
The (Turner), 142
Vien, Joseph-Marie, 5–7, 17–19
View from My Window, Eragny
(Pissarro), 411
View from the Forest of
Fontainebleau (Rousseau),
220–21
View of Auvers (Cézanne), 427
View of Florence from the Boboli
Gardens (Corot), 203
View of Genoa from Acqua Sola
(Corot), 203
View of Montmartre (Sisley), 390
View of the Boulevard des
Capucines (Monet), 355, 413
View of the Colosseum from the
Farnese Gardens (Corot), 201
View of the Colosseum Through
the Arcades of the Basilica of
Constantine (Corot), 201
View of the Forest of
Fontainebleau (Corot), 203
View of the Forum from the
Farnese Gardens (Corot), 201
View of the Luxembourg Gardens
(David), 25
View on the Stour Near Dedham
(Constable), 132
View over the Elbe Valley
(Friedrich), 112
Village of Bécquigny, The
(Rousseau), 222
Village Street in Marlotte (Sisley),
390
Ville d'Avray, the Cabassud
Houses (Corot), 403
Vincent, François-André, 17
Virgil Reading the Aeneid Before
Augustus, Livia and Octavia
(Ingres), 163

Virgin of the Harvest (Delacroix), 185

Viscountess d'Haussonville (Ingres), 168

Visions of the Daughters of Albion (Blake), 89

Vollard, Ambroise, 433

Volterra, the Citadel (Corot), 203

Von Schwind, Moritz, 251

Vow of Louis XIII, The (Ingres), 164

Walton Bridge (Turner), 143

Wanderer Above a Sea of Mist (Friedrich), 115

War: The Exile and the Rock Limpet (Turner), 151–52

War Unchained by an Angel, Fire, Pestilence, and Famine Following (Blake), 87

Washerwoman (Renoir), 384

Water Carrier, The (Goya), 69

Watering Place at Montfoucault, The (Pissarro), 407

Watering Place at Port-Marly (Sisley), 393

Water-Lilies (Nymphéas, Paysage d'Eau) (Monet), 364–65

Waterloo Bridge (Monet), 363

Waterworks at Marly, The (Sisley), 392, 393

Watteau, (Jean) Antoine, 207, 294, 295

Wave, The (Courbet), 264

Way to Calvary, The (Delacroix), 193

Wealth (Prud'hon), 51

Wedding (Goya), 62

Weislingen Captured (Delacroix), 192

Welsh Coast, South-West Wind (Sisley), 397

West, Benjamin, 78–79

We Three (Runge), 106

Weymouth Bay (Constable), 128

Whistler, James Abbott McNeill, 263, 264, 354

White Horse, The (Constable), 130, 131

Wilson, Richard, 124, 140

Winckelmann, Johann Joachim, 7–8

Windsor Castle from the Thames (Turner), 143

Winter (Faggot Gatherers) (Millet), 246

Winter (Friedrich), 112

Winter (Goya), 61

Winter, the Plain of Chailly (Millet), 244

Wisdom and Truth, Descending to Earth, Dispel the Darkness That Covers It (Prud'hon), 51

Witches' Sabbath (Goya), 71–72

Wivenhoe Park (Constable), 128

Woman Adjusting Her Garter (Manet), 307

Woman and Child at a Well (Pissarro), 409

Woman at the Window (Friedrich), 116

Woman Carrying a Child (Daumier), 236

Woman Getting Out of the Bath (Degas), 328

Woman in the Sunrise (Friedrich), 115

Woman in the Tub (Manet), 307

Woman Ironing, Seen Against the Light (Degas), 327

Woman Leaving the Tub, Drying Herself (Degas), 329

Woman of Algiers (Renoir), 373

Woman with a Parrot (Manet), 301–303, 349, 372

Woman with a Pearl (Corot), 209

Woman with Chrysanthemums (Mme Hertel) (Degas), 319, 321

Woman with Coffee Pot (Cézanne), 435

Woman with Parrot (Courbet), 262, 264, 281

Women Bathers (Cézanne; 1900–05), 439

Women Bathers (Cézanne; 1904–06), 439

Women in a Café, Boulevard Montmartre (Degas), 326

Women in the Garden (Monet), 349, 371, 404

Women Mocking a Man (Goya), 71

Women Sifting Grain (Courbet), 257, 259

Worshippers at the Door of a Church (Géricault), 177

Wounded Cuirassier Leaving the Field of Battle (Géricault), 174–78

Wounded Man, The (Courbet), 250

Wounded Mason, The (Goya), 61

Wrestlers, The (Courbet), 256, 260

Wright, Joseph (Wright of Derby), 139, 140

Yard of a Lunatic Asylum (Goya), 62

Young Bride in Greek Costume at Her Toilet (Vien), 6

Young Greek Girl Comparing Her Breast to a Rose Bud (Vien), 6

Young Ladies of the Village Giving Alms to a Cow Girl (Courbet), 255–57, 259, 260

Young Ladies on the Banks of the Seine (Renoir), 373

Young Ladies on the Banks of the Seine ("Summer") (Courbet), 260, 297

Young Tiger Playing with His Mother (Delacroix), 193–94

Young Woman in Spanish Costume Reclining on a Couch (Manet), 295

Young Women Under a Sun Umbrella (Goya), 69

Zephyr (Prud'hon), 53

Zeus (Flaxman), 160

Zola, Emile, 291, 298, 301–303, 310, 321, 345, 350, 357, 370, 403, 421–23, 429–31, 438

Zola (Manet), 434

Zoubaloff Sketchbook (Géricault), 175

Zuiderkerk at Amsterdam, The (Monet), 353

Zurbarán, Francisco de, 238, 252